for Bob
Cordially,
just as we are starting together
on the next one!

John

N.Y. February 1985

The A. W. Mellon Lectures in the Fine Arts

DELIVERED AT THE NATIONAL GALLERY OF ART, WASHINGTON, D.C.

1952 Creative Intuition in Art and Poetry *by Jacques Maritain*
1953 The Nude: A Study in Ideal Form *by Kenneth Clark*
1954 The Art of Sculpture *by Herbert Read*
1955 Painting and Reality *by Etienne Gilson*
1956 Art and Illusion: A Study in the Psychology of Pictorial Representation *by E. H. Gombrich*
1957 The Eternal Present: I. The Beginnings of Art. II. The Beginnings of Architecture *by S. Giedion*
1958 Nicolas Poussin *by Anthony Blunt*
1959 Of Divers Arts *by Naum Gabo*
1960 Horace Walpole *by Wilmarth Sheldon Lewis*
1961 Christian Iconography: A Study of its Origins *by André Grabar*
1962 Blake and Tradition *by Kathleen Raine*
1963 The Portrait in the Renaissance *by John Pope-Hennessy*
1964 On Quality in Art *by Jakob Rosenberg*
1965 The Origins of Romanticism *by Isaiah Berlin*
1966 Visionary and Dreamer: Two Poetic Painters, Samuel Palmer and Edward Burne-Jones *by David Cecil*
1967 Mnemosyne: The Parallel between Literature and the Visual Arts *by Mario Praz*
1968 Imaginative Literature and Painting *by Stephen Spender*
1969 Art as a Mode of Knowledge *by J. Bronowski*
1970 A History of Building Types *by Nikolaus Pevsner*
1971 Giorgio Vasari: The Man and the Book *by T. S. R. Boase*
1972 Leonardo da Vinci *by Ludwig H. Heydenreich*
1973 The Use and Abuse of Art *by Jacques Barzun*
1974 Nineteenth-century Sculpture Reconsidered *by H. W. Janson*
1975 Music in Europe in the Year 1776 *by H. C. Robbins Landon*
1976 Aspects of Classical Art *by Peter von Blanckenhagen*
1977 The Sack of Rome, 1527 *by André Chastel*
1978 The Rare Art Traditions *by Joseph Alsop*
1979 Cézanne and America *by John Rewald*
1980 Principles of Design in Ancient and Medieval Architecture *by Peter Kidson*
1981 Palladio in Britain *by John Harris*
1982 The Burden of Michelangelo's Painting *by Leo Steinberg*
1983 The Shape of France *by Vincent Scully*
1984 Painting as an Art *by Richard Wollheim*
1985 The Villa in History *by James S. Ackerman*
1986 Confessions of a Twentieth-Century Composer *by Lukas Foss*
1987 Imago Dei: The Byzantine Apologia for the Icons *by Jaroslav Pelikan*

John Rewald

Cézanne and America

DEALERS, COLLECTORS, ARTISTS AND CRITICS
1891-1921

with the research assistance of
Frances Weitzenhoffer

The A. W. Mellon Lectures in the Fine Arts, 1979

The National Gallery of Art
Washington, D.C.

Bollingen Series XXXV · 28

Princeton University Press

Copyright © 1989 by the Trustees of the National Gallery of Art,
Washington, D.C.
Published by Princeton University Press, 41 William Street,
Princeton, New Jersey 08540

This is the twenty-eighth volume of the A. W. Mellon Lectures in
the Fine Arts, which are delivered annually at the National Gallery
of Art, Washington. The volumes of lectures constitute Number
XXXV in Bollingen Series, sponsored by Bollingen Foundation

Manufactured in the German Democratic Republic
Published in Great Britain by Thames and Hudson Ltd, London

Library of Congress Cataloging-in-Publication Data

Rewald, John, 1912–
 Cézanne and America.

 (A. W. Mellon lectures in the fine arts: 1979)
(Bollingen series; XXXV, 28)
 Bibliography: p.
 Includes index.
 1. Cézanne, Paul, 1839–1906—Criticism and interpretation.
 2. Cézanne, Paul, 1839–1906—Appreciation—United States.
 I. Title. II. Series. III. Series: Bollingen series; 35, 28.
ND553.C33R374 1989 759.4 88-22578
ISBN 0-691-09960-X

Contents

Foreword 7

Dramatis Personae 10

I Unpromising Beginnings 11

II Slow Progress 31

III The Steins and their Circle 53

IV Ambroise Vollard · Cézanne at the Salon d'Automne ·
The Death of Cézanne 89

V Posthumous Exhibitions and American Reactions 107

VI Polemics · Cézanne's First Show in New York 129

VII Sales and Purchases · Preparations for the Armory Show 155

VIII Cézanne at the Armory Show 179

IX An Avalanche of Writings 211

X Willard Huntington Wright 237

XI Exit Leo Stein 247

XII Albert C. Barnes · The Not So Noble Buyer 263

XIII The War Years 281

XIV Cézanne in the Most Insulted and Exalted Ranks 311

Epilogue 337

List of Illustrations 346

Index 349

RELATIVE VALUE OF THE DOLLAR

The values of the dollar and the French franc fluctuated considerably during the period covered by this book, and do not relate to their values of today. This note may facilitate the translation of given amounts at a particular time into their present value.

When Cézanne's paintings reached comparatively high prices at the Chocquet sale of July 4, 1899, the American *Art Collector* (of Sept. 1, 1899) translated some of these prices as follows:

	1899	1987
Mardi Gras (Venturi 552), F.F. 4,400	$880	$35,200
Le Petit Pont (Venturi 396), F.F. 2,200	$440	$17,600
Un Dessert (Venturi 197), F.F. 3,500..................	$700	$28,000
Les Pêcheurs (Venturi 243), F.F. 2,350................	$466	$18,640
Pommes et gâteaux (Venturi 196), F.F. 2,000........	$400	$16,000

On the other hand, the value of the dollar around 1900 corresponded to roughly $40 of today. Between 1900 and 1910, the dollar's value decreased to $36 of today; by 1920 the corresponding value of the dollar was down to $20 of today and was worth F.F. 12.

This table has been established with the gracious help of David T. Schiff, A. Max Weitzenhoffer, Jr., and Malcolm H. Wiener, all of New York City.

Foreword

THIS STUDY is not concerned with Paul Cézanne's influence on American artists – a thorough and scholarly investigation of which has not yet been made – but instead explores the slow process through which Cézanne became known in America. Its purpose is to *relate* – to narrate, as well as to establish links between separate facts – a wealth of not always obviously connected data from which, it is hoped, a coherent story will emerge. This story concentrates essentially on Cézanne's initial reception by Americans, expatriates or not, and traces the role played by his first admirers – whether artists, collectors, dealers, journalists, or historians – in his step-by-step conquest of the New World. Some of the signal events of that conquest, such as Alfred Stieglitz's first exhibition of Cézanne's watercolors in 1910 in New York, or the historic Armory Show of 1913, are already well known and well documented. Yet they are by no means isolated elements, but part of a chain that spans decades. Here they are assigned their places in a succession of events, rather than singled out or detached from the general cultural background.

Since no research of this type had yet been undertaken, either for Cézanne or for any other European artist, this project required sifting through a great mass of material, separating the essential from the trivial, stressing aspects or contributions hitherto overlooked, and "balancing" the resulting story in such a way that each important event and each participant would find their logical place in the overall account. I am less concerned with possibly having exaggerated the roles of some (although I have aimed at giving everyone his due) than I am with having overlooked some who deserve more consideration.

A major problem in undertaking this project was the fact that this subject is not a circumscribed one. Almost anything connected with the world of modern art at the turn of this century – not only in the United States, but also in England and Europe – can, in one way or another, be related to Cézanne. The task of selection turned out to be a critical one, for, it soon became clear, countless articles and other writings of a serious nature and of considerable importance have not yet been brought to light. To deal properly with them meant, in some cases, reproducing them at length. There were also ridiculous and long-forgotten treatises that could not be ignored; while they might deserve oblivion, they are nevertheless part of an all-embracing narrative. For every impatient reader, there may be another who will find in these documents information of value.

To put some kind of order into the rich material, it seemed advisable to arrange it, as far as possible, chronologically, thus better acquainting the reader with the

advancement of Cézanne's reputation in America. In some instances, however, it was necessary to break this pattern to explore fully a specific subject. It was, in the end, the nature of the documents themselves that dictated the manner of their presentation in these pages.

This project originated as the A. W. Mellon Lectures in the Fine Arts delivered in 1979 at the National Gallery of Art, Washington, D.C. The first chapters of this book – drastically compressed – formed a series of six one-hour talks. But the lecture format could not cover the period from the arrival of the first two paintings by Cézanne in the United States in 1891 to his triumphant inclusion in the "Loan Exhibition of Impressionist and Post-Impressionist Paintings" at New York's Metropolitan Museum of Art exactly thirty years later. Nor could the lectures accommodate the numerous quotes from documents of the period, which, far better than secondhand reports, provide the flavor of those bygone days. Thus the manuscript grew to its present size. Two chapters included here – on the Steins and Cézanne, and on Leo Stein's last years – have since been delivered, shortened and condensed, as the Walter Neurath Memorial Lecture at Birkbeck College of the University of London and have been published as a small booklet under the title *Cézanne, The Steins and Their Circle* by Thames and Hudson of London in 1987.

During the years devoted to the preparation of this book, I used aspects of the subject as the basis for seminars at the Graduate Center of the City University of New York. My students enthusiastically began to hunt in many different directions for further material; their discoveries often proved useful, and their contributions are acknowledged in the relevant notes. I am grateful for their help, as well as for that of many friends.

My most profound thanks go to my former student Frances Weitzenhoffer. From the time the general plan for this project was conceived, she systematically gathered newspaper accounts, archival documents, exhibition catalogs, reviews, and countless previously unexplored sources with never-flagging energy. Her participation and contributions were such that a "footnote credit" could not possibly do them justice; without them the manuscript would have taken several more years to complete (provided I had had the courage to undertake the task for which she graciously volunteered).

Among the many others who have offered generous help I am anxious to name especially Francis M. Naumann, to whom I owe particularly the knowledge of a great wealth of articles by Willard Huntington Wright. Thanks to this still uncollected material, Wright can assume in these pages the important position he deserves. It is a privilege to establish the rightful place of a man whose splendid, pioneering role has gone almost unnoticed; this is even more rewarding because so many chapters of this book had to be devoted to negative assessments of Wright's totally insensitive contemporaries. Like Francis M. Naumann, Irene Gordon, my friend and always devoted editor, has provided me with a great deal of little-known material, this time concerning the numerous writings of Leo Stein, of which at least one – and a crucial one at that – is, through the tyranny of microfilming, no longer available in any New York City library.

I am also deeply grateful to Philippa Calnan for her generosity in lending me the few diary-notebooks of her grandfather Charles Loeser that escaped destruction

during World War II. Mrs. Pare Lorentz communicated valuable data and documents concerning her parents, Eugene and Agnes Ernst Meyer. My friend, the late Charles Durand-Ruel, gave me unrestricted access to the Paris archives of the Durand-Ruel galleries, which are a true mine of information, as are the archives of the Bernheim-Jeune gallery in Paris which were opened to me by MM. Henry and Jean Dauberville and the use of which was greatly facilitated by the patient and ingenious help tirelessly offered by M. Gilbert Gruet.

My colleagues Professors Ernest Samuels, Evanston, Illinois; Meyer Schapiro, New York; Arnold T. Schwab, Los Angeles; Milton W. Brown, New York, and William H. Gerdts, New York, were extremely kind in offering essential help. My specific debts to them are acknowledged in the notes; these are admittedly numerous and possibly cumbersome, but since there is no literature devoted more or less exclusively to the subject of this book, it did not seem advisable (or useful) to try to establish a bibliography. Instead, the notes will lead the researcher to the many and often unconnected sources from which the information provided here was drawn.

Among those who supplied me with recollections, documents, or other data and who are named in the notes are especially Ms. Ann B. Abid, St. Louis; Mme. Hélène Adhémar, Paris; the late Dr. Ruth Bakwin, New York; Ms. Vivian Barnett, New York; Mrs. Doreen Bolger Burke, New York; John Cauman, New York; the late Anthony M. Clark, New York; Ms. Joanna Clifford, London; Pierre Daix, Paris; Ms. Nancy Daves, New York; Monroe Denton, New York; Roland Dorn, Mannheim; Dominique Fabiani, Paris; Everett Fahy, New York; Walter Feilchenfeldt, Zurich; George G. Frelinghuysen, Hawaii; Ms. Gail Gelburd-Kimler, New York; Mme Dominique Godinau, Paris; Ms. Elizabeth H. Hawkes, Wilmington, Delaware; Herbert Henkels, Leiden; the late Mme Edouard Jonas, Paris; Robert Kirsh, New York; Bernd Krimmel, Darmstadt; Denis Longwell, New York; Ms. Patricia Mainardi, New York; Ms. Violette de Mazia, Merion, Pennsylvania; Ms. Patricia Pellegrini, New York; Mrs. Sandra Phillips, Annandale-on-Hudson; Antoine Salomon, Paris; Étienne J. P. Spire, Aix-en-Provence; Mrs. Jayne Warman, New York; Richard Wattemaker, Flint, Michigan; Daniel Wildenstein, Paris; Ms. Marion Wolf, New York; James N. Wood, Chicago.

It gives me profound pleasure to close this list with the names of a few friends of many years whose advice is always welcome and whose help is always deeply appreciated. It was the knowledge that I could count on them that gave me the temerity to undertake this project. They are the late Jean Adhémar of Paris, Sir Lawrence Gowing of London, and the editor for the English edition of this book, Nikos Stangos.

New York, February 1987

Dramatis Personae

Chocquet, Victor	1821–1891	Mather, Frank Jewett, Jr.	1868–1953
Durand-Ruel, Paul	1831–1922	Bernard, Émile	1868–1941
Degas, Edgar	1834–1917	Matisse, Henri	1869–1954
Cézanne, Paul	1839–1906	Quinn, John	1870–1924
Redon, Odilon	1840–1916	Glackens, William	1870–1938
Cassatt, Mary	1845–1926	Denis, Maurice	1870–1943
Chase, William Merritt	1849–1916	Bernheim-Jeune, Josse [Joseph] Jan.	1870–1953
Pellerin, Auguste	1852–1929	Bernheim-Jeune, Gaston [de Villers] Dec.	1870–1941
Ruckstull, F. Wellington	1853–1942	Morosov, Ivan A.	1871–1921
Shchukin, Sergei	1854–1926	Cézanne, Paul, *fils*	1872–1948
Havemeyer, Louisine	1855–1929	Barnes, Albert C.	1872–1951
Huneker, James Gibbons	1857–1921	Stein, Leo	1872–1947
Montgomery Sears, Mrs. Joshua [Sarah Choate]	1858–1935	Stein, Gertrude	1874–1946
Eddy, Arthur Jerome	1859–1935	Rutter, Frank	1876–1937
Sickert, Walter	1860–1942	Hartley, Marsden	1877–1943
Prendergast, Charles	1862–1924	Sterne, Maurice	1878–1957
Davies, Arthur B.	1862–1928	Steichen, Edward	1879–1973
Durand-Ruel, Joseph	1862–1928	Kuhn, Walt	1880–1949
Sumner, John O.	1863–1938	Zayas, Marius de	1880–1961
Loeser, Charles A.	1864–1928	Weber, Max	1881–1961
Stieglitz, Alfred	1864–1946	Bruce, Patrick Henry	1881–1936
Bliss, Lillie P.	1864–1931	Picasso, Pablo	1881–1973
Berenson, Bernard	1865–1959	Pach, Walter	1883–1958
Henri, Robert	1865–1929	Russell, Morgan	1886–1953
Fabbri, Egisto	1866–1934	Meyer, Agnes Ernst	1887–1970
Durand-Ruel, George	1866–1931	Dasburg, Andrew	1887–1979
Fry, Roger	1866–1934	Dawson, Manierre	1887–1969
McBride, Henry	1867–1960	Wright, Willard Huntington	1888–1939
Hoogendijk, Cornelis	1867–1911	Macdonald-Wright, Stanton	1890–1973
Vollard, Ambroise	1868–1939	Schapiro, Meyer	1904–
Maurer, Alfred	1868–1932		

I · Unpromising Beginnings

THE FIRST works by Paul Cézanne to cross the Atlantic were taken to America in 1891 by a Miss Sara Hallowell, a friend of Mary Cassatt and herself an American expatriate. She was being considered for director of the art section of the Columbian Exposition, or World's Fair, planned for 1893 in Chicago. As a local critic put it, Miss Hallowell had done "more for the art education of Chicago and the West generally than all your millionaires who have been buying costly old masters. . . . Furthermore, she is a good judge of modern paintings, has remarkable executive ability and is on the most friendly terms with artists at home and abroad."[1] Although she eventually declined the directorship, she did help organize the Women's Building and gathered an extensive loan exhibition for the fair, for which she assembled pictures by European artists from many American private collectors. Among these was H. O. Havemeyer who lent two recently acquired works: a large Corot and a Courbet.

When Sara Hallowell arrived back from France in September 1891, she apparently brought with her two medium-sized paintings by Cézanne.[2] Since it is most unlikely that she had been in touch with the artist himself, she must have obtained them – doubtless on consignment – from his dealer, *père* Tanguy, who was familiar to a few Americans. The pictures were obviously not meant to be shown in Chicago, for in that case she would hardly have selected two closely related still lifes of almost identical aspect. It must have been Miss Hallowell's intention to find *I, 2* buyers for these canvases among the many American collectors with whom her activities brought her in contact. Although her choice of two rather similar works appears surprising, she may well have felt that these firmly composed, soberly structured pictures in subdued colors with their solidly established everyday objects stood at least a fair chance of pleasing some of her countrymen, to whom the name of Cézanne was still completely unknown. It is also possible that *père* Tanguy could not offer many other works, since he owned only those canvases that Cézanne had actually traded for paint supplies. The greater part of Tanguy's stock of Cézannes seems to have consisted of pictures the artist simply left with him, and these he may have hesitated to entrust to an intermediary for the hazardous exploration of an overseas market.

Due to Miss Hallowell's initiative, the Palace of Fine Arts at the World's Fair featured works by Manet, Monet, Pissarro, Renoir, Sisley, and Degas (next to those of Meissonier, Gérôme, and others). Cézanne was not represented. But while this Loan Collection reputedly surpassed in selectivity the modern art section of the

Paris World's Fair of 1889, and although she found herself nominated as special European agent for the Art Institute of Chicago, Miss Hallowell was unable to dispose of the two Cézanne paintings.

Among the frequent visitors to the art exhibit was a young lawyer from Flint, Michigan, Arthur Jerome Eddy, recently established in Chicago, who was fascinated by the "discovery" of contemporary art. At the end of that same year he commissioned from Whistler in Paris a full-length portrait of himself, and a few years later he asked Rodin to do a bust of him. Rodin had been the subject of vivid controversy at the Chicago exposition; his *Kiss* was considered so immoral that it was eventually placed in a locked room, to be seen by invitation only. But despite Eddy's interest in art, it seems unlikely that he met Miss Hallowell and even more unlikely that he saw her two still lifes by Cézanne. He did not buy them nor was he ever to buy a work by the artist.

The news of *père* Tanguy's death in 1893 doubtless reached Miss Hallowell in the States, and she must have determined to sell the two still lifes at any cost. She may by then have lost her initial enthusiasm for Cézanne's work as a result of the indifference it had met; she may also have considered it pointless to take back to Paris two pictures for which the interest was minimal even there; above all, however, it is possible that she wished to raise money for Tanguy's destitute widow. This would explain why she offered them to the New York branch of Durand-Ruel which, on February 21, 1894, bought them for $150 each. But the gallery had no more luck with them than Miss Hallowell; in December 1895 it sold them, with a $100 mark-up for each, to the main establishment in Paris, where they remained until they were acquired – after the turn of the century – by Egisto Fabbri, an American, and Sergei Shchukin of Moscow.[3] Thus, the first works of Cézanne to reach America came and

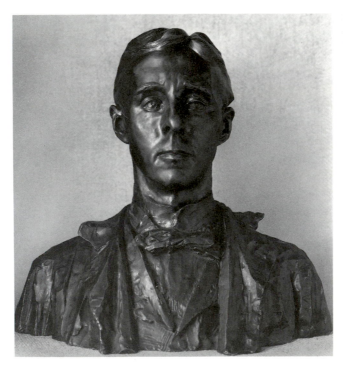

1 Auguste Rodin,
Arthur Jerome Eddy
1898

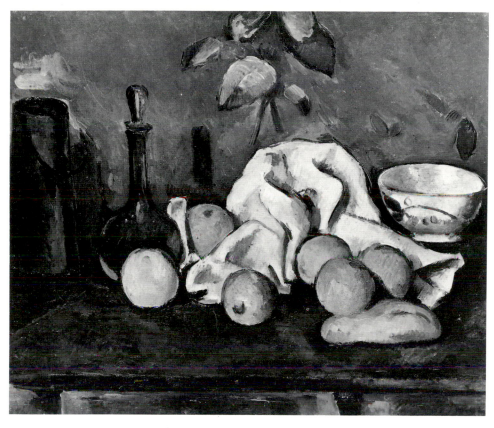

2 *Still Life with Milk-can, Carafe, and Coffee Bowl* 1879–80 (V.337)

went without leaving a trace other than the records of the Durand-Ruel galleries. As that firm, in those days, was not in any way connected with the artist, it may have acted mainly to oblige Miss Hallowell, who worked closely with the gallery, using her many social contacts in America to spur interest in the French Impressionists. This interest had steadily increased ever since Paul Durand-Ruel had organized his first exhibition in New York in 1886 and with it had gained a foothold in the United States.

Since then, Durand-Ruel had not only opened a branch in New York but also initiated there a very active program of exhibitions of the various Impressionists he represented on a more or less exclusive basis. Yet despite his constant efforts, the battle was far from won. When Theodore Child, one of the most important American critics, who regularly had gone to Paris to review the official Salons for *Art Amateur Magazine* or *Harper's*, published a volume entitled *Art and Criticism* in 1892, his short chapter headed "Impressionist Painting" concluded with the words, "If you proclaim Claude Monet and Renoir to be masters in the art of painting, you must have thrown overboard forever Velázquez, Rembrandt, and Titian."[4]

Child named Raffaëlli, Forain, Rouart, and Zandomeneghi among the Impressionists, but made no mention of Cézanne. Nor had Durand-Ruel included him in his historic show of 1886, although it had ranged from a few "tame" and even

academic painters all the way to such newcomers as Seurat and Signac. Cézanne had not been featured either in any of the subsequent exhibitions organized at the Durand-Ruel galleries of New York.

Durand-Ruel's efforts on behalf of the Impressionists notwithstanding, it took the painters a certain period of time to find acceptance even in America where the public was less prejudiced than in France. In 1896, George Santayana, who taught philosophy at Harvard, could still postulate: "Only the extreme of what is called impressionism tries to give upon canvas one absolute momentary view; the result is that when the beholder has himself actually been struck by that aspect, the picture has an extraordinary force and emotional value – like the vivid power of recalling the past possessed by smells. But, on the other hand, such a work is empty and trivial in the extreme; it is the photograph of a detached impression, not followed as it would be in nature, by many variations of itself."[5] It is not known what Impressionist paintings Santayana might have seen at that time, and it can safely be presumed that he had never found himself in front of a canvas by Cézanne.

The Englishman Roger Fry who, as a twenty-five-year-old aspiring painter, had come to Paris early in 1892 for a short apprenticeship at the Académie Julian was later to remember: "I was familiar enough with the names of some of the works of all the artists who had brought about the Impressionist movement in 1870, twenty years before, of all that is to say except one – the name of Cézanne was absolutely unknown to the art students of that day . . . throughout my student days in Paris I never once heard of the existence of such a man."[6]

The demand for Cézanne's works was no greater in Paris than it had been in New York. This was confirmed by the sale of *père* Tanguy's estate, which took place on June 2, 1894, after Miss Hallowell's return to France. The pictures sold there had either belonged to the old color-grinder and merchant or were contributed for the occasion by his many friends in support of his widow. The auction contained six canvases by Cézanne which fetched between 45 and 214 francs ($9–$43). It became obvious that Durand-Ruel had greatly overestimated their value when, a few months earlier, he paid $300 for the two still lifes in New York. All six of Tanguy's Cézannes were bought by a young dealer named Ambroise Vollard, newly established in the rue Laffitte.[7] That same year the liberal critic Gustave Geffroy, a friend of Monet's, spoke at length about the painter in the third volume of his *La Vie artistique*. "Paul Cézanne," he wrote,

has had for a long time a strange artistic fate. He could be described as somebody at once unknown and famous, having only rare contacts with the public yet considered influential by the restless and the seekers in the field of painting; known but to a few, living in savage isolation, disappearing and appearing suddenly among his intimates. The barely known facts of his biography, his almost secret production, his rare canvases that do not seem subject to any of the accepted rules of publicity, all these provide him with a kind of strange and already distant renown; mystery shrouds his person and his work. Those who are after the unfamiliar, who like to discover things never seen before, speak of Cézanne's canvases with knowing airs and make oblique references, as though they were exchanging passwords. . . .

The impression felt with increasing force, and which remains dominant, is that Cézanne does not confront nature with an artistic program, with the despotic intention of

submitting her to a law he has conceived, or force upon her some ideal formula that is in him. This does not mean that he has no program, no law, no ideal, but rather that he does not derive these from art, he derives them from the ardor of his curiosity, from his urge to take possession of the things he sees and admires. . . . It was not with hasty work, with superficial proceedings that he covered those canvases that were greeted with easy mockery at exhibitions and auction sales. Where many visitors and malicious collectors refused to see anything but indifferent smears and haphazard work, there was, to the contrary, a sustained application, the desire to approach truth as closely as possible.[8]

These were among the earliest really sympathetic words published concerning Cézanne. When Geffroy wrote them he did not yet know the artist; they met for the first time in the fall of that same year at Claude Monet's home in Giverny. It is a strange coincidence that Mary Cassatt was then staying at the only local inn in Giverny and there ran into Cézanne. But the account she gave of him was not concerned with his work; instead it offers a lively description of the man and his behavior in daily life of a kind no other acquaintance has provided. While it shows Cézanne as the extremely picturesque figure who, over the years, had given rise to, and would continue to give rise to, many anecdotes and myths, Mary Cassatt's letter was written with a certain warmth even tinged with admiration (her friend and mentor Degas was more wordly but also much less tolerant). "The circle [at the Hôtel Baudet]," Cassatt informed an American friend,

has been increased by a celebrity in the person of the first impressionist, Monsieur Cézanne – the *inventor of impressionism*, as Madame D. calls him. . . . Monsieur Cézanne is from Provence and is like the man from the Midi whom Daudet describes; when I first saw him I thought he looked like a cutthroat with large red eyeballs standing out from his head in a most ferocious manner, a rather fierce-looking pointed beard, quite gray, and an excited way of talking that positively made the dishes rattle. I found later on that I had misjudged his appearance, for far from being fierce or cutthroat, he has the gentlest nature possible, *comme un enfant*, as he would say. His manners at first rather startled me – he scrapes his soup plate, then lifts it and pours the remaining drops in the spoon; he even takes his chop in his fingers and pulls the meat from the bone. He eats with his knife and accompanies every gesture, every movement of his hand, with that implement, which he grasps firmly when he commences his meal and never puts down until he leaves the table. Yet in spite of the total disregard of the dictionary of manners, he shows a politeness towards us which no other man here would have shown. He will not allow Louise to serve him before us in the usual order of succession at the table; he is even deferential to that stupid maid, and he pulls off the old tam-o'-shanter, which he wears to protect his bald head, when he enters the room. I am gradually learning that appearances are not to be relied upon over here. . . .

The conversation at lunch and at dinner is principally on art and cooking. Cézanne is one of the most liberal artists I have ever seen. He prefaces every remark with: *Pour moi* it is so and so, but he grants that everyone may be as honest and as true to nature from their convictions; he doesn't believe that everyone should see alike.[9]

The following year, 1895, two landscapes by Cézanne entered the Luxembourg *3* museum with the shamefully truncated Caillebotte collection. During the controversies that raged around this bequest, Cézanne was hardly ever mentioned. He was too little known to present a target for the still virulent opponents of

Impressionism whose attacks were usually directed against such major, and by then quite famous, "offenders" as Monet and Renoir.

Among these opponents there was even an American expatriate, Frederic A. Bridgman, a pupil of Léon Gérôme, the man who led the loudest protest against the Caillebotte legacy. Bridgman, a hopelessly conventional painter, having absorbed all the academic formulas France had to offer, wrote a book, *L'Anarchie dans l'Art*, directed exclusively against Impressionism (though no Impressionist was named), to which, at the last minute, he added a chapter on the newly opened Caillebotte room. According to him it contained pictures in which the people looked like "tramps kept in quarantine because of an eruption of bubonic plague." (This was doubtless an allusion to Renoir's *Moulin de la Galette*.) He further declared that Impressionism had been "a very useful discovery for a band of disappointed but ambitious beginners and old women who not only find before the easel a consolation from family worries but also a new gateway to publicity and even notoriety."[10] The ungallant reference to old women obviously designated Berthe Morisot (who had just died) and the author's fellow American, Mary Cassatt, neither of whom, incidentally, was represented in the Caillebotte bequest.

In the guise of an assault on Impressionism, Bridgman's small volume presented a verbose defense of an art based, as he put it, on a "search for refinement, for expression, for poetic sentiments through fine drawing as well as a complete mastery of technique and execution,"[11] all qualities the absence of which created a sad gulf between the followers of Manet and those of Gérôme. Bridgman's book seems to have appeared in a French translation only and thus did not reach Anglo-American readers. Such readers nevertheless learned of the Caillebotte bequest through echoes in various art periodicals which spoke of the amazement caused by the legacy "of forty odd canvases by . . . Manet, Monet, Pessaro [sic], Sisley and Renoir," without bothering to mention Cézanne.[12]

Curiously enough, the London *Art Journal* published a long, well-informed, and enlightened article on the bequest. Any American who read that publication would have found there the first favorable comments on Cézanne in English. Signed with the name of Jean Bernac, the article spoke of the paintings by Caillebotte, and then discussed Monet, Renoir, Degas, Pissarro, and Sisley before coming to Cézanne. "To bring to a close this long procession of paintings . . . ," the author says,

I must conclude with Cézane [sic] . . . who scintillates through the medium of a view taken in the south at L'Estaque [V. 428]. The flux of the sea seems, by its ascending action, to drag the very earth and the surrounding mountains in its train. The force of a great brain has communicated to this picture the invisible fluid that charges the air with electricity and circles magnets round the roots of the very trees that rumble under the earth. Cézane [sic] has not exhibited since 1877, an epoch when an insane ridicule estranged an immense amount of struggling artistic talent. Hidden away in some proverbial nook, he has doubtless cultivated his acres with philosophy, thinking from time to time of Lamartine's

Mais la nature est là
Qui t'invite et qui t'aime

and that shall console mankind to the end of all time for the incredible imbecility of a contemporaneous majority that 'all like sheep' have flocked in a contrary direction.[13]

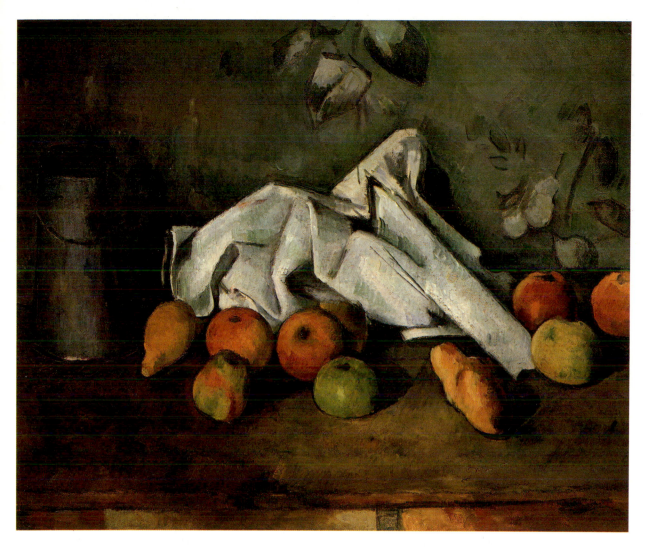

I *Milk-can and Apples* 1879–80 (V.338)

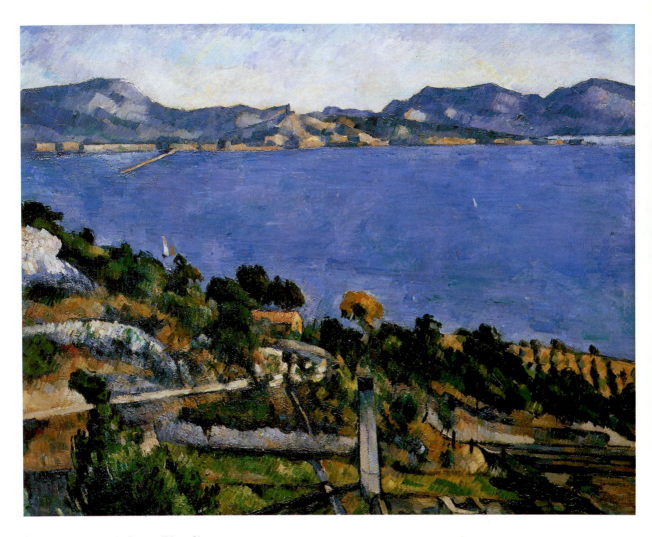

II *L'Estaque* 1878–79 (V.428)

Cézanne doubtless never knew of these lines. The real turn of the tide for him came about neither through Miss Hallowell's endeavors, nor Geffroy's writings, nor reluctant admittance to a Paris museum, nor the prophetic article published in London. It was due to Ambroise Vollard who, at the end of 1895, held the artist's first one-man show in his small gallery on the rue Laffitte. Cézanne was then fifty-six but, suffering from diabetes, he already considered himself an "old man."

As a result of Vollard's exhibition, Cézanne, the recluse of Aix, suddenly found himself much talked about in Paris art circles, a fact that seems to have disturbed him (he eventually even resented Geffroy's well-meant articles).[14] Neglect was now succeeded by curiosity which, little by little, gave way to genuine interest. While many skeptics and scornful antagonists remained, there was also an increasing group of enthusiastic admirers. This new attitude slowly made itself felt among American expatriates who had more opportunities to study the artist's work and – through prolonged contact with European cultures – may also have been more susceptible to it.

However, it was not an American but an Englishman (and a painter), William Rothenstein, who best described the impression produced by Cézanne's works, when he admitted many years later: "It never occurred to me, nor to anyone else at the time, that Cézanne would become an idol to be worshipped. I thought him a puzzling and provocative artist; his pictures seemed awkward, but they had a strange and powerful honesty, so that despite his lack of skill, they had an intensity which was denied to the pictures of men of greater natural capacity."[15]

Among the first Americans to notice Cézanne's paintings was an art historian and aesthete who, fresh from Harvard, had rushed across the Atlantic in 1887 and had since established himself in Florence, whence he roamed all over Europe, studying, classifying, and reattributing pictures of the Italian Renaissance. Yet Bernard Berenson was too avidly interested in new visual experiences not to look occasionally at modern art as well. Despite his esteem for such old-timers as George Watts and Puvis de Chavannes who reminded him respectively of Titian and of the Italian Primitives, Berenson was capable of considering more innovative endeavors. With a fine eye for – though not necessarily a complete grasp of – what was new, as early as 1892 he helped an affluent British friend acquire works by Boudin, Pissarro, and Degas.[16] "I am ready," he wrote his sister, "to appreciate any picture with quality to it whether it be Giotto, Masaccio, or Degas. . . ."[17] With this rather unusual disposition Berenson was soon to confront Cézanne.

Since Berenson does not seem to have gone to Paris during the winter of 1895 but did stop there the following year, it must have been then that he saw paintings by Cézanne for the first time. The Caillebotte bequest was on display at the Luxembourg museum from early February 1896. Whether what drove Berenson to the Luxembourg was the fact that Cézanne was constantly being discussed in the circles of cognoscenti, or whether it was his tireless and systematic inspection of all public collections will never be known. But he must have noticed the two landscapes by Cézanne among the Impressionist pictures that were part of the Caillebotte bequest; the opinion he then formed of the painter may well have been based on the view of the bay of L'Estaque V.428, the more important and typical of the two *II* canvases. Of course, Berenson may also have gone to Vollard's gallery, though he never mentioned having done so at this time.[18] In any case he was sufficiently

intrigued by the artist to refer to him in the book on which he was working, thus becoming the first American to speak of Cézanne in print.

Berenson was then completing his study of the Central Italian painters which was to appear in 1897. In it he would elaborate more extensively on theories concerning "tactile values" and "space compositions" which he was introducing into art criticism in the hope that these psychological rather than philosophic notions would help reveal the secrets of the enjoyment of art. The painter's task being to create an illusion of depth on a two-dimensional surface, he could do so, Berenson averred, only "by giving tactile values to retinal impressions," that is, by visually arousing the sense of depth. Applying this concept to the discussion of the Florentine masters first, and then to the Central Italian painters, he even drew on some modern examples. Berenson may have been struck by the lack of spatial continuity in *II* Cézanne's L'Estaque landscape. Indeed, he himself was hostile, or at least insensitive, to the way in which the artist had replaced transitions of planes and linear perspective with color relationships whose internal cohesion helped detach the diagonal foreground shore from the blue plane of the sea as well as the distant mountain range from the expanse of sky. It could have been this observation that prompted Berenson to insert an unexpected passage into his manuscript.

"Believe me," he wrote,

> if you have no native feeling for space, not all the labor in the world will give it to you. And yet without this feeling there can be no perfect landscape. In spite of the exquisite modelling of Cézanne, who gives the sky its tactile values as perfectly as Michelangelo has given them to the human figure, in spite of all Monet's communication of the very pulse beat of the sun's warmth over fields and trees, we are still waiting for a real art of landscape. And this will come only when some artist, modelling the skies like Cézanne's, able to communicate light and heat as Monet does, will have a feeling for space rivalling Perugino's or even Raphael's. And because Poussin, Claude, and Turner have had much of this feeling, despite their inferiority in other respects to some of the artists of our own generation, they remain the greatest European landscape painters – for space composition is the bone and marrow of the art of landscape.[19]

It was no mean feat at that time to mention Cézanne in the same breath with Michelangelo; however, what did this clever and ostensibly well-informed reference signify? There was, to be sure, among Berenson's readers in America or England hardly anyone who had heard of Cézanne, much less seen his works. And who were those artists of Berenson's "own generation" whom he thought superior to Poussin, Claude, and Turner, since he made it clear that Cézanne and Monet were not among them? Could he have been referring here to George Watts and Puvis de Chavannes? Be this as it may, Berenson's intriguing paragraph established that Cézanne's feeling for space was wanting, the exquisite modeling and tactile values of his skies notwithstanding, a statement that must have left most students of Central Italian painting completely indifferent.

One of Berenson's initial Harvard sponsors, Charles Loeser,[20] who had also settled in Florence, was, if not the first, at least among the first Americans to collect Cézanne's paintings. He was supposed to have begun buying them in 1898, but Vollard's records reveal that he did so as early as June 1896 and returned for more purchases in 1897, 1898, and 1899.[21] Berenson's reservations concerning the artist

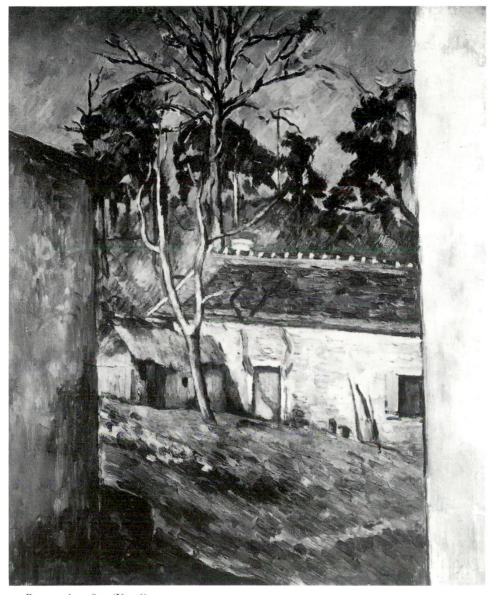

3 *Farmyard c.* 1879 (V.326)

obviously did not dampen Loeser's enthusiasm; they may actually have increased it. Indeed, constant jealousies, frictions, sulkings, and contrary viewpoints made for an extremely uneasy relationship between the two neighbors. "We come together often, but never to our mutual delight or instruction," Loeser reported in 1895 to a friend. "Our relations are a 'modus vivendi' which is at least more useful than peace and less irksome than war."[22] But since both men were afflicted with fragile egos, the "modus vivendi" could not withstand unlimited misunderstandings and recriminations. In November of that same year the unavoidable, open break occurred. After that it took a long time before the two antagonists settled into a slightly less acrimonious relationship of "enemy-friends."

4 Egisto Fabbri, photograph

At the time of his break with Berenson, in November 1895, Loeser did not yet own any works by Cézanne, and Vollard had barely begun to reveal the artist to a small coterie of connoisseurs. Thus it was not Loeser's involvement with the painter that drew Berenson's attention to him. Surprising though this must seem, Loeser and Berenson apparently "discovered" Cézanne quite independently. As a result, one of them began buying his pictures while the other wrote about him. But from the few friends permitted to cross through the barrier between the two men, Berenson must have learned of Loeser's "infatuation" with Cézanne, and one may wonder whether his startling reference to the artist in his *Central Italian Painters of the Renaissance* was not somehow directed at Loeser, one of the rare persons who not only was aware of the painter, but also was likely to be annoyed at seeing him accused of having 'no native feeling for space.'' (It was known that Loeser did not agree with the premises on which the entire book was based.)

But there was yet another Florentine who has an even more solid claim than Loeser to the distinction of having been the first American to purchase Cézanne's works, since he did so as early as January 1896, when he was thirty years old, compared to Loeser's first purchase in June of that same year. Egisto Fabbri was born in New York of an Italian father and an American mother. His father's oldest brother, after whom Egisto was named, was an economist and mathematician who became a partner of J. P. Morgan in 1876 and a member of the banker's inner circle. When the younger Egisto's father died around 1883, the uncle, being well-off, but without children of his own, adopted his three nephews and five nieces and helped their mother raise them. She eventually moved with her family to Florence.

Young Egisto, wishing to become a painter and having studied in the United States with J. Alden Weir, subsequently settled in Paris. According to Vollard's

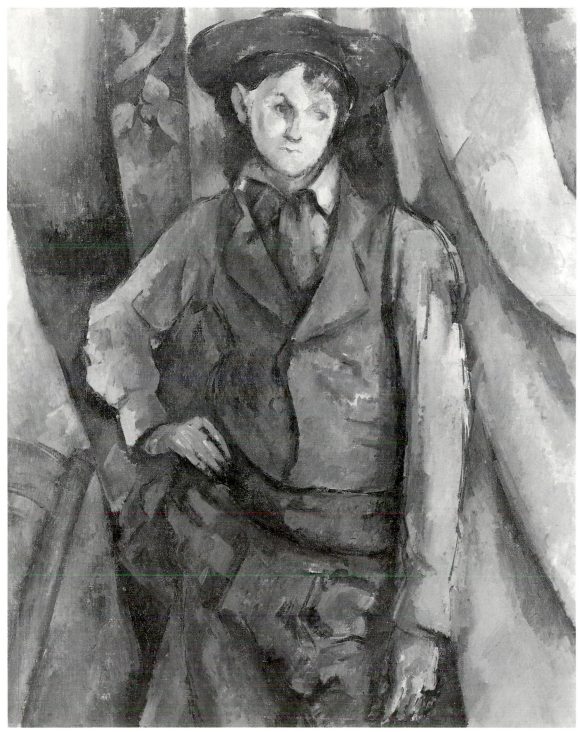

5 *Boy in a Red Waistcoat* 1888–90 (V.682)

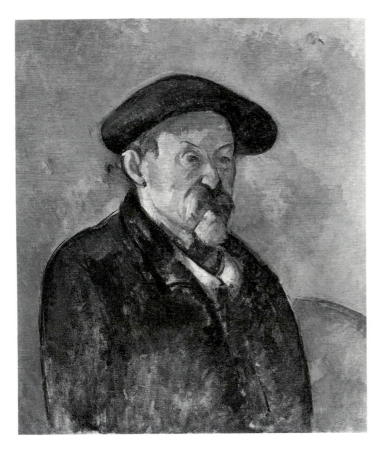

6 *Self-Portrait with a Beret* 1898–1900 (V.693)

7 (right) *Still Life with Rum Bottle c.* 1890 (V.606)

records, Fabbri bought three paintings by Cézanne in January 1896, a few weeks after the opening of the artist's first show in late November 1895. It is even likely that the exhibition was carried over into 1896, Cézanne having shipped to Paris many more canvases than Vollard could hang in his small gallery, so that the dealer had an ample supply for rotating the pictures and extending the show.

After his initial purchase of January 1896, Fabbri returned to Vollard's in March, May, and September, each time buying one more picture, followed by further acquisitions in December 1897, in May 1898, and in February 1899.[23] But whereas Vollard's ledgers document the sale of nine paintings to Fabbri between January 1896 and February 1899, in May 1899 the collector wrote to the artist, telling him that he owned *sixteen* of his works, whose "aristocratic and austere beauty represents for me what is noblest in modern art."[24] Fabbri deferentially expressed the wish to meet the author of these pictures. Cézanne's reply was somewhat ambiguous: "I find myself unable to resist your flattering desire to make my acquaintance. The fear of appearing inferior to what is expected of a person presumed to be at the height of every situation is no doubt an excuse for the necessity to live in seclusion."[25] If they did meet, they obviously did not develop a close relationship, despite Fabbri's boundless admiration; in any case, in later years he never mentioned having known the master.

But Fabbri went on buying works by Cézanne. Eventually he owned close to

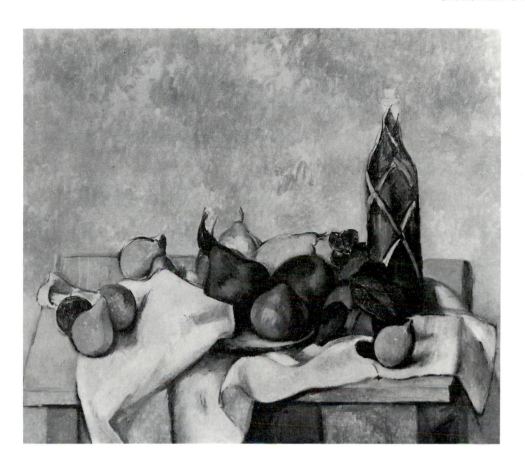

thirty, representing most of the artist's favorite subjects and extending over his entire output, from early dark canvases to sundrenched vistas (V.449), from small, exquisite still lifes (V.201) and paintings with heavy layers of pigment (V.397) to thinly brushed luminous landscapes (V.476), from strongly modeled groups of bathers (V.389) and a sober yet moving likeness of the artist's wife (V.292) to the majestic *Boy in a Red Waistcoat* (V.682), and finally, the detached and almost abstract *Self-Portrait with a Beret* (V.693), which shows Cézanne as he must have looked at the time Fabbri wrote to him.[26]

At first Fabbri had also purchased paintings by other artists, such as Daumier, Degas, and even Forain, but there seems to have come a time when he decided that conventional collecting was not for him and what really enriched his life as a painter was exclusively the work of Cézanne. When he traded his Degas for more Cézannes, he unknowingly exposed himself to Mary Cassatt's ire. Although she herself had acquired a Cézanne still life (V.606) as early as 1885 (if her memory is to be trusted),[27] she could not forgive Fabbri for preferring Cézanne to her revered mentor. Thus in 1910 she fired off a rather spiteful letter to an artist friend: "Egisto Fabbri I think does not produce anything; for some reason nothing is done in painting by him. Some years ago he saw one of Cézanne's best still life pictures in my dining room and could see nothing in it. Now he sees nothing but Cézanne and, with the rest of the crowd, puts him far too high, selling his Degas to buy Cézannes!"[28]

Mary Cassatt was obviously too irritated to be objective (something that happened to her on many occasions). There is no doubt that Fabbri had admired Cézanne long before the "rest of the crowd"; he even understood him better and loved him more than did Cassatt, who frequently spoke of him with reservations. Mary Cassatt's still *7* life is indeed extremely beautiful. The limpid clarity of its construction, the ascetic precision of its lines and planes, the delicacy of its thinly brushed background opposed to the strong accents of the fruit which strangely combine lushness with acerbity of color, all this cannot have failed to enchant Fabbri. The most plausible explanation for his attitude – provided Mary Cassatt's account of his reaction is accurate – would be that as the guest of a renowned colleague, Fabbri considered it rude to extol a painting by Cézanne rather than her own works.

Poor Fabbri did not seem to be able to do anything right. While Mary Cassatt did not think his appreciation of Cézanne was genuine, Berenson took a dim view of the quality of the pictures he had assembled. It is difficult to decide whether a real gap existed between Berenson's publicly expressed opinions and his privately held ones, or whether he was simply inconsistent – sometimes adopting the attitude of a man with advanced taste and at other times responding in a more conventional manner. The fact is that a few years after his early and – on the whole – not unfavorable reaction to Cézanne, he visited Fabbri, whose collection had by then grown to about twenty paintings. Though few dates of acquisition are known, among his more *I* recent purchases was one of the still lifes Miss Hallowell had taken to America. There can be no question that among Fabbri's many canvases there were already a few of the masterpieces for which the collection ultimately became famous. Yet, in a letter to his wife in which he reported his activities in Paris, Berenson merely mentioned that he had gone "to Febbri's [*sic*]. The Sézannes [*sic*] were disappointing."[29]

It seems that it was actually Camille Pissarro who helped initiate the attention that slowly began to focus on his erstwhile "pupil" Cézanne. According to one report, "Pissarro told Vollard about him, told Fabry [*sic*] . . . who told Loeser . . . in fact told everybody who knew about Cézanne at that time."[30] They in turn spread the word. A July 1896 entry in Vollard's account book indicates that he sold two Cézanne landscapes to a "friend of Fabbri."[31] And five months later another entry shows that Vollard sold what must have been a small painting by Cézanne (since it was priced at only 100 frs) to a buyer designated as "friend of Loeser."[32] The purchaser may have been a Bostonian, Harvard class of 1877, who, after post-graduate work in Germany and Italy, had become an art history instructor at M.I.T. in 1894. Although there is no record of his having been in Europe in 1895–96, and although he was not known as an art collector, John O. Sumners was acquainted with Loeser and did own a small *8* painting of harvesters by Cézanne (V.1517) which he apparently acquired in 1896.[33]

According to Vollard, the H. O. Havemeyers, who were Mary Cassatt's friends, acquired their first paintings by Cézanne in 1898. He recalled a visit from Mr. Havemeyer, who came alone to his shop, selected two pictures, and departed with them.[34] This seems somewhat peculiar. It is known that the impetus for collecting modern works came mostly from Mrs. Havemeyer, with strong support from her lifelong friend Mary Cassatt who, indeed, had informed Vollard of the Havemeyers' impending arrival. It appears strange, therefore, that the two women should not

8 *Harvesters c.* 1880 (V.1517)

have accompanied Mr. Havemeyer on his very first visit to Vollard's, nay, that the expedition should not have been initiated and the choice made by them, with Mr. Havemeyer gallantly coming along.

Also around 1898, Frank Jewett Mather, Jr., a young Ph.D. from Johns Hopkins, saw a few works by Cézanne, probably at Vollard's. While no particular canvas seems to have produced a lasting effect on him, in later years Mather did remember that the painter had struck him then as an "impressive figure."[35] However, at the time the future New York art critic and Princeton professor was too cautious and also too conservative in his taste to dwell further on such a controversial artist. Unlike others who gradually became involved with Cézanne's work, slowly learning to appreciate and eventually to admire it, Mather seems to have lost sight of Cézanne until he saw some of his paintings again at the Armory Show and contemplated them with considerable detachment.

But the Armory Show was still far in the future; meanwhile, among the few Americans who had so much as heard of Cézanne, there do not seem to have been many who considered the possibility of his work ever creating a stir on the other side of the Atlantic.

NOTES

1. Montague Marks, "My Note Book," *The Art Amateur* (April 1891), quoted in J. D. Kysela, "Sara Hallowell Brings 'Modern Art' to the Midwest," *The Art Quarterly*, no. 2 (1964), p. 159.

2. They were V.337 and 338. (Numbers preceded by V. refer to the entries in Lionello Venturi, *Cézanne: Sa vie, son oeuvre*, Paris: Paul Rosenberg, 1936.)

3. V.338, which Fabbri bought in 1901 from Durand-Ruel, Paris, for 5,000 francs ($1,000), is now owned by William S. Paley, New York; V.337, purchased by Shchukin in 1903 for 3,000 francs ($600) – it is somewhat smaller – is now in the Hermitage Museum, Leningrad.

4. Theodore Child, *Art and Criticism* (New York: Harper & Brothers, 1892), p. 167. Since the volume was composed of previously published articles, it is possible that the "Impressionist Painting" text had originally appeared a few years earlier.

5. George Santayana, *The Sense of Beauty* (New York, Chicago, and Boston: Charles Scribner's Sons, 1896), pp. 134–35.

6. Roger Fry, manuscript notes for a lecture given at Bangor, Jan. 18, 1927; Fry Papers, King's College Library, Cambridge, quoted by F. Spalding, *Roger Fry: Art and Life* (Berkeley and Los Angeles: University of California Press, 1980), p. 43.

7. The catalog listed Cézanne's works as *Les Dunes* (95 frs [$19]), *Coin de village* (215 frs [$43]), *Pont* (170 frs [$34]), *Ferme* (45 frs [$9]), *Village* (102 frs [$20.40]), and *Village* (175 frs [$35]). By comparison, a painting donated by Monet sold for 3,000 frs ($600) and one by Pissarro for 400 frs ($80); the highest bid for a work by Gauguin was 100 frs ($20). After the sale, Tanguy's widow complained that only dealers had attended the auction, 'ganging up' on her. Less than three weeks later, the poor woman said that if she had been better informed, she would have bought back many pictures because by then Vollard would not accept less than 800 frs ($160) even for a small canvas by Cézanne. See M. E. Tralbaut, *Van Goghiana* (Antwerp: Privately printed, Jan. 1963), vol. 1, pp. 45–47. On the Tanguy sale, see M. Bodelsen, "Early Impressionist Sales 1874–94 in the light of some unpublished 'procès-verbaux,'" *Burlington Magazine*, June 1968, pp. 346–48.

8. Gustave Geffroy, *La Vie artistique*, (Paris: E. Dentu, 1894), vol. 3, pp. 249–60. As Monet immediately informed the author, Cézanne had greatly appreciated his article. And when Geffroy wrote once more on Cézanne in *Le Journal* of Nov. 16, 1895, Monet again informed him: "I read yesterday your article on Cézanne and am anxious to tell you how much pleasure it gave me, combined with the pleasure to see that this very pure artist is receiving his due." (Claude Monet to Gustave Geffroy, Paris, Nov. 17, 1895; unpublished document, courtesy Daniel Wildenstein, Paris.)

9. F.-A. Bridgman, "Mauvais exemples publics," *L'Anarchie dans l'Art*, trans. from English (Paris: Société française d'éditions d'art, n.d. [1898]), pp. 88–89 (here retranslated from the French).

10. Ibid., pp. 242–43.

11. Ibid., pp. 242–43.

12. See Anonymous, "My Note Book," *The Art Amateur*, Feb. 1897, p. 32.

13. Jean Bernac, "The Caillebotte Bequest to the Luxembourg," *The Art Journal* [London], Aug., Oct., Dec. 1895, pp. 200–32, 308–10, 358–61; repr. in the catalog *Gustave Caillebotte, 1848–1894*, Wildenstein Galleries, London, 1966, p. 35. No critic by the name of Bernac is known. Since the text appears to have been translated, an analysis of its style is extremely difficult, yet certain ironic twists and the general attitude of sympathy for innovators, accompanied by abrasive comments on academic art, could point to someone like Félix Fénéon. After his involvement with anarchism, Fénéon had joined the editorial board of the *Revue Blanche* in 1894 but had practically given up writing and, significantly, no longer signed his occasional contributions with his name.

14. On this subject see John Rewald, *Cézanne, Geffroy et Gasquet* (Paris: Quatre Chemins-Editart, 1959).

15. William Rothenstein, *Men and Memories* (New York: Coward-McCann, 1931), vol. 2 [1900–22], p. 123.

16. See Ernest Samuels, *Bernard Berenson: The Making of a Connoisseur* (Cambridge, Mass.: The Belknap Press of Harvard University Press, 1979), p. 158. The Englishman was James Burke, Windlesham, Bagshot, Surrey. On Aug. 27, 1892, he purchased from Durand-Ruel, Paris, one painting each by Boudin, Degas, Pissarro, and Besnard. The Degas painting was the superb *Le Pédicure*, now in the Louvre (Isaac de Camondo Bequest). Burke sold it back to Durand-Ruel on Dec. 27, 1898; on Jan. 11, 1899, it was acquired by Camondo.

According to the Durand-Ruel archives (courtesy the late Charles Durand-Ruel, Paris), the galleries also repurchased the Boudin landscape, *La Rade de Villefranche* (see Robert Schmit, *Eugène Boudin* [Paris: R. Schmit, 1973], vol. 3, no. 2883). Burke does not seem to have kept his pictures for a very long time.

17. Bernard Berenson to Senda Berenson, Oct. 17, 1892, quoted in Samuels, *Bernard Berenson*, p. 160. See also Meyer Schapiro, "Mr. Berenson's Values," *Encounter*, Jan. 1961.

18. In a letter to the author, Professor Samuels states that Berenson "always made the rounds in Paris however brief his stay and his friend [Salomon] Reinach [whom Berenson first met in 1894] who seemed to know everything going on in Paris may well have put him on to the new luminary."

Salomon Reinach (1858–1932), French philologist and archaeologist, was a man of extraordinary erudition and probably the best known of the three remarkable Reinach brothers. The youngest, Théodore (1860–1928), a historian, was from 1905 until his death director of the *Gazette des Beaux-Arts*, to which Berenson occasionally contributed. The oldest, Joseph (1856–1921), an ardent republican, friend of and secretary for Gambetta, was deputy at various times and one of the most active defenders of Dreyfus's innocence; among the works of art that he bequeathed to the Louvre was a landscape by Cézanne (V.335), acquired as early as 1901.

19. Bernard Berenson, *The Central Italian Painters of the Renaissance* (New York: G. P. Putnam's Sons, 1897), p. 122.

20. Loeser was the heir to Frederick Loeser's Department Store in Brooklyn. "In 1886 a group of friends in Harvard, the chief of whom was a remarkable dilettante named Charles Loeser (probably the first American to buy a Cézanne) raised money for him [Berenson] to go to Europe"; Kenneth Clark, *Another Part of the Wood* (London: John Murray, 1974), p. 134.

21. Vollard's earliest-known account book, for the period Jan. 1896 to April 1899, contains the

9 *Gardanne c.* 1885 (V.430)

following entries concerning Loeser: 1896, June: Ch. Loeser, Cézanne, 1000; July: ami de Loeser, Cézanne, *Les Buveurs*, 100 [see note 32 below]; 1897, January: Loeser, Lautrec, Cézanne (250 prix auquel j'achète Lautrec), 200; Cézanne, *Lac-maison-l'eau*, 300; Cézanne, *Petit village*, 250; 1898, September: Ch. Loeser, 2 Cézanne, 650. In addition, there is on the last page an undated entry: Loeser, Cézanne 4 (1900 frs) reprise d'un Lautrec pour 500.

I am indebted to the late Mme Edouard Jonas, Paris, for communication of this unpublished notebook; see also note 23.

In 1898, when the American poet Harriet Monroe, a friend of Sara Hallowell's, went to Florence, she noticed two or three Cézanne landscapes in Loeser's house. See Harriet Monroe, *A Poet's Life* (New York: AMS Press, 1939), p. 159; this book was brought to my attention by Professor William H. Gerdts.

22. Charles Loeser to Miriam S. Thayer, Florence, 1895 (from the Houghton Library, Harvard University, Cambridge, Mass.), quoted in Meryle Secrest, *Being Bernard Berenson: A Biography* (New York: Holt, Rinehart & Winston, 1979), p. 199.

23. Vollard's account book (see note 21) contains the following references to Fabbri: 1896, January: Fabbri, 3 toiles de Cézanne, 1000; February: ami de Fabbri, 2 Cézanne, *ancien Auvers* et *Maison rouge clair étages en hauteur*, 450; March: Fabbri, *Gardanne maisons rouges* [V.430], 400; May: Fabbri, Cézanne, 400; September: Fabri [*sic*], Cézanne, 650; 1897, March: Fabbri, Daumier (*Loge de théâtre*), 200; June: Fabbri, Forain, 325; December: Fabbri, Cézanne, 950; 1898, May: Fabbri, Cézanne, 500; 1899, February: Fabbri, Cézanne, 750.

K. E. Maison, *Honoré Daumier, Catalogue raisonné of the Paintings, Watercolors and*

9

Drawings (London: Thames and Hudson; Greenwich, Conn.: New York Graphic Society; Paris: Arts et Métiers Graphique, 1967), vol. 1, lists three paintings as having once belonged to Fabbri but does not indicate Vollard as previous owner for any of them: Nos. I–99, *Un Homme lisant, et un petit garçon*; I–158, *Un Fauteuil d'orchestre*; I–187, *Fauteuil d'orchestre*. Either of the last two could have been the painting sold by Vollard in March 1897. See also Chapter II, note 33, below.

24. See Fabbri's letter to Cézanne, Paris, May 28, 1899; in Paul Cézanne, *Correspondance* (Paris: Bernard Grasset, 1978), p. 269, note 2.

25. Cézanne to Egisto Fabbri, Paris, May 31, 1899; ibid., pp. 269–70.

26. The Cézanne paintings that belonged to Fabbri were V.39, 40, 64, 94, 193, 199, 201, 220, 221, 238, 292, 297, 315, 319, 333, 338, 347, 374, 389, 390, 397, 408, 430, 449, 476, 542, 629, 637, 682, and 693.

27. In a letter of 1910, Mary Cassatt said that she had sold her still life by Cézanne which she had acquired twenty-five years earlier. But there is reason to doubt that she had made this purchase in 1885. Although she was then friendly with Camille Pissarro, who always championed Cézanne's work, the still life itself, from a stylistic point of view, can hardly have been painted before 1890. See also Chapter III, below, note 47.

28. Mary Cassatt to Adolphe Borie, Mesnil-Beaufresne, July 27, 1910; Archives of the Philadelphia Museum of Art, courtesy Anne d'Harnoncourt. This document is quoted incompletely (and with Fabbri's name deleted) in Nancy Hale, *Mary Cassatt* (Garden City, N.Y.: Doubleday, 1975), pp. 198–99.

29. Bernard Berenson to Mary Berenson [Paris], Hotel St. James & d'Albanie, July 1 [1904]. Berenson Archive, Harvard Center for Italian Renaissance Studies, Villa I Tatti, Florence. This document was brought to my attention by Irene Gordon.

It is not quite clear where Fabbri kept his collection. Berenson's letter of 1904 places it in Paris. According to Vollard's records, in 1900 Fabbri occupied 7, rue Tourlaque, Toulouse-Lautrec's former studio in Montmartre. But William Rothenstein, describing a visit to Florence in 1907, mentioned that "there was already a large collection of Cézanne's work in Florence, that of signor Fabbri" (Rothenstein, *Men and Memories*, p. 125). It is of course possible that Fabbri kept some of his thirty-odd pictures in Paris (where they are known to have been when the First World War broke out) and others in Florence.

30. Gertrude Stein, "Gertrude Stein in Paris, 1903–1907," *The Autobiography of Alice B. Toklas* (New York: Random House, 1933).

31. According to Charles Loeser's daughter, Mrs. Matilda Loeser Calnan, Los Angeles, her father and Egisto Fabbri knew each other around 1896. The *ami de Fabbri* who purchased two landscapes from Vollard in Feb. 1896 may therefore have been Loeser. This would confirm Gertrude Stein's statement (see note 30) according to which Pissarro told Vollard about Cézanne, "told Fabry [sic] … who told Loeser. …"

32. The painting in question is designated by Vollard as *Les Buveurs* (see note 21). This could have been the small picture now called more appropriately *The Reapers* (V.1517), which shows at left a standing figure drinking from a gourd.

33. While in America in 1921–22, Loeser noted on Jan. 24, 1922, in his unpublished diary: "… tea at J. O. Sumners … where had good look at Cézanne *Reapers*." (Courtesy Miss Philippa Calnan, Loeser's granddaughter.)

John Osborn Sumner died in Boston in Feb. 1938. Two years later his painting, *Les Moissonneurs*, was purchased by the Durand-Ruel galleries of New York from his estate. On Dec. 24 of that same year the Durand-Ruel records list it as being acquired by Duncan Phillips of Washington, D.C. According to the files of the Phillips Collection, however, the picture was bought from Durand-Ruel's in 1939; these files also indicate: "First Cézanne in this country 1895." The work was eventually traded for another canvas and its present whereabouts are unknown.

34. See Ambroise Vollard, *Recollections of a Picture Dealer* (Boston: Little, Brown & Co., 1936), pp. 139–40. The first documented Havemeyer purchases of Cézannes occurred in 1903, involving an early figure composition and a portrait of a man (see Chapter II, note 29, below). It is likely, however, that before acquiring these two paintings, the Havemeyers had already begun collecting Cézanne's works, especially still lifes, the only subjects of his for which Mary Cassatt – their advisor as well as friend – showed any appreciation.

35. Frank Jewett Mather, Jr., "Art Old and New," *The Nation*, March 6, 1913, p. 241. This mention occurs in a review of the Armory Show (see Chapter VIII below). Though he had taught English and Romance languages at Williams College since 1893, Mather studied at the Ecole des Hautes Etudes in Paris in 1897–98. In 1901 he left teaching for journalism, but in 1910 he joined Princeton University as a professor of art history.

II · Slow Progress

10 *The Deep-Blue Vase c.* 1880

DURING the last years of the nineteenth century there were quite a few American artists in Paris who had come to enroll at various schools and to study at the Louvre. Among them were Robert Henri, Alfred Maurer, Ernest Lawson, and Childe Hassam. But for them, the shock of the modern was produced by the Impressionists, whose spell they fought (being more attracted to Manet, as was Henri) or to whose influence they gently succumbed (as did Lawson and Hassam). Like Roger Fry before them, they apparently were not even aware of Cézanne's existence. Henri later complained that at the Académie Julian and the Ecole des Beaux-Arts "we were never allowed to hear about men like Cézanne and Gauguin."[1]

It does seem surprising that painters from faraway lands who had gone to Paris to immerse themselves in its art world needed to be "allowed to hear" about Cézanne or Gauguin in order to take notice of them. This can only mean that they avoided any contact with French colleagues who dared venture beyond the confines of

11 *The House of the Hanged Man, Auvers-sur-Oise c.* 1873 (V.133)

academicism. It also means that they did not visit any exhibitions except the official
Salons and thus did not see the works of Signac, Lautrec, or the *douanier* Rousseau at
the Salon des Indépendants, nor did they know of Gauguin's show at Durand-Ruel
in November 1893, comprised of forty of his Tahitian paintings, or of Cézanne's at
Vollard in November–December 1895. Cézanne's two landscapes at the
Luxembourg museum must similarly have escaped their attention, although it is
true, these were not sufficient to provide an idea of his innovations.

Meanwhile, in America, Cézanne's earliest proponent was Maurice Prendergast.
He had spent five years in Paris in the eighties without becoming aware of the
painter, but when he stopped there briefly on a trip to Italy in 1898–99, partly
financed by Mrs. Montgomery Sears, he apparently went to Vollard's, for this time
he returned to Boston transformed into the "first American artist to recognize
Cézanne."[2] His enthusiasm found little echo, however, not only because he lived in
poverty and obscurity and moved in a very small circle of artists and art lovers, but
above all, because nobody could share his admiration since there had not yet been
any opportunity to see Cézanne's work in the United States. Yet Prendergast's
fervor did leave its mark. John Sloan never forgot Prendergast's talking about the
paintings by Cézanne he had seen in France, and Walter Pach subsequently stated,
"The influence of Maurice B. Prendergast is not alone to be measured in terms of his
beautiful vision and his color: one needs to hear what the continual references to
Cézanne in his conversation meant to the Americans who knew him abroad and,

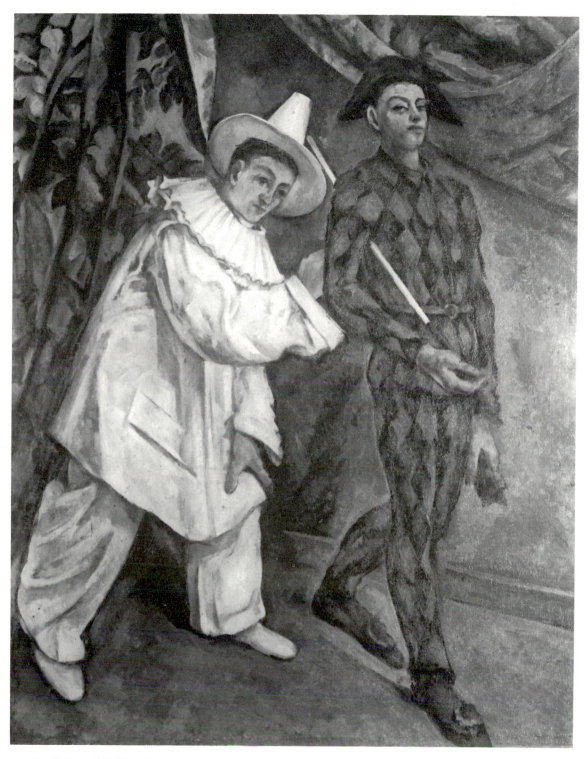

12 *Mardi Gras* 1888 (V.552)

10 later, at home."[3] (It is not impossible that a miniscule painting of a vase of flowers which Mrs. Montgomery Sears owned – and later lent to the Armory Show – was purchased for her by Prendergast in Paris, in which case it would have been one of the first to enter a collection in the United States.[4])

Thus the stage was set for Cézanne's gradual "conquest" of America. For a painter to gain a wide audience, four elements are essential: collectors willing to leave the beaten track; devoted agents or dealers; enlightened writers and critics; and, last but not least, committed fellow artists. Whereas Cézanne was slowly gaining such a following in France, by the turn of the century a small group of supporters was also forming in the United States, though mostly among well-traveled Americans. It seems fairly certain, however, that Cézanne himself remained totally ignorant of what such diverse Americans as Sara Hallowell, Charles Loeser, Louisine Havemeyer, Bernard Berenson, and Maurice Prendergast did or were trying to do on his behalf.

When, in the spring of 1899, a number of collections were dispersed at public auctions in Paris, several works by Cézanne reached unexpected prices even before the sale of the Chocquet estate on June 29 and 30 which closed the particularly active season. Victor Chocquet had been Cézanne's friend and longtime patron, accumulating more than thirty of his works, then the largest group ever offered for sale. But the critic of the Parisian *New York Herald* was utterly unimpressed. After visiting the pre-sale exhibition and commenting on various paintings by Delacroix, Courbet, Manet, Monet, Morisot, and Renoir, he finally turned to Cézanne:

"To conclude," he wrote, "I should speak of the thirty-one pictures by Cézanne, all of which are distinguished by the hardness and coldness which appear to me to be the characteristics of this artist's work. The best is a landscape not in the catalog, *11* called *The House of the Hanged Man, Auvers-sur-Oise* [V.133]. The most important, *12* which is called *Mardi Gras* [V.552], represents a harlequin and clown. I must confess that I can see no beauty in it."[5]

Much more comprehensive, though less detailed, was an article published after the event in the *New York Commercial Advertiser*, dateline July 6, London, headed "The Rising Vogue of the Impressionists." "By one chance or another," the paper's correspondent reported,

> within the last three months, an unusual number of pictures by the earlier impressionists – Manet, in his second manner; Monet, Renoir, Sisley, Pissarro and Cézanne – has been sold at auction in Paris. One or two collectors that were almost unknown even to dealers and to amateurs and that bought such pictures when there were few to purchase them, have died, and their heirs have promptly sent their canvases to the salesrooms. . . . Altogether, since the impressionists first began to make some stir in the world twenty years ago, so many of their pictures have not been sold, and at public sale, as in the last three months in Paris.
>
> The results have confirmed beyond peradventure the increasing liking of collectors for the work of the pioneer impressionists and the growing faith of dealers in a steady rise in its commercial value. When the long-hidden collection of the recluse, Chocquet, was sold this week, nine canvases by Renoir fetched, for example, 62,000 francs [$12,500], and ten by Monet 58,000 [$11,600], while at other recent sales their work and that of their brethren touched even higher prices. . . . In Paris, perhaps, it is good form, now, if one makes artistic pretensions, to have a Monet or a Renoir about, but the larger part of the purchasers were not of those that buy a picture because it is a new or a smart thing. . . .[6]

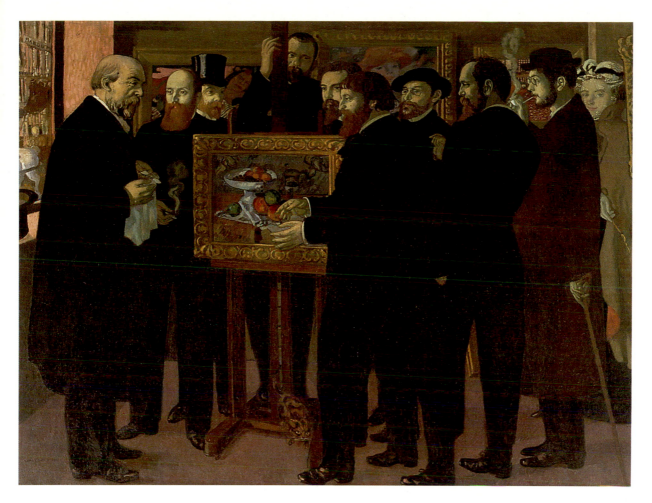

III Maurice Denis *Homage to Cézanne* 1900

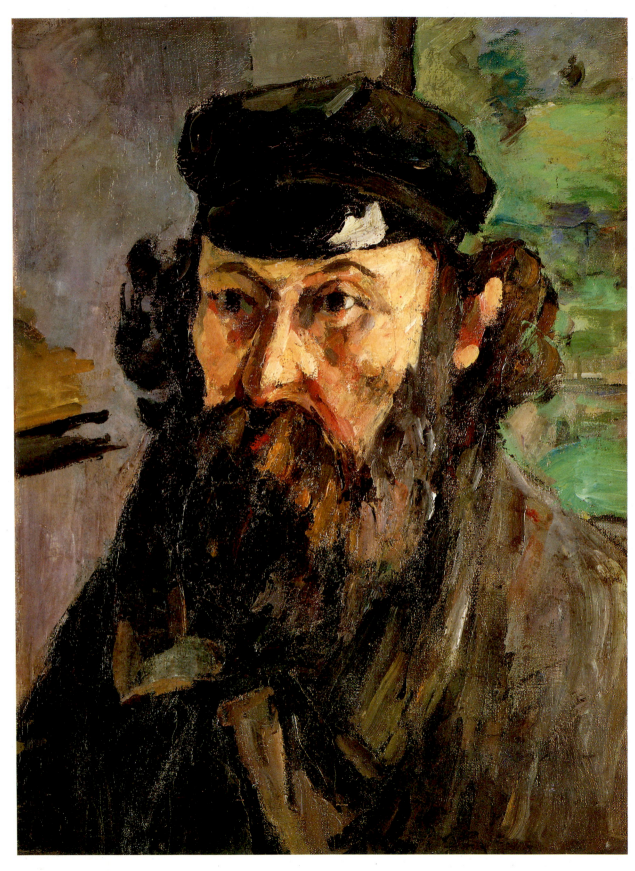

IV *Self-Portrait with a Cap c.* 1875 (V.289)

Indeed, as the author pointed out, he noticed a general interest in the Impressionists, not only in Paris but even in London. "The exhibitions that preceded these sales," he continued, "attracted scores of visitors that could not buy if they would, but that were full of intelligent admiration. It is said at the Luxembourg museum that more people now linger in the room set apart for the pictures by the impressionists that M. Caillebotte bequeathed to the state than in any of the other galleries. . . ."

It is symptomatic, however, that this unusually favorable report did not mention the fact that at these sales works by Cézanne had obtained, for the first time, bids going beyond a few hundred dollars. While at the disappointing sale of Sisley's studio on May 1, 1899, an unspecified landscape by Cézanne had reached only 2,300 francs ($460), at the auction of the well-known collection of Count Doria, a few days later, a winter landscape (V.336) had been sold for 6,750 francs ($1,350), at which *13* "sensational" price it was knocked down to Claude Monet. It was also Claude Monet who became responsible for the comparatively high prices paid for Chocquet's Cézannes. He encouraged Count Camondo to acquire *The House of the Hanged Man* *11* for 6,200 francs ($1,240), only slightly less than what he had paid for his own purchase. But more important still, Monet now persuaded Durand-Ruel to avail himself of this opportunity to add paintings by Cézanne to his tremendous stock of Impressionists. Even though the dealer had not yet disposed of the two still lifes bought from Miss Hallowell, he must have felt that the slowly increasing interest in the artist justified such an investment. The Impressionists were selling fairly well by now, not the least in America, and it seemed that the time for Cézanne's emergence from obscurity and neglect might not be far away. As a result, Durand-Ruel acquired about half of the Cézanne paintings that had belonged to Chocquet, among them *Mardi Gras*, for which he paid 4,400 francs ($880).[7] Half a dozen other *12* paintings were bought by the Bernheim-Jeune brothers, who were just venturing into the field of contemporary art, and five more by Vollard, who did not go beyond $200 for any of his acquisitions, probably because that was the price at which he could obtain Cézanne's canvases directly from the artist.[8]

In May 1900, less than a year after the Chocquet sale, a more modest group of paintings by Cézanne reached the auction block as part of the extensive Eugène Blot collection of modern art. Its catalogue was extremely well prepared and contained a series of individual studies on the artists whose works constituted the highlights of this offering. Among these were Carrière, Cézanne, Daumier, Guillaumin (an old friend of Blot's), Manet, Monet, Pissarro, Renoir, and Sisley. The unusually long text on Cézanne was signed by a young writer of symbolist–anarchist persuasion, Georges Lecomte, who a few years before had written a book on the Impressionist paintings in the private collection of Paul Durand-Ruel (in which Cézanne was not yet represented). Lecomte himself had not met Cézanne but he was close to Guillaumin and especially Pissarro. What he reported obviously came from these two painters, both of whom had befriended Cézanne in the early 1860s.

"The man?" Lecomte asked.

Nobody knows him. The friends of his youth only learn about him through hearsay. Some of them have not seen him for the last thirty years. One day, after a lapse of a decade, he may join a former comrade. For two or three months they work side by side. Then he

37

departs, leaving behind the memory of an odd, passionate, and unsociable fellow as well as of an admirable artist. Some four or five years ago it became known that he was in Paris. He renewed a very old friendship. The two or three privileged persons who knew his abode had to promise not to reveal it. Then once again, Cézanne disappeared. . . .

By now Cézanne's work is well known and very much in demand. Enlightened collectors fight for his canvases. These can be found in the most prestigious galleries [an allusion to the Bernheim-Jeunes?]. The dealers who not so long ago scorned his works now stock them [Durand-Ruel?]. They are frequently exhibited [obviously a reference to Vollard]. The art critics no longer ignore him. This is the big success. But Cézanne, unconcerned with such glorious ballyhoo, continues to offer himself the pleasure of painting the sites he loves. . . .[9]

Yet when it came to discussing Cézanne's landscapes, Lecomte appeared to be less at ease, unable to share Pissarro's warm appreciation; instead he strangely echoed Berenson's reservations. He was no more prepared than the latter to accept the fact that Cézanne's images emerged from a patient accumulation of brush strokes and carefully pondered relationships of colors without recourse to conventional perspective. (Succeeding generations of painters who adopted and frequently exaggerated Cézanne's way of coordinating the elements of nature into an entirely new and logical "structure" have conditioned us to his approach to such an extent that we can no longer fully understand the hesitations and surprises that Cézanne's contemporaries experienced in front of his pictures.)

According to Lecomte, when Cézanne paints a landscape, he

grasps its character, its color, its light. He translates its intimacy and its magnitude, but he fails in the task of placing its planes apart, of giving the illusion of space. There his

13 *Melting Snow at Fontainebleau* 1879–80 (V.336)

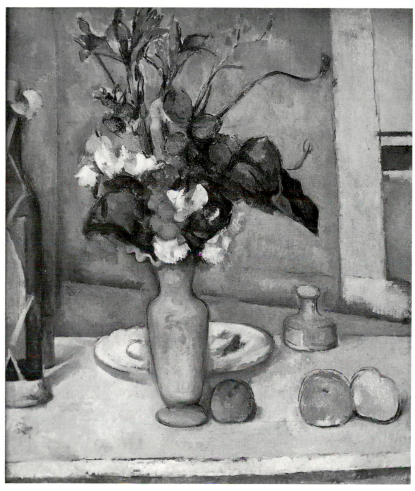

14 *The Blue Vase* 1889–90 (V.512)

insufficient knowledge betrays him. Cézanne does not have the faculty to render everything he perceives. He does the best he can. Frequently he is saved by his instinct and his experience. But just as frequently his spontaneity remains powerless. His studies of nature quite often are without depth. They give the impression of a sumptuous tapestry with no distance, a work of exquisite harmonies, of closely related values, of very simple flat tones that increase the impression of softness and charm. However, the various lines of the landscape do not recede in the atmosphere.[10]

Despite Lecomte's well-intentioned if slightly awkward send-off, buyers did not exactly "fight for Cézanne's canvases." The prices obtained for his paintings did not show any increase over those of the Chocquet sale and Blot bought all of them in. One was a superb still life of flowers in a blue vase (V.512) that reached only 2,000 francs. In 1906, when Blot tried to auction it off once more, it fetched three times that amount but again he decided to keep it. Only the following year did Count Camondo, who planned to bequeath his collection to the Louvre, obtain it for 25,000 francs ($5,000); this was considerably more than the Count had paid for *The House of the Hanged Man* at the Chocquet sale of 1899.[11]

While it is not known who were the unsuccessful bidders at the Blot auction, there had been relatively few private collectors who purchased works by Cézanne at the Chocquet sale, and among them not a single American. When the time would come for Americans to take a greater interest in Cézanne, they would turn to the three dealers who had been the biggest buyers at that auction: Durand-Ruel, Bernheim-Jeune, and especially Vollard. Yet these three did not always find it easy to sell Cézanne's canvases or, for that matter, those of any "radical" artist. When the then-famous French artist Edouard Detaille, painter of innumerable meticulous battle scenes that rated high on the consumer index, visited one of the Bernheims in the spring of 1900, he wrote in his notebook: "He showed us a succession of rubbish by a fellow called Van Gogh and by another one, named Cézanne. Bernheim tells us that Cézanne's barely decipherable indications have the charm of leaving to the viewer the task of unravelling them; they are dreams to be completed by the buyer himself. It is really something to have hit upon that."[12]

No wonder that the advancement of Cézanne's American reputation proceeded at an extremely sluggish pace, the more so as every step forward was met with violent opposition, which continued throughout the first quarter of the twentieth century. The gradual conquest was accomplished on three parallel though separate levels. First there were a few dedicated collectors who bought Cézanne's works (at extremely low prices); then there were notices in publications and even entire articles – not always flattering – which brought the artist to the attention of a wider public; and, somewhat later, there were exhibitions on a modest and inconspicuous scale until the Armory Show of 1913 put a spotlight on the painter. After that the road was open to ever more widespread recognition, reflected in the amazing number of oils, watercolors, and drawings assembled over the years by American collectors and museums. But Cézanne's steady, almost inevitable rise to fame also met with periodic setbacks. For a long time even well-meaning articles suffered from popular misconceptions or lack of reliable information, some of which can actually be traced to sources in France, where exhibition reviews and articles on Cézanne began to appear well before there were any in America.

Vollard's various one-man shows, organized after the first one of 1895, had begun to draw attention to Cézanne by giving him greater "visibility" than he had enjoyed before. Another signal event was a large composition by Maurice Denis, exhibited in 1901. As the American journalist James Huneker later remembered: "In 1901 I saw *III* at the Champs de Mars Salon a picture by Maurice Denis entitled *Homage to Cézanne*, the idea of which was manifestly inspired by Manet's *Homage to Fantin-Latour*. The canvas depicted a still life by Cézanne on a chevalet and surrounded by Bonnard, Denis, Redon, Roussel, Sérusier, Vuillard, Mellerio, and Vollard. Himself (as they say in Irish) is shown standing and apparently unhappy, embarrassed."[13]

There are several errors in Huneker's recollections; it was of course Fantin-Latour who had painted *Homage to Manet*, and not the other way round, but more important is the fact that "himself" does not appear in this canvas. Indeed, since Denis had not yet met the master, he could not represent him and thus chose to paint Redon standing next to Cézanne's still life. While Redon may have been somewhat embarrassed to become the focal point of a composition honoring Cézanne, whom he admired but not without reservations,[14] he does not really look "unhappy" in

15 James G. Huneker,
photograph, 1900

Denis's picture, but rather thoughtful and dignified, as befitted the solemn occasion.

In any case, Denis's *Homage* seems to have greatly impressed Huneker, possibly because he had never heard of Cézanne and now found Parisian artistic circles abuzz with his name, and with strange stories about his personality, but above all, with discussions of his work, his innovations, his influence. Priding himself on his growing reputation of being "thoroughly *au courant*,"[15] Huneker must have felt that here was a story for a journalist who took an interest in art matters. At the age of twenty-one he had studied music in Paris for several months[16] and later was to remember "the days when I haunted the ateliers of Gérome, Bonnat, Meissonier, Couture [who died in 1879] and spent my enthusiasms over the colour-schemes of Decamps and Fortuny. . . ."[17] He had visited the Paris World's Fair of 1879 and may also have seen the fourth exhibition of the Impressionist group (in which Cézanne did not participate but which included Mary Cassatt), though his recollections of these events were somewhat hazy. In any case he did not then, as he subsequently admitted, feel the "current of fresh air that swept through Parisian ateliers."[18]

Huneker was almost thirty when he saw Durand-Ruel's first Impressionist show in New York; however, art was not at that time one of his major concerns, as were music and literature. Somewhat later he was occasionally to discuss pictures in the *Musical Courier*, to which he contributed. "A man is to be pitied," he subsequently wrote, "who is out of joint with his own artistic times. He has no present or future – only a vague past."[19] Keeping in touch with the present, Huneker had visited Gauguin's large one-man show at Durand-Ruel's in Paris in November 1893, but apparently refrained from committing himself in writing about it. Since then Gauguin had become something of a legend in Paris, and when Huneker went there

again in 1901 and listened to the controversies surrounding Cézanne, he must have decided that this time he should investigate the possibilities for an article. He thus resolved to interview the artist or at least write a story about him and, to this end, supposedly journeyed to Aix.

"I met the old chap first in 1901 in Aix," Huneker was to write many years later in a private letter. "Cézanne, like John La Farge, hated handshakes. He loathed his origin. His father, first a barber, than a valet, finally a banker."[20]

It is obvious that Huneker could not have obtained these false data about the painter's father from Cézanne himself, and it is actually doubtful whether he spoke to him at all. It appears more likely that Huneker had to gather what little information – or misinformation – he could from various citizens of Aix whose knowledge of the artist was not burdened by any relevance to truth. Huneker may have sensed that, for he avoided, for the time being, publishing any of these petty details. What he did publish – sixteen years after their alleged meeting – was a description of the painter that is extremely close to what others had reported in the meantime.

"When I first saw him he was a queer, sardonic old gentleman in ill-fitting clothes, with the shrewd, suspicious gaze of a provincial notary, a rare impersonality, I should say."[21] Elsewhere Huneker wrote that Cézanne, "an unvarying experimenter . . . seldom 'finished' a picture. His morose landscapes were usually painted from one scene near his home in Aix. I visited the spot. The picture did not resemble it; which simply means that Cézanne had the vision and I had not."[22]

These superficial statements would indicate that – if Huneker really spoke to the painter – Cézanne showed himself as distrustful of new faces and as uncommunicative as ever when he did not feel an immediate sympathy based on some kind of artistic kinship. After all, in the painter's opinion, talks about art were almost useless.[23]

Huneker, nevertheless, did take some kind of interest in Cézanne, if only because he was still unknown in America and the journalist saw an opportunity of presenting his readers with the story of a new star (albeit in his opinion a short-lived one) on the European art firmament. He seems even to have done some research, studying the greatly admired writings of George Moore, whose friendship with Manet had somehow blinded him to Cézanne's merits. Indeed, Moore subsequently summed up his opinion of the painter by saying, "The intention of Cézanne was, I am afraid, never very clear to himself. His work may be described as the anarchy of painting, as art in delirium."[24] Huneker supposedly also discussed the artist with J. K. Huysmans, who – according to Huneker – appreciated the painter scarcely more than did Moore. As Huneker later revealed, "Huysmans spoke to me of the defective eyesight of Cézanne."[25] This was indeed an opinion Huysmans had held in 1883, but by 1888 he had changed his views – in part, apparently, due to Pissarro's vigorous protests – and in 1889 he included an admiring chapter on Cézanne in his book *Certains*.[26] It does seem peculiar that he should have reverted to his old prejudices in conversations with Huneker, which must have taken place between the *III* exhibition of Denis's *Homage to Cézanne* in 1901 and Huysmans's death in 1907. But in view of the disconcerting ease with which Huneker transformed into a personal experience something he had read, it is likely that he attributed to an interview with

16 *The Abduction* 1867 (V.101)

Huysmans what that author had written in his *L'Art moderne* of 1883. Possibly not yet familiar with Huysmans's subsequent writings (though he later alluded to them), Huneker may not have known of his more positive views of Cézanne, thus putting into Huysmans's mouth words he could not conceivably have uttered at the time the American journalist seems to have known him. In any case, Huneker's concepts of Cézanne were to show a disturbing similarity to opinions Huysmans had expressed in 1883 when he wrote to Pissarro:

> I find Cézanne's personality congenial, for I know through Zola of his efforts, his vexations, his defeats when he tries to create a work! Yes, he has temperament, he is an artist, but in sum, with the exception of some still lifes, the rest is – to my mind – not likely to live. It is interesting, curious, suggestive in ideas, but certainly he is an eye case, which I understand he himself realizes. . . . In my humble opinion the Cézannes typify the Impressionists who didn't make the grade. You know that after so many years of struggle it is no longer a question of more or less manifest or visible intentions, but of works which are full of results. . . .[27]

It is deplorable – if not to say tragic – that Huneker should have relied on so unregenerate a skeptic as Moore or on the early views of Huysmans instead of trying to understand Cézanne's work with the help of such writers and critics as Geffroy, Lecomte, Mirbeau, Vauxcelles, Roger Marx, or Duret who, around the turn of the century, already had a much more comprehending attitude toward the painter. What makes it even more deplorable is that Huneker's American readers would have

gained immeasurably from his articles if these had betrayed any kind of insight into Cézanne's aims.

Be this as it may, Huneker later claimed to have written on Cézanne as early as 1901, probably in connection with Denis's *Homage to Cézanne* or with his alleged visit to Aix. But he erred when he claimed that this article appeared in *The Sun*, to which he was not contributing at the period;[28] in any case there is no way of ascertaining whether Huneker, in 1901, mentioned his supposed encounter with the artist. Until 1917 none of Huneker's published writings on Cézanne contain the slightest hint of his having met the painter (he first mentions it in a letter of 1916). If it took place at all, theirs must have been a brief and unrewarding acquaintance.

While nothing is known about Cézanne's only meeting with an American reporter, equally little has come to light about the fashion in which the first American collectors bought his pictures. There exist practically no records as to when they acquired what from whom. Most of his pictures were probably purchased from Vollard who, after 1895, had become the artist's exclusive dealer, although by the turn of the century the Bernheim-Jeunes also handled his works, frequently in partnership with Vollard. The Havemeyers, however, who bought their Impressionist and even Old Master paintings mainly from Durand-Ruel, also purchased some of their Cézannes from him, as did Egisto Fabbri and Charles Loeser. The Havemeyers' first fully documented purchase of a work by Cézanne dates from 1903, when they acquired *The Abduction* (V.101), which they may have intended to buy at the auction of Zola's estate but failed to get. It was bought there by Vollard, from whom Durand-Ruel obtained it shortly afterward, apparently at the Havemeyers' behest (in those days, with no reproductions in sale catalogues, it was not always easy for foreign buyers to make up their minds and put in their bids on time). Yet it is more likely that by 1903 the Havemeyers already owned other paintings by Cézanne,[29] bought from Vollard whose account books – or at least those that have survived – yield very little information.

The manner in which Vollard kept his ledgers is both mysterious and frustrating. His very first – and rather vague – records covering the period from January 1896 to April 1899 are in a small notebook that contains a few pages of legal texts. It had obviously been used by Vollard around 1890 during his earliest days in Paris when he was studying law before his decision to become an art dealer. This notebook lists transactions by month, usually giving merely the name of the purchaser with the name of the artist whose work was sold, followed by the price paid. In a few cases a very brief description of the object is provided. Thus, in March 1896, Monet bought a "Cézanne, vue de Lestac [*sic*]" for 600 francs (V.492), Degas acquired "pommes de Cézanne, et baigneur" (V.190, V.544) for 150 francs, and Fabbri paid 400 francs for "Gardanne maisons rouges" (V.430). But in May, only "Fabbri, Cézanne, 400 francs" is recorded, followed in June by "Ch. Loeser, Cézanne, 1000 francs." Among other early clients were the Russian Shchukin, the Dutchman Hoogendijk, the Frenchman Pellerin (four Cézannes for 1,800 francs in December 1898), and the German Meier-Graefe (who bought a van Gogh for 2,500 francs). On the very last page of the book, an undated entry indicates that Loeser acquired four paintings by Cézanne for a total of 1,900 francs, giving in part payment a work by Toulouse-Lautrec valued at 500 francs.

17 *L'Estaque* 1879–83 (V.492)

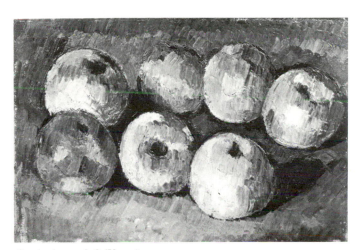

18 *Apples c.* 1878 (V.190)

19 *Bather with Outstretched
Arms* 1877–78 (V.544)

20, 21 Page from Vollard's ledger

20, 21 There are also two much larger ledgers in the form of regular commercial account books with columns for date and source of purchase, name of artist, description of the work, its size, cost price, date of sale, name and address of buyer as well as selling price. In addition to his stock numbers – which were not given in the small notebook – Vollard generally provided in the earlier of these two large registers short but usually sufficient descriptions of individual works (a helpful improvement over his first records), together with their dimensions; these often make identification possible. As source for his acquisitions of works by Cézanne, Vollard mostly listed "Cézanne" without distinguishing between the artist himself and the latter's son, from whom he made many purchases not only after the painter's death but also while he was still alive. Whereas Vollard often, though by no means always, recorded the purchase price, he rarely indicated the date of purchase and only seldom the date of sale, the price obtained, or the name of the buyer.

From the way individual entries are made, it would seem that the extant large logbooks do not represent day-by-day transactions with their inherent changes of the slant of the pen, the color of the ink, and so on. Indeed, most of the pages are filled with uniformly written notations, as though they were all transcribed at the same

Sortie

Dates de Sortie	Noms des Acquéreurs	Adresse des Acquéreurs	Prix vendu	Observations
[...] Février 1900	Fabbri	rue Boulogne n: 7	1.000	

time, perhaps representing a clean copy of an original, more disorderly, as well as more complete, record. Maybe Vollard practiced some kind of double bookkeeping, entering in these ledgers only what he wished? Most of the writing appears to be in Vollard's hand, but some of the entries, or rather groups of entries, were made by someone else. They are easily distinguished from Vollard's because of the incredible number of mistakes in which words and names are spelled phonetically. It would seem that these entries were dictated to a person who not only was unfamiliar with the names of the artists in whose works Vollard dealt, but was altogether badly in need of what would now be called "remedial spelling."[30]

The earlier of the two large registers reports transactions that took place at the end of 1899 and it can thus be presumed to have succeeded the small and more primitive notebook. The second large register dates definitely from a later period and contains even less information than the other. In it there is no clue as to the order in which the entries were made, except that they certainly do not follow a chronological sequence. Indeed, one finds in an incomprehensible hodgepodge: items from the 1918 sale of Degas's studio, followed by a work by Gauguin acquired directly from the artist (that is, before his death in 1903), and – on the same page – a mention of Vollard's

22　*Landscape near Bellevue* 1892–95 (V.449)

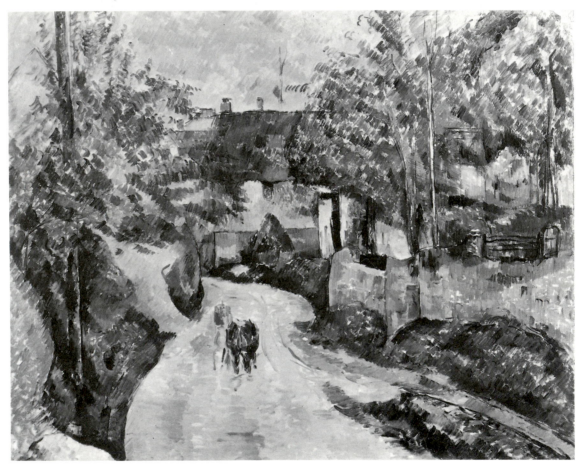

23　*Turning Road at Auvers-sur-Oise c.* 1881 (V.178)

portrait by Cézanne painted in 1899 (though it may indeed have been purchased at a later date), as well as a reference to a picture from the Tanguy sale, which had taken place in 1894. In other words, some of the undated yet datable entries reveal a span of a quarter of a century; it is difficult to imagine how Vollard himself could find his way through this maze. But then, it may actually have been intended to be impenetrable, since Vollard's relations with the tax collector were not, reportedly, the most cordial.

In the second register, dimensions of works are often missing, purchase prices and dates are never given, and the columns devoted to the date of sale, the name of the buyer, and the price obtained are left completely blank. On the other hand, there are occasional numbers pertaining to the photographs of the works in question which Vollard assembled in separate albums; these references make it possible to identify the paintings.

There are hardly any entries relating to American buyers. The earlier ledger reveals that on February 10, 1900, Fabbri, rue Tourlaque No. 7 (in Montmartre) purchased a small landscape by Cézanne for which Vollard had paid the artist or his *22* son 200 francs and which he sold for 1,000.[31] Six weeks later, on March 24, 1900, Fabbri purchased a composition of five bathers, which Vollard had also acquired from Cézanne – father or son – for 200 francs, for which he now obtained 2,500.[32] There is a further, undated entry, according to which Vollard bought from Fabbri a work by Daumier, *Les Amateurs d'estampes*, 34 × 27 cm, with no other specifics.[33] Vollard also obtained a landscape by Cézanne from Loeser which he probably had sold him previously, *Turning Road at Auvers-sur-Oise*, 60 × 73 cm; according to the *23* number of the photograph, this must have been V.178.[34]

While the names of Fabbri and Loeser thus appear from time to time in Vollard's account books, even though it is not always possible to identify the works they purchased, there is not a single reference to the other American collectors who evinced a comparatively early interest in Cézanne, namely the H. O. Havemeyers.

NOTES

1. Robert Henri quoted in Walter Pach, *Queer Thing, Painting* (New York: Harper & Brothers, 1938), p. 47.

2. See S. La Folette, *Art in America* (New York: Harper & Brothers, 1929), pp. 308 and 300.

3. Walter Pach, *Ananias or The False Artist* (New York: Harper & Brothers, 1928), p. 190.

4. Frank Crowninshield ("The Scandalous Armory Show of 1913," *Vogue*, Sept. 15, 1940, p. 115) gives a different version: "It was Mrs. Montgomery Sears, of Boston, who, after acquiring her Manets and Renoirs, purchased Cézanne's fine view of 'Auvers on the Oise,' in 1906, the year of the painter's death, thereby beginning the vogue for his works in this country." This can no longer be checked, nor can the landscape of Auvers be identified.

5. Unsigned article, *New York Herald* [Paris], June 29, 1899; quoted more extensively in J. Rewald, *Studies in Impressionism* (London: Thames and Hudson; New York: Abrams, 1985), pp. 162–63.

6. Unsigned, "Chronicle: Pictures in Europe," *New York Commercial Advertiser*, July 20, 1899.

7. Durand-Ruel now also began to promote Cézanne's work. In October 1900 he sent twelve paintings by the artist to Paul and Bruno Cassirer in Berlin for Cézanne's first one-man show in Germany. Among these were not only the two still lifes purchased from Miss Hallowell, but also

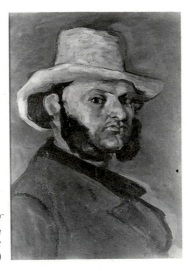

24 *Portrait of
Gustave Boyer with
Straw Hat
c.* 1871 (V.131)

six pictures from the Chocquet collection. Most of the exhibits were not for sale and no buyers presented themselves for those that were. In Jan. 1901, all twelve canvases were returned to Durand-Ruel.

In 1904, Emil Richter of Dresden prepared an exhibition of French Impressionists for which he requested loans, including works by Cézanne, from Durand-Ruel. But the latter sent him only five paintings by Renoir; works by most of the other Impressionists were lent by Cassirer, including several that Cassirer had on consignment from Durand-Ruel. The show opened on Nov. 10, 1904.

8. For details of the Chocquet sale see Rewald, *Studies in Impressionism*, pp. 160–78. That these prices were not artificially inflated became evident when an early still life by Cézanne (V.70), owned by one of the Shchukin brothers, was sold the following year in Paris with some of the contents of his Parisian apartment and brought 7,000 francs ($1,400); it was bought by the Bernheim-Jeunes.

9. Georges Lecomte, "Paul Cézanne," *Catalogue de tableaux ... composant la collection de M. E. Blot*, Hôtel Drouot, Paris, May 9–10, 1900, pp. 24 and 26. The paintings by Cézanne in the sale were V.644 (1,800 frs), V.659 (5,000 frs), V.512 (2,000 frs), V.612 (600 frs); all were bought in. There was also, for 1,000 frs, an early landscape of L'Estaque (V.55). In comparison with Cézanne's average of 2,800 frs, eight canvases by Guillaumin reached an average of only 2,125 frs. Five landscapes by Monet averaged 4,170 frs; one landscape by Sisley (who had just died) reached 11,000 frs, though the average for his six paintings did not exceed 3,825 frs. Two paintings by Renoir brought a total of 10,200 frs; the single work by Berthe Morisot rose to 8,000 frs, but a flower still

life by van Gogh from his Paris period was bought in at 1,100 frs.

10. Ibid., p. 29.

11. See Eugène Blot, *Histoire d'une collection de tableaux modernes (50 ans de peinture–de 1882 à 1932)* (Paris: Editions d'art, 1934) pp. 36–37.

12. Edouard Detaille, notebook entry, Apr. 14, 1900; see J. Humbert, *Detaille* (Paris: Copernic, 1979), p. 31. This document was brought to my attention by the late Jean Adhémar, Paris.

13. James G. Huneker, *Unicorns* (New York: Charles Scribner's Sons, 1917), p. 101; article reprinted from the *New York Sun*, Mar. 11, 1917.

14. On this subject see J. Rewald, *Studies in Post-Impressionism* (London: Thames and Hudson; New York: Abrams, 1986), pp. 228–30.

15. See the letter of Mar. 31, 1907, from F. J. Mather, Jr. to William Laffan, quoted in Arnold T. Schwab, *James Gibbons Huneker* (Stanford, Calif.: Stanford University Press, 1963), p. 176.

16. Ibid., Chapter 3. See also Samuel Lipman, "James Huneker as music critic," *The New Criterion*, June 1987, pp. 4–14.

17. James G. Huneker, "Coda," *Promenades of an Impressionist* (New York: Charles Scribner's Sons, 1910), p. 389.

18. James G. Huneker, *Steeplejack* (New York: Charles Scribner's Sons, 1920), vol. 1, p. 241.

19. James G. Huneker, article in the *New York Sun*, Oct. 24, 1907, quoted by Schwab, *Huneker*, p. 176.

20. James G. Huneker to Royal Cortissoz, London, Jan. 7, 1916; *Letters of James Gibbons Huneker* (New York: Charles Scribner's Sons, 1922), p. 204. For the source of Huneker's comment that Cézanne's father had been a barber, see Chapter V, p. 119.

21. James G. Huneker, *Unicorns*, p. 103; article reprinted from the *New York Sun*.

22. James G. Huneker, *Variations* (New York: Scribner's Sons, 1921), p. 97; article reprinted from the *New York Sun*, April 4, 1920 [?].

23. See Cézanne's letter to Emile Bernard, Aix, May 26, 1904; Paul Cézanne, *Correspondance* (Paris: Bernard Grasset, 1978), p. 302.

24. George Moore, *Reminiscences of the Impressionist Painters* (Dublin: Maunsel, 1906), p. 35.

25. James G. Huneker, *Variations*, p. 91.

26. On this subject, see George H. Hamilton, "Cézanne and His Critics," in *Cézanne: The Late*

Work, ed. William Rubin (New York: Museum of Modern Art, 1977), pp. 139–49.

27. J. K. Huysmans to Camille Pissarro, end of May 1883; quoted in J. Rewald, *The History of Impressionism* (New York: Museum of Modern Art, 1973), pp. 473–74.

28. It has not yet been possible to locate this article, which could actually turn out to be nothing but a general review of the 1901 Salon with a reference to Cézanne and to Denis's *Homage*. In view of Huneker's occasionally self-serving errors, the article may never have existed.

29. According to consular invoices in the archives of the Durand-Ruel gallery in Paris, two paintings by Cézanne were shipped to New York on May 7, 1903: *The Abduction* and *Portrait of a Man*. Another *Portrait of a Man* was shipped on Dec. 29, 1904; all were sent to a Mr. Huss, who may have been an agent for Mr. Havemeyer. It is known that through Durand-Ruel, Havemeyer purchased *The Abduction* (V.101) from Vollard, who had acquired it early in March 1903 at the Zola estate sale. The *Portrait of a Man* that accompanied it was doubtless the *Portrait of Boyer* (V.131) which the Havemeyers also bought from Vollard; it was bequeathed to the Metropolitan Museum of Art, New York. The separately shipped *Portrait of a Man* must have been Cézanne's *Self Portrait* (V.289), similarly acquired from Vollard; it is now in the Hermitage Museum, Leningrad. On this subject see Frances Weitzenhoffer, *The Havemeyers: Impressionism comes to America* (New York: Harry N. Abrams, 1986).

30. Names were spelled Cézane, Gaugin, Vuillar, Vangogue, etc. The entry for the large *Bather* (V.548; Museum of Modern Art, New York) reads: 'huile, homme nue [*sic*] les main [*sic*] sur le [*sic*] hanche [*sic*] regardan [*sic*] les piend [*sic*], font [*sic*] bleu, 131 × 98 cm" (actually 127 × 96.8 cm); the purchase price was 200 francs.

31. The description reads; "Petit paysage gris d'argent, maisons dans la campagne du midi – au premier plan un pouce de terrain dans presque toute la longueur. 35 × 51 cm." This is the landscape V.449 (now in the Phillips Collection, Washington, D.C.) whose exact dimensions are 36 × 50 cm.

32. The description says: "huile, cinq personnages nus dans des positions diverses au sortir du bain, 61 × 74 cm." This is the painting V.390 (measuring 60 × 73 cm); it was sold by 1904, possibly because Fabbri preferred a smaller version, V.389, measuring 34.5 × 38.1 cm.

33. This may have been the oil painting on panel, 35 × 26 cm; K. E. Maison, *Honoré Daumier:*

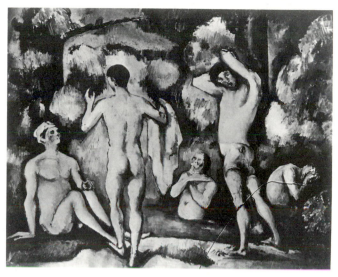

25 *Five Bathers* 1880–82 (V.390)

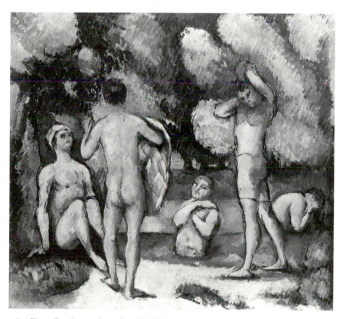

26 *Five Bathers* 1879–80 (V.389)

Catalogue Raisonné of the Paintings, Watercolors and Drawings, vol. I, No. I–236, where it is listed as having once belonged to Durand-Ruel, see Chapter I, note 23.

34. It was not known that this landscape (now in the Boston Museum of Fine Arts, John T. Spaulding Collection) had at least temporarily belonged to Loeser. I am grateful to Dominique Fabiani, Paris, for letting me consult Vollard's two large registers.

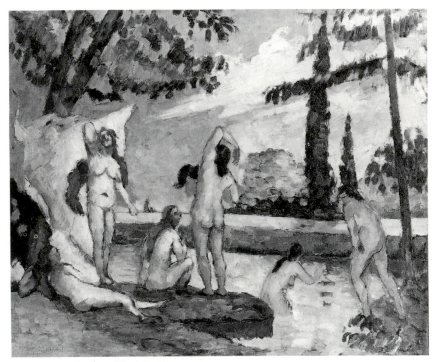

27 *Bathers* 1874–75 (V.265)

28 *Still Life with Cherries* 1885–87 (V.498)

III · The Steins and Their Circle

EARLY IN 1904, Leo Stein, an American who had been painting at the Académie Julian in Paris since the previous year, asked Bernard Berenson whether there were any living artists in France deserving attention. Berenson encouraged Stein to take an interest in Cézanne, whereupon the neophyte collector acquired a vertical landscape from Vollard (V.310).[1] That summer Stein went as usual to Florence where, as he later said, he spent more time with Cézanne than he did with the pictures in the Uffizi and the Pitti. This happened after Berenson told him that an American expatriate, Charles Loeser, his Florentine neighbor and "enemy-friend," owned many of the artist's works. "I thought that strange," Leo subsequently remembered, "as I had often been at Loeser's house, but Berenson explained that the Cézannes were not mixed with the other pictures which filled his house, but were all in his bedroom and dressing room. . . . He had begun buying Cézannes in the early days, when Vollard's was a kind of five-and-ten establishment, and had got together an interesting lot. . . . When I got back to Paris after the Cézanne debauch, I was ready to look further."[2]

Loeser's "interesting lot" eventually comprised more than a dozen paintings by Cézanne – among them two important still lifes – most of them probably acquired prior to Leo Stein's sojourn of 1904. When Berenson saw the total collection (possibly only after Loeser's death), he greatly admired the still life that included a scalloped plate with three peaches and, close by, a green pear, a work he considered, as he put it, "less exquisite, less delicate than Chardin, though with more flavor and more sensuousness."[3] The other still life was a beautifully balanced composition of a dish with red cherries and a plate with apricots behind which appears the vertical green shape of a glazed olive jar (V.498). The almost symmetrical arrangement of the two round dishes is alleviated by a white napkin that intrudes from the left and whose graceful folds expire gently near the right edge of the canvas beneath a single apricot, the only fruit that escaped from the white circles of the two plates.[4] *XVI*

28

Although there was also an early, yet colorful scene of bathers (V.265), the accent of the collection was on landscapes, among which a luminous and concisely structured view of a group of houses in front of Mont Sainte-Victoire was probably the most impressive, a painting of majestic limpidity and mysterious stillness that is truly awe-inspiring (V.435). Loeser's landscapes ran the gamut from some still hesitant works of the Auvers period, when Cézanne had first begun to paint directly from nature (the scene of bathers is somewhat related to that phase), to a confidently *27*

31

29 *House on the Marne* 1888–90

30 *The Forest* 1890–92 (V.645)

31 *Mont Sainte-Victoire and Hamlet near Gardanne* 1886–90 (V.435)

brushed view of a house on a hill near Aix, executed during the artist's very last years (which may not have been purchased until after Cézanne's death). Between these two poles were other landscapes, such as a richly nuanced aspect of the Marne River *29* where the distant bank is mirrored in the quiet waters, and a forest scene (V.645) in *30* which sinuous lines of branches divide the luxuriant vegetation.[5]

In addition, Loeser owned a number of smaller paintings, among them some with figures, but he did not possess a single important portrait or figure piece. Fabbri had several of these, yet Leo Stein never mentions seeing Fabbri's collection either in Florence or in Paris, where most of it was apparently housed;[6] nor does he allude to any favorites among Loeser's treasures or even refer to any specific work.

"Ready to look further" after his summer in Florence, Leo visited Vollard for new purchases to succeed the landscape acquired earlier that year. That landscape (V.310) of rippling greens, full of light, shows a fascinating juxtaposition of verticals, *33* horizontals, and a few discrete diagonals; its brushwork is much freer and more incisive than that of Loeser's pictures of the Auvers period, which Leo had not yet seen when he bought this canvas. Toward the end of 1904 Gertrude informed a friend, "We is doin business too we are selling Jap prints to buy a Cezanne at least we are that is Leo is trying. He don't like it a bit and makes a awful fuss about asking enough money but I guess we'll get the Cezanne."[7] That picture was doubtless the portrait of the artist's wife which had been shown at the Salon d'Automne of 1904 *V, 59* under the title *La Femme à l'éventail* (V.369).

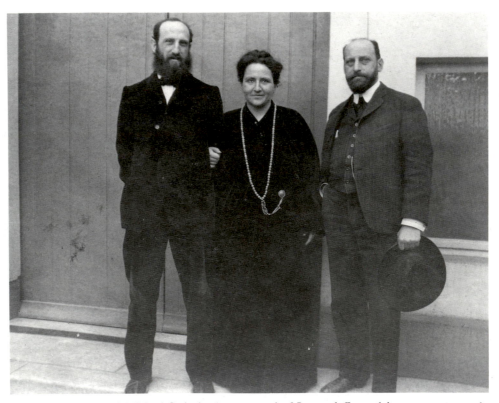

32 Leo, Gertrude and Michael Stein in the courtyard of Leo and Gertrude's apartment, rue de Fleurus, Paris, early 1906

No complete list of Cézanne's works owned by Leo and Gertrude Stein seems ever to have been established,[8] nor are the dates known when most of them were acquired, but among the oils and watercolors they assembled, this portrait of the artist's wife (V.369) was, in addition to the vertical landscape, the most important Cézanne in their collection. It was the only picture at the Steins that Fernande Olivier, Picasso's mistress, specifically remembered, for she spoke later of 'that beautiful likeness of the painter's wife in a blue dress, sitting in a garnet-colored armchair.'[9] There were also two medium-sized compositions of bathers (V.590 and 724), purchased from Vollard one day when their older brother Michael surprised them with a surplus in their modest funds; a small still life of powerfully modeled apples (V.191), acquired in December 1907 from Bernheim-Jeune; and a study of a man with a pipe (V.566). There were at least seven watercolors, of which one of a smoking peasant (RWC 381) was probably the most remarkable; four were landscapes, among them a view of Mont Sainte-Victoire (RWC 246, 522, 377, and 502).[10] Yet there may have been more; Fernande Olivier mentioned "a large quantity of watercolors by Cézanne, bathers in landscape settings, etc."[11] Vollard held his first exhibition devoted exclusively to Cézanne's watercolors in 1905, and it appears likely that the Steins' first purchases of watercolors date from that show. (Neither Loeser nor Fabbri nor the Havemeyers seem to have owned watercolors by Cézanne, possibly because the bulk of their collections had been formed before great numbers of them appeared on the market.[12])

V, 59

121

34

35

36

37

38

33 *The Conduit c.* 1879 (V.310)

34 *Group of Bathers*
1898–1900 (V.724)

35 *Five Apples* 1877–78
(V.191)

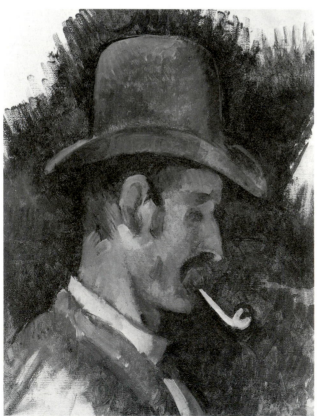

36 *Man with Pipe*
1892–96 (V.566)

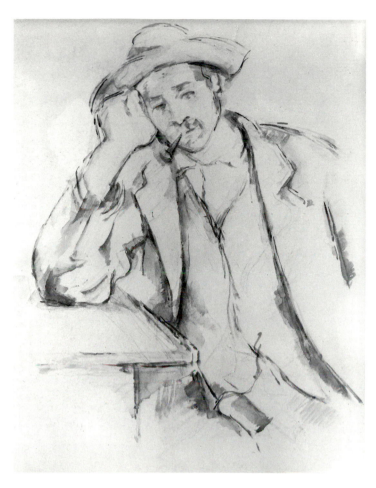

37 *The Smoker* 1890–91 (RWC.381)

38 (below) *Mont Sainte-Victoire*
1900–02 (RWC.502)

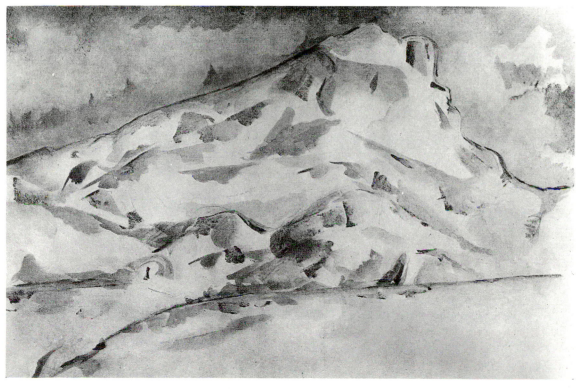

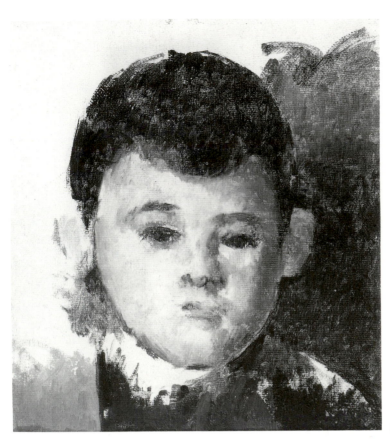

39 *Head of the Artist's Son c.* 1880

39 Leo's and Gertrude's brother, Michael, and his wife, Sally, who then also lived in Paris, had at least one painting by Cézanne, a tiny *Head of the Artist's Son*. An exquisitely delicate work of thin, transparent glazes that seem to touch the surface only lightly, with part of the bare canvas showing, it is nevertheless fully resolved as a tender statement. A friend of Michael and Sally later described how this small picture was acquired at the sale of the Viau collection in March 1907. "The bidding was lively," the friend remembered, "and I became so excited that I did not realize that Michael's last bid had been accepted. The next day a Paris newspaper commented upon the sale, speaking of 'the crazy American who paid one thousand francs [$200] for a Cezanne fragment.'"[13]

40 However, Michael and Sally Stein's collection was not so much geared to Cézanne as it was to Matisse, with whom they were to maintain closer and warmer ties than did Leo and Gertrude.[14] While they also generously opened their house to visitors, the atmosphere in their home appears to have been less fraught with the kind of discussion and controversy that Leo relished.

In the words of the same friend, Michael Stein's "favorite sport" was introducing American visitors to the treasures of the Paris museums and galleries "and making sure that they were properly respectful and appreciative of what they were privileged to see. One of the special attractions on his list was visiting the extraordinary collection of . . . paintings in the Durand-Ruel home. There, once a month the public was admitted by card procured at their gallery. The collection contained some of the

40 Michael and Sally Stein, Henri Matisse, Allan Stein (Michael and Sally's son), and Hans Purrman (a German painter and pupil of Matisse) at Michael and Sally's apartment, rue Madame, Paris, c. 1908. All the paintings are by Matisse

choice works of Renoir, a few Cezannes [from the Chocquet sale], Manets, Monets, and others of that period."[15]

There was a basic difference between such collections and that assembled by the Havemeyers, whose purchases immediately disappeared, so to speak, into their somber and stately mansion on Fifth Avenue where only a few select visitors were admitted, and then generally restricted to the downstairs galleries with the celebrated Old Masters. The Steins, by contrast, played an important role in the dissemination of Cézanne's fame, and that of Matisse and Picasso as well. Their house was virtually open, in particular to any fellow countryman passing through or living in Paris, and to many others too, such as, for instance, the English critics Roger Fry, Clive Bell, C. Lewis Hind, and Frank Rutter, or such Russian fellow collectors as Sergei Shchukin and Ivan Morosov.[16] Leo and Gertrude Stein owned more works by Cézanne than could be seen at the Luxembourg museum, not to mention the watercolors, of which the Luxembourg had none. Hardly any American artist or writer who went to Paris – which was becoming increasingly popular among the international avant-garde – failed to visit them or remained indifferent to the accumulation of paintings on the cluttered walls of their rue de Fleurus apartment.[17]

45, 46

41–44

41 *Landscape by the Waterside* 1878–80 (RWC.95)

42 *Forest Path* 1882–84 (RWC.170)

43 *The Coach House at Château Noir* 1890–95
(RWC.394)

44 *Olive Grove*
c. 1900 (RWC.522)

45 Leo Stein in the rue de Fleurus apartment, *c.* 1906. Among the paintings on the walls are works by Gauguin (second from left), Renoir (above Leo's head), Maurice Denis (*Maternity*), and Cézanne (*Group of Bathers, see Ill. 121*)

Typically, collectors influence their contemporaries; Leo, having been encouraged by the example of Charles Loeser, in turn transmitted his appetite to others. While there is no absolute proof, it does seem that Albert Barnes owed his introduction to Cézanne to the Steins. At least it can be said that Barnes's preferences show remarkable parallels to those of Leo. His vast collection was to be built around the two artists who were Leo's favorites, Renoir and Cézanne, to whom, among the younger artists, he added especially Matisse, a knowledge of whom he always connected with Leo Stein. Although Barnes subsequently also bought other moderns, he showed comparatively little interest in most of the French nineteenth-century painters that Leo neglected.

In the beginning, not all the visitors to the Steins shared their tastes in art. During the summer of 1905, when the collection was still in a very early stage, the painter Alfred Maurer and a fellow American, the sculptor Mahonri Young, took visitors to see the pictures while Leo and Gertrude were in Florence. "Young and I shocked some Americans the other day with them," Maurer gleefully reported to Leo. "The lady wanted to know if I was in earnest."[18] He was, although one could not always be certain of it, particularly when he discussed the problem of *finish*, which was constantly brought up in connection with Cézanne, whereas it was no longer questioned concerning the other Impressionists. In such instances Maurer would point to the *Portrait of the Artist's Wife* (V.369), declaring "you could tell it was *V, 59* finished because it had a frame."[19]

As Mabel Dodge, one of Leo's and Gertrude's intimates, later wrote: "In those early days when everyone laughed, and went to the Steins' for the fun of it, and half

angrily, half jestingly giggled and scoffed after they left (not knowing that all the same they were changed by seeing those pictures), Leo stood patiently night after night wrestling with the inertia of his guests, expounding, teaching, interpreting. . . ." According to Mabel Dodge, "Buying those distorted compositions and hanging them in his apartment, Leo felt the need for making others see what he found in them, and this turned him eloquent."[20] Leo himself spoke of "the obligation that I have been under ever since the Autumn Salon [of 1904], of expounding L'Art Moderne. . . . The men whose pictures we have bought – Renoir, Cezanne, Gauguin, Maurice Denis – and others whose pictures we have not bought but would like to – Manet, Degas, Vuillard, Bonnard, Van Gogh for example – all belong. To make the subject clear requires a discussion of the qualities of the men of '70 of whom the Big Four and Puvis de Chavannes are the great men and the inspirers in the main of the vital art of today. The Big Four are Manet Renoir Degas & Cezanne."

Whereupon Leo would launch into the "required discussion" for the benefit of his correspondent, devoting a paragraph to each of these artists:

> Manet is the painter par excellence. He is not the great colorist – that is Renoir – but in sheer power of handling he has perhaps not had his equal in modern times. He had a great conception of art but few great conceptions. . . .
>
> Renoir was the colorist of the group. He again was a man of limited intellectuality but he had the gift of color as no one perhaps since Rubens except perhaps Fragonard has had it, what you might call the feeling for absolute color. . . .
>
> Degas the third of the quartet is the most distinctively intellectual. Scarcely anything that he has done is inachieved [sic] either in part or in whole. He is incomparably the greatest master of composition of our time, the greatest master probably of movement of line with a colossal feeling for form and superb color. . . .
>
> Fourth comes Cezanne and here again is great mind a perfect concentration and great control. Cezanne's essential problem is mass and he has succeeded in rendering mass with a vital intensity that is unparalleled in the whole history of painting. No matter what his subject is – the figure – landscape – still life – there is always this remorseless intensity this endless unending gripping of the form the unceasing effort to force it to reveal its absolute self-existing quality of mass. There can scarcely be such a thing as a completed Cezanne. Every canvas is a battlefield and victory an unattainable ideal. Cezanne rarely does more than one thing at a time and when he turns to composition he brings to bear the same intensity keying his composition up till it sings like a harp string. His color also though as harsh as his forms is almost as vibrant. In brief his is the most robust the most intense and in a fine sense the most ideal of the four.[21]

But no sooner had Leo established a very special relationship with Cézanne, whose intellect and aims appear to have been closest to his heart (if not his eyes, which liked to feast on Renoir's exuberant colors), than there came the discovery of Matisse in 1905, supplemented quickly by a purchase of his work and acquaintance with the artist. This was followed shortly by the addition of Picasso to the Stein collection and to their circle of friends. With them grew Leo's "obligation" to extend his propagandizing efforts on behalf of their work, which soon displaced that of Manet and Degas in his enthusiasm, though it did not dull his commitment to Cézanne. "I expounded and explained," Leo subsequently wrote. "People came, and so I explained, because it was my nature to explain."[22] In later years Leo also remembered: "One man who came to my place in Paris told me that the only

46

46 Leo and Gertrude's apartment, rue de Fleurus, Paris, 1906, showing Matisse's *Bonheur de vivre* (top), works by Renoir (the two women and the head of a girl), and Cézanne (the portrait of the artist's wife and a composition of bathers to its left, *see Ills. V and 34*)

Cézannes he cared for were those he saw there. Certainly they were not the best Cézannes, but the place was charged with the atmosphere of propaganda and he succumbed."[23]

Even when he concerned himself with other artists, Leo often would wind up the discussion with references to Cézanne. In a letter to a friend he began by explaining:

> The thing that Matisse has as his dominant character is clarity . . . I can't speak of the clarity of his color or form properly, but rather for me his color & form result in a total expression for which clarity is the best term. Michael Angelo & Cezanne are so far as I know the great masters of Volume. In Pollaiuolo the dominant thing is Pressure. In Rembrandt so far as I have gotten at it it is Fullness. And so on. I believe that every authentic artist has some quality that is dominant and that will be found in his every artistic expression. . . . The difference between an apple of Cezanne & a nude of Michael Angelo lies mainly in the complexity of organization.[24]

When Bernard Berenson occasionally dropped in on the Steins, he probably was provoked into verbal jousts with Leo, who must have been happy to elaborate in still greater detail on the analogies between the masters of the Renaissance and Cézanne. It was at the rue de Fleurus that Berenson met Picasso, yet it was Sally Stein who introduced him to Matisse, with whose faculties and principles he was deeply impressed.[25] A few weeks after their meeting, Berenson went so far as to publicly defend the artist's seriousness of purpose and mastery of draughtsmanship. Whereupon the entire Stein family, as he later said (not too graciously), "who at that time arrogated to themselves the office of High Protectors of newness in painting, began to prod me to leave all I had and to dedicate myself to expounding the merits of the new school. When I would not, they sadly put me down as having made a great refusal."[26]

Whether Leo Stein had any further discussions concerning Cézanne with Berenson is not known, but Cézanne did remain on Berenson's mind and, in 1910, for example, he was to write from Ravenna to his wife: "I have never before noticed so clearly the resemblance between the technique of colour in mosaic and in our impressionists as in Cézanne for instance. They have in common a procedure of juxtaposition of tones."[27] It would have been very surprising had Leo agreed with this rather shallow analogy. In any case, a young American writer and friend of Leo, Willard Huntington Wright, would soon "reply" to Berenson, even though he was certainly not aware of Berenson's observation. Trying to explain Cézanne's aversion to the primitives in whom he saw only the rudiments of art, Wright stated: "How could Cézanne, preoccupied with the most momentous problems of aesthetics, take an interest in enlarged book illuminations, when the most superficial corner of his slightest canvas had more organisation and incited a greater aesthetic emotion than all the mosaics in S. Vitale at Ravenna?"[28]

But if Stein and Berenson no longer found any common ground for communicating on the subject of Cézanne, Leo did continue to discuss the artist with many, and more receptive, friends such as, among others, the American painter Morgan Russell who, upon his arrival in Paris in 1908, had passed through an interesting evolution of enchantments. At first Russell had been captivated by the paintings of Monet which he studied at an exhibition at the Durand-Ruel galleries and in whom he saw the "master of light." However, in a letter to his friend Andrew

47 Morgan Russell *Three Apples* 1910

Dasburg, Russell specified, "Monet is not the only one: wait till you get acquainted with Gauguin, Cézanne, and the younger men, Matisse, etc. . . ."[29] It was Leo Stein who had awakened Russell's interest in Cézanne, and when Russell was joined in Paris by Andrew Dasburg, the two young artists even borrowed the small still life of apples by Cézanne (V.191) from Leo and painted works directly inspired by it. "To me the original is infinitive," Dasburg wrote to his wife. "It will rest in my mind as a standard of what I want to attain in my paintings. . . . I wish that Stein would let me copy another one which he has. A figure composition that is a beauty."[30] Whereas Dasburg himself copied the Cézanne apples literally, his friend Russell copied them "in an analytical way," as Dasburg put it.[31] (However, after Russell abandoned Synchromism, Cézanne's influence was occasionally to reappear in his canvases.)

 Leo continued their discussions even from Fiesole, near Florence, telling Russell in a letter: "I noticed at Rome that nowhere on the ceiling has Michelangelo attained to the sheer expression of form that is often achieved in his drawings. I believe that nowhere is it as complete as in those apples of Cézanne's. Cézanne must for the . . . general public always remain a painter of still life because there only could he 'realize' in the ordinary sense of the word without sacrificing his aesthetic conscience."[32]

 Leo elaborated on this problem in relation to Cézanne many years later. "Aesthetic unity," he then wrote,

> can be obtained only by breaking through the defined contours of the inventorial object, and trough effecting a fusion of the content. Every aesthetic expression is dynamic, and therefore involves distortion. . . . Distortion in aesthetics means simply that the things which are normally given in the course of practical experience, are selectively and in combination so treated as to satisfy an end of personal interest, and that in the course of this process their inventorial identity is respected, not for its own sake, but only in so far as

35

47

the present attitudes of the self are compatable with it. By way of instance I recall what Matisse said to me several times, during that period when his pictures showed the most extreme distortions of natural forms. He said that he never began a picture without hoping that this time he would be able to carry it through without any distortion that would disturb the ordinary onlooker. But his greater demand was for certain qualities of plenitude and rhythm, and before he had managed to work up his inventorial items of human bodies and accessories to the conditions of his pictorial intention, they had been pulled entirely out of shape.

In Cézanne's pictures the conditions of distortion were the same. It was done on purpose but not, in childish language, intentionally on purpose. It happened once that a young painter asked me why Cézanne had distorted the dish in a certain picture that was before us. I told her to look at the picture, and to imagine the dish drawn as a proper ellipse. Of course she saw at once that this would not do. It would have been possible to have done a picture with the plate as a good ellipse, but in that case Cézanne would have had to make compensating distortions elsewhere. The kind of result he was after could not be obtained by keeping a group of normally seen objects constant to their normal appearances.[33]

Sometimes, when Leo took a personal interest in the education of a young artist, he would introduce the beginner to Vollard who would bring out half a dozen canvases.[34] Yet not even Leo's intervention could make the dealer depart from his habit of presenting only a few pictures at a time while hundreds of them were literally piled up in his closets. What Leo himself said in front of these paintings or at the Stein's Saturday soirées is not known,[35] the reason probably being that his personality was such as to leave many of his listeners somewhat confused. One of his oldest friends, Hutchins Hapgood, who had first met him in 1895 when traveling on the same ship to Japan (and who subsequently introduced him to Berenson at Settignano), admitted many years later:

> Whenever I think of Leo Stein, I like him better than when I am with him. He couldn't leave the slightest subject without critical analysis. He and I argued the livelong days. . . . He was almost always mentally irritated. The slightest flaw, real or imaginary, in his companion's statements, caused in him intellectual indignation of the most intense kind. And there seemed to be something in him which took it for granted that anything said by anybody except himself needed immediate denial or at least substantial modification. He seemed to need constant reinforcement of his ego, in order to be certain that all was well with the world and that God was in his heaven.

However, probably feeling that he had not done justice to his friend, Hapgood added: "But . . . there was something singularly pure, high-minded, and noble about him. Had it not been for the shadow of himself, his constant need of feeling superior to all others, he would have been a great man."[36]

No wonder that the irritating blend of overbearing quarrelsomeness, compulsive pontification, and intellectual purity startled Leo's guests rather than convinced them of the pertinence of his views. Leo himself later acknowledged that "Barnes once objected that I liked to expound my own aesthetics, but was impatient of listening to his expositions. He said: 'This hurts like Hell.'"[37] This attitude may explain the absence of any extensive reports of what Leo imparted to his audience.

It is likely that when Leo Stein discussed Cézanne, he most often spoke of what he

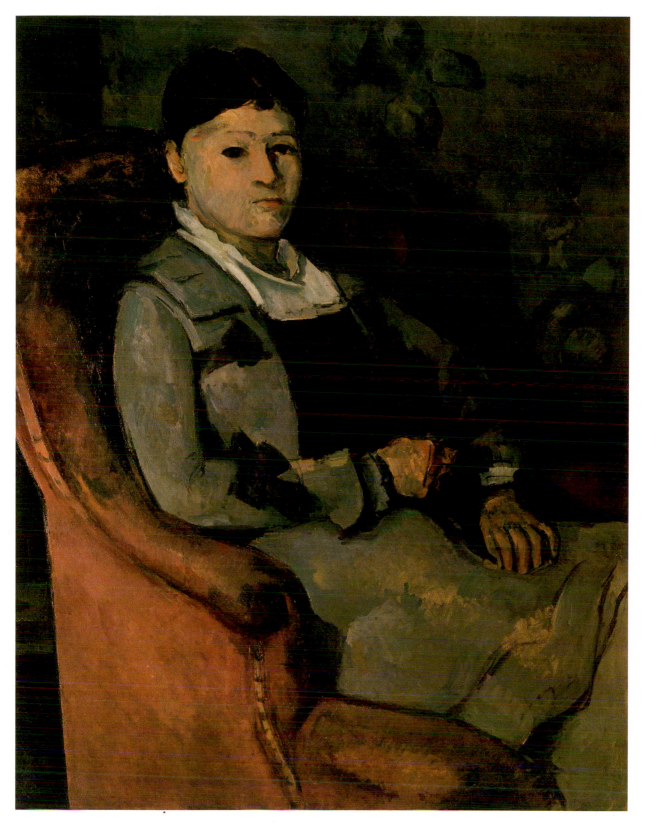

V *Portrait of the Artist's Wife* probably started *c.* 1878, reworked 1886–88 (V.369)

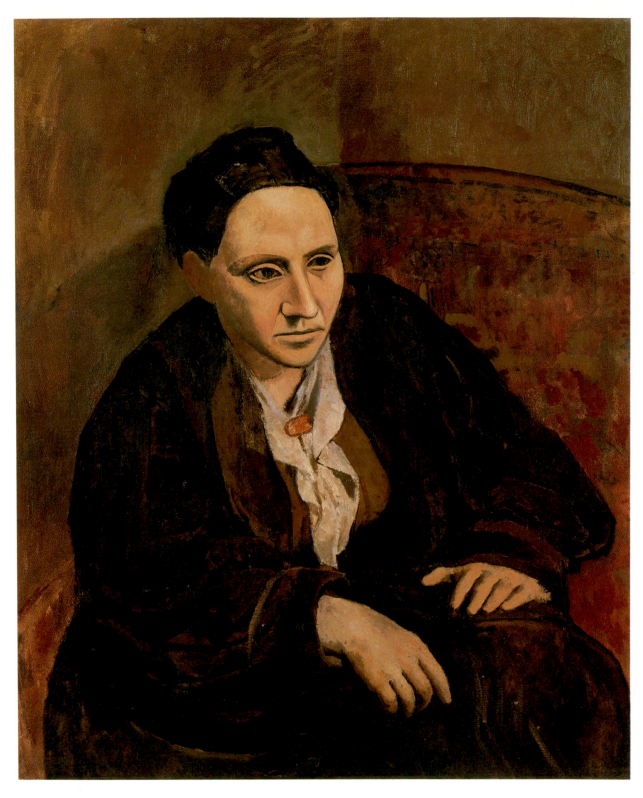

VI Pablo Picasso *Portrait of Gertrude Stein* 1906

considered to be the artist's superior mind, perfect concentration, and great control, as well as complexity of organization and sheer expression of form, of fullness, of mass. Eventually, Leo was to put it more succinctly when he wrote that in those early days he had been "especially obsessed by Cézanne's plastic presentations."[38] Not until the very twilight of his life was Berenson to express a somewhat similar thought when he compared Piero della Francesca and Cézanne, stating that "the former is almost as indifferent as the other to what we are accustomed to regard as physical beauty. Both are more aware of bulk and weight than of looks. . . ." But whereas Berenson eventually grasped some of Cézanne's traits, such as his tendency to express "character, essence rather than momentary feeling or purpose,"[39] Leo Stein moved in the opposite direction. Instead of penetrating ever deeper into the mysteries that the painter presented, he became – as time passed – actually less and less erudite in his interpretations.

Whether Leo Stein was too wrapped up in his explanations to listen to what others might have had to say of works in his collection, the fact is that he neglected to report any remarks provoked by the pictures on which he so endlessly held forth. As for Gertrude, in the beginning, according to Hapgood, she had been "possessed by a singular devotion to Leo; she admired and loved him in a way a man is seldom admired and loved."[40] But once their close attachment succumbed in the face of Gertrude's stronger relationship with Alice Toklas, and each withdrew into an almost monstrously self-conscious egotism, Gertrude may have lost interest in what Leo propounded. By the time she got around to writing the *Autobiography of Alice B. Toklas* in 1933, she had so successfully eliminated Leo from her life – including the years they had spent together – that she could speak of the early days in Paris and of their collection almost never alluding to her brother. But that was much later, of course. Once her fame had spread and she was invited to lecture in America, she must have felt that she was expected to say something about the by-then legendary Stein collection; she solved the problem by explaining:

> . . . Slowly through all this and looking at many many pictures I came to Cézanne and there you were, at least there I was, not all at once but as soon as I got used to it. The landscape looked like a landscape. . . . The same thing was true of the people there was no reason why it should be but it was, the same thing was true of the chairs, the same thing was true of the apples. . . . They were so entirely these things that they were not an oil painting and yet that is just what the Cézannes were they were an oil painting. They were so entirely an oil painting that it was all there whether they were finished, the paintings, or whether they were not finished. Finished or unfinished it always was what it looked like the very essence of an oil painting because everything was always there, really there.[41]

These may have been poorly digested and badly expressed notions of things Gertrude had picked up from conversations with Leo, Matisse, or Picasso. Even before she and Leo split up, she had been a notoriously poor listener, which meant that she didn't really care about the opinions of others. As a result, posterity has been deprived of the comments that such visitors to the rue de Fleurus as Matisse or Picasso cannot have failed to make. Matisse, whose intelligence greatly impressed

Leo and who profoundly admired Cézanne, must – at least occasionally – have commented on the works accumulated by his hosts, while the more whimsical and not yet very sociable Picasso may have uttered less memorable words. Conscious of his still somewhat rudimentary knowledge of French, Picasso did not always feel at ease in intellectual gatherings and frequently preferred to remain silent.[42]

V, 59
VI
That Picasso was far from indifferent to the Stein's *Portrait of the Artist's Wife* is shown by his likeness of Gertrude. It was painted during the winter of 1905/6 in Picasso's Montmartre studio rather than in the rue de Fleurus under the very eyes of Madame Cézanne, so to speak. Nevertheless, she seems to "hover" over Picasso's image of Gertrude, and there are definite analogies between the two paintings. These concern not only the curve of the armchair which in each case separates the sitter from the room that forms the background (and the vertical line that appears in both of them), but also the hands, particularly the left ones, the three-quarter angle of the pose, and – above all – the masklike appearance of each face. It is known that, dissatisfied with Gertrude's head as it emerged after many sittings, Picasso wiped it out, only to repaint it while she was in Italy, that is, without having his model before him. This accounts for the fact that her features appear so much less naturalistic than the rest of the picture.[43]

It would seem, although this has not been established with certainty, that something similar had occurred in the likeness of Madame Cézanne (V.369). The discreet wallpaper of bluish floral sprays in the background of her portrait can be identified with lodgings Cézanne occupied in 1879–80 (where Miss Hallowell's two still lifes had also been executed), but the much less volumetric head of the sitter appears to have been painted several years later. Here, too, it looks as though, after an interruption, the artist returned to the canvas to rework some parts, especially the face. Here, too, there is a perceptible hiatus, accented – as in Picasso's painting – by the sharp contour of the head, notably the line that leads from the ear to the chin, as though it were encompassing the area to which the alterations were confined. In both canvases there are also those penetrating yet almost "empty" and absent eyes that appear to be remembered rather than observed.[44]

When Picasso obliterated Gertrude's face and left it blank, waiting for the moment when a satisfactory solution would occur to him, he obviously was not imitating Cézanne; he probably did not even suspect that Cézanne may have proceeded in the same fashion. But he was too keenly observant not to have noticed the determined outline that sets off Madame Cézanne's face, nor the burning, dark eyes that, in his own painting, look like incisions, comparable to those African masks with which he was beginning to be fascinated. Did Picasso ever speak of Cézanne while Gertrude sat for him? We shall never know; she was thinking of a story she planned to write and even if she paid any attention to what he uttered, she never mentioned it afterward. The only thing she did say about the picture was that her first book, *Three Lives*, published in 1908, was written under the stimulus of Madame Cézanne's portrait.

Just as there were different opinions concerning the collection of the Steins, views on the Steins themselves also varied. When Mary Cassatt was taken by Mrs. Sears to one of their "evenings," she was appalled. "I have never in my life seen so many dreadful paintings in one place; I have never seen so many dreadful people gathered

48 Alice B. Toklas and Gertrude Stein, rue de Fleurus, Paris, 1922. Photograph by Man Ray

together," she declared.[45] In a letter to one of her nieces she subsequently explained: "Little by little people who want to be amused went to these receptions where Stein received in sandals and his wife [*sic*] in one garment fastened by a brooch which if it gave way might disclose the costume of Eve. Of course the curiosity was aroused and the anxiety as to whether it would give way. . . ."[46]

But Mary Cassatt's hostility was provoked by more than that anxiety. To an American acquaintance she wrote: "As to the Steins, they are Jews and clever, they saw they had no chance unless they could astonish, having not enough money to buy good things so they set up as apostles of Matisse and pose as the only ones who know, and it has succeeded! Amongst the foreign population in the student quarters and international snobs, it is very amusing but cannot last long. French people don't swallow Matisse, only German and Scandinavian is heard at his exhibitions. The dealers had nothing else to sell so they boomed Cézanne as against such men as Manet."[47]

Even though they came from a superb artist, Mary Cassatt's uncharitable comments were too loaded with prejudice to carry much weight. What seems more to the point were Clive Bell's blunt views of the Steins, according to which "neither, so far as I could make out, had a genuine feeling for visual art. . . . The truth is that they were a pair of theorists – Leo possessing the better brain and Gertrude the

stronger character – and that for them pictures were pegs on which to hang hypotheses. . . . It was their brother Michael who loved painting."[48]

It is a pity that nothing survives of the heated discussions that, in studios or cafés, accompany new trends, heralding the emergence of a new style. One rarely finds them reflected in occasional diary entries or letters that survive more or less by accident. There, burning exchanges of views or sudden perceptions are mentioned usually only in passing. It takes a writer to revive them on paper (as Zola had done rather successfully for the Impressionists in his novel *L'Oeuvre*). Neither of the Steins ever attempted to record anything of that kind. On the other hand, all hostile and stupid comments by critics remain available in cold print and can be resuscitated by diligent researchers. What emerges from them is thus a one-sided image that is historically "correct" only if one keeps in mind that the embers of vibrant exchanges and enthusiastic comments are usually allowed to die, while the chilling pronouncements of those bent on protecting society from novel aesthetic approaches live on in old newspapers, periodicals, and books. The important thing to realize is that history is not made by sterile words that gather dust on printed pages; artistic history is made in the studios where discussions spark achievements, where fresh ideas and stimulations are translated into works that explore uncharted domains. The volatile spoken word, carried by fervor and understanding, often contributes more than the written one to the evolution of our vision.

The gatherings at the Steins, however, furnished more than opportunities for endless discussions animated by Leo's analytical mind: they were also important for the display of pictures that the brother and sister (that is, in those days mostly Leo) had assembled. What made the Stein collection unique was that it provided fascinating juxtapositions of tendencies of the recent past with the latest developments. Cézanne was being increasingly regarded as the dominant figure among the precursors of contemporary art, whereas Monet and Renoir – then both still active – enjoyed less popularity with the young, though Leo Stein was and remained partial to Renoir and owned quite a few of his paintings. But to see Cézanne's works next to recent ones by Matisse and Picasso became a major attraction and offered visitors to the rue de Fleurus a singular initiation into prevalent new trends, extending from Cézanne to Fauvism and, subsequently, Cubism. Early on there had also been a small Manet and at least two paintings by Gauguin (one of them a Tahitian flower still life),[49] yet Leo disposed of them after he decided, as he later put it, that Gauguin "made an important departure, but he is only second-rate."[50] He was no longer attracted to van Gogh either, whose letters he preferred to his canvases, which he considered "pictorially too superficial to amount to much."[51]

By contrast, Leo followed the interest in the newly rediscovered El Greco, feeling that he ought to own a work by that artist. But when he showed his recent purchase to Loeser, the latter was not much taken with it. "Lunch with Steins (27 rue de Fleurus)," Loeser jotted down in his diary. "Saw his new Greco that is only partially good."[52] Leo may not have held on to it for long. On the other hand, the Steins owned a major and typical work by Toulouse-Lautrec,[53] whom Leo had first noticed at the Salon d'Automne of 1904. Leo became aware of Seurat only later but did not show any particular appreciation for him. (Barnes seems to have shared Leo's views

on Gauguin; he purchased only a few works by van Gogh and not always significant ones; but he did acquire signal paintings by Seurat.)

If some of the modern trailblazers were absent from the Stein collection, they were not represented in the Luxembourg museum either. To many guests of the Steins, Matisse and Picasso appeared almost too overpowering in their daring and unorthodoxy. Next to them, Cézanne assumed the position of a classic, and some younger Frenchmen, like Maurice Denis, began to hail him as such. He offered a means to go beyond Impressionism, which was only beginning to become popular but which – for many of the new generation of artists – already took on an air of being passé. To them it was Cézanne who opened the path to new and radical achievements, a path on which Matisse and Picasso were advancing boldly.

When Cubism made its appearance and claimed the recently deceased Cézanne among its forefathers, the master's work gained an additional significance. As Gertrude Stein began to acquire Picasso's early Cubist paintings – to which her brother was violently opposed – discussions at the rue de Fleurus might have been further amplified, but the opposite was the case. By 1910, Leo, as he later explained, "had had enough of intensive concern with so-called modern art. . . . When my interest in Cézanne declined, when Matisse was temporarily in eclipse, when Picasso turned to foolishness, I began to withdraw from the Saturday evenings."[54] In the absence of Leo and his stimulating ideas, his rather placid sister began to reign over the gatherings. Liberated from the intellectual dominance of her brother, Gertrude now liked to draw parallels between Picasso's Cubism and her own peculiar literary style,[55] but otherwise she did not contribute much to discussions on art.

Whenever she expressed herself on artistic matters, she would – true to herself – use a great many words for saying rather little. One of her pet theories was that paintings have a tendency "either to remain in their frames or to escape from them." She considered the works of the old masters and modern "old masters" like Cézanne as showing a tendency to go back into their frames or remain in them. Such paintings she termed "elegant" and said, "most elegant painting does not move does not live outside its frame and one does like elegance in painting."[56] She also used to explain that for her all modern painting was "based on that which Cézanne failed to do instead of being based on that which he almost succeeded in doing. When he could not make a thing, he turned aside from it and left it alone. He insisted upon showing his inability; he exposed his failure to succeed; to show what he could not do, became an obsession with him. People influenced by him were equally obsessed by the things which he could not obtain and they began the system of camouflage. . . ."[57]

This was a strangely ungenerous view of the artist and one that totally neglected to mention whatever, in Gertrude's view, he did *not* fail to do, the more so as she would only grant that he had *almost* succeeded in his aims. Though she does not seem to have cared for totally abstract art, it would seem that Gertrude's approach to painting was based on the premise that anything unconventional was attractive. And the more radical it was, the more she liked it. Beyond that, however, she was not really moved by pictorial qualities. Nor was she particularly observant. "I am afraid you don't look very sharply," Leo had once written to her. "All the Renoirs & Cézannes, the Manet & Daumier have been cleaned and varnished [while you were away]. I have never seen what the Cézanne landscape was like until it was cleaned.

The light yellows & the sky have become something entirely different."[58] In later years Leo stated more than once that his sister's art appreciation had been neither deep nor original and that her subsequent accounts of her aesthetic discoveries were not truthful. Nevertheless, she added many Cubist Picassos to the collection.

Although discussions of stylistic problems seem slowly to have slackened at the rue de Fleurus, especially after Leo had moved to Florence in 1914, taking several Cézannes and all the Renoirs with him,[59] the absence of his constant explanations may have done no harm to the reception of the pictures, which were now allowed to speak for themselves. The painters who came to see them were interested more in visual experiences than in listening to lengthy comments. But with Gertrude not very articulate on questions of art and with Leo hostile to Cubism, it seems doubtful that the Stein circle – which originally had been so eager to penetrate the mysteries of Cézanne's innovations – played a very active part in establishing the Cubist understanding of the artist as the orthodox mainstream tradition of that new style.[60]

Of course, each visitor to the Steins' legendary Saturday soirées reacted to their pictures according to his own inclinations. "I was at Gertrude Stein's yesterday," Marsden Hartley wrote to his friend Rockwell Kent in 1912, "looking at her collection of Picassos and Cézannes – and I assure you this man Picasso is a wonder."[61] If Hartley did not react more excitedly to the Cézannes, it was obviously because he had had a rare opportunity to see a group of his works before coming to Europe.[62] He was thus more "surprised" by the Spaniard, whom he was to meet repeatedly at the rue de Fleurus and who left a deep impression on him. Yet this does not mean that Hartley did not appreciate the other works he saw at Gertrude Stein's, especially Cézanne's watercolors, with which in 1912 he was not yet acquainted. A little later he was to write to his hostess: "It was from his water colors that I got most inspiration as expressing the color & form of 'new places' – those you have & others at Bernheim's."[63] And he subsequently informed Stieglitz that as a consequence of his trip to Europe he felt the necessity of "leaving objective things," that he found himself "going into the subjective, studying Picasso closely, finding a great revelation in the Cézanne watercolors – a peculiar psychic rendering of forms in space – and from this artistically I proceeded."[64]

Hartley's enthusiasm for Cézanne was to increase with the years. In 1926 he would even go to work in the countryside around Aix in order to "take up where Cézanne left off."[65] Still later he was to state that "there was in Cézanne the requisite gifts for selection, and for discarding all useless encumbrances, there was in him the great desire for purification, or of seeing the superb fact in terms of itself, majestically; and if not always serenely, serenity was nevertheless his passionate longing.'[66]

49, 50 Alfred Maurer, on the other hand, proved to be more receptive to Matisse's colors and execution, actually becoming the first American to work in a Fauvist vein. Among the many other American artists who visited the Steins were Max Weber, Robert J. Coady, Jo Davidson, Abraham Walkowitz, Arthur B. Carles (who lived briefly a few houses from the Steins at 23 rue de Fleurus), Walter Pach, Stanton
51 Macdonald-Wright (who, shortly after arriving in Paris in 1907, acquired four Cézanne watercolors),[67] Patrick Henry Bruce, and Edward Steichen, the latter still dividing his time between photography and painting. Steichen was eventually to

become a kind of Paris scout for the New York gallery of his friend Alfred Stieglitz, whom he also took to the rue de Fleurus.

Another American whom Steichen took to the Steins was a young journalist named Agnes Ernst. At the Salon d'Automne of 1908 she had found the paintings by Matisse to be nightmarish,[68] but Leo Stein's views on the artist did not leave her indifferent. "I came to feel a real sympathy for Leo Stein and genuine respect for his artistic judgment," she later wrote, adding: "But I was hampered in my relations with Leo because I conceived an immediate antipathy for his sister Gertrude. . . . Most of the visitors to the Stein apartment in 1909 paid little attention to Gertrude. The center of attraction was Leo's brilliant conversation on modern French art and the remarkable collection mostly of contemporary paintings which he made at little cost with the aid of his independent and exacting judgment."[69]

Agnes Ernst seems to have been more perceptive than most in her analysis of Leo's complex personality. In any case, she appears to have been the only one to have noticed the shyness that he hid behind a steady flow of words; as a matter of fact, she even stated that this flow was not quite as incessant as is usually reported. "Leo was cruelly shut off from easy communication with others by his inner conflicts," she explained. "But his extreme sensitivity, introspection and overly severe self-criticism aroused sympathy rather than aversion. When we looked at his collection together, he spoke little, but his occasional words and the intensity of his feelings revealed the modern paintings one saw with him in their highest significance. . . . What hampered him was his passion for honesty, clarity and exactitude."[70]

One of the few Americans who does not seem to have attended any of the Stein soirées was Charles Sheeler. It is true that he spent only a few weeks in Paris in January–February 1909. His reaction to the Paris art scene, however, was typical of the experience of those who went abroad after having listened to or read what Prendergast, Dasburg, and a few others had reported upon their return from Europe. "It is at this time," Sheeler later wrote, "I first saw the paintings of Picasso, Matisse, Braque and Derain . . . and of van Gogh and Cézanne among their immediate predecessors. They were very strange pictures which no amount of description, of which I had considerable in advance, could prepare me for the shock of coming upon them for the first time."[71]

52

This "shock" actually constituted the greatest thrill for those who set foot in France during those eventful years, yet Walkowitz – alone among American painters – would not admit to any surprise. Always eager to distinguish himself from his colleagues and somewhat scornful of facts when he perceived a chance for self-aggrandizement, Walkowitz insisted that he had been perfectly "prepared" for Cézanne. "I remember distinctly that I did not find him strange," he said late in life. "I could not see what people had found so revolutionary in his work. I felt at home with his pictures. To me they were simple and intensely human experiences."[72]

In contrast, a young aspiring painter from Chicago openly admitted to having been as deeply impressed with Cézanne's work as had been most of those who had preceded him to Paris. Manierre Dawson had been given a letter of introduction to Gertrude Stein by an American acquaintance and decided to see her, if only not to disappoint his obliging friend. "I do not know much about Miss Stein," he confided to his diary, noting however, that he had met an Englishman named Whitley,

49 Alfred Maurer *Still Life* 1907–08 50 Alfred Maurer *Fauve Landscape*

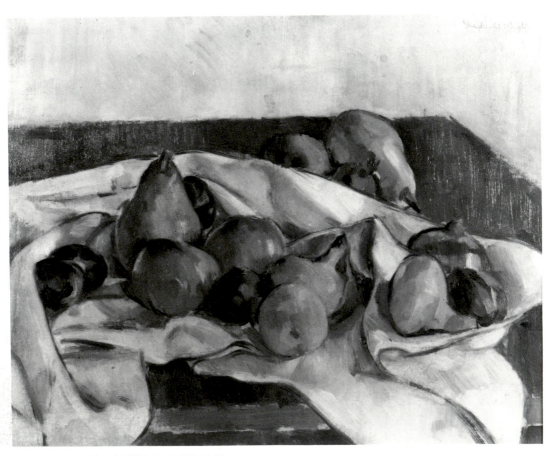

51 Stanton Macdonald-Wright *Still Life No. 1*

52 (above left) Andrew Dasburg *Floral Still Life* 1914

53 (above) Patrick Henry Bruce *Leaves* 1912

54 (left) Patrick Henry Bruce *Still Life* 1911

55 (below) Patrick Henry Bruce *Still Life c.* 1921–22

according to whom "she is becoming known to a few as a writer having a novel style and as being a collector of many things being talked about in Paris."[73] The entry continues: "I have called at Miss Stein's on Rue de Fleurus, showed my letter to the long-skirted woman who answered the bell. She spoke English like an American, didn't bother to read the letter and informed me that Miss Gertrude was busy that afternoon, but would be at home Saturday evening. Telling Whitley about it, he suggested we call together. . . . He said Saturdays brought a number of nationalities to Miss Stein's, but, while there was much confusion and the light was not good, one could see an extraordinary jumble of paintings, a few of them remarkable and well worth examining."[74] (Indeed, it was sometimes so dark in the large studio that Maurer occasionally lit matches so as better to study the pictures.)

The next Saturday, "Whitley introduced me to the hostess, a fat woman sitting in a very large chair."[75] Dawson does not mention the presence of the loquacious Leo. Due to his vivid interest in the Cézannes which he admired at the rue de Fleurus, on the following Monday Whitley took him to Vollard's or, as he wrote in his journal, "to a dealer on Rue Laffitte to see some of Cezanne's paintings. . . . The shop . . . had nothing about it that seemed to advertise its purpose. The window was empty. The dealer was polite, but as the conversation was in French, I got very little of it. The few paintings he showed impressed me extremely. I wanted to see more but he was very slow to bring each out. My mind has been full of the few things I saw."[76] So strong was the impact of his visits to the Steins and to Vollard that less than two weeks later, when Dawson summed up his impressions of Europe in an entry jotted down in Dresden, he mused: "I am beginning to settle on favorites: Tintoretto, Rubens, Poussin, Delacroix, Turner, Constable. I think I have been most affected by Cezanne who, in the few works of his I have seen, doesn't take the scene at face value but digs into the bones and shows them. He isn't afraid of bold lines in landscapes or figures and he makes the color what it should be."[77]

56 Max Weber *The Apollo Plaster Cast in Matisse's Studio* 1908

57 *Three Bathers* 1876–77 (V.381)

More than any other American of those days, Patrick Henry Bruce, a former pupil of W. M. Chase and Robert Henri, seems to have found the key to Cézanne's perceptions. Yet – as the true artist he was – he could not be satisfied with mere imitation. Even though he achieved a profoundly painterly expression in the wake of Cézanne, he soon did what every genuine creator must do: he used what his chosen master offered as a stepping-stone toward independent self-fulfillment.

In spite of the fact that Bruce exhibited at the Salon d'Automne of 1905, 1906, and 1907, where he must have seen Cézanne's shows, the decisive impetus for his involvement with Cézanne appears to have come from Matisse. Bruce had known the Steins since 1906, and in their collection Matisse's rather than Cézanne's paintings seem to have more deeply impressed him. Thus, his understanding of Cézanne was fostered, so to speak, by his encounter with Fauvism. Together with Sally Stein, Bruce became instrumental in setting up Matisse's Académie at the Couvent des Oiseaux, which opened in January 1908. There Matisse never tired of proclaiming that Cézanne was "the father of us all," guiding his students through word and example toward a full grasp of how color functions to model form in space.[78]

Among Matisse's students, Patrick Henry Bruce, a strangely intense but reticent man, apparently never expressed his boundless admiration for Cézanne, as the others were to do on many occasions. And his later evolution toward a very personal form of Cubism does not even hint at the sway Cézanne held over his early years in Paris. But a few peculiarly engaging canvases of around 1909–12 which have survived prove the extent to which Cézanne and Matisse assisted in the formation of his strong artistic individuality.

53–55

Max Weber also was a student at Matisse's Académie, while Leo Stein, Maurice Sterne, and Walter Pach dropped in occasionally. According to Weber's recollections,

56 a counterpoint and enhancement of the workaday spirit of the class were the occasional visits to Matisse's [own] studio in another part of the Couvent des Oiseaux. During those veritably festive afternoon hours, he showed us many of his early drawings and paintings, and spoke freely and intimately about them, explaining the various directions and tendencies. Along with his own work, he showed us with great pride and loving care examples of the work of his colleagues. I remember very distinctly the figure drawings in sanguine by Maillol, and black and white by Rouault, and four large ink drawings by van

57 Gogh. With great modesty and deep inner pride, he showed us his painting of *Bathers* by Cézanne [V.381]. His silence before it was more evocative and eloquent than words. A spirit of elation and awe pervaded the studio at such times.[79]

Although he was not the only one whose efforts helped create interest and understanding for the master, Matisse performed an extremely important role in the propagandizing of Cézanne's innovations. Through his friendship with Leo and Gertrude, as well as Michael and Sally Stein, Matisse reached a number of young American artists and thus contributed much to spreading Cézanne's "message" across the Atlantic.[80]

NOTES

1. See Leo Stein, *Appreciation: Painting, Poetry and Prose* (New York: Crown, 1947), p. 154; also Leo Stein, *Journey into the Self*, ed. Edmund Fuller (New York: Crown, 1950), p. 204. Although this episode is well documented through Leo Stein's writings, Van Wyck Brooks gave a rather garbled version of it in *The Dream of Arcadia* (New York: Dutton, 1958), p. 255.

Stein first met Berenson in Florence in the spring of 1896; see Hutchins Hapgood, *A Victorian in the Modern World* (New York: Harcourt, Brace, 1939), p. 59. On a subsequent meeting with Berenson in the fall of 1900, see Leo's letter to Gertrude Stein of Oct. 9, 1900, in *The Flowers of Friendship: Letters Written to Gertrude Stein*, ed. Donald Gallup (New York: Alfred A. Knopf, 1953), p. 19.

2. Stein, *Appreciation*, pp. 155–56.

3. Bernard Berenson, "Introduction," *La Peinture française à Florence*, exhibition catalog, Palazzo Pitti, Florence, Summer 1945, p. 21. Loeser was always very secretive about his collection and did not like to have objects he owned either photographed or identified. After his death in 1928, his widow remained faithful to this attitude and would not provide Lionello Venturi with photographs when the latter was preparing his catalog raisonné of Cézanne's work.

However, eight of Loeser's Cézanne paintings were shown at this 1945 exhibition organized to celebrate the liberation of Florence. Loeser's widow died in 1947. On the disposition of Loeser's collection see Epilogue, below, pp. 343–44.

4. How easily legends can be created is illustrated by what Alfred Frankfurter wrote about this picture: "The magnificent Cézanne still life of *Cherries and Apricots* . . . originally was owned by the distinguished American connoisseur in Florence, Charles Loeser, who, in buying this painting in Paris from Vollard, about 1890, had the advantage of drawing on the advice of his friend Bernard Berenson." A. Frankfurter, "Los Angeles: The New Museum," *Art News*, March 1965, p. 63. Not only could Loeser not have bought this painting around 1890, before Vollard was even established in Paris, but he was not truly a "friend" of Berenson, and the latter himself never pretended to have advised Loeser on his Cézanne purchases.

5. William Rothenstein, *Men and Memories* (New York: Coward-McCann, 1931), vol. 2 [1900–22], p. 123, was obviously mistaken when he wrote, speaking of a visit to Florence in 1907: "The cognoscenti in Florence had just [!] discovered Cézanne; Loeser had bought several of his smaller landscapes." Loeser's landscapes were

by no means "small"; at least three of them measured about 36 × 25 inches. Moreover, most of his pictures had been acquired some ten years before Rothenstein's visit; see above, Chapter I, note 21. It is possible, however, that the *Forest Scene* (V.645) was purchased at a later date, since a small pocket diary kept by Loeser mentions under the entry of Paris, March 31 [1911]: "At Vollard – Many Cézannes – liked particularly one landscape – wood with fine light – asking 30,000 Frcs." (Unpublished document, courtesy Miss Philippa Calnan, Loeser's granddaughter.)

6. On this subject see Chapter I, note 29.

7. Gertrude and Leo Stein to Mabel Weeks, Paris, n.d.; Beinecke Rare Book and Manuscript Library, Yale University. This document was brought to my attention by Irene Gordon who – on internal evidence – dates it Nov. 1904.

8. A tentative list of works by Cézanne owned by Leo and Gertrude Stein was established by Margaret Potter in 1969–70 during her research on their collection and that of Michael and Sally Stein for the exhibition titled "Four Americans in Paris," Museum of Modern Art, New York, 1970–71.

9. Fernande Olivier, *Picasso et ses amis* (Paris: Stock, 1923), p. 102.

10. Numbers preceded by RWC refer to the entries in John Rewald, *Paul Cézanne: The Watercolors*, A Catalogue Raisonné (Boston: New York Graphic Society; London: Thames and Hudson, 1983).

11. Olivier, *Picasso*, p. 102.

12. However, Loeser may have owned at least one watercolor by Cézanne. Despite his reluctance to have the works he owned reproduced or exhibited, he lent a watercolor (or drawing?) to a Cézanne show held at the Leicester Galleries in London in June–July 1925, in whose skimpy catalog it is listed as "No. 24, 'Nature Morte,' Lent by Charles Loeser, Esq." This catalog was brought to my attention by Joanna Clifford, London. It has not been possible to identify the work.

13. Annette Rosenshine, "Life's Not a Paragraph," Bancroft Library, University of California at Berkeley. This manuscript was brought to my attention by Irene Gordon, who identifies Miss Rosenshine as a young art student in San Francisco who accompanied the Michael Steins on their return trip to Paris in Nov. 1906, where she stayed until the summer of 1908. The painting was No. 17 at the "deuxième vente, Collection de M. George Viau," Paris, March 21, 1907, cataloged as *Tête d'enfant*.

14. It was obviously to Michael and Sally Stein's home rather than to Leo and Gertrude's that C. Lewis Hind referred when he wrote: "There's a large white room in Paris, in a private house, hung almost entirely with paintings by Matisse.

Students, disciples, and dilettanti gather there on Saturday evenings. Strangers come. The many are indignant; the few begin by being uneasy and end in fetters." C. Lewis Hind, *The Consolations of a Critic* (London: Adam and Charles Black, 1911), p. 81.

On this subject, see also the same author's *The Post-Impressionists* (London: Methuen, 1911).

15. Rosenshine, "Life's Not a Paragraph." Among American artists who visited the Durand-Ruel residence were notably Andrew Dasburg and Max Weber; the latter also saw the private collection of the Bernheim-Jeunes. Weber later spoke of a small portrait by Cézanne that he had admired at Durand-Ruel's and had in vain recommended for purchase to American friends; he thought it to be a likeness of Rochefort but must have meant the *Portrait of Victor Chocquet* (V.373), subsequently acquired by Lillie Bliss. (Tapes of Max Weber interviews, 1959, vol. 1, p. 194; Columbia University Oral History Project. These tapes were brought to my attention by John Cauman.) Unfortunately, no lists of the visitors admitted to Paul Durand-Ruel's home on the rue de Rome have been preserved.

16. It was Elizabeth McCausland, *A. H. Maurer* (New York: A. A. Wyn, 1951), p. 83, who first mentioned that the two Russians had been friendly with the Steins. Her dating of the acquaintance at "about 1905 or 1906" may be accurate for Shchukin but is probably a little too early for Morosov. On the other hand, a recently published account according to which Shchukin was encouraged by Durand-Ruel to take an interest in Picasso appears to be without any basis; see *Paris-Moscou, 1900–1930*, exhibition catalog, Centre National Georges Pompidou, Paris, May–Nov. 1979, p. 26.

17. One of the few exceptions was Preston Dickinson who was in Paris from 1911 to 1914. Even though he saw Charles Demuth there who knew the Steins, Dickinson does not seem to have met them. It is true that he apparently avoided English-speaking people. See Ruth Cloudman, *Preston Dickinson 1889–1930* (Lincoln: Nebraska Art Association, 1979), p. 18. Another noteworthy exception was Edward Hopper. As a pupil of Robert Henri, he had become friendly with Patrick Henry Bruce and had been introduced by him to the work of the Impressionists, particularly Sisley, Renoir, and Pissarro, although his own open-air studies executed in Paris reveal a greater influence of Albert Marquet. When Hopper was asked many years later whom he had known in Paris, his answer was: "Whom did I meet? Nobody. I'd heard of Gertrude Stein, but I don't remember having heard of Picasso at all." Brian O'Doherty, "Portrait, Edward Hopper," *Art in America*, Dec. 1964, p. 73.

18. Alfred Maurer to Leo Stein, Paris, Aug. 2, 1905; quoted by McCausland, *A. H. Maurer*, p. 89.

19. See Gertrude Stein, "Gertrude Stein in Paris, 1903–1907," *The Autobiography of Alice B. Toklas* (New York: Random House, 1933), p. 37.

20. Mabel Dodge Luhan, *Intimate Memoirs*, vol. 2, *European Experiences* (New York: Harcourt, Brace, 1935), pp. 321, 322.

21. Leo Stein to Mabel Weeks, Paris, n.d.; in Leo Stein, *Journey*, pp. 15–16. Irene Gordon, whose transcription of the original letter in the Beinecke Rare Book and Manuscript Library, Yale University, is given here, dates this letter on internal evidence to early 1905 (Jan. or Feb.).

22. Stein, *Appreciation*, pp. 200, 201.

23. Ibid., p. 84.

24. Leo Stein to Mabel Weeks, Paris, Feb. 15, 1910; Beinecke Rare Book and Manuscript Library, Yale University. This document was brought to my attention by Irene Gordon.

25. On Berenson's acquaintance with Picasso see Bernard Berenson, *Sketch for a Self-Portrait* (New York: Pantheon, 1949), p. 46. On his meeting with Matisse, see his letter to his wife, Paris, Oct. 9, 1908, quoted in *The Bernard Berenson Treasury*, ed. Hanna Kiel (New York: Simon and Schuster, 1962), p. 136.

26. Berenson, *Sketch*, pp. 44–45. The occasion was an unsigned review of the 1908 Salon d'Automne in *The Nation*, Oct. 29, 1908, containing a contemptuous remark concerning Matisse. Berenson replied in a "Letter to the Editor" that appeared on Nov. 11; see Alfred H. Barr, Jr., *Matisse: His Art and His Public* (New York: Museum of Modern Art, 1951), pp. 111–12, 114.

27. Bernard Berenson to Mary Berenson, Ravenna, Sept. 4, 1910; unpublished document, courtesy Prof. Ernest Samuels, Evanston, Ill.

28. Willard Huntington Wright, *Modern Painting* (New York and London: John Lane, 1915), p. 150.

29. Morgan Russell to Andrew Dasburg, Paris, late Aug. 1908; quoted by Gail Levin, *Synchromism and American Color Abstraction, 1910–25* (New York: George Braziller, 1978), p. 12.

30. Andrew Dasburg to his wife (the sculptor Grace Moll Johnson), Paris, April 24, 1910; quoted by Gail Levin, "Andrew Dasburg: Recollections of the Avant-Garde," *Arts Magazine*, June 1978, p. 126. Dasburg was so impressed with Cézanne's work that his biographer could state: "His life as an artist can be divided neatly into two parts: before and after the day he encountered Cézanne's work in Paris in 1910." Van Deren Coke, *Andrew Dasburg* (Albuquerque: University of New Mexico Press, 1979), p. 2.

31. Interview with Gail Levin, Nov. 1977; Levin, "Andrew Dasburg," p. 129. A literal copy of the picture still exists; it was formerly in the Dunan collection. However, it is impossible to establish whether this is the copy made by Dasburg or whether its author was the French painter Maxime Maufra, who had owned Cézanne's work before selling it to the Bernheim-Jeunes in Nov. 1907, from whom the Steins acquired it one month later. Maufra, an erstwhile Brittany follower of Gauguin, may well have copied the small still life before parting with the original.

32. Leo Stein to Morgan Russell, Fiesole, June 26, 1910; quoted by Levin, *Synchromism*, p. 12.

33. Leo Stein, *The A-B-C of Aesthetics* (New York: Boni & Liveright, 1927), pp. 122, 123–24.

34. See for example Maurice Sterne, *Shadow and Light*, ed. C. L. Mayerson (New York: Harcourt, Brace & World, 1952), p. 43.

35. According to Dasburg's recollections, expressed shortly before his death (see note 31 above), Leo Stein did not speak about his ideas, "but about the pictures he had. . . . He talked a great deal. . . ."

36. Hutchins Hapgood, *A Victorian in the Modern World* (New York: Harcourt, Brace, 1939), pp. 120, 122.

37. Leo Stein to Dr. Trigant Burrow, Settignano, June 30, 1934; see Stein, *Journey*, p. 140. Leo ascribed this episode to the years 1916–17.

38. Stein, *A-B-C*, p. 86. The sentence begins: "Twenty years ago when I was especially obsessed. . . ." This obviously points to the period around 1907.

39. Bernard Berenson, *Piero della Francesca or the Ineloquent in Art* (London: Chapman & Hall, 1954), pp. 6, 7.

40. Hapgood, *A Victorian*, p. 131.

41. Gertrude Stein, *Lectures in America* (New York: Random House, 1933), quoted in *Pictures for a Picture of Gertrude Stein as a Collector and Writer on Art and Artists*, exhibition catalog, Yale University Gallery, New Haven, Feb. 11 March 11, 1951, p. 21.

42. Information courtesy Pierre Daix, Paris.

43. Leo Stein is said to have felt that the artist's failure to rework the portrait around the newly

introduced face left the painting stylistically incoherent. When friends complained to Picasso that Gertrude did not look at all like his painting, he used to shrug his shoulders and say, "She will." See James R. Mellow, *Charmed Circle – Gertrude Stein & Company* (New York and Washington: Praeger, 1974), p. 93.

44. On Picasso and Cézanne, see Leo Steinberg, "Resisting Cézanne: Picasso's 'Three Women,'" *Art in America*, Nov.–Dec. 1979, pp. 115–33. Although Gertrude Stein's portrait is not discussed in this article, which deals with Picasso's Cubism, it is worth mentioning that the relationship of Picasso's *Three Women* of 1908 (which belonged to the Steins until Shchukin acquired it in 1913) to Cézanne's compositions of bathers is illustrated with a small canvas (V.724) that Picasso knew well since it was also part of the Stein collection (a fact not specifically stated). As Picasso was to tell a friend in 1943: "...Cézanne! He was my one and only master! Don't you think I looked at his pictures? I spent years studying them.... It was the same with all of us – he was like our father. It was he who protected us." Brassaï, *Picasso & Co.* (New York: Doubleday, 1966), p. 79.

45. On this 1908 incident see Frederick A. Sweet, *Miss Mary Cassatt* (Norman, Oklahoma: University of Oklahoma Press, 1966), p. 196.

46. Mary Cassatt to Ellen Mary Cassatt, Grasse, March 26, 1913. Though Cassatt spoke of Stein "and his wife," she was actually referring to Leo and Gertrude rather than to Mr. and Mrs. Michael Stein, as shown by her mention of sandals and the brooch which were "trademarks" of brother and sister. Cassatt obviously did not have a clear understanding of the Leo–Gertrude relationship. This letter is quoted by George Biddle, *An American Artist's Story* (Boston: Little, Brown, 1939), pp. 223–25.

47. Mary Cassatt to Adolphe Borie, July 27, 1910; unpublished part of the document quoted in Chapter I, above, note 27. Mary Cassatt added: "To be sure those who have the money buy Manets." She was obviously not aware of the fact that this was in direct contradiction to what she had written a few months earlier, on Feb. 22, 1910, to her friend Louisine Havemeyer: "The art world here is in a state of anarchy. That idiot Pellerin selling *all* his fine Manets and keeping his Cézannes of which he has a collection containing the very worst, figures really dreadful, neither drawing nor color...." (Archives of the Philadelphia Museum of Art.)

48. Clive Bell, "Paris in the 'Twenties,'" in *Old Friends* (London: Chatto & Windus, 1956), p. 173.

49. This was probably No. 601 in Georges Wildenstein, *Gauguin* (Paris: Les Beaux-Arts, 1964); see the photograph of Leo Stein in the studio at 27, rue de Fleurus, ca. 1905, in *Four Americans in Paris*, exhibition catalog, Museum of Modern Art, New York, 1970, p. 23.

50. Stein, *Appreciation*, p. 202.

51. Ibid., p. 198.

52. Charles Loeser, unpublished diary entry [Paris], Feb. 26, 1909; courtesy Miss Philippa Calnan (Loeser's granddaughter). According to Leo Stein, the picture, a *St. Francis*, came from South America (*Appreciation*, p. 198). Fernande Olivier also mentioned the painting (see note 9 above). The Stein collection seems always to have been in a certain state of fluctuation as Leo did not hesitate to give up works that, in the long run, disappointed him or that he could use in a trade for something he found more desirable. Thus, Picasso was rather adversely affected when he discovered that Leo had sold some of his paintings for a picture by Renoir (see Leo Stein, *Journey*, p. 51).

53. This was *Au Salon*, No. 501 of M. G. Dortu, *Toulouse-Lautrec et son oeuvre* (New York: Collectors Editions, 1971); see the photograph of the studio at 27, rue de Fleurus, early 1906, in *Four Americans in Paris*, p. 89.

54. Stein, *Appreciation*, pp. 166, 201.

55. See Janet Hobhouse, *Everybody Who Was Anybody: A Biography of Gertrude Stein* (London: Weidenfeld & Nicolson, 1975), pp. 77–78.

56. See Lamont Moore, preface to *Pictures for a Picture of Gertrude Stein*, p. 15.

57. Gertrude Stein, preface to catalog for Riba-Rovira exhibition, Galerie Roquepine, Paris, 1945, quoted by Moore, *Pictures for a Picture of Gertrude Stein*, p. 18.

58. Leo to Gertrude Stein, Florence, Aug. 29, 1912; *Flowers of Friendship*, p. 63. Gertrude had been in Spain with Alice Toklas while Leo had had the pictures cleaned, and he then left for Italy before his sister's return to Paris.

59. Among the Cézannes were the small still life with apples (V.191), at least one of the two compositions of bathers (V.590), and their first purchase, the landscape (V.310), unless the latter was sold to Barnes in 1913 in order to finance Leo's installation in Florence. On the division of the collection see Leo's letter to his sister, Paris, n.d. [1913-14], *Flowers of Friendship*, pp. 91–92.

60. It is true, however, that in 1923 Andrew Dasburg, who owed his introduction to Cézanne and Picasso to the Steins, was to state in an article: "In its inception Cubism was unconsciously a geometric definition of a state of feeling induced by Picasso's preoccupation with the tactile sensations of mass and movement in the work of

Paul Cézanne." Andrew Dasburg, "Cubism: Its Rise and Influence," *The Arts*, 1923, quoted in Van Deren Coke, *Andrew Dasburg*, p. 58.

61. Marsden Hartley to Rockwell Kent [Paris], Sept. 22, 1912; quoted by Garnet McCoy, "The Rockwell Kent Papers," *Archives of American Art Journal*, Jan. 1972, p. 5.

62. On this subject see Chapter V, note 43.

63. Marsden Hartley to Gertrude Stein, Berlin, Oct. 1913; *Flowers of Friendship*, p. 85.

64. Marsden Hartley to Alfred Stieglitz, Feb. 1913, quoted by Gail Levin, "Marsden Hartley and the European Avant-Garde," *Arts Magazine*, Sept. 1979, p. 160.

65. See Elizabeth McCausland, *Marsden Hartley* (Minneapolis: University of Minnesota Press, 1952), p. 38.

66. Marsden Hartley, "Whitman and Cézanne," *Adventures in the Arts* (New York: Boni & Liveright, 1921), p. 32.

67. Since there is no record of such a sale in the Bernheim-Jeune archives, Wright must have purchased these watercolors from Vollard, in whose ledgers his name also does not appear. What happened to these works is not known.

68. On Oct. 25, 1908, she wrote in her diary, after spending the previous day at the Salon d'Automne: "At this exhibition I appreciated for the first time the madness of the impressionists. Henri Matisse is the wildest of them all. They revolt my soul. I have nothing in common with them. Do not imagine I do not care about people like Monet, Manet, etc. but these latest chaps who have purple suns, and portraits with [illegible] green lips – bah, it is impossible to tell you what a nightmare a room full of Henri Matisses can be!" In a letter to Stieglitz of Jan. 5, 1909, she referred to the paintings by Matisse at the Salon d'Automne as things "to make one's hair stand on end." Both documents are quoted by Douglas K. S. Hyland, "Agnes Ernst Meyer and Modern Art in America, 1907–1918" (Master's thesis, University of Delaware, 1976), p. 10. This thesis was brought to my attention by Francis M. Naumann. See also Douglas K. S. Hyland, "Agnes Ernst Meyer, Patron of American Modernism," *The American Art Journal*, Winter 1980, pp. 64–81.

69. Agnes E. Meyer, *Out of These Roots: The Autobiography of an American Woman* (Boston: Little, Brown, 1953), pp. 80–81.

70. Ibid., p. 81. She also observed "Leo Stein was the only one of the many contemporary art critics I have known, not excepting Berenson, Roger Fry, or Meier-Graefe, who achieved complete integrity in his relationship to aesthetic values." In contrast, she said of his sister: "Gertrude was and remained, in my opinion, a humbug who lived when I first knew her in 1909 on what she could assimilate from Leo, and later, on what like a busy magpie she could glean from other artists and intellectuals among the avant-garde thinkers in Paris" (pp. 81–82).

71. Charles Sheeler papers, Roll NSH 1, Archives of American Art, New York. This statement precedes Sheeler's hand-written autobiography. This document was brought to my attention by Nancy Daves. By 1911, Sheeler owned a copy of Meier-Graefe's book on Cézanne, published in Munich (in German) in 1910 (see catalog 23 of R. W. Smith, Bookseller, New Haven, Conn. [1985], item 333).

72. See Alfred Werner, *American Artist* Aug. 1979. This article was brought to my attention by Gail Gelburd-Kimler.

On Manierre Dawson see also Karl Nickel, introduction to the exhibition *Manierre Dawson – Paintings 1909–1913*, Ringling Museum of Art, Sarasota, Florida, Nov. 1967; Norton Gallery and School of Art, Palm Beach, Florida, Jan.–Feb. 1968; also Mary Mathews Gedo, "The Secret Idol: Manierre Dawson and Pablo Picasso," *Arts*, Dec. 1981, pp. 116–24.

73. Manierre Dawson journal, Paris, Nov. 2, 1910; Manierre Dawson Papers, Roll 64, Archives of American Art. This document was brought to my attention by Doreen Bolger Burke.

74. Ibid.

75. Ibid.

76. Ibid.

77. Ibid., Dresden, Nov. 14, 1910; quoted in *Manierre Dawson Retrospective*, exhibition catalog, Museum of Contemporary Art, Chicago, Nov. 1976–Jan. 1977, p. 12.

78. See William C. Agee and Barbara Rose, *Patrick Henry Bruce: American Modernist* (New York: Museum of Modern Art, 1979).

79. Tapes of Max Weber interviews, vol. 1, p. 74. On Cézanne's *Bathers* that belonged to Matisse see Barr, *Matisse*, pp. 38–40; also Lawrence Gowing, *Matisse* (London: Thames and Hudson; New York and Toronto: Oxford University Press, 1979), pp. 34, 36.

80. On Matisse's "Academy" see Barr, *Matisse*, pp. 116–118 and 550–52; see also Hélène Seckel, "L'académie Matisse," in *Paris–New York*, exhibition catalog, Centre National Georges Pompidou, Paris, June–Sept. 1977, pp. 212–15. On Cézanne's and especially Matisse's influence on American artists see *The Advent of Modernism – Post-Impressionism and North American Art, 1900–1918*, exhibition catalog, ed. Peter Morrin, Judith Zilczer, William C. Agee, High Museum of Art, Atlanta, 1986.

VII Pablo Picasso *Leo Stein* 1906

VIII *Madame Cézanne and Hortensias c.* 1885 (RWC.209)

IV · Ambroise Vollard
Cézanne at the Salon d'Automne
The Death of Cézanne

THE BEST PLACE to study Cézanne's work was, of course, the small shop of the often recalcitrant and curmudgeonly Vollard who, when in the proper mood, could be very amiable, or, more often, would simply ignore visitors. As Leo Stein later remembered: "In my frequentations of the rue Laffitte, then the center of the Parisian art trade, I often passed Vollard's. But there never seemed to be any exhibitions on, and through the doors one had a glimpse of something like a junk shop, with heaps of pictures on the floor and against the walls, but nothing to indicate that one would be welcome."[1] Gertrude, whose unreliability has been vouched for by many of her acquaintances, provided a more graphic and, in this case, doubtless accurate portrait; hers is actually the most perceptive description that exists of the dealer in his early years, and it is certainly remarkable that such a vivid record should have been provided by an American.

"It was an incredible place," Gertrude Stein wrote. "It did not look like a picture gallery. Inside there were a couple of canvases turned to the wall, in one corner was a small pile of big and little canvases thrown pell mell on top of one another, in the centre of the room stood a huge dark man glooming. This was Vollard cheerful. When he was really cheerless he put his huge frame against the glass door that led to the street, his arms above his head, his hands on each upper corner of the portal and gloomed darkly into the street. Nobody thought then of trying to come in."[2]

Under these circumstances it took courage, especially for a foreigner, to enter even on days when Vollard's bulk did not block the door and ask to see the works by any specific painter. Yet, since Vollard was anything but predictable, he could also unbend and receive unknown visitors with a kind of casual courtesy. Andrew Dasburg remembered late in life how he had once seen some works by Cézanne in the window of a Paris gallery. "They fascinated me, so I went to the door and looked in and there were more, and the elderly gentleman [Vollard was about forty-one at the time of Dasburg's stay in Paris] who owned the gallery . . . invited me in. I spent a good deal of time looking at what was on the walls and then, after a while he invited me to come into his back room where he showed me others which were not on exhibition."[3]

Dasburg was lucky, for one of Vollard's more maddening traits was that he did not always get out from his racks or cellar what he was being asked for, so that, when Cézannes were requested, he could easily produce Renoirs. (Another rather unpleasant habit was his raising the quoted price at each successive visit; this

indisposed a number of prospective buyers and had caused Gauguin a great deal of irritation on his South Sea island.)

A young American art critic fared even better than Dasburg, since he was apparently given free access to the helter-skelter piles of pictures accumulated by the dealer. "I knew all the best canvases in the Vollard Gallery in Paris," he later wrote, "and can't say that I saw them well. There was a pleasurable sense of discovery in locating such great works of art in the dingy and dusty shop, turning them over to the light as they lay stacked in the corners or upon shelves, but it was rather the pleasure of the hunter tracking his quarry to its lair than the finer excitement that comes from true possession."[4]

It is strange that among those who dealt with Vollard in the early years, such as the Steins or various artists to whom he occasionally showed works by Cézanne, not one ever reported anything the dealer said about the painter. Could it be that Vollard never had much of interest to tell? It is likely that his taciturn and indolent nature not only prevented lively exchanges with clients, but also thwarted any close contact with a man as shy and suspicious as Cézanne was. In any case, Vollard met him only infrequently and does not seem to have established a particularly cordial relationship with him. Since the painter felt rather helpless in matters of business, nothing pleased him more than to see his son handle all transactions with the dealer, transactions on which the young man – aged twenty-four in 1895 – received a commission (supposedly from both his father and Vollard). When, after a relationship of several years, Cézanne decided, or was asked, to paint Vollard's portrait, he requested total silence from his sitter. Yet the dealer does appear to have begun early on collecting anecdotes about the painter and jotting down what he said.

58

Across the front page of his first extant account book, begun in January 1896, Vollard scribbled: "Cézanne greatly admires Signorelli, Poussin, Delacroix. . . . He finds that at present there is no direction in art, that everybody makes an individual effort but that nobody has as yet produced the work that will bring forth a movement in painting. – It is his ambition to do that."[5] Eventually anecdotes, quotes, and his own recollections were to be assembled by Vollard in a beautifully printed and illustrated though rather chatty volume on Cézanne.

Vollard's was strictly a "one-man operation" without any of the salesmen that such more spacious galleries as his neighbors Bernheim-Jeune and Durand-Ruel boasted. This led him to a closer, more personal contact with his clients, but it also exposed these to his whims and idiosyncrasies. He usually extracted four or five pictures from his well-stocked closet, the door of which was left tantalizingly open; while he did not rush the buyers, he did limit their choice to the works he was willing to produce. If they wished to ponder their decision and to come back in a few days, there was no objection or pressure from Vollard. But upon their return, the work they had meanwhile decided to acquire might no longer be around. Even if they thought they saw it beyond the open closet door, they might be told that it was not available.[6] This explains why some of Vollard's habitués took to stuffing their pockets with money so as to be able to pay on the spot and walk away with the purchase rather than risk disappointment. Vollard had an inordinate preference for cash settlements and – after the First World War – also for certain solid foreign currencies, a fact that made him partial to American clients.[7]

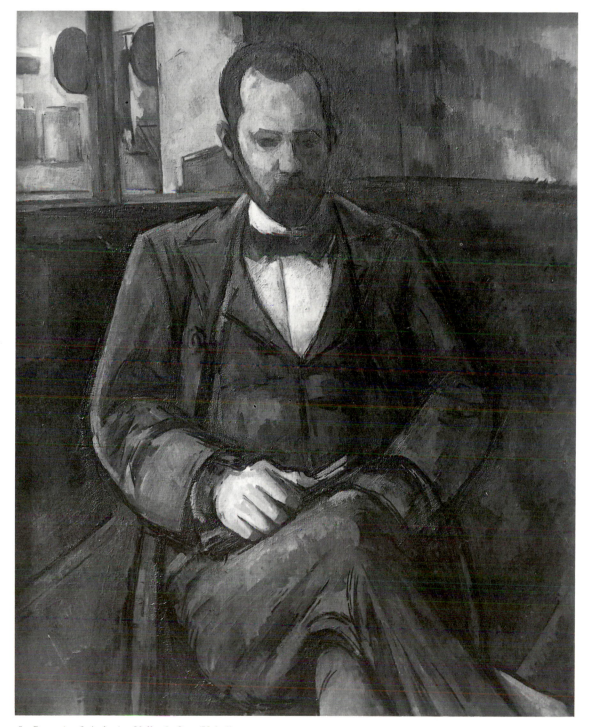

58 *Portrait of Ambroise Vollard* 1899 (V.696)

One could suspect Vollard of showing little affability toward artists interested in Cézanne because he thought that they were in no position to buy anything. Yet there were already quite a few painters who collected Cézanne's works – among them Monet, Degas, Pissarro, and later also Matisse – and the dealer was shrewd enough to realize that an artist's infectious enthusiasm can often be decisive in inspiring new patrons. But Vollard was a man full of contradictions, and there were, in those days, also some in Paris who said the dealer felt "that one should not show good pictures to painters and writers because they then talked and wrote about them, with the result that it became difficult to sell the bad works."[8] On the other hand, had not Vollard himself been originally encouraged by Pissarro, Renoir, Degas, and possibly Monet to take an interest in the then still totally neglected work of Cézanne? Moreover, the dealer supposedly did not restrict his uncooperative attitude to impecunious visitors. Among the countless stories that circulated about him, even in his lifetime, was one, certainly apocryphal, that concerned one of America's most active collectors, who is supposed to have entered Vollard's gallery one day, announcing: "I am Mrs. Havemeyer and would like to see your Cézannes." Vollard . . . asked the lady to be seated. He left her to continue a conversation with an artist. Half an hour elapsed. The young lady rose and said she had not much time left. Monsieur Vollard asked her to remain seated and resumed his conversation with the artist. Another half hour passed, and then Mrs. Havemeyer said that in an hour her boat was due to sail. Vollard politely answered: "Madame, I am certain that you could take another boat." She did. She remained to see the works of that "revolutionary" Cézanne.[9]

Even as fiction, this anecdote presents the type of myth that Vollard obviously enjoyed and encouraged – especially in his subsequent writings – although there were also potential clients who did not relish his erratic behavior. Though Henry Havemeyer, in 1901, apparently helped Vollard out of a financial predicament, it would seem that the Havemeyers preferred to deal with the much more reliable and much less temperamental Durand-Ruel who, notwithstanding his strong convictions and the courage with which he would stand up for them, had the manners of a businessman, which appealed to American tycoons. Only much later did it become actually fashionable to deal with the picturesque Vollard. Auguste Pellerin, too, the first and only Frenchman to collect Cézanne's paintings on a large scale, often dealt with the Bernheim-Jeunes, although they frequently offered him pictures they owned jointly with Vollard.[10] Handling works in which each of the partners held a half-share was particularly easy because the Vollard and Bernheim-Jeune establishments were next door to each other. From 1895, Vollard occupied premises at 6, rue Laffitte, while the Bernheim-Jeunes were located at number 9.[11] This also made it very convenient for clients to go from one gallery to the other.

In the summer of 1904 there appeared in a more or less obscure periodical an article on Cézanne written by a painter who had admired him for many years, and who had recently introduced himself to him. The article was signed by Emile Bernard (once a friend of van Gogh and Gauguin), who had spent a month in Aix earlier that same year and had had many conversations with the master. This enabled him to quote a number of Cézanne's sayings and also to print excerpts from a few letters he had received from him. In a way, this publication constituted the first authentic report on

the artist, reflecting his views, although Bernard had approached him with a certain bias: that of obtaining from the revered old man some confirmations of his own – by then rather antiquated – ideas. Yet Bernard had endeavored to quote Cézanne accurately, and for that alone his article deserved more attention than it seems to have received. At the same time Bernard had striven to explain what made Cézanne's position such a unique one in the eyes of the younger generation to which he himself belonged.

Cézanne "differs essentially from Impressionism," Bernard wrote,

> from which he derives but in which he cannot imprison his nature. Far from being spontaneous, Cézanne is a man who meditates; his genius casts a shaft of light into the darkness. As a result his very painterly temperament has led him toward decorative creations of a new kind, toward unexpected syntheses; and these syntheses actually constitute the greatest progress that has flown from the perceptions of our time, because they have crushed the routine of [Beaux-Arts] schools, have maintained tradition, and sealed the fate of ill-considered fantasy. . . . In fact, on the basis of his works, Cézanne has established himself as the single master on whom the art of the future can fruitfully be grafted.[12]

Did Leo Stein know of this article, some of whose information he must have welcomed and some of whose ideas he may have shared? It is not known; he never alluded to it. But there was another event in 1904 which heightened his interest in – not to say passion for – the painter. Indeed, the autumn of that year witnessed Cézanne's substantial showing in a large, general exhibition, that of the newly established Salon d'Automne in Paris. Its founders avoided the free-for-all that had undermined the quality of the juryless exhibitions of the Indépendants, but provided their annual shows with considerably more liberal statutes than the two tradition-locked "official" Salons, which carefully preserved their public from any harmful contact with Cézanne and his like.

The first Salon d'Automne had opened its doors on the last day of October 1903. With only about a thousand works shown, it was a rather subdued affair, even though among the participants were Bonnard, Matisse, Picabia, Rouault, and Vuillard. The focus of interest was a modest Gauguin memorial exhibition, consisting of four landscapes, one self-portrait, and three "studies." The artist's death had occurred early in May of that year on one of the Marquesas islands, but had become known in Paris only toward the end of August. (More impressive than the Salon d'Automne homage was the Gauguin retrospective of fifty oils and twenty-seven drawings that Vollard organized at the very same time, thus stealing a march on the new organization. No longer plagued by Gauguin's constant requests for remittances, Vollard was about to reap the fruit of his not always generous support of the artist.)

The second Salon d'Automne, that of 1904, was more than twice the size of the first one. In lieu of a belated inaugural manifesto, the organizers reserved special rooms for some invited contemporary masters, such as Renoir, Redon, Carrière, and Cézanne, as well as the late Puvis de Chavannes and Toulouse-Lautrec, who had died more recently. The catalog listings are not quite clear, but it would seem that twenty-three of Cézanne's paintings were lent by Vollard, five by Durand-Ruel (all from the Chocquet collection), and two by another dealer, Eugène Blot. Among

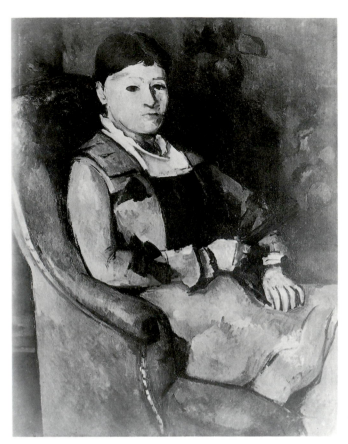

59 *Portrait of the Artist's Wife* started *c.* 1878, reworked 1886–88 (V.369)

V, 59 Vollard's loans were two works subsequently acquired by the Steins, the *Portrait of the Artist's Wife*, listed as *La Femme à l'éventail* (V.369), and a small composition of bathers.

 The Salon d'Automne of 1904 was the artistic event of the year. This time Mary Cassatt found a few words of appreciation. "I see," she subsequently wrote to Théodore Duret, "that the Cézannes have had a great success at the Salon d'Automne – it was about time."[13] In the same letter she refused an offer to sell her
7 own still life by Cézanne.

 Among the innumerable visitors to the Salon d'Automne was the American painter Maurice Sterne, who had come to Paris on a fellowship. His experience on this occasion must have been typical of that of many a young artist wholly unprepared for what Cézanne had to offer. As Sterne later reminisced:

 I first heard of Cézanne in 1904 when I arrived in Paris. I must not fail, I was told, to see the Salon d'Automne, where Puvis de Chavannes, the most successful and famous painter of his era, was honored with a one-man show. Another gallery was devoted to a comparatively obscure painter called Paul Cézanne. This was unfortunate. The outcry against Cézanne dimmed the rather feeble lustre of Puvis; and the critics in their violent denunciation of the master of Aix found little space for exultation over the immaculate art of the master of those lovely murals at the Pantheon. Go and see Puvis; you will learn something, I was told. And don't forget to look at Cézanne – you will have a good laugh. I

visited both many times. I did not learn anything from Puvis and I did not laugh at Cézanne. I was too horrified and upset for laughter. But I noticed something strange. The more I saw of Cézanne, the more Puvis shrank in stature. Yet Cézanne still remained a mystery I could not fathom.[14]

Similarly disturbed was another American visitor who reviewed the exhibition at great length for the *New York Sun*, with particular focus on Cézanne, next to Toulouse-Lautrec doubtless the least known among the featured precursors. But while Sterne could take his time and could slowly learn to understand and appreciate Cézanne – a process in which Leo Stein was to prove helpful – the author of the *Sun* article was forced to formulate immediately his reaction to the disconcerting painter, whom he knew primarily as hero of Denis's *Homage to Cézanne*. The unsigned article, written by James Huneker,[15] thus introduced Cézanne to American readers for the first time since the 1899 *New York Herald*'s report on the Chocquet sale, albeit still before they had seen any of his works. *III*

The *Sun*'s reviewer emphasized that he had carefully followed all the Salons since 1878 but never had observed "such flouting of traditions." (He obviously had avoided the exhibitions of the Indépendants, where Seurat had shown, where Signac still exhibited regularly, and where Cézanne had been represented by two paintings in 1901 and by three in 1902.) After stating that there were "many canvases the subjects of which are more pathological than artistic . . . only fit for the confessional or the privacy of the clinic," Huneker reported that "the main note of the Salon is a riotous energy . . . a flinging of paint pots. . . ." This, however, was not at all a gratuitous slander, since the *fauve* explosion at the next Salon d'Automne was just around the corner, so to speak.

To prove that he was no hopeless reactionary, the *Sun*'s critic showed appreciation for the other, older masters but wrote, concerning the new crop of artists, that "Degas has said rather scornfully to a friend of mine: 'Oh yes, they can all paint, these boys, not pictures, but stripes on a zebra.'"[16] Reviewing the special galleries, Huneker finally reached Cézanne, "*toujours Cézanne*, for this is the daily chant of the independents."

"If ardent youth sneered at the lyric ecstasy of Renoir," he told his American audience,

at the severe restraint of De Chavannes, at the poetic mystery of Carrière, their lips were hushed as they tiptoed into the Cezanne *salle*. . . . Sacred, crude, violent, sincere, ugly, and altogether bizarre canvases. Here was the very hub of the Independents' universe. Here the results of a hard laboring painter, without taste, without the faculty of selection, without vision, culture – one is tempted to add intellect – who with dogged persistence has painted in the face of mockery, painted portraits, still life, landscapes, flowers, houses, figures, painted everything, painted himself. . . . Cezanne has dropped out of his scheme harmony, melody, beauty – classic, romantic, symbolic, what you will! – and doggedly represented the ugliness of things. There is a brutal strength, a tang of the soil, that is bitter, and also strangely invigorating, after the fake, perfumed boudoir art of so many of his contemporaries.

Think of Bouguereau and you have his antithesis in Cezanne, whose stark figures of bathers, male and female, evoke a shuddering sense of the bestial.[17] Not that there is offense intended in his badly huddled, ill drawn nudes; he only delineates in simple, naked fashion the horrors of some undressed humans. His landscapes are primitive and are

suffused by a perceptible atmosphere; while the rough architecture, shambling figures, harsh coloring do not quite destroy the impression of general vitality. . . .

Cezanne's still life attracts by its whole-souled absorption. These fruits and vegetables really savor of the earth. Chardin interprets still life with realistic beauty; if he had ever painted an onion it would have revealed a certain grace. When Paul Cezanne paints an onion you smell it. Nevertheless, he has captured the affections of the rebels and just now is their god. And next season it may be some one else.[18]

In later years Huneker was to be even more specific when he wrote to a friend – as though Cézanne had confided in him – that the artist himself "would be the first to revolt against the idiotic idolatry which makes him a 'chef d'école.'"[19] But he thus admitted indirectly that the "affections of the rebels" for Cézanne had lasted well over a single season. Nevertheless, he was not ready, even in the light of what happened during the next dozen years, to change his basic opinion that Cézanne was a painter without taste, vision, culture, or intellect. No wonder that in 1901 the artist allegedly had shown no inclination to talk to a journalist who approached him not because he liked his work, but because he wanted a story such as "The Barber's Son from Aix" or "Why He Used a Shaving Brush for Disfiguring Subjects."[20]

If Huneker is to be believed, he saw the artist again at the Salon d'Automne of 1904: "Poor Cezanne, with his naive vanity, seemed dazzled by the uproarious championship of 'les jeunes,' and, to give him credit for a peasant-like astuteness, he was rather suspicious and always on his guard. He stolidly accepted the frantic homage of the youngsters, looking all the while like a bourgeois Buddha."[21] Huneker supposedly even tried to speak once more to the painter but, in his own words, "as I failed to address him as 'Cher Maître!' he didn't answer. Of course, he had quite forgotten that I had visited him at Aix for a newspaper story."[22] Even though the journalist's smugness on this occasion and the artist's bewilderment appear perfectly in character, Huneker's explanation as to why Cézanne did not answer sounds implausible; worse still, the entire episode casts doubt on the writer's memory. Indeed, as the French novelist Jules Renard jotted down in his diary: "At the Salon d'Automne . . . Cézanne, barbarian. One must first have admired a great many daubs before liking this carpenter of color. . . . The lovely life of Cézanne, all spent in a village in the South. He did not even come to his own exhibition. . . ."[23]

If Cézanne's early admirers in America, such as Prendergast, had hoped for a few words from Huneker's pen which would hint at something more admirable than "doggedness," they must have been disappointed. Nor were they to have the satisfaction of seeing Cézanne represented at the Saint Louis World's Fair of 1904. Efforts had been made by some French supporters of the painter to have at least one work of his included in the international art exhibition that was part of the Fair.[24] That section, however, was not organized by the American administrators of the event but was mounted by the various participating governments (a fact that led to a good deal of friction).[25] Thus the French contingent was selected by a committee of French officials headed by Henri Marcel, Director of Fine Arts. Marcel did make concessions for Monet, Renoir, and Pissarro (who had recently died), but obviously felt that the contemplation of a painting by Cézanne might hurt the French reputation for leadership in good taste as well as the art perception of the citizens of Saint Louis and elsewhere.[26]

It is true that the Parisian press showed scant consideration for Cézanne and often criticized the painter more savagely than Huneker had. There were, however, also a few appreciative reviews which Huneker must have read, since he was to use some of the facts and information they provided. One of the critics who had praised Cézanne's entries at the Salon d'Automne even received a thank-you note from the artist:

> I have read with interest the lines that you were kind enough to devote to me in the two articles in the *Gazette des Beaux-Arts*. I thank you for the favorable opinion that you express on my behalf. My age and my health will never allow me to realize the dream of art that I have been pursuing all my life. But I shall always be grateful to the intelligent amateurs who had – despite my own hesitations – the intuition of what I wanted to attempt for the renewal of my art. To my mind one does not substitute oneself for the past, one merely adds a new link to its chain. With the temperament of a painter and an ideal in art – that is to say, a conception of nature – sufficient means of expression would have been necessary to be intelligible to the general public and to occupy a decent position in the history of art.[27]

Among those who had an "intuition" of what Cézanne wanted to attempt were several young painters who undertook pilgrimages to Aix to meet the old man and benefit from his advice. The artist sometimes cordially enjoyed these interruptions of his ceaseless and solitary labors, but at other times became irritable and withdrew from new contacts. His life-style remained the same. Most of the year 1905 was spent at Aix, except for a brief trip to Fontainebleau. He sent ten paintings to the Salon d'Automne or, more likely, Vollard selected them (the catalogue provided no names of lenders).

Maurice Sterne, who had found Cézanne an unfathomable mystery the previous year and who meanwhile had been to Vollard's in Leo Stein's company, returned to the 1905 Salon d'Automne. But despite many visits to the room with Cézanne's works, his appreciation of them still "made no progress." Then, late one afternoon, "I found two elderly men intently studying the paintings. One, who looked like an ascetic Burmese monk with thick spectacles, was pointing out passages to his companion, murmuring 'magnificent, excellent.' His eyes seemed very poor, and he was very close to the paintings. I wondered who he could be – probably some poor painter, to judge from his rather shabby old cape."[28]

By sheer accident, Sterne was to discover that the old man in the shabby cape was Degas, the artist he held in the very highest esteem. The young American now found himself in a quandary, having witnessed that his hero "was an admirer of what appeared to me to be uncouth daubs."[29] From that day on, Sterne looked at Cézanne's pictures with different eyes and gradually learned to understand, then to admire them. What Leo Stein's proselytizing had failed to obtain, Degas had achieved with the words *magnifique, excellent*.

Cézanne was represented again at the Salon d'Automne of 1906, which opened on October 6. Owners were named for only two of his ten paintings, one of them being Vollard. Among the anonymous lenders, however, was Egisto Fabbri, whose "*Jeune homme au foulard blanc*" (V.374) was exhibited. At the same time Paris was abuzz with rumors concerning another collector, and Maurice Denis confided to his diary: "The American who has bequeathed forty Cézannes (there are only seven says

60

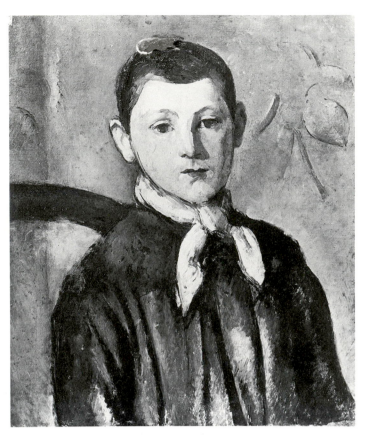

60 *Young Man with a White Scarf* (*Portrait of Louis Guillaume*) 1879–80 (V.374)

Vollard) to the Uffizi in Florence is a Mr. Loeser."[30] But the news was both incorrect and premature.

Although Max Weber had already seen the Stein collection, the real impact that Cézanne's work produced on him was provided by the Salon d'Automne of 1906 (where he, too, exhibited). As he was to remember until the end of his life, "When I saw the first ten pictures by this master, the man who actually, I should say, brought to an end academism, I said to myself as I gazed and looked, after several visits, 'This is the way to paint. This is art *and* nature, reconstructed,' by what I should call today an engineer of the geometry of aesthetics. I came away bewildered. I even changed the use of my brushes. A certain thoughtful hesitance came into my work, and I constantly looked back upon the creative tenacity, this sculpturesque touch of pigment by this great man in finding form, and how he built up his color to construct the form. . . ."[31]

Other American visitors, however, remained unimpressed, such as Edward Hopper, who wrote from Paris that he found the 1906 Salon d'Automne "for the most part very bad."[32]

When Cézanne died at Aix on October 23, black crepe was attached to his name near his pictures at the Salon. Even though Abraham Walkowitz later pretended that he had found nothing unexpected in the paintings, he never was to forget the black crepe. Two months later, the *New York Sun* devoted a surprisingly long obituary to the painter whose work was still unknown to the American public. This article was

again written by Huneker.[33] It was obviously not a perfunctory job culled from the paper's ever-ready "morgue," but a more detailed and, despite reservations, less scathing appreciation than his 1904 Salon d'Automne review. It treated the artist – if only through its exceptional length – as a major figure on the French art scene. But there was not the slightest indication of any personal acquaintance of the author with Cézanne.

"There died," the article began, "a few weeks ago at his home in Aix, in Provence, the painter Paul Cézanne, an intimate friend of Emile Zola and a man of stubborn force and individuality. His passing away was hardly noticed outside France, for he exhibited but little of late years,[34] and his accession as chief of a school was of such recent date that it had hardly time to crystallize in the public mind before the man himself was dead."

The obituary then referred to the *Sun*'s review of the 1904 Salon d'Automne and to the artist's long association with Zola, whose name had received special, worldwide prominence through his role in the Dreyfus affair. "It seems strange in the presence of a Cézanne picture," Huneker continued,

> to realize that he, too, suffered his little term of lyric madness and wrestled with huge mythological themes – giant men carrying off monstrous women. Connoisseurs at the sale of Zola's art treasures were astonished by the sight of a canvas signed Paul Cézanne, the subject of which was *L'Enlèvement* [V.101; the painting acquired by the Havemeyers], a *16* romantic subject and not lacking in the spirit of Delacroix. . . .
>
> At first blush, for those whose schooling has been academic, the Cézanne productions are shocking. Yet his is a personal vision, though a heavy one. He has not a facile brush; he is not a great painter; he lacks imagination, invention, fantasy; but his palette is his own. He is a master of gray tones, and his scale is . . . a very intense one. He avoids with relentless care the anecdote, historic or domestic. He detests design, prearranged composition. . . . He paints what he sees without flattery, without flinching from any ugliness. Compared with him Courbet is as sensuous as Corregio. He does not seek for the correspondences of light with surrounding objects or the atmosphere in which Eugène Carrière bathes his portraits, Rodin his marbles. The Cézanne picture does not modulate, does not flow; it is too often hard, though always veracious – Cézanneish veracity be it understood. But it is an inescapable veracity. There is, too, great vitality and a peculiar reserved passion, like that of a Delacroix *à rebours*, and in his still life he is the great master of his century, greater even than Manet. He never paints a pretty picture.

Having said this, Huneker could not resist the temptation of repeating his favorite analogy:

> The difference between an onion painted by Chardin and one painted by Cézanne is this: Chardin's onion is beautiful, but you can *smell* Cézanne's. . . .
>
> His landscapes are real, without the subtle poetry of Corot or the blazing lyricism of Monet. . . . An eye – nothing more is Cézanne.[35] But an abnormal eye is his. He refuses to see in nature either a symbol or a sermon. Withal his landscapes are poignant in their reality. . . .
>
> Slowly grew his fame as a sober, sincere, unaffected workman of art. Disciples rallied around him. He accepted changing fortunes with his accustomed equanimity. Maurice Denis painted for the Champs de Mars Salon of 1901 a picture entitled *Hommage à* *III* *Cézanne*. . . . This *hommage* had its uses. The disciples became a swelling, noisy chorus, and in 1904 the Cézanne room was thronged by overheated enthusiasts who would have

offered violence to the first critical dissent. The older men, followers of Monet, Manet, Degas and Whistler, whispered as if the end of the world had arrived. Art is a serious affair in Paris. However, since Cézanne, appeared the paintings of the half crazy, unlucky genius, Vincent van Gogh, and of the gifted but brutal Gauguin. And in the face of such offerings Cézanne may as yet, by reason of his moderation, achieve the unhappy fate of becoming a classic! . . .

His paintings one could have bought a few years ago for eight, ten and twenty dollars apiece. Nowadays their price is high and mounting higher. There is a Cézanne in New York in the gallery of H. O. Havemeyer. You may see specimens of his strong charmless work from time to time at the galleries of Durand-Ruel.[36] That he will ever become popular in America is doubtful, though his still life will always be sought for, always and rightfully admired.[37]

Prophecies are risky, especially when read eighty years later, but at least here was an author who, in 1906, tried to do the painter some justice rather than merely convey the by then oft-repeated image of an eccentric and impotent recluse. Torn between the clichés and prejudices with which traditionalists always dismiss innovators, and the vague notion that there had to be something valid in Cézanne's legacy since ever more people disinterestedly acclaimed him, Huneker valiantly tried to balance backhanded tributes with naïve and pedantic objections. He had evidently read up on his subject and even referred several times to Théodore Duret's *Histoire des peintres impressionnistes* which had just appeared in Paris.[38] While Duret had been particularly close to Manet, Pissarro, and Monet, he had been less well acquainted with Cézanne. Just the same, he wrote about him with more appreciation and sympathy than the two authors whose books were already available in English. One of these, the French critic Camille Mauclair, was a rather belated convert to Impressionism. His volume, *The French Impressionists*, had appeared in New York and London in 1903, before the original French text was issued in Paris the following year.[39] Being the very first study of the subject, it enjoyed considerable success. The work found a particularly receptive audience among the members of the London Bloomsbury group, always on the lookout for new perceptions.[40] Huneker, of course, had read Mauclair's small volume, and it was no accident that his views often coincide with those of its French author.

Mauclair had devoted individual chapters to Manet, Degas, Monet, and Renoir, lumping the others together in a single chapter called "The Secondary Painters of Impressionism – Pissarro, Sisley, Cézanne, Morisot, Cassatt, Caillebotte, Boudin, etc." The lone paragraph devoted to Cézanne reads:

Paul Cézanne, unknown to the public, is appreciated by a small group of art lovers. He is an artist who lives in Provence, away from the world; he is supposed to have served as model for the Impressionist painter Claude Lantier, described by Zola, in his celebrated novel "L'Oeuvre." Cézanne has painted landscapes, rustic scenes and still life pictures. His figures are clumsy and brutal and inharmonious in colour, but his landscapes have the merit of a robust simplicity of vision. These pictures are almost primitive, and they are loved by the young Impressionists because of their exclusion of all "cleverness." A charm of rude simplicity and sincerity can be found in these works. . . . Cézanne is a conscientious painter without skill, intensely absorbed in rendering what he sees, and his strong and tenacious attention has sometimes succeeded in finding beauty.[41]

These, however, were the most positive words Mauclair was ever to write on the subject of Cézanne. As the artist's reputation increased, the critic adopted a more and more negative attitude, describing Cézanne as a poor, provincial painter stricken with incompetence and ambition, and attributing his growing fame to speculations and maneuvers by a few art dealers anxious to unload their worthless stock.

The second author whose book had already appeared on the scene was an English painter named Wynford Dewhurst, who greatly admired Monet; he published in 1904 *Impressionist Painting, Its Genesis and Development*, after it had been serialized in *The Studio* the previous year. He did not follow Monet in his appreciation of Cézanne whom, strangely enough, Dewhurst treated as a "forerunner" of Impressionism, together with Jongkind and Boudin. His comments were rather similar to Mauclair's. Cézanne's landscapes, Dewhurst wrote, "are crude and hazy, weak in colour, and many admirers of Impressionism find them entirely uninteresting. His figure compositions have been called 'clumsy and brutal.' Probably the best work is to be found in his studies of still life, yet even in this direction one cannot help noting that his draughtmanship is defective."[42]

While Huneker knew Mauclair's book, he does not seem to have been acquainted with Emile Bernard's basic essay of 1904, which might have provided some of the insights he so sorely needed (unlike Mauclair's and Dewhurst's writings, Bernard's essay was not available in English). What Huneker may have used without acknowledgments[43] were various French newspaper articles, in particular reviews of the Paris Salon d'Automne of 1904 on which he himself had written. There were, for instance, the comments by the critic of the *Echo de Paris*, who began by stating: "I am by no means among the fanatical admirers of this uncertain, enigmatic, and disturbing painter," but who concluded his paragraph on Cézanne with this advice to his readers: "I would wish that – disregarding facile jeers, nasty or stupid jibes – you look at all this with sympathy, making an honest effort to understand. And I should be happy if you let yourself be seduced by the evident sincerity, of which a certain clumsiness is actually the proof, as well as by the moving simplicity of certain touches."[44]

Still closer to Huneker's views were the lines that the critic of *Gil Blas*, Louis Vauxcelles, had devoted to Cézanne, lines – incidentally – that seem to have been inspired by Lecomte's essay of 1900.[45] "Who is this Barbarian?" Vauxcelles wrote,

> peaceful, candid people accustomed to docile painting will ask. . . . Well, he is a Barbarian, a primitif, a Gothic artisan, clumsy, incomplete, inharmonious, brutal. He lives alone, far away, in Provence. Paris doesn't know him. He was a friend of Zola, who represented him as Claude Lantier in *L'Oeuvre*. He has [always] loved life and searched for truth. . . . He has a horror of facile skills. Certainly, there is sometimes in his works a lack of atmosphere, of the fluidity through which planes are placed at different distances in space and that which is remote appears far away; forms are occasionally awkward, proportions are not correct; there is chaotic imbalance . . . yet this precursor shows a rough loyalty that has been exploited by many an imitator. . . .[46]

But the text that Huneker might have read with the greatest benefit was an extensive obituary by the same Louis Vauxcelles which appeared in *Gil Blas* on October 25, 1906. It was in itself remarkable that a Parisian daily (albeit an anti-

establishment one) should honor on its front page – in the space usually reserved for editorials – a painter who was still far from universally accepted.

A laconic telegram informs me of the death of Cézanne. The public at large will pay very slight attention to the news; only the elite admired the artist who has disappeared. The large-circulation newspapers will mention the death in one line and continue to publish sensational reminiscences and news. As for the "art world," the death of Cézanne, the life and work of Cézanne, hardly touches it. . . . But it doesn't matter, after all. Hasn't it always been like that? While Flandrin, Cabanel, Meissonier, Gérome produced, lived, died to the accompaniment of dithyrambic acclamations from an ignorant but idolatrous bourgeoisie that covered them with gold . . . Delacroix, Courbet, Puvis de Chavannes, the Impressionists fought, worried, were not understood, were booed, belittled, jeered. But posterity puts everything right. What remains now of the glorious representatives of officialdom, of the triumphant masters of the Ecole des Beaux-Arts, of those possessed by all the technical cunning of the Academy? Nothing, or almost nothing. And the name of Manet grows greater every day.

The name of Cézanne, venerated by a generation of young and ardent colorists, who are conscious of what they owe one of their fertile pioneers, will – twenty years hence – be as famous as are those of Pissarro, Renoir, Monet, Sisley, Gauguin, and van Gogh. And his still lifes will join in the Louvre those by Chardin. . . .

Cézanne is one of those exceptional artists for whom "values" are everything in painting. He manipulates them with prodigal sureness. With him there are no fireworks, no insincere bravura, no tricks. No hazard of the palette. Every touch – intended and judged – is the right tone. Thus his work has the full weight of truth. As a whole his painting, which appears as a single unit, is slowly executed, in thin layers, that wind up by becoming compact, dense, rich. . . .

Fully to appreciate Paul Cézanne's strength, one must perhaps compare him to Poussin, whom everybody talks about without ever looking at; Cézanne's studies of the nude, of which the forms have a Michelangeloesque physique, those bathing scenes from antiquity, "blue and pink bodies that recall the contorted elongations of El Greco," have a kinship with sketches and wash-drawings by Nicolas Poussin.[47]

What distinguished Vauxcelles's writings was that they contained none of that condescending praise that consisted in enumerating Cézanne's many "shortcomings" while appreciating mainly his sincerity and persistence in the face of an "imperfect" execution, as though these were qualities that could save a work of art from mediocrity. Unlike many of his French colleagues, and unlike Huneker, Vauxcelles did not infuse his article with a barely concealed regret that, if only the artist had listened to his well-meaning critics, he might have overcome what they considered his awkwardness, lack of draftsmanship, inharmonious colors, or absence of atmosphere (which had already bothered Berenson). By contrast, Vauxcelles claimed, as Geffroy had done previously, that Cézanne's place was in the Louvre, and his prophecy, in contrast to Huneker's, was to prove accurate. Most important, perhaps, was that Vauxcelles judged and praised Cézanne for his achievements, whose essential nature he grasped, taking a positive attitude rather than indulging in one-upmanship. Within a few years, others – among them also Americans – were to find their way to such a perception of the painter. Although Huneker later rightly claimed to have been among the first in the United States to have written about Cézanne, the truth is that – possibly owing to a desire to show himself up-to-date –

he had, in his obituary, spoken of Cézanne with greater deference than he actually thought the artist deserved. At least this can be inferred from his private letters with their less guarded expressions.

At the very time when Huneker's Cézanne obituary appeared in the *New York Sun* of December 20, 1906, he was appointed regular art critic of that paper. As an often highly perceptive man with vast culture and with a great zest for life who did care for art in its multiple manifestations, and who commanded an eloquent pen, Huneker seemed much better qualified to deal with the contemporary scene than his more scholarly colleague of the *New York Evening Post*, Frank Jewett Mather, Jr., or the pompous and reactionary Royal Cortissoz of the *Tribune*. His new position was to offer Huneker further opportunities to write about Cézanne, but even though he was to state, in 1917, that "Huysmans was clairvoyant when nearly a half-century ago [actually in 1889] he spoke of Cézanne's work as containing the prodromes of a new art,"[48] he himself always avoided any elaboration on this vital subject. Quite the contrary; ten years after the artist's death, having seen many more of Cézanne's works and read some of the recent publications about him, Huneker appears to have further downgraded his appreciation of the master.

"While I haven't revised my opinion of the strength and sincerity of Cézanne," he was to write in 1916 to Royal Cortissoz, "yet I've deemed it necessary for my own critical health to see him in perspective. . . . All this to prove I'm not a *Cézanne-ist*, even if I like – above all – his still life. His landscapes are all alike – he is the Single Speech Hamilton of landscapists. . . . He was little more than third-rate, after all, this grumpy old bird, wasn't he?"[49]

It is deplorable that the first major and more or less widely circulated article on Cézanne to appear in the United States, an article that might have attracted many who were looking for new artistic avenues, was based on such narrow, provincial, and almost cynical premises.

Photograph of Cézanne's tomb at Aix

NOTES

1. Leo Stein, *Appreciation: Painting, Poetry and Prose* (New York: Crown, 1947), p. 154.

2. Gertrude Stein, "Gertrude Stein in Paris, 1903–1907," *The Autobiography of Alice B. Toklas* (New York: Random House, 1933), pp. 33–34.

3. Andrew Dasburg interview, Nov. 1977; see Gail Levin, "Andrew Dasburg: Recollections of the Avant-Garde," *Arts Magazine*, June 1978, p. 129.

4. Henry McBride, "Important Cézannes in Arden Galleries," *New York Sun*, March 4, 1917. McBride must have visited Vollard some time after the Grafton exhibition of 1910–11.

5. From Vollard's unpublished account book, 1896–99, courtesy the late Mme Edouard Jonas, Paris.

6. Information courtesy the late Dr. Ruth Bakwin, New York.

7. The prices quoted by Vollard reflected this policy (especially after the First World War); he volunteered to lower them according to a complicated scale in case payment was to be made in cash, partly in dollars, entirely in Swiss francs, etc. When Vollard once showed Kenneth Clark a batch of small drawings and watercolors by Cézanne, Clark (as he once told me) decided not to examine them individually, fearing that Vollard might change his mind – or his price – but to buy the entire lot. He then rushed to his hotel to inspect his purchase. He was not disappointed.

8. Max Raphael, *Aufbruch in die Gegenwart* (Frankfurt am Main and New York: Qumran, Campus Verlag, 1985), p. 17. Originally published in "Erinnerungen um Picasso" [1911], *Davoser Revue*, Aug. 15, 1931.

9. Edith de Tierey, "Mrs. Havemeyer's Vivid Interest in Art," *New York Times*, Feb. 3, 1929.

10. Pellerin first appears in Vollard's account book with a purchase of four paintings by Cézanne in Dec. 1898. In July 1899 he acquired a Cézanne landscape at the Chocquet sale. In Jan. 1900 he began to deal with the Bernheim-Jeunes and continued to do so until 1912; on his relations with that firm see J. Rewald, "Some Entries for a New Catalogue Raisonné of Cézanne's Paintings," *Gazette des Beaux-Arts*, Nov. 1975, pp. 165–67.

11. Vollard remained at that address, with the exception of the 1914–18 war years, until 1924, when he moved into a large private house in the rue de Martignac, where he also lived and where he received only by appointment. Although he had established a perfect space for exhibitions there, he never held any shows.

Until 1905, the Bernheim-Jeune gallery was directed by Alexandre Bernheim-Jeune, born in 1839, the same year as Cézanne. However, between 1900 and 1906, two branches were opened, at 36, avenue de l'Opéra, and at 1, rue Scribe, which were run by Alexandre's sons, Josse and Gaston, both more interested in contemporary art than he was. In 1904, Félix Fénéon joined the younger Bernheim-Jeunes, first as advisor, then as director of their new gallery. This new gallery was established in 1906, after the two branches had been closed. It was opened first in temporary quarters as 15, rue Richepanse until adjoining premises on the boulevard de la Madeleine could be added to form a spacious gallery (with two street addresses).

After April 1907, when their father retired, the two brothers began to organize large exhibitions in their new location, such as the two important Cézanne shows of 1907 and 1910. Many of their exhibitions were initiated by Fénéon, as were the gallery's contracts with such artists as Signac, Cross, Bonnard, Matisse, etc.

The Durand-Ruel galleries were located at 16, rue Lafitte with an entrance on the rue Le Peletier, where they remained until 1925–26.

12. Emile Bernard, "Paul Cézanne," *L'Occident*, July 1904; reprinted in *Conversations avec Cézanne*, ed. P. M. Doran (Paris: Collection Macula, 1978), pp. 37–38.

13. Mary Cassatt to Théodore Duret, Nov. 30 [1904]; *Cassatt and Her Circle, Selected Letters*, ed. N. C. Mathews (New York: Abbeville Press, 1984), p. 295.

14. Maurice Sterne, *Shadow and Light*, ed. C. L. Mayerson (New York: Harcourt, Brace and World, 1952), p. 42.

15. Huneker later said that he was the author of this review; he included a somewhat revised version of it in his *Promenades of an Impressionist* (New York: Charles Scribner's Sons, 1910). Prof. Arnold T. Schwab, *James Gibbons Huneker*

(Stanford, Calif.: Stanford University Press, 1963), p. 117, states that this was, "in all likelihood, his first piece of art criticism for the *Sun*, although Huneker referred to his elusive article of 1901 in *Unicorns* (New York, 1917, p. 97) as having been published by that paper: 'In the *Sun* of 1901, 1904, and 1906 (the latter the year of his death) appeared my articles on Cézanne, among the first, if not the first that were printed in this country.'"

On Huneker see also John Loughery, "The *New York Sun* and Modern Art in America: Charles Fitzgerald, Frederick James Gregg, James Gibbons Huneker, Henry McBride," *Arts Magazine*, Dec. 1985, pp. 77–82.

16. This *bon mot* by Degas seems to have escaped attention. It may have been reported to Huneker by George Moore, yet he could also have heard it from Mary Cassatt, though there is no evidence that he knew her, except that as an American art critic he might have been in touch with an expatriate painter in Paris who was enjoying an increasing reputation at home. Moreover, Mary Cassatt's own opinions are known to have coincided with those expressed by Degas.

17. Huneker was to explain this comparison with Bouguereau in a letter of Jan. 7, 1916, to Royal Cortissoz (*Letters of James Gibbons Huneker* [New York: Charles Scribner's Sons, 1922], p. 204) after the latter had attacked it in an article (reprinted in R. Cortissoz, *Personalities in Art* [New York and London: Charles Scribner's Sons, 1925], pp. 300–301). Wrote Huneker: "If I said that Cézanne was the antithesis of Corot – as you suggest – I would have put too high a price on his worth; Bouguereau is the more apposite comparison. . . ."

18. Anonymous [James G. Huneker], "Autumn Salon is Bizarre," *New York Sun*, Nov. 27, 1904 (article datelined Paris, Nov. 20).

19. James G. Huneker to Royal Cortissoz, Jan. 7, 1916, *Letters*, p. 204. Camille Mauclair was to express the same view.

20. In his letter to Cortissoz, ibid., p. 205, Huneker jokingly suggested these very titles in a postscript. In spite of what had been published since he supposedly went to Aix in 1901, especially by Vollard, Huneker continued to believe that Cézanne's father had been a barber. For the origin of this error, see Chapter V, p. 119.

21. James G. Huneker to Royal Cortissoz, ibid., p. 204.

22. Ibid.

23. Jules Renard, diary entry of Oct. 21, 1904; J. Renard, *Journal* (Paris: Gallimard, 1960), pp. 926, 927.

24. On this subject see Ambroise Vollard, "Les dernières années," *Paul Cézanne* (Paris: Vollard, 1914); also Georges Rivière, *Paul Cézanne* (Paris: Floury, 1923), p. 227.

25. I am grateful to Ms. Ann B. Abid, Librarian, Richardson Memorial Library, The Saint Louis Art Museum, for explaining to me the mechanism of selections for the fair's art section.

26. Efforts to find the records of the deliberations of the French jury for the Saint Louis World's Fair, kindly undertaken in Paris by Mme Dominique Godinau, Attachée de Presse de l'Académie des Beaux-Arts, have yielded no results so far.

27. Cézanne to Roger Marx, Aix, Jan. 23, 1905; Paul Cézanne, *Correspondance* (Paris: Bernard Grasset, 1978), pp. 311–12. According to Vollard, it had been Roger Marx who had tried to have a work by Cézanne shown at the Saint Louis World's Fair.

28. Sterne, *Shadow and Light*, p. 43.

29. Ibid., p. 44.

30. Maurice Denis, diary entry of 1906; Maurice Denis, *Journal, Tome II (1905–1920)* (Paris: Editions du Vieux Colombier, 1957), p. 46. Charles Loeser did not leave his Cézannes to the Uffizi. When he died in 1928, his will provided that his Italian paintings and sculptures go to the city of Florence, to be installed in the Palazzo Vecchio. (This bequest was made partly for the purpose of securing permission for the rest to leave Italy.) Loeser bequeathed a collection of 262 drawings to the Fogg Art Museum; see *Old Master Drawings – Selections from the Charles A. Loeser Bequest*, ed. K. Oberhuber (Cambridge, Mass.: Fogg Art Museum, Harvard University, 1979). A good many of Loeser's attributions have since been revised. Loeser's eight most valuable paintings by Cézanne were left to the president of the United States; the majority of them are now in the National Gallery of Art, Washington, D.C. (I am grateful to Agnes Mongan for personal recollections of Charles Loeser, as well as for the communication of his will.)

31. Max Weber, interview, 1959; transcript, vol. 1, pp. 118–19; Columbia University Oral History Project. This text was brought to my attention by John Cauman.

32. Edward Hopper to his mother [Paris], Oct. 30, 1906; Gail Levin, *Edward Hopper – The Art and the Artist* (New York: W. W. Norton, 1980), p. 23.

33. On this subject, see note 15 above.

34. Actually Cézanne exhibited *more* in his last years than in his earlier ones, during which he had

gained admission only to the Salon des Refusés of 1863 and had shown with the Impressionist group in 1874 and 1877. But precise biographical data were not yet available to Huneker, whose article also contains other errors.

35. Huneker obviously did not know that Cézanne had said the same thing of Monet.

36. This statement is not quite clear. Appearing as it does between two sentences that refer to New York and America, it would seem that Huneker is alluding here to the New York branch of the Durand-Ruel gallery. However, research in the archives of that establishment reveals that – with the exception of the two Hallowell still lives of 1894–95 (see Chapter I) – there was not a single work by Cézanne in the New York branch, either on consignment or in stock, between 1894 and 1914, and that the Paris firm did not send any Cézannes there between Jan. 1903 and March 1906. (Information courtesy the late Charles Durand-Ruel, Paris.) Huneker must therefore have meant the Paris gallery.

37. Anonymous [James G. Huneker], "Paul Cézanne," *New York Sun*, Dec. 20, 1906.

38. Duret had already devoted a pamphlet to the Impressionists in 1878, in which, however, he had not spoken of Cézanne. He added a chapter on the artist to the new, considerably expanded version of 1906. An English edition was to appear as *Manet and the French Impressionists* (Philadelphia: Lippincott, 1910).

39. Camille Mauclair, *The French Impressionists* (London: Duckworth; New York: Dutton [1903]).

40. To Vanessa Bell, for instance, this book "opened a window onto a fresh view of art," and suggested, as she later wrote, "that after all living painters might be as alive as the dead and that there was something fundamental and permanent and as discoverable now as in any other age." Quoted in Frances Spalding, *Vanessa Bell* (New

Haven and New York: Ticknor & Fields, 1983), p. 37. Despite her dislike for lectures, Vanessa Bell subsequently even attended one on French Impressionism, given at the Grafton Gallery by Frank Rutter, who was to become a member of Gertrude Stein's circle.

On this subject see Beverly H. Twitchell, *Cézanne and Formalism in Bloomsbury* (Ann Arbor, 1987). This book appeared too late to be considered in the present study.

41. Mauclair, *The Impressionists*, pp. 141–42. Mauclair's short-sightedness concerning Cézanne was soon to be overcome, particularly in the case of Vanessa Bell, by the enlightened enthusiasm that her intimate friend Roger Fry began to manifest for the painter.

42. Wynford Dewhurst, *Impressionist Painting, Its Genesis and Development* (New York: Charles Scribner's Sons, 1904), p. 16.

43. See Schwab, *James Gibbons Huneker*, pp. 175–76, about "Huneker quoting verbatim, and without acknowledgement, from art reference books."

44. Gustave Babin, 'Le Salon d'Automne," *Echo de Paris*, Oct. 14, 1904.

45. For Lecomte's text, see Chapter II, note 9.

46. Louis Vauxcelles, "Le Salon d'Automne," *Gil Blas*, Oct. 14, 1904.

47. Louis Vauxcelles, "La Mort de Paul Cézanne," *Gil Blas*, Oct. 25, 1906.

48. James G. Huneker, article in the *New York Sun*, March 11, 1917; reprinted in James G. Huneker, *Unicorns* (New York: Charles Scribner's Sons, 1917), p. 99.

49. James G. Huneker to Royal Cortissoz, Jan. 7, 1916, *Letters*, p. 205; on this letter and Cortissoz's article to which it replied, see notes 17 and 19 above.

V · Posthumous Exhibitions and American Reactions

WE HAVE LEARNED in modern times that there are many great contemporary figures about whom hardly anything derogatory is – or can be – said during their lifetimes. But no sooner do they disappear than revelations follow revelations until their once shiny reputations are torn to shreds. For many of the geniuses of the nineteenth century the historic process was just the opposite. Defenseless and misunderstood, they experienced public abuse to an extent difficult to imagine today, the more so as by now, and partly as a result of what happened to them, critical disparagement is no longer seen as a total disgrace; quite the contrary, there are those who consider it a confirmation of their value since it has happened to so many great men before. No such "comfort" existed for Cézanne, because in his day it still seemed unfathomable that artists and public should be separated by such a tremendous gap and that the critics should fail so completely in their task of bridging it. Instead, it often looked as though the critics had been appointed to shield the public from any unorthodox tendencies, outdoing themselves in their sometimes ferocious endeavors to deride those creators who would not conform to their concepts and prejudices. While posterity seemed generally willing to redress such injustices, this was small consolation for those who, like Cézanne, had actually fled the Parisian hubbub yet had been unable to escape their share of vicious attacks. No wonder he had shown little inclination to exhibit his works until urged to do so by Vollard, as well as by admirers such as Maurice Denis, who insisted that his paintings be seen in Paris. No wonder, either, that he had occasionally been reluctant to receive those who had taken the trouble of coming to call on him in Aix, though he was usually glad to speak to fellow artists and actually wrote to his son a few days before his death, "I believe the young painters to be much more intelligent than the others; the old ones can only see in me a disastrous rival."[1]

There was a certain pride in these words, since a "disastrous rival" could only be one who had something positive to offer, whose achievement constituted a real *threat*. When the painter K.-X. Roussel accompanied his friend Maurice Denis on a visit to Aix in January 1906, he promised the old master to send him the *Journal* of Delacroix which had just been published. Cézanne received the gift with great pleasure and immediately wrote to Roussel: "I thank you very much for your kind sympathy, which is for me a precious proof of the fact that my efforts toward the realisation of art – to which I have always devoted myself – are not altogether in vain since the young show me an approbation that is as disinterested as it is flattering."[2] It was obvious that the respect the new generation was showing him at last provided the

61

61 Cézanne letter to K.-X. Roussel, February 22, 1906

aging artist with the satisfaction of knowing that he was indeed becoming a successful rival to "the others" he despised. This was a development that not even the ridicule heaped on him could alter. Yet it came late, and he was not to witness its culmination.

After Cézanne's death things began to change slowly. Since he had never sought the limelight and had always let his paintings speak for themselves, his disappearance neither added to nor detracted from the work he left behind. To a certain degree Cézanne had actually stood in the way of the spread of his reputation. For those who admired him the task of propagating his message now became easier because they were no longer faced with his reluctance to cooperate, his reserve and passivity, or his insistence on dealing exclusively with the unpredictable and even lazy Vollard. Their mission was a twofold one: not only was it essential to persuade art lovers that Cézanne was a true innovator while he simultaneously constituted a link with the great French tradition (something his admirers strove to do through their writings and through exhibitions), but it was also equally important to demolish those pseudo-masters like Meissonier, Cabanel, or Gérôme, whom few critics had yet dared to attack. It was not easy to convince collectors that what they had been assembling and adoring was undeserving of their investment both in money and proprietary vainglory. Even though Cézanne's paintings could no longer

be bought for twenty dollars, they were still considerably cheaper than works by Bouguereau or Rosa Bonheur. On the other hand, Impressionist pictures did not yet, in America, constitute a status symbol for the private galleries of the very rich, nor were they deemed museum-worthy.

It would seem that the Frenchmen who did not care for Cézanne began to resent the fact that he was achieving a reputation abroad. Shortly after Cézanne's death, at one of the dinners at which Vollard liked to entertain his friends in the cellar of his gallery (which soon became famous), the painter Forain made fun of "those snobs, those Americans, who buy Cézannes, who do not understand Cézanne; with them it is a craze, like the fads of certain erotomaniacs."[3]

Charles Loeser, who attended Vollard's gatherings when in Paris, would enter in his diary: "Dinner Vollard with Degas and Mme d'Annunzio. Degas talked admirably."[4] But on another occasion he enjoyed himself much less and noted: "Dinner at Vollard's with . . . Mary Cassatt and one Bernard d'Heudecourt [a *62* collector]. The Cassatt a tiresome cackling old maid with loud opinions very Bostonese – most boresome."[5] It seems quite possible that, to please Loeser, Vollard might have directed the conversation toward Cézanne, with Degas on one occasion discussing his work "admirably" and Mary Cassatt on another occasion putting forth rather narrow-minded views.

62 February 20, 1909 entry from Charles Loeser's diary

Vollard apparently avoided inviting Loeser together with Forain, for among the latter's favorite subjects were his hatred of (a) Cézanne, (b) Americans, and (c) Jews, this last aversion fanned by the Dreyfus affair. In all fairness to Forain it should be said that his prejudices and arrogance knew no bounds. His aggressive opinions were always sprinkled liberally (their only liberal aspect) with what may be called Gallic viciousness and were proclaimed with such sparkling wit that his listeners tended to overlook his wickedness. Not content with chiding Americans for having contributed to Cézanne's success, he also accused them of indulging their bad taste for Bouguereau (and in both cases he was, evidently, not altogether wrong, though his reasoning tended to be, to put it mildly, absurd).

"M. Bouguereau," Forain exclaimed,

do you believe that this man was born to be an artist? No, of course not. He has simply the soul of a good and honest haberdasher. And who appreciates him, who gorges him with gold? The Americans, those people without race or traditions, who recently made their fortunes after selling pigs all their lives; people who, fifty years ago, were still a little bit

nègres. How do you expect those people to know anything, to be sensitive to the synthesis of a form or to the apparent monotony of a picture? What they want is *good workmanship* where the intervention of the hand cannot be perceived, women who are flawless and sleek like porcelain, and only M. Bouguereau can provide them with that ideal![6]

It is true that in 1906 the English art historian Roger Fry, who had just become "aware" of Cézanne, said somewhat the same thing, though in much more elegant terms, when he stated that among the holdings of the Metropolitan Museum of New York "there is only one aspect of the art which is adequately represented and that is the sentimental and anecdotic side of nineteenth-century painting."[7] But the trustees obviously felt that there was not yet enough of that insipid and expensive stuff. In 1905 they had purchased – fresh from the easel – a huge and outmoded *Christ* by Lhermitte; in 1906 they added a sugary *Madonna* by Dagnan Bouveret; and in 1908 they followed it with one of Raffaëlli's standard Paris scenes, then considered "modern." During his short curatorial tenure, Roger Fry was able to acquire only Renoir's large *Madame Charpentier*. Of Cézanne there was never any question. He was left to the Havemeyers, whose Old Masters were famous, having been seen in public on various occasions, but whose modern paintings were known only to their intimates (not all of whom appreciated them).

When Henry O. Havemeyer died in 1907, the *American Art News* complained that very little notice had been paid in the obituaries to "his art taste and the exceeding richness, beauty and value of his collections, and so scanty mention made of the probable disposition of these collections." The paper assured its readers that Mr. Havemeyer had stipulated that these remain intact, be left to his widow, and that no auction sale was contemplated. It also denied another rumor: "It has been inaccurately stated that he had tired of the paintings of the French impressionists, which years ago he began collecting with interest and enthusiasm. Nothing could be further from the truth. He left his family at least 25 examples each of the impressionist painters, Manet, Monet, Degas and Cézanne and several examples each of their fellows, Renoir, Pissarro, Sisley, Mary Cassatt and Berthe Morisot." The article concluded with the words, "The best monument of Mr. Havemeyer is not the Sugar Trust – nor his stately mansions in town and country, nor his millions – but the beautiful pictures and art objects he has left to testify to succeeding generations of his life of and for the beautiful. . . ."[8]

Yet this monument remained, as before, inaccessible to the general public, which must have been surprised to learn from the *American Art News* that the Havemeyers owned twenty-five paintings by Cézanne rather than the single canvas mentioned by Huneker the previous year. Though half that figure would have been more correct, it was still a startling enough revelation that there were so many pictures by Cézanne in New York which hardly anybody had ever seen.

In Paris, meanwhile, Cézanne's works appeared in steadily greater numbers in public exhibitions, starting in June 1907 with a show of no fewer than seventy-nine of his watercolors at the Bernheim-Jeune gallery. In March of that year the Bernheim-Jeune brothers, together with Vollard, had acquired a lot of about two hundred watercolors from the artist's son and it was their share of this bounty that they put on display.[9] It was the first major show of its kind and also the first arranged by a dealer other than Vollard, who chose not to exhibit his portion of the purchase.

As a matter of fact, Vollard became ever less inclined to organize exhibitions. It was thus left to the Bernheim-Jeunes to reveal an aspect of Cézanne's output that had remained almost unknown. The few watercolors that Chocquet had owned, which were dispersed at his sale of 1899, had been early gouaches that did not really announce the unequaled transparency and the glow of colors that distinguished the artist's later work in this medium. For the time being, however, these delicate sheets with their disconcerting freedom of expression seem to have been appreciated mostly by painters, among them Matisse.

Edward Steichen took his friend Alfred Stieglitz, newly arrived in Paris, to the Bernheim-Jeune show. Stieglitz's first impression was of "hundreds of pieces of blank paper with scattered blotches of color on them."[10] They both, in Steichen's words, "laughed like country yokels" at the exhibits, but when Stieglitz priced them, they were rather stunned to learn that these watercolors cost 1,000 francs ($200) apiece. Steichen subsequently suggested that they play a joke on the New York critics: he would in a single day produce a hundred watercolors like those at Bernheim-Jeune, none signed, and Stieglitz could announce an "Exhibition of Watercolors by Cézanne." The plan was that, after the critics had come and gone, Stieglitz would publicly admit that the whole thing was a practical joke. It is fortunate that the two friends eventually abstained, for such an undertaking would certainly not have helped to secure Cézanne's still shaky reputation.

What did contribute to the spread of Cézanne's reputation was the increasing frequency with which his works were displayed and the influence they exerted. In those days one-man shows put on by dealers were still not very common; Cézanne had had to wait until he was fifty-six for his first solo exhibition. Young or little-known artists seldom found occasion to show significant numbers of their works. Only the various Paris Salons offered them opportunities to manifest themselves at all. As a result, these Salons played an incomparably greater role in the careers of most artists than they do nowadays. Moreover, at the Salons the exhibitors could measure themselves against others and thus establish their place in the maze of new trends.

But conditions had not always been thus. When the Impressionists – unable to surmount the barriers erected by a conservative jury – were refused admission to the official Salon (the only one then in existence), they had been forced to arrange their own exhibitions where they could present themselves as a more or less cohesive group. This independent action, however, had been frowned upon by conventional circles. Since those days, various new movements had initiated more liberal Salons in which to vie for public attention. Seurat and his followers had exhibited at the Salon des Indépendants, founded in 1884, and – by hanging their pictures in the same room – had been able to render their new concepts more impressive. In 1905, the Fauves had done the same when they appeared together at the Salon d'Automne, established only two years earlier. The Fauves owed part of their considerable impact to the fact that their statement was much more forceful in this fashion than it could have been in a series of individual shows.

In the years after his death, the Salons also provided clear evidence of Cézanne's increasing influence on the younger generation. As the visitors walked through room after room of the Indépendants or the Salon d'Automne, they were confronted with

a multitude of works that – consciously or not – drew on Cézanne's example. This experience, however, was limited to those who attended the Paris Salons, since nothing similar existed elsewhere. Only those Americans who had the opportunity to see these yearly exhibitions were cognizant of the evolution of French art and of Cézanne's role in it. Yet, as one New York collector was soon to point out, these Salons took place either in the spring or in the fall, that is, not during the season in which affluent Americans usually traveled abroad.

In October 1907, the Salon d'Automne honored Cézanne's memory with a retrospective of over fifty oils and watercolors (almost half of which came from Pellerin who, unlike the Havemeyers, was a very generous lender). Leo Stein, that faithful visitor of exhibitions, later remembered: "Hitherto Cézanne had been important only for the few; he was about to become important for everybody. At the Autumn Salon of 1905 people laughed themselves into hysterics before his pictures, in 1906 they were respectful, and in 1907 they were reverent. Cézanne had become the man of the moment."[11]

Max Weber went to the Salon d'Automne in the company of his friend, the *douanier* Rousseau.

> We came there and found the galleries packed. . . . It was a great event. . . . Rousseau and I walked around, we looked, and he became quite absorbed, picture after picture. Then he turned to me and he said, "*Oui, Weber, un grand maître*, this is a great artist, *mais, vous savez, je ne vois pas tout ce violet dans la nature*, I don't see so much violet in nature." Then he looked up at a picture of bathers, probably the largest canvas that Cézanne painted [V.719]. And . . . as in certain of the watercolors, much of the barren paper is visible. But somehow, the way he painted, the canvas, though bare, geometrically plays as important a part as the parts that were covered with pigment. So Rousseau found it, of course, an unfinished picture. So he looked up, and he said, "Ah, Weber, if I had this picture at home – *chez moi* – I could finish it."[12]

63

While Weber marveled at the old man's childlike self-confidence, he was literally overwhelmed by Cézanne's work and began to consider his contribution to art a "great blessing for all times."

Back in the United States, Huneker wrote about the event to a friend in Paris: "The Autumn Salon must have blistered your eyeballs. Nevertheless Cézanne is a great painter – purely as a painter, one who seizes and expresses *actuality*. This same actuality is always terrifyingly ugly (fancy waking up at night and discovering one of his females on the pillow next to you!). There is the ugly in life as well as the pretty, my dear boy, and for artistic purposes it is often more significant and characteristic. But – ugly is Cézanne. He could paint a bad breath."[13]

However, most artists who visited the show experienced it as a breath of fresh air. One of them was the young American Walter Pach, on whom it made a lasting impression. On his first trip to Europe in 1904, Pach had noticed a painting by Cézanne in a gallery in Dresden before he even knew how to spell the artist's name.[14] When he returned to Paris for a year in 1907, he was drawn into the Stein circle and thus was truly prepared for the "Cézanne experience" of the Salon d'Automne. But when he tried to introduce his teacher, the famous William Merrit Chase, for whose summer school he worked, to the art of Cézanne, he met with total failure. Despite the fact that the show contained many highly accomplished works, among them a

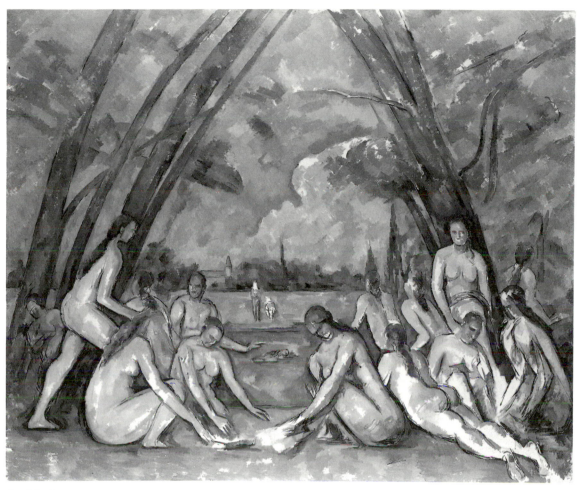

63 *The Large Bathers c.* 1906 (V.719)

number of large still lifes and the gripping *Woman with a Rosary* (V.702), the *X, 102*
inclusion of a few rather sketchily executed canvases seems to have been considered
objectionable. As Pach soon informed a friend: "I wrote Mr. Chase about Cézanne.
His one pupil Bernard, and Monet (a great admirer of his) protest against such
exhibitions as that which Mr. Chase saw (unfinished, unrepresentative things which
he [Cézanne] threw aside) and I think Mr. Chase will give him another
consideration."[15]

Chase did give Cézanne another try when he met Charles Loeser in Florence and
was invited to visit his house which, as he discovered, "simply bristled with
Cézannes." Pach has related the master's outburst of indignation: "I told that young
man [Loeser was over forty], 'Sell the stuff now while you can still get some money
for it. You won't, if you wait long. People won't ever take to your Cézanne in any
numbers.' And do you know, he just twiddled that little mustache of his and said in
his confounded way, 'Well I never did think he'd be popular with the mahsses.' I
ought to have taken my hat and walked out of the place. Do you know what he meant
by 'the Mahsses.' He – meant – me!"[16]

Pach was not the only one to be fascinated with the Salon d'Automne retrospective. Another visitor from across the Atlantic was Maurice Prendergast. He had returned to Paris for several months in 1907 and, in the autumn of that year, wrote to his patron, Mrs. Oliver Williams of Boston: "I have been extremely fortunate in regard to the exhibitions, not only in the spring with the Salons, but Chardin, Fragonard, etc., and the delightful fall exhibitions which last during the month of October; they have all Paul Cézanne, Berthe Morisot, and Eva Gonzalès. Cézanne gets the most wonderful color, a dusty kind of grey, and he had a watercolor exhibition late in the spring which was to me perfectly marvelous. He left everything to the imagination; they were great for their sympathy and suggestive qualities."

Obviously referring to the Fauves, Prendergast also informed his patron: "I am delighted with the younger Bohemian crowd: they outrage even the Byzantine, and our North American Indians, with their brilliant colors would not be in the same class with them. . . . I wish we had some of it in Boston or New York. Our exhibitions are so monotonous." By contrast, the shows in Paris, as he put it, "worked me up so much that I had to run up and down the Boulevards to get off steam." About to leave for home, Prendergast concluded: "I got what I came over for, a new impulse. I was somewhat bewildered when I first got here, but I think that Cézanne will influence me more than the others. I think so now."[17]

The dissimilarity between the Paris and New York art scenes was, surprisingly enough, also emphasized by Huneker when, a short while later, he reviewed an exhibition of the just emerging "Eight" at the Macbeth Gallery. "Compared to the performances in paint at the Paris Autumn Salon . . . this show . . . is decidedly reactionary," he wrote. "The truth is that New York in the matter of art is provincial. . . . Any young painter recently returned from Paris or Munich – the Munich of the secessionists – would call the exhibition of the eight painters very interesting but far from revolutionary. If some of us sit up aghast now, what will happen to our nerves when Cézanne, Gauguin, Van Gogh appear? Therefore let us try to be catholic. . . . Let us study each man according to his own temperament. . . . To miss modern art is to miss all the thrill and excitement that our present life holds."[18] No wonder that so many young American artists felt the urge to cross the Atlantic and see for themselves what was happening in Paris. No wonder, too, that once over there, they sooner or later gravitated toward the hospitable Steins.

The year 1907 had not only seen two large Cézanne shows in Paris, it was also the year in which the first volume of Zola's collected letters appeared, containing many early ones written to his boyhood friend Cézanne and revealing the romantic aspects of the painter's imagination, which had up to this time been known only through hearsay. In September a lucid article by Maurice Denis appeared, attempting to formulate once again what Cézanne's contribution had been and what it meant to the new generation, which by now had established a real cult in his name.[19] A few weeks later, Emile Bernard published his recollections of the artist, accompanied by the important letters he had received from him.[20] Bernard had of course already written on Cézanne during the artist's lifetime (though the latter had told him that as a painter he should paint rather than write) and had often pestered him with questions as well as explanations of his own views. These the old man had timidly or furiously, but mostly unsuccessfully tried to escape. Yet at the time, only the Austrian poet

Rainer Maria Rilke, who "discovered" Cézanne and developed a true passion for him at the Salon d'Automne of 1907, was subtle enough to sense that there had been tension and misunderstanding between the solitary painter of Aix and young Bernard. In various letters to his wife, Rilke reported on Bernard's publication and referred to him as "a painter who writes, that is one who is no painter"; he also called him "a not very sympathetic artist."[21]

However, to the many who were anxious for any kind of information about Cézanne, Bernard appeared as the trusted legatee of the master. Thus Denis's appraisal of Cézanne's role and Bernard's recollections, as well as Cézanne's letters (written mostly in answer to Bernard's queries), were to form for many years the foundation for much that was being published on the painter. But there was also still a good deal of adverse criticism, led in France by the influential Camille Mauclair (who remained glued to his incomprehension for half a century). He was joined by Max Nordau, an Austro-Hungarian physician who was an extremely popular and widely translated psychologist, philosopher, and sociologist. Living in Paris and having visited the Salon d'Automne of 1904, Nordau appointed himself art historian. His book, *Von Kunst und Künstlern*, appeared in 1905; two years later it became available in an English version, published in Philadelphia.[22]

Nordau had many interesting ideas, except that in questions related to culture he was frighteningly retarded. In his philosophy, it was morality that provided a work of art with beauty; only what was "moral" as well as "useful" could benefit humanity. But his definitions of these issues were both narrow and conventional, leaving no room for any creativity that did not conform to his philistine concepts. Indeed, in a weighty volume titled *Degeneration* he had found degeneracy wherever there was an original contribution, no matter how widely acclaimed the artist was, be he Tolstoy or Zola or Rodin. According to such premises there was definitely no chance for an "outcast" like Cézanne to pass muster. As a matter of fact, Nordau's views were so thoroughly bourgeois that the only difference between him and Queen Victoria was that Her Majesty successfully abstained from aesthetic theory.[23]

Although Huneker disagreed with Nordau, there was at least one point on which they shared an opinion. Had not Huneker already noticed Cézanne's penchant for the "ugly"? Now Nordau belabored this point, without making any concessions for either landscapes or still lifes. He declared Cézanne's bathers "immoral" and explained:

> It is his nature that ugliness has for him an attraction. He sees only what is abnormal, unpleasant, and repulsive in life. If he paints a house, it must be warped, and threaten to tumble down soon. If he portrays a human being, the latter has a distorted face, apparently paralysed on one side, and a deeply depressed or stupid expression. Every model that submits himself to him is put in some sort of convict's dress. Here is a female portrait. A withered, dried-up face, mud bedaubed clothes that look as if they had been trailed through the gutter. Doubtless a "professional" who . . . after a night in the cells of the police station, was discharged? Nothing of the sort. She is a respectable lady of the upper middle-class. . . . It is curious to me how any one can allow himself of his own accord to be painted by Cézanne, unless it were done in a contrite, penitential mood. . . . To be sure, one cannot be angry with him, for he does not treat himself any better than his other victims. . . . And his morose eye disfigures not only faces, heads, and raiment, but also the rest.[24]

Since these comments reflected widely held views, they were immediately translated, whereas more favorable opinions, such as those of Emile Bernard, Geffroy, or Mirbeau, could not be read in English, and other authors, such as Meier-Graefe, Duret, and Maurice Denis, had to wait much longer than Mauclair or Nordau before finding a wider audience.

It was not until 1908 that the heavy tomes of Julius Meier-Graefe's *Development of Modern Art* appeared in New York. Originally published in Germany in 1904, while Cézanne was still alive, they referred to the artist in the present tense, which the translators neglected to change. Meier-Graefe's ambitious and rambling enterprise covered all of European art from Goya to Bonnard. Crammed with interesting observations, vivid descriptions, and novel attempts to establish stylistic connections, it is also rife with a good deal of misinformation, due to a certain superficiality as well as the scarcity of reliable references. It is strange to read, for instance, that Cézanne, "since his sojourn with Dr. Gachet [at Auvers-sur-Oise in 1872–74] has never, as far as I know, left the South of France. He lives, I have heard, at Aix." It would seem that the author could have checked such simple facts with Vollard, with whom he had been acquainted for years.[25] (On the other hand, he did go to the trouble of writing to Gauguin in the South Seas while preparing this work; he may also have written to Cézanne without receiving any reply.)

Meier-Graefe's often bombastic style was not – nor in all probability could it be – helped by the translators. As a result, the relatively short chapter on Cézanne, though vibrant with lyrical admiration, is full of wordy, not to say obscure passages. Thus, one learns that, according to Gachet, Cézanne was "the exact antithesis of Van Gogh, utterly incapable of formulating his purposes, absolutely unconscious, a bundle of instincts, which he was anxious not to dissipate." To this the author added, "The result with him was a purely sensuous form of art. He gave what he could and what he would, not a fraction more, and in external things not even so much as this." This mysterious statement is followed by another, specifying that Cézanne, more than almost any artist, makes strong "demands on aesthetic receptivity" since we are, in addition to other factors, "astonished by something quite different, something enigmatic, that from a distance strikes us as positive insanity. There is enlargement, and we cannot rightly say what is enlarged." Frustrating though this may be, it is not helped by the discovery that Cézanne "is much quieter than Van Gogh afterwards was; his brushing is less vehement." Nor does such an "analysis" of Cézanne's execution offer any clarification, except that the reader is also told that, "like Manet, he breathed his own individuality into every technique, and made it significant."

Even Meier-Graefe's voluble summing-up fails to provide the reader with any concept of Cézanne's work (though there are a few helpful illustrations):

> The variety with which Cézanne applied his little brush-strokes sets all systems at defiance, and yet is systematic in the highest sense. The instinct that always guided him, gave to him in rich abundance, and we enjoy his pictures with a kind of physical instinct. He paints the warmth of his home, and we feel a flow as we look at his landscapes; he shows us the parched red earth, under which we divine the hard stone, burning with the accumulated fire of centuries. How grateful is the luxuriant vegetation beside this flaming sunshine, the green that overspreads the ground like cooling waters! The eternal heavens

THE ART OF PAUL CÉZANNE

By OTTILIE DE KOZMUTZA, PARIS

PAUL CEZANNE

"LANDSCAPE"
(Photo loaned by M. Vollard, Paris)

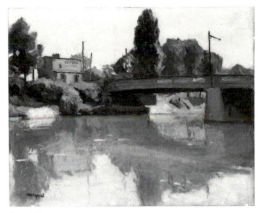

65 Albert Marquet *River Landscape*

PAUL CÉZANNE, a painter little known to the American art world, and scarce accepted even in his native France by the public at large, is nevertheless to the connoisseur, and to his fellow artists, a power not to be ignored.

He is a man very sincere and very simple, and he speaks or rather lisps in a voice so soft that it is often very difficult to understand his grave and significant language; but his art is solid, well composed, sane and just, and being deeply contemplative one cannot help being impressed with the ring of truth that is the keynote of all his canvases.

He works long over his pictures; laying one thin coat of paint over another until viewing the infinite gradations of color and values which all his work shows and which could only be the result of the most painstaking research.

The menta. attitude of the man is shown in the following incident. One day a young painter came to him seeking advice and Cézanne replied: "Go to the Louvre, but when you have viewed the masterpieces assembled there make haste to come away. This is important, for it vivifies in yourself when in contact with nature the instincts and sensations which reside in your heart."

This good counsel given to others, he was not loth to apply to himself, for the spirit which dictated the above is plainly trac-

64 Page from Burr-McIntosh Monthly, 1908, showing Cézanne article

sink down behind it, in all the tones of purest sapphire. The earth is but a puny interruption of this everlasting blue.[26]

It may not be altogether fair to excerpt such passages, since in the original version they do not sound quite as trivial or inept. Nevertheless, the prose is still torrential, the contradictions are there, and – above all – there is the essentially literary approach of the facile phrasemaker drunk with the sound of his words. Whereas in England one does find references to Meier-Graefe, notably from the pen of Roger Fry, American art literature is practically devoid of them. This probably was not so much because the author championed a still little-known painter (and constantly compared him to the equally unknown van Gogh), but rather because what he had to say was neither easily digested nor very convincing. To counteract the negative opinions expressed by a Mauclair, a Dewhurst, or a Nordau, something quite different, clearer, and more factual was needed.[27]

The year 1908 did witness the beginning of a mild activity on behalf of Cézanne in America. Yet, like Meier-Graefe's volumes, most of this activity originated abroad. In March 1908, the *Burr McIntosh Monthly* published a very short article on the artist by a correspondent in Paris with the unlikely name of Ottilie de Kozmutza. The most unexpected aspect of this otherwise insignificant piece is that it appeared

64

in a periodical that was primarily devoted to photography of the worst kind: full-page pictures of theater personalities, tinted in alluring pinks; idyllic scenes from faraway lands; and occasional studies on such subjects as "The Madonna in Art," accompanied by reproductions of works by Botticelli, Titian, Raphael, and Bouguereau. In the midst of such contributions, Ottilie de Kozmutza spoke of Cézanne in the present tense, as though he were still alive (which may have been copied from Meier-Graefe). "His art is solid, well composed, sane and just," she declared. But there was also a startling innovation: her article is illustrated by three paintings, doubtless the first works by Cézanne reproduced in an American periodical.[28] Unfortunately, one of the three photographs, precisely that which *64, 65* appeared at the head of the article, was not of a work by Cézanne, but a landscape by Albert Marquet.[29]

At the same time there appeared in the London *Burlington Magazine*, widely read among American art lovers, a rather pointed reply by Roger Fry to a recently published editorial:

> *66* There is no need for me to praise Cézanne – his position is already assured – but if one compares his still life [V.70] in the [current] international Exhibition with Monet's, I think it will be admitted that it marks a great advance in intellectual content. It leaves far less to the casual dictation of natural appearance. The relations of every tone and colour are deliberately chosen and stated in unmistakable terms. In the placing of objects, in the relation of one form to another, in the values of colour which indicate mass, and in the purely decorative elements of design, Cézanne's work seems to me to betray a finer, more scrupulous artistic sense.[30]

A few months later, in August 1908, the *New York Sun* published its third article on the painter which, like the previous ones, without a byline, was by Huneker. Despite the fact that its title was "Souvenirs of Cézanne," this article did not at all concern itself with whatever supposed recollections the author would later scrape together; as a matter of fact, Huneker still chose not to mention that he had "met" the artist at Aix in 1901 and at the Salon d'Automne of 1904, as he would subsequently announce. Instead, he offered his readers a condensed translation of Emile Bernard's "Souvenirs" (naming them as his source) which had appeared in the *Mercure de France* of October 1907. The explanation may be that Huneker was genuinely interested in Cézanne and that Bernard's text offered an engrossing subject during the dull and uneventful summer season.

As was to be expected, Huneker avoided discussing most of the artistic questions on which Bernard had dwelt, preferring to limit himself almost exclusively to the many anecdotes reported by him. But all the salient facts are there, from Bernard's 1904 journey by tramway to Aix (the same journey Huneker later claimed to have made) to Cézanne's uncontrolled outburst when Bernard accidentally touched him. There is Bernard's long report on how difficult it had been to find Cézanne's address in Aix, followed by descriptions of Cézanne's appearance, his solitary life, his suspicions, his religion, his relentless work, his lack of satisfaction with what he accomplished, his working methods, his frugal existence despite the fortune he had inherited, his destruction of many of his own canvases, his generosity to beggars, the children that ran after him in the street, in a word, a picture of Cézanne as harmless eccentric. There are also occasional mistranslations. The artist is supposed to have

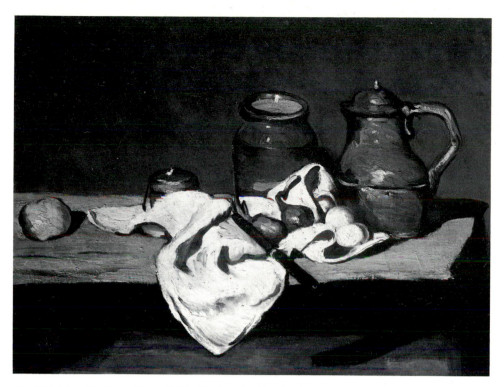

66 *Still Life with Green Jug and Tin Kettle* 1867–69 (V.70)

called his studio on the Lauves hill "Le Motif," so that when he said "let's go to the motif," he meant climbing up to his studio, whereas in reality he meant going out to paint from nature. But the most serious misunderstanding is the one that prompted Huneker to declare that Cézanne's father had been "first a barber, then a valet, finally a banker."[31] The origin of this statement is to be found in Bernard's report that Cézanne told him his father had been "un petit chapelier qui coiffait toute l'aristocratie d'Aix, il avait la confiance de tous, il se fit banquier et réalisa une rapide fortune, car il était honnête et le monde venait à lui." Correctly translated, this says that the artist's father had been "a modest hatter who made hats for the entire aristocracy of Aix, everybody trusted him, he turned to banking and rapidly amassed a fortune because he was honest." But Huneker's French was not good enough to help him understand that the hatter "qui *coiffait* toute l'aristocratie d'Aix" had not shaved, barbered, or otherwise groomed the nobles of Aix! And thus one of the most amazing myths was born.

Huneker concluded his article with a few observations of his own:

A painter by self-compulsion, a contemplative rather than a creative temperament, a fumbler and seeker, nevertheless Paul Cézanne has formed a school, has left a considerable body of work. His optic nerve was abnormal, he saw his planes leap or sink on his canvas; he often complained, but his patience and sincerity were undoubted. Like his friend Zola his genius – if genius there is in either man – was largely a matter of protracted labor. . . . It would prove a profitable and interesting experience if a representative exhibition could be given in New York City of Cézanne's paintings. Messrs. Durand-Ruel, who believed in him from the first, might be persuaded to draw upon their large collection for this purpose.

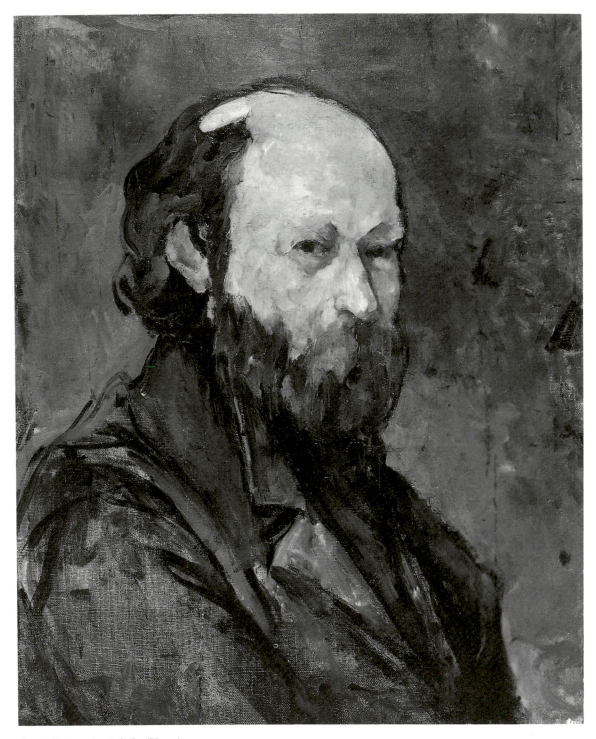

67 *Self-Portrait* 1878–80 (V.290)

Then, perhaps, the younger American artists who are just now called 'extravagant' might seem conventional by comparison with the eccentricities of Cézanne.[32]

It was of course not true that Durand-Ruel had believed in Cézanne "from the first," but this should not detract from the fact that Huneker, as early as 1908, suggested that a Cézanne exhibition be arranged in New York. There were also other indications of a rising interest in Cézanne in America. According to Walter Pach, Bryson Burroughs told him in 1908 that the Metropolitan Museum had been offered an opportunity to acquire an important self-portrait by Cézanne (V.290) for $2,000; *67* yet he felt it was "too modern" for the trustees, who would never consent to its purchase. Burroughs suggested, however, that if "Pach were to persuade someone to buy it and present it to the museum, the picture would be accepted." Pach thereupon convinced Benjamin Altman to become the donor. When he informed Burroughs of this arrangement, the latter almost burst into tears and exclaimed: "But the critics will say terrible things about it, the trustees will refuse to hang it, and Altman will be so angry that we will never get the Altman collection!" Faced with Burroughs's despair, Pach informed Altman that the whole thing had been a mistake.[33]

The following year, another opportunity for the Metropolitan Museum to purchase a Cézanne painting presented itself. Burroughs apparently had been in Paris and there had acquired from Vollard a rather secondary picture by Manet, *The Funeral.* Vollard took advantage of this transaction to offer Burroughs a fairly large painting by Cézanne – a still life or landscape, since it was a horizontal canvas. When he announced that the Manet had been shipped, Vollard returned to the subject: "I am sending you enclosed the photograph of the Cézanne. I told you that the size of the picture is 65 cm high [$25\frac{1}{2}$ inches], 81 cm wide [$31\frac{7}{8}$ inches]. The last price at which I can let the museum have it is *fifteen thousand francs*."[34] But nothing seems to have happened.

At the end of 1908, Walter Pach published in the December issue of *Scribner's* the first informed appreciation of Cézanne to appear in the United States. He spoke of the "wonderful retrospective" at the Salon d'Automne the previous year, he had read Bernard's writings, and he had done some research in Europe, discovering that Cézanne was then "by all odds the strongest of recent influences in continental painting, and practically an unknown name in America! . . . A German painter tells me that in many . . . a small city in his native land, there are more works by Cézanne to be seen than there are in the Luxembourg museum. . . . Within the last few years much writing about Cézanne has been done; and widely differing judgments of his works have been made. Nowadays, the trend is more and more insistently to eulogy." Pach also noted that since Vollard's first show "the prices of his works have mounted uninterruptedly until with the advent of an American multimillionaire, they soared almost hopelessly out of the reach of people, often of modest means, who were the first to buy his works." This obvious allusion to the recently deceased H. O. Havemeyer implied that he had been buying Cézanne paintings in considerable numbers, although the Germans – and a few Russians as well – had similarly contributed to the Cézanne "inflation."

"And what," Pach asked,

are the qualities of this work which at first seemed so absurd and later so fine? . . . Cézanne's greatness lies more in an intensely individual way of seeing nature than as an

expressor of abstract artistic concepts. In other terms, he falls in with the class headed by such men as Giotto and Rembrandt, who merged their aesthetic qualities inextricably with their particular viewing of the world. . . . Cézanne, interested in character, in form, and in color, from which he drew such a rare beauty, concerned himself little with realistic finish which the public of his time demanded, nor with the finesse and subtlety of line-drawing and the care as to accurate natural proportion which they had learned from Ingres to expect. But it is the fortunate, or rather the great artist, who knows how to choose what is important and hold to it even when he must give up the less important.[35]

Pach's article impressed another, somewhat older American painter, Arthur B. Davies, who subsequently befriended its author. Davies's only trip to Europe, fifteen years before, had not been oriented toward new tendencies, and his own romantic pictures did not betray a revolutionary spirit. If he was indebted to any nineteenth-century French artist, it was Puvis de Chavannes. Yet Davies had an exceptionally adventurous mind and an intellectual curiosity that were anything but conventional. Having gained admission to the Havemeyer collection, Davies was among the few American painters of consequence who had an opportunity to study the amazing array of French pictures hidden behind the fortresslike façade of 1 East 66th Street.

It had taken Mrs. Havemeyer some time after the death of her husband in 1907 before she once more regularly received guests. Eventually she even began to collect again, purchasing mostly Impressionist works. However, in 1909 she unaccountably disposed of two paintings by Cézanne, taking this decision at the urging of her friend and adviser, Mary Cassatt, who had grown less enthusiastic about Cézanne. Through Cassatt, Durand-Ruel received – on consignment from Mrs. Havemeyer –

IV
68
a Cézanne self-portrait that had been purchased from Vollard (V.289) and a river landscape (V.630). The transaction was not handled by Paul Durand-Ruel himself who, with advancing age, had begun to rely more heavily on his two sons, George and Joseph, especially for the affairs of the American branch. Of the two, George did not have the slightest appreciation for Cézanne, whereas his brother Joseph advocated that six of the unsold Cézannes from the Chocquet collection be kept in the family (together with prized Impressionist pictures) and actually hung some of them in his own home.[36]

Huneker saw the two "discarded" Havemeyer Cézannes in New York during the summer of 1909 and reported in the *New York Sun*:

It is a pity that before Joseph Durand-Ruel went to France he did not exhibit the two new Cézannes he recently purchased in this country; but both pictures soon followed him to Paris, where they will command a big price. In America no one cares for Cézanne, that is, cares to bid against French amateurs. Where these splendid examples came from we may only guess. M. Durand-Ruel did not divulge the name of the former owner. One of them is a famous self-portrait, a reproduction of which appears in Mauclair's book on Impressionism [the French edition]. It depicts the painter in a cap with a deep visor, a splash of white serving as a highlight; the face is painted in flat, big spots, the cheekbones salient, the eyes cavernous, the hair falling stringily and over the ears in the style described by Dickens as "Newgate knockers." Gallician Jews also wear the same sort of face curls. Not a prepossessing face; and George Luks, even in his most exuberant paint slinging, is a Bouguereau as to finish when compared to this Cézanne. Nevertheless it is an uncommon portrait. Viewed from afar it evokes life itself, a man looks at you across space with enigmatic eyes. Cézanne was not in love with his features. Indeed he was distinctly

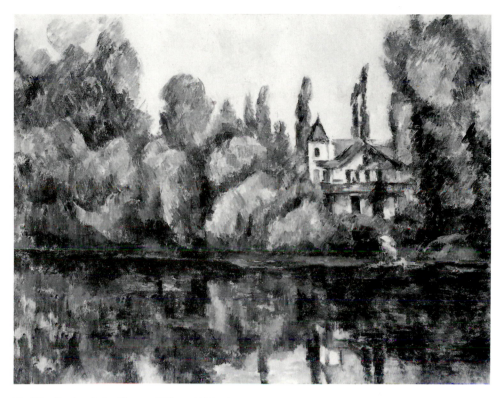

68 *The Banks of the Marne* 1888–90 (V.630)

unflattering, for in real life he was agreeable looking. We recall another self-portrait, once a storm center in Paris, which was a Shylock in a gaberdine, broad brimmed hat and patriarchal beard. The paint was laid on plaquewise. It was indescribably ugly, but vital and powerful. [Huneker refers here to V.366, which he had seen at the Salon d'Automne of 1904.]

The second of the Durand-Ruel pictures was a landscape, so harmonious of composition as to shock the eye of those who expect of the Aix artist fulminating color dissonances. A deep emerald is the general scheme, though there are various chords of this green that emerge as you study the work. Cool, somber, noble in sentiment, this is a canvas of which you could never tire. Again, it is a pity such Cézannes go to Europe. We might easily spare some of the "old masters" that are sure to visit America in hoards next season for two such modern masterpieces. And once they jeered at the humble Cézanne! Time may come (it has already come in Paris) when one Cézanne of quality will outclass half a dozen Barbizons.[37]

It seems extraordinary that Huneker, who certainly never had encouraged his fellow Americans to import any works by Cézanne, found such eloquent words and even spoke of "masterpieces" at the moment they were leaving this country. If Mrs. Havemeyer derived comfort from his prediction that these pictures would command "big prices" in Europe, she was soon to learn otherwise when George Durand-Ruel wrote to her from Paris:

We could not get more for them than $3,000 net for you. But that is a fairly high price; I do not believe that you could have sold them for more had you waited longer; it is even likely

that the prices for the works of this artist will not maintain themselves at the high level they have now reached. . . . In spite of the noise made around this artist, there are still only very few buyers for his pictures, especially when they are not of a very fine quality. Only in Germany and in Russia are they being paid the high prices which they now reach, prices which, incidentally, I do not understand.[38]

George Durand-Ruel was not only too pessimistic, he was also completely wrong (and even slightly insolent) when he implied that Mrs. Havemeyer's two paintings were "not of a very fine quality." Whereas Cézanne's early self-portrait was not exactly an "easy" picture, the landscape was a superb one, of which, incidentally, Charles Loeser owned a related version. The buyer of the paintings turned out to be the Russian Ivan Morosov, who paid $6,000 for the two, of which the Durand-Ruels kept exactly half as their commission.[39]

Later on, Mrs. Havemeyer was to regret bitterly having let these pictures go,[40] but it is not known whether she replaced them through new purchases. According to one account, she is supposed to have kept her Cézannes in upstairs maids' rooms, some even behind headboards, because her friends did not approve of these works. It is true that Cézanne's *The Abduction* (V.101) hung on the uppermost landing of a staircase that also led to the servants' quarters, a fact that may have caused some confusion. In the regal rooms on the main floor the "gilt-edged" Old Masters reigned, the collection being internationally famous for its unique group of Rembrandt portraits. A German museum director, who visited the Havemeyer collection sometime before 1910, later wrote that he noticed only two Cézannes, "Hanging in a rather dark hallway, so that one could see how little appreciated they were."[41]

It would seem fairly implausible that such a dedicated and in many ways adventurous collector as Louisine Havemeyer should have assembled a superb

16

69 *The Gulf of Marseilles Seen from l'Estaque c.* 1885 (V.429)

70 *Mont Sainte-Victoire with Viaduct, Seen from Bellevue* 1882–85 (V.452)

group of still lifes, landscapes, and portraits by Cézanne without displaying at least
some of them where they could be seen and enjoyed. It is, of course, possible that
various pictures were shifted around and that, for instance, some of the Cézannes
were hung downstairs only after the death of Mr. Havemeyer, whose taste was
considerably more conservative than that of his wife. Eventually, however,
Cézanne's paintings joined other acknowledged masterpieces in the Havemeyer's
main picture gallery. There, next to works by Veronese and Rubens, next to nudes
and landscapes by Courbet, next to the collection's single Renoir, and close to
paintings by El Greco, notably his *View of Toledo*, hung landscapes by Cézanne.[42]
These were obviously *The Gulf of Marseilles Seen from l'Estaque* (V.429) and *Mont* *69*
Sainte-Victoire with Viaduct (V.452), two of the artist's most majestic works. *70*
Nothing, incidentally, would have pleased Cézanne more than to find himself in the
company of Veronese, Rubens, Courbet, and El Greco; unwittingly, Mrs.
Havemeyer presented his pictures in a perfect context.

The disposal of two paintings by Cézanne through the Durand-Ruels left Mrs.
Havemeyer with a still remarkable and, in America, unmatched group of his works.
It is not known when Arthur B. Davies first visited her collection, but by 1911–12 he
was well enough acquainted with the hostess to bring Marsden Hartley along.[43] As
Hartley was soon to explain to Gertrude Stein, Davies "took me to Mrs.
Havemeyer's house to see her collection among which are nine Cézannes – very fine
over all – that was my first actual glimpse of him."[44] While there were altogether

eleven Cézannes, Hartley may not have seen all of them, though his report clearly indicates that the majority of the paintings were accessible to interested visitors. And because this was so, it can be said that thanks to the Havemeyer collection, a man like Davies, who had not seen any of Cézanne's canvases abroad, was more familiar with the artist's work than many an American painter who had been to Paris.

For five years after Davies and Pach had become acquainted through their common interest in Cézanne, they met more or less frequently. Davies was eager to learn about the important moderns in Paris, where Pach had lived, and also asked the latter to translate various magazine articles for him, Pach being fluent in French (as well as in German).[45] Thus, Pach's visit to the Salon d'Automne of 1907, which led to his admiration of Cézanne and prompted him to publish his 1908 article on the artist, brought him into contact with the already well-known Davies; the two of them would soon become involved in a surprising and grandiose enterprise.

NOTES

1. Cézanne to his son, Aix, Oct. 15, 1906; Paul Cézanne, *Correspondance* (Paris: Bernard Grasset, 1978), p. 332.

2. Cézanne to K.-X. Roussel, Aix, Feb. 22, 1906; unpublished document, courtesy Antoine Salomon, Paris.

3. Maurice Denis, diary entry of Dec. 1906; M. Denis, *Journal, Tome II (1905–1920)* (Paris: Editions du Vieux Colombier, 1957), p. 49.

4. Charles Loeser, unpublished diary entry [Paris], Feb. 13, 1909; courtesy Miss Philippa Calnan.

5. Charles Loeser, unpublished diary entry [Paris], Feb. 20, 1909; courtesy Miss Philippa Calnan.

6. [J.-L. Forain], "Peinture," *Le Fifre: Journal hebdomadaire illustré par J.-L. Forain*, May 11, 1889.

7. Roger Fry, *Metropolitan Museum of Art Bulletin*, I (1906), p. 59; quoted by W. H. Howe, *A History of the Metropolitan Museum of Art* (New York: Metropolitan Museum, 1946), vol. 2 [1905–1941], p. 58. Such acquisitions continued for another fifty years – at least in the form of gifts – since the Museum still added works by Béraud (1955), Chabas (1957), and Benjamin-Constant (1959) to its collections.

8. Anonymous, "A Great Art Collector Passes," *American Art News*, Dec. 4, 1907; reprinted in *The Art World*, ed. B. Diamonstein (New York: Art News Books, 1977), pp. 11–12.

9. In March 1907, the artist's son had sold 187 watercolors and 12 paintings to Vollard and the Bernheim-Jeunes for a total of 110,000 francs.

Shortly before, they had purchased from him a group of 17 canvases for 165,000 francs. See John Rewald, *Paul Cézanne: The Watercolors* (Boston: New York Graphic Society; London: Thames and Hudson, 1983), p. 39; for detailed information on the watercolor exhibition of 1907, see ibid., p. 469.

10. Dorothy Norman, *Alfred Stieglitz: An American Seer* (New York: Random House, 1960), pp. 104–5. Edward Steichen in his recollections, *A Life in Photography* (Garden City, N.Y.: Doubleday, 1963), [p. 67], says that they went to see an exhibition at the Bernheim-Jeune gallery in 1910. But since the 1910 show, held in Jan., was made up of 48 oils and only 20 watercolors, and since both Stieglitz and Steichen connect the visit with a summer trip to Europe, Stieglitz's recollection of their seeing the watercolor exhibition of 1907 must be the correct one.

11. Leo Stein, *Appreciation: Painting, Poetry and Prose* (New York: Crown, 1947), p. 174.

12. Max Weber, interview, 1959; transcript, vol. 1, pp. 229–30; Columbia University Oral History Project. This text was brought to my attention by John Cauman.

13. James G. Huneker to Charles J. Rosebault [New York], Dec. 25, 1907; *Letters of James Gibbons Huneker* (New York: Charles Scribner's Sons, 1922), p. 76.

14. See Walter Pach, *Queer Thing, Painting* (New York: Harper & Brothers, 1938), pp. 12, 14. The exhibition Pach had seen in Dresden was obviously the one held in Nov. 1904 at the Galerie Emil Richter; see above, Chapter II, note 7. The

identity of the picture by Cézanne cannot be ascertained.

15. Walter Pach to Alice Klauber [Paris], Nov. 16, 1907; Archives of American Art, Alice Klauber papers, No. 583, frame 557. This document was brought to my attention by Sandra Phillips.

Some French critics, too, complained that the works shown were mostly 'unfinished', one of them writing: "In order to satisfy that group of researchers gone astray, many rough drafts by Cézanne were assembled in a special room. Let us admit that the result was disastrous. Cézanne loses half of his renown. Those who, justifiably, praised his famous apples, the perfect clarity of their outlines, the solidity of their greens and reds, perceived, so to speak, as they fell from the tree, those who, for that reason, venerated the memory of that obstinate specialist, presently lament the ridicule which, as of now, tarnishes an honest notoriety. It is certain that the good Cézanne did not welcome any publicity for those ridiculous figures, drawn and painted in the least knowing fashion [doubtless an allusion to the large *Bathers* (V.719)]. One should, however, except the old peasant woman with a rosary [V.702]." Paul Adam, *Dix ans d'art français* (Paris: Albert Méricant, [ca. 1908]), p. 309. For another quote from this review, see below, Chapter VIII, note 41.

16. Pach, *Queer Thing, Painting*, p. 37.

17. Maurice Prendergast to Mrs. Oliver Williams, Paris, Oct. 10, 1907; correspondence between Mrs. O. Williams and M. Prendergast, Roll 917, frames 192–240, Archives of American Art.

18. James G. Huneker, *New York Sun*, Feb. 9, 1908.

19. Maurice Denis, "Cézanne," *L'Occident*, Sept. 1907 (subsequently translated by Roger Fry, *Burlington Magazine*, Jan. and Feb. 1910; see Chapter VI); reprinted in *Conversations avec Cézanne*, ed. P. M. Doran (Paris: Collection Macula, 1978), pp. 166–80.

20. Emile Bernard, "Souvenirs sur Paul Cézanne et lettres inédites," *Mercure de France*, Oct. 1 and 16, 1907; reprinted in *Conversations*, pp. 49–80.

21. Rainer Maria Rilke, letters to his wife, Paris, Oct. 21 and Oct. 9, 1907; Rilke, *Briefe aus den Jahren 1906 bis 1907* (Leipzig: Insel Verlag, 1930), no. 205, p. 402 and no. 191, p. 365.

22. Max Nordau, *On Art and Artists*, trans. W. F. Harvey (Philadelphia: George Jacobs [1907]).

23. George Bernard Shaw, commissioned by an American philosophical anarchist, wrote a spirited refutation of Nordau's principles under the title *The Sanity of Art: An Exposure of the Current Nonsense about Artists Being Degenerate*. However, Nordau had not touched on the question of Cézanne in his *Degeneration* volume, and Shaw did not discuss the artist either. On this subject and on Nordau's philosophy, see George L. Mosse's introduction to M. Nordau, *Degeneration* (New York: Howard Fertig, 1968); see also Kate Flint, ed., *Impressionists in England* (London: Routledge & Kegan Paul, 1984). Flint reports that the English translation of Nordau's *Degeneration* ran to four editions in the year of its appearance, 1895. As to Nordau's theories, she summed them up as follows: "Nordau's argument, based on the researches of the Italian, Caesar Lombroso, was to prove that degeneracy was not confined to 'criminals, prostitutes, anarchists and pronounced lunatics', indeed it was found also among authors and artists, particularly among those who in some quarters had been much revered as the creators of new art. Such madness, when exhibited through literature and art, is especially disturbing since, he argues, it is from these productions that an age derives its ideals of morality and beauty." (No. 44, pp. 127–38.)

24. Nordau, *On Art and Artists*, pp. 236–37.

25. According to Vollard's ledgers, Meier-Graefe had bought a Seurat drawing as early as Jan. 1896, followed by a Manet drawing in Dec., for 25 francs. He purchased a van Gogh drawing in Feb. 1899 for 150 francs, and a few months later paid 2,500 francs for a painting by him. But there is no record of any acquisition of works by Cézanne.

26. Julius Meier-Graefe, *The Development of Modern Art*, trans. Florence Simmons and George W. Chrystal (New York: Putnam's, 1908), vol. 1, pp. 266–70.

27. Two years later, in 1910, Meier-Graefe published in Munich a small, illustrated monograph of Cézanne, the first book devoted to the artist. On Jan. 25, 1911, Stieglitz's friend Marius de Zayas announced from Paris that he was sending him a copy of it, adding: "I wanted to read something of this man who has left so many followers, admirers and fanatics, and the only thing I found was this book in German, which hasn't even been translated into French." (This document, in the Stieglitz Archive, Beinecke Rare Book and Manuscript Library, Yale University, was brought to my attention by Francis M. Naumann.) Stieglitz spoke fluent German. Marsden Hartley and Charles Sheeler also came to know this book.

28. See Ottilie de Kozmutza, "The Art of Paul Cézanne," *Burr-McIntosh Monthly*, March 1908. This article was brought to my attention by Sandra Phillips.

29. The painting is recorded and illustrated as by Marquet – *River-landscape*, $19\frac{7}{8} \times 24\frac{3}{8}''$ – in the catalog of the Sotheby sale, London, April 2, 1981, no. 381.

30. Roger Fry, "To the Editor," *Burlington Magazine*, March 1908; see *Letters of Roger Fry*, ed. Denys Sutton (New York: Random House, 1972), vol. I, p. 300, no. 242.

31. Anonymous [James G. Huneker], "Souvenirs of Cézanne," *New York Sun*, Aug. 29, 1908; this article was brought to my attention by Professor Arnold T. Schwab.

32. Ibid.

33. Anonymous, "Walter Pach Hasn't Got Really Mad for 13 Years," *New York Post*, April 29, 1941; this article was brought to my attention by Sandra Phillips.

There does not seem to exist any possibility of substantiating this anecdote which was not published by Pach himself.

34. Ambroise Vollard to Bryson Burroughs, Paris, Feb. 25, 1910; unpublished document, archives of the Metropolitan Museum of Art, New York. The photograph mentioned by Vollard is no longer attached to this letter, making it impossible to identify the work, except that – being horizontal – it cannot have been the self-portrait referred to in the Pach anecdote mentioned above.

35. Walter Pach, "Cézanne – An Introduction," *Scribner's*, Dec. 1908, pp. 765–68. On Pach see S. S. Phillips, "The Art Criticism of Walter Pach," *The Art Bulletin*, March 1983, pp. 106–21.

36. These six were: *Le Mur d'enceinte* (V.158), *Vase de fleurs* (V.181), *Pommes et gateaux* (V.196), *Le Plat de pommes* (V.207), *Portrait de Victor Chocquet assis* (V.373), and *Le Verger* (V.442). Of these, V.158, 207, and 373 are now in American public or private collections; only V.181 and 196 remain in the Durand-Ruel family. Information courtesy the late Charles Durand-Ruel, Paris.

37. Anonymous [James G. Huneker], "Art Notes," *New York Sun*, June 11, 1909.

38. Georges Durand-Ruel to Mrs. H. O. Havemeyer [Paris], Aug. 20, 1909. Durand-Ruel archives, Paris, courtesy the late Charles Durand-Ruel, Paris. On Aug. 31, Mrs. Havemeyer replied: "I have just received the check for $3,000 and thank you for having sold my pictures so well." (Durand-Ruel archives.)

39. According to Morosov's records, he paid 12,500 francs for the *Self-Portrait* (V.289) and 18,000 francs for *The Banks of the Marne River* (V.630), a total of 30,000 francs equivalent to $6,000; see Anna Barskaya, *Paul Cézanne* (Leningrad: Aurora Art Publishers, 1975), pp. 165, 175.

40. Many years later, Mrs. Havemeyer was to write that at the urging of a dealer, whom she didn't name, "I sold . . . three of my best Cézannes, for which he paid me only $3,000." But she erred as to the number of paintings, since she sold only two, and it seems extremely unlikely that she was "urged" to do so by the Durand-Ruels; see Louisine W. Havemeyer, *Sixteen to Sixty: Memoirs of a Collector* (New York: Privately printed, 1961), p. 8. Three years later, on the occasion of the Rouart sale in Paris, Mary Cassatt *did* urge her to sell some Cézannes to raise money for a coveted picture by Degas (see Chapter VII), but Mrs. Havemeyer declined to do so.

41. Emil Waldmann, *Sammler und ihresgleichen* (Berlin: Bruno Cassirer, 1920), p. 147. This book was composed of articles published during the previous decade. The author had been in the United States before World War I; an article by him, "Französische Bilder in amerikanischem Privatbesitz," had appeared in *Kunst und Künstler* in 1911.

42. I am greatly indebted to Mr. George C. Frelinghuysen, Honolulu, Hawaii, grandson of Mrs. Havemeyer, for sharing with me his recollections as to where *The Abduction* and other paintings by Cézanne were hanging in her house during the twenties.

43. According to William I. Homer, *Alfred Stieglitz and the American Avant-Garde* (Boston: New York Graphic Society, 1977), p. 154, the visit of Davies and Hartley to the Havemeyer collection took place "late in 1911 or early in 1912."

44. Marsden Hartley to Gertrude Stein, Berlin, Oct. 1913; *The Flowers of Friendship: Letters Written to Gertrude Stein*, ed. Donald Gallup (New York: Alfred A. Knopf, 1953), p. 85. Hartley was almost right when he spoke of nine paintings by Cézanne in the Havemeyer collection; there were actually eleven: *The Abduction* (V.101); *Portrait of Gustave Boyer with Straw Hat* (V.131); *Flowers in a Glass Vase* (V.184); *Still Life with a Green Jar and a White Cup* (V.213); *The Gulf of Marseilles, Seen from l'Estaque* (V.429); *Mont Sainte-Victoire* (V.452); *Still Life with a Ginger Jar and Eggplants* (V.597); *Rocks at Fontainebleau* (V.673); there was also an Auvers landscape, a flower piece, and a vase of flowers (these last three not recorded by Venturi).

45. See Walter Pach, "A Recollection of Arthur B. Davies," *A. B. Davies Exhibition*, exhibition catalog, Whitney Museum of American Art, New York, 1962–63, p. 5.

VI · Polemics
Cézanne's First Show in
New York

It is one of the indescribable attractions of history that it presents no isolated facts. There are sometimes obvious, but more often invisible threads that link events. To pursue them and to relate them to one another means to reestablish the logic and continuity that lie beneath all the data which constitute the past. When the threads are placed in proper context, and are woven together once more, the texture of the fabric reveals a fascinating view of bygone days. After a dormant phase, the discrete thread that spun from Cézanne to Pach to Arthur B. Davies was to emerge again; but that moment had not yet arrived.

The time seemed ripe, however, for introducing Cézanne to America through his own production. While no detailed records are available, it would appear – so far as can be deduced from the few known facts – that Steichen approached Vollard on behalf of his friend Alfred Stieglitz who was anxious (or whom Steichen had persuaded) to show Cézanne's work at his small Photo-Secession Gallery at 291 Fifth Avenue in New York.

71

In many ways Stieglitz must have resembled Leo Stein, since he, too, was a compulsive explainer, although he probably appeared warmer, less cerebral, and more confident of his own judgment. Steichen later remembered that Stieglitz was in his gallery from ten o'clock in the morning until six or seven at night. "He was always there, talking, talking, talking; talking in parables, arguing, explaining. He was a philosopher, a preacher, a teacher, and a father-confessor."[1]

From the beginning of his commercial venture, which he combined with his pioneering efforts as a photographer, Stieglitz had gone his own way. Being financially independent, he was able to single out artists in whom he believed and introduce them to a small circle of friends and followers, a circle subjugated by his apostolic disposition. As Marsden Hartley once put it, the 291 gallery "did a work that was never done before, and one that is not likely to be done again, for the same degree of integrity and faith in one person will not be readily found."[2]

Among the many artists sponsored by Stieglitz, Cézanne may not have been so much his discovery as he was that of Steichen, who was soon to be described by a critic as "the first American painter who, comprehending the example of Cézanne, has been able to fit it to his own personality."[3] But Vollard seems to have been less impressed by the enthusiasm of Stieglitz's envoy than he was by the young American's apparent lack of cash. He therefore decided to try their mercantile potential with three lithographs.

In Paris, the year 1910 had begun with another large Cézanne retrospective at Bernheim-Jeune's, whose public activity on behalf of the artist by now far outstripped that of Vollard. Their show comprised forty-eight paintings and twenty watercolors. Among the lenders were a few dealers, a number of private collectors, and several artists (not only Monet, but also such younger men as Matisse, Bonnard, Signac, and Vuillard), as well as several American collectors: Egisto Fabbri, then *XI* residing in Paris, with eight oils – among them a portrait of Madame Cézanne which Rilke had particularly admired at the 1907 Salon d'Automne (V.229); Michael and Leo Stein, with one painting each; and Mrs. Montgomery Sears with her small vase *10, 7* of flowers and a large still life (V.606) that Mary Cassatt had once acquired for 100 francs and had just sold for 8,000 ($1,600).

In June, even Vollard shook off his customary lethargy long enough to open an exhibition of twenty-four portraits and figure paintings by Cézanne which, however, he did not advertise and for which he issued merely a single-page catalogue. If nothing else, this show offered an opportunity to the many timid souls (among them quite a few Americans) who did not dare cross the threshold of the formidable lair. Provided they found out about this rare occasion, they could now go and visit an exhibition that contained a number of rather important works. Yet none of the Americans then living in Paris ever alluded to this event, nor were there any reviews in the press, except for a note by Guillaume Apollinaire who announced that although the show was supposed to close by the end of July, it was still hanging in September.[4] (It was eventually succeeded by a Picasso exhibition for which Vollard did not even bother with issuing a checklist.)

Earlier that same year in New York, James Huneker had published a volume of art studies titled *Promenades of an Impressionist*. It was by no means a book on Impressionism and it actually devoted only one of fifteen chapters to that movement, or rather to Monet, Renoir, and Manet, although there was also a chapter on Degas. The majority of chapters concerned Botticelli, Chardin, Watteau, Velázquez, El Greco, and others. As the author specified in a "Coda": "The foregoing memoranda are frankly in the key of impressionism. They are a record of some personal preferences, not attempts at critical revaluations."[5] Obviously, the word *Impressionism* by then was considered to be rather fetching for the title of a book (the following year Lafcadio Hearn published his *Leaves from the Diary of an Impressionist*).[6]

Since Huneker's volume was a collection of writings that had first appeared in the *New York Sun*, it was not surprising that it should have opened with a study of Cézanne, for which the author used both his review of the 1904 Salon d'Automne and his Cézanne obituary of 1906, augmented by elements from his 1908 condensation of Bernard's "Souvenirs." Huneker skillfully combined these pieces, adding some fresh material and deleting some of his favorite observations, such as his olfactory distinction between Cézanne's onions that "smell" and Chardin's that don't. On the other hand, he repeated once more that the painter had been an artist without vision, culture, or intellect. At the same time he used generous excerpts from a December 1908 article by Bernard on *père* Tanguy, though it was only indirectly concerned with the painter. Among the new passages was one in which Huneker stated that Durand-Ruel had informed him "that a fine Cézanne to-day is a difficult

71 Edward Steichen *Alfred Stieglitz at "291"* 1915

fish to hook. The great public won't have him, and the amateurs who adore him jealously hold on to their prizes."[7] Just the same, Huneker announced: "Whether for good or evil, Cézanne's influence on the younger men in Paris has been powerful, though it is now on the wane."[8]

Huneker's article contained a number of biographical data, quite a few of which were inaccurate. This is especially surprising since Huneker knew of Duret's 1906 book on the Impressionists and its chapter on Cézanne which – though somewhat uninspired – provided a good deal of reliable information on the painter. In 1910, an English translation of this volume appeared in London and Philadelphia, attracting many Americans because it treated not only Cézanne, but also the other artists with more simplicity and warmth than Mauclair had done. Huneker, nevertheless, again repeated his assertion that Cézanne's father, "before becoming a banker, had been a hairdresser, and his son was proud of the fact."[9]

At the very moment at which Huneker's book was published, a show entitled "Younger American Painters," organized by Stieglitz, once more unexpectedly drew attention to Cézanne. Among the artists included were Hartley, Marin, Maurer, Steichen, and Weber, whose works prompted Guy Pène du Bois, a painter and journalist who also had been in Paris, to state in his review that there were "'followers of Matisse' among the young men who exhibit . . . at the Photo-Secession Gallery." But while he considered Matisse to be the "father" of the group, he wondered whether the "children" had not "gone over his head to Cézanne and appreciated in the work of the 'grandfather' his theories – much that the mind of the father has failed to grasp." He concluded his article with the exclamation: "We need here a comprehensive exhibition of the work of Matisse, and, better still, Cézanne. What an opportunity for the Metropolitan Museum of Art!"[10]

In Paris that same year (1910) there appeared a study on Cézanne by the French philosopher-historian Elie Faure, which made a deep impression on Walter Pach. He subsequently was to bring it to the attention of Arthur B. Davies and to translate it into English. Except for Denis's essay, it was probably more articulate and original than anything on the artist that had appeared before. Pach was particularly struck by a passage that he was often to quote: "Men do not draw well or ill, any more than they write well or ill. In drawing or in writing, one says something or one says nothing, one repeats without emotion the words over which others trembled with ardor as they pronounced them, or one goes forth to seek from the mingled form and spirit of things which are strong to the extent that they tally with the unknown sources opened up every day in adventurous brains by the incessant evolution of the world."[11] The few Americans who had as yet "experienced" Cézanne were indeed stirred by the new character of his work.

Toward the end of 1910, Stieglitz opened an exhibition of drawings by Rodin, lithographs by Manet, Renoir, Lautrec, and Cézanne, as well as some small paintings and drawings by the *douanier* Rousseau – lent by Max Weber – which most startled the reviewers. Having been gripped "once and forever" by Cézanne's works at the Salon d'Automne, Weber had purchased a dozen or so photographs of Cézanne's paintings before leaving for New York, which he knew to be still "a pretty barren place." The photographs were to be a kind of "buttress" for him, and they probably constituted the first Cézanne reproductions brought to America.[12] Upon his return from France, Weber had become an intimate of Stieglitz, and he gladly showed the photographs to his friends; they were even included in Stieglitz's exhibition. Weber now joined the few artists who could speak of Cézanne with the glow of experience. Abraham Walkowitz, who had returned to the States in 1908, did likewise.

Another American painter who frequently invoked what he had seen abroad was Andrew Dasburg. In the fall of 1910, he had come back from Europe "inflamed like a newly converted evangelist," as he later put it. "I talked endlessly about what I had seen and found a good many sympathetic listeners."[13] Dasburg's enthusiasm, Walkowitz's reports, and Weber's photographs and explanations are likely to have been more impressive than the lithographs by Cézanne in Stieglitz's show.

Stieglitz does not seem to have published any catalogue for his first group exhibition of European artists, but he did issue a short text on Rousseau, who had just died. The press took little notice of Cézanne's prints, although the *American Art News* called his lithographs "strong and typical," which was strange praise, since these were the most atypical of his works. Indeed, Cézanne executed a total of three lithographs, doing so at Vollard's urging, and it is more than doubtful that he himself touched the stones. But such was the "mystique" of Cézanne's name by then that the reviewer felt he had to comment on these works; for want of anything better to say and in the absence of any comparative material, he called them "typical." The *New York Times* ventured to predict that "none of the younger painters can very certainly be heralded as a master of the art of the future," yet in the same breath estimated, concerning the "more revolutionary Cézanne," that his "vast primitive talent seems to promise a fame even more enduring than that of the others."[14]

As a matter of fact, the climate was changing at that moment with the first great

Post-Impressionist exhibition, which had opened at the Grafton galleries in London in November 1910. Organized by Roger Fry, assisted by Clive Bell, it aimed at presenting to the British public not merely contemporary French art, but, above all, its major sources. For that purpose they began their survey with the last "old-masterly" as well as the first modern painter of the nineteenth century, Edouard Manet. From him, without wasting any time on the Impressionists, they proceeded directly to Cézanne, van Gogh, and Gauguin, the three immediate precursors of modern art, who were still almost unknown in England.

As explained in an unsigned preface to the catalogue,[15] "The Impressionists were artists, and their imitations of appearances were modified, consciously and unconsciously, in the direction of unity and harmony; of course, as artists, they selected and arranged. But the receptive, passive attitude towards the appearances of things often hindered them from rendering their real significance." The next generation was bent on exploring and expressing the emotional significance that lies in things, with the result that those

> who felt most the restraints which the Impressionist attitude towards nature imposed upon them, naturally looked to the mysterious and isolated figure of Cézanne as their deliverer. Cézanne himself had come in contact with Manet and his art is derived directly from him. . . . Cézanne, however, seized upon precisely that side of Manet and his followers, which Monet and the other Impressionists ignored. Cézanne, when rendering the novel aspect of nature to which Impressionism was drawing attention, aimed first at a design which should produce the coherent, architectural effect of the masterpieces of primitive art. Because Cézanne thus showed how it was possible to pass from the complexity of the appearance of things to the geometrical simplicity which design demands, his art has appealed enormously to later designers. They recognize in him a guide capable of leading them out of the *cul de sac* into which naturalism has led them. Cézanne himself did not use consciously his new-found method of expression to convey ideas and emotions. He appealed first and foremost to the eye, and to the eye alone.[16]

After discussing Cézanne, the introduction touched on the contributions of van Gogh, Gauguin, and Matisse. To further underline these prefatory thoughts, the exhibition itself began with an octagonal hall devoted exclusively to the works of Manet and Cézanne, while in an adjoining large gallery a great number of paintings by Gauguin were hung, surrounded by more Cézannes next to canvases by van Gogh, Seurat, Signac, Cross, and a vertical picture of a nude girl by Picasso, lent by Leo Stein. In two other galleries were additional Gauguins and van Goghs; Matisse was represented by only two paintings; there was a second canvas by Picasso, a single flower piece by Redon, and various works by Denis, Sérusier, Marquet, Vlaminck, Derain, Rouault, and other younger men.

The twenty-one paintings by Cézanne were lent mostly by dealers such as Vollard (with eleven loans), Druet, Bernheim-Jeune, Durand-Ruel, and even Cassirer of Berlin. Among these were a portrait of the artist's wife (V.229) and a somber and *XI* emphatic canvas of almost dramatic intensity although at the same time astonishingly simple, an old woman with a rosary (V.702). Van Gogh was *X, 102* represented by an equal number of paintings, whereas Gauguin was allotted a considerably larger share. The Steins did not lend any of their Cézannes but, in addition to their Picasso, apparently also lent a Matisse, and Berenson sent to

London a small Matisse landscape he owned which, however, is listed only in the second, revised edition of the catalogue.[17]

In view of their close relationship, one may wonder whether Berenson and Fry ever discussed Cézanne, whether Fry – he too being first of all a student of the Renaissance – ever questioned his colleague about his early reference to the artist in his *Central Italian Painters* of 1897, and whether Berenson ever directed Fry to Loeser's collection, as he had done Leo Stein. From the few facts that are known, this seems extremely unlikely. For one, Berenson was still not on speaking terms with Loeser, whom he had obviously mentioned to Stein only because of the latter's enthusiasm for Cézanne. Moreover, as Berenson's friendship for Fry began to cool in 1903,[18] that is, before Fry evinced any interest in Cézanne, the painter's name probably did not come up in conversations between the two men.

The strange atmosphere of suspicion, intellectual snobbery, bruised scholarship, and stubborn grudges that engulfed the small Anglo-American colony of Florence and its surroundings did not present the proper conditions for Cézanne's renown to spread. Fry, for instance, accused one of the peripheral members of that colony of speaking about art "as though connoisseurship were a game of billiards,"[19] and he himself became something of a pawn in these internecine quarrels when "Loeser & Co.," as he put it, attacked his book on Bellini, thinking that by so doing they were dealing a blow to Berenson.[20] Indeed, Loeser continued for many years to harbor an exasperated bitterness against Berenson.[21] Whether Fry was able to enter into Loeser's good graces after he had been dropped from Berenson's is rather unlikely; in any case Fry never mentioned either Berenson or Loeser as having helped him to discover Cézanne.[22]

It would seem that Roger Fry's "conversion" to Cézanne occurred rather suddenly in 1906. In January 1905, in connection with a large Impressionist exhibition organized by Durand-Ruel in London, he had still written that he found it impossible to have "so high an opinion" of Cézanne as he had of Boudin; he had even implied that Cézanne was a second-rate artist.

The Durand-Ruel show had included no fewer than ten paintings by Cézanne, all from the Chocquet collection and most of them representative of the tight execution of the late seventies that Chocquet apparently favored, although among them were a landscape and a flower piece painted around 1890 in a quite different style.[23] Fry did consider two of the five still lifes (without specifying which) to be "comparative successes," except that the mere memory of Fantin-Latour prevented him, as he said, from truly appreciating them.[24]

But exactly one year later, two other pictures by Cézanne in a London exhibition caused him to change his mind and to say so in print.[25] Fry's praise, as he later admitted, still sounded "grudging and feeble," but at least it indicated that he was "ready to scrap a long cherished hypothesis in face of a new experience."[26] Indeed, his highly perceptive comments on the two pictures were followed by a rather lukewarm conclusion. "We confess," he wrote, "to having been hitherto sceptical about Cézanne's genius, but these two pieces reveal a power which is entirely distinct and personal, and though the artist's appeal is limited, and touches none of the finer issues of the imaginative life, it is nonetheless complete."[27]

Fry was not alone in being "sceptical about Cézanne's genius," yet once he began

studying his work, his admiration for the French master steadily increased. Many years later he was to provide a somewhat indirect explanation for this change of attitude – a change that affected Fry as both art historian and painter – when he said that in those days he had "maintained that impressionism had made artists so insensitive to constuctive design that perhaps the world would have to wait a century or two before it would once more apply the great principles of painting as they were exemplified in the great works of the sixteenth and seventeenth centuries."[28] With the revelation of Cézanne, Fry at once realized that there was no need to wait a century or two, because here was a contemporary artist profoundly concerned with "constructive design." Since neither Berenson's knowledge nor Loeser's collection seems to have contributed to the evolution of Fry's perception, or to have prepared him for an eventual understanding of Cézanne, this can only mean that Fry found his way unaided.[29] His sole guide had been the supreme logic of his own sensitivity. Yet once he had determined that Cézanne was actually the cornerstone of all modern art, his conviction became infectious. The organization of the Grafton show of 1910 was simply one of the many activities through which Fry promulgated his newly formulated beliefs.

As an "introduction" to that exhibition, where Cézanne's works were for the first time shown in significant numbers outside France (he had previously been seen on a more modest scale in Berlin, Dresden, Vienna, and Brussels), Fry translated Denis's article on the artist for the *Burlington Magazine*,[30] thus making it accessible also to American readers. Indeed, the *New York Times* immediately drew attention to it by announcing:

> The current number of the Burlington Magazine contains among other interesting features a very valuable article upon the art of Cézanne by Maurice Denis, with an introduction by Roger Fry. Cézanne's influence is seen in so much of the modern French art that an intelligent discussion of the principles and characteristics of his painting ought to prove helpful to the American connoisseur in his efforts to grasp the intention of much of the Franco-American as well as much of the purely French art that is reaching America. It ought also to help them to discriminate between Cézanne's authoritative and structural use of color and the imitative work done by inferior painters who have learned his methods without assimilating his art.[31]

In publishing Denis's study, Fry may have felt that a text "imported from the continent" would sound more detached and therefore stand a better chance of persuading. But that was not how the British critic D. S. MacColl saw it when he mentioned that "in the chaste pages of the *Burlington Magazine* . . . there appeared, with Mr. Fry's editorial blessing, a startling rhapsody on Cézanne. Its author affirmed a faith already orthodox in Germany, where the enthusiastic Meier-Graefe leads the song. The Germans, so enviably endowed for music, for science, and for business, are eager for all the arts. Denied almost entirely an instinct for the art of painting, they study it, they "encourage" it, egg it on, adore, and even buy."[32]

It is fortunate that MacColl apparently was not aware of the fact that some Americans also had succumbed to such a reprehensible eagerness. Since they could not pretend to be "admirably endowed" for music or for science, he may only have granted them a sense for business, which obviously would have made their activity of collecting works by Cézanne even more suspect. And it is easy to imagine how those

Americans with a true flair for business, who had successfully eliminated Fry from the Metropolitan Museum, must have felt upon reading of his newest capers back in London.

Not to be outdone, the devilishly clever, irreverent, and occasionally downright nasty British painter Walter Sickert now remarked maliciously: "I notice that when an English writer is faced with a question about Cézanne, he waves the enquirer gracefully forwards to another department, and begs Monsieur Maurice Denis to serve the gentlemen. Mr. Fry, even, called upon for explanations, clears his throat and – translates Maurice Denis – admirably, I need not say, quite admirably."[33]

As Fry's subsequent studies on Cézanne were to demonstrate, this was certainly not true. Even in this instance, Fry had prefaced his translation with a short statement destined to explain Cézanne's historic position:

> Anyone who has had the opportunity of observing modern French art cannot fail to be struck by the new tendencies that have become manifest in the last few years. A new ambition, a new conception of the purpose and methods of painting, are gradually emerging; a new hope too, and a new courage to attempt in painting that direct expression of imagined status of consciousness which has for long been relegated to music and poetry. This new concept of art, in which the decorative elements preponderate at the expense of the representative, is not the outcome of any conscious archaistic endeavour. . . . It has in it . . . the promise of a larger and fuller life. It is, I believe, the direct outcome of the Impressionist movement . . . and yet it implies the direct contrary of the Impressionist conception of art.
>
> It is generally admitted that the great and original genius – for recent criticism has the courage to acclaim him as such – who really started this movement, the most promising and fruitful of modern times, was Cézanne.[34]

The article was accompanied by a few illustrations for which figure pieces had been selected rather than the better-known landscapes and still lifes. Among these reproductions were *Woman with a Rosary* (V.702) and *Young Man with a White Scarf* (V.374), the latter belonging to Fabbri.[35] John Sloan saw the January and February 1910 issues of the periodical at the New York Public Library and on May 25, 1910, noted in his diary: "I looked at a few numbers of the *Burlington Magazine*. Was much interested in the work of Cézanne, some of which was reproduced. A big man this, his fame is to grow."[36]

Echoes of the controversial Grafton exhibition, which had been previewed in these articles, were of course reaching America, where Cézanne himself continued to be represented only in a minor key. The *American Art News* published a letter from its London correspondent dated November 9, 1910 (that is, one day after the show opened), announcing: "At last we have a real art sensation. The miracle has happened, and for the moment everybody is talking about modern paintings."[37] The author mentioned that there were thirty paintings by Cézanne as well as works by Gauguin, van Gogh, and Matisse, the last three "practically unknown to the London public," that huge posters with a striking Tahitian picture by Gauguin were to be found even in subway stations, and that the English critics had actually started taking sides before the opening of the exhibition. That was the extent of the report, even though Fry's extraordinary show – the first to assemble works from Manet to the present and the occasion when the word *Post-Impressionism* was coined – offering

a panorama of the different artistic trends of the past thirty years, was a truly pioneering undertaking. Nothing like it had ever been attempted, either outside France or indeed in France itself.[38]

As was to be expected, the response to the event was extremely mixed, from indignant outcries and accusations of *fumisterie* to great enthusiasm, especially among young artists. Many of the antagonistic critics, such as D. S. MacColl, belonged to the by-then international variety that professed admiration for Manet, Degas, or Renoir the better to denounce Cézanne's "awkwardness" and "limitations." Camille Mauclair had done this before, and so had Huneker, except that the latter had managed to appreciate Cézanne's still lifes, whereas MacColl conceded some merit only to his landscapes.

C. J. Holmes, a painter who was then director of the National Portrait Gallery in London (and was soon to direct the National Gallery itself), insisted – as many had done and more were yet to do – on Cézanne's "sincerity", as though this were a particular virtue that might conceivably explain or excuse the so-called shortcomings which Holmes simultaneously denounced. Nobody ever seemed to wonder whether sincerity could save a picture from being a daub, or whether a masterpiece could be anything but sincere. In the early days of Impressionism, when the painters had been accused of pulling the public's leg, there had been some need for pointing to their seriousness and sincerity, but now that Monet's or Renoir's sincerity was no longer questioned, why should it still have been an issue in the case of Cézanne?

Summing up what he thought of Cézanne, Holmes stated: "Wherever he seeks to render delicacy, the coarse handling of his [impressionist] school is accentuated by consistent personal clumsiness of touch. This clumsiness is not relieved by any supreme intellectual power; indeed, Cézanne frequently fails in grouping his matter into a coherent design – sometimes in expressing his intentions not [sic] at all. Nevertheless, he was a genuine artist."[39]

Reviewing one by one the pictures in the Grafton show, Holmes graded them as if they were the papers of school children. For one of Cézanne's paintings his only comment was: "Unfortunate," and of the *Woman with a Rosary* he wrote: "A failure. If the intensity of vision and the technical science of a Rembrandt are needed to make a great picture from such a subject, any well trained art student could make a good study from it. Cézanne's ill-success proves, if any proof were needed, that his heaviness of hand was due to sheer want of competence."[40]

A brilliant contrast to such narrow views and possibly even a psychological explanation of them is provided by what was one of the most perceptive analyses of the significance of the Grafton show. It was jotted down by the painter Vanessa Bell, wife of Clive Bell and soon to become an intimate friend of Roger Fry, in other words, by an artist close to the two men who had been most involved in this historic event.

> It is impossible, I think, that any other single exhibition can ever have had as much effect as did that on the rising generation. . . . Here was a sudden pointing to a possible path, a sudden liberation and encouragement to feel for oneself which were absolutely overwhelming. Perhaps no one but a painter can understand it and perhaps no one but a painter of a certain age. But it was as if one might say things one had always felt instead of

trying to say things that other people told one to feel. Freedom was given one to be oneself and that to the young is the most exciting thing that can happen. Even the elderly caught the spirit. Sometimes one or two old painters who had plodded patiently all their lives painting as they understood they should paint, threw their petticoats, should one say, over the windmill and became comparatively honest and sensitive. Of course many did foolish things... but that does not matter. The important thing, how important one cannot know, is that one or two perhaps who might, like the old brigade, have said their say by the age of 35 may, owing to that influx of new life and all that followed, find as did Rembrandt, Titian and Cézanne new things to say, fresh feelings to express as long as they lived. Such surely should be the fate of the artist. But in England at least he needed rescue in the early years of this century.[41]

It was of course comparatively easy to dismiss the resistance of the old guard as a sign of ossification (which it was) and as an expression of outdated ideas, completely lacking touch with new art currents (which also was the case). But it was much more

72 difficult to brush aside Walter Sickert's wickedly ingenious comments that – on the surface – seemed inspired by a genuine appreciation of Cézanne, until the reader noticed how Vollard, though not named, was accused of clever speculations (of which Mauclair had already spoken), that there were hints of venal critics (meant for Fry?), mention of works finished by other hands to insure better salability, and how, in the end, Cézanne was declared a failure. It was a curious performance in which praise was used as a "build-up" before everything was mercilessly torn down.

Sickert started out by stating innocently enough:

Cézanne was fated, as his passion was immense, to be immensely neglected, immensely misunderstood, and now, I think, immensely overrated. Two causes, I suspect, have been at work in the reputation his work now enjoys. I mean two causes, after all acknowledgement has been made of a certain greatness in his talent. The moral weight of his single-hearted and unceasing effort, of his sublime love for his art, has made itself felt. In some mysterious way, indeed, this gigantic sincerity impresses and holds even those who have not the slightest knowledge of what were his qualities, of what he was driving at, of what he achieved, or of where he failed.

Then we must remember that, if dealers cannot easily impose on the world as fine work, work which has not some qualities, dealers, and those critics who directly or indirectly depend on them, can to a great extent hold back or unleash a boom to suit themselves. In Cézanne that were all the conditions most ideal for the practice of great "*opérations*", as they are called in Paris by the able "brewers of affairs" who control the winds from their caves full of paintings.... And if, of two unhappy apples standing by a shaky saucer, one is without a blue authenticating contour, would it be a very great crime to employ a talented youth to surround it – oh! for Germany or America? *C'est si loin, tous ces pays-là.* ...

History must needs describe Cézanne as *un grand raté*, an incomplete giant. But nothing can prevent his masterpieces from taking rank. ... It is useful that we should see the hundred failures on which is built the hundred and first success.[42]

Sickert was not the only one who piously endeavored to "protect" Cézanne from his admirers; Huneker had already tried to rescue the painter from those who saw in him a *chef d'école*. But it was not without irony that he should now establish for Cézanne the ratio of one hundred failures for every success. If his total output was about a thousand paintings, plus an unknown number of destroyed canvases, his

72 Walter Sickert *Self-Portrait* 1897

masterpieces would number roughly a dozen. One wonders whether Sickert would willingly have accepted such a proportion for his own production.

Undaunted by the controversies, Fry, at the end of the Grafton exhibition, stated his conviction that "without any reminiscences of the classic tradition of France, Cézanne is, in fact, one of the most intensely and profoundly classic artists that even France has produced, and by classic I mean here the power of finding in things themselves the actual material of poetry and the fullest gratification for the demands of the imagination."[43]

It is indicative of the interest with which some Americans followed the events on the European art scene that excerpts from Fry's article appeared the very next month in the *Brooklyn Daily Eagle*.[44] Nevertheless, the hubbub surrounding Fry's Post-Impressionist show in London does not appear to have caused much of a stir in the United States. [45] It is the more noteworthy, therefore, that an Irish-American lawyer, John Quinn, a power in finance and public affairs who was embarking on an incredibly acquisitive career that began with an interest in Irish literature and art, should have collected reports on the London exhibition. Early in 1911 he wrote from New York to his British friend Augustus John: "All the artists here are grumbling. The dealers seem to be over-stocked and the two or three . . . who are interested in modern work don't seem to make much of a go of it and some of the poor devils are hard up – I wish the Post-Impressionist pictures were brought over here."[46]

They were not, but what must have reached New York was a modest book of fifty-six pages – almost a pamphlet – which a young British critic had been inspired to write on the occasion of the exhibition: *Revolution in Art: An Introduction to the Study of Cézanne, Gauguin, Van Gogh, and Other Modern Painters.* Its author was Frank Rutter, one of the occasional guests of the Steins. His text was dated

November 1910 (the very month in which the historic show had opened), and it featured, on the back of the title page, the following lines:

> TO THE REBELS OF EITHER SEX ALL THE WORLD OVER WHO
> IN ANY WAY ARE FIGHTING FOR FREEDOM OF ANY KIND, I
> DEDICATE THIS STUDY OF THEIR PAINTER COMRADES.

Like Huneker, Rutter relied – to a certain extent – on previous publications, among which he named Meier-Graefe's *Development of Modern Art*, but he also brought an entirely new slant to his subject, equating artistic radicals with political ones. Although he stated in his very first chapter that "the revolution in art to be dealt with here has nothing to do with the republicans of Portugal or the nihilists of Russia,"[47] Rutter could not resist the temptation to declare, while speaking of Cézanne and Gauguin, "The two deceased painters are to their younger comrades what Marx and Kropotkin are to the young social reformers of the day."[48]

One may wonder how Mrs. Havemeyer, for instance, felt about such revelations. Suffragist though she was, she cannot have been too happy about the notion of harboring under the roof of her Fifth Avenue mansion a number of works by the Karl Marx of art. As Mrs. Havemeyer had never taken any interest in Gauguin, she at least escaped the blame of simultaneously favoring the Kropotkin of painting.

Rutter's political orientation also prompted him to write that Cézanne's "idealism led him to join the Communist movement which succeeded the Franco-Prussian war."[49] Other details of his biographical summary were equally inaccurate, except for the generous quotes from Théodore Duret. But the end of his essay was strangely at odds with his insistence on the painter's revolutionary aspects: "We," he concluded, "who forget the mighty effort put forth by Nature to produce fruit spread idly on our tables have to be stunned and knocked over, as by cannon balls, with the pears and apples of Cézanne before we call to mind the hidden forces which brought them to birth. It is this plainly expressed love of primitive strength which makes Cézanne more of a reactionary than a progressive, which entitles him to be hailed as a sort of Nietzsche of painting."[50]

To this Huneker predictably replied, "I can't agree with those who call Paul Cézanne the 'Nietzsche of painting,' because Nietzsche is brilliant and original while the fundamental qualities of Cézanne are sincerity, a dogged sincerity."[51]

Rutter's readers were left with the choice of perceiving Cézanne as either Marx or Nietzsche, a "communist" or a "reactionary" of art. While the author obviously had meant all this to be flattering, to those who were buying the works of Cézanne, any contact with anarchism must have appeared – to say the least – disturbing. If Cézanne continued to attract adventurous collectors, it was certainly not because of what Rutter had written, but possibly in spite of it.

The ranks of such collectors were now joined by John Quinn. Since the London exhibition did not come to New York and since he had decided to make some significant and major purchases, it meant that he would have to go to Europe. Quinn felt he must own works by the key figures of Post-Impressionism: Cézanne, van Gogh, and Gauguin. This choice was an obvious one (Rutter having just singled out these three), but in Quinn's case it was particularly striking, as he had not yet

ventured into modern French art. On the other hand, these were also the men whom Huneker had mentioned in his 1908 review of an exhibition of the "Eight," when he had wondered, "What will happen to our nerves when Cézanne, Gauguin, Van Gogh appear?" Quinn's nerves were ready for them, the more so as Huneker was a friend of his, as was Augustus John. The lawyer liked to listen to them, as well as to many others, including dealers, all selected for their enlightened views. Among those who were close to him and whom he consulted were notably the painters Walter Pach (by nature rather prudent), Walt Kuhn, and especially Arthur B. Davies, whom Quinn was to describe as "keen about everything that is new and vital and interesting. He is an exceptional man altogether."[52] Quinn not only collected art, he also collected opinions; but the diversity of his involvements shows that he did not follow a single mind or a well-traced line of conduct. This is not surprising, since he was driven by an ever-ready enthusiasm and a limitless appetite for making purchases, which were not necessarily guided by a selective taste or an original perception.

When Quinn subsequently went to London and then Paris in the company of Augustus John, he visited the Durand-Ruel gallery and there traded a Manet for a Puvis de Chavannes, whose style appeared more relevant to recent tendencies and was doubtless favored by Arthur B. Davies. Quinn heard of course about the Steins but apparently did not visit them. Nor did he on that trip buy any works by the three key masters he wished to own.

Meanwhile Steichen was negotiating in Paris with Picasso for a one-man show and also for the loan of a group of watercolors by Cézanne for a New York exhibition. He obtained twenty watercolors from the Bernheim-Jeunes, who seem to have been more cooperative than Vollard. It was with evident relief that Steichen finally informed Stieglitz:

> Well, the Cézannes are out at sea on the Savoie. It meant a certain amount of "manoeuvre" to get them, so they did not get off as soon as I hoped. . . . The Cézannes are a really fine lot, the cream of what the Bernheims have. – And I managed to get the collection as *varied* as possible; in that way I did sacrifice a few corking things I might otherwise have included. – I had them insured in transit . . . at about half of the list price. . . . I should have liked to have had some Cézanne water colors that Vollard has, but it was impossible to make the show up from two houses. – The Bernheims are very much interested in our work, and as a matter of fact offered to put us up in a big gallery in New York if we want it. Of course I realized this would not be possible as it would mean we would become Bernheim-Jeune. – Their interest of course is purely commercial and they showed it by even making us pay for the *packing* of the Cézanne pictures which they can do in their own place here.[53]

How Steichen's selection was made is not known, except that he was assisted in his choice by the Bernheims' director, Félix Fénéon. Quite obviously, the Bernheim-Jeunes were unlikely to send their finest Cézanne watercolors on consignment to a little-known, small gallery in New York, particularly as they were keeping a considerable number of these for their own private collections (where some still remain). On the other hand, Steichen evidently picked with an eye to what pleased him, even though, as he explained, he had to "sacrifice a few corking things." And since he was an artist, Steichen was not concerned with the question of "finish,"

73 *Turning Path with Well in the Park of Château Noir c.* 1900 (RWC.513)

74 *Mont Sainte-Victoire* 1885–87 (RWC.279)

which was still one of the sacred tenets of academic teaching. What did it matter to
him that the works showed no minutely drawn contours to which a careful brush had
routinely added colors in predictable shades? On the contrary, he must have been
enchanted with the total freedom of execution, the lightness of touch, the suggestive
power of vaguely indicated shapes, the freshness of color, the delicacy of the
draftsmanship that appeared on these sheets, among them one of the artist's wife
Hortense next to a hydrangea (hortensia), primarily a pencil drawing with a few *VIII*
bright washes of green in the leaves of the plant (RWC.209).

The exhibition of Cézanne's watercolors at Stieglitz's 291 gallery took place in
March 1911. Stieglitz had already exhibited a group of watercolors by Rodin, whose
deft pencil lines – defining the movements of models – were illuminated by
transparent, loosely flowing splashes of color. Despite their extreme simplification
these works had been appreciated by many reviewers.[54] The radical shorthand of
these watercolors had in turn prepared the New York public for the still more radical
nature of Matisse's offerings (whose colors Huneker was to admire). But Cézanne's
works presented a complicated problem because there often seemed to be nothing
that resembled a composition or even a subject and – worse still – the little that was
there could not always be easily deciphered. What looked like a curve in a road was *73*
dominated by tortuous lines that may have been branches, but these were nowhere
clearly defined and there was no attempt at shading to provide them with a
suggestion of volume (RWC.513). A mountain could be seen rising above trees that *74*
were shapeless and beyond a foreground that was vague (RWC.279). There were
lines indicating roofs above bodiless houses; behind them appeared a tree and then a *75*

75 *Roofs and a Tree* 1888–90 (RWC.360)

background that could not be precisely made out (RWC.360). A tree trunk rises from
76 nowhere and extends its branches more to the left than to the right (RWC.287). The
color is not always what one would expect from local color and is not applied to
clearly circumscribed areas; moreover, it is made up of various layers of transparent
washes freely distributed on the white sheet. As a result, whatever touches of color
there are often seem to float on the white surface, suffused with light but totally
lacking in "solidity."

There was only one still life in the group and it cannot be identified, whereas most
of the other watercolors can.[55] There were few figure pieces, the majority of the
sheets being landscapes, and most of these were executed with spontaneity. The
colors, sparsely applied or not, established delicate or powerful rhythms, and there
was an admirable freshness to all of them. Whether Steichen, while contemplating
his choices, ever thought of American collectors and prospective buyers is
impossible to determine. It is more likely that he was excited by the prospect of
introducing his fellow countrymen to these rare and precious manifestations of a still
little-known genius.

When the shipment arrived at Stieglitz's gallery, he was curious to see how he
would react to the watercolors at which he had laughed four years earlier. As Stieglitz
later told it: "The box of framed Cézannes was opened, and lo and behold, I found
the first one no more nor less realistic than a photograph. What had happened to me?
The custom house man looked up; 'My lord, Mr Stieglitz,' he said, 'you're not
going to show this, are you – just a piece of white paper, with a few blotches of
color?'

76 *The Large Pine Tree c.* 1890 (RWC.287)

"I pointed to the house, rocks, trees and water. The appraiser asked, 'Are you trying to hypnotize me into saying something is there that doesn't exist?'"[56]

Before the opening of the exhibition Steichen had not forgotten his original idea of a prank to "test" the public and the critics. Years later he reported,

> So I painted a fake Cézanne. It was not an imitation of any one picture but a landscape in the style of the Cézanne watercolors. These were all as abstract as anything we had seen in Paris up to that time. In spite of my attempt to make it exactly like the Cézannes, my fake was probably a little more naturalistic. When the exhibition was hung in New York, my fake Cézanne attracted particular attention, possibly because it was more literal.
> At any rate, the Cézanne watercolors drew a very hostile response. People "laughed their heads off," critics as well as visitors. Of all the exhibitions we had at 291, this one was probably the most sensational and the most outrightly condemned. Of course, appreciators of avant-garde art thought it was the best we ever had.
> Several people tried to buy my fake, but I explained that it was only on loan and was not for sale. I was petrified by the whole experience. I burned the fake as soon as I could get my hands on it, and only then did I breathe freely again. The "experiment" had given me a clear picture of the snobbery of people who pretended to appreciate things they didn't really understand.[57]

But Steichen may have been too harsh in his judgment: since nobody in New York was familiar with Cézanne watercolors, it would have been extremely difficult for such inexperienced visitors to distinguish a genuine one from Steichen's probably very clever imitation.

In addition to the checklist – there was no catalog – there was a short text,

obviously by Stieglitz, which subsequently appeared in *Camera Work*, and which may also have been available on the premises: "On first glancing at the few touches of color which made up the water-colors by Cézanne, the fount of inspiration of the younger school of painting, the beholder was tempted to exclaim, 'Is that all?' Yet if one gave oneself a chance, one succumbed to the fascination of his art. The white paper, no longer seemed empty space, but became vibrant with sunlight. The artist's touch was so sure, each stroke was so willed, each value so true, that one had to admire the absolute honesty, sincerity of purpose and great mentality of him whom posterity may rank as the greatest artist of the last hundred years."[58]

This was the boldest claim ever made on behalf of Cézanne, and the public, on the basis of such apparently ephemeral works, was not yet ready to accept it. Even the newly converted Quinn could not refrain from telling Stieglitz, "Cézanne was a great painter, but this stuff is just trash. You oughtn't to show such things."[59] The *New York Evening World* spoke of the watercolors as "fragmentary drawings washed in here and there with spots and patches of flat tint. Where does the paradox come in? It lies in the fact that this is the first show given to the American public of works of an important artist whose name stands as a sort of historical landmark on the borders of Impressionism and Post-Impressionism, yet it falls flat and insignificant, and students who know nothing of Cézanne except what they learn here, will go away knowing even less. . . . Cézanne . . . possessed a vague natural power which might have developed into positive genius, though it didn't, he never really arrived."[60]

The reviewer for *The Evening Mail* took a similar stance: "The watercolors of Cézanne . . . are certainly a long drop from the inspired color-clairvoyance of Marin. The Cézanne watercolors here shown are merely artistic embroys – unborn, unshaped, almost unconceived things, which yield little fruit for either the eye or the soul."[61]

The critic of the *New York Globe* also was disappointed but at the same time provided a glimpse of the "hypnotic" atmosphere of Stieglitz's gallery. "There is a lot of sanity here," he wrote of the exhibition,

> even if it be mingled with eccentricity, and our objections take the form of a protest at the painter stopping just where the real difficulties begin. Here are innumerable delightful suggestions, beginnings, indications, or spottings-in, but stopping there when the spectator has a reasonable right to ask for a logical conclusion. Thus we have the *Boat in Front of Trees* [RWC.472], and the "boat" might be a log in a stream for any indicated form of craft it has, while there are no trees or even suggestions of them though there is a bit of green shadow. As it stands the work is meaningless, and hundreds of clever students could obtain an equally dextrous swish-on of color.[62] There are other drawings in front of which the present writer was unable to make out the intentions, mistaking a landscape for a branch of blossoms until corrected by the ever-cheerful cicerone, Mr Stieglitz. However, in these galleries, one must start out to find certain things and then only, with the aid of a powerful imagination, duly prompted by the guide, and an utter subordination of all one's preconceived notions of nature one may arrive somewhere, as long as the hypnotic influences of these agreeable rooms prevail, for the Photo-Secession's offerings are an acquired taste, an obsession, as it were, for the full enjoyment of which one must be of the cult. . . . You are solemnly told of the beautiful qualities present, of the lovely things to see, and you look – but, alas! in vain. To the man hungry after art they fail to supply nutrition; on leaving you have your appetite still with you.[63]

77 *Trees and Rocks c.* 1890 (RWC.328)

A better-informed, more perceptive, and almost glowing report appeared in the
74 *New York Times*, except that it mentioned only one work (RWC.279), using it as a
pretext for an erudite discussion of the relationship of Cézanne's watercolors to
Oriental art. But since this was done in a rather positive way, the article offered an
original contribution to a better understanding of the artist. "After the heated
discussion occasioned by the exhibition of the Post Impressionists in London," the
anonymous reviewer wrote,

> the announcement of a roomful of water color drawings by Cézanne, the master of the
> whole school, might be expected to create a sensation among the followers of new
> movements. Whatsoever the announcement may have done the exhibition itself will create
> no sensation whatever, to the master's credit be it said. His two-score little pictures well
> hung on the walls of the Photo-Secession Gallery are as quiet and cool and self-possessed
> as nature herself in her most untroubled moments. One fine little landscape, a mountain
> that might be Fujiyama, but appears in the catalogue as "Mount Victoire" rising very
> solid, very dignified, and serene, is modeled with a few forcible strokes of pale greenish
> grayish neutral color. There is so little to say about the picture, and it is so potent to stir the
> imagination of the lover of nature, that one is tempted to leave the rest of the exhibition
> alone and go an inch or two into the cause and effect of this kind of art. It is supposed to be
> very cryptic and to appeal chiefly to artists. Probably it does, as artists more than other
> people love nature. . . .
>
> The Chinese and Japanese as a people love nature more consistently than any of the
> Western races, and many of their greatest works in essence resemble this by Cézanne –
> they are executed, that is, almost in monochrome and with an extreme economy of
> treatment, on the ground, to quote a Japanese critic, that "the provision of too many

78 *Group of Trees* 1880–85 (RWC.233)

79 *The Well in the Park of Château Noir* 1895–98 (RWC.428)

sensible attributes in a painting is apt to hinder the play of the imagination on the part of its beholders," and "in the ultimate analysis painting is, aesthetically speaking, but a product of the imagination, and is to be enjoyed by the same faculty."[64]

The reviewer for the *Brooklyn Daily Eagle* was not only more affirmative and more specific, he also quoted some fervent and penetrating lines that had just been published, though they concerned a painting (V.402) rather than a watercolor.

The art of the post-impressionist, Cézanne, about which Europe is talking, may be seen for the first time in this country at the Photo-Secession galleries. . . . As the water colors have no backgrounds and as the brush seems to only have swept the paper, in some cases, the first impression is that the pictures are marvelous for delicacy, lightness of atmosphere, suggestiveness and simplicity. Anyone can admire the way Cézanne painted *A Curtain of Trees* [RWC.233], and such examples as *Chestnut Tree* [RWC.287], *Tree Trunks* [RWC.328], *Hortensia* [RWC.209], and washerwomen at work at one end of a flatboat on a river [RWC.103], as well as *The Fountain* [RWC.428], with deeps of forest opening behind it. But to ordinary eyes the landscapes seem to be on the point of disappearing from the paper. To show how Cézanne is considered abroad this, by Roger Fry, in the current Burlington Magazine may be of interest:

78, 76, 77
VII, 80
79

80 *Washerwomen c.* 1880 (RWC.103)

"Certainly nothing at first sight could appear more banal, more trivial, less worthy of an artist's deliberate care than the little wayside scene in the South of France which Cézanne has taken for his motive. . . . The composition, apparently accidental and unarranged, is in reality the closest, most vividly apprehended unity. Out of these apparently casual rectangular forms, from the play of a few bare upright and horizontal masses, a structure is built up that holds the imagination. To the inquiring eye new relations, unsuspected harmonies continually reveal themselves; and this is true no less of the subtle, pure and crystalline color than of the linear construction of the pattern."[65]

James Huneker could not go that far. Since the appearance of his *Promenades of an Impressionist* (1910) with its chapter on Cézanne, he was considered the American expert on modern French art. Now he once again skillfully solved the problem of whether or not to admit that he really did not care for the artist (after all, the "Cézanne fad" was lasting much longer that he had predicted) by giving him a kind of noncommittal praise. "The Cézanne water colors," he wrote in the *New York Sun*, "are mere hints rather than actual performance, yet finely illustrative of the master's tact of omission. These thin washes tell the students secrets by reason of what is left out of the design, and some of them are bold enough, it must be confessed." Having wrung this "confession" from the ambivalent depth of his soul, Huneker could not help but finish with a kick in the direction of the man responsible for the exhibition. "We are," he wrote, "indebted to Alfred Stieglitz for his pioneer work in the matter of bringing to the ken of art lovers the more recent art manifestations of Paris, Hades and Buxtehude."[66]

There seem to be hardly any accounts from artists who saw the show, relating how they reacted to their first contact with Cézanne's work. But Man Ray, who had just turned twenty-one, saw the exhibition on his first visit to Stieglitz's place and remembered to the end of his life: "I was terrifically excited. . . . Just a few touches of color on a white paper. The watercolors looked unfinished, this is a quality I admired most as well as the use of the white of the paper as part of the painting. It was marvellous."[67]

Strangely enough, the one American painter who subsequently was to express particular interest in Cézanne's watercolors, Marsden Hartley, apparently was in Maine and failed to visit the exhibition.[68] (It was from Maine, during the summer of 1911, that he asked Stieglitz to send him a photograph of a typical Cézanne still life for study; Stieglitz may well have obliged with one of Weber's reproductions.)

Only a single item in the show was sold – if one discounts those eager to buy Steichen's fake – to Arthur B. Davies. But since the watercolors had been admitted under bond (because in those days a fifteen percent duty was levied on imported works of art), everything had to be returned to France. Stieglitz, planning a new trip aboard, suggested that he could bring it back later. This he did, and after declaring it at its correct price of $200 and undergoing another dialogue with the customs officer about people crazy enough to pay good money for such stuff, he disbursed $30 and was able to deliver the watercolor to its owner.[69] Davies must have shown his purchase to Miss Lillie Bliss. From about 1907 the painter had found in this remarkable woman a generous and enthusiastic patron, whom he slowly initiated into the intricacies of modern art. The thread that had led from Cézanne to Pach and then to Davies was now being extended to Miss Bliss.

NOTES

1. Edward Steichen, *A Life in Photography* (Garden City, N.Y.: Doubleday, 1963), facing plate 44.

2. Marsden Hartley, "291 – and the Brass Bowl," in *America and Alfred Stieglitz*, ed. Waldo Frank et al. (Garden City, N.Y.: Doubleday, Doran, 1934), p. 241.

3. Charles H. Caffin, "The Art of Edward J. Steichen," *Camera Work*, April 1910, p. 35. This article was brought to my attention by John Cauman.

4. Guillaume Apollinaire, in *L'Intransigeant*, Sept. 27, 1910; see *Apollinaire on Art: Essays and Reviews, 1902–1918*, ed. L. C. Breunig, trans. S. Suleiman (New York: Viking Press, 1972), pp. 104–5. The exhibition had been announced as "Figures de Cézanne," Galerie A. Vollard, 6, Rue Laffitte, Paris – du Lundi 27 Juin au Samedi 23 Juillet [1910].

5. James G. Huneker, *Promenades of an Impressionist* (New York: Charles Scribner's Sons, 1910), p. 389.

6. Hearn's book had nothing to do with painting even though its title was implicitly explained by a quotation from Delacroix: "Jeune artiste, tu attends un sujet? Tout est sujet; le sujet c'est toi-même: ce sont tes impressions, tes émotions devant la nature. C'est toi qu'il faut regarder, et non autour de toi."

7. Huneker, *Promenades*, p. 21. This statement can safely be attributed to Joseph Durand-Ruel, whom Huneker had seen during the past summer when he was shown the two Cézanne paintings from the Havemeyer collection; see above Chapter V, note 36.

8. Ibid., p. 12.

9. Ibid., p. 15. But a few years later, while still promoting this story, Huneker was to write to his fellow critic Royal Cortissoz that Cézanne

"loathed his origin." Such blatant inconsistencies, heaped on what is a glaring mistake in the first place, left the reader with the impossible task of deciding which of these versions could be believed when – as a matter of fact – both should be discarded.

10. Guy Pène du Bois, "Exhibitions ...," *New York American*, March 21, 1910, p. 8. This article was brought to my attention by John Cauman.

11. Elie Faure, quoted by Walter Pach, *Queer Thing, Painting* (New York: Harper & Brothers, 1938), pp. 261–62; Faure's essay was reprinted in Elie Faure, *Les Constructeurs* (Paris: G. Crès, 1921), pp. 209–55.

12. Max Weber, interview, 1959, tapes, vol. 1, pp. 248–49; Columbia University Oral History Project. This text was brought to my attention by John Cauman.

13. Andrew Dasburg, "Recollections," ca. 1972, quoted in Van Deren Coke, *Andrew Dasburg* (Albuquerque, N.M.: University of New Mexico Press, 1979), pp. 18–19.

14. The reviews are reprinted in Stieglitz's *Camera Work*, Jan. 1911, p. 50.

15. The preface was written by Desmond MacArthur from notes provided by Fry. See Benedict Nicolson, "Post-Impressionism and Roger Fry," *Burlington Magazine*, Jan. 1951, p. 13, note 15. On this exhibition, see also Alan Bowness, "Introduction," in *Post-Impressionism*, exhibition catalog, Royal Academy of Arts, London, 1979–80. For an interesting though highly critical article, see Richard Cork, "A Postmortem on Post-Impressionism," *Art in America*, Oct. 1980, pp. 83–94, 149–53.

16. Preface to *Manet and the Post-Impressionists*, exhibition catalog, Grafton Galleries, London, Nov. 8, 1910–Jan. 15, 1911, pp. 8, 9, 10.

17. This was *Trees near Melun*, 1901, now in the Belgrade Museum of Art and Archeology (Gift of Bernard Berenson); the picture is reproduced in Alfred H. Barr, Jr., *Matisse: His Art and His Public* (New York: Museum of Modern Art, 1951), p. 308.

18. Mrs. Berenson, however, kept up her friendship with Fry. I am indebted for this information to Professor Ernest Samuels.

19. Reference to Langdon Douglas in a letter from Fry to Mary Berenson, Dorking, Jan. 21, 1903; *Letters of Roger Fry*, ed. Denys Sutton (New York: Random House, 1972), vol. 1, p. 200.

20. See Fry's letter to R. C. Trevelyan, Florence, Nov. 15, 1899, ibid., p. 175.

21. When he could not agree with Berenson's article on Ugolino Lorenzetti in the Oct. 1891 issue of *Art in America*, Loeser wrote in a letter from Florence, Nov. 11, 1891, to Edward W. Forbes, of "Berenson's tremendous argumentations, and travels from China to Peru ... to demonstrate I know not what, unless it be that he is himself the omniscient God whose ways are dark, so dark that not even his own appointed prophet may follow in his tracks." Archives of the Fogg Art Museum, Harvard University, Cambridge, Mass.; this letter was first quoted by K. Oberhuber, "Charles Loeser as a Collector of Drawings," *Apollo*, June 1978.

22. According to Frances Spalding, *Roger Fry: Art and Life* (Berkeley and Los Angeles: University of California Press, 1980), p. 117, "Fry had first met Loeser at La Roche-Guyon [between Paris and Rouen] in 1894 and with [his wife] Helen he visited him in Florence in 1897 in order to see his collection; another visit was made in November 1908." But as recorded by Leo Stein (see above, Chapter III, note 2), visitors to Loeser's home usually were not taken to the upstairs rooms with the Cézanne paintings.

23. The ten paintings were V.156, 158, 173, 181, 196, 197, 207, 373, 442, and 617; information courtesy the late M. Charles Durand-Ruel, Paris. On this exhibition, see John Rewald, "Depressionist Days of the Impressionists," *Art News*, Feb. 1, 1945, pp. 12–14, reprinted in John Rewald, *Studies in Impressionism* (London: Thames and Hudson, 1985; New York: Harry N. Abrams, 1986), pp. 203–8.

24. Anonymous [Roger Fry], in *Athenaeum*, Feb. 11, 1905, p. 186; this article, not recorded in Donald A. Laing, *Roger Fry: An Annotated Bibliography of the Published Writings* (New York: Garland Publishing, 1979), was brought to my attention by John Cauman.

25. The two paintings were an early still life (V.70) and a landscape recently identified as V.164 by A. Bowness, "Introduction", p. 12, note 3.

26. Roger Fry, "Retrospect," in *Vision and Design* (New York: Brentano's [1921]), p. 289.

27. This unsigned article, "The New Gallery," *Athenaeum*, Jan. 13, 1906, pp. 56–57, was first quoted by Virginia Woolf, *Roger Fry, A Biography* (London: Hogarth Press, 1940; reprinted New York: Harcourt, Brace, Jovanovich, 1976), pp. 111–12. See also Laing, *Roger Fry*, p. 141, No. C455.

28. Roger Fry, "The Present Situation," manuscript notes for a lecture delivered in Feb. 1923; quoted by Spalding, *Roger Fry*, p. 73.

29. Strangely enough, it would seem that subsequently Fry deliberately obscured previous opportunities to have become aware of Cézanne when he wrote: "By some extraordinary ill luck I managed to miss seeing Cézanne's work till some considerable time after his death. I had heard of him vaguely from time to time as a kind of hidden oracle of ultra-impressionism, and, in consequence, I expected to find myself entirely unreceptive to his art. To my intense surprise I found myself deeply moved. I have discovered the article in which I recorded this encounter." Fry, "Retrospect," p. 289.

The fact is that Fry's first, rather negative reaction to Cézanne was published in 1905 (see above, notes 23–27) and that even his more positive comments of 1906 (note 26) appeared in January of that year, when Cézanne was still alive.

30. Roger Fry, *Burlington Magazine*, Jan. and Feb. 1910.

31. Anonymous, *New York Times*, Feb. 20, 1910.

32. D. S. MacColl, *Confessions of a Keeper* (London: A Maclehose, 1931).

33. Walter Sickert, "The Devil among the Tailors," *Fortnightly Review*, Jan. 1911; reprinted in *A Free House*, ed. Osbert Sitwell (London: Macmillan, 1947), p. 101.

34. Roger Fry, introductory note to M. Denis, "Cézanne," p. 207.

35. The works reproduced with the two articles were: *Self-Portrait* (V.578), *Young Man with a White Scarf* (V.374), *Woman with a Boa* (V.376), *Poële dans l'atelier* (V.64), *Woman with a Rosary* (V.702), *Bathers* (V.273), and *Lutte d'Amour* (V.379).

36. *John Sloan's New York Scene* (New York: Harper & Row, 1965), p. 426. This passage was brought to my attention by Elizabeth H. Hawkes, Curator, John Sloan Archives, Delaware Museum, Wilmington, Delaware.

37. Anonymous, "London Letter," *American Art News*, Nov. 9, 1910, p. 5.

38. On the Grafton Gallery exhibition, see notably Douglas Cooper, *The Courtauld Collection* (London: University of London, Athlone Press, 1954), pp. 52–55.

There was to be a large, privately organized show titled "Art Moderne" in Paris during the summer of 1912, but it totally lacked the adventurous character of Fry's undertaking (or of the 1912 Sonderbund exhibition in Cologne, on which see Chapter VII). The French retrospective assembled masterpieces by Manet, Monet, Renoir, Degas, Cézanne, Pissarro, Sisley, Morisot, and Cassatt, with each artist's works hung together on ornately draped backgrounds. Also represented, as "equals," were Raffaëlli and Forain, as well as, to a lesser degree, van Gogh and Toulouse-Lautrec. But not a single more radical and less time-tested artist – such as Matisse, Picasso, Bonnard, or even Gauguin – was allowed to intrude upon this selection of by-then universally recognized masters. See Arsène Alexandre, "Exposition d'Art Moderne à l'Hôtel de la Revue 'Les Arts,'" *Les Arts*, Aug. 1912, pp. II–XVI.

39. C. J. Holmes, *Notes on the Post-Impressionist Painters – Grafton Galleries, 1910–11* (London: Philip Lee Warner, 1910), p. 12.

40. Ibid., pp. 20–21.

41. Vanessa Bell, undated memoir (no. VI), quoted by Frances Spalding, *Vanessa Bell* (New Haven and New York: Ticknor & Fields, 1983), p. 92.

42. Sickert, "The Devil," pp. 102, 103, 105.

43. Roger Fry, "Acquisitions by the National Gallery at Helsingfors," *Burlington Magazine*, Feb. 1911, p. 293.

44. *Brooklyn Daily Eagle*, March 8, 1911. This article was brought to my attention by Dennis Longwell.

45. On this subject see Carol A. Nathanson, "The American Reaction to London's First Grafton Show," *Archives of American Art Journal*, vol. 25, no. 3 (1985), pp. 3–10.

46. John Quinn to Augustus John, Feb. 2, 1911; quoted in Judith Zilczer, *"The Noble Buyer": John Quinn, Patron of the Avant-Garde*, exhibition catalog, Hirshhorn Museum and Sculpture Garden, Washington, D.C., 1978, p. 21. On Quinn as collector, see also Douglas Cooper's review of this book, "The Erratic Magpie," *New York Review of Books*, Dec. 7, 1978, pp. 32–34.

47. Frank Rutter, *Revolution in Art* (London: Art News Press, 1910), p. 8.

48. Ibid., p. 18.

49. Ibid., p. 21.

50. Ibid., p. 25.

51. James G. Huneker, *Ivory, Apes and Peacocks* (New York: Charles Scribner's Sons, 1915), pp. 252–53.

52. John Quinn to Ezra Pound, July 7, 1916; quoted in Zilczer, *"The Noble Buyer,"* p. 40.

53. Edward Steichen to Alfred Stieglitz [Paris], Tuesday, n.d. [early 1911]; leaf 347, Stieglitz Archive, Beinecke Rare Books and Manuscript Library, Yale University. This document was brought to my attention by Dennis Longwell.

54. On Stieglitz and his exhibitions, see notably William Innes Homer, *Alfred Stieglitz and the American Avant-Garde* (Boston: New York Graphic Society, 1977).

55. Only a checklist was issued for the exhibition. Most of the works cited there, as published in Donald E. Gordon, *Modern Art Exhibitions, 1900–1916* (Munich: Prestel Verlag, 1974), vol. 2, pp. 462–63, can now be identified thanks to the records of the Bernheim-Jeune gallery in Paris, courtesy M. Henry Dauberville, and to the efforts of Jayne Warman. Following is the list of works shown, as published by Gordon, accompanied where possible by the Rewald references: 1. *Landscape*; 2. *Boat in Front of a Tree* (RWC.472); 3. *A Curtain of Trees* (RWC.233); 4. *Trees in X* (RWC.484); 5. *The Fountain* (RWC.428); 6. *Tree Study* (RWC.235); 7. *Chestnut Tree* (RWC.287); 8. *Mount Victoire* (RWC.279); 9. *Still Life*; 10. *Landscape*; 11. *Green Turf* (RWC.551); 12. *Houses and Trees* (RWC.390); 13. *The Bridge* (RWC.326); 14. *The Winding Way* (RWC.513); 15. *Washerwomen* (RWC.103); 16. *Tree Trunks* (RWC.328); 17. *Gables* (RWC.360); 18. *Reading* (RWC.187); 19. *Hortensia* (RWC.209); 20. *Landscape*.

On this exhibition, see also John Rewald, *Paul Cézanne: The Watercolors* (Boston: New York Graphic Society; London: Thames and Hudson, 1983), p. 470.

56. Quoted by Dorothy Norman, *Alfred Stieglitz: An American Seer* (New York: Random House, 1960), pp. 105–6.

57. Edward Steichen, *A Life in Photography* (Garden City, N.Y.: Doubleday, 1963), pp. 67–68. On this strange incident, see also Agnes E. Meyer, *Out of These Roots: The Autobiography of an American Woman* (Boston: Little, Brown, 1953), p. 102.

58. Anonymous [Alfred Stieglitz], "Cézanne Exhibition," *Camera Work*, Oct. 1911, p. 30.

59. Alfred Stieglitz, *Twice a Year*, no. 1 (1938), pp. 83–84.

60. Excerpts from the reviews appeared in *Camera Work*, Oct. 1911, pp. 47–48.

61. Joseph Edgar Chamberlin, "Cézanne Embryos," *The Evening Mail* (New York), March 8, 1911.

62. Huneker said exactly the opposite; this was the only work specifically mentioned in his review, of which he wrote: "The Boat in Front of Trees' is worth close attention." Anonymous, *New York Sun*, March 12, 1911.

63. Anonymous [Arthur Hoeber], "Art and Artists," *New York Globe and Commercial Advertiser*, March 3, 1911.

64. Anonymous, "Water Colors by Cézanne," *New York Times*, March 12, 1911.

65. Anonymous, *Brooklyn Daily Eagle*, March 8, 1911.

66. Anonymous [James G. Huneker], "Seen in the World of Art," *New York Sun*, March 12, 1911; see also note 62 above.

67. Man Ray, interview with Arturo Schwarz; see A. Schwarz, *Man Ray: The Rigour of Imagination* (New York: Rizzoli, 1977), p. 25. This text was brought to my attention by Francis M. Naumann. Man Ray said more or less the same thing in his *Self Portrait* (Boston: Atlantic Monthly Press Book, Little, Brown, 1963), p. 18.

68. On this subject, see Homer, *Alfred Stieglitz*, pp. 154, 285, note 80.

69. See Norman, *Alfred Stieglitz*, p. 106.

VII · Sales and Purchases Preparations for the Armory Show

WHILE IN PARIS, in 1911, Steichen and Stieglitz called on Picasso, Rodin, Vollard, and the Bernheim-Jeunes, among others, often in the company of Marius de Zayas, a young Mexican artist who had recently joined Stieglitz's circle in New York. Together, they saw hundreds of Cézannes, any number of van Goghs and Renoirs. When they visited Matisse, he took them to his dining room where they admired, opposite his breakfast table, a series of splendid Cézanne watercolors, placed next to one another in a row. If Steichen and Stieglitz still needed any confirmation of their growing enthusiasm, it was this trip and Matisse's reverence for the master that produced it.

Stieglitz had just commissioned, for the summer 1911 issue of *Camera Work*, an article on Cézanne by the English-born Charles H. Caffin, from 1901 to 1905 art editor of the *New York Sun* (where he had preceded Huneker). The task of "explaining" Cézanne to readers who had still not seen any of the artist's paintings proved once more to be a difficult one, the more so as the article was not even illustrated. Caffin revealed himself to be fixed on the idea that the artist had had a scientific mind. This was, no doubt, brought about by Cézanne's advice to Bernard to treat nature by means of the cylinder, the sphere, and the cone, advice which, just then, was being hotly debated in Paris among proponents of the recently emerged Cubism. But possibly unaware of the way in which Cézanne's theories had germinated into a completely new and unexpected style, Caffin belabored his concept of the artist's "scientific" attitude throughout his essay, which also provided a short biography that relied mostly on Bernard's writing and his correspondence with Cézanne. Neither Walter Pach's article nor Maurice Denis's study were allowed to interfere with Caffin's own notions. Discussing Cézanne's work, he repeatedly proffered such wisdom as, "Perhaps he had more sense of truth than of beauty," echoing what Huneker had already set forth. But to this he added, "At any rate, in lieu of creative imagination, he brought to bear upon nature a scientific attitude of mind, tempered by a taste unusually fine."

"If one may venture to try and express in one word Cézanne's most personal contribution to art," Caffin concluded, "it is that he has tended to *intellectualize* it. He has pointed the way for placing it on that basis which alone counts today in any department of human activity – the scientific one. Further, his influence is working to elevate painting, on the one hand, from the barrenness of merely natural representation and, on the other, from the effeminate surplusage of sentiment. His example is a virilising force; and, while it may be true that his concern was more with

truth than with beauty, as the latter is generally understood, he is the prophet of a new beauty, one, namely, that is to be found in scientific truth."[1]

In that same year of 1911 there appeared in the English *Art Journal* another article on Cézanne which, if not particularly original, had the advantage of accurately describing the "position" the artist had achieved at that time. "His admirers in France are not legion, it is true," the author stated, "but they are tenacious and fully convinced. Abroad, Russia and Germany have boomed him; and there is Mr. Berenson, the American writer on art, who proclaims he would sooner have Cézanne's pictures on his walls than those of any other painter.[2] Already in 1899, M. de Tschudi, Director of the National Gallery of Berlin, had introduced into his *81* museum a Cézanne landscape [V.324] in company with canvases by Manet, Degas, Pissarro, Sisley and Monet. It should be stated, however, that he was careful to remove the former while the Emperor was inspecting these latter."

After naming such early collectors as Fabbri, Stein, and especially Pellerin, and after listing Vollard, Bernheim-Jeune, and Hessel as the principal dealers, the author presented exactly the same views as Caffin (though without any reference to the "effeminate surplusage of sentiment"): "Incontestably, Cézanne's vision was back in his brain rather than in his eye; it was partly mystical, partly logical, and always abstract. The idea of truth more than that of beauty reigned in his mind, so that the appearance of the thing for its own sake was commonly not prized."

This article also provided a bit of practical information that, better than almost anything else, reflected Cézanne's increasing renown. Whereas Vollard was said to have originally sold pictures for 500 or 600 francs, "today, the same canvases fetch twenty to thirty thousand."[3] Yet even at these prices – the equivalent of $4,000–$6,000 – demand was increasing as a steady stream of new buyers appeared on the market.

But Cézanne had still not been properly shown in America. In his review of the watercolor exhibition, Huneker had complained: "It seems a pity . . . that we have thus far seen no representative Cézannes in New York. The late H. O. Havemeyer had a remarkable gathering, but they will never be publicly exhibited. Whenever the Durand-Ruels find a Cézanne in America they buy it and immediately send it to Paris where it will command a big price."[4]

Though it is true that until Mrs. Havemeyer's death in 1929 the paintings did not leave her residence at 1 East 66th Street in New York, it is difficult to ascertain how word got around that the Havemeyer pictures would "never be publicly exhibited." Nevertheless, Stieglitz now felt that the time had come for a major showing of modern art revolving around Cézanne, something he could not possibly arrange in his small gallery and something, he thought, that should be free of any commercial context. On December 14, 1911, he therefore addressed a letter to the editor of the *New York Evening Sun*, expressing the conviction that the Metropolitan Museum

owes it to the Americans to give them a chance to study the works of Cézanne and Van Gogh; although deceased, their work is the strongest influence in modern painting. I firmly believe that an exhibition, a well-selected one, of Cézanne's paintings is just at present of more vital importance than would be an exhibition of Rembrandts. Believe me, the conclusion has not been arrived at through any snap judgment or without the most careful study and thought. Without the understanding of Cézanne – and this one can get

81 *The Mill on the Banks of La Couleuvre near Pontoise* 1881 (V.324)

only through seeing his paintings, and the best of them – it is impossible for anyone to grasp, even faintly, much that is going on in the art world today. . . . I hope that you will use your influence toward the realization of such an exhibition at the Metropolitan, or if not there, at least in some prominent art institution.[5]

Needless to say, this appeal went unheeded, even though Bryson Burroughs, recently appointed curator of the Metropolitan Museum (and a painter) was not hostile to Cézanne and had quietly begun to look at his paintings. Before succeeding him, Burroughs had been tutored by Roger Fry during his short tenure at the museum and was to remain on friendly terms with him. Burroughs has been called an "enlightened but often frustrated curator"[6] of that institution. As he was to report in 1913 to one of his trustees, "I saw several works [by Cézanne] in Paris two years ago for sale from 30,000 to 40,000 francs [$6,000–$8,000]."[7] But nothing further happened.

On the very day on which Stieglitz had written his letter advocating a comprehensive American showing of the works of Cézanne as well as van Gogh, another event took place that was eventually to lead to the realization of such a project in a form that went far beyond the hopes of even its initiators. On that day four American painters (one of them Walt Kuhn) assembled in New York to discuss the possibility of organizing a society for the purpose of exhibiting progressive works of art. Thus, the Association of American Painters and Sculptors was born, among whose initial members were also William Glackens and Arthur B. Davies.

Even though it might be presumed that Steichen and Stieglitz felt great sympathy for the aims of this new group, especially since they themselves had by then been active for several years along similar lines, there does not seem to have existed a particularly warm relationship between the members of the association and Stieglitz's circle.

While there is evidence of only a few private transactions, a partial record does exist for a very significant one that took place early in 1912. Again it involved Edward Steichen and, this time, a young woman who had originally come to the 291 gallery as a reporter for the *New York Sun* to interview Stieglitz. Agnes Ernst – "the Sun girl!" as Stieglitz soon fondly called her – had met Steichen in Paris in 1909 and was to form a lifelong friendship with him. It must have been Steichen who introduced her to the Steins, and it cannot have taken him long to make her share his admiration for a rather unlikely threesome: Rodin, Cézanne, and Brancusi.[8]

In the spring of 1910, Agnes Ernst had married the New York banker Eugene Meyer and had changed her status from that of a single working woman to that of a potential patron of the arts. When, at the beginning of 1912, the Meyers stopped in London on an extended trip abroad, Steichen went to see them and advised them on works of art to purchase. It would be pleasant to relate how – fired by Steichen's words – the couple rushed over to Paris to look at Vollard's paintings and, with their friend's assistance, made some judicious selections. But this did not happen, since Eugene Meyer, it would seem, could not be persuaded to go to Paris on such an errand. Undaunted or desperate (whatever the case may have been), Steichen suggested the next best solution, which he reported to Stieglitz:

> I tried to get Vollard to bring over to London a few Cézannes. He promised to – but then backed out. He certainly is a *type*. However, I was so insistent on one Cézanne still life, that Meyer practically gave me the order to get it, but I am sending him the photos of it first. I don't want to appear too aggressively cock sure – even if I feel it *myself*. – It is the finest still life Cézanne ever painted, I am sure, and I don't know if anyone but Chardin ever painted as good a one . . . and I would rather have a Cézanne than a Chardin. If they take that picture, America will have a Cézanne – for fair – I don't think I should have taken that attitude about anything else."[9]

Steichen's enthusiastic "attitude" carried the day. With a splendid confidence in his judgment, the Meyers bought the painting, a sumptuous arrangement of white crockery, a cascading curtain, and apples and peaches in glowing reds and yellows. It was a work from the artist's very last years, both stark and mellow, although his ultimate phase was then still neglected and Vollard does not seem to have offered many pictures from the period to prospective buyers. It is possible that only Auguste Pellerin and the Russian rivals Morosov and Shchukin had previously been able to appreciate paintings from Cézanne's final years (Morosov owned three acquired before 1912; the dates of purchase for Shchukin's two late canvases are not known). Even if Steichen guided his friends toward this still life and helped them perceive its unusual and strong character, the fact that the Meyers accepted his advice shows an admirable readiness to disregard convention.

According to family tradition,[10] Eugene Meyer paid $10,000 for the still life, certainly a very respectable price and doubtless one of the highest, if not the highest, obtained until then.

82 *Still Life with Fruit and Flower Holder c.* 1905

If any confirmation of Vollard's shrewdness were needed, it could be provided by the story of the pictures representing an old man in a sailor's cap, usually identified as Vallier, the artist's gardener in Aix.[11] Cézanne painted three rather similar versions of this subject, all more or less the same size; one had been in the possession of the artist's son (V.716), one belonged to Vollard, and one was owned by a M. Bernstein *83* in Paris (V.717). In March 1907, less than six months after his father's death, *84* Cézanne's son sold his version, together with other canvases and numerous watercolors, to Vollard and the Bernheim-Jeunes, who subsequently divided the lot between them.[12] Two years later, in February 1909, the son's version was sold by the Bernheim-Jeune gallery to Auguste Pellerin, or rather, they traded it – something commonly done in those days – for four of his pictures, estimated at a total of 12,220 francs ($2,666).[13] The version in the Bernstein collection was scheduled to be sold at auction in June 1911 with three other important paintings by Cézanne. As Vollard used to do on such occasions, and as was the practice of many dealers who had large stocks of certain artists (such as Durand-Ruel), he decided to bid up the Cézannes in the sale to prevent their being knocked down at low prices. This meant, of course, that he risked actually buying them and spending cash on pictures he did not really

83 *The Old Sailor* 1905–06

84 (right) *The Old Sailor, Full Face*
1905–06 (V.717)

"need." That, however, was preferable to being undersold at a public auction, the results of which would be published and widely quoted.

It was then, in the spring of 1911, that Josef Müller, son of a Swiss industrialist and a painter with a passion for collecting, who was all of twenty-five years old, came to Vollard because it was his dream to own a late figure painting by Cézanne. The dealer, who saw his opportunity, would not let him buy the one he coveted, explaining with surprising altruism: "Why don't you wait a few weeks? There will soon be an auction of more important Cézannes than those I can sell today, and you'll probably pay less for them than for those in my shop."[14] At the auction, Vollard purchased the first two pictures by Cézanne, both landscapes, for 15,000 and 19,000 francs respectively (20,000 francs – or $4,000 – probably being the limit he had set himself). Müller then found himself bidding against Vollard on a figure painting. But once Vollard had pushed it up to a satisfactory level, he let the young man have it for 24,000 francs ($4,800), which was actually the highest price reached by any of the four Cézannes in that sale and – except for a nude by Renoir that fetched 25,000 francs ($5,000) – also the highest of any of the bids. Having thus "protected" the value of his own version of the old man in the sailor's cap, Vollard was able to hold out for more. The amount eventually paid by Eugene Meyer demonstrates that Vollard's "patience" paid off. Within a period of a few years, Cézanne's prices had risen spectacularly. In 1909, Pellerin had paid the equivalent of $2,666 for the man in

the sailor's cap, as compared with the $4,800 bid by Müller two years later, and the
$10,000 spent by Meyer early in 1912 for his still life.[15]

82

At the very time the Meyers concluded their purchase, the painter William
Glackens prevailed upon his friend Dr. Albert Barnes to send him to Paris on a
picture-buying mission, concerned especially with acquiring works by his two
favorite artists, Cézanne and Renoir. Barnes gave him $20,000,[16] and Glackens
made the rounds in Paris accompanied by his old friend Alfred Maurer, who
introduced him to the Steins. But soon Glackens reported to his wife: "I have been
all through the dealers' places and have discovered that Mr. Barnes will not get as
much for his money as he expects. You can't touch a Cézanne under $3,000 and that
for a little landscape. His portraits and important pictures range from $7,000 to
30,000. I got a fine little Renoir at Durand-Ruel, a little girl reading a book, just the
head and arms, in his best period, I paid 7,000 francs for it [$1,400]. They asked eight
but came down. I consider it a bargain. This is all I bought so far. Am still looking
around."[17]

Eventually Glackens did manage to find a Cézanne landscape, a densely painted,
richly nuanced but not very large Sainte-Victoire (V.424) with an enamel-like
surface. He acquired it on February 28, 1912, from Bernheim-Jeune (who had
obtained it from the critic Théodore Duret) for 13,200 francs ($2,640). In view of the
prices quoted elsewhere, this, too, was a real bargain.

85

When the sale of the famous Rouart collection was announced for early December 1912, Dr. Barnes himself journeyed to Paris. There were only five Cézannes in the collection, for which Henri Rouart, a friend of Degas and a participant in the Impressionist group exhibitions, reputedly had paid $100 apiece. With the exception of a composition of bathers, all were small, and some were even unusually tiny canvases, minor works in a collection renowned for its innumerable Corots, its important Daumiers, its exceptional Degas, its fine Delacroix, its superb Millets and Monets, as well as various masterpieces by Gauguin, Manet, and others. When the
86 Cézanne bathers (V.383) was put up, Barnes was right there; with bids coming in from all sides, the estimate of 8,000 francs was left far behind by his victorious bid of 18,000 ($3,600). There were rumors that this had been a "speculative maneuver" wholly unconnected with any real appreciation for the artist's work, but such interpretations were merely indicative of the French mentality that still would not accept Cézanne as an "established" master. Barnes also bought two small still lifes
87 (V.202 and V.192) for 2,000 and 7,000 francs respectively ($400 and $1,400). These, together with Glacken's acquisition of the Sainte-Victoire landscape, constitute Barnes's first documented purchases of works by Cézanne.[18]

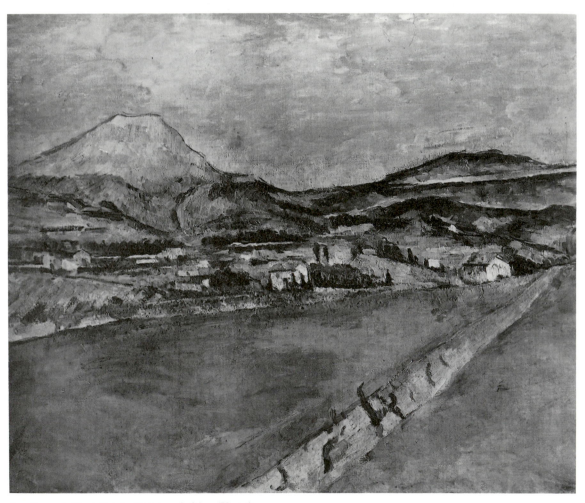

85 *Toward Mont Sainte-Victoire* 1878–79 (V.424)

86 *Five Bathers* 1877–78 (V.383)

Cézanne's paintings were among the lesser attractions of the Rouart collection, but the steadily increasing interest in the artist had a strange effect on another Philadelphian, Mary Cassatt. Although she had met Cézanne back in 1894 and had not shown any hostility in her report on their encounter at Giverny, and although in 1904 she had rejoiced in his belated success at the Salon d'Automne[19] and at that time had refused to part with the superb still life by him she owned, her attitude had changed radically during the succeeding years. In 1910 she had finally sold that still life for 8,000 francs because she felt that Cézanne's prices had reached their peak and because she preferred to acquire a painting by Courbet instead. That same year she "discovered" that it was Hugo von Tschudi whose appreciation of the artist was to blame for Cézanne's inflated reputation. "I met Tschudi, [presently] the Director of the Munich Gallery," she wrote to her friend Louisine Havemeyer, "and now I know why Burroughs [of the Metropolitan Museum] spoke to you of Cézanne's *nature morte*. It is Tschudi who infects them all. I told him what I thought of Cézanne, I was one of his first admirers, but I certainly never put him where they do and draw the line as to his being a great figure painter, ah, *no*. Interesting but very incomplete. I told him one could judge when one saw your gallery. He, Tschudi, actually admires this Matisse. When they get there they should be shut up."[20]

87 *Grapes and a Peach on a Plate* 1877–79 (V.192)

In the fall of 1912, with the approaching Rouart sale, Mary Cassatt had taken up the subject once more, and with some "practical suggestions" this time. "I wanted to tell you about the Cézanne prices," she wrote her friend Louisine. "It *can not* last. Why don't you make a selection, and don't deal either with the Durand-Ruels or Vollard, but with Bernheim [-Jeune] and get good prices and put your money into something really fine in the Rouart sale? How many Cézannes have you? Mme Renoir bought a little *pochade* by Cézanne for 100 francs long ago, not so very long ago, and now they offer her 18,500 francs for it, but she wants 20,000 francs. It is folly."[21]

Yet Mrs. Havemeyer may already have begun to regret the disposal of two paintings by Cézanne through Durand-Ruel in 1909 (on the advice of Mary Cassatt); she now had no intention of getting rid of any more. Even though she had set her heart on an important work by Degas that was bound to attract many bidders at the forthcoming Rouart auction, she apparently pointed out to Cassatt that she could well afford further purchases without sacrificing any Cézannes. "Of course," the latter replied slightly annoyed, "I know you are able to buy anything you want without selling your Cézannes still I strongly advise you to sell. Mrs. Sears was offered 12,500 francs for that nature morte a bottle and an apple [obviously not the one bought from Mary Cassatt] I think very sketchy. Bernheim made this offer for an amateur, she thinks he would even go to New York if there were enough pictures you were willing to part with. I think you might send them over here and I would have them in my apartment for them to show. The whole boom is madness and must fall."[22]

Mrs. Haveymeyer, however, did not rise to the bait. She kept her Cézannes and, at the Rouart sale of December 9–11, 1912, successfully bid for Degas's *Danseuses à la barre*, one of the jewels of the Rouart collection. She paid 478,500 francs ($95,700) for the canvas, a world record for the work of a living artist and for an Impressionist besides. This did much to encourage the defenders of the moderns, who could now claim that contemporary art, besides being beautiful, also represented an excellent

investment. Just a few months later the always eager John Quinn pointed out, "At the recent Rouart sale the Louvre bid the highest price ever paid for the work of a living artist and even then failed – to get a picture by Degas."[23]

As a matter of fact, the Louvre had just received the considerable Isaac de Camondo Bequest with several important works by Cézanne as well as by Degas, and the French administration never entertained any notion of such an exorbitant purchase as Rouart's famous *Danseuses à la barre*. In those days it was still the government policy to buy from the official Salons or to commission official artists; whatever "controversial" pictures managed to enter a French museum did so in the form of gifts or bequests, and even some of these were disdainfully rejected. Just the same, Quinn's comment about the expensive Degas sounded convincing enough, though it came from a recent convert. Indeed, it was only in January 1913 that Quinn himself finally made his first acquisitions from Vollard on the lines of what he had planned: a portrait of the artist's wife by Cézanne (V.229), which had been included *XI* in the Grafton Post-Impressionist show, for 25,000 francs ($5,000), a large Tahitian Gauguin for 16,000 francs ($3,200), and a self-portrait by van Gogh for 8,000 francs ($1,500). The three pictures arrived in New York with one day to spare for inclusion in the Armory Show, which opened on February 17, 1913.

The Armory Show is of course regarded as the decisive event in modern American art history, introducing not only Cézanne in a representative form to this country, but also Picasso and Matisse, as well as Redon, Marcel Duchamp, and countless others.[24] This exhibition was the product of the efforts and devotion of a small group of artists, supported by the enthusiastic John Quinn.

Once more Cézanne's increasing fame would be due to other painters. Those who, in the last years of his life, had invited him to participate in the Paris shows of the Indépendants and the Salon d'Automne had been fellow artists, and among his personal friends who admired and collected, or at least owned, his works were Pissarro, Monet, Degas, Renoir, Gauguin, and even Mary Cassatt. Rouart had been a painter, and so was Egisto Fabbri. Among the first to write about him were such painters as Emile Bernard, Maurice Denis, and Walter Pach. Roger Fry was a painter, as were Bryson Burroughs of the Metropolitan Museum and Leo Stein. Some of the most eminent American collectors received advice from artists: the Havemeyers from Mary Cassatt; Mrs. Montgomery Sears of Boston – herself an artist – was a friend of both Mary Cassatt and Maurice Prendergast; Albert Barnes was counseled by William Glackens and Leo Stein; Miss Lillie Bliss, who was to embark on an extremely active collecting career at the Armory Show, did so under the tutelage of Arthur B. Davies; and Mr. and Mrs. Eugene Meyer could count on Edward Steichen. John Quinn surrounded himself with a bevy of artists, all of whom were more or less involved in the preparation of the Armory Show.[25] Altogether, as Walter Pach put it years later, "It was the slow, collective pressure of conviction by the artist that brought men like Cézanne and van Gogh from their apparent hopeless neglect to their immense prestige of today."[26] But it must be admitted that there were also some painters among those who denied any talent to Cézanne, for example, Walter Sickert, C. J. Holmes, and Whistler, not to speak of William M. Chase.

It is not surprising that the impetus for the momentous Armory Show came from

artists. One of the tenets of their newly formed association was that of "exhibiting the works of progressive and live painters – both American and foreign – favoring such work usually neglected by current shows and especially interesting and instructive to the public."[27] This program was reaffirmed in the official platform of the association, which spoke of "holding exhibitions of the best contemporary work that can be secured, representative of American and foreign art."[28] This appeared to be a deliberate rephrasing, since the second formulation no longer refers to "live painters," but mentions "contemporary work" instead. More significant still is the fact that both declarations insisted that American as well as foreign works be shown, indicating a definite awareness of the new trends that were gathering strength abroad, which America had barely perceived. This awareness had been fostered by those who had traveled in Europe, by Stieglitz's exhibitions, and by published materials, such as Huneker's articles. The founding members of the fledgling association obviously hoped that direct contact with these foreign trends would prove beneficial to the American art scene over which the National Academy of Design was still casting its complacent shadow. By forgoing the clause that limited foreign participation to living artists, the group automatically opened its doors to Cézanne, as well as to van Gogh, Gauguin, and Seurat, most of whom had not yet been seen in America but whose names came up ever more frequently in studio talk.

Arthur B. Davies was eventually elected president of the new organization, partly because he could not be accused of any subversive tendencies, even though he was not a member of the National Academy. As it turned out, he was less beholden to convention and tradition than even his friends knew, or cared to admit. There had seldom been an artist who, without himself being an avant-gardist, was so sympathetic to all endeavors that left the beaten track and who seemed able to detect promise where others saw only wild groping. The association could not have found a bolder president.

In London, at the same time, Roger Fry was preparing a second Post-Impressionist show and Quinn, closely linked with the new American association, asked his English friends for as much information as they could gather. Fry's show, which was to run from October to the end of December 1912, would contain only five oils and half a dozen watercolors by Cézanne (all of the last lent by Bernheim-Jeune).[29]

Meanwhile, in Cologne, the German Sonderbund opened on May 25, 1912, a truly staggering international exhibition that not only rivaled but far surpassed Fry's undertaking of 1910. In some ways this show may have derived its cues from the Paris Salon d'Automne of 1904, insofar as it devoted a series of special rooms to the forerunners of contemporary art. Whereas Fry had felt obliged to begin his survey with Manet, so as to provide an "underpinning" for the shock British visitors would experience in front of the disconcerting new movements, the German organizers obviously took it for granted that their public needed no lesson about the prevailing trends in nineteenth-century painting. They could, therefore, concentrate on those masters who, in their view, had spawned all the recent artistic innovations. These were evidently van Gogh, Cézanne, and Gauguin, the accent being on van Gogh, whose concepts, colors, and execution were particularly relevant to the efforts of the German Expressionists. While Cézanne was profoundly admired in Germany, it was

van Gogh – whose letters were already widely read – who exerted a stronger influence on the younger generation.

The Cologne exhibition presented no fewer than one hundred eight paintings by van Gogh (of which one-third had German owners) and sixteen drawings. There *88* was a room with twenty-six canvases and two watercolors by Cézanne (seventeen of which belonged to German collectors). Gauguin also had a special room, with twenty-five oils, watercolors, and pastels. Among other individually featured artists were Picassso and Munch. The exhibition was arranged in such a way that the visitor – after crossing five rooms filled with works by van Gogh – reached the collection of Cézannes, then proceeded to the Gauguin room, which was adjacent to Picasso's section. The effect of this condensation of recent stylistic tendencies must have been overwhelming. In addition, there was a room devoted to H.-E. Cross and Signac, not to mention – incorporated into their national groups – works by such younger artists as Cuno Amiet, Bonnard, Braque, Derain, Heckel, Hodler, Jawlensky, Kandinsky, Kirchner, Klee, Kokoschka, Marc, Matisse, Nolde, Pechstein, Schiele, Schmidt-Rottluff, Vlaminck, and Vuillard, to name only a few.

Although at least one otherwise appreciative reviewer pointed out that Matisse had not received his due, suggesting that after the Gauguin room a larger group of Matisse pictures would have made more sense,[30] and although the Cross–Signac ensemble could not compensate for the total absence of Seurat, there was an abundance of positive aspects. One of these was the unexpected and brilliant idea of including one true Old Master (not listed in the catalogue): in the midst of the room containing the early, dark canvases by van Gogh there hung a beautiful, almost elegant *John the Baptist* by El Greco, and it seems that additional works by him could be found in other rooms.

That El Greco should have been singled out as the one representative of the more distant past whose style appeared linked to the nineteenth and twentieth centuries, as the ancestor who offered a certain element of "actuality," is not altogether surprising. He had only recently been "rediscovered," thanks partly to Meier-Graefe who, on a 1908 trip to Spain, had been overwhelmed by the master's work, then still little known outside his adopted country. In a diary kept during the journey, Meier-Graefe gave eloquent testimony to his enthusiastic appreciation. One short entry from this diary, made after a visit to Vollard's during a stopover in Paris on the way back to Germany, seems sufficient to provide a clue to the artist's inclusion in the Sonderbund show: "In Toledo, in the Prado and in the Escorial it was Renoir and Cézanne who made the comprehension of El Greco more easy. And now in turn it was El Greco who made the moderns precious to us."[31]

Another remarkable innovation of the Cologne show was the magnificent installation, which underlined the clear concepts of historic evolution that had presided over the whole undertaking. All rooms were uniformly white with discreet *88* black skirting and black frames for doorways, providing an unobtrusive element of structure. The pictures were hung more or less symmetrically in single rows or one above the other, but with enough space between them to avoid any visual interference.[32] The rigor of this arrangement was softened by the presence of pieces of sculpture of varying size; among these were several works by Lehmbruck, notably his *Kneeling Woman*.

Despite the exceptional qualities of this exhibition, there were of course philistine voices that lamented (a) the presence of so many foreign works, (b) the influence of alien movements – such as Fauvism – on German artists, and (c) the obvious "degeneracy" of all modern art. But there were also favorable reactions, and one critic even went so far as to admit that, next to Cézanne, "Leibl, whom we venerate as our greatest artist, must appear . . . naturalistic, almost as a genre-painter." To this he added that Cézanne's "influence lies possibly still in the future; he is probably truly understood only by Picasso and, to some extent, Kokoschka."[33]

When Arthur B. Davies obtained a copy of the illustrated and well-presented catalogue of the Sonderbund show, he was so impressed that he urged Walt Kuhn as secretary of the Association of American Painters and Sculptors to rush to Germany.[34] Kuhn reached Cologne on September 30, the last day of the exhibition, but was permitted to visit it again while it was being dismantled.

On the very day of his arrival, Kuhn dashed off a postcard to his wife: "Sonderbund great show, Van Gogh and Gauguin great! Cézanne didn't hit me so hard. Am going back in half an hour."[35] Two days later he wrote at greater length. "Van Gogh and Gauguin are perfectly clear to me," he observed. "Cézanne only in part, although they say his exhibit is not evenly good, two or three are perfectly beautiful, a couple of portraits and one or two still lifes, his landscapes are still Greek to me, but wait, I'll understand before I get home."[36]

In New York meanwhile, Davies was busy raising funds. He was extremely good at obtaining contributions from various anonymous sources, which to this day have not been identified. He informed Kuhn that he was "gently milking a millionaire friend and must say I have big hopes for his help with our show – he still insists I am a bigger man than old Cézanne, and I shrink at such possibilities – that being the same old provincial loyalty which has hurt us so long."[37]

In Cologne, Kuhn met Munch and Lehmbruck and invited both to participate in the American exhibition. He then went on to The Hague in pursuit of loans of works by van Gogh but also saw there for the first time oils and pastels by Redon, to which he responded with great enthusiasm. After productive side trips to Munich and Berlin, Kuhn finally reached Paris. There the talk was of the massive Cubist presence at the Salon d'Automne and the Futurist exhibition held earlier that year at the Bernheim-Jeune gallery, which had since traveled to other European cities. It had been visited by a young New York dealer, Martin Birnbaum, who reported to Quinn: "There is also a great Futurist show here in which I am much interested. I wish I had some modern sympathetic person with money to back me up, and I would give America the exhibition of its life. . . . We are way behind the times in America, and I shall do my best to wake them up."[38]

Quinn, who cannot have failed to detect Birnbaum's barely veiled appeal for financial backing, apparently was already too involved with the Armory Show to pursue this matter separately. Moreover, he must have known that to "wake up" America was beyond the means of one sole and impecunious dealer. Stieglitz had been devoting himself to a similar goal and still had not been able to reach more than a small sector of the art-conscious public. Instead, it was decided that the Futurists should be represented in the Armory Show.

88 One of the Van Gogh rooms at the "Sonderbund" exhibition in Cologne, 1912

Pleased with the way things were progressing – though contact with the Futurists proved elusive – Kuhn informed his wife on October 23: "I am getting more information regarding all those freak cubists etc. . . . So far as I've gone everything has been O.K. and if I get the promised Van G's and Cézannes from the Hague and Berlin I think I can say that I have had more than a success."[39]

After the frantic negotiations of the past weeks, everything seemed to fall into place in Paris. "We have not been able to judge at home what this thing over here really means," Kuhn wrote. "The few imitators we knew could not do justice to it." Then he added on the subject of the Cubists: "I sum them up as intensely interesting now that I have had a chance to study them. . . . They have helped me understand Cézanne. He's growing every day with me."[40]

In Paris, Kuhn met his old friend Alfred Maurer and was introduced by him to Vollard who, as Kuhn later said, "although willing to listen remained somewhat non-committal."[41] But the task and responsibility of gathering loans in a comparatively short time in various countries became too taxing for Kuhn, even though – in addition to Maurer – Walter Pach had taken him under his wing in Paris.

As soon as Pach had read in the papers of the founding of the new association in New York and of its plans for a large international exhibition, he had written to Davies, offering his assistance because, as he put it, he knew "the most important artists, collectors and dealers."[42] Immediately Pach seems to have started looking for available pictures. When Charles Loeser informed him that a friend of Berenson, "Count" Enrico Costa,[43] wished to dispose of a Cézanne landscape, he told Davies, who thought the work might be of interest to Miss Bliss. Somehow the New York dealer William Macbeth also got involved in this affair, as shown by a letter Davies

wrote to him on September 13, 1912: "I enclose the last letter I received from Mr. Pach having reference to the Cézanne painting. Of course you know I am not the purchaser but only acting as advisor as to its quality and authenticity."[44]

When it became obvious that Pach's and Kuhn's efforts could not suffice for the tremendous job that had to be done, and when the responsibility for decisions that had to be made became too burdensome, Kuhn – late in October – cabled Davies for help. Davies arrived in Paris on November 6. For little more than a week the three Americans visited studios, galleries, and private collections, selecting and soliciting loans.

Davies immediately shared Kuhn's and Pach's admiration for the still little-known Redon who, it was decided, should be particularly featured in New York (he had been poorly represented in London and not at all in Cologne). It is a measure of the degree to which Davies enjoyed the confidence of Miss Bliss that he now discreetly reserved one of Redon's pastels for her, even though she had not yet begun to collect European art. It must also have been during this brief visit to Paris that Pach showed Davies the Cézanne painting about which they had corresponded; Pach alluded to it many years later when he wrote that he "bought for him (or, finally, for Miss Bliss) a landscape by Cézanne."[45] In fact, this work was included in the Armory Show without mention of either lender or price (usually listed for items that were for sale); it later turned up in the collection of Miss Bliss and was eventually bequeathed by her to the Museum of Modern Art. It was a strange choice, though, since the beautiful and lively lower part of the picture is in sharp contrast to the uniformly painted and completely flat upper part. That section – as was subsequently discovered – had been considerably repainted, partly because the canvas had been folded[46] and partly because it may have been otherwise damaged or was simply never finished.

Obtaining paintings by Cézanne proved to be something of a problem since Vollard, who had been perfectly willing to lend a representative group of them (as well as of works by Gauguin), became less amenable upon learning that his
X, 102 competitor, Druet, had agreed to send to New York his *Woman with a Rosary* (V.702), which had already been shown in London. Vollard may have considered this picture more important than any of the canvases he himself contemplated
82 lending; indeed, it belonged to the same, magnificent category as the still life he had recently sold to Mr. and Mrs. Eugene Meyer, Jr. Vollard's objections were finally overcome, not the least because it was agreed that the superb illustrated books he had published and his editions of lithographs by Cézanne as well as by Bonnard, Denis, Gauguin, Redon, Renoir, and Vuillard would also be displayed.

As a matter of fact, the six paintings by Cézanne that Vollard contributed to the undertaking were not among the artist's most startling works. It is likely that Vollard, as was his wont, did not let the organizers of the show choose what they wished, but instead himself determined what he would lend them. However, it is of course possible that the six paintings were selected precisely because they were least likely to shock an unprepared public. On the other hand, Vollard was then lending pictures by Cézanne right and left (not to mention works by Gauguin which were also in great demand). Early in 1912, he had participated with seventeen paintings by Cézanne – and also works by Gauguin, Bonnard, and others – in an exhibition at St.

Petersburg; he subsequently lent to the Paris Salon d'Automne and to Fry's second Grafton show in London; he may have been an unnamed participant in the Cologne Sonderbund Ausstellung (in which his frequent partners, the Bernheim-Jeunes, occupied an official function). In one way or another, Vollard may also have been involved in a number of smaller exhibitions organized mostly by commercial galleries. In the course of 1912 alone, there had been such events in Paris, Berlin, Dresden, Frankfurt, Munich, and Vienna. Both in Frankfurt and at the Salon d'Automne, Vollard had had to suffer the presence of Druet's *Woman with a Rosary* which now was also going to appear in New York. This canvas was obviously a thorn in his side.

In view of Vollard's susceptibility it became impossible to ask the Bernheim-Jeunes for loans of additional works by Cézanne; instead they contributed paintings by Bonnard, Matisse, Signac, Toulouse-Lautrec, and Vuillard. The majority of European lenders were dealers, who were evidently prompted by the desire of opening up a new and as yet untapped market for contemporary art. But a number of artists, approached directly, were similarly eager to avail themselves of this opportunity to reach the American public. However, mercantile considerations were probably not the only factor. The ardor of the three artist-ambassadors must have been infectious. Even Durand-Ruel, who had his own gallery in New York, agreed to lend seventeen Impressionist paintings; he may have hoped that in this way he would reach a public quite different from the affluent businessmen who were his usual clients, although some of the pictures he lent were not for sale. (The association was to receive a commission on all sales. It was expected that this would cover the considerable expenses of crating, shipping, and so on.)

The private collectors in Paris who proved most cooperative were all Americans: Egisto Fabbri lent two drawings by Ingres; Leo Stein lent one canvas by Matisse and two by Picasso; his brother, Michael, lent, two more by Matisse (none of these works was for sale); Leo also introduced Pach and his friends to Matisse himself, from whom they obtained further loans, almong them several that were already hanging in Fry's second Grafton show in London. But neither Fabbri nor the Steins were apparently willing to let any of their Cézannes travel to America. It does not seem impossible that the Steins felt a certain obligation to propagandize the work of their friends, whereas they may have considered the promotion of Cézanne to be the task of the various dealers who handled his paintings. If Pach did approach Auguste Pellerin or Charles Loeser in the hope of obtaining some Cézanne pictures from them, he must have met with refusals.

But this by no means dampened Kuhn's enthusiasm. "Our show is going to be fully as good as the one at Cologne, and that's going some," he announced from Paris five days after Davies's arrival. "We already have a better Cézanne and Gauguin collection than Cologne, only in Van G's they beat us. Our run of other material is much better."[47]

It may be ungracious to quarrel with this jubilant statement, but the truth is that as far as Cézanne was concerned, the group of his works shown in Cologne had not only been numerically far superior to what Davies, Kuhn, and Pach were able to assemble, but had also contained many more outstanding canvases. Not a single important still life had been garnered for the Armory Show, whereas there had been

several truly superb ones in Cologne; not a single view of Mont Sainte-Victoire or of Bibémus quarry would be seen in New York, while there had been at least one of each in the German exhibition, and although the *Woman with a Rosary* would cross the Atlantic, the Sonderbund had been able to present several fine figure pieces. On

97 the other hand, Vollard was lending a composition of bathers (probably V.384), of which there had been none in Cologne.

Altogether seven oils by Cézanne would be sent to New York; the promised loans from The Hague and Berlin, of which Kuhn had boasted to his wife, did not materialize. As a result, the number of Cézannes was in sharp contrast to the Redon shipment which comprised no fewer than thirty-one oils, six pastels, one black chalk drawing, and a large number of lithographs and etchings. It is true that the organizers hoped to borrow more works by Cézanne in the United States, while no Redons were likely to be added to the European contingent.

On their hurried return to New York, Davies and Kuhn stopped briefly in

89 London and managed to "raid" the Grafton exhibition, much to the annoyance of Roger Fry. They succeeded in obtaining the loan of some pictures which – in order to reach New York on schedule – had to be sent off before the actual closing date of the second Post-Impressionist show. Although there was no work by Cézanne among the pictures, to make up for these unexpected withdrawals, Fry quickly obtained twenty more watercolors by Cézanne from the Bernheim-Jeunes.[48]

Despite the crucial importance the organizers of the Armory Show attributed to Cézanne, he was of course neither their sole nor their main concern. The goal of their venture was to assemble on a continent which in those days still appeared to be far from Europe, everything that was new and unconventional and to exhibit it next to the best, most vital, and most advanced endeavors of their own countrymen. Since they had set out with a boundless energy that they knew could in no way be matched by their funds, what they achieved during their rapid mission abroad went beyond their most optimistic expectations. Elated though they were with the results, they also realized that the display of hitherto unknown and almost mythical European works of art would overshadow the American section of their exhibition. Kuhn had no illusions about this when he wrote his wife shortly before returning to the States: "The American annex of course will be a sad affair. Instead of being in any way depressed by seeing such great stuff, I feel great, and have mental material to last several years."[49]

No sooner was Kuhn back in New York than he fired off a long letter to Pach in Paris, requesting thumbnail biographies and even photographs of the more important French participants, to be fed to an information-hungry press that knew little or nothing of many of them. On December 12 he wrote:

> Today I gave the papers the list of European stuff which we know of definitely. It will be like a bomb shell, the first news since our arrival. You have no idea how eager everybody is about this thing and what a tremendous success it's going to be. Everybody is electrified when we quote the names, etc. The outlook is great.... Chicago has officially asked for the show, and of course we accepted....
>
> John Quinn, our lawyer and biggest booster, is strong for plenty of publicity, he says the New Yorkers are worse than rubes, and must be told. All this is not to my personal taste, I'd rather stay home and work hard at my pictures shoving in some of the things I have

89 Roger Fry(?) *View of the Second Post-Impressionist Exhibition, London, 1912*

learned, but we are all in deep water now and have got to paddle. – Don't disappoint me on this – Our show must be talked about all over the U.S. before the doors open. . . . We want this old show of ours to mark the starting point of the new spirit in art, at least as far as America is concerned. I feel that it will show its effect even further and make the big wheel turn over both hemispheres.'[50]

With this aim in mind, the organizers now set out to supplement the works obtained in Europe with loans secured in America. There were only a few collectors who owned works by Cézanne, and not all of them were willing to cooperate. Mrs. Montgomery Sears lent her small flower piece but not the large still life that had *10* belonged to Mary Cassatt. John Quinn offered his newly acquired portrait of the artist's wife (V.229). (He also lent thirty-seven works by his friend Augustus John *XI* and was altogether one of the most generous lenders to the show.) Professor John O. Sumner of Boston lent his small composition of harvesters (V.1517),[51] while a *8* recently established New York dealer of German origin, Stephen Bourgeois, not only lent a Cézanne self-portrait (V.514) from his private collection, but also *100* prevailed upon one of his clients, Sir William Van Horne of Montreal, to send a likeness of Madame Cézanne (V.520). Bourgeois had studied art history in Paris and *101* had been active there as a dealer since 1906, that is, about the same time as Daniel-Henry Kahnweiler, who also lent extensively. Bourgeois, who had moved to the United States in 1911, was represented by nine works of French nineteenth-century artists at the Armory Show, although for only one of these was a price listed.[52]

There was but one watercolor by Cézanne in the show, and it was lent anonymously. In all likelihood this was the one that Arthur B. Davies had recently purchased from Stieglitz (RWC428). In view of his active participation in the preparation of the exhibition, Davies may not have wished to be named as its owner. He also lent anonymously a marble torso by Brancusi, which he had purchased directly from the sculptor during his recent short stay in Paris. Yet three drawings by the French nineteenth-century artist Charles Serret were listed as belonging to Arthur B. Davies. None of Davies's loans were for sale.

Unfortunately, the people who were doubtless the three most important collectors of works by Cézanne in America did not cooperate. Henry O. Havemeyer had always been opposed to lending, but since his death in 1907, his widow had occasionally relented, especially where exhibitions of works by her favorite painter, Degas, were concerned. However, she had never lent any of her Cézannes before and certainly was not going to do so on this occasion, Mary Cassatt having insistently warned her against such "farceurs" as Matisse.[53] Even at that early date, Barnes had apparently already formed a pathological aversion to sharing his treasures with the general public. He abstained, despite the fact that his friend Glackens was among the initial members of the association and an exhibitor. While it is not known how many of Cézanne's works Barnes owned at the time, two years later, in April 1915, he could boast of "the fourteen Cézannes in my collection."[54]

The Eugene Meyers did not lend their picture either, although they were to prove more generous on future occasions. It is possible that their abstention was motivated by certain tensions in the Stieglitz camp. A rift was developing between Stieglitz and Steichen who, in 1912, had suggested in vain that a special issue of *Camera Work* be devoted to Cézanne.[55] Steichen had no connection with the Armory Show, and since the Meyers felt closer to him than to Stieglitz, they may have adopted a similar aloofness.

It is not known why the organizers did not ask for Steichen's collaboration; he had many contacts in Paris and more experience in obtaining loans than any other American there. Yet, at an unknown date Steichen wrote from France to Stieglitz: "I am certainly in the dark as far as the so-called 'big' exhibition in New York is concerned. Everybody is asking me about it, from Rodin to newspaper men – and I don't know a d———. Feel like a fool not to be able to say yes or no. I called on Brugière . . . his wife told me . . . that Hartley had told them about the big modern show in New York and that he was busy helping get things for it – that he had gotten some fine Van Goghs, etc. – He was out here with us for Thanksgiving dinner and never said a word about the exhibition in question – although I tried to lead to the subject several times."[56]

Stieglitz's own relationship with Davies seems to have been somewhat ambiguous and anything but warm,[57] but he did lend a drawing and a bronze by Picasso, as well as six drawings by Matisse; however, compared with other lenders, such as Bourgeois, Druet, Durand-Ruel, Hessel, Kahnweiler, the American dealer Macbeth, or notably Quinn, his participation was rather modest. Just the same, he was an honorary vice-president of the association (together with Monet, Renoir, Redon, Augustus John, and others). On January 16, 1913, he wrote to Davies: "I hope that the big show is coming along nicely and that there will be no serious hitch.

That the country is wildly interested is proven by the fact that I am receiving letters from every part of the United States inquiring about it. The 'art writers' are panic stricken."[58]

Ten days later, Stieglitz published an article in the *New York Sunday Times* in which he announced: "A score or more of painters and sculptors who decline to go on doing merely what the camera does better, have united in a demonstration of independence – an exhibition of what they see and dare express in their own way – that will wring shrieks of indignation from every ordained copyist of 'old masters' on two continents and their adjacent islands. This glorious affair is coming off during the month of February at the Sixty-ninth Regiment Armory in New York. Don't miss it."[59]

And Gertrude Stein received an enthusiastic letter from her old friend Mabel Dodge, who had arrived in New York late in 1912, informing her:

> There is an exhibition coming off the 15 Feb to 15 March, which is the most important public event that has ever come off since the signing of the Declaration of Independence, & it is of the same nature. Arthur Davies is the President of a group of men here who felt the American people ought to be given a chance to see what the modern artists have been doing in Europe, America & England of late years. So they have got a collection of paintings from Ingres to the Italian futurists taking in all the French, Spanish, English, German – in fact *all* one has heard of. This will be a *scream*! 2000 exhibits, in the great armory of the 69th Regiment! The academy are frantic. Most of them are left out of it. . . . Somehow or other I got right into all this. I am working like a dog for it. I am *all* for it. . . . There will be a riot & a revolution & things will never be quite the same afterwards.[60]

NOTES

1. Charles H. Caffin, "A Note on Paul Cézanne," *Camera Work*, April-July 1911, pp. 47–51. On Caffin see notably John Loughery, "Charles Caffin and Willard Huntington Wright, Advocates of Modern Art," *Arts Magazine*, Jan. 1985, pp. 103-9.

2. This somewhat unexpected statement is actually at odds with what Berenson was to write at the end of his life when he said that he could not see himself living with works so little in harmony with an Italian dwelling (see Epilogue, note 12).

3. Frederick Lawton, "Paul Cézanne," *Art Journal* (London), 1911, pp. 55–60.

4. Anonymous [James G. Huneker], "Seen in the World of Art," *New York Sun*, March 12, 1911.

5. Alfred Stieglitz to Fitzgerald, editor of the *New York Evening Sun*; quoted in Dorothy Norman, *Alfred Stieglitz: An American Seer* (New York: Random House, 1960), p. 109. The letter also states: "Should the Metropolitan desire to extend the scope of the exhibition, it might include the work of Matisse and Picasso, two of the big minds of the day expressing themselves in paint." (Stieglitz Archive, Beinecke Rare Book and Manuscript Library, Yale University.)

6. Alfred H. Barr, Jr., *Matisse: His Art and His Public* (New York: Museum of Modern Art, 1951), p. 139.

7. Bryson Burroughs to John G. Johnson, New York, March 6, 1913; Archives of the Metropolitan Museum of Art, New York.

8. See Agnes E. Meyer, *Out of These Roots: The Autobiography of an American Woman* (Boston: Little, Brown, 1953).

9. Edward Steichen to Alfred Stieglitz [Paris], n.d. [early 1912]; partly quoted by Dennis Longwell, *Steichen: The Master Prints, 1895–1914* (New York: Museum of Modern Art, 1978), p. 136; more extensive excerpts from leaf 259, Stieglitz Archive, Beinecke Rare Book and Manuscript Library, Yale University, courtesy Dennis Longwell.

10. Information courtesy Mrs. Pare Lorentz, daughter of Eugene and Agnes E. Meyer.

11. Douglas Cooper, "Masters, Maniacs & magna opera," *Books and Bookmen*, April 1979, has suggested that the man who posed in a sailor's cap for V.716, V.717, and the Meyer version is *not* identical with the one generally identified as the gardener Vallier, represented in V.715, V.718, V.1092, V.1102, and V.1524. This observation appears to be justified.

12. On this transaction see John Rewald, *Paul Cézanne: The Watercolors* (Boston: New York Graphic Society; London: Thames and Hudson, 1983), pp. 30, 40, note 32.

13. Archives of the Bernheim-Jeune gallery, Paris, courtesy M. Henry Dauberville. The pictures traded by Pellerin for V.716 were two Cézannes, *Femme à la poupée* (V.699) and *Les Contrebandiers* (V.108), a head of a woman by van Gogh, and *Monsieur Laporte* by Toulouse-Lautrec.

14. Vollard quoted in Phyllis Hattis, "Zu den Bildern in der 'Schanzmühle,'" *Du*, Aug. 1978, p. 45.

15. It is not easy to provide comparative prices, but in 1910 Vollard had sold Cézanne's *Fumeur* (V.686) for 35,000 francs ($7,000) and in 1912 a late landscape, *Paysage bleu* (V.793), for the same price to Morosov; see Barskaya, *Paul Cézanne* (Leningrad: Aurora Art Publishers, 1975), pp. 184, 189.

16. Barnes's former schoolmate, John Sloan, gives a slightly different version in his *Gist of Art* (New York, 1939; reprinted, Dover, 1977), p. 25.

17. William Glackens to his wife, Paris, Feb. 16, 1912; see Ira Glackens, *William Glackens and the Ashcan Group* (New York: Crown, 1957), p. 158.

18. According to information kindly supplied by Miss Violette de Mazia, Director of Education, Art Department, Barnes Foundation, Merion, Pa., Dr. Barnes did not keep any chronological records of his purchases.

19. On this subject see Chapter I, note 9 and Chapter IV, note 13 above.

20. Mary Cassatt to Louisine Havemeyer, Mesnil-Beaufresne, Nov. 13 [1910]; partly quoted in *Cassatt and her Circle: Collected Letters*, ed. Nancy Mowll-Mathews (New York: Abbeville, 1984), pp. 301–02.

21. Mary Cassatt to Louisine Havemeyer, Mesnil-Beaufresne, Sept. 6 [1912]; partly quoted by Frances Weitzenhoffer, *The Havemeyers: Impressionism comes to America* (New York: Harry N. Abrams, 1986), pp. 207–08.

22. Mary Cassatt to Louisine Havemeyer, Mesnil-Beaufresne, Oct. 2 [1912]; partly quoted by Frances Weitzenhoffer, ibid., p. 208.

23. John Quinn, "Modern Art from a Layman's Point of View," *Arts and Decoration*, March 1913, p. 157 (special Armory Show issue). Quinn's assertion was based on a wholly inaccurate newspaper report. In reality the French Council of Museums had voted to spend altogether 200,000 francs ($40,000) at the Rouart sale, to be divided as follows: 150,000 francs for Corot's *Femme en bleu* (for the Louvre), 30,000–40,000 francs for *L'Espérance* by Puvis de Chavannes (for the Luxembourg museum), and the balance for drawings. The Corot was eventually acquired for 172,530 francs and the Puvis de Chavannes for 62,000 francs. This being the end of the year, museum funds were depleted and the council had trouble obtaining the necessary credit. At no time was there any question of bidding on the Degas, especially since the Camondo bequest with several masterpieces by that artist had been unanimously accepted by the same council on May 8, 1911, and was to enter the national collections by government decree on Dec. 17, 1912, that is, only a few days after the Rouart auction. It was said that the underbidder on the famous Degas (bought for Mrs. Havemeyer by Durand-Ruel) was the Spanish painter José-Maria Sert. Information courtesy Mme Hélène Adhémar, honorary Conservateur en Chef des Galeries du Jeu de Paume et de l'Orangerie, Paris.

24. On the Armory Show, see especially Milton Brown, *The Story of the Armory Show* (Greenwich, Conn.: New York Graphic Society, 1963).

25. A little later Stephen C. Clark relied on the opinions of Eugene Speicher; at least one subsequent American collector with a true passion for Cézanne, Carroll S. Tyson, Jr., was a painter, while Duncan Phillips was married to one.

26. Walter Pach, *Queer Thing, Painting* (New York: Harper & Brothers, 1938), p. 20.

27. Brown, *Story of the Armory Show*, p. 30.

28. Ibid., p. 31.

29. The exhibition was composed of three distinct groups of living artists: British, French, and Russian. This time Matisse and after him Picasso occupied the most prominent places, with loans from both Leo and Michael Stein.

30. See P. F. Schmidt, "Die internationale Ausstellung des Sonderbundes in Köln, 1912," *Zeitschrift für Bildende Kunst*, July 1912.

31. Julius Meier-Graefe, *Spanische Reise* (Berlin: S. Fischer, 1910); here quoted from *Spanish*

Journey, trans. J. Holroyd-Reece (London: Jonathan Cape, 1926), pp. 457–58.

32. On this exhibition, see particularly Günter Aust, "Die Austellung des Sonderbundes 1912 in Köln," *Wallraf-Richartz Jahrbuch*, 1961, pp. 275–92; also the illustrated catalog with a floor plan and a list of exhibits room by room in *Internationale Kunstausstellung des Sonderbundes westdeutscher Kunstfreunde und Künstler zu Cöln, 1912*.

33. Schmidt, "Die internationale Ausstellung," p. 230.

34. For Davies's letter to Kuhn of Sept. 2, 1912, see Philip R. Adams, *Walt Kuhn, Painter: His Life and Work* (Columbus: Ohio State University Press), 1978, p. 46.

35. Walt Kuhn to his wife [Cologne], Sept. 30, 1912; ibid., p. 46.

36. Walt Kuhn to his wife [Cologne, Oct. 2, 1912; ibid., p. 47.

37. Arthur B. Davies to Walt Kuhn [New York], Oct. 1912; ibid., pp. 48–49.

38. Martin Birnbaum to John Quinn [Copenhagen, July 1912], quoted in J. Zilczer, *"The Noble Buyer": John Quinn, Patron of the Avant-Garde*, exhibition catalog, Hirshhorn Museum and Sculpture Garden, Washington, D.C., 1978, p. 26.

39. Walt Kuhn to his wife [Paris], Oct. 23, 1912; Adams, *Walt Kuhn*, p. 48.

40. Walt Kuhn to his wife, Paris, Nov. 6, 1912; ibid., p. 50.

41. Walt Kuhn, *The Story of the Armory Show* (New York: Walt Kuhn, 1938), p. 10; reprinted in *The Armory Show*, vol. 3, *Contemporary and Retrospective Documents* (New York: Arno Press, 1972).

42. Walter Pach, "A Recollection of Arthur B. Davies," *Arthur B. Davies Exhibition*, exhibition catalog, Whitney Museum of American Art, New York, 1962–63, p. 5.

43. Enrico Costa, noble or not, was born in Paris of Italian parents. A scholar at heart, he had known Berenson during the latter's early years in Europe; they often traveled and studied together. Costa's name appears repeatedly in Berenson's writings. But at some point he apparently was dropped from Berenson's circle, possibly because he had struck up a close friendship with Loeser. Costa died suddenly on Dec. 6, 1911, in Florence, at the age of forty-four and Loeser informed Berenson in a long letter of his last hours. An obituary that had appeared in 1912 in *Rassegna d'Arte* was found among Berenson's papers (courtesy Professor Ernest Samuels). According to this text, Costa had been interested not only in the Italian Renaissance but also in Japanese art and, as a result, had become "one of the first to understand the innovative quality of French Impressionist painting...." As early as 1892 he supposedly owned one painting each by Degas and Cézanne "which – with his old master paintings – strangely constituted his small but select collection." Costa may have learned about Degas from Berenson, but it was probably Loeser who urged him to buy the painting by Cézanne; this, however, must have happened after 1895 rather than in 1892. It is somewhat intriguing that Loeser should have referred to Costa as a "friend of Berenson" when he endeavored to sell the Cézanne painting, obviously for Enrico Costa's estate.

44. Arthur B. Davies to William Macbeth [New York], Sept. 13, 1912. This letter, written *before* Davies left for Paris, also said: "I think Mr. Pach can be reached by cable in Paris – *maybe* Count Costa bought the painting of a dealer there?" Macbeth, Papers Archives of American Art, Roll NMc37:1135. This document was brought to my attention by Doreen Bolger Burke.

45. Pach, "A Recollection," p. 5.

46. See Alfred H. Barr, Jr., *The Lillie P. Bliss Collection*, exhibition catalog, Museum of Modern Art, New York, 1934, no. 2, p. 22, catalog entry by Jerome Klein.

47. Walt Kuhn to his wife, Paris, Nov. 11, 1912; Adams, *Walt Kuhn*, p. 50.

48. The existence of the supplement to the second Post-Impressionist show at the Grafton galleries was only recently discovered by Jayne Warman; it is therefore not recorded in her list of exhibitions of Cézanne's watercolors appended to Rewald, *Paul Cézanne*, p. 470.

49. Walt Kuhn to his wife, Paris, Nov. 11, 1912; Adams, *Walt Kuhn*, p. 50.

50. Walt Kuhn to Walter Pach, New York, Dec. 12, 1912; ibid., p. 52.

51. On this picture, see Chapter I, note 33.

52. Stephen Bourgeois came from an old Cologne family, three generations of which had been art dealers. After arriving in New York in 1911, he opened a gallery in 1914. He distinguished himself as advisor to Adolph Lewisohn, the catalog of whose collection he published in 1928. Unfortunately, this catalog does not indicate when Lewisohn began to assemble his very important collection, nor when or from whom individual purchases were made.

53. Nancy Hale, in *Mary Cassatt* (Garden City, N.Y.: Doubleday, 1975), p. 251, quotes a 1913 letter from Mary Cassatt to Mrs. Havemeyer in which Cassatt states "Matisse is a facteur" and learnedly explains the meaning as "[literally, a postman; in slang, 'the bad news,' as of a bill come due]." Unfortunately, Hale's knowledge of French slang is even more rudimentary than her ability to read Cassatt's handwriting. No saying even faintly resembling "facteur" and "bad news" exists in French The misread expression is simply *farceur*, which can be found even in Webster.

54. Albert C. Barnes, "How to Judge a Painting," *Arts and Decoration*, April 1915, quoted in Henry Hart, *Dr. Barnes of Merion – An Appreciation* (New York: Farrar Straus, 1963), p. 56.

55. Instead, Stieglitz published a special issue in Aug. 1912 devoted to Matisse and Picasso, which also featured Gertrude Stein's word-portraits of the two artists. When Steichen received it, he acknowledged it with the following observation: "The Matisse Picasso number was good in every way – and I suppose it served a purpose you had and saw – but I feel it was putting the cart before the horse. – A Cézanne number would have seemed more logical but of course the text must have been your chief reason in itself. – The first time I read it of course I laughed – the second time [it] interested me [;] the next time I got it. And now I don't care if I ever read it again." (This document, in the Stieglitz Archive, Beinecke Rare Book and Manuscript Library, Yale University, was brought to my attention by John Cauman.)

In June 1913 (after the Armory Show), *Camera Work* was to bring out a special issue with some reproductions of works by Cézanne.

56. Edward Steichen to Alfred Stieglitz, Voulangis, France, n.d.; Stieglitz Archive, Beinecke Rare Book and Manuscript Library, Yale University. This document was brought to my attention by Dennis Longwell.

57. Brooks Wright, in *The Artist and the Unicorns: The Lives of Arthur B. Davies* (Rockland County, N.Y.: The Historical Society, 1978), p. 59, says on this subject: "Curiously, there seems to be nothing – not so much as a letter or an anecdote – linking Davies and Stieglitz." This, however, is somewhat of an exaggeration, since there are letters from Stieglitz to Davies of which Stieglitz preserved carbon copies; see note 58 below and Chapter VIII, note 7.

58. Alfred Stieglitz to Arthur B. Davies [New York], Jan 16, 1913; Stieglitz Archive, Beinecke Rare Book and Manuscript Library, Yale University. This document was brought to my attention by Francis M. Naumann.

59. Alfred Stieglitz, *New York Sunday Times*, Jan. 26, 1913.

60. Mabel Dodge to Gertrude Stein, Atlantic City, Jan. 24 [1913]; *The Flowers of Friendship: Letters Written to Gertrude Stein*, ed. Donald Gallup (New York: Alfred A. Knopf, 1953), pp. 70–71.

VIII · Cézanne at the Armory Show

AND THUS it happened. Even though – after London and Cologne – New York was something of a Johnny-come-lately in the international steeplechase of modern art, at least it arrived with a superb bang!

In many ways it was a miracle that what Stieglitz had announced as a "glorious affair" came off at all. Those responsible for it had scurried in all directions like frantic ants, picking up and accumulating whatever they could, assembling vast numbers of works of art in a chilly new armory that had nothing to offer but tremendous space. Yet, in the words of Frederick James Gregg, public relations representative for the Association of American Painters and Sculptors, "within less than half a week, the handsomest exhibition hall ever seen in America was brought into existence."[1] Even an otherwise unimpressed reviewer had to concede that simply with "good taste and good managment, the floor of the . . . armory has been converted into fifteen galleries with a spacious entrance hall. The light streams in from above, the hanging is effective."[2] Everywhere there were potted plants and freestanding sculptures, while the walls and partitions were crowded with pictures hung literally frame to frame.

Admittedly, the organizers of this enormous exhibition did not command the erudition and aesthetic discernment of a Roger Fry, nor the sober concentration and rigor that had made the Cologne show so memorable, but what they lacked in experience was amply compensated for by their enthusiasm and devotion. If the result appeared overwhelming as well as confusing, it was because there had not always been time for careful selection and for coordination. It would seem that in the absence of a strict plan as to what was desirable and what was to be avoided, the organizers wound up taking more or less whatever they could get, so that, finally, the exhibition resembled a grab bag of anything that was new, merely interesting, or simply available.

As far as masters of the past were concerned – those who could be considered the progenitors of all recent tendencies – there was a smattering of their works although no really cohesive representation, ranging from a sixteenth-century Italian drawing to a Goya miniature, from two drawings by Ingres to one painting by Delacroix, from a few oils by Corot, Daumier, and Whistler to a picture by Monticelli, and from proportionately too many works by Puvis de Chavannes (a favorite of Arthur B. Davies and John Quinn) to four canvases by Manet, the authenticity of one of which was subsequently questioned by its lender, who was none other than Frank Jewett Mather, Jr., of Princeton.[3] The representation of more extensively featured artists

was strangely unbalanced. While Redon was allotted thirty-seven paintings and pastels (and, in addition, many lithographs and etchings), Augustus John had thirty-eight works in the show, due once more to Quinn's sponsorship. It is true that among these were only twenty-one oils, the rest being drawings and gouaches. No American, dead or alive, could boast a comparable number of exhibits, the organizers themselves being extremely modest in their allotments.

Because the exhibition was not meant to defend any specific viewpoint but was aimed at providing a general panorama, Impressionists like Monet, Pissarro, Renoir, Sisley, and also Degas, who had been absent from both the London and Cologne events, were represented by up to five works each (all lent by Durand-Ruel), and this despite the fact that the American public had had quite a few occasions to become acquainted with them.

Whereas Matisse had been relatively neglected and Picasso emphasized in Cologne, New York reversed the procedure, showing seventeen works by the former (including notably sculpture) and only eight by the latter. Neither the Cologne nor the London nor the New York exhibition attempted to treat these two as equally significant leaders of contemporary art, as the Steins had originally perceived them. Van Gogh was given the lion's share among the immediate precursors of modern art, as had been done in Cologne. There were seventeen paintings by him and one drawing (a far cry from his share in the Sonderbund show), compared with thirteen oils and one watercolor by Cézanne and thirteen works by Gauguin, in addition to their prints lent by Vollard. Seurat and Toulouse-Lautrec occupied minor positions with two and four paintings respectively, but since there had been only two paintings by the former and none by the latter at the Grafton Gallery, and since neither artist had been seen in Cologne, the Americans made it clear that they were not following anybody else's selections but had made their own choices. This they also demonstrated by so heavily favoring Redon and including such newcomers as Brancusi, Picabia, Marcel Duchamp and his two brothers, as well as many others. However, the works of the participants were not necessarily hung together (nor did the hastily prepared catalogue list them consecutively), so that visitors did not easily become aware of their individual representation.

Among American exhibitors, too, there were cases of overemphasis or understatement, as almost had to be expected from an enterprise whose several organizers did not always know what the others were doing. And there were also problems of pride. When only two canvases by Max Weber were selected instead of the eight or ten to which he felt "entitled," he decided to withdraw his pictures altogether. He did, however, agree to lend the small works by the *douanier* Rousseau that he owned. On the whole, the various artists associated with Stieglitz did not fare conspicuously well; Abraham Walkowitz may have come off best with five paintings and a number of drawings, though Marin was represented by ten watercolors. One of the peripheral oddities was the case of Mary Cassatt, who had one oil and one watercolor in the show, the first lent by Durand-Ruel, the second by John Quinn. She herself did not lend anything and – if consulted – would doubtless have refused to be seen in the company of the "wild men" and others whose products had horrified her on her memorable visit to the Steins. Most other living artists lent eagerly to the show, among them Matisse.

What mattered in the end was the assembly under one roof of so many works of different and even clashing tendencies, illustrating through the best available examples the amazing variety of contemporary art. Due to prior commitments, only the Futurists were unable to participate in the event. But beyond being a pioneering venture, the Armory Show was also an extremely brave gesture, organized as it was by a group of artists who – in the eyes of many – saw themselves relegated to a back seat as they played host to all that was new and daring and, almost exclusively, came from abroad. "There is," wrote one reviewer, "a distinct self-sacrificing and public-spirited willingness to center the interest of the show in the foreign exhibits."[4]

Yet there were also those who, confronted with what appeared to be utterly bewildering if not shocking, found reassurance in American art because it was less venturesome and outrageous, although Arthur B. Davies and his friends may not have expected such a reaction or wished for it. Whereas the exhibition did not present a complete overview of recent international tendencies, it did accentuate the considerable gap that existed between that which was being created in America and that from across the Atlantic. One American painter later lamented, "Our land of opportunity was thrown wide open to foreign art, unrestricted and triumphant; more than ever before, we had become provincials."[5] This attitude, however, was not too widely shared. While the organizers were running the risk, as their spokesman put it, "of the deadly comparison which is sure to be made by the newly awakened and even by the casual spectator,"[6] they offered their fellow artists an opportunity to study what had been achieved elsewhere and thus to catch up with more advanced currents.

How well the Armory Show reflected all these tendencies could of course be judged only by those already familiar with the European art scene. Alfred Stieglitz, who had been a pioneering link with that scene, sent a congratulatory letter to Davies the very day of the opening. "A vital blow has been struck," he wrote. "Whether Cézanne, Van Gogh or any other individual is fully represented or not makes but little difference. Whether the pictures can be represented more efficiently or not is also immaterial in view of the actually big fact established. You have done a great work. My compliments also must be extended to all those who helped you to realize the big task you set yourself."[7]

Did Stieglitz change his mind as time passed and he had the opportunity to study the displays more thoroughly, or was he simply an editor tolerant of his authors' views? In the June issue of *Camera Work* he published an article by the painter Oscar Bluemner, one of the participants in the Armory Show, who pointed out that "the work undertaken by the originators of the show failed through their ambition. Moreover, the two important masters and fathers of the art-revolution, Cézanne and Van Gogh, were quite inadequately represented by the number as well as the quality of their pictures. Neither was the European section, generally, a complete survey of the variety of modes of expression that make up the new movement."[8]

The question of what mattered more in those days, the judicious proportioning of individual representations or the mere fact of assembling such an international event of a heretofore unknown scope, will probably never be answered. But although there were many who did not "like" what they saw, Bluemner's attitude was not generally

shared, if only because to most visitors the exhibition offered their first access to any of the new tendencies. At the same time, the initial press reviews, even when somewhat bewildered and negative, admitted that the show was an organizational triumph.

In the words of Guy Pène du Bois, then editor of *Arts and Decoration*, which devoted a special – and sympathetic – issue to the exhibition, "the Armory Show was an eruption only different from a volcano's in that it was made by man. To the American critics it was like a shot in the dark. Unforeseen, it had to be met without preparation. They had heard a little of the famous trio – Cézanne, Van Gogh and Gauguin, and perhaps seen some scattered examples of their work. The majority of them were just beginning to learn the language of art criticism."[9] As Walt Kuhn cynically explained to him, "The reason the American critic was never bought or bribed was because he was not worth buying."[10]

The fact is that the huge exhibition suddenly confronted an unprepared public and an almost equally unprepared press with a tremendous harvest of aesthetic experiences, although with it came the difficult task of separating wheat from chaff. In the midst of violent assaults by visual cacophonies, not everybody noticed the subdued voice of Cézanne. While the vibrant colors of Matisse vied for attention with the puzzling cubes of Picasso and the mystifying titles that accompanied Duchamp's enigmatic pictures, there were so many "much-talked-about" works to see that Cézanne occasionally escaped the attention of those merely hunting for a new kind of thrill. Indeed, the *succès de scandale* of the show sometimes dangerously obscured its countless positive aspects.

When it was all over, the painter Kenneth Hayes Miller wrote to his friend Rockwell Kent about the "great sensational success though artistically I am sure less must be said. It was in fact so very sensational that people could not get into the frame of mind to take it in the spirit of art and they scarcely made the effort. Notwithstanding this there can be no doubt the exhibition had a broadening influence and accomplished in a few weeks what in the ordinary course would have taken many years. It was like setting off a blast of dynamite in a cramped space – it blew everything wide open. I feel that art can really be free here now.'[11]

Since they had certainly not expected a success that would neglect "the spirit of art," the organizers had done everything to provide information and enlighten serious visitors. Just as Roger Fry had translated Maurice Denis's article on Cézanne in conjunction with the first Grafton exhibition, so Walter Pach now rendered into English Elie Faure's essay on the painter, the very one he had originally brought to the attention of Arthur B. Davies. In addition, Pach – who had come to New York for the show – wrote a short text on Redon, while Walt Kuhn translated excerpts from Gauguin's *Noa Noa*; all were published as pamphlets by the Association of American Painters and Sculptors.[12]

Faure's study was a poetic evocation of Cézanne's background and a psychological interpretation of his attitude toward life and art. It also provided biographical data (partly based on Emile Bernard's writings) and socio-philosophical considerations on his historic position, together with general observations on the painter's work. Cézanne, Faure explained,

seized any object without the least concern as to its ugliness or beauty, and it was then that his choice began. The object took a character of unity and expressive force so strong that it governs like a law. From the world he interrogated there issued a synthesis in which the bare summits of the idea strike the mind like the rhyme at the end of a verse. Never the shade of an anecdote; never a concession; not a single effort to interest or please. He was purely and simply a painter, one for whom facts had no interest and who seized only certain generalities in a world which they organized for him according to inexorable laws of harmony. Never had anyone accepted the whole of visible life with such complete indifference – to transport it to the life of the spirit with such a sober splendor. . . . He was a painter. Nothing in the world attracted him save the combination of form and color that light and shadow impose on objects to reveal to the eye laws so rigorous that a great mind can apply them to life and through them demand its directions – metaphysical and moral.

In view of the more recent evolution of painting, Faure specified:

Cézanne classified all the aspects of nature according to the sphere, the cone and the cylinder. But though always synthesizing the images in which these figures made their imprint on his mind, he never went in his pictures to the point of linear abstraction. When he spoke of reducing the world to those simplified figures, he was only borrowing from the language of mathematics the purest symbol he could find to express his tendencies. But he remained a painter. . . . If in the world of the senses he perceived spiritual correspondences, it was through the world of the senses that they revealed themselves to him and to that world they always brought him back.[13]

It is difficult to say how much this essay contributed to a wider understanding of Cézanne in America; no references to Faure's pamphlet can be found in reviews of the Armory Show or in the texts of those who subsequently wrote about it.

After a somewhat sluggish attendance during the first two weeks, tremendous crowds began to stream through the Armory. Dr. Barnes endeavored to collect newspaper clippings for Leo Stein, whom he subsequently informed that the show had proved a big money-maker for the organizers. The attendance was frequently 10,000 a day, many paintings were sold and the newspapers had columns almost daily about it. Barnes also reported that academic art had received a blow from which it would never entirely recover. The works of Matisse – the critics said – did not indicate that he was as great a painter as he had been acclaimed. Picasso and the outré Cubists got more attention than all the rest of the show but the public attitude toward them was largely that of amusement, curiosity and derision. And Barnes added, obviously tongue-in-cheek, "You had better sell all your Picassos."[14]

A few days after the opening, Quinn stated in an article that "up to this time those who like myself are interested in vital contemporary art, have had to go abroad to see it, and when like myself they make their annual visit in the summer, they miss the exhibitions in London and Paris in the autumn and spring."[15] Quinn's frustrations notwithstanding, the real historic importance of the exhibition was that it brought vital contemporary art to those who had never been abroad, who could not afford annual trips to Europe, in either autumn, spring, or summer. It was for them, thirsting for initiation and firsthand experience, to whom Cézanne, van Gogh, Matisse, or Picasso had been only names, that this show opened new horizons. They had read about these painters, but what does even the most eloquent article provide to someone who has never seen the work itself? Moreover, eloquent articles had not

X, 102 been plentiful. Having been impressed by a black-and-white reproduction of Cézanne's *Woman with a Rosary* (V.702), discovered almost accidentally in an issue of the *Burlington Magazine*, how would John Sloan react once he stood before the original with its intense, barely concealed emotion, its uncommon colors, its heavy crust of pigment, evidence of long, sustained labor?[16]

No American artist or art lover, young or old, who visited the overpowering Armory Show, was the same afterward. For the first time it became possible to discuss Cézanne's impact, to look and study, to absorb or reject without leaving these shores. Cézanne, who – like so many other artists in the exhibition – had been a mystery, now became a reality. He could, at last, take his place among his contemporaries, such as the Impressionists who no longer offered any real "surprises." Yet Cézanne's works were by no means the focus of the exhibition, nor were they the most controversial among the foreign imports.

Works of art have a real impact only on those who are "ready" for them, who wish to absorb what they have to offer instead of approaching them with preconceived ideas. The people who went to the Armory Show to laugh and jeer were not likely to appreciate Cézanne. When Maurice Sterne, at the Salon d'Automne, had found his way to Cézanne, it was not because he was overwhelmed by his greatness, but rather because he had been disapppointed by those he had come to admire and because this collapse of his values had made him receptive to new experiences. No masterpiece by Cézanne or Matisse or Picasso could expect to stir the sensitivities of those who were steeped in academic concepts, be they painters, critics, or the proverbial "man in the street." Cézanne's influence – and that of other moderns as well – was obviously strongest on younger artists still in their formative years who welcomed him with tremendous expectations, prepared to be convinced of his supremacy. Yet there are few specific testimonials as to what such first confrontations meant to the many American painters in whose lives the Armory Show became a pivotal date.

One of the few painters who left a record of how he experienced the exhibition was the then eighteen-year-old Stuart Davis, who informed a cousin that the room with the works of Cézanne and van Gogh was "in many respects the most notable gallery. . . . Wonderful."[17] But in later years, when evaluating what the Armory Show had meant to him, Davis no longer mentioned Cézanne, saying that he "responded particularly to Gauguin, van Gogh, and Matisse because broad stylization of form and the non-imitative use of color were already practices within my experience. I also sensed an objective order in these works which I felt was lacking in my own."[18]

With reviewers the situation was quite different; their own outlook and production were not directly related to how they responded to Cézanne. As a matter of fact, their reactions appeared perfectly predictable, conditioned as they were by their own previous performances. Critics seldom visit exhibitions with an unbiased frame of mind, ready – if warranted – to be "swept away" by what they see, willing even to reverse or contradict themselves in order to do justice to a new discovery. Instead of looking for promising talents among the hosts of unknown or insufficiently appreciated artists at the Armory Show, they found there a chance to elaborate on their philosophies by illustrating their ingrained prejudices, both pro and con, with examples in the exhibition.

This was exactly what had happened at the Post-Impressionist exhibition in London, when the English sculptor Eric Gill had reported to a friend:

All the critics are tearing one another's eyes out over it and the sheep and the goats are inextricably mixed up. [Augustus] John says "it's a bloody show" and Lady Ottoline [Morell] says "oh charming", Fry says "what rhythm" & MacCall says "what rot". As a matter of fact, those who like it show their pluck and, those who don't, show either great intelligence or else great stupidity. The show quite obviously represents a reaction and a transition and so if, like Fry, you are a factor in that reaction and transition then you like the show. If, like MacCall & Robert Ross, you are too inseparably connected with the things reacted against and the generation from which it is a transition, then you don't like it.[19]

Frank Jewett Mather, Jr., now professor of art history at Princeton, deployed his legendary "common sense" to deal with the newest tendencies in art as embodied in Post-Impressionism. He regretted that Cézanne no longer cut the impressive figure that he had noticed in 1898,[20] thus implying that the artist had somehow grown weaker in the intervening years while he, Mather, had strengthened his critical perceptions. Although he did appreciate the *Woman with a Rosary* (V.702), he added that some of Cézanne's "paler landscapes have for me the exquisite balance of John Twachtman's."[21] As Mather put it, Cézanne, "formerly the 'last word' of the radical in art . . . now is all but a back number with those who run with Matisse and his fellows." The fact that Matisse himself constantly spoke of Cézanne to his students did not seem to affect Mather's concept of the Post-Impressionist artist who, according to him, "boils within and overflows upon the canvas without any aid from outside, just as a sufficiently enterprising and self-centered silk worm might convert himself into fishing gut by raveling out his own insides. Such is the doctrine of Matisse and his followers. 'We express ourselves immediately in paint,' is their cry; 'and our forms and colors are not those of nature, but those of our own inner emotions.' In such a view lies either lamentable self-deception or utter charlatanry." Mather was tempted to opt for the latter when he concluded, "So far as Post-Impressionism rests on a desperate struggle for originality and a false theory of the emotions it is a negligible eccentricity which will soon run its course."[22]

It is one of the ironies of history (which occasionally is endowed with a splendid sense of humor) that exactly the same words – "self-deception," "charlatanry," "eccentricity," and others – had not so long ago greeted the first exhibitions of the Impressionists in Paris. But the historian Mather obviously had learned nothing from the blunders of his colleagues.[23] If a respected Princeton professor could venture to predict the early demise of modern art (and compare Matisse to a silkworm), why be surprised that a journalist with a solid reputation for reactionary views now gleefully jumped into the fray? Where Mather had prudently abstained from discussing Cézanne at greater length, Royal Cortissoz was only too happy to explain that Cézanne was actually at the root of much of the present evil.

He wrote:

His style was rough to the point of brutality. Sometimes the object is clearly and handsomely realized in his work. More often it is lost in an obscurity of coarse, unlovely pigment. He is one of those types who convey the impression that they are feeling their

way toward something large and beautiful, but never have fully mastered a sound technical method. Looking at Cézanne quietly and disinterestedly, one would recognize in him a rather crochety man of talent, many of whose pictures should have been discarded as crude attempts. . . . Cézanne was simply an offshoot of the Impressionist School that we know, who never quite learned his trade, and accordingly, in his dealings with landscape, still-life, and the figure, was not unaccustomed to paint nonsense.

After this "quiet and disinterested" approach, Cortissoz's conclusion was of a rather partisan harshness: "From the incomplete, halting methods of Cézanne, there has flowed out of Paris into Germany, Russia, England, and to some slight extent the United States, a gospel of stupid license and self-assertion which would have been swept into the rubbish-heap were it not for the timidity of our mental habit."[24]

Cortissoz was not alone in fighting this reprehensible "timidity." His article actually appeared after similar opinions had been voiced by Kenyon Cox, who spoke with the authority of a veteran fighter against new ideas, a man who could truly be called a reactionary's reactionary. With the pompous joviality becoming a National Academician reputedly "recognized here and abroad [?] as one of America's foremost painters," Cox told a *New York Times* interviewer that the decline of art had begun with the Impressionists because they denied "the necessity of any knowledge of form and structure." This process, according to him, had led to Cubism and Futurism (a movement *not* represented at the Armory) whose aim, as Cox saw it, was to "simply abolish the art of painting." It came as no surprise to Cox's friends and admirers – nor to his foes, for that matter – that he considered the exhibition both pathological and hideous. But he went further, following a line of thought previously expressed by Walter Sickert in connection with the first Grafton show in London. "With Matisse . . . and above all with the Cubists and the Futurists," Cox explained, "it is no longer a matter of sincere fanaticism. These men have seized upon the modern engine of publicity and are making insanity pay." Heating up an old chestnut that had already been served by Durand-Ruel's enemies (and even by Mary Cassatt), Cox concluded with undisguised relish, "I have been told that the dealers in France have found the home market for Cubist and Futurist pictures worked out, and that they are now passing their wares hopefully on to the American market."[25]

As the British writer C. Lewis Hind had alrady observed on the occasion of the first Grafton show, "The bitterest opponents of the Post-Impressionist pictures have not been critics but painters."[26]

Kenyon Cox did more than just grant interviews. The matter was serious enough for him to put down his brushes and publish some "Reflections" on the exhibition. These took the form of a stern and fatherly admonition addressed to art students and the general public, warning them not to allow themselves "to be blinded by the sophistries of the foolish dupes or the self-interested exploiters of all this charlatanry. . . . If your stomach revolts against this rubbish it is because it is not fit for human food. Let no man persuade you to stuff yourselves with it."

Having thus defended those beholden to the academic establishment against the dangers of contamination, Cox hardly felt the need to single out individual culprits for reprobation. Among Americans, only Marsden Hartley was scolded by name; Gauguin was dismissed as "a decorator . . . tainted with insanity," and van Gogh was

called "unskilled," a surprisingly mild reproach. Cézanne, however, received more extensive treatment and the lines devoted to him sound at first like an attempt at a fair consideration:

> Cézanne is by far the most interesting, as he is the most extravagantly praised of the modernists. I believe him to have been a perfectly sincere searcher, and I admit in him some of the elements of genius. He seems to have had a sense of the essential character in portraiture, just as he had a sense of the essential squareness of houses and the essential roundness of apples. He seems always to have aimed at the great things. But he seems to me absolutely without talent and absolutely cut off from tradition. He could not learn to paint as others did, and he spent his life in the hopeless attempt to create a new art of painting for himself. Fumblingly and partially he can express himself to the few – he will never have anything for the many.

This was, one might say, a complimentary appraisal with a vengeance. It was bad enough to be considered a genius without any talent, but to be credited with a 'sense of the essential squareness of houses and the essential roundness of apples" appeared to be little more than disguised mockery. Cézanne, however, came off much better than Matisse, of whom Cox said, "it is not madness that stares at you from his canvases, but leering effrontery."[27] All the unflattering impressions that Cox imparted to the readers of *Harper's Weekly* had been gained, as he specified, during an "appalling morning" spent at the Armory. It was this rather imprudent admission that prompted Robert Henri to state with obvious reference to Cox: "Critical judgment of a picture is often given without a moment's hesitation. . . . I remember hearing a prominent artist on entering a gallery declare "My eight-year-old child could do better than this." The subject of the charge was a collection of modern pictures with which the artist was not familiar. There were pictures by Matisse, Cézanne and others. Works of highly intelligent men; great students along a different line. The works, whatever anyone might think of them were the results of years of study. The 'critical judgment' of them was accomplished in a sweep of the eye."[28]

Cox's sweep of the eye, moreover, was an openly biased one, as he himself acknowledged when he declared, "Of course I cannot pretend to have approached the exhibition entirely without prejudice." It would doubtless have been more truthful had he said that he went to the show *because* of his prejudices, looking for pretexts for reinforcing his reactionary views while selecting targets for scorn. Instead of wishing to learn from the exhibits, Cox was hunting for material to be used in the controversies sparked by his aggressive narrowmindedness. During his "appalling morning" at the Armory, Cox was confronted by more than eleven hundred works of art from many parts of the world and from countless artists whose names he probably had never heard. How carefully did he examine them while striding through the eighteen galleries at what must have been a jogger's pace? No wonder Cox and many other reviewers refrained from discussing individual paintings. They were unwilling to study them, having decided they had no use for the works in the first place. It was much easier to agree with Cox that the Armory Show had been a worthwhile experience because, "In a case of necessity one may be willing to take a drastic emetic and may even humbly thank the medical man for the

90

90 Extremely hypothetical photograph of Kenyon Cox running through the Armory Show while reviewing it (still from Jean Luc Godard's movie *Bande à Part*, 1964)

efficacy of the dose. The more thorough it is the less chance is there that it may have to be repeated."[29]

91 While he was rushing through the Armory, manfully absorbing his drastic emetic dose, Kenyon Cox apparently ran into Arthur Jerome Eddy, the lawyer from Chicago who had come to inspect the exhibition on behalf of the Art Institute where it was to be shown after its New York run. Not wasting any time, Eddy, on the train home, composed a lengthy report to the director of the Art Institute, written on February 22. His impressions were somewhat mixed. He had found that a "considerable fraction of the works exhibited, if offered by themselves, would not arrest attention by any original or striking characteristics, but would appear simply incompetent, just plain bad: uncertain in drawing, crude and tasteless in color, careless and ignorant in execution." But to this he added:

> The fraction of the exhibition comprising the real modernists – the post-impressionists, cubists, pointilists, futurists – six or seven galleries, is eminently satisfactory. Anything more fantastic it would be hard to conceive. Some of the works are mere unmeaning assemblages of forms, with gay color, conveying no idea whatever, but bearing such titles as "Dance" or "Souvenir." A few, more logically, have no titles, but merely numbers. As an appeal to curiosity this part of the show is a decided success. . . .
>
> I went over the exhibition with Mr. Davies, the President of the new association, and with Mr. Kuhn, the Secretary; and also with Mr. Kenyon Cox and Mr. Frederick Crowninshield. I also met at the exhibition, Blashfield, Chase, Bellows, Redfield, and others. Mr. Davies is a sincere and attractive man, and as a painter an accomplished technician. His works are freakish, but they contain fine passages of color and form, which

any critic, however classical, will admire. He is eccentric, but his eccentricities are sanity itself compared with the works of the extremists. He however pointed out, with evident sincerity, in the works of such artists as Matisse beauties which I was unable to see. His associates of course expressed similar appreciations, but I saw in their own work no evidence of competency for criticism. I suspect we have here the representatives of the two classes of radicals. First, a few eccentrics, some of them, like van Gogh, actually unbalanced and insane, who really believe what they profess and practice; secondly, the imitators, who run all the way from sheer weakness to the most impudent charlatanism. The choice is between madness and humbug. . . .

With regard to the desirability of bringing the exhibition to Chicago, my opinion has changed. I at first thought it would be a good thing to satisfy the curiosity of the public, and as I visited the exhibition for the first time I felt a sort of exhilaration in the absurdity of it all. I still think it would be reasonable and right for us to exhibit a single gallery, perhaps fifty examples, of the most extreme works, so that our public may know what they are. But when it comes to bringing a large part of the exhibition here (we could accommodate about one-half), to incurring great expenses, to turning the Art Institute upside down . . . I hesitate.

We cannot make a joke of our guests. It becomes a serious matter. As I visited the exhibition repeatedly I became depressed, to think that people could be found to approve methods so subversive to taste, good sense and education; of everything that is simple, pure, and of good report. In this feeling I was confirmed by a conversation with Mr. Wm. M. Chase, whom nobody can call a bigot in art matters. I have scarcely ever seen Mr. Chase so serious on any subject. He pointed out that the inevitable inference for an art student, whose inexperience and sensitiveness to impressions must be fully recognized, the only inference from the respectful recognition of such work, must be, that education

91 James McNeill Whistler
Portrait of Arthur Jerome Eddy 1894

92 *Portrait of Gustave Boyer c.* 1870 (V.130)

and technical training are wholly unnecessary and useless. The whims of ignorance are just as good as the well considered productions of highly trained persons. In this I find myself in agreement with Mr Chase.

To these considerations, Eddy appended a few thumbnail sketches of artists prominently featured at the Armory:

Matisse's work: If this work were submitted to me without explanation, I should regard it as a joke. It is asserted that he is an accomplished painter. I have never seen anything to show it, and I am of the opinion that if he ever did anything really distinguished it would now be exhibited. I think it probable that Matisse, failing to distinguish himself in regular lines, resorted to this work to attract attention. Certainly the work is without merit. It has no subtlety of line, no sweetness of color, no refinement of sentiment, no beauty of any kind.

Redon's work: This work gives more [the] impression of a sincere but unbalanced mind. It is not without beauty and evidence of training, and yet it is irrational. Some of the flower painting, which is much admired, appears to me poor and ineffectual. Davies' work is somewhat akin to this, but technically better. . . .

93 Photograph of the Armory Show in New York, 1913

Van Gogh's work: Not so good as I expected from some prints [reproductions?] I have seen. Other people have done the same thing better. It is well known he was violently insane.

Duchamp and Picabia: the wildest of the cubists. Humbug – not incapable.

Gauguin: Heavy and ugly.[30]

Strangely enough, Eddy's report did not contain the slightest reference to Cézanne. Just as strange is that after his return to Chicago, he bought a number of paintings and prints shown at the Armory; for obvious reasons, no works by Matisse, Redon, van Gogh, or Gauguin were among them. On the whole, Eddy's choices were rather tame and show a penchant for precisely those imitators whom he had condemned in his letter. What must have attracted him to them was the well-known fact that imitators always prettify and dilute the style of those who inspire them. Thus, Eddy preferred the derivative cubism of Gleizes to the real one of Picasso, Braque, or Gris, and the landscapes of Segonzac to those of Cézanne. He was also partial to such routine performers of adulterated "modernism" as Leon Kroll and Eugène Zak. But at the same time, he did acquire two paintings by Marcel Duchamp and one by Picabia. When the exhibition came to the Art Institute of Chicago (where it was shown on a larger scale than he had suggested), Eddy found three paintings by Sousa Cardozo to be utterly irresistible. Altogether, there is no doubt that, in view of the extraordinary choice available, he could have selected works of a much higher quality as well as greater significance.[31]

To make it easier for critics and the general public to appraise the contributions of the more important artists featured at the Armory Show, the organizers had intended to provide separate rooms for the works of Cézanne, Redon, Gauguin, van

94, 95 Photographs of the installation of the Armory Show in Chicago, 1913

Gogh, Matisse, the Cubists, and even the Futurists, had they come to New York.[32] But lack of space, and probably also the extreme pressure under which the pictures had to be hung, prevented such a clear and logical display. In the end, Cézanne had to share a room with van Gogh, though it would doubtless have been more instructive to pair the Dutchman with Gauguin. At least Cézanne's and van Gogh's paintings were not scattered over two or more rooms, as were those by Degas, Gauguin, Puvis, Manet, Matisse, Renoir, and others.

The official catalog was even more confusing than the hanging, particularly since it was not compiled in alphabetical order. Cézanne was listed between Kandinsky and Hartley, and seven entries were recorded for him: 214, *Femme au chapelet*, lent by E. Druet; 215, *Portrait de Cézanne*; 216, *Baigneuses*; 217, *Colline des pauvres*; 218, *Anvers* (for Auvers); 219, *Portrait*; 220, *Melun*; the last six owned by Vollard. These were loans obtained in Paris. A subsequent supplement with additions and errata listed more works by Cézanne: 1069, *Harvesters*, lent by Professor J. O. Sumner; 1070, *Landscape*, lent (no name filled in); 1071, *Portrait de Cézanne*, lent by Stephen Bourgeois, Esq.; 1072, *Portrait of Madame Cézanne*, lent by Sir William Van Horne. Yet even this was not a complete listing. When, in a somewhat reduced form, the show moved to Chicago and Boston, the catalogs were not only arranged alphabetically by name of artist, but the entries were also numbered consecutively. In contrast to the New York listings, these catalogs carried additional items: a group of Cézanne lithographs lent by Vollard, a second portrait of Madame Cézanne, lent by John Quinn, *Flowers* (*The Deep-Blue Vase*), lent by Mrs. Montgomery Sears, and a watercolor for which neither title nor lender was indicated.[33]

X

XI

10

All three catalogs merely listed the titles of the works; those lent by Frenchmen were given in French, those obtained from American lenders were in English. No dimensions or dates of execution were provided, even though Vollard had supplied dates for all of his loans, dates – incidentally – that have more or less withstood the test of time.[34] In the absence of such information the visitor was left without any help for the study of Cézanne's evolution as reflected by these thirteen canvases and the single watercolor. Only extremely dedicated and perceptive students could hope to arrive at some kind of chronology (a chronology that, to this day, is fraught with countless problems).

The earliest picture in the group was a portrait (No.219; V.130) which represents – though this was not stated – the artist's boyhood friend Gustave Boyer, painted around 1870. Vollard, who lent it, dated it 1867 (all of Vollard's dates were given as fixed, he never used the term *circa*); the price was $4,000. It is a fairly dark picture in which the main accent is provided by the white zigzag of the open-necked shirt underlining the black beard of the frontally seen and prematurely bald sitter. This likeness is more brooding and much less "dashing" than another portrait (V.131) of the same man, wearing a straw hat, that belonged to Mrs. Havemeyer and with which Arthur B. Davies must have been familiar.

From about the same early period was the *The Road* (No.1070; V.52) which had recently been sold to Miss Bliss from the collection of Enrico Costa through the efforts of Davies and Walter Pach.[35] Even though the flatness of the upper part (not all of which may have been visible at the time) contrasts with the lively treatment of the road turning amid rocks and vegetation beneath curved clouds, at least one

92

24

96

96 *The Road c.* 1871 (V.52)

reviewer singled out this work for special praise. Mather wrote: "A little brown landscape, with its constructive planes sharp and simple, perhaps best represents the technical excellence to which [Cézanne] gave himself single-mindedly."[36] Actually the canvas was not really "little" since it measured $23\frac{1}{2} \times 28\frac{1}{2}$ inches (unless some 5 to 7 inches of the top had been folded back). The picture was lent anonymously and was not for sale.

97 Close to ten years separate the *Four Bathers* (No.216; V.384), lent by Vollard, from the two preceding works. Vollard dated it 1878 and asked $6,500 for it. This was one of a number of similar pyramidal compositions, erotic symbols of happiness in a landscape setting. But since the four nude women were not painted with the minute care for detail and the obvious tendency toward prettiness made popular by academic presentations of such subjects, neither the critics nor the public showed any interest in this work. And yet it presents a harmony of luscious greens in the midst of which the four nudes with flowing red, blonde, and dark hair form a closely 57 knit group by a small stream. It is related to the composition of bathers (V.381) owned by Matisse, who used to analyze it for his students, admiring its "solidity" and calling it a "very complete realization of a composition that [Cézanne] carefully studied in various canvases."[37]

The *Four Bathers* was more or less contemporaneous with a landscape cataloged 98 as *Melun* (No.220; V.304) lent by Vollard, who dated it 1879 and put a price of $8,000 on it. Cézanne had lived at Melun from April 1879 to March 1880; while this picture

97 *Four Bathers* 1877–78 (V.384)

does not represent the town of Melun itself, it must have been executed in its vicinity. Many shades of green dominate the view, contrasting with a strip of yellowish fields (or a road) in the foreground. Pronounced diagonal brush strokes, typical for that phase of the artist's evolution, can be observed in the trees that occupy the middle ground, whereas farther away the brushwork is less regular, so that the overall aspect of the canvas is freer than in other, more systematically painted works of that period. The gray and lightly brushed sky shows faint traces of red (a setting sun?), a very unusual effect for Cézanne. The size of this painting matches that of the earlier landscape, but the vibrant execution and the diffused light seems to link it to the many Impressionist landscapes with which New York gallery-goers were by then acquainted.

Some of the same colors and brush strokes prevail in another, much larger, upright landscape, measuring almost 36 by 29 inches. It was cataloged as *Anvers*, later corrected to *Auvers* (No.218; V.312) and was also lent by Vollard, whose date for it was 1880; its price of $9,500, the highest among Vollard's loans, may have been determined by the considerable size of the canvas. It was the most austere among Cézanne's works in the Armory Show, and its composition was quite exceptional, with pronounced verticals of trees above slanting furrows. There is a constant "pull" of opposite directions which contrasts with the greater softness and harmony of the Melun landscape. Painted on a slightly yellow canvas that shows here and there in the thinly covered sky which seems less "finished" than the rest of the picture, this

99

98 *Landscape near Melun c.* 1879 (V.304)

work provides valuable clues to Cézanne's methods. Apparently he first loosely
established the general color areas before applying diagonal and usually short strokes
to achieve cohesion and texture. It looks as though he worked from the bottom to the
top of the canvas, providing sketched-in color indications where needed. In this case
he seems to have been preoccupied especially with the central region of slanted
furrows where the brush strokes build up planes most successfully and which is also
distinguished by a great variety of color nuances.

Cézanne is known to have worked with Pissarro at Pontoise near Auvers-sur-Oise
in 1881 and again for a short time in 1882. If – as is likely – this picture represents the
Pontoise–Auvers region, it would have been painted in 1881–82 rather than in 1880,
as suggested by Vollard.

Two smaller works, both of around 1880 or a little later, show a smoother
technique, increasingly adopted by the artist after his phase of diagonal brush
strokes. They are the *Harvesters* (No.1069; V.1517), measuring $10\frac{1}{4} \times 16\frac{1}{8}$ inches,
lent by Professor J. O. Sumner, and *The Deep-Blue Vase*, $13\frac{5}{8} \times 11\frac{3}{4}$ inches, lent by
Mrs. Montgomery Sears, both of Boston. Neither of the two canvases was for sale.

The *Harvesters* is executed thinly in fairly luminous though not vivid colors,
showing how the artist began to dilute his paint and to abandon the heavy impasto as
well as the accumulation of square, parallel strokes, in favor of a more homogenous
coat of almost transparent pigment without insistence on separate, apparent brush
strokes. The technique used for the small *The Deep-Blue Vase* painting is similar,

99 *Landscape near Auvers-sur-Oise c.* 1881–82 (V.312)

100 *Self-Portrait with Bowler Hat c.* 1885 (V.514)

although here the color accents are stronger since the deep-blue vase contrasts sharply with a few delicate blossoms and leaves. Charming though this bouquet is, it could not, in any way, represent Cézanne's accomplishments as a painter of still life. Since Stieglitz had obtained but one still life for his watercolor exhibition of 1911, and the Armory Show presented only this small flower piece, the American public still had had no opportunity to judge the splendid harmonies of color, the superb arrangements of objects that characterized Cézanne's achievements in this genre and actually made his still lifes the most "accessible" and imposing of his works.

XI Thinness of pigment also distinguishes the painting of Madame Cézanne (V.229) that John Quinn lent to the show; it was of course not for sale. The artist's wife is shown – as so often – with a rather blank expression. A slight trace of red appears around her weary eyes. Her age is undetermined (she must have been around thirty-five). Stylistically the picture shares many features with Cézanne's work of the early eighties, not only thin application of paint, but also loose brushwork, clarity of contours (in the face), and a chromaticism that is much "sharper" than before. Madame Cézanne wears a greenish-black dress and is separated from the light greenish-blue-gray background by a purple armchair, the color and curves of which strongly set off her figure. The heaviness of the dark, softly striped dress is relieved by a touch of pink that indicates her joined hands in the lower left corner; an almost black curtain (or whatever it may be) in the upper left focuses attention on the sitter's

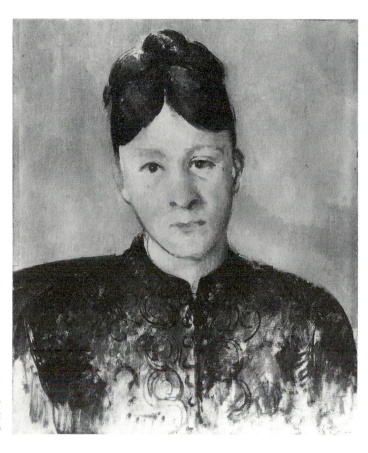

101 *Portrait of the Artist's Wife c.* 1865 (V.520)

face. When Cortissoz conceded that "sometimes the object is clearly and handsomely realized"[38] in Cézanne's work, he may conceivably have been thinking of this picture.

Certain similarities with this likeness of Madame Cézanne can be observed in the artist's *Self-Portrait* (No.1071; V.514), lent from his private collection by the dealer Stephen Bourgeois, who dated it 1892 on the entry blank, although the middle eighties would appear to be a more likely date of execution. In contrast to the portrait of his wife, however, Cézanne has not pushed this work beyond a sketchy state. The turpentine-diluted paint is once more applied very thinly, except for the face, where some closely assembled diagonal strokes in the beard even appear like a throwback to an earlier technique. But the black jacket and bowler, as well as the grayish-yellow background, are very loosely indicated, without any attempt at covering the canvas ground. And whereas the solid black rim of the hat strongly sets off the reddish face, the upper curve of the bowler has remained strangely unfinished, thus – intentionally or not – drawing attention to the artist's features. He turns his head over his right shoulder to observe himself in a mirror; while doing so, he also seems to look straight at the beholder. There is no denying that despite the incomplete nature of this painting, the image is both clear and alive.

Executed at about the same time was another *Portrait of the Artist's Wife* (No.1072; V.520), lent by Sir William Van Horne of Montreal. Her softly colored

100

101

face, though thinly painted, appears once again more finished than the rest of the painting: the bluish-gray background and the shoulders of the sitter, who wears a blue-black dress, the sketchily indicated material of which is enlivened by loosely traced circles, possibly of embroidery. The artist's wife is seen full face in a fairly conventional presentation and with an impassive expression. Yet the beautiful oval of her head seems rendered with a tenderness that belies the indifference apparent in many other likenesses of her. This oval is further accented by the symmetrical parting of the hair, the line of which corresponds to the opening in the collar of the dress. The painting, possibly the most immediately appealing among Cézanne's works at the show, was not for sale. (Matisse owned a likeness of Madame Cézanne (V.521) that is similar although somewhat more alert, her head being turned to the right, so that the picture appears less static. It is not known, however, when he acquired this portrait and whether he already owned it in the days when he taught at the Couvent des Oiseaux.)

IX Yet another landscape – the fourth in the show – was lent by Vollard. *The Hill of the Poor* (No.217; V.660) was dated 1887 by him and priced at $8,000. It was again a canvas thinly covered with vivid, multidirectional brushwork, this time with a greater variety of subtle nuances. Even though the canvas ground is often left uncovered where rapid brush strokes do not completely fuse, the execution is not really "sketchy" and there are no areas left entirely untouched, so that, despite the loose texture of the brushwork, the artist's purpose has been achieved.

X, 102 Quite different in execution was the already widely shown *Woman with a Rosary* (No.214; V.702), lent by the Paris dealer Eugène Druet, who asked the staggering amount of $48,600 for it, by far the highest price listed for any work in the Armory Show. It was painted between 1895 and 1896; the poet Joachim Gasquet, who had obtained the canvas directly from the artist, later said that Cézanne had spent eighteen months on it. This intense and prolonged effort resulted in a considerable accumulation of pigment forming a kind of surface crust. Even if Cézanne had started with thin and bright colors – which is by no means certain – the work had increasingly darkened as touch after touch, coat after coat was applied in successive sessions. The result is a surprisingly somber picture, whose richly modulated surface contrasts sharply with the translucent quality of the artist's work of the eighties. This solemn aspect is inseparable from an undefinable weightiness that pervades the canvas. The hunched figure of an old woman is set against a dark gray-blue-brown wall; she is draped in a deep-blue shawl thrown over her drooping shoulders; beneath it she wears a brownish garment whose sleeves protrude from beneath the shawl. Her skirt or apron is of a much brighter blue than the shawl, but the lightest part of the picture is a pleated white cap that hugs her weather-beaten face; the clenched hands pressed against the body respond to the burned color of the face.

Alone among Cézanne's works in the Armory Show, this painting lent itself, at least superficially, to literary interpretation. Indeed, despite its monumental simplicity, there appears, in this image of a bent, worn-out old woman clasping her rosary, a gripping air of fervor and resignation that relates it to the intense and moving mystery so frequently found in Rembrandt's late paintings; it is a statement of profound human compassion.

Among the visitors impressed by it was President Theodore Roosevelt who, as a

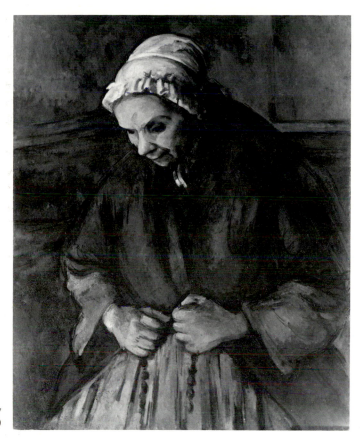

102 Woman with a Rosary
1895–96 (V.702)

member of his entourage later remembered, "stood in front of it . . . for a long time, and from his remarks on that occasion would probably disagree with [those who felt] that Cézanne could not paint."[39]

When the picture was shown for the first time, at the Paris Salon d'Automne of 1907, where such Americans as Leo Stein, Max Weber, Charles Demuth, Walter Pach, and Maurice Prendergast, among others, must have seen it,[40] the reception had been somewhat mixed. Paul Adam, an erstwhile Symbolist writer and admirer of Seurat and Redon, distressed his friends, including Félix Fénéon, by denigrating all the Cézannes exhibited with the exception of this work, which he approached from a rather peculiar biological angle. Describing the old peasant woman (who supposedly was a defrocked nun) he wrote: "Her stubborn forehead, her benumbed nose, struck by yellowish light, indicate a kind of ossification, or hardening of the entire being, affected by ankylosis of advanced age. And the blue of the apron wrapped around the protuberance of the belly deserves to be appreciated."[41]

At the first London Post-Impressionist exhibition, C. J. Holmes, the British equivalent of Kenyon Cox, had been even more antagonistic, calling the painting "a failure."[42] Most American reviewers did not waste time on the picture, with the exception of Mather who did consider it an 'extraordinary character study."[43] And at least one New York collector was to show interest in *Woman with a Rosary*.

Chronologically, the last of Cézanne's works in the Armory Show was another

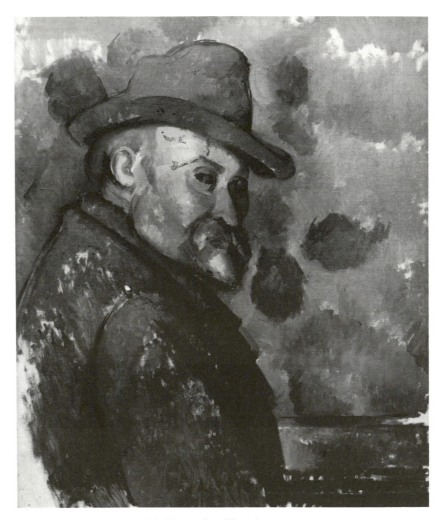

103 *Self-Portrait with a Felt Hat c.* 1890 (V.579)

103 self-portrait (No.215; V.579), lent by Vollard who priced it at $5,600 and indicated a date of 1892 on the entry blank; it appears more likely, though, that it was executed some ten years later. The painter has represented himself in the left part of the canvas, glancing once again over his right shoulder and wearing what looks like a crumpled felt hat. The brushwork is emphatic, forming sizable blotches that are not interwoven. The pigment is no longer diluted to a thin film; applied in spots, almost like patchwork (at least in the background, which occupies practically half of the canvas), it provides an animated surface and attests to an extraordinary freedom of execution. The opaque colors are muted, dominated by purplish, greenish, bluish, and gray tonalities. A strong shadow cast on the left side of the face underlines the bridge of the nose while almost obliterating the left eye, so that the right one is strangely accented as it peers from beneath the old felt hat. In a peculiar way the artist himself looks almost as battered as the hat he wears.

In addition to these thirteen paintings there was a single watercolor lent anonymously and not for sale which must have been the landscape Arthur B. Davies

had bought out of Stieglitz's exhibition (RWC.428); no other Cézanne watercolor is 79 known to have been in America at that time. Finally, there were also several lithographs lent by Vollard of which various proofs were acquired by, notably, Miss Bliss, Arthur B. Davies, Walt Kuhn, John Quinn, and Alfred Stieglitz, none of whom could be said to have been "converted" to Cézanne by the Armory Show. Yet there was at least one new collector, Walter C. Arensberg, who included a Cézanne lithograph among his modest purchases. The lithographs were considerably less expensive than the oils, for which apparently there were few serious contenders.

There was, however, one eminent and wealthy collector, Henry Clay Frick, who demonstrated his discernment by expressing interest in the most remarkable of Cézanne's works at the exhibition. As Walter Pach subsequently related: "Had it not been for the adept handling of the dealer who came with him, Mr. Frick would almost certainly have bought our great Cézanne of the *Woman with the Rosary*."[44] X, 102 The dealer in question must have been Frick's friend, advisor, and art purveyor, Charles Carstairs of the Knoedler galleries,[45] who might conceivably have tolerated his client's foolish fancy were it not for the picture's extremely high price. Frick, of course, did not have to worry about the $48,600, but Carstairs obviously felt that such a considerable amount would be better spent on his own merchandise. And since Cézanne was not yet considered a safe enough value to be offered by the Knoedler firm to its distinguished clientele, Carstairs, in good conscience, could not allow Frick to indulge in such a costly and risky whim.

Meanwhile, at the Metropolitan Museum, where Frick was a trustee, Roger Fry's successor, Bryson Burroughs, felt that the time had come to try to persuade his trustees to acquire some modern works. Having looked at Cézanne paintings on his latest trip to Paris (and priced them), he now seized the occasion to send out feelers. A few days after the opening of the show, he drafted a letter to John W. Alexander, President of the American Academy of Design and member of the museum's Purchasing Committee:

February 20th, 1913

Dear Mr Alexander:

The exhibition of the American Society of Painters and Sculptors, open till March 15th, in the Armory on Lexington Avenue between 26th and 27th streets, gives the first public opportunity in New York to see the work of certain foreign artists very well known in Europe. When you go to the exhibition please notice in particular these pictures which I wish to call to your attention, works which seem to me worthy of a place in the Museum:

	Prices asked:	
By Cézanne – 217, La colline des Pauvres	$8,000	IX
By Gauguin – 173, Faa iheihe	$8,100	
By Maurice Denis – 317, Nausica	$5,400	
or 313, La plage	$8,100	
By Odilon Redon – 300, Le Silence	$540.[46]	

The draft of the letter ends here; it is annotated: *not sent*. Burroughs may have felt that he was asking for too much and should concentrate instead on a single item. Within a week, he wrote, and this time mailed, another letter to Mr. Alexander, drawing his attention only to Cézanne's painting.

Even though Cézanne's landscape in the Armory Show must have looked rather "tame" compared with the works of the Fauves, the Cubists, and the Abstractionists, not to mention such "showstoppers" as Duchamp's *Nude Descending a Staircase*, Burroughs's task was by no means an easy one. Robert de Forest, recently elected president of the museum, was resolutely against such a purchase, as were several trustees. The painting selected by the curator was actually the least "aggressive" among the Cézannes in the show (only half of which were for sale). It was a delicately colored, lightly brushed, almost lyrical picture with the added advantage of being signed, a fact indicating that, despite its loose execution and thin film of pigment which did not totally cover the canvas, the artist himself had considered it "finished." It was, moreover, the only signed work by Cézanne in the show as well as one of only a small number of canvases he signed (though this may not have been known to many at that time).

IX In any case, *The Hill of the Poor* had nothing of the superb vehemence and furious daring of Cézanne's early paintings, nor did it show the uncompromising austerity of the phase characterized by his diagonal and constructive brush stroke, any more than it presaged the often tortured and always energy-charged surfaces of his last years. Instead, it has a peculiar softness and a shimmering light that seems to ripple through the shapeless foliage and to illuminate the sun-baked walls of distant buildings. Gentle curves separate multi-nuanced wooded hills from a limpid sky whose serene expanse contrasts with the richly textured slopes. It is a pleasant rendition of a peaceful site and one unlikely to disturb anybody familiar with the works of Monet, Renoir, or Sisley. Nevertheless, a good deal of opposition had to be overcome before the picture could be presented at a meeting of the trustees of the museum.

Among the few documents in the archives of the Metropolitan Museum which relate to this event is a letter of March 4, 1913, from John G. Johnson, a Philadelphia lawyer, collector, and trustee, whom Burroughs must have approached as he had John W. Alexander: "I regret that I will not be able to get to New York in time to see the Exhibition at the Lexington Avenue Armory before it closes. Whilst I would think $8,000 for a Cézanne would be a high price, yet I know you are far better able to judge its commercial and artistic value than I am, and if you think the painting at that price is a desirable acquisition, I will concur thoroughly in your judgment."

Burroughs replied immediately: "If there seems to be any chance that the Committee will wish to consider its purchase, I am going to arrange to have it sent to the Museum for the meeting on the 17th [of March]. The asking price, $8,000, is high but 15% duty will be deducted from that making the price to the Museum $6,800, and I think that that amount could be shaved somewhat. It might be bought, I should think, for $6,000, or a little over, and at this price would be very reasonable. It is a very good work, painted in the early 90's. . . . It would be a popular purchase with a large number of our public and would make valuable friends for the Museum."

Johnson, ever fair-minded and inclined to accept the curator's view (something not all trustees do), now answered, "I regret that I cannot be present at the next meeting, owing to an engagement in Court. I will be heartily in accord with the purchase of the painting at $6,000, if, in your judgment, it is thoroughly

representative, and a good example, of Cézanne. Whilst the Impressionist Art does not appeal very strongly to me, I recognize that this is a mere matter of individual taste, and that it does appeal very strongly to very many connoisseurs of the highest taste and best judgment. I think it well, also, for any Museum to have represented on its walls, examples, as far as possible, of everyone who stands for something in art. Cézanne does thus stand."

It is not known what Burroughs told the members of the Purchasing Committee when, on March 17, 1913, he recommended Cézanne's landscape to them. But his comments must have been similar to those that were to appear in the *Bulletin of the Metropolitan Museum of Art* as part of an article on recent accessions. If much of what Burroughs said appears strangely "dated" today, it is of course because our attitude toward and our understanding of the artist has evolved greatly since that time. After describing the picture whose forms he found "grandly simplified as if by one who worked with rude [?] tools," the curator explained that in this work "the wide divergence of [Cézanne's] tenets from those of the Impressionists, with whom it was formerly the practice to class him is evident at all points. There is no attempt to imitate the exact colors or relationships in nature. These, like the forms, are largely epitomized in their translation to pigment, and the power of the artist's vision lends an independent nobility to a subject which in itself has nothing unusual."[47]

Though the minutes of the meeting are still considered confidential, it is known that a small majority acceded to Burroughs's recommendation and authorized the acquisition of the painting, whose price the curator had been able to "shave" only by another $100, thus bringing it to $6,700. Votes for the purchase included not only John W. Alexander and the collector George Blumenthal, but also the famous sculptor Daniel Chester French, despite his solid reputation for academic views. It is likely that John G. Johnson's absentee ballot could also be counted in favor of Cézanne's painting. Robert de Forest predictably voted against the acquisition, while the Baltimore collector Henry Walters, who was by no means tied to conventional concepts, decided to abstain.[48] Dr. Edward Robinson, as director of the museum, formally approved the purchase and the picture remained in New York when the bulk of the Armory Show traveled to Chicago and then to Boston.[49] None of the other available works by Cézanne found buyers.

On April 2, 1913, Burroughs wrote directly – and in French – to Vollard to say how happy he was with the acquisition of this excellent picture, adding that Walter Pach had been unable to provide any further information, except that, according to the artist's son, it was painted in 1887. Burroughs now wanted to know whether it was done in the south of France and where.

It took Vollard six weeks to reply: "I am quite late in answering your kind letter concerning the title of the painting by Cézanne, *La colline des pauvres*, acquired by the New York museum. The place by this name is situated in the vicinity of Aix-en-Provence. Monsieur Cézanne fils has told me that nothing precise is known about the origin of this title. In any case, it is a spot with scarce and poor vegetation. I am very happy that this beautiful picture is in New York where it will make Cézanne known."

104

Actually, the canvas represents the Domaine Saint-Joseph as perceived from a spot near the terrace of Château Noir between Aix and the foot of Sainte-Victoire

104 Vollard letter to Bryson Burroughs, 1913

mountain. The estate was originally occupied by Jesuits; the structure seen among the trees (whose greens mixed with yellows point to autumn) is a chapel, while the main quarters – to the left – are hidden by vegetation. After 1880, when the once powerful order was driven from France, the property fell into private hands and underwent extensive alterations which, however, affected the chapel less than the main building. In their youth, Cézanne and Zola had made frequent excursions to this area, taking the road that passes below the nearby Château Noir and crossing the Domaine Saint-Joseph to reach the rocky gorges beyond the Colline des Pauvres in the heart of which was the large dam with its lake planned by Zola's father to provide Aix with water. Some of the slopes, beyond which lies Bibémus quarry, may long ago have been sparsely covered with vegetation, but when Cézanne went to paint them they were quite green and they have remained so since.

What little information Vollard's letter provided, it arrived too late for the May 12 press view of new acquisitions. The occasion was vividly remembered by Henry McBride, a young critic who was just beginning to review exhibitions for the *New York Sun* and who was to reveal himself not only as extremely bright and interested in new trends, but also as the only twentieth-century-oriented member of the art press New York could then boast. As McBride later wrote, Dr. Robinson, on that occasion, held forth at considerable length upon the grandeurs of a Tintoretto recently bought by the Metropolitan without at all alluding to the Cézanne painting. When McBride broached this matter, the museum's director looked at him in frank astonishment and said, "Why, yes, that is true." Whereupon he announced to the

retreating journalists, "I was forgetting to mention that we have also purchased a Cézanne landscape."[50]

In the article McBride devoted to the accession, he did not show himself overwhelmed by the picture. "There does not seem to be anything dangerous or revolutionary about it," he wrote. "It hangs now in the room at the museum with the Renoirs the Monets and Manets and holds its own in such company firmly but quietly. To the students of art who rely exclusively upon the Metropolitan for their knowledge of contemporary French work, why the advent of so innocuous a landscape should be considered momentous must be puzzling."[51]

Indeed, at a time when Cézanne was claimed or decried as ancestor of almost every unorthodox movement in art, *The Hill of the Poor* failed to reveal any radically new approach to nature. Although it was the only work by Cézanne to be sold out of the Armory Show, and although it was the first of his canvases to enter an American museum, it was not what John G. Johnson had expected it to be, a "thoroughly representative, and good example" by the artist. However, as Burroughs doubtless knew, a more significant, more unusual as well as more typical work would have had no chance of being accepted by the Purchasing Committee.

NOTES

1. Frederick James Gregg, ed., *For and Against* (New York: Association of American Painters and Sculptors, 1913), p. 14; reprinted in *The Armory Show: International Exhibition of Modern Art, 1913* (New York: Arno Press, 1972), vol. 2, *Pamphlets*.

2. Frank Jewett Mather, Jr., "Art Old and New," *The Nation*, March 6, 1913, p. 240.

3. The painting is reproduced in Arthur Edwin Bye, *Pots and Pans or Studies in Still-Life Painting* (Princeton: Princeton University Press, 1921), opp. p. 118. Elsewhere it has never been considered to be by Manet.

4. Mather, "Art Old and New," p. 241.

5. Jerome Myers, *Artist in Manhattan* (New York: American Artists Group, 1940), p. 36.

6. Frederick James Gregg, "The Attitude of the Americans," *Arts and Decoration*, March 1913, p. 165; reprinted in *The Armory Show*, vol. 3, *Contemporary and Retrospective Documents*.

7. Alfred Stieglitz to Arthur B. Davies [New York], Feb. 18, 1913; Stieglitz Archive, Beinecke Rare Book and Manuscript Library, Yale University. This document was brought to my attention by Francis M. Naumann.

8. Oscar Bluemner, "Audiator et altera pars: Some Plain Sense on the Modern Art Movement," *Camera Work*, June 1913, p. 32.

9. Guy Pène du Bois, *Artists Say the Silliest Things* (New York: Duell, Sloan & Pearce, 1932), pp. 166–67.

10. Ibid., p. 166.

11. Kenneth Hayes Miller to Rockwell Kent [New York], March 23, 1913; quoted by G. McCoy, "The Rockwell Kent Papers," *Archives of American Art Journal*, Jan. 1972, p. 4. On this subject, see also Meyer Schapiro, "Rebellion in Art," in *America in Crisis*, ed. Daniel Aaron (New York: Alfred A. Knopf, 1952), pp. 303–42, reprinted in *The Armory Show*, vol. 3; and Meyer Schapiro, *Modern Art* (New York: George Braziller, 1978).

12. They and others have been reprinted in *The Armory Show*, vol. 2.

13. Elie Faure, *Cézanne*, trans. Walter Pach, ibid., pp. 52–53, 54, 66–67.

14. Dr. Albert C. Barnes to Leo Stein, Philadelphia, March 30, 1913; Leo Stein papers, Beinecke Rare Book and Manuscript Library, Yale University. This document was brought to my attention by Richard J. Wattenmaker.

15. John Quinn, "Modern Art From a Layman's Point of View," *Arts and Decoration*, March 1913, p. 155; reprinted in *The Armory Show*, vol. 3.

16. Sloan served on the hanging committee of the Armory Show but his reaction to Cézanne's *Woman with a Rosary* is not known, except that he later said that he assimilated a great deal from studying the work of Cézanne, Renoir, and Picasso at the exhibition. See Helen Farr Sloan, "Chronology of John Sloan," in John Sloan, *Gist of Art* (New York, 1939; reprinted Dover, 1977), p. XXIX; see also Sloan's recollections, ibid., p. 15.

17. Stuart Davis to Hazel Foulks [New York], Feb. 22, 1913; quoted by John R. Lane, *Stuart Davis: Art and Art Theory* (New York: The Brooklyn Museum, 1978), p. 10. This text was brought to my attention by Vivian Barnett.

18. Stuart Davis, *Stuart Davis* (New York: American Artists Group, 1945), unpaginated; quoted in Lane, *Stuart Davis*, p. 10.

19. Eric Gill to William Rothenstein, Ditchling, Sussex, May 12, 1910; *Letters of Eric Gill*, ed. Walter Shewring (New York: Devin-Adair, 1948), p. 35.

20. Mather, "Art Old and New," p. 241; see also above, Chapter I, note 35.

21. Ibid.

22. Frank Jewett Mather, Jr., "Newest Tendencies in Art," *The Independent*, March 6, 1913, p. 509; reprinted in *The Armory Show*, vol. 3.

23. At least one critic alluded to this fact when he began his review of the Armory Show with the words: "It is not the purpose of the present writer to condemn, even what seems to be the most inexplainable and inartistic works of the men who represent the foreign movements and their followers here, for he too well remembers that in 1883, 30 years ago, he passed a hasty and immature judgment when art writer for the 'N.Y. World,' on the works of Monet, Pissarro, Sisley, and their fellows and followers, that he called them 'crazy painters' and 'bumptuously' proclaimed that 'such so-called art could not live.' Realizing how he has learned, with other older students of and writers on art, to admire the work of the so-called French Impressionists, and to recognize their influence upon the art of all lands, he hesitates to even predict that another generation will repudiate the 'Futurists' and 'Cubists' of today." James B. Townsend, "A Bomb from the Blue," *Art News*, Feb. 22, 1913; reprinted in *The Art World: A Seventyfive Year Treasury of Artnews* (New York: Artnews, 1977), p. 24.

24. Royal Cortissoz, "The Post-Impressionist Illusion," *The Century Magazine*, April 1913, pp. 808–9, 815; reprinted in *The Armory Show*, vol. 3.

25. "Cubists and Futurists Art Making Insanity Pay," interview with Kenyon Cox, *The New York Times Sunday Magazine*, March 16, 1913; reprinted ibid.

26. C. Lewis Hind, *The Post-Impressionists* (London: Methuen, 1911), p. 36.

27. Kenyon Cox, "The 'Modern' Spirit in Art. Some Reflections Inspired by the Recent International Exhibition," *Harper's Weekly*, March 15, 1913, p. 10.

28. Robert Henri, undated note, *The Art Spirit* (Philadelphia and New York: J. B. Lippincott, 1923; reprinted 1960), pp. 191–92.

29. Cox, "The 'Modern' Spirit."

30. Arthur Jerome Eddy to the director of the Art Institute of Chicago; unpublished document dated "Feb. 22, 1913. On the train"; Archives of the Art Institute of Chicago, courtesy the Art Institute of Chicago. This document was brought to my attention by Francis M. Naumann who is preparing an article on the collection of A. J. Eddy.

31. For Eddy's purchases see Milton Brown, *The Story of the Armory Show* (Greenwich, Conn.: New York Graphic Society, 1963), p. 313. Most of Eddy's acquisitions together with works by Balla, Boccioni, Brancusi, Cézanne, Gauguin, Gris, Jawlensky, Kandinsky, Klee, Leger, Marc, Matisse, Picasso, Rousseau, Severini, van Gogh, etc. are reproduced in A. J. Eddy, *Cubists and Post-Impressionism* (Chicago: A. C. McClurg, 1914). On this book, see Chapter IX below.

32. On the hanging of the Armory Show, see Brown, *Story of the Armory Show*, pp. 57, 92–94.

33. For the various catalogs see *The Armory Show*, vol. 1, which also contains a floor plan of the New York exhibition (p. 70), the index of names and galleries, and the Supplement, pp. 3–21.

34. Brown, *Story of the Armory Show*, pp. 217–302, has provided a valuable revised list in alphabetical order, with the entry numbers of the New York catalog and, where possible, present whereabouts of the works; it also gives the dates

that Vollard supplied for his loans. However, the identification of some of Cézanne's paintings (with references to Venturi) has been corrected here with the help of photographs of the Chicago installation.

35. See above, Chapter VII, note 42.

36. Mather, "Art Old and New," p. 241.

37. See Matisse's letter to Raymond Escholier, Nice, Nov. 10, 1936; in Alfred H. Barr, Jr., *Matisse: His Art and His Public* (New York: Museum of Modern Art, 1951), p. 40. On this subject, see also above, Chapter III, notes 78, 79.

38. Cortissoz, "Post-Impressionist Illusion," p. 808.

39. L. J. Lesh, "Modernist Art Exhibit has Strong Defender," *Philadelphia Ledger*, Sept. 6, 1921. It is known, however, that Roosevelt was not an admirer of modern art.

40. On American artists at the 1906 Paris Salon d'Automne, see above, Chapter IV, p. 98.

41. Paul Adam, *Dix ans d'art français* (Paris: Albert Mericant [ca. 1908], p. 309.

42. For C. J. Holmes's comments, see above, Chapter VI, note 39.

43. Mather, "Art Old and New."

44. Walter Pach, *Queer Thing, Painting* (New York and London: Harper & Brothers, 1938), p. 200. Pach added that had Frick bought *The Woman with a Rosary*, "his collection would have had a different aspect from what it did when it was opened as a public gallery. I am sure, even, that had he acquired that masterpiece . . . his development would have gone along different lines thereafter."

45. I am indebted to Everett Fahy, formerly director of the Frick collection, for helping me identify the dealer to whom Pach alluded by pointing out that Frick did not begin his association with Duveen until after 1915.

46. This letter and the following documents from the archives of the Metropolitan Museum of Art were made accessible to me by the late Anthony Clark. Of the paintings listed by Burroughs, the Gauguin belonged to Vollard, who subsequently sold it to Joseph Duveen; in 1919 the latter presented it to the Tate Gallery in London. In view of its size, $21\frac{1}{4} \times 66\frac{1}{2}$ inches, it is astounding that it was only slightly more expensive than the Cézanne landscape. The work is No. 569 in Georges Wildenstein, *Paul Gauguin* (Paris: Les Beaux-Arts, 1964).

Both paintings by Denis were lent by Emile Druet; *La Plage (du Pouldu)* now belongs to the Musée du Petit Palais, Paris. Redon's *Le Silence* was lent by the artist, whose price was certainly a very modest one. The picture was purchased from the Armory Show by Lillie P. Bliss and bequeathed by her to the Museum of Modern Art, New York, which still owns it.

47. Bryson Burroughs, "Recent Accessions," *Bulletin of the Metropolitan Museum of Art*, May 1913, p. 108.

48. I am grateful to Mrs. Patricia Pellegrini, Archivist of the Metropolitan Museum, for informing me how Alexander, Blumenthal, French, de Forest, and Walter voted.

49. For the run of the Armory Show in Boston see Garnett McCoy, "The Post Impressionist Bomb," *Archives of American Art Journal*, No. 1, 1980, pp. 13–17.

50. Henry McBride, "Collecting from a Critical Viewpoint," *Art News Annual*, Feb. 25, 1939, p. 66.

51. Henry McBride, "Cézanne at the Metropolitan," *New York Sun*, May 18, 1913; reprinted in Henry McBride, *The Flow of Art*, ed. Daniel Catton Rich (New York: Atheneum, 1975), p. 33.

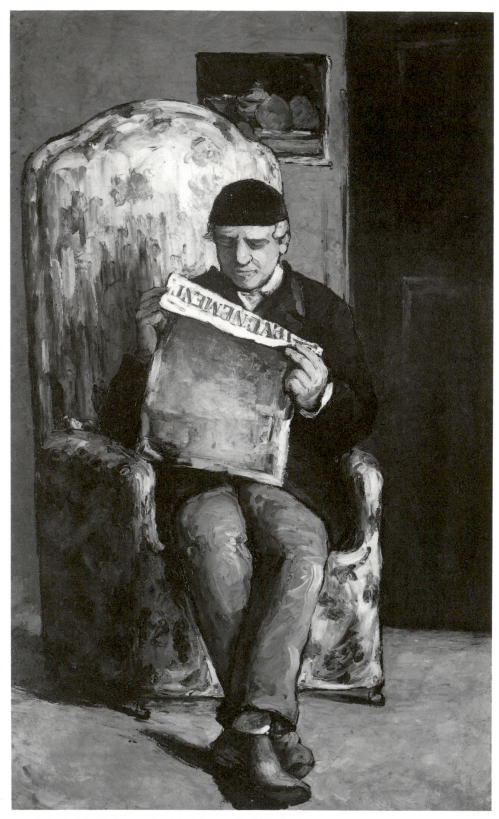

105 *The Artist's Father reading "L'Evénement"* 1866 (V.91)

IX · An Avalanche of Writings

IT IS A strange fact that the Armory Show – which, as far as art was concerned, suddenly propelled New York and the rest of the country into the twentieth century – did comparatively little to assert Cézanne's role in the evolution of modern painting. After all that had been said and written about him, his representation at the exhibition somehow failed to provide a clear perception of his achievements and his historic importance. One reason was that the works selected spanned twenty-five years of the artist's development without making visible the coherence of his progression. Another was that the works did not necessarily reveal a single purpose, a unifying and obvious tendency. This meant that Cézanne remained a mystery – and a much publicized one at that – for all those unwilling or unable to approach him on his own terms.

What added to the complexity of the situation was that Cézanne appeared at the Armory Show in the midst of numerous infinitely more startling innovators, many of whom claimed him as their forebear. Among the critics, only one, a young newcomer named Willard Huntington Wright, seems to have clearly defined Cézanne's position after the Armory Show when he wrote at the end of 1913 (from France where he had gone with his brother, the American Synchromist painter Stanton Macdonald-Wright):

> Cézanne was destined to have an immense influence on all art up to our day. Had he been understood this would have been a salutary thing for those floundering about in artistic speculation. But, like the influence of most great men, his was deplorable. His acolytes saw only wherein he differed from his immediate predecessors. They hurriedly gulped the strange elements in his art, entirely failing to grasp the totality of his genius. To name the men who are and have been his disciples it would be necessary to compile a dictionary of modern painters. He has become a fetish. His letters have been learned by heart. In his every word, his followers sense a mysterious meaning. One of his sentences serves as an adequate basis for the founding of a new school. At the bottom of it all, however, lay a healthy discontent with the old and hackneyed forms. It was the beginning of a renaissance of youth in painting. A clean score was wanted to begin on. It all pointed out to a gaping and dumbfounded world that the Flemish primitives and Rembrandt, Mantegna and Raphael, Titian, and Velasquez, while no doubt excellent painters, were *no longer relative* to the twentieth century.[1]

Wright insisted that Cézanne had "posed the question of aesthetic beauty itself. He abandoned the illustrative obstacle. He explored deeper emotional regions. Seldom did he sign his pictures; never did he give them a name."[2]

Yet in spite of Cézanne's continued remoteness, outwardly, at least, his "triumph" could be considered remarkable, culminating as it did with the Metropolitan Museum's reluctant purchase. This success notwithstanding, only those who had a more extensive knowledge of the artist's work – and they were few – could relate his pictures at the exhibition to his unique stature. But practically none of them spoke up. Arthur B. Davies, who knew the extraordinary group of Cézanne paintings in the Havemeyer collection, understandably did not say anything; he could not be expected to "torpedo" the show over which he had presided. Nor was Walter Pach likely to voice any criticism, although it would have been easy for him to make comparisons with the overwhelming Salon d'Automne retrospective of 1907, which had so deeply impressed him in Paris. Steichen, well acquainted as he was with the canvases accumulated by Vollard and the Bernheim-Jeunes in Paris, also chose to remain silent, the more so as he felt slighted by the organizers of the Armory Show and probably did not wish to leave himself open to a charge of sour grapes.

What rare critical expressions there were that emanated not from adversaries but from admirers of the artist originated with commentators either of European background or at least of extensive European experience. Among them was the German-born Oscar Bluemner who stated that he found Cézanne "quite inadequately represented by the number as well as the quality" of his pictures at the Armory.[3] Yet this observation appeared only in June, after the show had finished its run even in Boston, its last stop. Another European, Stephen Bourgeois, did not actually question the quality of the offerings, since he himself had been among the lenders; instead he deplored the reaction of the visitors. The moot question obviously remains whether the reception of Cézanne would have been different had there been any major still lifes, such as Huneker fancied, as well as more works of the caliber of Van Horne's or Quinn's portraits of Madame Cézanne (V.520 and 229), not to mention the incomparable *Woman with a Rosary* (V.702).

101, XI
X, 102

In a letter written from Paris in June 1913, Bourgeois combined regrets with prophecies. He told Walter Pach:

> What astonishes me is that the great French [Post-] Impressionist masters have not received the attention which is due them. Finally, I believe that it is only a question of time before they will achieve it; it will come some day as it did in Germany, which has for several years been buying everything that is best in France. Unfortunately, Americans will begin to form interesting collections of modern art when the prices will have become exorbitant, a situation which in my opinion is not far off. . . . I tell you frankly that I was basically very disappointed by the lack of public interest in Cézanne and Van Gogh who are like giants among the other painters. . . . If our effort, yours in that magnificent exhibition and mine in business, has not found its merited reward, we are convinced that our opinion will prevail some day. . . .[4]

But the most revealing comments and the most sympathetic analysis appeared in, of all places, the *New York Times* (one of Kenyon Cox's forums), which, on July 6, 1913, published a long, anonymous article in its section "Art at Home and Abroad." It was an unusually extensive review of an exhibition in Darmstadt which, at first glance, seemed to have been modeled on the two Grafton Gallery shows and on the Cologne Sonderbund, except that it was part of a series of special exhibitions devoted to works owned privately in Germany. As the subtitle of the *Times* article

106 *Struggling Lovers c.* 1880 (V.380)

specified, it concerned "A Private Collection in Germany that contains Fourteen Examples of the Art of Paul Cézanne, a Great Modern, Who already is Placed with the Old Masters." All the works on view supposedly belonged to Gottlieb Friedrich Reber from Barmen, a prominent industrialist of the Rhineland, who had assembled not only German Old Masters and Dutch paintings, but also many important French works of the nineteenth century, among them paintings by Corot, Courbet, Manet, Renoir, Degas, Gauguin, and, especially, a large group by Cézanne.[5]

It is true, however, that there are some rather peculiar and "hidden" aspects to this show, aspects which must remain forever unexplained. As the Bernheim-Jeune records reveal, as late as April 1913, shortly before the Darmstadt exhibition was to open, Reber purchased no fewer than six watercolors by Cézanne,[6] as though he wished to "pad" his collection up to the very last minute. Eventually Reber was to settle in Switzerland and to become what is called a *marchand-amateur*. It is possible that the Darmstadt display of his "private collection" constituted a first endeavor in this commercial direction.

Nevertheless, the exhibition was dominated by the canvases of Cézanne for whom Reber evinced an early and particularly enlightened passion and some of whose major works he did own. As stated in the local press, "The works by this interesting Frenchman in the Reber collection are the most outstanding pieces of his artistic legacy and there probably doesn't exist another private collection in Europe that can

107 *The Harvest c.* 1877 (V.249)

108 *Cardplayers* 1890–92 (V.560)

109 *Still Life with Basket of Apples c.* 1893 (V.600)

boast of the same number of works of a similar quality."[7] This was, however, a slight exaggeration since by then Egisto Fabbri's collection had grown beyond the number of Cézannes accumulated by Reber, and their quality could compare favorably with any competition. But Fabbri was an intensely private person and hardly anybody knew of his acquisitive fervor for Cézanne.

The *New York Times* reporter, in any case, was duly impressed with the Darmstadt event and devoted a special and lengthy article to it. There can be little doubt that the article was by Willard Huntington Wright, who must have gone to study the Reber collection and thereupon decided to write a report on it. Nobody else then could have spoken with so much insight of Cézanne's works and those of the other artists in the exhibition. Unaccountably, while contrastig the remarkable German offering with the recent Armory Show, the writer saw fit to speak disparagingly of the most important picture by Cézanne featured in New York, the *Woman with a Rosary* (V.702).[8] But otherwise the prominently displayed and illustrated review was highly perceptive and certainly more informative than anything the New York critics had written on the occasion of the Armory Show.

X, 102

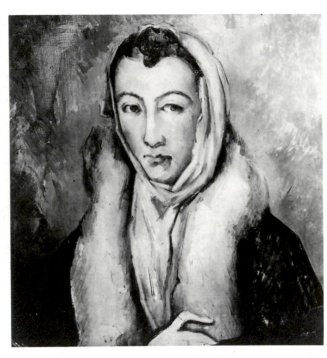

110 *Woman with a Boa*
(after El Greco) *c.* 1885
(V.376)

Among students of modern art Cézanne has aroused more discussion and interest than any other painter save perhaps Van Gogh and more than newer Matisse. To discover in one room fourteen examples of his work of different periods and phases is well worth a half-day journey and a spiral climb at the end of it to the top of the "Wedding Tower" on the lovely Mathildenhohe. . . .

Cézanne in the International Exhibition in New York last winter declined to pluck out the heart of his mystery for us. Those who recall the canvases there shown and in particular the old peasant woman telling her beads, will not remember having received any very thrilling sensation. Most of the crowd hastened by these comparatively undisturbing works to gape aghast at the sensational Matisse and the gentleman [*sic*] eternally descending his splintered stair in the still more modern section.

But Cézanne spaciously hung on the quiet colored screens of the Wedding Tower is a different matter. We pass to him from Courbet and Manet with a sense that here is an art that weighs more and has a deeper color. Cézanne made good his intention of adding substance to Impressionism and making it an art for museums. That, at least, is clear to the most casual observer.

He did much more. He made for himself a new form of expression that is simple without naiveté. Nothing is more pitiful than twentieth century efforts toward naiveté. However simple and strong the expression of the modern spirit may be through sheer native force, it necessarily is a simplicity compounded of multitudinous experiences and reactions. . . . Cézanne felt no temptation toward archaistic retrogression and the reversion of outworn forms. He was content to look with his own eyes upon his near surroundings and paint. He was discriminating, selective, original. The public, not knowing the desperate struggle with brush and pigment that must come before any artist can assert his individuality, perhaps will find it difficult to reconcile Cézanne's originality of vision with the fact that he delighted in copying his contemporaries and immediate predecessors, serving himself now with the color theory of Delacroix, now with the brush stroke of Manet, now with Pissarro's granular surfaces.

IX *The Hill of the Poor* (*La Colline des pauvres*) 1888–90 (V.660)

X *Woman with a Rosary* 1895–96 (V.702)

But it should be understood that these were experiments in method only, the mastering of a contemporary idiom, that personal ideas might be expressed with the accumulated force of assimilated experience and with a purely personal accent.

The vision was Cézanne's own, and it was a vision that had the straight forwardness of a peasant unlearned in juggling with appearances and eluding the obvious. His portraits have been thought to resemble El Greco's, and his *Woman with Head-dress and Boa* [V.376] has been considered a copy of Sir John Stirling-Maxwell's *Dama del Armino*, to which, certainly, it bears a striking likeness.[9] But the resemblance in general between Cézanne's work and that of the Greco is purely superficial. *110*

It takes little acquaintance with the two painters to recognize that where El Greco is emotional to the verge of ecstasy . . . Cézanne's people possess their soul in peace. The air moves about them with a fuller sweep than in Manet's flickering atmosphere: the light is ambient but within the agitations of living are subdued. . . . From the *Newspaper Reader* of *105* 1865 [V.91] to the *Cardplayers* of twenty years later [V.560] may be noted a succession of *108* untroubled and untroubling types, sitting for the most part solid and serene. In the *Reaper* [V.249] the moderate activity of the man at work is balanced by the nerveless repose of his *107* companions; *The Smoker* [V.684] is eloquent of mental idleness; *The Young Philosopher* *111, 112* [V.679] in the Reber collection sits before his table on which lies a skull, with ruminative calm. In the *Struggling Lovers* [V.380] there is physical activity, but it is solely an affair of *106* muscle and sinew.

Yet Cézanne has been called a mystic, perhaps because his mind is so free from cloudy thoughts. . . . His deviations from the regular are as direct, as supremely knowing, as any to be found in early cathedral building.

He seeks the normal only, it appears, for the purpose of intelligently departing from it. There is, nevertheless, no painter in whose work we more clearly perceive the working of universal law. These great rhythms and magisterial arrangements of space are certainly not the outcome of a petty rebellion against convention, eagerly scattering what it cannot reconstruct. . . .

But he worked in his later years chiefly with planes of color. "Color sensations" were intense with him, and he found Manet but moderately endowed with sensitiveness to color. He is quoted as saying in reference to method: "No modelling, no drawing. When the color has due richness the form will have due plenitude. Contrast and the relation of tones, there is the secret of drawing and modelling."

This doctrine, illustrated by the magnificent study of still life [V.600] in which the most delicate tones suggest fullness and richness of color carries conviction as it cannot without such illustration.[10]

Unlike the articles by most critics who – before the Armory Show – had addressed themselves to an American readership that did not really know what they were talking about, the *New York Times* report was obviously written for a better informed public. As a matter of fact, this public was now provided from all sides with a true avalanche of comments, unleashed by the historic New York exhibition. Although Cézanne's name had not exactly become a household word overnight, it was turned into something of a badge of modernism, designating those who flashed it around as being strongly *au courant*. No wonder that he was referred to constantly in the steadily increasing number of articles and books devoted to modern art. Sometimes it didn't even seem to matter *what* was said, as long as Cézanne was invoked in one form or another. Indeed, the upheaval caused in the art world by the Armory Show had the same effect on art writers that the morning dew has on

111 *The Smoker c.* 1891
(V.684)

rosebuds, except that the blossoming forth of art writers did not always have enchanting results.

George Orwell has said that "painting is the only art that can be practised without either talent or hard work."[11] Painters are not likely to agree with this – and why should they? – they could just as legitimately defend the premise that art criticism is an activity that can be indulged in without any training or even aesthetic perception. It is probably because so little is required, that so many feel the urge to share with innocent readers their not always very original insights into matters of art, limited though these may be (the insights, but sometimes also the innocent readers). Among the most exasperating practitioners of such endeavors are those who have nothing to say but say it anyway. High on the list of such offenders was one Margaret Steele Anderson who elaborated upon the Armory Show in *The Study of Modern Painting*, which actually featured reproductions of works by Seurat, Renoir, Manet, Gauguin, and even Matisse, next to, of course, those of academic producers of elaborate brushwork. Unfortunately, the illustrated canvases of the moderns were not mentioned in the text and must have represented an effort by the hapless publisher to capture a few readers interested not only in Arnold Boecklin, William Orpen, Laura Knight, and others of that ilk, but also in somewhat more advanced efforts (such as the book's title promised).

What this author had to say on Cézanne would not warrant quoting except that it reflects the strong influence James Huneker still exerted on American art writers and

112 *The Young Philosopher*
1896–98 (V.679)

simultaneously demonstrates that the Armory Show had not changed everybody's perception of the artist. "His color is glowing," she wrote, "yet is also crude and childish, though of this he apparently is unconscious. It is not like the childishness of Gauguin and Matisse, but is, at least, as much part of himself as Rossetti's mystery was part of Rossetti's self, or even as Turner's color was of Turner. By a certain element of the jeunesse dorée he is worshipped as a master, but this is a youth which is drunken with modernity, a species of absinthe that produces strange obsessions." To escape from such obsessions (which, at their most objectionable, are "matched by the worst of Baudelaire"), the resourceful author had a suggestion nobody had yet voiced: "There must speedily come about a change," she declared, "otherwise, we cannot deny our fears for French paintings! The stay, we think, is largely in the Ecole des Beaux Arts, or, at least, in the academic quality and element. Complacent it may be, stiff and deliberate and very hard to influence – but in these selfsame qualities lies the safety and hope for French art. Without them the whole world of painters would turn radical, and anarchy be the rule of all the world! From such a fate academism perpetually preserves us – standing, as it does, for that great element in the French people which is sane, conservative and reliable."[12]

Obviously unaware of this challenge that a "perceptive" American had tossed into its lap, French academicism, suffocating in its own mediocrity, never rose to it.

Not all publications, of course, defended such antiquated viewpoints. Among those eager to contribute a more positive concept was Marius de Zayas who, during

his trips to Europe and through his friendship with the Eugene Meyers, had been able to study a good many works by Cézanne. In collaboration with his friend Paul B. Haviland he brought out a small pamphlet dated March 1, 1913, and published by 291, that is, by Stieglitz. It was called *A Study of the Modern Evolution of Plastic Expression*, and it presented ideas de Zayas had already developed in several recent articles in *Camera Work*. In twenty-six short pages the authors covered a vast territory (from the Egyptians to Cubism), doing so in a slightly dogmatic tone tinged with a certain naïveté. Their philosophy appears to be woven of some kind of latex material that seemingly provides a firm grip while being stretchable in any direction. The concluding statement is: "Up to Cézanne art had its basis of inspiration in the inner self and expressed itself through the outside world, through facts. The artist tried to animate the objects which he represented, to make them live by themselves. The basis of inspiration of the new movement is the outside world and the artist tries to represent his inner conception of form. He studies the life of things and tries to express their organism. The important difference, between the old expression and modern expression is therefore primarily one of direction."[13]

Whereas de Zayas used the context of the Armory Show to expound concepts formed over a number of years, others, who had not previously been exposed to ultramodern tendencies, were provided by the exhibition with the impulse to write books on advanced art. If many of these endeavors were amateurish, others were guided by a more adventurous attitude and even a certain enthusiasm for the accomplishments of the present generation. It was thus that the Chicago corporation lawyer Arthur Jerome Eddy rather unexpectedly turned into an apostle for all that was new and daring in contemporary art (or at least seemed so to him). It is true that he was also credited with having been the first to ride a bicycle and to own an automobile in Chicago.[14]

Eddy's reputation as an eccentric was well established in Chicago; he was, indeed, a highly unusual person, writing plays, novels, short stories, poetry, travelogues, law treatises, political tracts and economic theories, as well as articles and books on art. He was also an expert fencer, dancer, connoisseur of wines and foods. It could be said of him that he "tried everything once and usually wrote about it afterwards – all the while engaged in an extensive law practice...."[15] But if there was a subject to which he always remained committed, it was his interest in art. Since the Chicago World's Fair, exactly twenty years before, where he had been attracted by the works of Whistler and Rodin, he had never ceased to dabble in art criticism and in collecting. He seems to have been constantly on the lookout for new purchases in Chicago and New York as well as on his trips abroad where he met, notably, a number of German Expressionists, among them Franz Marc, with whom he subsequently corresponded. He also befriended Kandinsky and exchanged many letters with him.

Eddy's purchases of works of art followed no discernible pattern except that, despite his considerable income, he generally avoided the already "established" and more expensive modern artists, such as the French Impressionists, and preferred to make his own discoveries among still unknown contemporaries. While he sometimes showed great acumen in his selections, he more often succumbed to a predilection for mediocrity. A list of the artists he passed up and who were still quite "affordable" would be extremely long. His art appreciation was utterly without consistency of

113

1, 91

113 Marius de Zayas *Portrait of Paul B. Haviland c.* 1910

taste. It is true, however, that Eddy could admire such totally divergent masters as Manet and Klee. Yet his fellow Chicagoan, the painter Manierre Dawson, was not particularly impressed by a visit to the lawyer's home: "Have been to Eddy's and have seen his big collection of paintings which he has hung in nearly every room in the house. It is somewhat indiscriminate. The newspapers have made a big notice of his having bought the Picabia *Dance at the Spring* [at the Armory Show] and two or three Sousa-Cardoza. Cézanne is strangely missing and Picasso is represented only by a small, early, pointillist picture of an old Spanish woman."[16]

Yet Eddy's taste had not always been that "advanced." Back in 1902 he had published a small volume of five lectures titled *Delight the Soul of Art*, the elaborate triteness of which is almost touching. In it he held forth on painting, music, architecture, poetry, and related subjects, devoting lengthy platitudes (and quotes from many authors) to Velázquez, Millet, Hokusai, Corot, Milton, Omar Khayyám, Whitman, and others. He liked to impart to his readers such philosophical pearls as "Strive to write a Hamlet and the result will be pitiable," or "The painter who tries to remember a scene as he paints it is leaning upon a straw."[17]

Eddy did not have much to say about recent French art, except to announce that he had "no sympathy with 'Impressionism' in its cruder and ranker forms," though he did believe "firmly in impressionism in its pure and subtle realization."[18] While he chose not to specify on what criteria this distinction was based, his likes or rather dislikes can be deduced from his treatment of Degas and Monet, the only modern

painters to whom he devoted some attention (and who were both still active). Eddy made short shrift of Degas, writing that his "art – fine as it is – is an illustration of the triumph of technique. He paints well, wonderfully well, the things he sees, but he is quite indifferent as to what he sees, and often sees things scarce worth painting at all."[19] The author devoted more space to Monet as "the conspicuous exponent of a school," although he hinted that he belonged to the cruder and ranker branch of Impressionism. His total incomprehension of artistic problems of any kind led Eddy to proclaim that Monet was "a painter by theory rather than conviction . . . but his conviction is of a scientific character rather than religious, formal rather than emotional, theoretical rather than intentional, reasoned rather than felt."[20] It is almost impossible to misunderstand Monet's approach to nature more completely. Eddy's conclusion was that "for the time being Monet and his immediate forerunners have disturbed the equilibrium of French art, and it will be many a long day before an art so susceptible absorbs and assimilates all that is good in his school and regains its equipoise."[21]

In 1903, the year after having issued his book on the "Soul of Art," the lawyer published a biography of Whistler which appeared immediately upon the artist's death. It was well documented, if somewhat overburdened with anecdotal material. Exactly ten years later, Eddy's first reaction to the Armory Show, as reflected in his letter to the director of the Art Institute,[22] was not exactly a hymn to modern art. Instead, it sounded as though it had been at least partly inspired by Kenyon Cox, whom Eddy had met at the exhibition. But this was not really surprising in view of what he had expressed in his book published in 1902. What was surprising was that Eddy made a number of purchases in New York among which were some extremely advanced works, such as paintings by Marcel Duchamp. When the exhibition subsequently moved to Chicago, Eddy made still more purchases and also began to give lectures that proved to be so popular, they had to be repeated. There can be no doubt that these lectures, spontaneously though they may have been conceived, became the basis for Eddy's third book on art, *Cubists and Post-Impressionism*, which, appearing in 1914, was the first publication in America to cover this broad subject. As such, it attracted considerable attention, even though it suffered from the author's pedantry and his deplorable habit of making a point and then belaboring it in the most uninspired prose. If there were any need to prove that laudable intentions do not a good book make, Eddy's new volume could serve as a classic example.

Since he dealt with an as yet uncharted territory, Eddy felt compelled to establish various categories to guide the reader through the maze of modern art. But he did not find very fortunate solutions for this problem, stating for instance that "*Substantial* or Cézanne Impressionism led naturally to the Virile-Impressionism of today, a way of seeing and painting things that is a compound of the Impressionism of Manet with that of Cézanne."[23] And when it came to list "Virile-Impressionists," he cited Winslow Homer, Sargent, Robert Henri, Leon Kroll, and Dunoyer de Segonzac. Nor was Eddy particularly felicitous in defining the efforts of individual artists, writing, notably, that "Seurat and Signac simply attempted to out-Monet Monet."[24] But most of the time Eddy avoided the slippery ground of stylistic definitions, being content with assembling a true bouillabaisse of quotes from many, generally French sources, not all of which he had really digested.

Ever the lawyer, Eddy pleaded for the cause of modern art even in cases where no plea was needed. Thus he could state that "because there were a number of ugly – ugly to the extent of being objectionable – pictures in the [Armory] exhibition, that should not and does not detract from the merits of men who did not paint them."[25] Having thus established the startling principle that people cannot be held responsible for what they have not done, Eddy could rest the defense and protect such "Virile-Impressionists" as Leon Kroll from "jokes" represented by Matisse's work.

Since Eddy's concern both as a collector and as an author was with the post-Cézanne period, it is not surprising that he neglected to acquire any works by Cézanne or to devote any special section of his book to him. Yet Eddy was familiar with Emile Bernard's writings and, indeed, referred to Cézanne throughout his volume with the reverence due the master in whom he found "the sense of the substance, the fundamental reality. . . . It was these characteristics which made him a profound Impressionist, in the wider significance of the term, but also the first of the Fauves."[26]

These scrambled ideas were fairly well received on the whole, except for Eddy's fellow lawyer and collecting rival John Quinn, who may have been the only one to judge Eddy's volume with appropriate severity. "It is monstrous," Quinn wrote to a friend. "Horrible on the outside, cheeky as hell on the inside. Conceited, laughable, just what one would expect from a Chicago 'asspirant'. And to think that that chap wrote personal recollections of Whistler! But seriously, it seems to me that a book like that can do no good but only harm. I have only glanced at it and dipped into it here and there. It seems to have everything jumbled and pitch-forked together without rhyme or reason, and it doesn't seem that he understands or knows in the least."[27]

Eddy's book, richly illustrated with works mostly from his own collection, pursued the twin goals of explaining the validity of contemporary art and fighting against current prejudices, such as the one concerning the "ugliness' of modern painting, a prejudice of which, however, he himself was by no means free. Nevertheless, Eddy – despite his clumsiness and even ignorance – must be regarded as an ally in the struggle for new art then being fought in America.

While Cézanne was being treated as only one of the forefathers of that new art – albeit the crucial one – he became the subject of a full-length biography which first appeared in French. Yet such was the interest in the subject that Vollard's lavish volume on the painter was reviewed in America. It was the dealer's first venture as a biographer, and there is no denying that it was a highly successful one. Vollard not only had taken notes after his occasional conversations with the artist,[28] although these may have been less frequent than he would have liked his readers to believe, he had also interviewed many of the painter's friends, especially his son, and had read the letters addressed to him during the last year of his father's life.[29]

Vollard had an undeniable gift for the picturesque, and if the Cézanne he depicts lacks the natural dignity and profound wisdom we like to associate with genius, he has, on the other hand, all the foibles, the manias, the unpredictability, the contradictions, and the oddities that make him appear eminently human. Biographers who cannot rise to the lofty heights of their subjects often – if not always – tend to drag them down to their own level. This is a temptation to which Vollard

succumbed or, rather, which he could not avoid. Whatever Cézanne may have said or done that went beyond his dealer's comprehension was simply left unrecorded, so that the painter who emerges from his pages merely represents the aspects of the artist that lay within Vollard's more or less limited grasp. Yet, by the same token, the Cézanne evoked by Vollard was in easy reach of his readers. With an uncanny sense of the kind of colorful "original" the public prefers to the impenetrable and suffering loner, Vollard delivered exactly what was expected.[30]

Vollard seems to have been, to put it mildly, extremely pleased with his product, treating all his visitors to samples of it. Acting as his own publisher, he was also spared the anguish suffered by most novices who fear the rejection of their manuscripts. Nevertheless Vollard's next two biographies of artists he had known – Degas and Renoir – turned out to be much more chatty and hence less successful.

Reporting toward the end of May 1914 to Stieglitz on a visit he and Picabia had paid the dealer, Marius de Zayas wrote: "We had lunch today at Vollard's. . . . He read part of his book on Cézanne that will soon be published. It really is very interesting. Among the many remarkable paintings that he showed us, he pulled out what he considers the best picture of Cézanne, a still life which indeed makes the rest of the work of Cézanne look pale.[31] What I call a real masterpiece. I never even suspected that Cézanne had reached that note. He also showed us about fifty rotten Renoirs that he tried to make us believe were wonders."[32] To this, Stieglitz replied:

> And so you had lunch with Vollard. He is a great fellow. I have heard about that Cézanne book. It goes without saying that it will prove interesting. Although Vollard has a habit of not making entirely good when it comes to his publications. There is always just a trace of "business" back of it all. But only a trace. He is a shrewd old fellow. But of his type a masterpiece. You make my mouth water when you speak of that Cézanne. I know how chary you are with the use of the term masterpiece. . . . I wonder if I did see it that afternoon when Steichen and I were at Vollard's. I saw a marvelous still life there, which at the time, was a question in my mind whether it was not finer than the one the Meyers finally got. But I had seen so much that day before going to Vollard's and so much marvelous stuff at Vollard's that I did not consider myself fit to judge. I do remember a lot of inferior Renoirs. Renoir has done a lot of potboilers, and I think Vollard has a goodly batch of them.[33]

Vollard's biography of Cézanne appeared in Paris toward the end of 1914 or possibly early in 1915. Although it was not translated immediately into English, Robert J. Coady, a painter turned art dealer who had been a member of Gertrude Stein's coterie in Paris, translated at least one chapter, the one in which Vollard describes how Cézanne had painted his portrait. It appeared in New York in 1915 as a small pamphlet under the title *Cézanne's Studio*, without illustrations.

Among the Americans who reviewed the Cézanne biography – albeit after a considerable delay – was Royal Cortissoz. While Vollard's text had not exactly increased the critic's appreciation of the artist, he at least found the book entertaining. Just the same, he concluded his review with words he had already uttered many times (and which gained nothing in the repetition), "Cézanne stayed what he was at the beginning, a painter wandering about in worlds unrealized, too imperfectly equipped to say what he had to say, if, indeed, that was worth saying."[32]

Cortissoz's article, added to the steadily growing interest in Cézanne, seems to have triggered Huneker's long-suppressed (?) recollections of the master. The time had come for him to move back into the forefront of those who had a personal contribution to make. In a letter written to Cortissoz in January 1916, Huneker for the first time provided specific information about his alleged encounter with Cézanne. "I met the old chap first in 1901 at Aix," he wrote. "We went via tramway from Marseilles. Hot, dusty, dirty Aix!"[35] It was true, of course, that Huneker had been the first American to discuss Cézanne in the American press (on the occasion of the Salon d'Automne of 1904 and in an obituary of 1906),[36] but it appears strange that he should have waited fifteen years before revealing his acquaintance with the artist. And that is when the fib hit the fan! Indeed, Huneker betrayed his lame inventiveness when he insisted on an otherwise innocent detail: that in 1901 he had taken the tramway from Marseilles to Aix. This tramway first began to run on June 28, 1903.[37] Huneker's source for his tale of "meeting" the painter had obviously been Emile Bernard's detailed account of visiting Cézanne in 1904, an account of which Huneker himself had published a condensed translation in the *New York Sun* of 1908.[38] In that translation he had actually alluded to the fact that, upon Bernard's arrival in Marseilles, "a chance word told him that there had been installed an electric tramway between Marseilles and Aix."

Whether Huneker, in the meantime, had persuaded himself that he was truly speaking from personal experience or whether he knowingly and brazenly cheated will probably never be known. Persons with vivid imaginations often tend to appropriate what they have heard or read, with the result that in the end they themselves no longer can distinguish fact from fiction. In any case, once he had mentioned his imaginary meeting with Cézanne in a letter, Huneker proceeded to allude to it in two articles on the painter, the first of which appeared in March 1917, and the second – repeating more or less literally the previous piece – in April 1920. In both he spoke of "the nervous, shrinking man I saw in Aix" and described him (leaning heavily on Bernard's recollections) as "a queer, sardonic old gentleman in ill-fitting clothes, with the shrewd, suspicious gaze of a provincial notary."[39]

Thus, the first and only American journalist ever to claim that he spoke to Cézanne never actually did so. The entire incident is ridiculous rather than historically important and can be put down as a kind of gratuitous bragging were it not that Huneker himself had stated a few years earlier, "It is a simpler matter to tell the truth than casuists admit."[40] Huneker "simplified" this matter still further by resolutely blurring the distinction between truth and invention.

If anything, American art criticism degenerated even more after World War I broke out. When stupidity, reactionary attitudes, and nationalism combine to assault everything modern, the results usually are depressing unless one finds the strength to consider them comical. Wars frequently offer fertile ground for such attacks since they provide a rabid and benighted fringe with the most demented arguments to fight not only the political enemy, but modern art as well, often treating them as though they were one and the same thing. (It is remarkable in this context that Willard Huntington Wright, despite sympathy for the Kaiser's Reich, never permitted his pro-German convictions to influence his avant-garde concepts of art. In this as in so many other fields, he pursued his lonesome and not always popular way.)

"During the early days of the [first] World War," Walter Pach subsequently wrote, "M. Frederic Masson and others tried to imbue the public mind of France with the idea that the Cubists were favorable to Germany as their best patron. Our well-known painter of Society portraits, Mr. Carroll Beckwith, outdid the French Academicians by the ingenious explanation of Germany's blood-lust which he published in the "New York Times": at bottom, he said, France was responsible for it, for she had been systematically exporting large quantities of modern art to her neighbor . . . and it was German consumption of such stimulants that had driven the good, industrious nation to madness and war."[41]

Beckwith found an ally in an American sculptor whose first, rather modest, contribution to the war effort consisted of changing the German spelling of his name from Ruckstuhl (meaning, roughly, rocking chair) to Ruckstull (which can be vaguely translated into something like the underside of a buttered slice of bread). However, there were no repercussions from this shattering transformation to affect his frenetic mind or his output of huge, atrociously boring marbles that must now clutter the basements of many American museums whose patrons were once seduced by their total lack of originality. If insignificance could attack stone the way rust attacks iron, F. Wellington Ruckstull's monuments of banality would have long since disintegrated. But unfortunately they were made of imperishable materials.

While Ruckstull's work was indeed unspeakably boring, he himself spoke up at every occasion. He liked to begin his lectures with pious statements according to which "there are only two truly worthy energies in this life – and they are Love and Art."[42] Whereupon, in what must have been an outburst of that love, he vilified

114

114 F. W. Ruckstull
Evening c. 1887

every original creator he could think of, lashing out with unmatched vigor at that "semi-maniac Baudelaire," a "diabolical piece of human effrontery," or accusing Renoir of "vulgar 'intellectualism'" and speaking in similarly flattering terms of Manet, Monet, Degas, and others. His special rage was reserved for Rodin for having "besmirched the face of man and God." The venomous fury with which he pursued Rodin's "crimes in marble" could never disguise Ruckstull's own frustrations, his impotent envy of a successful rival.

The war provided Ruckstull with a new basis for his rantings. The patriotic feelings it aroused, coupled with the financial backing of a well-intentioned millionaire and fellow philistine, inspired Ruckstull to issue a periodical (to which Kenyon Cox and allied spirits also contributed), in which he did valiant battle for the most outdated, narrow, and actually lunatic ideas, defending the purity of an American academicism that had been mercifully dead for decades, defending it against the invasion of dangerous modern tendencies that he unhesitatingly equated with mental derangement.

Such things had been thought and written before (often more clearly and more articulately), but never had a man of such submediocre "talent" indulged in such flows of invective, in such ferocious spewing of soured stupidity. It goes without saying that next to his usual victims, the "excretions" of Matisse and Picasso, and especially those of Cézanne, were Ruckstull's favorite targets. If there was anything new in his vituperative approach, it was that he became the first to appropriate the only recently established vocabulary of psychoanalysis to the discussion of works of art. His writings literally bristle with references to pathological tendencies, schizophrenia, sadism, masochism, and so on. This is not surprising, however, since Ruckstull saw in modern art nothing but manifestations of insanity.

Discussing a Provençal landscape by Cézanne (V.433), Ruckstull discovered in it, as well as in similar works,

> glaring proof of Cézanne's penchant *to mutilate* [italics in original], which we find throughout his work, and which is an insult to nature. It may be said, that these are extreme examples of his mutilation of nature's forms. Granted! But, a cursory examination of *all* of his works will show therein a *general tendency* towards mutilation: either by commission or omission. And that he seems to have been a sex-pervert seems probable when we study his many, more or less vulgar, nude studies and pictures . . . in the sumptuous volume on "Cézanne," by the Paris art-dealer, Ambroise Vollard, written apparently to *boost the prices* of his "collection" of Cézanne's work – in order to unload them, at gigantic profits, on those American collectors who have lost their sense of discrimination, and have developed a weakness for succumbing to the cynical, weasel-propaganda conducted by the masters of the art-world of today, the astute dealers in art – instead *of going to the artists direct*, and buying what truly appeals to them and emotions their own soul. And then these dealers – through some of these buncoed collectors – will either easily inflict these sadistic atrocities on some of our art museums, or jimmy them in through "influence," or by browbeating some poor director, who is powerless to protect the public against the hanging of these things in the great museum over which he presides.[42]

When Ruckstull wished to penetrate even more deeply into the psyches of artists he so passionately loathed, he submitted their features to similarly profound

115

examinations. Much evidence "could be marshalled," he wrote, "to prove that Cézanne was semi-insane. Indeed we have only to look at the construction of his own head as any good photograph of him will show, to see evidences of degeneracy lurking in the eyes and radiating from his cranium. So patent is this that he seems to have felt it himself, as revealed in some of his lucubrations which now and then appear in print."[45]

After the war, Ruckstull continued his crusade and, to nobody's surprise, began to rant against Bolshevism in art, this being only one of many movements devoted to foisting modernism on an unsuspecting world (some of the others being Anarchism, Nihilism, Socialism, Jacobinism, Communism, Mormonism, Agrarianism, Fournierism). But the enemy was still the same, and Ruckstull began to sound rather tired and monotonous, unable as he was to promote more than a single lame idea over several decades: "Having succeeded," he wrote,

> by their intensive propaganda in making the simpletons of the world believe Rodin to be the greatest sculptor since Michael Angelo – this, we repeat, for the greater prestige of Paris and French commerce – the art-politicians of Paris now looked about for a painter whom they could likewise thus boost into notoriety as the greatest painter since Raphael, and thus again increase the prestige of Paris; and they fell on Cézanne, a '*demi-fou*,' a half-witted country yokel who tried to paint pictures by main strength and awkwardness, as the Irishman plays the fiddle, but engendered nothing save pathological daubs and insanities.[46]

115 *House in front of Mont Sainte-Victoire near Gardanne* 1886–90 (V.433)

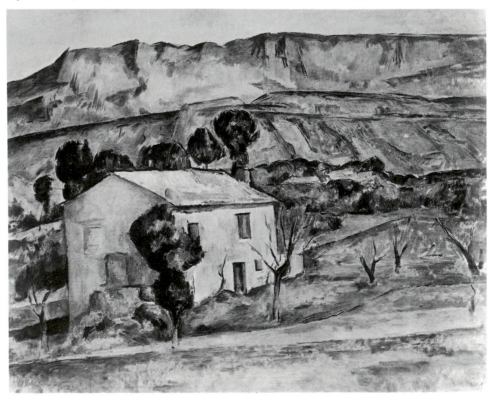

116 Cézanne in his Lauves Studio in front of his large composition of *Bathers*. Photograph by Emile Bernard, 1904

The only thing truly pathological (or sad, or funny) about all this is that after ten years of such hysterical outbursts, Ruckstull had not been able to curb in the slightest the steady growth of Cézanne's reputation (accompanied by a continuously increasing number of his works entering American collections). Ruckstull's peculiar way of expressing his "Love" for art obviously did not reach those he wished to convince or, if it did, it totally failed to impress them. Nor were they impressed, one presumes, by the kind of washed-out prose that appeared ever more frequently in "well-meaning" books devoted to modern art. When the British critic C. Lewis Hind came to the States during the war (where he wrote mostly for the *Christian Science Monitor*), he, too, felt called upon to explain Cézanne and did so without saying anything of the slightest interest or originality. Hind's articles were subsequently assembled in a volume with the excruciatingly immodest title *Art and I*.[47] It is difficult to read it today with any benefit, and just as difficult to read it with any pleasure; and once these two basic functions of the printed page are absent, there is absolutely nothing left to look for.

NOTES

1. Willard Huntington Wright, "Impressionism to Synchromism,' *The Forum*, Dec. 1913, pp. 762–63. This article was brought to my attention by Francis M. Naumann.

2. Ibid., p. 762.

3. Oscar Bluemner, "Audiator et altera pars: Some Plain Sense on the Modern Art Movement," *Camera Work*, June 1913, p. 32, quoted in Chapter VIII, note 8.

4. Stephen Bourgeois to Walter Pach, Paris, June 10, 1913; quoted in Milton Brown, *The Story of the Armory Show* (Greenwich, Conn.: New York Graphic Society, 1963), pp. 190–91.

5. The catalog specifies: "Sonderausstellungen deutscher Privatsammlungen im Städtischen Ausstellungs-Gebäude auf der Mathildenhöhe zu Darmstadt. II. GEMAELDE-SAMMLUNG G. F. REBER, BARMEN." The exhibition lasted from the middle of May to the middle of June 1913. It was subsequently shown at the Galerie Paul Cassirer in Berlin. Cézanne's works were listed as follows: 4. Die Brücke, 80 × 64 cm. Galerie Vollard. 5. Harlekin, 61 × 46 cm. Galerie Vollard. 6. Der junge Philosoph, 103 × 98 cm. Familie Cézanne. 7. Badende Männer, 60 × 81 cm. Galerie Vollard. 8. Grosses Stilleben mit Aepfeln, 72 × 100 cm. Sammlung Paul Cassirer, Berlin. 9. Stilleben (Aquarell), 47 × 63 cm. Galerie Vollard. 10. Mann mit gekreuzten Armen, 92 × 72 cm. Galerie Vollard. 11. Stilleben mit Aepfeln und Krug, 49 × 40 cm. [no origin indicated]. 12. Stilleben mit Birnen, 49 × 60 cm. Galerie Vollard. 13. Der Fuhrmann, 80 × 64 cm. Sonderbundausstellung Köln 1912. 14. Lutteurs amoureux, 37 × 45 cm. Sammlung A. Renoir, Paris. 15. Blumen, Farbenstudie, 39 × 28, oil on canvas [no origin indicated]. 16. Avignon [?], 90 × 73 cm, oil on canvas [no origin indicated]. 17. Mont-Victoir, 60 × 73 cm., oil on canvas [no origin indicated].
There was also a section B. ZEICHNUNGEN, listing Cézanne, Millet, Pissarro, Manet, Daumier, and Forain, but giving no titles of works, nor their numbers, dimensions, etc.
This rare document was brought to my attention by Roland Dorn of Mannheim and Walter Feilchenfeldt of Zurich.

6. But the catalog of the exhibition (see note 5 above), lists only *one* watercolor, for which Vollard is given as origin. It is possible, however, that there were further watercolors in the section devoted to Drawings, though this appears rather unlikely.

7. Article in *Darmstadter Tagblatt*, May 16, 1913; courtesy Bernd Krimmel, director of Mathildenhöhe, Darmstadt.

8. The illustrations accompanying the article are somewhat misleading, since among them are several of works (also mentioned in the text) that did not belong to Reber, such as *Woman with a Rosary*. But in those days available photographs were often used for reproductions, whether they were pertinent or not.

9. On this subject, see John Rewald, "Une Copie par Cézanne d'après Le Gréco," *Gazette des Beaux-Arts*, Feb. 1936, pp. 118–21. Cézanne's interpretation of El Greco's painting was not included in the exhibition, nor were his *Newspaper Reader*, *Cardplayers*, *Reaper*, and *The Smoker*, mentioned in the next paragraph.

10. Anonymous [W. H. Wright], "Art at Home and Abroad," *New York Times*, July 6, 1913, Section V, p. 15.

11. George Orwell, *Burmese Days* (New York: Harper, 1934), Chapter VII.

12. Margaret Steele Anderson, *The Study of Modern Painting* (New York: The Century Co., 1914), pp. 62–63, 75–76. This book was brought to my attention by Francis M. Naumann.

13. Marius de Zayas and Paul B. Haviland, *A Study of the Modern Evolution of Plastic Expression* (New York: 291, 1913), pp. 35–36.

14. I am indebted for some details to a seminar report on Eddy and Cézanne by Mrs. Marion Wolf.

15. See Paul Kruty, "Arthur Jerome Eddy and His Collection: Prelude and Postscript to the Armory Show," *Arts Magazine*, Feb. 1987, p. 40. This is an excellent article crammed with information and documents (pp. 40–47). On Eddy, see also the catalog *The Arthur Jerome Eddy Collection of Modern Painting and Sculpture*, intro. by Daniel C. Rich (Chicago: Art Institute of Chicago, 1931). Only 23 works from the collection were bequeathed by Eddy's widow to the museum; many others were sold by her or dispersed at an auction sale organized by her son.

16. Manierre Dawson, diary entry, May 25, 1914; Archives of American Art, Manierre Dawson papers, roll 64, quoted by Kruty, "Arthur Jerome Eddy," p. 45.

17. Arthur Jerome Eddy, *Delight the Soul of Art* (Philadelphia and London: J. B. Lippincott, 1902), pp. 184 and 134.

18. Ibid., p. 99.

19. Ibid., p. 179.

20. Ibid., pp. 202–3.

21. Ibid., p. 207.

22. See Eddy's letter to the director of the Art Institute of Chicago, Feb. 22, 1913, quoted above, Chapter VIII, note 30.

23. Arthur Jerome Eddy, *Cubists and Post-Impressionism* (Chicago: A. C. McClurg, 1914), p. 209.

24. Ibid., p. 27.

25. Ibid., p. 157.

26. Ibid., p. 37.

27. John Quinn to Mitchel Kennerley, New York, April 12, 1914; quoted partly by Kruty, "Arthur Jerome Eddy," p. 45, and partly by Judith Zilczer, "John Quinn and Modern Art Collectors in America, 1912–1914," *The American Art Journal*, Winter 1982, p. 60. This article was brought to my attention by Francis M. Naumann.

28. About notes taken by Vollard, see above, Chapter IV, note 5.

29. The absence of any letters from other years can conceivably be explained by the supposition that at the end of every year Cézanne's son used to gather together and destroy all useless papers accumulated during the past twelve months, including the letters received from his father. But by the end of 1906 the painter having died only a few weeks before, filial piety may have prompted him to preserve his father's ultimate messages. None of the letters the artist may have written to his wife has ever surfaced.

30. There had been rumors in Vollard's lifetime that he had not really authored his books but had relied on a ghostwriter. I can testify (for all that it's worth) that I once found Vollard in his Paris dining room-office, nervously pacing around the large round table while dictating to a secretary. He explained that he had discovered that the English version of his *Recollections of a Picture Dealer* (London and New York, 1936), which had appeared before the French one, did not contain any description of Renoir and that he was in the process of adding one for the French edition (Paris, 1937).

31. It is not possible to identify this work, which may conceivably have been V.757, a still life that de Zayas subsequently purchased from Vollard and sold to the Eugene Meyers.

32. Marius de Zayas to Alfred Stieglitz [Paris], May 26/27, 1914; Collection of American Literature, Beinecke Rare Book and Manuscript Library, Yale University. This document was brought to my attention by Francis M. Naumann.

33. Alfred Stieglitz to Marius de Zayas [New York], June 9, 1914; Collection of American Literature, Beinecke Rare Book and Manuscript Library, Yale University. This document was brought to my attention by Francis M. Naumann.

34. Royal Cortissoz, "Paul Cézanne and the Cult for his Paintings," *New York Tribune*, Jan. 9, 1916. On this article, see also below, Chapter XIII, note 28.

35. James G. Huneker to Royal Cortissoz, Westminster Court, Jan. 7, 1916; in *Letters of James Gibbons Huneker* (New York: Charles Scribner's Sons, 1922), p. 204.

36. Huneker's articles are discussed in Chapter IV, above.

37. Information courtesy ingénieur Etienne J. P. Spire, Aix-en-Provence.

38. Huneker's article concerning Emile Bernard's recollections of Cézanne is discussed in Chapter V, above, pp. 118–19.

39. James G. Huneker, "The Case of Paul Cézanne," *New York Sun*, March 11, 1917; reprinted in James G. Huneker, *Unicorns* (New York: Charles Scribner's Sons, 1917), p. 103; and James G. Huneker, "Cézanne," *New York Sun*, April 4, 1920; reprinted in James G. Huneker, *Variations* (New York: Charles Scribner's Sons, 1921), p. 97.

40. James G. Huneker, "Masters of Hallucination," *New York Times*, May 11, 1913. (This article was indirectly inspired by the Armory Show on which Huneker published no specific comments.)

41. Walter Pach, *Ananias or the False Artist* (New York and London: Harper & Brothers, 1928), p. 104; on Beckwith, see also below, Chapter XIII, note 1.

42. F. Wellington Ruckstull, *Social Art* (New York: The National Arts Club, 1915), unpaginated. This pamphlet was brought to my attention by Monroe Denton.

43. Ruckstull's language was subsequently taken up by psychiatrists such as R. W. Pickford, who wrote: "Cézanne showed . . . ambivalence towards the destruction or preservation of many of his works. His paintings were unconsciously anal objects which he used as gifts or weapons, and sometimes as both together in a sadistic way, so that they were often channels for the combined expression of libido and aggression and the control of these by his ego. Many of his paintings were collected by Vollard after Cézanne had given them away to people who took them only because they cost nothing. Cézanne had consigned them to oblivion, but he had chosen, unconsciously, a kind of oblivion from which they might reappear. Many of his pictures, however, he burned or slashed to pieces"; *Studies in Psychiatric Art: Its Psychodynamics, Therapeutic Value, and Relationship to Modern Art* (Springfield, Ill., 1967), p. 37. This text was brought to my attention by Patricia Mainardi.

44. F. Wellington Ruckstull, *Great Works of Art and What Makes Them Great* (Garden City, N.Y.: Garden City Publishing Company, 1925), p. 24.

45. F. Wellington Ruckstull, *Art World*, Dec. 1916, p. 206.

46. Veritas [F. Wellington Ruckstull], *Bolshevism in Art and Its Propaganda* (New York: Veritas, 1924), p. 35. This text was brought to my attention by Monroe Denton.

47. C. Lewis Hind, *Art and I* (London and New York: John Lane, 1921).

XI *Portrait of the Artist's Wife in a Striped Dress* 1883–85 (V.229)

XII Stanton Macdonald-Wright *Willard Huntington Wright* 1913–14

X · Willard Huntington Wright

NOT ALL THOSE in America who concerned themselves with Cézanne in those years were as flippant as Huneker or as sour as Cortissoz. Fortunately, there were a few art critics who sincerely admired Cézanne and did so intelligently (stupid admirers can actually be dangerous, since they are easily dealt with by clever or cunning adversaries such as Kenyon Cox). In first place among those who seriously studied Cézanne's work and wrote about it with insight, erudition, and a philosophical as well as historical point of view was Willard Huntington Wright. *XII*

His older brother, Stanton Macdonald-Wright, was a painter who had studied in Paris since 1907, and who, with his friend Morgan Russell, admired Cézanne (he supposedly even owned several watercolors) and knew the Steins. Willard Huntington Wright arrived in Paris in the spring of 1913, a twenty-five-year-old writer, son of a college president, already having been a journalist and a literary editor, in the course of which activities his brilliant, sardonic, irreverent, and whimsical mind, coupled with an often elitist and arrogant attitude, seems to have gained him as many enemies as friends (with H. L. Mencken among the latter). Having left California in 1912 for New York, Wright saw the Armory Show but – more important for his professional debut in the East – ran into trouble with the owner of the periodical consigned to his editorial guidance, a guidance charged with contradictions and provocations. It may have been to escape further complications of a promising yet at least temporarily compromised career that the young man joined his brother Stanton in Paris. He apparently arrived there before Leo and Gertrude Stein split their collection, since he was able to admire their Cézanne watercolors, which made a deep impression on him. (He had still been on the West Coast with the *Los Angeles Times* when Stieglitz held his 1911 exhibition at New York.)

Living in Paris in the midst of the prevailing artistic turmoil, the young American seems to have successfully avoided all the petty intrigues that divided the various movements. The first articles he sent back to New York are bare of any gossip and hardly ever mention any names. It is known, however, that Wright enjoyed discussions with Leo Stein, with whom he shared a few likes and dislikes; both admired the more recent works of Renoir and both were highly critical of Cubism, opposing claims that it derived from Cézanne. At the same time, Wright's views were more or less strongly influenced by his brother and Morgan Russell who, while tutoring the newcomer, evidently insisted on the overriding merits of their own Synchromism.

It was obviously no accident that one of Wright's first reports from Paris, which appeared in New York at the end of 1913, concerned itself with the artistic evolution from "Impressionism to Synchromism."[1] Of the latter movement, "sired by two Americans," as he put it, Wright boldly declared that it seemed "destined to have the most far-reaching effect of any force since Cézanne."[2] On this point, however, he can hardly have found himself in agreement with Leo Stein.

At the outset, Willard Huntington Wright's major preoccupation had been with philosophy and, while in Paris, he must have been finishing his very first book, *What Nietzsche Taught*, which was to appear in New York in 1915. Thenceforth, when Wright concerned himself with philosophical and aesthetic considerations, what Nietzsche had taught him frequently lingered behind his words and did not exactly contribute to winning friends for him at a time when Germans in general and the "Superman" in particular were not exactly popular in the United States, especially after World War I had broken out. However, Wright did not devote himself exclusively to pro-Germanic writings (which even placed him under suspicion of being an agent of the Reich[3] and lost him the friendship of H. L. Mencken and George Jean Nathan); in those years he was incredibly productive in various fields. He not only wrote an autobiographical novel whose limited success left him bitterly disappointed, but at the same time also embarked upon a volume on modern painting, concerned extensively with Cézanne. The foreword for this book is dated "Paris, 1915," yet by the summer of that year both Wright brothers had returned from war-torn France to America. The book appeared in London and New York later that same year.[4]

Wright's work provides a sober summing up of original observations that make it abundantly clear that he did not waste his two years abroad (April 1913 to May 1915). It also underlines the fact that such an ambitious survey – the first of its kind to be undertaken by an American – could only have been written after intensive study in Paris. While he carefully avoided allusions to personal experiences (although he did mention that he saw many Cézanne watercolors at the Bernheim-Jeune gallery), Wright obviously had examined thoroughly many of Cézanne's paintings, among which those of the artist's last years were of particular interest to him. But where he saw them is not revealed; in addition to Vollard and the Bernheim-Jeunes, he probably had access to other collections, such as those of Durand-Ruel, Pellerin, and possibly even the painter's son. On the other hand, Wright apparently made no attempt to interview any of those – mostly artists – who had known Cézanne, being satisfied with available printed sources. These, however, he submitted to a more careful scrutiny than had ever been attempted, using and quoting only what he found confirmed by Cézanne's work. Cézanne's paintings were Wright's point of departure and remained his sole guide.

As was to be expected, Wright made extensive use of Bernard's writings, but not without selecting what he found "acceptable." What nobody had yet said he stated bluntly when he wrote: "Emile Bernard was little different from the average critic. In attributing to Cézanne his own limitations, he restricted what he might otherwise have learned. But the literalness with which he recorded the artist's sayings makes his book of paramount interest."[5]

In his foreword, Wright took pains to clarify his aims (his entire book is written

117 Photograph of Willard Huntington Wright *c.* 1916

with great concision and without any concessions to belletristic adornments). "Modern art has become a copious fountain-head of abuse and laughter," he wrote,

for modern art tends toward the elimination of all those accretions so beloved by the general public – literature, drama, sentiment, symbolism, anecdote, prettiness and photographic realism. This book inquires first into the function and psychology of all great art, and endeavours to define those elements which make for genuine worth in painting. Next it attempts to explain both the basic and superficial differences between "ancient" and "modern" art and to point out . . . the superiority of the new methods over the old. By this exposition an effort is made to indicate the *raison d'être* of the modern procedure. After that, modern painters are taken up in the order of their importance to the evolution of painting during the last hundred years.[6]

It was evident that in a recapitulation of this kind Cézanne would have to receive his due, together with such other pathfinders as Manet, Renoir, Gauguin, Degas, Matisse, Picasso, Futurism, and, obviously, Synchromism (although in some cases Wright was quite critical of their achievements). In any event, the author did more than merely insert Cézanne's contribution among those of his contemporaries and successors; he actually devoted to him what may be considered the central chapter of his book, and also by far the longest, of which several pages concerned a comparison between Cézanne and Renoir. In spite of Wright's eloquent admiration for the latter (who was then still alive), it was Cézanne who emerged as the greater and more innovative master. In addition, the volume featured a color frontispiece of one of Cézanne's already famous views of Mont Sainte-Victoire (V.454), as *118* well as two black-and-white illustrations, one of a still life (V.732) and the other *119*

239

63 of the artist's ultimate large composition of bathers (V.719), then owned by Pellerin. But Wright's text did not discuss these works specifically, as he refrained altogether from referring to any individual paintings. His chosen task was clearly to analyze succinctly Cézanne's logical progress and to do so step-by-step rather than picture-by-picture, since practically all of the works were still unknown to his readers. Such an analysis, Wright felt, would also illuminate the artist's aesthetic aims.

Despite his resolve to speak with philosophical restraint about Cézanne, "that astounding and grotesque colossus," Wright did not manage to maintain complete detachment as he tried to demonstrate why he considered the artist to be "the highest type of the creative mind, always in search of something better, never satisfied with present results." Eventually he could think of but a single analogy. "One can find," he wrote, "a parallel for this intellectually ascetic creature only in the old martyrs. He was the type that renounces all the benefits and usufructs of life in order to follow the face of a dream."

After establishing that the young Cézanne had been more deeply influenced by Courbet than by Manet, and that the Louvre as well as Pissarro had decisively contributed to his evolution, Wright went on to point out that "the exact reproduction of nature in any of its manifestations never held him for a moment. He saw its eternal aspect aside from its accidental visages caused by fluctuating lights. In this he was diametrically opposed to the Impressionists who recorded only nature's

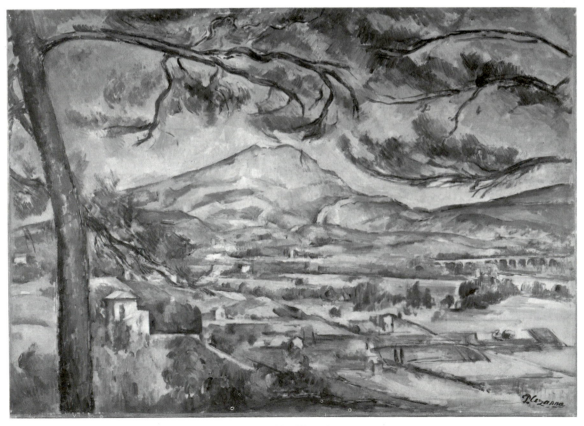

118 *Mont Sainte-Victoire with a Large Pine Tree c.* 1887 (V.454)

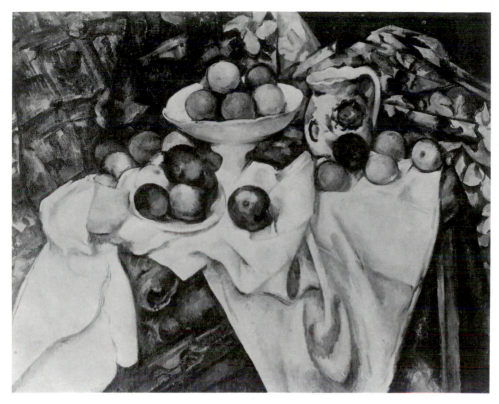

119 *Still Life with Apples and Oranges c.* 1899 (V.732)

temporary phases. . . . Cézanne, regarding its atmosphere as an ephemerality, portrayed the *lasting force* of light."

"In a Cézanne of the later years," Wright pursued,

> not only is the form poised in three directions, but the very light is also poised. We feel in Cézanne the same completion we experience before a Rubens – that emotion of finality caused by the forms moving, swelling and grinding in an eternal order; and added to this completion of form, heightening its emotive power, is the same final organisation of illumination. The light suggests no particular time of day or night; it is not appropriated from morning or afternoon, sunlight or shadow. . . . Whether the picture be hung in a bright sunlight or in half gloom, it is a creator of its environment. Its planes, like those of nature, advance and recede, swell and shrink. In short, they are dynamic.
>
> If this feat of Cézanne's seems to border on metaphysics, the reason is that there has been no precedent for it in history.

After explaining how Cézanne had studied gradations of tone and also the role of the local color of an object as it modifies the natural colors of the light and shadow, Wright demonstrated that, as a result, the colors Cézanne applied would, "as they retreated from the most highly illuminated point on the picture, absorb a graduatingly smaller quantity of actual light, and would thus create emotional form in the same manner that nature creates visual form. Hence, the planes in a Cézanne canvas advance or recede *en masse*, retaining their relativity, as the eye excludes or

receives a greater or a lesser quantity of light; and since the light never remains the same for any period of time, the planes bulge toward the spectator and retract from him with each minute variation of illumination."

Thus, as Wright saw it, Cézanne, "stripped the Impressionists' means of their ephemeral plasticity, and, by using the principles, and not the results, of nature's method, gave them an eternal plasticity which no great art of the future can afford to ignore, and which in time, no doubt, will lead to the creation of an entirely new art."

Wright then proceded to explain that Cézanne

> constructed his canvases as nature presents its objects to the sight, as a unique whole. With all the older painters drawing came first, chiaroscuro second and colour third – three distinct steps, each one conceived separately. . . . Cézanne conceived his drawing, form and colour as one and the same, in the exact manner that these qualities, united in each natural object, present themselves to the eye. . . . In his best canvases there seems no way of veering a plane, of imagining one plane changing places with another, unless every plane in the picture is shifted simultaneously. Cézanne's solidity is organized like the volumes in Michelangelo's best sculpture. . . . There is a complete ordonnance between every minute part, and between every group of parts.

As a next step, Wright studied Cézanne's ability to achieve a perfect rapport of lines. "Cézanne, better than any other painter up to his day, understood how one slanting line modifies its direction when coming in contact with another line moving from a different direction." Being aware of this, Cézanne, in Wright's words,

> looked upon nature with perhaps the most delicate and perceptive eye a painter has ever possessed, and his vision became a theatre for the violent struggles of some one line against terrible odds, for the warring clashes of inharmonious colours. He saw in objective nature a chaos of disorganized movement, and he set himself the task of putting it in order. In studying the variations and qualifications of linear directions in his model, he discovered another method of accentuating the feeling of dynamism in his canvases. He stated lines, not in their static character, but in their average of fluctuation. We know that all straight lines are influenced by their surroundings, that they appear bent or curved when related to other lines. The extent to which a line is thus optically bent is its extreme of fluctuability. Cézanne determined this extreme in all of his lines, and by transcribing them midway between their actual and optical states, achieved at once their normality and their extreme abnormality. The character, direction and curve of all lines in a canvas change with every shifting of the point of visual contact. Since the unity of a picture is different from every focus, all the lines consequently assume a slightly different direction every time our eye shifts from one spot to another. Cézanne, by recording the mean of linear changeability, facilitated and hastened this vicissitude of mutation."

In addition, as Wright went on to explain, Cézanne, "by understanding the functioning elements of colour in their relation to texture and space, was able to paint forms in such a way that each colour he applied took its relative position in space and held each part of an object stationary at any required distance from the eye. As a result of his method we can judge the depth and sense the solidity of his pictures the same as we do in nature." Wright continued:

> We demand a greater stimulus than an art of two dimensions can give; our minds instinctively extend themselves into space. So it was with Cézanne. He left no device

untried which would give his work a greater depth, a more veritable solidity. He experimented in colour from this standpoint, then in line, then in optics. With the results of this research he became possessed of all necessary factors of colossal organization. He knew that, were these factors rightly applied, they would produce a greater sensation of weight, of force and of movement than any artist before him had succeeded in attaining.

Their application presented to Cézanne his most difficult problem. He must use his discoveries in these three fields in such a way that the very disposition of weights would produce that perfect balance of stress and repose, out of which emanates all aesthetic movement. The simplest manifestation of this balance is found in the opposition of line; but in order to complete this linear adjustment there must be an opposition of colours which, while they must function as volumes, must also accord with the character of the natural object portrayed. In short, there must be an opposition of countering weights, not perfectly balanced so as to create a dead equality, but rhythmically related so that the effect is one of swaying poise. Obviously this could not be accomplished on a flat surface, for the emotion of depth is a necessity to the recognition of equilibrium. Cézanne finally achieved this poise by a plastic distribution of volumes over and beside spatial vacancies. He mastered this basic principle of the hollow and the bump only after long and trying struggles and tedious experimentations. He translated it into terms of his own intellection: to the extent that there was order within him so was he able to put order into his pictures. This vision of his was intellectual rather than optical. . . . His art was his thought given concrete form through the medium of nature. His painting was the result of a mental process – an intellectual conclusion after it had been weighed, added to, subtracted from, modified by exterior considerations, and at last brought forth purged and clarified and as nearly complete as was his development at the time.

Toward the end, Wright states, somewhat abruptly, that Cézanne's greatest achievement is his watercolors. He devotes a long passage to them concluding: "In these water-colours, more than in any of his other work, has he posed the question of aesthetic beauty itself. When we contemplate them, we are more than ever convinced that Cézanne was the first painter, that is, the first man to express himself entirely in the medium of his art, colour. . . . Eventually, when a true comprehension of this great man comes, they will supplant his other efforts. His desires for a pure art are here expressed most intensely."[7] Although these are not the words with which Wright terminates his extensive chapter on Cézanne, this statement does sum up as adequately as any other quote from his study, his attitude toward Cézanne's uniqueness.

Whether some or all of Wright's interpretations and conclusions have withstood the test of time appears less important today than the fact that his book constituted the only lucid effort to express in words what the Armory Show had meant to demonstrate: that contemporary art was the logical outgrowth of all that had gone before, that it represented a decisive step toward the still undefined future, and that it deserved to be studied and appreciated with the same seriousness and respect accorded the acknowledged masters of the past. From that point of view, Wright's volume can be seen as a true landmark in the literature on modern art and should, at least to some extent, have put an end to the asininities that were still being written on that subject. This, however, did not happen, as antagonists of modernism not only failed even to consider Wright's demonstrations, but also continued to keep their prejudices alive, serving a rehash of them whenever opportunity arose.

Fortunately, Wright also found a way to deal with these antagonists, inflicting upon them a decisive though admittedly little noticed blow.[8] One by one he examined – and made short shrift of – the pretensions of the most prominent art critics of the day, exposing their nakedness beneath their verbose trappings. Ruckstull, however, was not among them, since this maniacal nonentity did not even deserve being discussed in their company. On the other hand, by analyzing and demolishing the positions of the well-known but obsolete writers on art, Wright automatically concerned himself with all those who, over the years, had opposed Cézanne (he did not use Cézanne as his gauge, but – rightly – applied a wider, more comprehensive one: the Armory Show). Wright's article acted like a broom that, at last, swept perennial misconceptions and biases out of the way. He declared:

It is not entirely the fault of the American people that they lag far behind all other civilized nations in aesthetic appreciation. The aggressive ignorance and theopneustic cant fed them by the majority of native critics . . . are in themselves sufficient to bring about an indefinite deferment of intelligent artistic taste. There has grown up a sort of sacred awe in the aesthetically illiterate for such reactionary writers as Royal Cortissoz, Kenyon Cox, Professor Frank Jewett Mather, Jr., and Charles H. Caffin; and so long as their influence persists, America will retain its innocence of all those deeper problems of art which must be mastered before a true understanding can be brought about. These gentlemen, blind to the graver concerns of painting and faultlessly disguised in a borrowed cloak of superficial and dogmatic erudition, woo the ear of the untutored by the platitudes of a pseudoculture, until the subject is hopelessly obscured.

The critic to whom, above all others, is attributable our lack of understanding of the aspirations and achievements of painting is Mr. Cortissoz, the *doyen* of our art reviewers – an industrious, sincere, well-informed, commonplace, unillumined writer, who possesses a marked antipathy for all that is new. He belongs to the aesthetic and intellectual vintage of the [eighteen] sixties: he is, in fact, almost pre-Raphaelitic in attitude, clinging with a kind of desperate fear to the established and accepted past, preferring the easy security of precedent to the more exacting security of the present. . . . He displays all the college professor's timidity of thought, and lack of interest and enthusiasm for that which has not been written down and agreed to. Thus he always plays safe by adhering doggedly to the musty text-books. . . . His rage was unbounded when he beheld the Armory Show of 1913. . . .

Mr. Kenyon Cox's sole contribution to our knowledge of art is native assertion that all progress in painting is an illusion. This is equivalent to saying that all progress in psychology, biology, heliotropism and chemistry is an illusion, for the science of aesthetics is founded on all of these other sciences. . . . To close one's mind to these things is to deny the existence of the floor on which one pretends to walk. Mr. Cox, however, unwittingly admits this basis, as is seen in his elaborate and erroneous explanation of composition, or, as he chooses to call it, "design." Why should certain rhythmic lines and balances of volumes produce aesthetic pleasure? Mr. Cox evades the answer, implying that what pleases him is right and what displeases him is wrong. . . . He dogmatizes his own preference, setting up his personal taste as an inflexible standard. . . . Were Mr. Cox's taste always correct one might forgive his assumption of omnipotence and perfection: but since he is at such variance with the conclusions of wiser and profounder students of aesthetics, we can only congratulate him on his self-satisfaction. . . . Of the deeper art knowledge Mr. Cox is benignly innocent, and he is sometimes so inexcusably superficial as to attempt to refute the merit of certain artists' work by hanging on them the label of insanity. . . .

Mr. Cox's aesthetic ossification is due to the very common error (which grows out of one's limit to understand) that, in order to appreciate modern painting (and I do not mean merely Post-Impressionism, Cubism, etc.), one must forgo the older masters. The reverse is true. A work of modern art must be judged by the same aesthetic principles that one applies to the older art; and modern painting must stand or fall on its adherence to those principles. The application of these principles to the complexities of modern art is more difficult, of course, than to ancient art; and because the academician is unable to apply these principles, he denies that the principles apply. Thus he raises his ignorance to a virtue, and proceeds to condemn the new art, frightening away the public by cries of "madness," "distortion," "rubbish." The method, if childish and simple, is sometimes effective. . . .

Frank Jewett Mather, Jr., is Professor of Painting at Princeton, and reveals few qualities which distinguish him from the typical scholastic pedant. His contributions to aesthetic criticism differ only in detail from the conventional artistic theories. His prejudices are of educational rather than emotional origin. That which is inoffensive from the standpoint of puritan culture, provided it is thoroughly established and has the indelible imprint of traditional approval upon it, sways him toward praise. Paradoxically he is an admirer of Roger Fry, but he entirely lacks Fry's courageous attitude toward modern painting. Professor Mather failed completely to comprehend the significance of the Armory show, and wrote himself down an inherent conservative who was unable to adjust himself to such conditions as were immediately grasped by both Roger Fry and Berensen [sic] on the occasion of the Post-Impressionist exhibition at the Grafton Galleries, London. The Armory pictures, being stripped of habitual and superficial integuments, offered no opportunity for vague sentimental generalizations, but demanded precision of thought and definiteness of exposition. These qualities being alien to the academic theorist, Professor Mather and his fellow rhetoricians withdrew in confusion and splashed about disconcertedly in water that was not over their heads.

Charles H. Caffin . . . evidently cares naught for the aesthetics. The problems of art are far from his thought. . . . He has courage without direction; independence without beliefs. Mr. Alfred Stieglitz converted him to modern art, largely through hypnotism, I am inclined to think, for Mr. Caffin possesses almost none of Mr. Stieglitz's knowledge or feeling for painting. As a recorder of the external events of art's development, he is of considerable value. I read his books myself – as I would a dictionary. But if we go to him for mental food, we go to an empty larder.

Nor is the very entertaining Mr. James Huneker a source of aesthetic stimulation. Mr. Huneker does not pretend to help us toward a clearer understanding of art problems. He tacitly admits he knows little of the underlying principles of aesthetics, and is honest and courageous enough to disclaim any assumption of standard setting. . . .

To not one of these eminent writers can the public turn for accurate and helpful information. . . . Our critics, for the most part, are timid, personal, ignorant, careless, intolerant or hopelessly scholastic. Consequently they are neither guides nor philosophical detractors; and painting as a whole suffers. This is not true of any other civilized country. In Europe there are capable men of the Roger Fry, Clive Bell and Apollinaire type. These men differ in conclusions, but they at least take the artistic effort seriously and do not attempt to hide their lack of knowledge behind a veneer of scorn and patronage. They try to learn the merits or demerits of a new method to which intelligent artists have given their lives. . . . Only the meagerly enlightened man assumes the omniscience that characterizes the average American art writer. I hold that Mr. Leo Stein is one of the ablest and most searching living critics of painting, despite the fact that he and I disagree wholeheartedly when we discuss the subject.[9]

It may have been an act of great bravery to tear so mercilessly into the ranks of the famous American pundits, but there was one aspect of the problem tackled by Wright to which he did not allude. And that was the fact that despite the practically united and wholly negative front presented by the professional commentators, modern art in America had been making great strides since the Armory Show. Whether the "sacred awe" of the reactionary critics Wright spoke of was being slowly overcome, whether the gap between European and American appreciation of modern art, which Wright deplored, was already in the process of being narrowed, the fact is that even if the old guard was almost totally united in a common stand, there was a constantly increasing number of new and sympathetic commentators, dealers, and collectors (while museum circles maintained their hostility). In the end, the evolution of taste in America did not depend on antagonistic professional art scribes – who had outlived their time – but on those who infused their attitude toward modern art not only with intuitive understanding and with knowledge, but also with enthusiasm. Wright had alluded to Alfred Stieglitz and Leo Stein, but there were others (among them Wright himself, of course), such as Henry McBride, Edward Steichen, the Arensbergs, Marius de Zayas, E. N. Montross, and even, despite his eccentricity, Dr. Albert C. Barnes, who were beginning to discover that their once "heretic" views were being met with increasing acceptance. Each of these in his own fashion, together with countless others, helped prepare the ground for a better understanding of all the new art movements, an understanding that in one way or another began (or sometimes ended) with a fuller grasp of Cézanne.

NOTES

1. Willard Huntington Wright, "Impressionism to Synchromism," *The Forum*, Dec. 1913, pp. 757–70; excerpt quoted above, p. 211.

2. Ibid., p. 768.

3. An article titled "He Hopes our Nation Will Become Nietzschean," *New York Tribune*, March 26, 1916, 5, p. 2, quotes Wright as saying "that Kaiserism embodied a healthy philosophical outlook that ought to be embraced by the American people." See Myron O. Lounsbury, "Against the American Game: The 'Strenuous Life' of Willard Huntington Wright," *Prospects*, 1980, pp. 528–29. This long article also provides a list of Wright's books (under note 3) and references to writings on Wright. For the most complete listing of Wright's books as well as articles, see Walter B. Crawford, "Willard Huntington Wright: A Bibliography," *Bulletin of Bibliography and Magazine Notes*, vol. 24, May–Aug. 1963, pp. 11–16. Another article, Carl Richard Dolmetsch, "The Writer in America: The Strange Case of S. S. Van Dine," *Literatur und Sprache der Vereinigten Staaten* (Heidelberg), 1969, was brought to my attention by Vivian Barnett. For recent studies, see Marianne W. Martin, "Some American Contributions to Early Twentieth-Century Abstraction," *Arts*, June 1980, p. 164 and John Loughery, "Charles Caffin and Willard Huntington Wright, Advocates of Modern Art," *Arts Magazine*, Jan. 1985, pp. 103–9. These last two articles were brought to my attention by Francis M. Naumann.

4. Willard Huntington Wright, *Modern Painting: Its Tendency and Meaning* (London and New York: John Lane, 1915). It has been said that S. Macdonald-Wright "was his brother's unofficial collaborator in authorship of *Modern Art* [sic], *Its Tendency and Meaning*." See *The Art of Stanton Macdonald-Wright*, exhibition catalog, Smithsonian Institution, Washington, D.C., 1967, p. 10 (footnote).

5. Ibid., p. 143.

6. Ibid., p. 8.

7. Ibid., quotes selected from pp. 130, 132, 133, 137, 138, 140, 141, 144, 145, 146, 147, 149, 150–51, 152, 160, and 161.

8. Willard Huntington Wright, "The Aesthetic Struggle in America," *The Forum*, vol. 55, no. 2 (Feb. 1916), pp. 201–10. This article was brought to my attention by Francis M. Naumann.

9. Ibid.

XI · Exit Leo Stein

In May 1915, Leo Stein returned to the United States for – among other reasons – a second attempt at psychoanalysis, having been dissatisfied with a first one. It is not clear why he had not sought treatment from Freud himself, with whose work he had been familiar for a number of years, especially since there would not have been any language barrier between them. But Italy was then on the verge of joining the Allies and it may not have been easy to leave for Austria. At about the same time Leo reached New York, Willard Huntington Wright and his brother also arrived back in the United States.

In New York Leo reestablished contact with friends such as Mabel Dodge, Marsden Hartley, Maurice Sterne, and Wright, while making new acquaintances, reporting to his sister that he had met Jules Pascin, Francis Picabia, Eli Nadelmann, Marcel Duchamp, and Albert Gleizes. Many of these belonged to the circle of Florine Stettheimer, who represented Leo in two paintings of her assembled artist *120* friends; in one of them he occupies a central position. He was also in touch with Albert Barnes who was "still collecting, chiefly Renoirs, of which he has now about sixty."[1] Leo was writing and giving occasional lectures.

Meanwhile, Wright involved himself in what was to become famous as the Forum Exhibition, named after the periodical that published many of his articles and that sponsored the event. Wright was the driving force behind the show, and contributed one of the six forewords to the catalogue, as did also Robert Henri and Alfred Stieglitz. The exhibition was a presentation devoted exclusively to American avant-garde painting, assembled much more carefully – and held to a smaller scale – than the Armory Show had been three years before.[2] For his introductory essay, Wright simply used the first chapter of his recently published volume, *Modern Painting: Its Tendency and Meaning*.[3] Although this was a rather general text, what he had said there on Cézanne now took on a more precise meaning due to the special context, since the exhibition, while not containing any works by Cézanne, featured a number of important Synchromist paintings. Indeed, Wright hailed Cézanne as the forebear of the Synchromists when he summed up the recent artistic evolution as follows:

> The Impressionists, being interested in nature as a manifestation in which light plays the all-important part, transferred it bodily onto canvas from that point of view. Cézanne, looking into their habits more coolly, saw their restrictions. While achieving all their atmospheric aims, he went deeper into the mechanics of color, and with this knowledge achieved form as well as light. This was another step forward in the development of modern methods. With him color began to near its true and ultimate significance as a

functioning element. Later, with the aid of the scientists, Chevreul, Superville, Helmholtz and Rood, other artists made various departures into the field of color, but their enterprises were failures. Then came Matisse, who made improvements on the harmonic side of color. But because he ignored the profounder lessons of Cézanne he succeeded only in the fabrication of a highly organized decorative art. Not until the advent of the Synchromists, whose first public exhibition took place in Munich in 1913, were any further crucial advances made. The artists completed Cézanne in that they rationalized his dimly foreshadowed precepts.[4]

Although, with respect to this show, Cézanne was perceived mainly as a milestone on the road to Synchromism, Wright was careful not to reduce his historic role to that of a mere forerunner of his brother and his friends. At the same time, Wright now began to review exhibitions, notably one of watercolors by Cézanne, whose importance he never tired of stressing.

Shortly after his arrival in New York and in order to finance his trip as well as his treatment, Leo Stein disposed of his small composition of bathers by Cézanne (V.590). All he now had left was the small still life of apples (V.191) and a few watercolors by the painter, as well as some works by other artists, especially Renoir. The *Group of Bathers* was acquired by Dr. Barnes, but some months after this

121
122

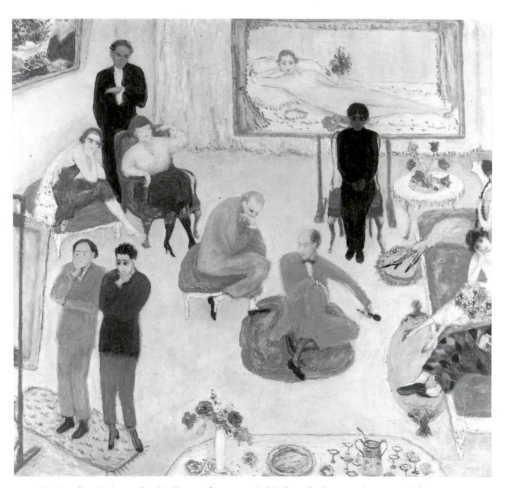

120 Florine Stettheimer *Studio Party* after 1915 (with Leo Stein seated, center right)

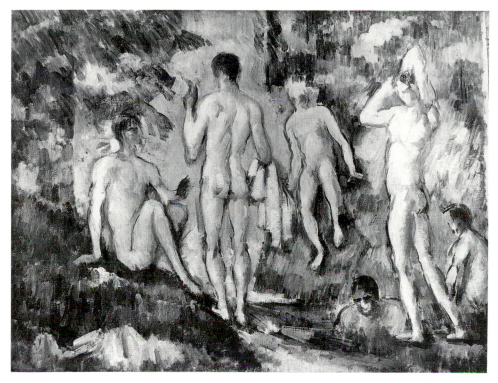

121 Group of Bathers 1892–94 (V.590)

transaction, Michael Stein informed their sister Gertrude: "Just had a letter from Leo. . . . He sold his Cézanne figure piece to Barnes for five thousand dollars. Also he and Barnes have had an old fashioned epistolary vituperative quarrel and don't talk anymore. The quarrel was not about business; but personal. I think it began in a controversy they had in print in the New Republic about aesthetics."[5]

In a strange parallel, both Leo Stein and Willard Huntington Wright were then immersed in problems of philosophy and aesthetics. They seem to have met frequently in Stieglitz's "291" gallery, where they engaged in extremely animated discussions.[6] Having just published his volume *Modern Painting*, Wright, in all likelihood, was then preparing his next publication, *The Creative Will: Studies in the Philosophy and the Syntax of Aesthetics*, which was to appear in 1916. Leo Stein, meanwhile, though not yet actually working on his *A-B-C of Aesthetics*, which he was to publish some twelve years later, was constantly concerning himself with problems connected with this ultimate project. Partly to keep himself busy and possibly also to round out his meager budget, Leo, as he wrote his sister after a very long silence, had broken "into authorship . . . to the extent of a couple of articles in a new review, one of Cézanne and one a criticism of a book. They want me to write regularly for them, and I am trying to get into the habit."[7]

It was no accident that Leo's very first article should have been devoted to Cézanne. On the one hand, he found that the painter was a popular topic in American artistic circles, and on the other, this was a subject on which he had something to say and around which much of his incessant speculating had evolved. It

is not surprising, therefore, that Leo did not merely speak of Cézanne but tied various considerations on art in general to this subject. Leo began:

> The pleasures that art gives and those that commerce with men and things affords differ only in this, that in our ordinary life feeling is an accompaniment of action, whereas in aesthetic contemplation it is the product of frustrated action and is felt as belonging to the thing that we regard. This means that the impulse to action aroused in us by what we see is contradicted by an impulse to sit quietly and look, and the feelings that arise in connection with these active and counteractive tendencies are experienced as a quality of the thing beheld. To the picture that stimulates these impulses and consequent feelings, because it is the object of our attention, we attribute the qualities that the feelings themselves imply. The range of these aesthetic values is practically as wide as the range of values in actual life, and one has only to review the pictures of all kinds that one has known, to realize the variety of feelings which pictorial expression can awaken.
>
> A work of art deserves importance largely from its capacity to give stability and durability to fluctuating and evanescent values. Things that an artist sees when he is looking with an artist's eye can be preserved. These things are often quite uninteresting to ordinary seeing. A china plate by Chardin may be beautiful, although the same plate in itself would pass unnoticed. It did not pass unnoticed by Chardin, and there precisely is the important point. The artist did not look to see what the plate was like, but just to see it, and anything so looked at comes to have the value of existence. With practice even people who are not artists can learn to see so as to become conscious of a thing's reality. Man has a deep sense of his insecurity and transitoriness, and nothing appeals to him more strongly than reality. The metaphysician studies it, the moralist ponders it, the plain man demands it, and even children often ask, "But is it really real?" In painting no one has dealt so powerfully with the rendering of some aspects of reality as Cézanne.

After a short paragraph devoted to biographical data, Leo provided a psychological portrait of the artist in his old age, based mostly on Bernard's and Vollard's accounts:

> He had become a man absorbed in painting, and negligent of everything else. He lacked completely the sense of practical affairs. Naturally trusting and affectionate, he had become suspicious and embittered through rejection and neglect. He felt profoundly his inability to cope with men or things, and answered to disturbances with fits of violent rage or sulks. He had innumerable phobias and manias. Especially he feared women and the designs on him which he imputed to them all. He was a man oppressed, tormented, isolated, with only one real aim in life – to paint, attain to mastery, and in the end to create.
>
> It seems at first sight strange that just this man, whose generous, sensitive, intelligent nature had been so wrested from sanity, who had become so unregulated in his conduct and so unbalanced, should have been, above all other painters, he who most persistently struggled with the problem of rendering matter stable and organic form substantial. Nor was this true only with reference to the object represented. The picture as a whole was organized and made coherent, its parts interrelated and compacted, to a degree that before had never been approached. Cézanne came into possession of impressionist means and their idea of color. A picture was to be built up of color elements entirely, and light and shade should serve not to gradate large areas of single color, but as a character of those small color spots whose contrasts and harmonies built up the form. Monet and Pissarro had fully freed themselves from blocks of single color, and built up the whole picture of minute color elements. Their interest, however, and especially with Monet, was in the play of light and in things seen as bathed in light. Cézanne, employing the same method,

gave no thought to the light in which things floated, but fixed his mind upon the solid thing itself. He tried to get, above all else, substantiality, finality, the eternal, the secure.

There is an obvious opposition between the character of Cézanne's work and the man's character, but there is no contradiction. A genuinely creative artist sees the world not as he is taught to see it, but freshly, in the light of his own needs. Cézanne, tormented, agitated, a prey to endless fears, with nothing in the world around him to sustain him, created for himself the thing he needed. Not, of course, the whole of it, for his ideal far outstripped his powers. His longing went out to a world not only solidly but joyously and conqueringly alive. Many of his early works show the spirit of the romantic illustrator, and this temper never left him. Unfortunately he had no freedom of imagination. He could not work without a model sitting with endless patience. Even if he had wished to pose a nude – and the female nude he could not use because of his pathological pudicity – no model possibly could stand as Cézanne required. His romantic compositions were therefore replaced occasionally by the groups of nudes called bathers, for which he utilized the studies made in his academy days, but in the main he painted instead the apples and landscapes and rare persons that were sufficiently amenable to his requirements. As flowers did not last until a picture could be finished, he used paper flowers instead, and these had sometimes faded almost white before the picture had reached completion. In fact, it very rarely happened that a picture was to his mind completed. Existence, and more existence, was almost an obsession with him. There were some canvases on which he worked for several decades.

There is no painter of our time so pedestalled as Cézanne. Some hold him quite the greatest of all painters, and give their reasons why he should be so regarded. Those persons who decry him utterly can be neglected because their failure to see anything of worth in him does not refute what others see. It is absurd to say that he lacks beauty. No form that reaches organization can fail of that, and Cézanne's form is so effectively built up with color, cleanly, delicately and firmly welded, and through his best work run reverberant rhythms, that one who feels all this can sympathize with his extremest advocates. He is perhaps the most important figure in the history of modern painting, because of his elaboration of constructive color – color, that is, which models form. This was his legacy and made him a precursor. Most of the important painters immediately after him felt this great influence, and perhaps the most serious of the many faults of cubism and kindred movements is that they have diverted painting from this vital trend.

Against the splendid mastery of organized matter we must, however, place the limitations of Cézanne's effective interest. To those with an esoteric attitude toward paint this is an irrelevant matter, but, as I tried to show at the beginning, all that in life can interest us can do so in art. And if we compare the range of life experience set forth by Cézanne with what the greatest masters have expressed, we see how narrow is that range. When one thinks of Giotto, Rubens or Giorgione, of Titian, Renoir, Delacroix, and Michelangelo, presenting in substantial form so much of their passionate interest in nature, life and love, the field of Cézanne's interest is seen as something almost painfully restricted. He himself knew these limitations and bitterly regretted them, for his was a soul intense and palpitating; but his gifts did not allow him freedom, and his febrile, tormented spirit, driven in upon itself, narrowed still more the range of his creative sympathies. He did a limited thing, but one so fundamental – he realized so splendidly the beauty and power of sheer substance – that those who can for the time being dispense with other elements of satisfaction find in him a source of illimitable content.[8]

Albert Barnes immediately took issue with this article, not because – as one might have expected – he did not like Stein's reference to Cézanne's "limitations," but because he could not agree with the opening statement of the author. Barnes

therefore hastened to send a rebuttal to the editor which appeared some weeks later under the title, "What Causes Aesthetic Feeling."

"Sir," wrote Barnes:

The article on Cézanne by Mr. Leo D. Stein in your issue of January 22nd is sound and illuminating. It is unfortunate, however, that Mr. Stein should have based his introduction upon questionable psychological principles. I refer to his explanation of the genesis of aesthetic feeling as "a product of frustrated action." The result of a frustrated act is displeasure, the very opposite of what one experiences in the presence of a satisfying work of art; Mr. Stein's explanation seems therefore to constitute a paradox. Introspection would never confirm the implied assertion that in aesthetic experience a person is kept from doing what he wishes, nor will it reveal any conflict of wishes. That view would suggest an application of the Freudian principles of conflict and repression beyond their proper sphere.

After referring to the writings of Santayana and Vernon Lee (a friend of Leo Stein's at Settignano and a neighbor as well of the Berensons), Barnes concluded: "The key to the problem of aesthetic experience is probably to be found in the conception of sublimation, in the accurate Freudian sense. The psychology of sublimation has yet to be written, but the beginning has been made by Freud and his disciples, and the results thus far are more than promising. Frustration may play a small part, may even pave the way for it in some instances, but certainly cannot exhaust the full process."[9]

To this challenge, Stein replied somewhat more briefly:

Mr. Barnes objects to my psychology in the article on Cézanne as paradoxical. But one of his "representative" authors, Vernon Lee, quotes with approval in her book, "Beauty and Ugliness," the following from Professor Munsterberg: "The suppression and inhibition of the idea of practical future end thus creates a suppression of the real external movement, an effect which is produced in the organism by an intervention of antagonistic muscles. . . . But further we have assumed that nothing beyond the idea of the optical impression was to be in our mind. . . . The result must be that the feelings of strain and impulse which go on in ourselves are not projected into our body, but into the visual impression. . . ." What I have stated in my own way for the immediate purpose is, *pace* Mr. Barnes, essentially orthodox.[10]

It is rather startling that in this learned controversy the work of Cézanne was not mentioned once, the entire argument being confined to psychological definitions. Thus, the man who had been among the first to appreciate Cézanne, and who may actually have "infected" Barnes with his enthusiasm, and the man who by then owned more works by the artist than anybody in America carried on a private feud that did not even pretend to be concerned with Cézanne. As time was to show ever more clearly, Dr. Barnes was long on aesthetic and philosophical theories, but somewhat short on artistic perceptions; he was also deplorably lacking in humility, tolerance, or plain old-fashioned kindness. It may not be irrelevant, however, to remember that in those days Barnes was extremely impatient with Leo, reproaching him for expounding his own aesthetic ideas while being unwilling to listen to the doctor's expositions.[11] The *New Republic* provided Barnes with a platform from which he could make his own frustrations and his opposition to Leo's views known.

He did so once more in answering Leo's rejoinder, and the magazine dutifully published his second rebuttal, wearily titling it, "That Psychology Again."[12] With this the incident was closed and the two former friends stopped speaking to each other.[13]

At the same time, but under different circumstances, Leo Stein came close to losing his distant though not uncordial relationship with Willard Huntington Wright. When Leo had informed his sister in February 1916 that he had written two articles, one on Cézanne and the other a book review, he was referring in the latter case to a criticism of Wright's *Modern Painting*, which had appeared under the not very promising title, "An Inadequate Theory." Indeed, Leo had taken issue with the book's central premise, according to which the art of the past was essentially a prelude to the ultimate phase of contemporary art, Synchromism. This Leo would not and could not accept. He therefore began with a quote from Wright that asserted, "Giotto, El Greco, Masaccio, Tintoretto, and Rubens, the greatest of the old painters, strove continually to attain form as an abstract emotional force." Wright, Leo reported,

> is not only the advocate of the extreme abstractionists in painting, the men who believe that representation interferes essentially with the artist's freedom and expressive power, but in addition to this he is so obsessed by the value of his aesthetic doctrines that he cannot believe that real artists ever thought otherwise than those of his predilection do to-day. It makes no difference that none of the men he mentions in the quoted passage, nor any of their contemporaries or followers, ever expressed themselves to such effect, and that all their works give evidence of the most intense interest in dramatic representation. Mr. Wright, like many another theorist, knows better, and can recognize a slavery that the slave despite his genius could not feel. He can see that Rubens was hampered more than he was aided by the wealth of figures whose physical splendor and moral conflicts he depicted, and that Michelangelo would have been better off without the nude through which to express his passion – that an abstract form generating by its inherent logic other forms would have led to something emotionally much richer than anything we find in the Sistine ceiling.
>
> A thesis so improbable and so remote would hardly ask for serious discussion if it had not become important through its development in various forms of contemporary art. We are likely to have in New York a number of exhibitions where all kinds of cubist, synchromist, orphist, vorticist, pictures will be shown. They all, whether dealing chiefly in color or in line, are concerned with the viewpoint of "pure art."[14]

Leo summed up these new concepts:

> Form and rhythm alone are the bases of aesthetic enjoyment, all else is superfluity. Therefore a picture, in order to represent its intensest emotive power, must be an abstract representation expressed entirely in the medium of painting, and that medium is color. . . . With his freedom of distortion, Cézanne "opened up the road to abstraction"; Matisse made form even more arbitrary, and Picasso approached still nearer to the final elimination of natural objectivity. Then Synchromism, combining the progress of both Cézanne and the Cubists, took the final step in the elimination of the illustrative object, and at the same time put aside the local hues on which the art of Cézanne was dependent. Thus was brought about the final purification of painting. Form was entirely divorced from any realistic considerations, and color became an organic function. The way was opened, and it rests now with the artists to follow it.[15]

Leo concluded: "As Mr. Wright himself insists so much upon his thesis, it is not unfair to him to insist upon its fallacy. Rather it is unfair to the reader to obscure by this insistence the value of Mr. Wright's discussion of modern art. Bad as the theory is when over-applied, it is of worth in stiffening and clarifying his treatment of the different painters and their relations to each other. . . . I know no other discussion of all this matter half so good. . . . The chapter on Renoir . . . is the best thing on that painter that I know. The Cézanne chapter, making always due allowance for the 'theory of non-representation' is very good; and what he has to say about more recent movements is in the main fair and discriminating."[16]

While proceeding with his psychoanalysis which, in letters to his future wife and to various friends, he sometimes declared a success and sometimes an utter failure, Leo endeavored to cure himself of his neuroses. He continued to write for the *New Republic* where, in March 1918, he published an article on Renoir and the Impressionists.[17] This subject entailed, of course, a short discussion of Cézanne, although this time Leo's words appear written not so much with restraint, as with a total lack of enthusiasm. Cézanne no longer seemed to be the focal point of his artistic concepts; in the unavoidable comparison with Renoir, it was to the latter that Leo's preference went, a preference expressed in rather facile terms, it must be said.

Here the paths of Willard Huntington Wright and Leo Stein crossed once more. When Wright had compared the two masters in his *Modern Painting*, he had explained why, despite his admiration for Renoir, he considered Cézanne the greater painter. "In Cézanne," Wright stated, "the importance of parts is entirely submerged in the effect of the whole. Here is the main difference between these two great men: we enjoy each part of Renoir and are conducted by line to a completion; in Cézanne we are struck simultaneously by each interrelated part."[18] And he concluded, "Cézanne, judged either as a theorist or as an achiever, is the preeminent figure in modern art. Renoir alone approaches his stature. Purely as a painter he is the greatest the world has produced. In the visual arts he is surpassed only by El Greco, Michelangelo and Rubens."[19] In his article on Renoir, Leo did not allude to Wright's views on the painter, which he had unstintingly praised in his review of his book, while in an earlier article Wright had referred briefly to their discussions.[20] Nor did Leo show any of Wright's perceptiveness when he discussed the various Impressionists. This time Leo chose not to acknowledge any awareness of the writings and ideas of one of the few authors who, like himself, was profoundly concerned with aesthetic problems.

In the course of his article on Renoir and the Impressionists, Leo devoted a lengthy portion to Cézanne,

> that strange man secluded in the south, at Aix in Provence, who with eager passion sought to make reality more real, to make into a picture the very substance of God's word. Cézanne's eye was not turned to nature in admiration of the world of things; there was no simple joy in things; there was no taking anything for granted. Here was again the romantic temper at its deepest, the wish to recreate a world near to the heart's desire, a world that should be the symbol of a forth-reaching passion, of the will for a profounder emotional and intellectual life. But to Cézanne, unlike Courbet, the world was a means and a means only. He had much affection but very little sympathy for men and things. His eyes indeed looked outward, but his soul's vision turned within and he sought with endless,

passionately impatient insistence, to make the outer world the carrier of his inner need. He did not paint most of his pictures for the picture's sake but rather from a desire for the mastery that would permit of adequate self-expression. The only picture that for Cézanne really counted was the picture that he would paint when, like a god knowing and compelling to the uttermost, he would fling forth his definitive creation. Cézanne was a kind of Faust who never knew despair, but strove indomitably to be master of the moment when he could say to that which he had made, "O still delay, thou art so fair." In the meantime he was almost indifferent to the stuff that he actually succeeded in producing, for it was so hopelessly unlike that which he longed to see. Although he never lost his faith, he recognized that he himself would not in the flesh enter the holy valleys of the promised land. "I shall die," he said, "the primitive of the way that I have discovered."

No greater contrast to Cézanne could be found than Renoir, the last of this illustrious group to come to recognition, and in whom the blend of the romantic with the realist is almost perfect. Whereas Cézanne was always painting on tomorrow's picture with passionate aspiration, Renoir with equally passionate joy was busy with today's. Whereas Cézanne despised even his best, Renoir enjoyed all that he did when he was in the right mood, and he was almost always in the right mood.

And Stein concluded this fairly trite comparison with the words, "Cézanne cared for nothing but his soul's purpose and his soul's salvation, while Renoir finds his soul wherever he looks abroad."[21]

By pure coincidence, Matisse, a few weeks earlier, had also spoken of Cézanne and Renoir. He had done so in a much more illuminating fashion in the short foreword to an exhibition in Norway. Leo obviously had not read the piece, but it is more than likely that Matisse had developed similar ideas when discussing the works of the two artists while viewing the collection in Leo's rue de Fleurus apartment. But then, Leo may have been too impatient to listen to Matisse, or else he had forgotten what the other had said. "After the work of Cézanne," Matisse wrote,

> whose great influence was first evident among artists, it is the work of Renoir that saves us from what is desiccating in pure abstraction. The rules that are sought in the study of the work of these two masters may seem harder to discover with Renoir, because he better hid his labors. Yet Cézanne's unremitting mental exertion and his lack of confidence in himself may have prevented him from fully revealing himself to us in the revisions that are so apparent, from which rules of mathematic exactitude have been (all too easily) deduced.
>
> Once Renoir's purpose is accomplished, his modesty, as well as his confidence in life, have allowed him to display – rid of his repetitiveness – all the generosity with which he is equipped. The appearance of his work makes visible to us an artist who has been endowed with the highest gifts, which he has had the insight to respect.[22]

By December 1919, Leo was back in Settignano where he continued his analysis, but his marriage in 1921 to a woman with whom he had been involved for about ten years was credited by some of his friends for his eventually reaching a state of greater mellowness and for overcoming some of his neuroses. As the war had greatly reduced Leo's modest financial reserves, he wrote the following year to Barnes to ask for his counsel concerning the disposal of the Renoirs left from his Paris collection.[23] When Barnes asked Leo to send him a list of whatever still remained in his possession, Leo replied, on March 8, 1921, that he had several Renoirs (among them various "small and slight" ones) and "some other things, a Delacroix, Cézanne water colors, a Daumier, a Cézanne painting, and a bronze of Matisse."[24]

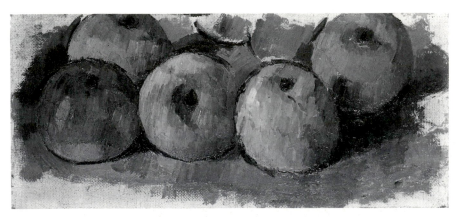

122 Five Apples 1877–78 (V.191)

It would seem that Leo had sold his green landscape by Cézanne, the so-called
123 Spring-House (V.310), to Barnes in 1913, at the time of his separation from his sister,
to finance his move to Settignano; he had also sold a Matisse still life to Barnes. The
following year he had disposed of two more paintings by Matisse in Germany and
little by little other works had followed, among them a number of Renoirs (in April
1914 Barnes had acquired a Renoir from Leo), until Barnes purchased the *Bathers* by
121 Cézanne (V.590) soon after Leo's arrival in America. Now Leo shipped to New York
a number of the works listed in his letter to Barnes of March 8. Barnes found the
Renoirs too sketchy and insignificant – it is true that by then he owned a great
number of paintings by the artist, among which mediocre works were already well
represented. On the other hand, it was somewhat cruel of Barnes also to reject the
122 small Cézanne painting of apples, now that Leo was in need.[25] This powerfully
constructed composition was certainly just as fine, if not actually better, than a
related still life (V.202) that Barnes had acquired at the Rouart sale back in 1912.[26]
Durand-Ruel purchased the small canvas (V.191) – which Leo had once described to
his sister as having a "unique importance to me that nothing can replace"[27] – for
$800.

Leo was now left without a single work by Cézanne and possibly also Renoir, but
then he was constantly moving away from what had once been of paramount and life-
enhancing importance to him. Over the next decades he somehow made peace with
his sister (at least superficially) and began preparing his own version of their early
years in Paris as a reply to the fanciful and self-aggrandizing pages of her
Autobiography of Alice B. Toklas (1933). He hoped that his sober and factual account
would set the record straight and would prevail over Gertrude's completely
unreliable stories.[28] Yet at the same time, he seemed to undertake a savage
destruction of the very things that, in contrast to his sister, he tried to put into a solid,
historical perspective. Why he could not do this without demolishing so much that
he had once revered is difficult to explain, but the fact is that when Leo now spoke of
the green landscape that had been his first purchase of a work by Cézanne, he
sounded surprisingly uninspired and indifferent. His words are as flat and
repetitious as many of his sister's monotonous statements (which he hated). "The
composition is a good one," he wrote, "and the space handling for the most part even

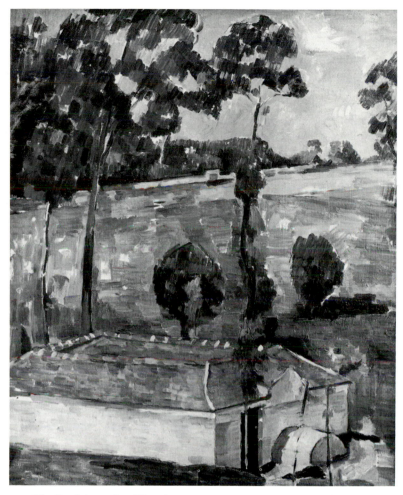

123 *The Conduit c.* 1879 (V.310)

exceptionally good. It was altogether a good beginning."[29] And that was all he found
to say about the very picture that had launched him on his career as the most eclectic
and discerning collector of modern art in those distant days! It is a fact, however, that
this prodigious career had been a very short-lived one, and that Leo had soon tired of
Matisse, of Picasso as he turned to Cubism, and now, to a certain extent, even of
Cézanne. When, toward the end of his life, he again saw the pictures that once
belonged to Loeser, which had been such a revelation to him in 1904, he wrote to a
friend that in this group, "A little figure composition [V.265?] is charming and there
is one fine olive tree landscape [V.645?]."[30] Yet there were several infinitely more
imposing works in the collection. What had happened was that Leo – cured of his
neuroses? – had lost his capacity for enthusiasm. He himself must have been aware of
this, for in another comment on the Loeser collection he said (possibly with a tinge of
regret), "The pictures are about as they were, but I am not, and only one or two still
seemed to me important."[31]

Many years ago, Leo had once said that he was through with talking about art. In
those days when "everybody who was anybody" practically identified him with

modern art and when this identification provided him with a kind of halo, Leo's remark was thought to have been made in jest. But he had really meant it; except that he did not actually stop talking – or writing – about art, he simply stopped loving it. Art turned out to have been one of many phases in his life, though admittedly an intense one, just as Cubism had been one in Picasso's. Leo's erratic pursuit of many different goals, from painting (his own) to countless theoretical speculations, had turned his life into a series of bursts of enthusiasm, each of which was sooner or later followed by disillusionment. Leo himself may have considered this a healthy sign of perpetual renewal, but from what is known about his life, there are very few indications that he experienced much happiness. Even his letters to his bride-to-be admonish more than they express warmth. And while the systems of philosophy and psychology that he constantly built and dismantled made it difficult for him always to cling to the feeling of superiority he so badly needed, they simultaneously induced a peculiar isolation and loneliness.

Cézanne was no longer an essential peg in Leo's aesthetic system, yet to give him up was to break with a relatively happy phase of his past. Step by step he nevertheless detached himself from Cézanne, and this detachment eventually almost turned into contempt. As Cézanne's art was ever more widely acclaimed, Leo Stein, one of the very first to have recognized its crucial significance, literally tried to reverse his position. His negative attitude was first expressed openly in an article on Picasso which he wrote in 1924 for the *New Republic*. It offered him an opportunity to vent his bitterness over the evolution of the artist whom he could not forgive his Cubist phase, long passed, but who also seemed unable to please him with any of his succeeding styles, even his drawings. It was as though he had to take revenge for once *VII* having admired Picasso without foreseeing that Picasso would develop in directions of which he, Leo, would not approve. But while he thus, in a way, settled an old account with the painter for having disappointed him, Leo also availed himself of the occasion to speak of his steadily increasing disaffection with Cézanne. It was of course easy to link Picasso with Cézanne, and this he proceeded to do, writing:

> The group of artists in which Picasso found himself [in the Rue Ravignan days in Paris] was feeling more and more strongly the influence of Cézanne and tending more and more to regard as an end what to Cézanne had been a means – substantial form. Cézanne's personal ideal had two poles: to make of impressionism something solid like Poussin, and to do over Poussin in impressionistic terms. His ideal, that is, was of a complete pictorial art. In fact, he rarely got as far as this, and was entangled to the end in the problem of means. Much of his work makes on me the painful impression as of a man tied up in a knot who is trying to undo himself. However, his concern with an essential problem, that of adequate expression in modern terms, made him the chief of the modern clan.[32]

But Leo also made it clear that he did not think much of this "modern clan." Instead of rejoicing because time had proved him right in his pioneering advocacy of Cézanne, he now almost perversely insisted on asserting his total independence of judgment by turning against the painter. He who so early had heralded the artist's genius now appeared almost anxious to be the harbinger of his ultimate doom.

If Leo did not also publicly detach himself from Matisse, it was possibly because he did not feel similarly "betrayed" by him. Within three years of his first purchase of a Fauve canvas by Matisse, he had stopped buying any more works by the artist.

This was just another instance of Leo's almost chronic restlessness, of his constant readiness to reject what he had admired and to go after new experiences (not necessarily connected with art), to which he was often little more "faithful" than to his earlier ones. He left Matisse to his brother and sister-in-law, Michael and Sally Stein, and continued on a path that was remarkably lacking in constant or longlasting attachments. By cutting off so many creative links, it was he who was the poorer.

It is true, however, that Leo was preparing passages on Matisse – as well as on Picasso – for his ultimate book, which would appear shortly before his death in 1947. Meanwhile he was rather pleasantly surprised when somebody casually informed him by letter that Barnes had dedicated his book on Matisse to him (Barnes himself apparently never told him of his intention to do so, nor, even less, asked for his permission).[33] There can be no doubt that the irascible and unpredictable collector could not forget – despite their disagreements, to which Leo's attitude toward Cézanne must have added considerably – that it was Leo who, long ago, had introduced him to both Matisse's work and the painter himself. While Barnes had been unwilling to spend a few hundred dollars for Leo's last Cézanne when Leo was in need, at a time when he himself was accumulating a vast fortune, he obviously found it easy – because less costly – to acknowledge his debt of gratitude. The volume on Matisse carries the following dedication:

TO
LEO STEIN
WHO WAS THE FIRST TO RECOGNIZE THE
GENIUS OF MATISSE AND WHO, MORE THAN
TWENTY YEARS AGO, INSPIRED THE STUDY
WHICH HAS CULMINATED IN THIS BOOK.

Though all this was now far removed from his preoccupations (Leo had taken up painting again in the company of Ottokar Coubine, a mediocre French painter of Czech origin some ten years younger than himself, whose work he had begun to collect), he was obviously pleased with Barnes's belated homage. Yet none of this changed the course of Leo's total break with the past. After his 1924 article on Picasso with its disturbing image of Cézanne, the prolific expounder completed the sorry evolution that led him from the concept of "Cézanne and I" to the much less rewarding one of "I and Cézanne." Leo Stein's tortured mind having run dry and become blasé – at least as far as contemporary art was concerned – he found it expedient to accuse Cézanne of no longer stirring it, of no longer arousing his emotions. As he had put it in his book on aesthetics which had appeared in 1927:

"There was a moment when Cézanne brought something fresh which I assimilated with great enthusiasm and joy. What Cézanne gave was important, but his own expression of it was limited, constrained, and in many ways extremely insufficient, and when I had made the assimilation I found very little of him left over that was endurable. For awhile, no painter excited my interest more vitally. Now no pictures interest me less. He is for me more completely the squeezed lemon than any other artist of anything like equal importance."[34]

Thus taking leave from Cézanne, it was Leo Stein who gave "the painful impression as of a man tied up in a knot who is trying to undo himself."

NOTES

1. Leo Stein to Gertrude Stein [New York], Feb. 15, 1916; Leo Stein, *Journey into the Self: Being the Letters, Papers & Journals of Leo Stein*, ed. Edmund Fuller (New York: Crown, 1950), pp. 71–72.

2. On this exhibition, see Christopher Knight, "On Native Ground: U.S. Modern," *Art in America*, Oct. 1983, pp. 186–74 [*sic*, for 194].

3. On this publication, see Chapter X, note 4.

4. Willard Huntington Wright, "What is Modern Painting," introductory essay, *The Forum Exhibition of Modern American Painters*, exhibition catalog, Anderson Galleries, New York, March 13–25, 1916, p. 23; reprinted in a facsimile edition (New York: Arno Press, 1968).

5. Michael Stein to his sister Gertrude, Cannes, June 3, 1916; Beinecke Rare Book and Manuscript Library, Yale University. This unpublished document was brought to my attention by Irene Gordon.

6. See Jerome Mellquist, *The Emergence of an American Art* (New York: Charles Scribner's Sons, 1942), pp. 211, 246.

7. Leo Stein to Gertrude Stein, Feb. 15, 1916; Leo Stein, *Journey*, p. 71.

8. Leo Stein, "Cézanne," *New Republic*, Jan. 22, 1916, pp. 297–98.

9. Albert C. Barnes, "What Causes Aesthetic Feeling," letter in *New Republic*, Feb. 19, 1916, p. 75. This letter was brought to my attention by Irene Gordon.

10. Leo Stein, "Supports His Psychology," letter in *New Republic*, Feb. 26, 1916, p. 105. This letter was brought to my attention by Irene Gordon.

11. See Leo Stein to Dr. Trigant Burrows, Settignano, Florence, June 30, 1934; Stein, *Journey*, p. 140.

12. See Albert C. Barnes, "That Psychology Again," letter in *New Republic*, March 18, 1916, p. 188. This letter was brought to my attention by Irene Gordon.

13. Dr. Barnes gave a somewhat different account of the event when, in 1942, he told a reporter that he and Leo Stein often quarreled. In the words of the reporter: "One of these quarrels profited the Philadelphian [Barnes]. He had disagreed vehemently with something Leo had written on the psychology of Cézanne. Leo owned Cézanne's Blue Bathers, which Barnes was eager to have. The collector offered to bet Leo $5,000 against the picture that he was right. Leo said he couldn't afford to bet; still he would sell the Blue Bathers for $5000. Barnes values the Blue Bathers now at $30,000." Carl W. McCardle, "The Terrible-Tempered Dr. Barnes," *Saturday Evening Post*, April 4, 1942, p. 19. For historical accuracy, Barnes barely rated a D-minus: the publication of Barnes's estimate of the picture's value in 1942, while Leo was still alive and not exactly prosperous, was yet another indication of the Philadelphian's tactlessness.

14. Leo Stein, "An Inadequate Theory," *New Republic*, Jan. 29, 1916, p. 339.

15. Ibid.

16. Ibid., p. 340.

17. Leo Stein, "Renoir and the Impressionists," *New Republic*, March 30, 1918, pp. 250–60. This article was brought to my attention by Irene Gordon.

18. Willard Huntington Wright, *Modern Painting: Its Tendency and Meaning* (London and New York: John Lane, 1915), p. 157.

19. Ibid., p. 163.

20. See Willard Huntington Wright, "The Aesthetic Struggle in America," *The Forum*, Feb. 1916, p. 210. This article was brought to my attention by Francis M. Naumann.

21. Stein, "Renoir and the Impressionists," p. 260.

22. Henri Matisse, foreword to *Den franske Utstilling*, exhibition catalog, Kunstnerforbundet, Kristiania [Oslo], Jan.–Feb. 1918, p. 12; translated here from the French with the assistance of Prof. Sir Lawrence Gowing.

23. See Leo Stein to Albert C. Barnes [Settignano], Dec. 29, 1920; Stein, *Journey*, p. 84.

24. Leo Stein to Albert C. Barnes, Settignano, March 8, 1921; ibid., pp. 86–87.

25. On another occasion, because Leo voiced a mild criticism of Barnes's first book, *The Art in Painting* (New York: Harcourt, Brace, 1925), Barnes was even more cruel. Having used a quote

of Leo's in praise of his book on the back cover of an issue of the *Journal of the Barnes Foundation*, Barnes subsequently directed an extremely ungenerous gibe at his "friend," coldly designed to hurt him deeply; see William Schack, *Art and Argyrol: The Life and Career of Dr. Albert C. Barnes* (New York: Thomas Yoseloff, 1960), pp. 158–59.

26. On Barnes at the Rouart sale, see above Chapter VII, p. 162.

27. Leo Stein to Gertrude Stein [Paris], 27, rue de Fleurus (undated); *Journey*, p. 57. See also Chapter III, and John Rewald, "Some Entries for a New Catalogue Raisonné of Cézanne's Paintings," *Gazette des Beaux-Arts*, Nov. 1975, pp. 162–63.

28. See Leo Stein, *Appreciation: Painting, Poetry and Prose* (New York: Crown, 1947). It is Leo's version that has generally been used for the account given in this volume because his recollections, set down decades later, agree with the documents of the time.

29. Ibid., p. 155.

30. Leo Stein to Maurice Sterne, Settignano, June 29, 1945; Stein, *Journey*, p. 252.

31. Stein, *Appreciation*, p. 156.

32. Leo Stein, "Pablo Picasso," *New Republic*, April 23, 1924, p. 229. This article was brought to my attention by Irene Gordon.

33. See Leo Stein to Mabel Weeks, Settignano, Feb. 6, 1934, and to Albert Barnes, Oct. 20, 1934; *Journey*, pp. 136, 147. The monograph, *The Art of Henri Matisse* by Albert C. Barnes and Violette de Mazia (New York and London: Charles Scribner's Sons) appeared in 1933.

34. Leo Stein, *The A-B-C of Aesthetics* (New York: Boni & Liveright, 1927), p. 267. The problem as to *when* Stein first alluded to Cézanne as a "squeezed lemon" is an extremely thorny one. In his 1916 article on the artist (see pp. 250–51) Leo still spoke with appreciation of the painter. It would seem that his total disenchantment with Cézanne only set in somewhat later, but this is not certain. Unfortunately, Walter Pach gives no date for a conversation with Picasso which he relates in *Queer Thing, Painting* (New York and London: Harper & Brothers, 1938), p. 128: "Questioning me once about a difficulty I had had with a certain critic, whom I will call L., he got the quotation from the latter which I had objected to: that Cézanne was of no more use, a sort of 'squeezed lemon,' to be exact. 'Well,' said Picasso, 'if Cézanne is a squeezed lemon, you may be sure that M. L. has never had a taste of the juice.'"

Aline B. Saarinen in *The Proud Possessors* (New York: Random House, 1958), p. 192, places Leo's detachment from Cézanne around 1910. But this does not appear plausible since, toward the end of 1913, when Leo and Gertrude divided their collection between themselves, Leo was still absolutely adamant about the small still life of apples (V.191) that he would not give up. He only sold it several years later.

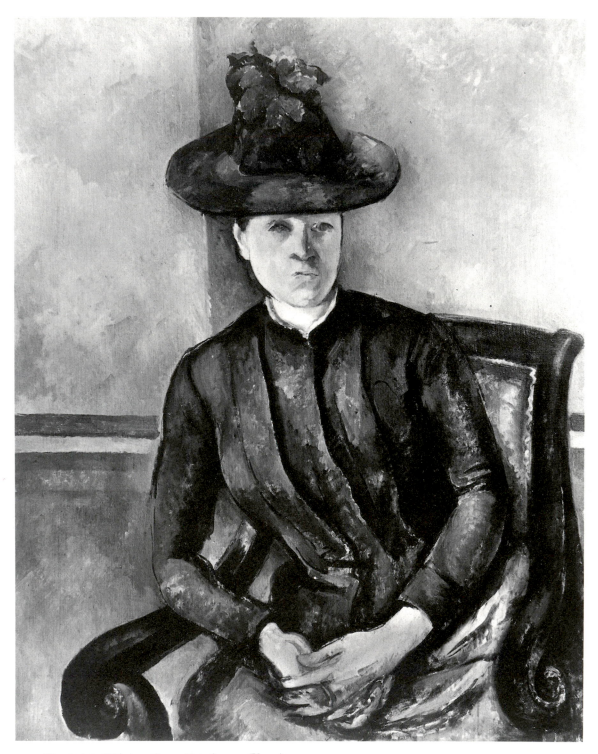

124 *The Artist's Wife in a Green Hat* 1891–92 (V.704)

XII · Albert C. Barnes
The Not So Noble Buyer

ARTHUR JEROME EDDY had been one of the major buyers at the Armory Show, yet it was John Quinn, whom one of his painter friends had named "the noble buyer," who made the greatest number of purchases at the exhibition, as well as the greatest number of loans to it.[1] By comparison, Dr. Albert C. Barnes cut a rather poor figure; *126* he had of course lent nothing and his acquisitions were confined to a lone landscape by Vlaminck, sent over by Kahnweiler. If Barnes was tempted by any of the Cézannes in the show, he resisted that temptation, not so much, obviously, because he had lost interest in the artist, but apparently because he was addicted to a kind of wheeling and dealing in which he could not decently indulge while trying to drive bargains with the American artists responsible for the show itself, and for the sales.

While the Armory Show was being prepared and at about the same time as Quinn went to Paris to acquire his portrait of Madame Cézanne,[2] Barnes was also there and, *XI* in addition to the three Cézanne paintings he purchased at the Rouart sale,[3] he bought, on December 10, 1912, three more Cézannes from Vollard. But it seems that Barnes did not like to deal directly with the latter. In any case, on December 12 it was the Durand-Ruel gallery that shipped to Philadelphia the Cézannes from the Rouart collection together with those obtained from Vollard. According to their statement and the bill of lading, these last three paintings were:

> Cézanne, *Portrait de femme*, 1889 [V.528]. Purchased December 10, 1912, from A. Vollard, 6, rue Laffitte, Paris. 39,950 francs.
> Cézanne, *Baigneuse*, 1888. Purchased December 10, 1912, from A. Vollard. 14,980 francs.
> Cézanne, *Fruits*, 1885 [V.352?]. Purchased December 10, 1912, from A. Vollard. 4,975 francs.[4]

Since the bills provide no dimensions, it is not easy to identify these works, except to deduce from the prices that the portrait of a woman must have been a fairly important canvas whereas the still life of fruit obviously was of a small size.

During the run of the Armory Show in New York, Barnes was negotiating with Durand-Ruel the purchase of another Cézanne still life (V.605), which also belonged *125* to Vollard and of which he had received a photograph. The gist of these negotiations was that Barnes did not wish to pay Vollard's price, nor did he want to appear as buyer, a fact that forced Durand-Ruel to lend himself to a rather shoddy deception. Barnes was prepared to pay up to $6,000 for the painting which, incidentally, was a

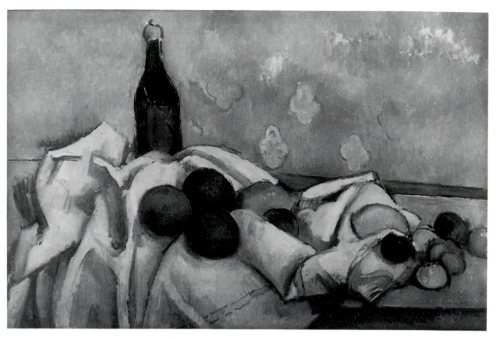

125 *Still Life with Bottle, Tablecloth, and Fruits c.* 1890 (V.605)

composition strangely lacking in firmness of forms and design. On April 5, 1913, Joseph Durand-Ruel, then directing the New York gallery, informed Barnes:

> You will note that we succeeded in obtaining a much larger reduction than you expected. My brother [George] writes [from Paris] that it took a week's parleying to succeed. Of course your name was never mentioned and Vollard thought we wanted the painting for ourselves. He stuck for a long time to his price of 30,000 francs, saying he could easily obtain it later, which is quite true. He finally consented to accept our offer, to please us and in the hope of selling us more pictures, but on the condition that we should not ourselves sell it under 30,000 francs to anyone. I must consequently ask you not to mention at any time that we purchased that picture for you, nor the price that you paid for it. The amount stated: 23,000 francs is correct. . . . No commission whatever is included and the amount is the net cost paid by us. Adding the commission would make 25,300 francs which you will please send to Paris as you offered in your letter.

Barnes's reply to this letter did not contain a single word of thanks or appreciation; it consisted of a draft with a few comments to the effect that the amount of 25,300 francs implied a payment to Durand-Ruel of a commission of 10 percent, whereas it had always been Barnes's impression that 5 percent was the amount charged for services of this kind. If he was correct in this matter, Barnes requested that he be credited for the difference.

The remarkable thing was not so much that Barnes haggled over the commission for a drawn-out and complicated affair, but that the Durand-Ruels, extremely upright and honorable people conducting their business in an impeccable style, became involved in outright lies and petty deals with a conniving and penny-pinching American millionaire. However, Barnes had probably hinted at the many

future purchases he planned to make (his favorite enticement) and the Durand-Ruels were obviously anxious to please a customer with such potential, even though, until then, he had not entered into any major deals with them. How important a customer Barnes promised to become was made clear two months later when, while in Paris, he established an impressive program of purchases with them, part of which consisted of provisions for monthly installments, something on which he frequently insisted, either because of lack of large amounts of cash or because he did not trust the people with whom he dealt. But within twenty-four hours after having reached a satisfactory arrangement, the Durand-Ruels received a letter from Barnes, dated June 13, 1913, saying that in view of the many demands upon his income that year to conduct his real estate operations, it would be unwise for him to assume further financial obligations by buying paintings according to the plan mentioned the previous day. He was canceling the orders for the Renoirs selected the day before, and also the paintings from Vollard, and the buying orders given the Durand-Ruels for the [Marczell de] Nemes sale.[5] It was going to take him the balance of that year to build the five country houses which were under way. When they were finished, Barnes expected to be in a position to buy more paintings, and he would then take up with the Durand-Ruels the question of selection. In the meantime, he asked them not to save the Renoirs for him, but to sell them elsewhere if they had the opportunity. Concerning Vollard, Barnes expressed no regrets because he felt that Vollard did not treat him as a financially responsible businessman should be treated.

Barnes added that he appreciated the Durand-Ruels' courtesy of selling him paintings according to the plan which made it easy for him to buy them, assuring them that once his houses were sold, they would find him a good customer. He felt sure, he said, that they would understand that he was just then under heavy expense in investing in real estate and that in deciding not to buy the paintings at that time, he was acting in a conservative manner which would protect him from carrying unduly heavy financial burdens and protect them from having the paintings come back in case his income should not be sufficient to meet his real estate obligations and the additional payments to the Durand-Ruels. As stated above, he concluded, he was surely going to buy more paintings, and it would not be long before he would come to see them with sufficient money to buy anything they had for sale.

To this Barnes added a postscript, saying that if they could buy the Cézanne and Picasso from Vollard for 35,000 francs and could make arrangements with him for monthly payments of 7,000 francs, he would buy them from the Durand-Ruels and send them a draft every month for 7,200 francs. If they could do this, he would have them send the paintings to the steamer on which he planned to sail, or directly in bond to Philadelphia. He had no doubt that Vollard would allow them a commission on the sale, and requested that they write him about this immediately to Heidelberg. He would then give them instructions concerning which steamer he would be taking so that he could carry the paintings with him as baggage and save express charges.

The irony is that while reproaching Vollard for not treating him like a financially responsible businessman, Barnes demonstrated his total lack of financial responsibility by making a deal with Durand-Ruel and the very next day reneging on it because of other obligations, of which he must have been aware all along. Durand-Ruel nevertheless – ever the correct businessman – approached Vollard with

Barnes's new offer, to which Vollard answered by naming his own conditions, which Durand-Ruel duly transmitted to Barnes, who replied on June 6 that he had rearranged his finances to suit the requirements of "his Majesty, Vollard, the first." He would pay 50,000 francs for the Cézanne, Renoir, and Picasso, under the following conditions: Paintings were to be packed very securely in one box, and the frames packed in a separate box to be ready to be delivered to him on Thursday, June 12 in Paris so that he could take them along on the S.S. *La France*. The Picasso was to be placed on a new stretcher provided with keys to tighten the canvas. The Renoir was to have a suitable frame which would fit the painting. The Picasso was to have the frame in which Vollard showed it, cut down to fit the picture. The cost of packing and transportation to Le Havre was to be paid by Vollard. Barnes thought that the Durand-Ruels could buy the paintings from Vollard so that they would get 10 percent on the transaction. He would send them a Paris check for 50,000 francs on July 1, 1913. If this proposition concerning Vollard's paintings was accepted, Barnes asked that the Durand-Ruels telegraph him. He would return to Paris to receive the paintings and to talk to them about a special price on the Renoir "bed-room scene." His New York account with the Durand-Ruels would be settled during the summer, and he thought that they would be able to agree on other paintings for his collection.

Durand-Ruel sent the requested telegram, in which he apparently also announced that Barnes would receive a letter from Vollard, who, it seems, had openly displayed misgivings about monthly payments that he would have no way of collecting in America in case of default. To this Barnes replied on June 7, thanking him for his telegram about Vollard and adding that he never knew Vollard to keep his promise; consequently he would be very much surprised if he received a letter from him. As soon as Barnes reached Heidelberg, he cabled his secretary to defer his real estate operations for one month so that he could get Vollard's paintings; everything was arranged as he wished.

The next day, Barnes wrote once more: Vollard *had* written to him. Barnes suggested that Durand-Ruel go to see Vollard and offer him 45,500 francs spot cash, expecting Vollard to yield, particularly if Durand-Ruel were to mention that Barnes was so provoked at him that he would never again buy from him. If Durand-Ruel could obtain the pictures at that price, Barnes could take them with him and would send him a Paris draft for 50,000 francs a few days after he arrived home. This arrangement would oblige Barnes to give Durand-Ruel 5 percent on his money, and, he believed, would benefit the dealer in future business transactions with Barnes. The arrangement suggested that he did not have enough of the necessary cash on hand to satisfy Vollard, and that he counted on Durand-Ruel to advance the money until he could pay it back from the States. Barnes added a postscript that shows how rankled he was by Vollard's insistence on cash, emphasizing that he did not trust Vollard enough to let him enter his house – so that the feeling between them was about equal.

The complicated business was finally settled after Barnes's return to Philadelphia when, on June 23, he dictated a letter to his secretary who was not yet familiar with the names of all the artists that were to crop up repeatedly in the doctor's correspondence. The letter, addressed to Durand-Ruel, stated that in accordance with his agreement with him, Barnes had sent his check for $11,067.96 to Durand-Ruel's New York branch to reimburse him for the same amount which he had paid

Vollard on June 10, 1913, for paintings by Cézanne, Renoir and "Peccatso," which paintings he had received.

Unfortunately, it is not possible to identify the work by Cézanne that was part of the transaction. As his payment indicates, after having selected and then rejected pictures from Durand-Ruel, Barnes finally limited his purchases to three canvases from Vollard, paying for these despite his real estate operations and using Durand-Ruel as his negotiator (not to say his errand boy).

On April 29 of the following year, Barnes made some further purchases in Paris, acquiring an El Greco and four Renoirs from Durand-Ruel, a Renoir from Leo Stein, and two unspecified paintings from the Bernheim-Jeunes (one by Courbet, the other by Conder). On May 14, Durand-Ruel bid for Barnes on a painting owned by Teodor de Wyzewa, obtaining for him a Renoir of a woman combing her hair for 40,000 francs. Barnes also acquired an unidentified Cézanne which was shipped with his other purchases on June 3, 1914.[6] On June 9, Barnes informed Durand-Ruel that he planned to assemble an "Album de luxe" of his collection, asking him to obtain photographs from various dealers, such as Druet, Bernheim-Jeune, and Vollard. Apparently it did not occur to him that he could have requested these photographs directly rather than send Durand-Ruel on further errands; and obviously he was even less prepared – with the pictures assembled in Philadelphia – to have them photographed at his expense by a local photographer (thus obtaining the negatives for future use). At the same time, Barnes now offered cash instead of installments, expecting a 5 percent discount for this mode of payment, which Durand-Ruel rejected, finding the rate too high.

On June 26, 1914, Barnes informed Durand-Ruel that he wished to return the recently acquired El Greco because an American collector, whom Barnes refused to name, had pronounced it of doubtful authenticity. Durand-Ruel replied that the picture came from the highly respected Cherfils collection and had been purchased by Cherfils some forty or fifty years ago upon the advice of Degas and the latter's friend Paul Lafond (coauthor with Maurice Barrès of a book on El Greco). Not only did Degas himself own two splendid paintings by El Greco (and Rouart had owned even more), but Durand-Ruel, by then in his seventies, had undertaken several trips to Spain to secure important works by the artist; he had obtained the *View of Toledo* and the portrait of Cardinal Don Fernando de Guevara for the Havemeyers. But there were other matters on Barnes's mind: some of the frames in the last shipment, packed separately, had been damaged in transit and Barnes wished to collect insurance. However, his letter reached Paris after the outbreak of World War I and Durand-Ruel replied somewhat philosophically: "As you must suppose, business is entirely at a standstill. The question of claiming any damage for the broken frames will have to be taken up later on, after the war is over. It is not likely that we will be able to get anything for these broken frames."

The letters exchanged between Barnes and Durand-Ruel after August 1914 no longer make any mention of the allegedly inauthentic El Greco. As the future was to reveal, Barnes had a chronically unlucky eye with Old Masters, accumulating a number of works whose attributions are badly in need of revision. Some day a cynic may even state that the only genuine work painted before 1850 that Barnes ever acquired was the El Greco he wished to return to Durand-Ruel.

126 Photograph of
Dr. Albert C. Barnes
by Carl Van Vechten

The war slowed down Barnes's acquisitive endeavors, yet when he heard that Renoir had entrusted a self-portrait to Durand-Ruel for safekeeping, Barnes wrote to Paris on January 25, 1915, to express interest in the work, which was not for sale. He asked Durand-Ruel to explain to Renoir that he now had fifty of his paintings, that he considered him to be the greatest of modern painters, and that his collection was to be given to the city of Philadelphia with the Widener and Johnson collections. But Renoir could not be persuaded to part with it, which was probably just as well, since it might have put Barnes under an obligation to bequeath his collection to Philadelphia, which is something he eventually decided not to do.

124 Barnes was more fortunate with a portrait of Madame Cézanne. He had written on January 15, 1915, to Durand-Ruel that he wished to acquire this painting owned by Vollard and reproduced by Meier-Graefe, explaining that she was wearing a very peculiar hat, tilted somewhat over her head. This was the painting now titled *The Artist's Wife in a Green Hat* (V.704), for which Barnes offered 35,000 francs. It was only on March 29 that Durand-Ruel actually obtained it from Vollard for 33,000 francs; the very same day he sold it to Barnes for 40,000 francs (the days of favors and 10 percent commissions were over, though not the days of Barnes's attempts to take advantage of the Durand-Ruels).

After the hiatus caused by the war, the first important transaction concerning Cézanne presented itself in the summer of 1920, when the collection of a Dutchman Cornelis Hoogendijk, who had died in 1911, became available. His accumulation of

Old Masters as well as of modern works, including those of living artists – since his many Cézannes had been acquired in the painter's lifetime – had been without question the most important collection gathered in those days in Holland and even beyond. Born in 1867 to a wealthy family, Hoogendijk had begun to collect before he was twenty years old. On his first trip to Paris in 1894–95 he must have gotten in touch with Vollard and made his initial purchases of works by Cézanne. His last trip to Paris and London took place in the spring and summer of 1899. Upon his return from this trip he fell ill, all his activities stopped, and he bought no more works of art. He was then in his early thirties; his collecting period had lasted less than ten years, during which he had acquired over thirty paintings by Cézanne (and had thus become a rival of such contemporary collectors as Egisto Fabbri and Charles Loeser). Before he died in 1911, his family had begun to lend a number of his pictures to the Rijksmuseum, to which it donated fifty Old Master works after his death, while also selling a few others. In 1912, part of the still extensive collection was sold at auction, including two large paintings and one watercolor by Cézanne. The remaining Cézannes, however, were tied up in litigation.[7]

Hoogendijk's heirs had negotiated with the German collector Karl Ernst Osthaus, founder of the Folkwang Museum, the sale of most of the Cézannes until, for reasons still unknown, the transaction led to a lawsuit. It is entirely possible that, had it not been for these complications, some – if not all – of the Hoogendijk Cézannes might have been lent to the Armory show. The lawsuit, interrupted by the war, was continued after the armistice of 1918, at which time Osthaus insisted on delivery of the paintings; however, prices for Cézanne's works having risen considerably since 1912–13, the Hoogendijk family refused to comply and eventually won the case. It was then, in 1920, that the paintings were sold to what was called a "foreign syndicate," which consisted of the Paris dealers Paul Rosenberg, assisted by Jos. Hessel (related to the Bernheim-Jeunes), with some financial backing from the Durand-Ruels who, however, were silent partners and never actually owned any of the canvases.[8] But they were, of course, anxious to offer some of these paintings to Albert Barnes, except that Rosenberg reserved a number of works for his own clients, the more so as Barnes's proclivity for bargaining and drawn-out payments did not exactly make him a darling of the French dealers.

As Durand-Ruel subsequently explained to Barnes (without mentioning that he himself had a stake in the pictures), "When the collection reached Paris [in the summer of 1920], in spite of the advanced season, twelve were purchased at once by French collectors and museums, though most of the buyers were already out of town. When I saw them, I at once thought of you, cabled urging you to take them, stopped further sales here, and finally obtained with great difficulty that the pictures should not be shown or offered here until I obtained your reply." Durand-Ruel's cable concerned thirteen paintings. He informed Barnes, after receiving his answer: "the offer you made was at first refused, but I insisted, as I did not want you to lose the collection, and sacrificed part of my commission to facilitate the transaction. I further had to accept that all expenses incurred after the delivery of the Cézannes to me in Paris should be borne by our firm. This has made the transaction very costly and left us only a small profit not corresponding to the importance of the affair and the continuous attention I had to give it."

127 Durand-Ruel invoice to Albert C. Barnes of July 8, 1920

The deal must have been concluded late in June or early in July 1920, without
127 Barnes actually having seen the works he acquired. Durand-Ruel's bill, which may
have also been a customs invoice, is dated July 8, after which date there began an
extensive correspondence between Philadelphia and Paris concerning the origin of
the pictures. "I have just received the history of the Cézannes which you bought,"
Durand-Ruel's letter of July 30 began.

A Dutch amateur, Mr. Hoogendijk, purchased these paintings in Paris over twenty years
ago. Nobody knows exactly what he paid; the amount must have been small, but was then
considered very high. Mr. Hoogendijk was not quite sound in mind and spent part of his
time in a sanatorium up to . . . his death. His pictures were kept in the Rijksmuseum [in
Amsterdam] where they were admired by all the visitors for many years. It was generally
thought that they belonged to the museum and people were surprised when they heard
that they had been purchased from the heirs by a foreign syndicate. The Cézannes were
exhibited in the Rijksmuseum in the modern paintings section.

In a follow-up letter, Durand-Ruel specified that Hoogendijk had purchased
modern French paintings in Paris from 1890 to 1898 [actually 1899], adding: "It is
stated that members of his family had him interned in an insane asylum for wasting

his fortune. I have no proof of this, but it is certain that he lived in a sanatorium until
. . . his death." It has been denied that Hoogendijk was declared insane because he
collected unorthodox paintings, but it was a story that had a certain morbid appeal.
In another letter, dated August 12, Durand-Ruel endeavored to assure Barnes of the
authenticity of the paintings, though no true admirer of Cézanne should have needed
such assurances: "The thirteen paintings by Cézanne were bought by Vollard from
the artist himself and sold by him to Mr. Hoogendijk more than twenty years ago; as
we wrote you before, they have hung ever since in the Rijksmuseum. There cannot
be the slightest doubt as to their genuineness." At the same time, Durand-Ruel had
to broach the question of payment, Barnes not having lived up to his promises and
having availed himself of fluctuations in exchange rates to "reduce" his cost-price.
Durand-Ruel wrote:

> We never had any intention ourselves of speculating in foreign exchange and that is
> why, from the beginning, we wanted it understood that the affair would be transacted at 12
> francs to the dollar. When we received your second payment of 780,000 francs, our New
> York house had just sent us the letter you wrote them on July 9, saying that you had made
> your offer in the form of American money in order to avoid the uncertainty of the
> fluctuation in the exchange rates and that if, when the paintings arrived, the exchange rate
> was less than 12 francs to the dollar, you would be entitled to defer payment, as you could
> not be expected to pay more than the $130,000 offered. We had hoped therefore that you
> would have paid the second half to our New York house in dollars as you did the first time
> and that we would have recuperated the loss in exchange which we had on the first
> transaction (Francs 13,650). When we accepted your offer to the owners of the paintings,
> our commission had to be reduced considerably in order to make it acceptable to them.

The list of the thirteen pictures shipped to Philadelphia is quite impressive:

Sainte-Victoire (V.457)	Francs 249,650	128
La Chaumière (V.451)	79,800	129
Cruche, pommes et rideau (V.499)	120,000	131
Nature morte (V.745)	70,000	133
Petite Estaque, vue de la mer (V.293)	99,700	130
Pommes, rideau, cruche, serviette (V.601)	199,650	XIII
Pommes et poire dans une assiette (V.740)	99,775	132
Chrysanthèmes (V.755)	99,600	135
Rosiers, cafetière, bouteille et rideau (V.602)	179,650	134
Fruits et tête de mort (V.758)	119,850	139
Pot vanné, fruit et serviette (V.737)	189,650	137
Fruits et rideau bleu (V.611)	25,000	136
Fruits dans une assiette et pot de confitures (V.363)	25,000	138

It was an extraordinary group, the single particularity of which was that it
comprised only still lifes and landscapes, to the exclusion of any figure pieces,
whether portraits, bathers, peasants, or mythological scenes. (Barnes was to make up
handsomely for their absence, notably through the acquisition of Cézanne's large
compositions of bathers and cardplayers.) But within these limits, Barnes now saw
his collection overtaking numerically the group of Cézannes owned by Mrs.
Havemeyer and, above all, he came into possession of some of Cézanne's finest

128 *The Arc Valley and Mont Sainte-Victoire* 1892–95 (V.457)

128 works. The landscape of Sainte-Victoire, in its limpidity, rigor, sharpness of focus, and almost liquid clarity of color does not have many equals among Cézanne's views of Provence. Among the still lifes there was not only a tremendous variety of compositions and objects, from fruits to jugs, from flowers to a skull, from ample folds of colorful drapes to bare table tops, there was also richness of texture, of vibrant brushwork, of smooth delicate strokes. It was a review of some of the artist's greatest achievements, represented by a number of works each revealing a different aspect of his genius.

Yet, Dr. Barnes's reaction to this astounding group was not altogether favorable. With the insensitivity and rudeness with which nature had so generously endowed him, he complained to Durand-Ruel about his purchase. To this the dealer replied on August 13, 1920: "Regarding the uncomplimentary remarks you made about the quality of some of the pictures, I believe that upon closer examination you will alter your mind altogether. The twenty-five Cézannes of Mr. Hoogendijk were purchased when the best could be had at moderate prices and they were selected from among all Cézannes in the market by a connoisseur of judgement surrounded by good advisors."

No matter how Barnes felt then – or later – about the thirteen Hoogendijk pictures, they represent without any doubt the most important single group of works by Cézanne that has ever come to America. Despite his real or feigned disappointment, Barnes was to keep adding other, often important paintings by Cézanne to his collection, frequently dealing with Vollard through Durand-Ruel.

129 *House near Aix-en-Provence c. 1886 (V.451)*

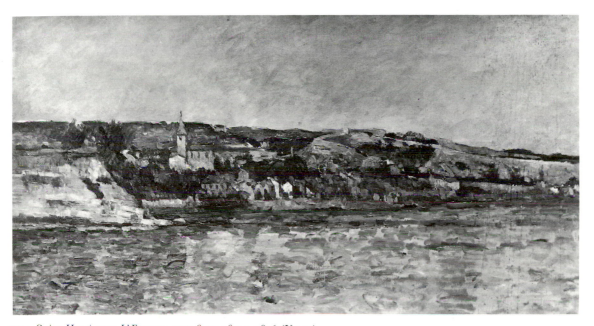

130 *Saint-Henri near L'Estaque, seen from afar c. 1876 (V.293)*

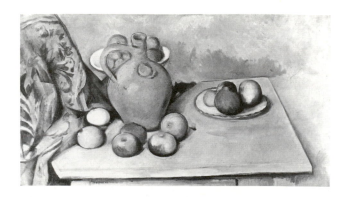

131 (above right) *Still Life with Jug and Fruits* 1893–94 (V.499)

132 (right) *Still Life with Apples and a Pear on a Plate* 1895–98 (V.740)

133 (below) *Still Life with Milk-pot and Curtain* 1892–94 (V.745)

134 (below right) *Still Life with Potted Plants, a Coffee Pot, and a Rum Bottle c.* 1890 (V.602)

135 (right) *Chrysanthemums* 1896–98 (V.755)

136 (below) *Still Life of Fruits against a Blue Curtain* 1893–94 (V.611)

137 (below right) *Still Life with Ginger Jar, Fruits, and Towel c.* 1895 (V.737)

138 (below left) *Still Life of Fruits in a Dish and a Small Pot of Preserves* 1880–81 (V.363)

139 *Still Life of a Skull and Fruits* 1896–98 (V.758)

Barnes remained constantly on the lookout. As early as 1913 he had told Leo Stein that he wished to make it known to *collectors, not dealers*, that he was in the market for important Renoirs and Cézannes. Since collectors often took risks and found themselves hard up, having to sacrifice their paintings to top dealers, Barnes felt that they would do better by dealing with him.[9] It wasn't so much that Barnes was prepared to pay more than dealers might, but that if advantage could be taken of an owner's distress, Barnes was the one who wished to do so, and if a bargain could be struck, he wanted to be the one to strike it.

This became clear during the thirties, when the doctor enjoyed his greatest moment. Barnes subsequently boasted openly of having been an outright freebooter. "I just robbed everybody," he said. "Particularly during the depression my speciality was robbing the suckers who had invested their money in flimsy securities and then had to sell their priceless paintings to keep a roof over their heads."[10] This may simply have been an outburst of bad taste, but Barnes did glory in the fact (if true) that Vollard had come to him when strapped for money, and that he, Barnes, availed himself of this occasion to obtain for $70,000 Cézanne's coveted large *Bathers Resting* (V.276), for which Vollard had previously turned down a bid of $200,000. In a similar way, Barnes took advantage of the dealer G. F. Reber's temporary embarrassment to acquire for $50,000 Cézanne's *Young Man with a Skull* (V.679) which its owner had priced earlier at $200,000. Even the Durand-Ruels appear on Barnes's list of those whose predicaments he exploited. When he heard that Paul Durand-Ruel's daughter Jeanne – whose portrait as a young girl by Renoir he had

140

tried to acquire over some twenty years – was badly in need of money, he showed up in 1935 with $50,000 in cash and carried it off, fully aware that it was worth considerably more.[11] It was evident that Barnes knew nothing of moral qualms or of gratitude, and since the daughter of the man – by then dead – who more than any other had helped him assemble his collection, was obviously enough of a "sucker" to be in difficulties, he could see no reason for treating her differently from the other people of whose precarious circumstances he enjoyed taking advantage.

Time did not soften Barnes's character; to the contrary, it made it worse and sharpened all his unpleasant and sometimes even revolting traits. Having established his foundation at Merion, Pennsylvania, he immediately made it clear that the general public was strictly barred from it. His special hatred was reserved for scholars who not only could not obtain admission, but were also refused photographs of works in the collection, even though for this he could hardly invoke the excuse he used for banning visitors, namely, that their presence would interfere with the classes from which the young foundation students benefited. Thus, Meyer Schapiro, even though recommended by John Dewey, whom Barnes considered his master, could not gain access to the collection, and Lionello Venturi was refused photographs while he was preparing his catalogue of Cézanne's work. In his courses, Barnes prided himself on telling his listeners what "pictures were all about in the forthright speech of a bricklayer."[12] A journalist, who for no known reason obtained permission to visit the foundation, interview Barnes, and write at length about him, reported that "since Barnes lives scientifically, his approach to art is scientific.

140 *Bathers Resting* 1876–77 (V.276)

According to Barnes, art is simply an expression of everyday experience."[13] In consequence of this profoundly philosophical approach, "in their four-year course at the foundation, the students are taught to examine a painting with the detachment of an automobile mechanic studying a crankshaft."[14]

The man whom Barnes entrusted with the task of presenting him, his work, his collection, and these views to the general public was a reporter for the popular magazine *Saturday Evening Post*, which was even authorized to take color photographs of certain rooms and of individual pictures (a privilege that to this day has not been granted again, not even concerning color slides for lectures). In the course of providing information for the series of four lengthy articles in the *Saturday Evening Post*, Barnes made no secret of the fact that he got "his greatest personal satisfaction out of writing poison pen letters."[15] He even provided at least one sample of his epistolary style or, rather, produced at least one letter that could appear in the series without having expletives deleted. It concerned a "titled refugee" who had innocently written and asked for the pleasure and privilege of seeing Barnes's two hundred Renoirs, one hundred Cézannes, seventy-five Matisses, and thirty-five Picassos. Barnes's reply was gracious in the extreme. "It saddened him to be obliged to tell her Highness that on the day she mentioned the Barnes gallery had been reserved for a charity affair by the fashionable suburb in which he lived. This was to be an art exhibit of a somewhat different sort. If her Highness must know, he said, it was to be a strip-tease contest for debutantes. And to his distress, he could not invite her Highness to this event because, out of consideration for the intrinsic modesty of the debs, it had been decided to limit the guests to the boy friends of the contestants."[16]

Barnes had of course a constitutional right to indulge in vulgarity, and his deplorable sense of humor – if humor it can be called – need not even be discussed, if behind his dreadful, crude, and unspeakably stupid manners a real tragedy did not lie hidden. For it was this obnoxious man who, on the strength of owning a great many works by Cézanne and other masters, decided arbitrarily who could and who could not see them. In other words, a considerable part of Cézanne's output was actually sequestered by a vain and authoritarian individual who took it upon himself to determine for whom Cézanne had created the pictures that only his money, his cunning, his ruthlessness, and his lack of scruples had brought to Merion.[17] If he had had the slightest understanding and admiration for Cézanne, he would actually have *wanted* to share these pictures with others. Instead, Cézanne and those who loved his work were the victims of someone who can only be described – although this expression did not then exist – as an ugly American.

NOTES

1. On Quinn, see notably Judith Zilczer, *"The Noble Buyer": John Quinn, Patron of the Avant-Garde*, exhibition catalog, Hirshhorn Museum and Sculpture Garden, Washington, D.C., 1978.

2. See Chapter VII above.

3. See Chapter VII above.

4. All documents (bills, invoices, letters, etc.) quoted or referred to in this chapter for which no specific footnotes are provided come from the archives of the Durand-Ruel gallery in Paris and were graciously – and without any restrictions – put at my disposal by the late Charles Durand-Ruel and his staff, consisting of his daughter,

Mme Caroline Godfroy and Mlle France Daguet. Without their patient help and lively interest in this project, these pages could not have been written, the more so as many of the documents have only recently been discovered in the dusty recesses of those invaluable and not yet completely sifted archives.

5. The Marczell de Nemes sale was scheduled for June 18, 1913.

6. The painting was designated merely as *Le Moulin*. It was sold to Barnes on May 25, 1914, for 15,000 francs, but the invoice of May 28, in contrast to most other invoices, does not specify from whom it was obtained. It seems possible, however, that this was the landscape V.646, which Barnes reproduced as early as April 1915 in his article "How to Judge a Painting," *Arts and Decoration*, April 1915, p. 217. The single house in the painting may well have formerly been a mill.

7. I am indebted for much general information on Cornelis Hoogendijk to Herbert Henkels, Leiden, Netherlands.

8. According to René Gimpel, *Journal d'un collectionneur marchand de tableaux* (Paris: Calmann-Lévy, 1963), p. 165, diary entry of June 5, 1920, the participating dealers "paid a very high price for the Hoogendijk collection."

9. See Albert C. Barnes's letter to Leo Stein, Philadelphia, March 30, 1913; Leo Stein papers, Beinecke Rare Book and Manuscript Library, Yale University. This document was brought to my attention by Richard I. Wattenmaker.

10. Albert C. Barnes, quoted by Carl W. McCardle, "The Terrible-Tempered Dr. Barnes," *Saturday Evening Post*, April 4, 1942, p. 18 (third article in a series of four). On the "background" of this group of articles see Howard Greenfeld, *The Devil and Dr. Barnes* (New York: Viking, 1987), pp. 217–19.

11. Ibid., pp. 18–19.

12. Ibid., p. 34.

13. Ibid., March 21, 1942, p. 93.

14. Ibid.

15. Ibid., p. 9.

141 *Mill* 1888–90 (V.646)

16. Ibid.

17. I am anxious to establish that I did not wait for Dr. Barnes's death to express these objections. In an article devoted to the Cone Collection in Baltimore, which appeared while Etta Cone was still alive (*Art in America*, Oct. 1944), I wrote: "Miss Cone is always willing to share her treasures, and her day often resembles that of a guide for her collection. Her deep respect for the artists and their works has kept her conscious of the immense privilege she enjoys. Whereas a man like Dr. Barnes misuses this same privilege by deciding arbitrarily who may and who may not see his collection, thus imposing on the artists the choice of those for whom their works were created (an attitude which violates above all the artist's right and function to address himself to all of humanity)."

This article was published *before* I wrote to Barnes for permission to see his collection, since I did not want – in case of a more or less expected refusal – to be accused of taking this attitude out of revenge. When I explained this in a letter to Barnes, accompanied by the article, admittance to the foundation was of course denied, but the letter of insults I received was so unoriginal and dull that it must have been dictated on one of his less-inspired days.

142 *Still Life with Putto c.* 1895 (V.706)

XIII · The War Years

HISTORY sometimes has a knack for providing dates which, at a distance, appear almost symbolic. Without any undue twisting or straining such dates suddenly establish links between apparently unconnected events, providing them with additional meaning. It is thus that 1913, the year of the Armory Show, at which America first discovered all the new tendencies and achievements of contemporary European art, can now also be perceived as having lowered the curtain on the extraordinary period of intense and pacific creativity of which the exhibition was such an eloquent manifestation. While the show was traveling from New York to Chicago and then to Boston, Europe was readying itself for a conflict that would put an end to the very atmosphere in which that creativity had flourished. Yet the eruption of the conflagration into which America refused to be drawn did, if anything, favor artistic exchanges with France, the cradle of most of what was important and promising in art. Indeed, World War I was to benefit the propagation of French art in the United States and, in the process, promote the spread of Cézanne's reputation, which, thanks to the Armory Show, had become intimately linked with everything modern.

But this did not happen without opposition from those who had garnered nothing but contempt from the Armory Show. Among these was Carroll Beckwith, one of America's most undistinguished, not to say benighted, academicians. In a letter to the *New York Times* devoted to "The Worship of Ugliness," he protested against the perverse ways of modern art. The result was a strange battle fought parallel to the European war although this one has long since been forgotten. Beckwith quoted banalities uttered by his French colleague Léon Bonnat who, blessed by nature with a total absence of talent, consequently had become the official painter of the Third Republic and had harvested all the medals and honors that go with such an exalted position. Since many Americans had studied under Bonnat at the Ecole des Beaux-Arts, it can even be said that – to some extent – he was responsible for the deplorably low level of American academic painting.

Ranting against the perniciousness of modern art, Beckwith discovered in it the hidden reasons for current events. "I cannot dissociate," he wrote, "in my own mind the monstrous aberrations of Germany in the present war with this awful development in my own profession. Some two years ago, in a picture dealer's shop in Paris, Vollard by name, I was horrified to find the entire collection composed of the most extreme works of the Cubists, Futurists, Pointillists, and all the insane schools of mental maniacs. I remarked to the dealer my horror and asked if he ever sold them.

'I take three car-loads of them to Germany every Spring and Fall and sell every one.'"[1]

In a letter to the editor, Frederick James Gregg, a member of the Armory Show "crew," immediately pointed out that Vollard did not handle the works of the artists Beckwith had ostensibly seen in his gallery. "Mr. Beckwith must be incapable of telling the difference between a Renoir and a Cubist, or a Degas and a Futurist," Gregg observed; "How then could we expect him to tell a Cézanne or a Gauguin when he saw it? In spite of Mr. Beckwith, the Vollard gallery owes its fame – as everybody but Mr. Beckwith knows – to the richness in the works of Renoir, Degas, and Cézanne. It is to see the paintings of these masters that people go there from all over Europe and America."[2]

A more elaborate reply and one that more decisively put Beckwith's accusations to rest came from none other than Agnes Ernst Meyer. "Let us examine the logic of the situation as described in Mr. Beckwith's letter," she wrote.

He says that modern art was purchased in large quantities by the Germans, and that, since Germany brought on the war, "this perversion of his own profession" must be at fault. Now it is admitted, nay, generally asserted, by the Allies that the militaristic or ultra-conservative party in Germany deliberately caused the war. But surely nobody would suspect these reactionaries of purchasing the most revolutionary art that was ever created. Evidently the class of people in Germany who bought Cézanne, Picasso, and Matisse are not the same class that brought on the war. . . . Where is the connection between this art and the war?

As a matter of fact this insidious attack on Modern art, which is just as French as that of any other era (for in what foreign country can a painter be found to stand beside Cézanne or Picasso?), this use of the hatred of Germany to befog another issue, was successfully launched by some Paris dealers who hate the modern movement because, though there is comparatively little money in the new pictures, their appreciation will kill forever the sales of the eternal sunsets and cathedrals and sheep and other time-honored artistic prettinesses. Those dealers saw their chance to make of modern art a treason against France. . . . If France, in the stress of primitive emotions, rejects one of her greatest contributions to the modern intellectual struggle, may our young men be strong enough in purpose and in mind to continue the combat.[3]

The final word in this debate was provided by Joseph Pennell, who predicted that if the war continued 'it will prove the greatest aid to new art, for the old will be wiped out," but simultaneously pointed out that "the new art preceded the war just as the art of Egypt, Greece and Rome preceded their downfall." To this gloomy prospect Pennell added his own evaluation, according to which the work of the European Post-Impressionists was "composed of indecency or decadence and incompetence." Venturing into recent history, Pennell also came up with some startling revelations concerning Cézanne who, in Pennell's words, "was only tolerated by the Impressionists because he with his father's money hired them a house near Paris, where they could paint nudes in the open."[4]

Not unexpectedly, in his diatribe, Pennell echoed the refrain of those clever dealers who "have taken up, for a mere song, the work of utter incompetents and unloaded it on a waiting public at an enormous profit." Yet this was just as false as were most of Pennell's other assertions. Indeed, things had not gone well for dealers shortly before the outbreak of the war. When the Paris dealer Eugène Blot obtained

twenty-six watercolors from Cézanne's widow (who was a chronic gambler) for 40,000 francs (a mere song?) and exhibited them in November 1913, he reported, "Never did I see so many visitors in my gallery. People came from everywhere: Germany, Austria, Russia, America, and never did I sell so little . . . even though the prices ranged from 400 to 2,000 francs for the larger and finest works. And that was rather lucky for me, since it is true that beautiful things do not suffer from having to wait and do not have to worry about the future. Even while the war was raging, one of the watercolors was sold for 5,000 francs in Switzerland and another one for 10,000 francs in America."[5]

In the summer of 1914, Mrs. Eugene Meyer had gone back to Paris, looking at many things but apparently buying little. As Stieglitz informed Marius de Zayas, she "writes that if her husband will let her she will buy a Cézanne which is a beauty. I suppose this is the one you wrote so enthusiastically about."[6] A short time later he continued, "Of course business is still rotten here and I don't know how Meyer will feel about the picture. I hope he will see his way clear to let his wife get the picture. And if she gets it we must, by hook or brook [sic], show the two Meyer Cézannes at '291,' even if it is only for two or three days. A batch of the fellows can sleep up in the place and act as guards."[7] However, the Meyers did not acquire the painting.

At the declaration of war in 1914, Vollard had to stop taking the seasonal three carloads of "monstrous aberrations" to Germany, of which Beckwith had spoken so authoritatively. As a matter of fact, the French dealers of Cézanne, as well as of Matisse, Picasso, Bonnard, and others, now discovered that many of their best clients had turned into "enemies" overnight. Although Russia was an ally, the Shchukins and Morosovs, together with the German dealers, collectors, and museums who had bought with so much enthusiasm, discernment, and independence, disappeared from the art market with no immediate replacement in sight. But as fortunes were soon reaped in some of the neutral countries, it was to them that the French dealers turned: to Switzerland, Scandinavia (for which the Norwegian Walther Halvorsen, an ex-painter and ex-student of Matisse, became an active agent), and of course to America. Due to increased activity in the direction of these centers, which were already beginning to prosper, new collectors appeared on the scene, replacing those whom the hostilities had eliminated. Whereas Vollard seems to have decided to close his gallery and simply wait out the war, his imperturbable confidence in his stock convincing him that better days would return, the Bernheim-Jeunes constantly explored new avenues. This became necessary because France itself had never evinced a very lively interest in such painters as Cézanne or Seurat; indeed, the one great French collector of Cézanne's work, Auguste Pellerin, had unaccountably stopped trading with the Bernheim-Jeunes shortly before the outbreak of the war, although he probably continued to deal with Vollard. At the same time, their war-torn country mustered less and less attention for cultural problems as the news from the front provided scant cause for celebration.

Under these circumstances, the land with the greatest potential, the greatest wealth, and the greatest opportunities for transforming an already awakened interest into a more active patronage was the United States. What was absent there, however, were outlets. The Durand-Ruels had their own branch in New York but seldom

handled Post-Impressionist works; the Knoedler galleries were still committed to Old Masters with hardly a foray into the modern field, for which Duveen, when he established a foothold in the New World, had no use at all. The rare places that represented modern endeavors were small galleries such as that of Stieglitz, who actually was not interested in a purely commercial enterprise, nor equipped to handle one. But as usual in such situations, when a real need makes itself felt, it is eventually filled.

It was Stieglitz's protégé Marius de Zayas who took the initiative. As he explained many years later,

> Stieglitz' mission as an importer of French Modern Art was interfered with by the war. Most of the French artists had become soldiers [others, notably Marcel Duchamp and Francis Picabia, had come to the United States where they had gained a certain status through the Armory Show]. It was known that the art market in Paris was practically closed. An altruistic spirit invaded the Photo-Secession, inspiring the idea that the 'moderns' should be helped in some way, most particularly those artists whose work had been shown at the Photo-Secession for 'experimental purposes' only. It was therefore proposed to open another gallery, a branch of "291" in which works of art would be used both for propaganda and for sale, in order to help the needy. The result of this suggestion was the opening of the Modern Gallery.[8]

For the funding of this venture de Zayas had obtained the support of Eugene Meyer who "provided for it with the conviction that there would be no returns. . . . The commercial side of the Modern Gallery was, therefore, very negligible" as it would not "depend on sales for existence."[9] Moreover, Picabia felt certain that his many wealthy acquaintances could be counted on to rally round the new gallery.

De Zayas went to great lengths in explaining to Stieglitz how the somewhat unlikely business partners planned to proceed: they would work with Paul Guillaume in Paris, a young dealer particularly interested in modern painting and African art, although their relationship would be a "purely commercial" one. They would have a Parisian delegate in the person of a friend of Picabia's (whom he did not name), "a painter himself . . . who works for his own pleasure . . . [and] who will try to connect us with Vollard and [the print dealer] Mme Sagot in case that we should need their assistance."[10] But there was no mention of the Bernheim-Jeunes, with whom Stieglitz himself had dealt through Edward Steichen.

It was with considerable assurance and zeal that de Zayas eventually penned a lengthy circular announcing the creation of his gallery and specifying its aims. Yet by doing so he implied, knowingly or not, that these aims had not been attained by what was the "parent" organization, Stieglitz's own 291. "We have already demonstrated," he wrote, "that it is possible to avoid commercialism by eliminating it. But this demonstration will be unfertile unless it be followed by another: namely that the legitimate function of commercial intervention – that of paying its own way while bringing the producers and consumers of art into a relation of mutual service – can be freed from the chicanery of self-seeking."[11]

However, when de Zayas asked that his long-winded circular be published in *Camera Work*, Stieglitz balked. On the one hand he felt that he owed explanations to no one; on the other, he may have wondered whether the "chicanery of self-seeking" was an allusion to the way in which he ran his Photo-Secession. Stieglitz could also

XIII *Still Life with Apples, Pears, and a Gray Jug* 1893–94 (V.601)

XIV *Mountains in Provence (near L'Estaque?) c.* 1879 (V.490)

have suspected that, by teaming up with an artist whom he himself had sponsored, Mrs. Meyer, the "Sun girl," with her immensely rich husband, was now trying – all denials notwithstanding – to divert his disinterested efforts into something quite different, an openly business-oriented enterprise. The notice that Stieglitz did insert in the October 1915 issue of *Camera Work* was therefore very short and devoid of any soul-searching proclamations:

> "291" announces the opening of the Modern Gallery, 500 Fifth Avenue, New York, on October 7th, 1915, for the sale of paintings of the most advanced character of the Modern Art Movement, Negro Sculpture, pre-conquest Mexican Art, Photography.
>
> It is further announced that the work of "291" will be continued at "291" Fifth Avenue in the same spirit and manner as heretofore. The Modern Gallery is but an additional expression of "291".[12]

Marius de Zayas had very definite ideas about how this "additional expression" should distinguish itself from 291. Many years later he was to specify that "the attitude of the Modern Gallery vis-a-vis the public was entirely different, in fact, quite the opposite of that of the Photo-Secession. Stieglitz experimented with the public; his place was, as he called it, a laboratory. "I let the public work out its own salvation; I left it alone. . . . Besides, I do not have the ability, intelligence, and facility of speech that Stieglitz had and lavished on the public. Stieglitz had prepared the way, opened the roads, and I only had to let matters take their natural course – I let the pictures and sculpture do their own talking. Although, in truth, most of the exhibitions at the Modern Gallery were accompanied also by an introductory note."[13] (This was exactly how Stieglitz had proceeded.)

The first exhibition of the Modern Gallery was merely an assembly of drawings and paintings by, among others, Braque, Dove, Marin, Picabia, Picasso, and Walkowitz, including also works by de Zayas himself, photographs by Stieglitz, and African sculpture. While this did not constitute a particularly auspicious or distinctive beginning, de Zayas had plans for a more systematic presentation of the evolution of modern art, which would have contrasted sharply with the didactic procedure adopted by his mentor. "When the Modern Gallery opened," he later recalled, "I had the pretention of showing the public how that [modern] movement came about with a series of chronological exhibitions. I intended to begin with the work of Gauguin who first introduced into European contemporary art the exotic element, and with the work of Van Gogh who started talking about the psychological meaning of color. Gauguin's paintings of Tahiti were not available even at that time. But I could get in Paris a few paintings by Van Gogh loaned by dealers. And the Van Gogh exhibition was in reality the opening one at the Modern Gallery."[14]

As a matter of fact, on November 20, 1915, the *New York Evening Post* informed its readers that "Mr. Stieglitz announces that Marius de Zayas has secured for the Modern Gallery, 500 Fifth Avenue, a series of unusual examples of modern art. These include work by Van Gogh, the complete evolution of Picasso (including his very last paintings), Brancusi (his last piece of sculpture), important Cézannes, a new and rare group of negro sculpture, and other things."[15] Eight paintings by van Gogh would be on view for three weeks.[16]

That de Zayas could not inaugurate his exhibition series with canvases by Gauguin can probably be explained by Vollard's unwillingness to lend any. In the

143 List of works by Cézanne lent by the Bernheim-Jeune Gallery, Paris, to the Montross Gallery, New York, in 1916

case of Cézanne, on the other hand, he would not have had to depend on the cooperation of the Paris dealer, as he could count on help from the Meyers. Meanwhile, however, he lost the initiative there, for the article of the *New York Evening Post* that drew attention to his van Gogh show continued its report by saying: "This announcement, which will raise every young painter's expectation, follows close on the announcement by Mr. Montross that he will hold a small and select exhibition of works by Cézanne early in January [1916]. It has been insisted often in this column that a fuller opportunity should be afforded the Americans interested in modern art to study directly the works of Cézanne, Van Gogh, Gauguin, Picasso, and the other men who count, before the little men like Picabia and a host of others equally unimportant are thrust upon them."[17]

Whether or not he smarted under the parting dig at the "little men," among whom his friend Picabia was singled out, de Zayas must have been even less happy about the disclosure that he was not the only new promoter of contemporary European art in New York. While he and Stieglitz were more or less openly at odds about who should do what in his respective establishment, others were also trying to take advantage of the new situation on the Paris art market. Thus Newman Emerson Montross launched a venture that closely followed Stieglitz's (or should one say Steichen's?) lead. In early 1915 he had held an important exhibition of works by Matisse, selected and arranged by Walter Pach.[18] It was also through Pach that he subsequently approached the Bernheim-Jeunes in Paris and found them willing – possibly even eager – to help him present a new Cézanne exhibition. They agreed to ship the seven paintings and thirty watercolors of which the show would be

355

	Report		226 500 f
17007	Maison sur la colline, aquarelle	"	4000
16991	La futaie	id	2500
16985	Arbres parmi les rocs	id.	2400
16975	Arbres dans la montagne	id.	2800
16969	Arbres au fond d'un mont	id.	1400
16979	Troncs d'arbres	id.	2000
16956	La Corbeille	id	2400
16935	Les pêcheurs	id	2000
16985	L'hortensia	id	1500
16954	Fleurs	id	2000
16989	La tranchée	id	2000
16978	Entablement de rochers	id	1300
17001	Le ravin	id	1200
16950	La feuillée	id	2200
17015	Le chemin	id	1800
16980	Les roches	id	1800
16984	L'escarpement	id	1500
	à reporter		261300

356

	report		261 300
17017	Arbres dans un ravin, aquarelle		1200
16957	Maison et arbres	id	2600
17001	Deux arbres	id	1800
16953	Reflets dans l'eau	id	2000
16946	Paysage	id	2000
16940	Paysage	id	2000
17016	Le hêtre	id	1400
16971	Les barques	id	1000
16994	Troncs blancs	id.	1500
17009	Verdures	id.	2500
16972	Les pèlerins	id	2200
16928	Le pont	id	1500
			282 800

Yours faithfully
Pour Bernheim-Jeune et Cie
Fénéon

comprised. In other words, the entire exhibition was composed of Bernheim-Jeune *143* loans. Among the watercolors were a number that had already been seen at Stieglitz's in 1911, but there were also a good many new ones. Above all, this was to be the first exhibition at which both the artist's paintings *and* watercolors would be on view; at the Photo-Secession there had been only the latter, and the Armory Show had featured only oils, with the exception of a single watercolor.

As had to be expected, there was a great deal of advance interest because, as Frederick James Gregg explained, it was timely to consider Cézanne's "relation to our own period. For whatever is disturbing, violent, or heterodox in the art of the day is to be attributed mainly to the influence of the Old Man of Aix."[19] But there were also those all-knowing experts ready to find fault with the exhibition because it did not include works they pretended to admire. With great disappointment they proclaimed that it was presenting "a much meaner idea of this, the most adored of the prophets of modern art, than we got out of the few canvases from his brush gathered at the Armory show. There were apologies offered because of the scarcity of Cézannes at the Armory exhibition. There were no apologies offered for this one."[20]

In reality, there was no need for apologies. The Montross event was, if anything, more coherent and better selected than the Armory Show. One of the reasons for this was evidently the fact that it had been assembled by a single person – the perceptive Félix Fénéon[21] – with an eye for a balanced choice of the artist's subjects and styles. Although the catalog did not provide dates of execution, or follow even a vaguely chronological sequence (only Wright, in his review, worked out a chronology), there was a definite attempt at spanning some thirty years of Cézanne's production. His

146
145

144
XIV

147

150
142

148

evolution was illustrated, to begin with, by a small and dark early landscape in a style reminiscent of Courbet and painted in heavy impasto (V.136), followed by another one, executed a little later in delicate, light tonalities after Cézanne had begun to work at Pissarro's side (V.140). There were the ubiquitous apples with their strongly modeled shapes (V.195); Cézanne's emphasis on solid structure was still more masterfully emphasized in a painting called (wrongly) *The François Zola Dam* (V.490), once the pride of Paul Gauguin's collection and the work by Cézanne he admired most. It was more important than any landscape included in the Armory Show; the same applies to a view of L'Estaque (V.406), although executed in a completely different vein, in light, almost transparent brush strokes, a work of luminous serenity and soaring lyricism, somewhat related in its handling of paint to a portrait of a man in a slightly awkward position (V.1519), which turned out to be the favorite of most critics. Finally, there was a large still life with a plaster Cupid (V.706), a complicated and fascinating assembly of objects, painted with clear colors and limpid strokes – a masterwork that did not have its equal at the Armory Show either (where there had not been a single important still life). And there was even a last-minute addition, not listed in the small catalog and not mentioned in the reviews, when Mrs. Montgomery Sears, having apparently decided to sell it, entrusted Montross with the superb still life that had once belonged to Mary Cassatt (V.606).

Such an unusual group of paintings notwithstanding, the accent of the Montross show was on the thirty watercolors; the short catalog introduction was, in fact, devoted exclusively to these. It was signed by Max Weber, one of the painters originally championed by Stieglitz, who had gone over to Montross, thus providing another indication of the fact that Cézanne's admirers were still essentially the same people, regardless of their association with different galleries. In his comments on Cézanne's watercolors, Weber declared:

> The rhythms, the interlaced and contrasted quantities and their energy of contour, are what he sought out in nature through these water colors.
>
> They are expressions of the first vital fresh sensations he received from closest and intense observation, and they are his freshest expressions of what one might call colored geometry sought out by him in the landscape. They serve as a most satisfying and comprehensive introduction to his complete sculpturesquely painted pictures, the areas of which are constructed with color nuances and gradations – only Cézannesque – unknown to and unequaled by any other master or school in the history of painting. His art is the most marvelous example of the reorganization of the natural into a purely plastic domain. The reality of his art is so marvelous, concrete and poetic, that he succeeds to a rare degree in making the static to vibrate. It is the very spiritualization of matter-form on earth. They are the first writings of a powerfully creative, placid organizing, mind controlling emotion and blazing intellect. In these water colors can be seen and felt his power of synthesis in transforming the chaotic into the purely architectural plastic.
>
> So intense, and often final, are these colored contours, that the blank areas stir the imagination, for they are imbued with constructive color and form, and are at once as satisfying as if they had been carried as far as his most complete works. So full of suggestion are these water colors that the spectator, artist or layman, must for the time being become creative. To me these water colors are complete works of art of great distinction, wholly as important as the oil pictures.[22]

144　*Seven Apples and a Tube of Color* 1878–79 (V.195)

It is of course possible that Weber's ardent plea on behalf of the "completeness" of Cézanne's watercolors was prompted by the fear that they would be less understood than the paintings – a not unreasonable assumption. Indeed, the canvases selected for the show were on the whole quite "finished" (except that the critics tended to praise or at least mention the less important ones in preference to the three overpowering masterpieces that the Bernheim-Jeunes had included in their shipment: V.406, 490, and 706). But as Henry McBride, who of course admired the watercolors, soberly pointed out while quoting Weber's text in his review: "There is little hope that Max Weber's 'foreword' to the Cézanne catalogue will explain much to the academicians. As art appreciation it will seem to them to be as wild as the pictures. It is, however, only fair to reprint it, as it shows the way the young now talk. The modern artists will like it, and nothing derisive or derogatory that the philistines may say will affect their appreciation. Who cares what philistines say anyway?"[23]

Cézanne's admirers obviously did not, although the readers of the various reviews were treated to a vast amount of double-talk and conflicting views. When, for instance, the critic of the *New York Times* called the portrait in the show "a study in the third dimension," the reviewer for the *American Art News* retorted a few days later (without direct reference to him), "the twaddle of Cézanne's most fevered champions about 'three dimensions' is the merest mockery of pedantry in the face of a genius tantalizing in his simplicity."[24]

The *American Art News* reviewer was a master of ambiguity. "The extravagant claims of supereminence that have been made for the painter Paul Cézanne should not disturb anybody," he wrote.

145 *Turning Road in a Forest c.* 1873
(V.140)

146 (below) *The Oil Mill c.* 1872
(V.136)

147 *View of L'Estaque and the Château d'If* 1883–85 (V.406)

148 *Still Life with Rum Bottle c.* 1890 (V.606)

But they do disturb, as if extravagant claims were not constantly being made for all sorts of painters every day. That Paul Cézanne was a painter of fine quality it would be idle to deny – that his art is a decadent art it would be equally idle to deny. . . . Ye "literary" critics of art, go to! What about it, what does it mean? How marvelous does a simple genius of a painter become when his slightest eccentricities turn to a grist of golden guineas. . . . How simple all this. Why the perplexity? If Cézanne were not a dead man, we would be tempted to say "Bon jour, old bogie, your battered blue derby makes a fine note on the red carpet at Montross, welcome – to the carpet.[25]

In *The Nation*, Frank Jewett Mather, Jr., went to great lengths in discussing the exhibition and trying to be equitable. He found qualities in several of the oils as well as the watercolors, which he referred to as "coarse [!] webs of slight and iridescent tones upon the white papers, entirely casual on first inspection. One must go far from the picture to let the harsh [!] planes balance, and then one will be surprised at the massiveness and spatiality of the work, at its paradoxical solidity and sobriety." This perception, however, did not prevent Mather from condemning the painter for being "uncivilized," a conclusion he reached in a most erudite way. He began by stating that Cézanne's watercolors "are among the most abstract forms of expression conceivable." But having granted this, he pursued:

Like Far Eastern drawings, they are merely symbols for swing and spatiality. Indeed, most of the landscape is so highly schematized and syncopated, so disregardful of minor

realities, that it is comparable in abstraction to the landscape background of a Perugino. The difference is instructive, for the intention is by no means dissimilar. One seems painted by a person with capacity for reverie, the other by a disembodied intelligence. There is no mood in a Cézanne – just superior vision and athletic workmanship. All the values that come from civilization are absent in his case. When one recalls that he adored Poussin, the Dutchmen, the Venetians, even Courbet, Couture, and Delacroix, and yet, save in a few youthful romantic experiments, kept all these influences out of his art, one must admit that he achieved the very difficult task of decivilizing himself. . . . For that plus quality of lovely workmanship which the civilized artist rarely fails to value he cared absolutely nothing. He was capable of it, as many of the still lifes attest, but generally his surfaces are raw, the touch as nondescript as assured. The preciousness which would make any detached square inch of a Fra Angelico, a Titian, a Vermeer, a Watteau a desirable possession, is completely absent from a Cézanne. And this preciousness – what is it but the artist's desire to please, his acceptance of a social code of beauty – in short, his civilization? Of course, I am aware that this is utter sentimentality to those for whom artists of Cézanne's type are the greatest. Yet at the risk of seeming sentimental I am willing to give the values of sentiment their place in the sun. The most radical trouble with Cézanne, in my opinion, is that, not caring to please anybody but himself – which is at once a defect in civilization – he did not really care greatly about nature. He cared tremendously to be right about nature; his own rectitude was what engrossed him. This Calvinistic tinge – or, since he was a good Catholic, let us rather say Augustinian – is what limits his art. It has next to no humanity in it, no humility, no love. In view of these facts, it seems to me quite absurd to speak of Cézanne as a great artist. He lacked the requisite greatness of soul.[26]

Mather's review was a tour de force and, like so much of this kind of learned criticism, his was a verdict without the possibility of appeal. Once Cézanne's love of nature and humility were denied, the key to his achievement was lost, buried under the weight of clever and cold arguments. The most radical trouble with Mather, to paraphrase his conclusion, was "that, not caring to please anybody but himself – which is at once a defect in civilization – he did not really care greatly about *art*. He cared tremendously to be right about art; his own rectitude was what engrossed him."

Mather was not alone, however. There was also the renowned Royal Cortissoz, who seemed to have waited patiently for an occasion to get even with his colleague, rival, and friend, James Huneker, the man he considered the American champion of Cézanne. That Huneker had never spoken a word of unstinted praise about the artist, that even his moderate appreciation had always been mixed with reticences, did not seem to matter because, after all, Huneker had indeed brought the painter to the attention of the American public by writing, as Cortissoz put it, "shrewdly if not altogether convincingly" about him.

Combining a review of Vollard's biography of Cézanne with extensive comments on the Montross exhibition, Cortissoz dipped his pen into the rich fluid of prejudice and superficial intelligence with which nature had so amply endowed him. His one merit was that of putting to rest, at last, the perennial reference to Cézanne's sincerity, a notion out of which Huneker had gotten considerable mileage. Sincerity, Cortissoz explained, "may be, indeed, a virtue, but not in the sense that it is also an asset, a quality automatically productive of beauty. It is compatible of course, with

the production of stupid ugliness. . . . It is important, therefore, to recognize the fact that Cézanne's sincerity is beside the point." But having stated this, Cortissoz concluded, "It does not keep him from being commonplace, mediocre, a third rate painter." (It was this unequivocal assertion that prompted Huneker to write to Cortissoz to explain his position and to conclude with the meek admission that he, too, considered Cézanne a third-rate artist, after all.)[27]

Cortissoz's piece was generously sprinkled with negative formulations such as the one in which he denied that there had been any evolution in Cézanne's work, even though at Montross there was a fairly representative range of paintings illustrating the artist's development. In Cortissoz's opinion "Cézanne stayed what he was at the beginning, a painter wandering about in worlds unrealized, too imperfectly equipped to say what he had to say, if, indeed, that was worth saying." Under these circumstances it can be no surprise that the watercolors came in for some uncharitable words: "The hints at form which they contain have no artistic charm. They are but the shreds and patches of an uncertain purpose. In those fumblings of his around the secrets of nature, Cézanne may have had glimpses which did make him less forlorn, but he transmits to us nothing of the joy he may have derived from them. Partly this is due to his limitations as a workman, to the harsh, uninspired technique which excludes all hope of style, of linear felicity. But even more it is due to the humdrum nature of his vision."

And he went on to conclude: "Celebrities like Cézanne are the products of mistaken enthusiasm. Their vogue in Paris is explicable on the ground of an amiable weakness. . . . But there is really more occasion for sorrow than for mirth in the facility with which these specious reputations are drummed up in modern art. The mission of the painter is to create beautiful pictures. It is a function which Cézanne pathetically missed."[28]

Yet it would be wrong to think that there were only negative comments; after all the Armory Show had opened some eyes, taught some lessons, eliminated some provincialisms. The very first review to appear, an unsigned piece published in the *New York Times Magazine* the day before the opening of the Montross exhibition, was full of perceptive praise. Having discussed each of the seven oils, the author examined the watercolors.

> When you turn from these magisterial paintings in which everything is realized with the greatest intensity . . . to the water color sketches, you perceive the futility of identifying any great artist with a single style. The slightly roughened texture of the paper shows through the clear pale washes of color and is left untouched in great patches of which the emptiness is filled with air. And not always with air. There is a study of rocks [probably RWC435 or 433] in which a few horizontal and perpendicular and oblique lines are fortified by a few splashes of yellow, and brown and blue, and the rest is white paper — solid white paper which is cajoled or forced into expressing the weight and volume of rock. Cézanne's palette in these water colors is of singular purity, and although he uses thin fluid washes, he entirely avoids edginess. . . . Painters will linger and wonder over these wonderful water colors. . . . We have not yet learned the exquisite rightness of just enough and no more. . . . The exhibition at the Montross Galleries is a loud call to the young who are always in danger of following false gods and clinging to them, first from loyalty and then from laziness. There could be no master more wholesome than Paul Cézanne.[29]

149 *Rocks and Trees* 1890–95
(RWC.399)

After the close of the exhibition there appeared an article by Willard Huntington Wright, who expressed a similar enthusiasm for the watercolors, in which he found "the essence" of Cézanne. "The virility of his organisation," he wrote,

> the hardy surety of his lines, the justness of his colour–form juxtapositions are all set down, one might say, without adjectives, adverbs or participles. There is no apparent striving for photographic realism; and no one can accuse Cézanne of making illustration his objective. Lines which delimit volumes which, in turn, are colours, are drawn, not to give us a reproduction of the subject, but to make of that subject a theatre where vast volumnear forces balance and sway rhythmically, on the threshold of eternal action, in counter-balance with other poised masses, thus creating that movement which translates itself into our physical consciousness and causes what Lipps has termed *Einfuehlung*. In these pictures one will notice that where a stone or tree trunk has been outlined against a hill or ravine, the colour is placed only along the contours of these objects, and that these thin strips of colour indicate the relative spatial relation between the picture's volumes. So accurately consistent are these colours that they "carry" for the entire mass which is left nine-tenths white.[30]

But how did the public react in view of these highly contradictory comments? That artists flocked to the exhibition can be taken for granted, yet what about others? It may be rewarding some day to study the effect that reviews – both supportive and adverse – have on the success of a show. After reading what such widely respected pundits as Mather and Cortissoz thought of Cézanne's watercolors (and their views

carried more weight than those of Wright), one could presume that no buyers dared appear. After all, only one work out of twenty had been sold from Stieglitz's 1911 exhibition and, as de Zayas was quick to point out, not only were many of the same pieces among those shown at Montross, but they were also considerably more expensive (Bernheim-Jeune had priced them at an average of about 2,375 francs, or $475, but it is not known whether this included the commission for Montross, expenses for shipping, or other costs).

The fact is that the exhibition turned into a financial success. On March 17, 1916, after the show closed, Montross acquired four of the watercolors. A week later, on April 4, he bought seven more, followed on May 18 by another two. Since all were consigned to him, this means that he had found collectors for them; and since the Bernheim-Jeunes apparently did not insist on their return, Montross purchased three more on April 13, 1917, and a last one as late as January 21, 1920.[31] Thus, seventeen watercolors, slightly more than half of those exhibited, were eventually sold; of these, Miss Lillie P. Bliss – obviously under the guidance of Arthur B. Davies – acquired no less than six. She also purchased one oil painting, the still life *148* Mrs. Montgomery Sears of Boston had decided to sell. Davies himself bought one *149* watercolor (RWC399).

The critical reception of the few oil paintings shown at Montross was of course as varied and contradictory as that of the watercolors. The canvas on which most *150* reviewers agreed was the so-called *Portrait of a Man* (V.1519), which was actually a likeness of Cézanne himself, based on a photograph (a fact established only many years later).[32] Since the photograph is oval and merely shows the artist's bust, Cézanne, in "transferring" it to a rectangular, upright canvas, added hands resting on what looks like the back of an upholstered chair. Whether or not, in doing so, he referred to his mirror image is open to question; in any case, there exists an unusual hiatus between the upper and lower part of the picture. This, however, did not bother the New York critics, although several of them noticed a certain clumsiness in the sitter's pose.

Henry McBride considered all the paintings in the show fine though not overpoweringly convincing, "with the exception of the superb portrait of a man,"[33] whereas Royal Cortissoz condescendingly termed it "an acceptable bit of ordinary realism."[34] The most perceptive comment came from the anonymous author of the *New York Times Magazine* article; scrutinizing the features of the model, whom obviously he could not identify, he drew a surprisingly succinct portrait of Cézanne: "His big brow," he wrote, "tells you that he is intelligent, his big protruding under lip tells you that he is sensuous, his reflective glance tells you that thought controls him."[35] Wright, for his part, saw the picture primarily as an abstraction turned into a recognizable image.

> The *Portrait of a Man*, though a slight work, is worth more to the serious artist in search of information than a year at the art schools. Let him stand before this canvas and forget that he is looking at an objective portrait. Let him ignore the face and body as such, and look at it simply as a series of colour patterns. Fix the eye steadily on one spot – gradually those colour patterns will shift, contract and expand, ally themselves one to another in such a way that finally they will form a solid mass out of which will spring bumps and into which hollows will sink, all converging to make a face. With Cézanne this is the only

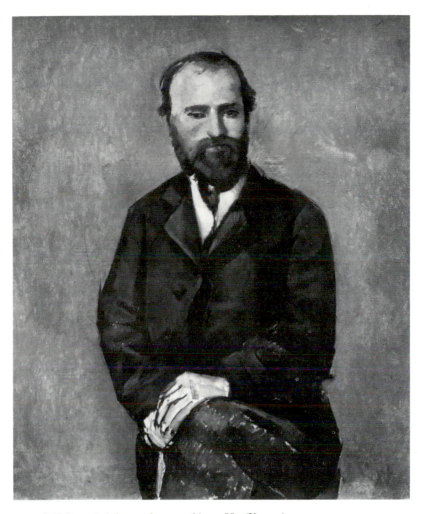

150 *Self-Portrait* (after a photograph) *c.* 1885 (V.1519)

possible method of approach. We cannot force realism from his colours at first glance, or experience his rhythm by a mental process; nor can we sense his impenetrable solidity by a recognition of natural objects. Appreciation of Cézanne is wholly a question of experiencing, passively and in spite of ourselves, the coming together of his colour planes (or coordinated forces) whose total results in reality.[36]

In his analysis of the so-called *François Zola Dam* (V.490), Wright stated: "It possessed that quality of linear depth which gives it synthetic movement. Cézanne, when sitting before nature, tried to penetrate to the motivating rhythm of his subject, irrespective of preconceived ideas as to what the rhythm should be."[37] This was contradicted by Royal Cortissoz who wrote of the same landscape: "Obsessed by some vague theory – of no earthly interest to the spectator until it is justified by results – he gropes around his ground forms and strives painfully to bring them into some sort of pictorial unity. The effort fails. The canvas is crude, unlovely."[38]

It is a fact that critics usually do not write for an indifferent readership, since people not interested in the arts do not as a rule read art criticism. Those who do, can

XIV

151 *Conversation (The Two Sisters)* 1870–71
(V.120)

152 (below) *The Roofs of L'Estaque* 1883–85
(V.405)

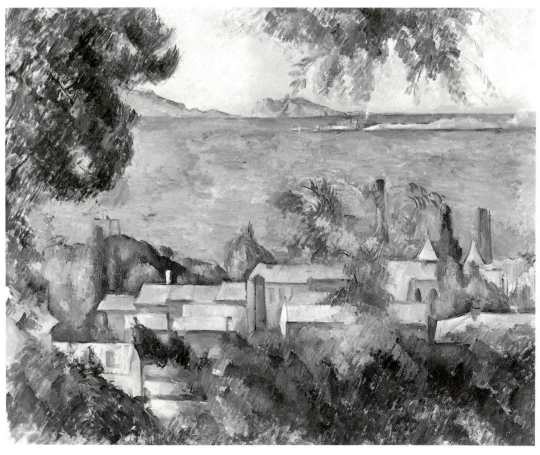

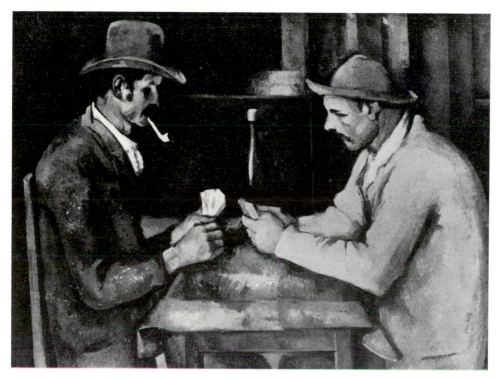

153 *Cardplayers* 1892–93 (V.556)

generally be divided into partisans and foes of each reviewer. It seems unlikely that those addicted to Cortissoz's columns would have visited the Montross exhibition, except possibly out of sheer curiosity or to find there a confirmation of their prejudices. On the other hand, whatever followers Wright may have had did not wait for the publication of his comments (which actually appeared only after the show closed) to visit the Montross Gallery and study its offerings. The history of the slow acceptance of Impressionism in France had shown that artists can make a breakthrough despite almost unanimous critical scorn, provided they have a few supporters and find opportunities to exhibit.

Cézanne was no longer a newcomer to the American art scene; he already had some fervent admirers, while those who continued to confront his work with a prudent and reluctant "yes, but" attitude (of which the "yes" was much weaker than the "but") were generally known for their reactionary views. After the outbreak of war in Europe, the public would have many occasions to study Cézanne's output regardless of blame or acclaim.

In January 1916, almost simultaneously with the Montross show, the Knoedler galleries held an exhibition entitled "Modern French Pictures," which was actually a rather incoherent assemblage of much that was not "modern." But there were also two paintings by Cézanne: yet another landscape of L'Estaque (V.405) and a *152* comparatively early painting called *The Conversation* (V.120), which may have been *151* copied from a fashion print. The L'Estaque picture was eventually acquired by Stephen Bourgeois, who subsequently sold it to a new collector, Adolph Lewisohn, whose advisor he became.

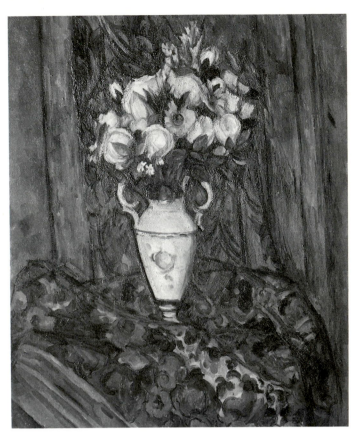

154 *Bouquet of Flowers* 1900–03 (V.757)

154, XV Meanwhile de Zayas had secured from Vollard two works by Cézanne, a *Bouquet of Flowers* (V.757) and a view of Château Noir (V.796), as well as two watercolors, which he showed at the Modern Gallery in January 1916. As de Zayas later explained, it had been no small triumph to obtain these two canvases from Vollard who sold only when he felt like it.

153 The paintings he had from one artist had to be sold chronologically according to their intrinsic importance. One had to invoke and propitiate the spirits of Machiavelli and others to help perform the miracle of getting him to sell. One had to listen and enjoy his innumerable stories of all kinds for several days. He had to be absolutely sure that the picture he sold was leaving France and he had to be paid in cash, preferably in gold, and the picture taken then and there. His methods were unshakable. It took me two years to make him decide to sell the *Joueurs de Cartes*, the largest, if not the best picture Cézanne ever painted. I had several subscribers willing to pay the price and present it to the Metropolitan Museum. The price he gave me was $15,000 with an option of one month. I offered it to the Metropolitan in the name of the subscribers, but the curator of painting told me that although they would be glad to receive the painting they could not promise to put it on exhibition as it was against the rules of the Museum. The option was cancelled. Vollard was relieved and the painting was sold that same year at a much more substantial price.[39]

De Zayas had more luck with the bouquet of flowers and the view of Château Noir he acquired from Vollard. There were extensive comments on these two canvases in

XV *Château Noir* 1900–04 (V.796)

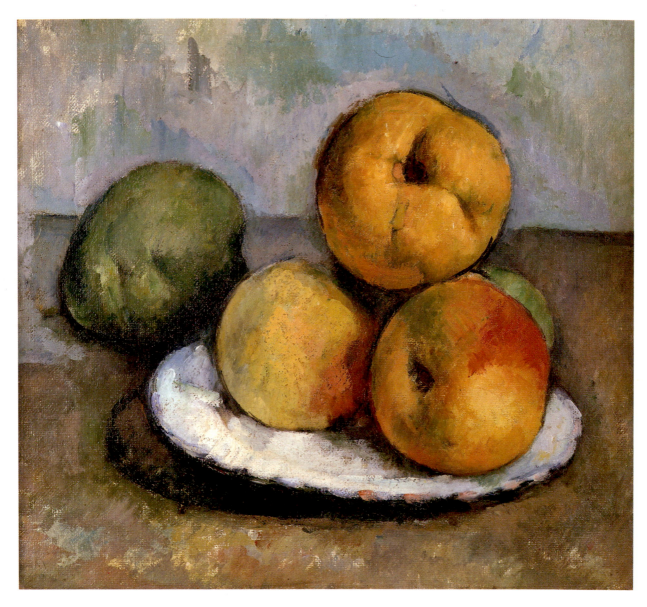

XVI *Still Life with Three Peaches* 1885–87

155 Bill of the Modern Gallery for purchases made by Eugene Meyer, New York, August 28, 1916

the press; the *Christian Science Monitor* concluded its review with the statement, "Such pictures compel a certain amount of thoughtful, studious attention, which it seems a considerable portion of the metropolitan public just now is willing to give, so all's not vanity in these sporadic Cézanne shows."[40]

Both works were acquired by Eugene Meyer for $10,000 each, plus commissions and expenses; he may also have bought one or two of the watercolors. A little later, in July 1916, Meyer purchased yet another Cézanne painting, representing an old sailor, a work which Vollard had had since before 1907.[41] It was in this connection that Meyer wrote to de Zayas: "I have been enjoying *Le Marin* this morning and wanted to tell you how glad I am to have it. Mrs. Meyer will be in town on Friday and I am sure she will be equally happy to see it."[42]

Thus, by the summer of 1916, the Meyers owned four important paintings by Cézanne, all – as it happened – from the artist's final years. It is possible that it was partly on account of his close cooperation with the banker that de Zayas had meanwhile given up all connections with Stieglitz, a decision that was almost unavoidable given their diametrically opposed viewpoints. De Zayas had now also established contact with Miss Bliss to whom he eventually sold at least two important pictures by Cézanne, one of these being an unusually large canvas of a standing bather (V.548). When, in the spring of 1916, he held another group show, of works by van Gogh, Picasso, Picabia, Braque, and Diego Rivera, he could not include any of the recently sold paintings (his purpose being to offer works that were for sale); nevertheless he was able to feature two new landscapes by Cézanne which cannot be identified. Other exhibitions followed, but by April 1918, when the United States had also been drawn into the Great War, the Modern Gallery ceased to exist.

However, such was the interest in Cézanne by then that constant efforts were being made to promote further exhibitions of his work. In February 1917, Miss Bliss had approached John Quinn with the request that he participate in a new show being prepared by the Arden Gallery. This was to be an exhibit composed of loans gathered from local collections rather than a commercial venture. Quinn's reaction was positive. "If Mrs. Havemeyer will lend her Cézannes," he replied, "and Mrs. Myers [*sic*] hers and you your two, the proposed Cézanne exhibition would be a very swell one. I am quite willing, of course, to lend my Cézanne . . . the portrait of Mme Cézanne."[43]

This time Mrs. Havemeyer relented; in recent years she had occasionally agreed to participate in exhibitions that were not geared to sales and that were either benefits for causes close to her heart, such as the Suffragist movement, or that concerned artists whose renown she wished to support, such as Degas or Cassatt. But never *16* before had she lent a work by Cézanne; she selected *The Abduction* (V.101) from the Zola estate but, as always, lent it anonymously. (It is not impossible that in this instance Arthur B. Davies served as Miss Bliss's emissary to the not easily accessible Mrs. Havemeyer.)

It does not seem that a catalog of the exhibition was issued, so its components can only be guessed at from references in various reviews, none of which mentioned any owners; this makes it likely that not only Mrs. Havemeyer, but the other lenders as well preferred to remain anonymous. What is certain is that the show featured at least nine works; four of these were still lifes: the one Miss Bliss had acquired from *148* Montross, which had originally belonged to Mary Cassatt (V.606); the bouquet of *153* flowers recently purchased from de Zayas by the Eugene Meyers (V.757); and the first still life the Meyers had bought in Europe on Steichen's insistent advice,[44] *82* which combined white crockery with a cascading brownish curtain and apples and peaches in glowing reds and yellows. The fourth still life, described as a "flower piece with fruit," cannot be identified.

XI There were three portraits: the likeness of Madame Cézanne owned by Quinn; the *83* so-called *Sailor*, the latest purchase of the Meyers; and what was described as a self- *92* portrait although it actually represented Cézanne's friend Boyer. This early painting had been lent to the Armory Show by Vollard, who may have left it in New York in the hope of finding a buyer there. It eventually returned to Paris and was acquired by Auguste Pellerin. Finally, there were two landscapes: one of these was the Meyers' *XV* *Château Noir*; the second, called *Landscape with Figures*, was *The Abduction*.

Yet there may have been other works not mentioned by the critics, such as Miss *96* Bliss's landscape (V.52) from the Enrico Costa collection already shown at the Armory Show. The truly impressive group brought together at the Arden Gallery prompted Henry McBride to comment: "The general effect is monumental and serious. . . . It really seems that the people who go about asking 'is Cézanne great?' will be able to answer the question to their satisfaction in the Arden galleries this time. They will not dare to ask the question once in the gallery, though. It would be just like listening to a Beethoven symphony and asking 'is he great?'"[45]

Willard Huntington Wright, presumably the anonymous reviewer of the *New York Times Magazine*, who had written such an excellent report on the show of the Reber collection in Darmstadt in 1913,[46] even compared the Arden exhibition with

156 *The Large Bather c.* 1885 (V.548)

that event. He was particularly impressed with *The Abduction*, the most "salient" *16*
work in the show, and described it as a "romantic early composition painted before
the artist was thirty years old and while he was still under the influence of Delacroix
.... The magnificent autumnal richness of the color, deep vibrating greens and blues
and ruddy browns, is quite without the kaleidoscopic quality that came later into
Cézanne's work. The massive structure of the elongated figure and the wide expanse
of land and sea, emphasized by the figures of the little bathers, unite in an impression
of elemental vigor."[47]

At the end of March, Quinn wrote to Miss Bliss: "I am glad I was able to
contribute in a small way to the success of the Cézanne exhibition. I thought your
Cézannes were lovely, and they were among the best, if not the best in the
exhibition."[48] That was a gracious note, indeed, but the fact is that whether or not
the press acknowledged this, the true highlight of the show had been the four late and
sublime paintings from the collection of Mr. and Mrs. Eugene Meyer.

While this was not the last time that Miss Bliss intervened actively on behalf of

Cézanne, it was the final manifestation of its kind before the end of the hostilities. Had Carrol Beckwith still been alive, he might have demonstrated irrefutably that Germany's defeat was attributable mainly to the carloads of Cubists, Futurists, and Pointillists that the Kaiser's subjects had so eagerly taken off Vollard's hands.

After the war, things slowly returned to normal. Early in 1919, Marius de Zayas informed Quinn from Paris that "modern paintings have a great demand and are rather scarce. Most of them are gone to Holland, Switzerland and Scandinavia. Art conditions are rather peculiar. . . ."[49] The great change was that the French dealers of modern art had established a solid foothold in the United States. Russia had dropped out forever, eventually selling Cézannes and other works rather than buying any; much of what was sold went to America. Holland, Switzerland, and Scandinavia did not remain active long; when the Scandinavian art market experienced a postwar slump, Walther Halvorsen from Oslo in a single day sold twenty-seven watercolors and five drawings by Cézanne to the Bernheim-Jeunes, apparently having given up all hope of finding buyers for them in Denmark, Sweden, or Norway. Germany recovered only slowly but subsequently endeavored to regain the time and occasions lost. England began gradually to develop the interest in modern art awakened by Roger Fry and his circle.

In April–May 1919, de Zayas, with Mrs. Meyer's assistance, organized another exhibition at the Arden Gallery, under the title "The Evolution of French Art from Ingres and Delacroix to the Latest Modern Manifestations." This show featured seven watercolors by Cézanne, most of them lent, but apparently no paintings. Among the new collectors whom de Zayas cultivated were notably the Walter Arensbergs, who had begun with modest purchases at the Armory Show, then befriended Marcel Duchamp during the war years and manifested an early enthusiasm for Brancusi. Although Cézanne did not fit particularly well into their collection with its strong accents on Duchamp, Matisse, and Picasso, they had acquired two small but very fine paintings by him as well as two watercolors, apparently obtained through the efforts of de Zayas.[50]

In October 1919, de Zayas resumed his activities as a dealer (temporarily, it turned out) in a new gallery that carried his own name. But by now Cézanne had reached the stature where it seemed advisable to show him in a museum exhibition, something Stieglitz had advocated even before the Armory Show. Indeed, as Henry McBride had stated in connection with the 1917 Cézanne retrospective at the Arden Gallery, "time works curious revenges. We now have Cézanne in the most exalted ranks. He is acknowledged as the most potent influence upon the art of this time. Museum directors will shortly learn who he is and what his art stands for. He enters the museums as Bouguereau quits them. Poor Bouguereau."[51]

Museum directors, among others, indeed soon learned who Cézanne was and what his art stood for. But what McBride could not possibly have predicted is that his mock expression of pity for poor Bouguereau was somewhat premature. Never would it have occurred to him that several decades later, in America as well as Europe, new generations of art historians and collectors, not to mention dealers, would dust off Bouguereau's products and – gripped by a revisionist frenzy – proclaim them neglected masterpieces deserving rehabilitation. He could not have imagined that in the last quarter of the twentieth century the saccharine faces,

vacuous smiles, custom-made bosoms, hairless pubic mounds, and rosy buttocks of Bouguereau's frolicsome nymphs, virgins, or bacchantes would be covered with gold. And yet, more than one hundred years ago, Winslow Homer had already stated: "I wouldn't so much as cross the street to see a Bouguereau. His pictures look false; he does not get the truth of what he wishes to represent; his light is not outdoor light; his works are waxy and artificial. They are extremely near being frauds."[52]

NOTES

1. Carroll Beckwith, "The Worship of Ugliness," letter in the *New York Times*, Oct. 4, 1915. On this incident see also above, Chapter IX, note 41.

2. Frederick James Gregg, "The Worship of Ugliness," letter in the *New York Times*, Oct. 8, 1915.

3. Agnes Ernst Meyer, "No Treason in Art," letter in the *New York Times*, Nov. 15, 1915. Perhaps the strangest aspect of this affair was the fact that in those days there was at least one highly educated and articulate American – Willard Huntington Wright – who managed to combine a profound admiration for the Kaiser with a sincere appreciation for Cézanne. It is doubtful, however, that His Imperial Majesty ever reciprocated these feelings; the German Emperor is known to have had the lowest possible opinion of the painter and, in all likelihood, he thought, if anything, even less of Wright.

4. Anonymous, "Pennell Hits 'New Art,'" *American Art News*, Jan. 1, 1916 (report on an article dismissing the views of C. Beckwith and of A. E. Meyer that had appeared in the *New York Times*).

5. Eugène Blot, *Histoire d'une collection de tableaux modernes* (Paris: Editions d'art, 1934), pp. 75-76.

6. See the exchange of letters of May and June 1914 between Marius de Zayas and Alfred Stieglitz in Chapter IX above, notes 32, 33.

7. A. Stieglitz to M. de Zayas, [New York], July 7, 1914; Stieglitz Archive, Beinecke Rare Book and Manuscript Library, Yale University. This unpublished document was brought to my attention by Francis M. Naumann.

8. M. de Zayas, "How, When, and Why Modern Art Came to New York," ed. Francis M. Naumann, *Arts Magazine*, April 1980, p. 116.

9. Ibid., p. 117.

10. M. de Zayas to A. Stieglitz, [New York], Aug. 27, 1915; Stieglitz Archive, Beinecke Rare Book and Manuscript Library, Yale University. This unpublished document was brought to my attention by Francis M. Naumann.

11. M. de Zayas, "How, When, and Why," p. 116.

12. Ibid., p. 117.

13. Ibid., p. 117.

14. Ibid., p. 117.

15. Anonymous, *New York Evening Post*, Nov. 20, 1915; see also M. de Zayas, "How, When, and Why," p. 117.

16. The eight paintings by van Gogh were listed as *Berceuse*, *Les Baux*, *Nuages*, *Niege* [*sic*, for *Neige*], *Vase de soleils*, *Fleurs-Lilas*, *Hollandaise*, and *Les Harengs*. It is not known which Paris dealer consigned these works to de Zayas (it may have been Barbazanges), nor whether any of them found buyers.

17. *New York Evening Post*, Nov. 20, 1915; see also M. de Zayas, "How, When, and Why," p. 117.

18. Judith Zilczer, "'The World's New Art Center': Modern Art Exhibitions in New York City, 1913–1918," *Archives of American Art Journal*, 1974, p. 4.

19. F. J. Gregg, "Paul Cézanne – At Last," *Vanity Fair*, Dec. 1915, p. 58.

20. Anonymous, "The Cézanne Show," *Arts and Decoration*, Feb. 1916, p. 184.

21. The Bernheim-Jeune list of loans with their titles and insurance values is written entirely in Fénéon's hand.

22. Max Weber, "Cézanne Water Colors," *Cézanne*, catalog of the Cézanne exhibition, Montross Gallery, 550 Fifth Avenue, New York, Jan. 1916.

23. Henry McBride, "Cézanne," *New York Sun*, Jan. 16, 1916; reprinted in H. McBride, *The Flow of Art*, ed. D. C. Rich (New York: Atheneum, 1975), p. 98.

24. Anonymous, *American Art News*, Jan. 8, 1916, p. 2.

25. Ibid.

26. F[rank] J[ewett] M[ather], Jr., "Paul Cézanne," *The Nation*, Jan. 13, 1916, pp. 57–59.

27. On the Cortissoz-Huneker exchange, see Chapter IX above, notes 34, 35.

28. Royal Cortissoz, exhibition review, *New York Tribune*, Jan. 9, 1916.

29. Anonymous, "A Representative Group of Cézannes Here," *New York Times Magazine*, Jan. 2, 1916, p. 21.

30. Willard Huntington Wright, "Paul Cézanne," *International Studio*, Feb. 1916, p. CXXX.

31. Information courtesy of the Bernheim-Jeune gallery archives, Paris.

32. For a comparison of the painting and the photograph, see Fritz Novotny, *Cézanne und das Ende der wissenschaftlichen Perspektive* (Vienna, Anton Schroll, 1938), figs. 48, 49.

33. H. McBride, "Cézanne," p. 96.

34. R. Cortissoz, exhibition review, *New York Tribune*.

35. Anonymous, "A Representative Group of Cézannes Here."

36. W. H. Wright, "Paul Cézanne."

37. Ibid.

38. R. Cortissoz, exhibition review, *New York Tribune*.

39. M. de Zayas, "How, When and Why," p. 100.

40. Anonymous, exhibition review, *Christian Science Monitor*, Feb. 5, 1916, quoted by M. de Zayas, ibid., p. 101.

41. On Vollard's handling of this painting see Chapter VII above, pp. 159–161.

42. Bill and letter from M. de Zayas to Eugene Meyer, Jr., and from E. Meyer, Jr. to M. de Zayas, New York, July 12, and Aug. 28, 1916. Unpublished documents, courtesy Mrs. Pare Lorentz, née Meyer, Armonk, N.Y. (see fig. 155.)

43. John Quinn to Lillie P. Bliss, [New York], Feb. 23, 1917; see J. Zilczer, "John Quinn and Modern Art Collectors in America, 1913–1924," *The American Art Journal* (Winter 1982), p. 61. Quinn's mention of Miss Bliss's *two* paintings by Cézanne – if it was accurate – would mean that at that time she only owned the landscape purchased from the estate of Costa (V.52) and the still life (V.606) recently acquired from Mrs. Montgomery Sears at the Montross exhibition. (The show did not comprise watercolors, of which Miss Bliss owned several.)

44. On this painting see Chapter VII above, p. 158.

45. H. McBride, "News and Comment in the World of Art," *The Sun*, March 4, 1917.

46. On this article see Chapter IX above, note 10.

47. Anonymous [Willard Huntington Wright], exhibition review in the *New York Times Magazine*, March 4, 1917.

48. J. Quinn to Miss L. P. Bliss, [New York], March 28, 1917; see J. Zilczer, "The World's New Art Center," p. 61.

49. M. de Zayas to J. Quinn, [Paris], Feb. 14, 1919; ibid., p. 64.

50. The paintings are not recorded by Venturi. For the watercolors see J. Rewald, *Paul Cézanne – The Watercolors* (London and Boston: Thames and Hudson and New York Graphic Society, 1983), nos. 233 and 581.

51. H. McBride, "Important Cézannes in Arden Galleries," *The Sun*, March 4, 1917.

52. Winslow Homer quoted by George W. Sheldon, *Hours with Art and Artists* (New York: D. Appleton, 1882), p. 114; see *In Support of Liberty: European Paintings at the 1883 Pedestal Fund Art Exhibition*, ed. Maureen C. O'Brian (The Parrish Art Museum, Southampton, New York, and the National Academy of Design, New York, 1986), p. 66.

XIV · Cézanne in the Most Insulted and Exalted Ranks

AFTER Henry McBride's assertion in 1917 that Cézanne was by then "in the most exalted ranks," apparently little remained to be done to improve that position. Yet the enemies of all modern art were by no means ready to concede defeat. Once peace had been restored and they were free of more urgent preoccupations, they resumed the attack. Although Cézanne's work was seldom directly involved in these renewed controversies, it was considered to be the root of all evil, even when the brunt of disapproval was borne by the production of such younger men as Picasso and Matisse. Nevertheless, in spite of overt hostility from certain quarters, a considerable share of the increased activity observed on the cultural scene in the postwar years could be attributed to Cézanne. Thus, his stature continued to grow in America, and considering Cézanne "in the most exalted ranks" was no longer confined to a few avant-garde artists and intellectuals.

One highly significant piece of evidence that affirmed this elevated position was to remain a secret for another decade. Mrs. Henry O. Havemeyer, who, in a will of 1917, had left all her belongings to her three children, on July 24, 1919, wrote a codicil in which she designated, among many other works, four extremely important paintings by Cézanne as a bequest to the Metropolitan Museum of New York. These were *Portrait of Boyer in a Straw Hat* (V.131); *Still Life with Green Jar and White Cup* (V.213); *The Gulf of Marseilles Seen from L'Estaque* (V.429); *Mont Sainte-Victoire with Viaduct* (V.452). To these Mrs. Havemeyer's son Horace eventually added a fifth painting, *Rocks at Fontainebleau* (V.673). This would give the museum a considerable head start among American public institutions, although Dr. Albert Barnes – who did not hide his admiration for the Havemeyer collection as a whole – by then would own more of Cézanne's works than the Metropolitan Museum can count among its holdings even today.

Early in 1920, the Montross Gallery mounted yet another exhibition of Cézanne watercolors. The press was once more divided between those who considered the offerings "too slight" and those who admired the artist's sublime command of his craft and his medium, on which, as one anonymous critic noted, "a lifetime of experience, observation, thought, and feeling had been spent."[1] What was new, however, were reviews that claimed long-standing admiration, such as, "Cézanne was a genius in organization, that has been admitted so often in recent years that already it has become a truism; he was the most plastic of painters, that also has been known for a generation, and that he is a master in the use of his materials."[2]

24, 157
69, 70

158

Under these circumstances it seemed only natural that Cézanne should be shown at last in a major American institution. If New York was not yet ready for such a step, Philadelphia wwas, even though the Pennsylvania Academy of the Fine Arts was known for its resistance to new trends. Nevertheless, on April 17, 1920, the academy opened aa large exhibition entitled "Paintings and Drawings by Representative Modern Masters." It was a truly ambitious undertaking, comprising altogether some two hundred and sixty works, although many of these were lithographs and etchings. The show was assembled by the painter Arthur B. Carles (who had studied in Paris) and an equally brave committee. The exhibition spanned most of the nineteenth century from Daumier and Courbet to Degas, Manet, Monet, Morisot, Cassatt, Renoir, Pissarro, and Cézanne, extending to include Gauguin, Toulouse-Lautrec, Matisse, Picasso, and Braque, and even de La Fresnaye, Gleizes, Laurencin, and a few other minor artists. Although the title of the event did not say French Masters, nearly all the painters included were French, with the exception of Mary Cassatt who, while considering herself a Philadelphian, lived in France, as did the Spaniard Picasso. There were also three works by the American Synchromist Stanton Macdonald-Wright.

The lenders were made up of private collectors and a few dealers, among whom Durand-Ruel and Marius de Zayas were represented by the greatest number of loans (de Zayas lent many lithographs by Toulouse-Lautrec, while Mrs. J. Gardner Cassatt contributed an extensive series of Cassatt's etchings). Other lenders were the Philadelphia painter Carroll S. Tyson, Jr., who subsequently assembled an important group of paintings by Cézanne as well as other outstanding French nineteenth-century pictures; Adolph Lewisohn (Stephen Bourgeois's new client); and Alfred Stieglitz, who provided notably a number of drawings by Matisse. A startling innovation was a brief introduction in the catalog by Leopold Stokowski, then conductor of the Philadelphia Orchestra.

"It is curious," he wrote,

> that while the music of Debussy, Strauss, Skryabin, Stravinsky, and Schoenberg is known and accepted in Philadelphia as of great aesthetic value, the paintings of Seurat, Renoir, Cézanne, Degas, Picasso and Matisse, outside of a few connoisseurs, are unknown or ridiculed. And yet in the art-centers of Europe it is a received opinion that both the above groups of painters and composers have simultaneously developed in new and often similar directions of deep and lasting significance. Will Philadelphia realize this? It is important intrinsically, and also because a new school of painters is arising in America which is penetrating still farther in the direction taken by such masters as Cézanne, Picasso and Matisse. It would be a great national loss if these should be unrecognized in their own country.[3]

The significant fact of these few lines is that Stokowski named Cézanne in the same breath with Picasso and Matisse. While the last two were alive and in the prime of their activity, Cézanne was, at least by his dates, essentially a painter of the past century who had barely managed to slip into the present one (whereas Degas and Renoir had only recently died and Cassatt and Monet were still among the living). Yet, it was Cézanne who was increasingly perceived as an artist of the twentieth century, because his posthumous influence had become so great that he had a determining share in whatever was being created after him.

157 *Still Life with Green Jar and White Cup c. 1877 (V.213)*

158 *Rocks at Fontainebleau 1893–94 (V.673)*

159 *Pines and Rocks (Fontainebleau?)* 1896–99 (V.774)

Cézanne's representation at the exhibition was substantial: three landscapes, two
lent by Miss Bliss (*Turning Road* [V.52] and *Pines and Rocks* [V.774]), the other by de
Zayas (probably *Houses in Provence* [V.397]; two still lifes, one lent anonymously, the
other by Walter C. Arensberg; one small composition of bathers, also lent by
Arensberg;[4] four watercolors, all lent by Miss Bliss, among them *Bathers*
(RWC130), *Rocks near the Caves above Château Noir* (RWC435 or 436), and *Bathers
under a Bridge* (RWC601); there were also two lithographs, one lent anonymously,
the other by Alfred Stieglitz. At the last minute Mrs. Eugene Meyer lent her still life
with crockery as well as her bouquet of flowers. These two loans had to be cataloged
separately, but there can be no doubt that they added tremendously to the artist's
impact. This time, it seems that John Quinn did not lend his portrait of the artist's
wife.

96, 159

161

160

162, 164

160 *Still Life with Fruits and Wine-glass* 1877–79 (fragment)

161 *Houses in Provence* 1878–82 (V.397)

162 (above) *Group of Bathers* 1892–94

163 (left) *Bathers* 1885–90 (RWC.130)

164 (below) *Bathers under a Bridge c.* 1900 (RWC.601)

The exhibition was hailed as "a milestone in local art affairs. It is the first formal recognition by the academy of the fact that in the past twenty years there have been definitely new tendencies, new ideas, new forms in the art of painting."[5] The author of these lines noticed particularly "a landscape and two rich and beautiful still lifes by Cézanne which will give pause to those of us who are apt to think of him as simply anarchistic."[6] Another reviewer singled out "a rich, passionate landscape dramatic in character and full of mood and brooding mystery."[7] It is impossible to identify this painting, though it may have been Miss Bliss's *Turning Road* (V.52).

96

Despite favorable reviews, however, the show was neither truly selective nor well coordinated, although it is likely that because of the newness of the venture its lack of balance and other shortcomings went unnoticed. That Mary Cassatt, the "local" artist, was allotted nineteen paintings and even more etchings cannot surprise, yet was it logical that Berthe Morisot should be shown with a single work? Pissarro, too, was represented by a lone canvas whereas – partly thanks to Durand-Ruel – Renoir's contribution comprised seven paintings, as many lithographs, and one pastel. The three Synchromist pictures by Stanton Macdonald-Wright did not really fit with the other loans. Corot, Sisley, van Gogh, Seurat, Bonnard, Vuillard, and Gris, among others, were not included at all.

Shortly after the Philadelphia show opened, New York's Metropolitan Museum celebrated its fiftieth anniversary with an exhibition composed of loans from private collections in and around New York as well as of works from its own collections. It took place in May 1920 and was fairly modest in scope; such consistently generous lenders as Miss Bliss, Adolph Lewisohn, William Church Osborn, and John Quinn contributed two paintings each. Cézanne was represented by Mrs. Eugene Meyer's *The Old Sailor* and Quinn's portrait of the artist's wife (which may explain why it did not appear in Philadelphia). One of the reviewers used the occasion to point out the progress that had been made since the Armory Show:

83, XI

> It is important . . . to consider to what an extent the Museum reflects the contemporary spirit, the art of the age that the present generation is living in. Take the men of the modern school of painting as they are represented on this notable occasion! Barely seven years ago Cézanne, Van Gogh, Gauguin and Redon were less than so many names – rather shadows of names to the majority of New Yorkers who were interested in the fine arts. Today their works are in the company of the canonized immortals. But after all in extending the hospitality to the post impressionists the Museum is but continuing an American tradition. For long before the French had ceased to quarrel among themselves about Manet and Monet, Degas and Renoir and the other impressionist leaders, their pictures had found their way into the houses of persons who were to prove themselves real friends and benefactors of the Metropolitan. There is no finality in art any more than there is in science.[8]

Yet the native tradition of hospitality did not always reign over the art world. This became painfully clear when the Philadelphia Academy, emboldened by the success of its 1920 show, followed it up in 1921 with an all-American exhibition of modern paintings, as though it had taken to heart Stokowski's admonition that there was a new school of art arising in America that should not go unrecognized. This second show assembled works by Thomas Hart Benton, Arthur B. Carles, Walt Kuhn, Joseph Stella, Alfred Stieglitz, and others. It was this exhibition of contemporary

American artists that unleashed an outburst of public indignation. "Artistic Bombshell Exploded in the Stronghold of Conservatism," *The Philadelphia Record* informed its readers,[9] while *The Public Ledger* announced: "Art that Looks Crazy on Display."[10] But the real bombshell exploded two weeks later, when the *Ledger* explained why the works looked "crazy," referring to a report on the findings of a number of physicians who felt called upon to apply their professional qualifications to the appreciation of art. It was a grotesque performance, blown up to gigantic proportions by the press.

Essentially, these newly minted experts endeavored to demonstrate that much of what passed for art in modern galleries was the product of imperfectly balanced minds. According to the report written by one Harvey M. Watts for the University of Pennsylvania's *Weekly Review* and widely reprinted,[11] a group of physicians publicly discussed at a meeting of the Philadelphia Art Alliance the sanity of the exhibitors. Among the participating doctors were Charles W. Burr; Francis X. Dercum, the alienist who was called into consultation on the breakdown of President Wilson; J. Madison Taylor, long a student of individuals given over to illusions and delusions; and W. B. Wadsworth, a well-known pathologist, who had studied the extremists (!) in Paris as early as 1909. They discussed candidly and at length what might be called adolescent degradation of the fine arts as revealed in the so-called expressions on the walls of the academy.

Dr. Wadsworth's talk was entitled "Abnormality in Art" and contained technical discussions of those who were defective in vision and were unable to see color and form clearly, of whom he noted six types in the exhibition. But if he named the artists who demonstrated these deficiencies, the press did not reveal their identities. Studying the pictures as a clinician, he also found that they represented those "ghastly lesions of the mind and body which usually land people in the hospitals and in the asylums," but sometimes, as he expressed it, permit them to "walk around, feed themselves, avoid a commission in lunacy, and paint."[12]

Dr. Burr's paper, "Evils of False Art," recorded much that he found degenerate, creating – or intended to create – unhealthy feelings of pleasure in the diseased onlooker, and that an artist with a healthy soul would not have painted. Also, he found pretense and fraud in some of these artists, who, not knowing real art, lacking the soul and the handicraft, had become "quacks." Speaking of the modern critics who defend this art, Dr. Burr noted that some of their literature "is of little more use as an intellectual illuminant to guide the stumbling steps of the eager seeker for truth than the phosphorescence of the fish is to illuminate the world."[13]

Dr. Dercum, a specialist in mental diseases, said about the exhibition after mentioning a number of extraordinary examples: "I can only infer that, in a large degree, the pathological element enters into these paintings and drawings, both in the representation of colors and of the forms. I can not draw any other conclusion. I believe, also, that a certain number of the people who paint these curious pictures are merely shallow tricksters who try to achieve prominence by coming in on the wave and floating into the public eye, getting some sort of reputation which they could not get by legitimate hard work."[14]

Two other noted alienists of Philadelphia also spoke at the meeting. They, too, had studied the incriminating pictures, but one of them had even closely examined

two of the exhibitors without their knowing that they were being observed by a psychiatrist. "It is needless to say," Mr. Watt's report concluded, "that these two specialists agreed with their associates." It also seems needless to say that none of these experts was questioned about his knowledge of art, and that it was never established whether they were able to distinguish a Botticelli from a Bouguereau. More important still, nobody tried to find out what the conclusions of a painter might have been, had he closely examined two psychiatrists from the city of Brotherly Love without their knowing that they were being studied by an artist.

In truth, however, nothing in the doctors' findings was new or original; they had been aired over the years on many occasions in France and later in England as well as in America where antagonists of modern art had frequently used similar arguments for their untiring attacks.

The year 1921 was fated to be a time of many signal events. In February the Wildenstein Gallery opened an important exhibition of "Impressionists from the Collection of M. Paul Rosenberg of Paris." (In those days, Wildenstein and Rosenberg were associated, the former handling Old Masters and the latter specializing in modern art.) Rosenberg included six paintings by Cézanne in his "collection." That same month, before the Pennsylvania Academy opened its controversial exhibition of contemporary American art, the Brooklyn Museum had been host to a group of works displayed under the title "Paintings by Modern French Masters Representing the Post-Impressionists and their Predecessors." It was a rather strange show that ran for only one week, from February 8 to 14. Its nucleus consisted of fifty-nine pictures from the private collection of Dikran K. Kelekian, a respected Paris-based dealer of Near Eastern antiquities among whose clients were a number of Americans such as Charles Freer and Henry O. Havemeyer; he was also on very friendly terms with Mary Cassatt. Kelekian's personal collection ranged from Corot, Courbet, Daumier, and Delacroix to Degas, Pissarro, Manet, Cézanne, Renoir, Gauguin, and Toulouse-Lautrec; it even included works by Vincent van Gogh, Bonnard, and Vuillard, with an especially strong representation of Matisse and Picasso. All these works had been selected with great discrimination, and the canvases by Cézanne constituted a particularly oustanding group.

It would seem that Kelekian was already thinking of auctioning off this collection in New York. He may have been dissatisfied with the brief showing at the Brooklyn Museum. After its closing he increased his loans from fifty-nine to the impressive total of one hundred thirty-five works, while also prevailing on two dealers in Zurich, Gustav and Leon Bollag, to participate in a revamped exhibition at the same museum. They consequently sent sixteen pictures to New York, among them one painting each by Corot, Courbet, Sisley, Signac, and Vlaminck, two canvases by Matisse, three by Renoir, and a pastel by Gauguin, in addition to two oils and three watercolors by Cézanne. One of the Cézanne paintings was a small canvas of a standing bather with outstretched arms (V.544) that had previously belonged to *165* Degas and was somewhat related to the large picture of a bather that Miss Bliss had acquired from de Zayas (V.548). Gustav Bollag even came to New York, but he was *156* unable to sell anything except a painting by Renoir for $5,000. The remaining Bollag loans were shipped back to Switzerland.

165 *Bather with Outstretched Arms*
1877–78 (V.544)

What was peculiar about the second, extended Brooklyn exhibition which ran through the month of April was not only the overwhelming participation of Kelekian, but also that the critic Hamilton Easter Field could announce in the *Brooklyn Eagle* that "the first step has been taken. An important American museum has opened an exhibition of modern French art which is really representative of modern tendencies. That the museum is our own Brooklyn Museum is a cause for pride."[15] Since the Pennsylvania Academy had opened its exhibition exactly one year earlier, this was not quite true, although it could be argued that the Philadelphia institution was not exactly a museum. In any case – and Field did not disguise this – the Metropolitan Museum of New York would soon follow suit. Yet, as he saw it, "Brooklyn has led the way. . . . The show is a splendid one," he wrote. Its beauty, he specified, "is due largely to the quality of the paintings by Matisse, by Picasso, and by Cézanne. They alone would give distinction to any exhibition."[16]

The critic of the *American Art News* specifically discussed three masterworks by Cézanne: "'Landscape in Provence' [V.472], thrilling in its simplicity of blues and greens warmed by reds and orange and its big airy quality. There is no extravagance in it, neither is there in the rich but refined 'Sketch – Four Peaches' [V.614], and the large and acridly beautiful 'Still Life' [V.736]."[17] But the magazine also declared that the Metropolitan Museum was arranging, at the very same time, an "even more comprehensive display of 'Modern French Paintings' which will include forty selected examples from the Kelekian collection along with representative works from other distinguished sources."[18]

The origin of the large "Loan Exhibition of Impressionist and Post-Impressionist Paintings" which opened at the Metropolitan Museum on May 3, 1921, and ran until September 5, can be traced to a letter addressed to Robert W. de Forest, the

166
167
168

166 *Provençal Landscape* 1892–95 (V.472)

167 *Four Peaches on a Plate* 1890–94 (V.614)

168 *Still Life with Apples* 1895–98 (V.736)

president of the museum's board of trustees. Dated January 26, 1921, and signed by Agnes E. Meyer, Paul Daugherty, John Quinn, Lillie P. Bliss, Gertrude V. Whitney, and Arthur B. Davies, it read:

> Being deeply interested in having at the Metropolitan Museum a special exhibition, illustrative of the best in modern French art, and believing that interest in such an exhibition would be shared by a large public, we would like to call your attention to the fact that there are now available for this purpose unusually fine examples of the work of Degas, Cézanne, Renoir, Gaugain [sic], Monet, Derain, and others.
>
> We should be glad to co-operate, as far as we can, if it be deemed advisable by the Museum, in securing the loan of these paintings. In our opinion it would be desirable that an exhibition of this nature should open, if possible, not later than April 15th, continuing at the discretion of the Museum authorities. Hoping for your favorable consideration of the project, we remain . . .[19]

When, in 1911, Alfred Stieglitz had suggested that the Metropolitan Museum show works by Cézanne and van Gogh,[20] there had been no reaction, but less than a decade later the situation had changed (and Stieglitz was not even asked to add his name to the list of signatories). It may well have been that Bryson Burroughs, curator of paintings at the Metropolitan Museum, had already hoped for an exhibition of modern French paintings; if so, the letter signed by prominent New Yorkers could have provided him with a welcome opportunity to take action. He soon discovered that there were collectors eager to collaborate, among them not only the authors of the letter, but also Mrs. Henry Payne Bingham, Walter Arensberg, and Adolph Lewisohn. Since the museum would not show works owned by dealers, Kelekian as well as de Zayas agreed to a subterfuge: they lent their pictures anonymously. But so did certain private collectors, among them Miss Bliss (who sometimes let her name be used and sometimes not) and Mrs. Havemeyer, who had begun to adopt a more cooperative attitude toward loan exhibitions, although this time she lent only a single canvas, by Courbet.

John Quinn, as always, enthusiastically supported the project, offering Burroughs advice about selections to be made from his own collection. Yet, he protested in vain the omission of examples of Picasso's Cubist work and, despite his insistence on sending a still life of apples by Matisse to the museum, he did not succeed in having it hung in the galleries.[21]

Robert W. de Forest himself seems to have given only halfhearted support to the exhibition. The *American Magazine of Art*, published by the American Federation of Arts of which he was also president, chose to head its June 1921 issue with an unsigned article that deplored the absence of charm in modern art. "Great art," it proclaimed, "is spontaneous and is called into existence by the ripeness of the time. 'Modern Art' is for the most part a self-conscious effort and though it may reflect life, it does not reflect it at its best, and its tendency is to depress rather than to uplift, to cause stagnation rather than forward movement, to pull down rather than to build up. An art without charm! An art stripped of that peculiar quality which makes it most worth while."[22]

"Charm" was thus proclaimed as the criterion of true art, despite the fact that such a vague concept could only create confusion rather than illuminate the arduous problem of quality in art. For if it were applied rigorously, Greuze and Boucher

169, 170 Installation photographs of the "Loan Exhibition of Impressionist and Post-Impressionist Paintings" at the Metropolitan Museum, New York, 1921

would have to be declared greater masters than Caravaggio, Rembrandt, or El Greco, to name but a few of the countless giants who had never wasted a single instant worshiping at the altar of the fickle goddess of charm. Yet it was doubtless the absence of charm that prompted the Metropolitan Museum to exclude Picasso's Cubist paintings from the forthcoming show. How this was done will probably never be known, except that internal battles must have been waged around this thorny issue. Indeed, it cannot be an accident that Bryson Burroughs, in his introduction to the catalog of the show, would write – in a kind of indirect apology and rebuke – concerning Picasso, "the most famous of his manifestations is cubism, of which no example is included in this exhibition."[23]

But even without Cubist works the show presented such a radical departure from what the Metropolitan Museum usually considered worthy of being presented to its visitors, that Burroughs felt compelled, before the exhibition opened, to provide an explanation and even some disclaimers. "The art of Cézanne, Gauguin, Van Gogh, and the others who follow them has been subjected to most extravagant praise on the one hand and most extravagant abuse on the other – there has been practically no mean position between these two extremes. In response to a wide general interest in the matter and to a particular request of a group of collectors and artists ... the coming exhibition has been undertaken." He continued by stating that the show was organized strictly for the purpose of exemplifying the development of the modern styles and that the representation of such artists as Monet, who "is already well known and recognized here in New York," would be proportionately small. By

contrast, Cézanne, "the battle cry of the enthusiasts," would benefit from a large showing since "practically all of his pictures which are available will be exhibited."[24]

There would be no fewer than twenty-four paintings by Cézanne, as compared to twelve each by Renoir and Degas, ten by Gauguin and also Redon, and nine by Matisse. All the works, a total of one hundred twenty seven, would be assembled in one large, skylit gallery, hung in two crowded rows (this compression was the only negative aspect of the event). The general level of quality was extraordinarily high, partly because the selection had been guided by the strictest principles, but partly also because so many New York collectors had within recent years acquired superb works. This was a startling revelation if one considered that at the time of the Armory Show – merely eight years before – there had not been a single Redon in America, nor any work by Seurat, whereas Adolph Lewisohn now lent not only Seurat's study for *A Sunday Afternoon at the Grande Jatte*, but also one of Gauguin's most important paintings, *Ia Orana Maria*, and a L'Estaque landscape by Cézanne (V.483). Another highly significant Tahitian canvas by Gauguin was lent by William Church Osborn. Had there still been any need to demonstrate that the Armory show had opened up America to modern art, there could have been no better proof than the array of masterpieces the Metropolitan Museum was able to assemble in 1921. The museum itself, however, was not yet very rich in this area. Next to several major works by Manet and the large Renoir that Roger Fry had purchased (*Madame Charpentier and Her Children*), it still owned only a single Cézanne, *The Hill of the Poor*, selected from the Armory Show. However, the museum chose not to include

169, 170

IX

any of its own pictures in the exhibition, preferring to present the public with an impressive group of little-known or even unknown paintings from (mostly) private collections.

Since Bryson Burroughs had insisted that the show did not aim at being a strictly historical survey, he tried to provide a condensed account of the evolution of modern art in his catalog introduction, while simultaneously endeavoring to gear his text to the special aspects of the exhibition. This led him to devote considerable space to Cézanne. "The dominating force in today's development is the great and mysterious figure of Cézanne," he wrote. "His early tastes were romantic and baroque; he resembled Daumier and, like him, delighted in . . . contrasts of lights and heavy black shadows in the manner of . . . Caravaggio, Ribera, and the Carracci. Later he displayed a certain likeness to Tintoretto; his pictures of the nude have something of the nervous statement of the drawings of the great Venetian, while his spiritual analogy to Greco, that other late manifestation of a powerful tradition tired of robust natural forms and demanding a new expression in their distortion, has been frequently noted."[25]

After briefly discussing Pissarro's influence on Cézanne, whom he credited with "the most personal expression of the nineteenth century," Burroughs even touched upon Cézanne's relationship to Salon art, a rather ticklish subject, since among the trustees and members of the museum there were still quite a few whose expensive lack of taste preferred Rosa Bonheur to Bonnard. "The age was heartily tired," he explained,

> of the output of the [official] school of Art. The number of useless pictures often of great technical competence, produced each year in Paris alone, was appalling. Thousands of these covered the walls of each exhibition gallery; great size, sensational subject, astonishing virtuosity, anything was resorted to for the purpose of attracting attention. Disgusted people turned away from it all and discovered Cézanne. His pictures, moderate in size, of simplest motive and hesitating workmanship, make no pretense. They only record the sensations of a single-minded, very sensitive painter before the sunlight on an ordinary house with a bare hill back of it, or the tired commonplace head of a woman against a nondescript wall, or some fruit on a dish. His fresh, lovely color, his haunting sincerity, his readily grasped arrangements were hailed as the manifestations of a regeneration of art, and the aesthetes found delicious stimulation in his wayward distortions of natural forms and in his choppy and abrupt brush strokes.[26]

Some of these observations may sound like simplistic and awkward compliments, but their somewhat reticent praise did not really matter too much as long as Cézanne's work dominated the exhibition. And his paintings could demonstrate, better than any explanation, the nature of his originality as well as how he had pursued his goal, alluded to by Burroughs in quoting the artist's famous statement that he wished "to make of Impressionism something lasting, like the art in the museums." Never in America had there been so many works by Cézanne assembled in one room, and while the catalog did not list all twenty-four in chronological order, an effort had been made to give most of them approximate dates, so that the interested visitor could try – to some extent – to follow the painter's evolution.

There were two early works, part of the decorations of the Jas de Bouffan that had recently been detached from the walls (after the French government had refused to

171 *Portrait of Uncle
Dominique c.* 1866
(V.73)

accept them as gifts). Both were lent anonymously by Marius de Zayas (V.109 and
111), who also lent a powerful and startling portrait executed with a palette knife
(V.89). This last would eventually be acquired by Miss Bliss who already owned five
canvases by Cézanne, all of them in the show; one of these was the majestic still life *148*
that had once been Mary Cassatt's (V.606), another was a late still life with a ginger *172*
jar (V.738). John Quinn lent his portrait of Mme Cézanne (V.229) and Kelekian lent *XI*
another (V.526). Among the latter's loans was a splendid late still life that would also
enter the Bliss collection (V.736). In addition, Kelekian was represented by the
colorful Provençal landscape (V.472) which had already attracted attention at the *166*
Brooklyn exhibition. Altogether, Kelekian lent four paintings by Cézanne and de
Zayas lent six. The highlights of the Cézanne group were doubtless Miss Bliss's large
Bather (V.548), representative of Cézanne's middle years, and the four late paintings *156*
from the Meyer collection (listed, as always, as lent by Mrs. Eugene Meyer, Jr.).

 The exhibition was fairly well received. Hamilton Easter Field (who also was a
lender) commented in *The Arts*: "The show is amazing. It is not as well hung as the
Brooklyn exhibition was. The gallery is not so well adapted for the purpose. That
does not prevent the show from being amazing ... there has probably never been a
finer public exhibition of modern French art in the world."[27] The reviewer for the
American Art News, while predicting that the show was "sure to arouse bitterness
and enthusiasm," added: "Its importance to the art world is two fold – first, from the
fact that it affords the best basis for an estimate of Post-Impressionism that the
country has yet had; second, from the recognition of Modernism by a great
institution like the Metropolitan Museum."[28]

172 *Still Life with Ginger Jar, Sugar Bowl, and Oranges* 1902–06 (V.738)

It was shortly after the exhibition of the Metropolitan Museum had opened that the Philadelphia alienists unleashed their "scientific" attack on modern art. From one day to the next all the press seemed to be interested in was the mental health of any painter who could be considered "controversial." But worse was still to come. Early in September, a few days before the New York exhibition was to close, pamphlets were mailed out by A Committee of Citizens and Supporters of the Museum, which addressed to its fellow citizens a virulent *Protest Against the Present Exhibition of Degenerate "Modernistic" Works in the Metropolitan Museum of Art*. And the uproar started all over again.

"There are three prime stimuli responsible for the so-called 'Modernistic' cult in the Arts," the anonymous statement averred.

They are:–

First – the World wide *Bolshevist propaganda*. This aims to overthrow and destroy all existing social systems, including that of the Arts. This "Modernistic" degenerate cult is simply the Bolshevic philosophy applied in art. The triumph of Bolshevism, therefore, means the destruction of the present esthetic system, the transposition of all esthetic values and the deification of ugliness. . . . The Bolshevists would open the gates of the Temple of Art to the mentally lame, halt and blind of the human race. And, it is evident that one of the *Salient* features of the present exhibition is its direct appeal to, and assertion of, the Bolshevic philosophy – in art. Is it possible that the Trustees of the Museum intended to permit its magnificent galleries to be used for this purpose?

The Second moving force back of the "Modernist" movement in art is *human greed*.

The whole propaganda of the "Modernistic" art movement is a negation of common sense, and was *organized* by a coterie of European Traffickers in fraudulent art; but the real cult of "modernism" began with a small group of neurotic Ego-Maniacs in Paris who styled themselves "Satanists" – worshippers of Satan – the God of Ugliness. . . .

This cult of "Satanism" appealed to a limited number of European painters and sculptors, for the most part men of no talent, and handicapped by taints of hereditary, or acquired, insanity. To this class the cult of the ugly, and obscene, became the prime stimuli of their work. From these, since the early [eighteen] sixties to the present time, there came a steady output of hideous examples of mental degeneracy in the plastic arts. It goes without saying that the work of these artists was not generally approved. Their paintings and sculptures were refused, regularly, at the exhibitions, at Paris and elsewhere, and they were flouted as men of defective mentality, or charlatans – playing for sensation. . . .

The "Modernistic" cult, in painting and sculpture, had hard sledding, until certain picture dealers came to the rescue. These art dealers in Europe, during the eighties and nineties, had worked up an enormous traffic in pictures. By the most crafty methods they had unloaded – especially in America – vast quantities of French and Dutch "pot boilers." This had reached the point of saturation. At this point a certain class of dealers saw in the "Modernistic" cult something entirely "*new*" and *novel*; so, they began, quietly to secure the output of the most freakish of the new cult. This was accomplished with a small outlay of capital, as the pictures were absolutely worthless, either as works of art, or as units of value in the picture market. Consequently, great numbers of paintings by Cézanne, Toulouse-Lautrec, Gauguin, Van Gogh, and other European artists: "Cubists," "Tube-ists," "Futurists," etc. were garnered by the enterprising dealers, and a Machiavellian campaign was organized to prepare the public, of two continents, for the unloading of these works. . . . At the same time every crafty device known to the picture trade was resorted to in order to discredit and destroy the heretofore universally accepted standards of aesthetics.

In order to conceal the *real* object of the new movement, a smoke screen was thrown out: – of a *lying* pretense of revolt against academic traditions; claims to new discoveries in aesthetic symbolism; and a departure from the visual realism of natural objects: – this last being a valuable asset, in the propaganda, for it excused the ghastly mutilation of natural forms and transposition of perspectives and color values so much in evidence in the works of this monstrous art. Above all, this mutilation of the form was *new* – and therefore a dominant article of faith in the new "Modernistic" movement.

The Third moving force of "Modernistic" art is – a well known form of insanity. The symptoms of this mania can be detected in two directions. One is a deterioration of the optic nerve, whereby all values and proportions are transposed. . . . This peculiar type of visual derangement has been noted and explained by some alienists of the first rank. Their diagnosis has been confirmed by examples of the drawings of insane people, in asylums, which are identical, in respect of visual derangement, with pictures exhibited in the Society of Independent Artists, also by some of those in the present Exhibition in the Metropolitan Museum.

Many of the pictures exhibit another form of mania. The symptom of this is: – an uncontrollable desire to *mutilate* the human body. In acute stages of this malady, the person so possessed is urged to slay his victim and afterwards mutilate the body. In criminal medical annals there are numerous cases revealed of this mania. Jack the Ripper is a case in point. It is only necessary to search the records of the lives of certain artists to find proof of this. [Here follow lengthy excerpts from the reports of the Philadelphia psychologists, evidently to buttress the author's theories.]

At present there seems to be, as part of this movement, an organized intrigue, by a clique of art dealers, in Europe and America, to utilize American Art Museums – to impose this neurotic "Modernistic" cult, as represented in the works of Cézanne, Gauguin, Toulouse-Lautrec and their followers, as the *only true art*, for the present and future. This suspicion seems to be well founded. There are now many dealers ... whose shops are filled with such abominable rubbish as is now on exhibition as "Modernist" art in the Metropolitan Museum. It appears to be the object of these dealers to enlist the *influence* and *authority* of the Metropolitan and other American Museums to unload this rubbish on the American public – by investing it with a *fictitious* value. That is the prime reason why we protest against this exhibition.

We are not interested in any small campaign to prevent the *exhibition* of this artistic rot – in the caverns of certain crafty art dealers, to buncoe the unthinking, to enliven the gaiety of bored people, or to add to the "spice" of the "Tenderloins" of New York and Europe. That is the affair of the police. But we must energetically protest against the exhibition of these art-crimes on the walls of the splendid Museum, which we gladly help to sustain.

In our denunciation of this exhibition as a whole we specifically except the works of Courbet, Puvis de Chavannes, Monet, Manet, one by Renoir, and five of the twelve by Degas, and some of the drawings. ... As particularly disquieting works, showing either mental or moral eclipse, we note the following: – Numbers 2 [Cézanne's *Sorrow*; V.111], 3 [Cézanne's early *Bather*; V.109], 10 [Cézanne's large *Bather*; V.548], 20 [Cézanne's *Provençal Landscape* from the Kelekian collection; V.472], 23 [Cézanne's *Château Noir* lent by Mrs. Eugene Meyer, Jr.; V.796], 24 [Cézanne's *The Old Sailor*, lent by the same], 31 [Degas's *Before the Race*, lent anonymously], 32 [Degas's *The Bather*, lent anonymously], 34 [Degas's *Woman on a Couch*, lent by Adolph Lewisohn], 35 [Degas's *Two Dancers Seated*, lent anonymously]. These are either vulgar in subject, or corrupt in drawing, or childish in conception.

The following are simply pathological in conception, drawing, perspective and color – Nos. 40 [Derain's *Still Life – Fruit and Wine Bottle*, lent by John Quinn], 41 [Derain's *Window on the Park*, lent by the same], 42 [Derain's *The Pine Tree*, lent anonymously], 43 [Derain's *Woman – Half-Length*, lent by Walter C. Arensberg], 11 [Cézanne's *Still Life*, lent by the same], 47 [Gauguin's *Ia Orana Maria*, lent by Adolph Lewisohn], 51 [Gauguin's *Landscape*, lent anonymously], 52 [Gauguin's *Hina – Tefatou*, lent anonymously], 66 [Matisse's *Window on the Garden*, lent anonymously], 69 [Matisse's *Spanish Girl*, lent by John Quinn], 71 [Matisse's *Interior*, lent anonymously], 79 [Picasso's *Woman at a Table*, lent by John Quinn], 80 [Picasso's *Woman Dressing Her Hair*, lent by John Quinn], 81 [Picasso's *Landscape*, lent anonymously]. No. 111, "Girl arranging her chemise" [by Renoir, lent by Josef Stransky], is vulgar in subject, ugly in face and form and weird in color. Much more might be said. But the above will suffice.

It is understandable that the Museum should decide, in the interest of public enlightenment, to lend its galleries for the Exhibition of such Art Monstrosities in order to give the public an opportunity to see and ponder over specimens of so-called "Art" which has been boosted into notoriety in Europe and now here, by the most vulgar, crafty and brazen methods of advertisement. ... But, when they do lend the galleries for this purpose – of opening the eyes of our citizens, they should publicly state that purpose, and disclaim all intention of lending the prestige of the Museum in support of the propaganda for Bolchevistic Art, which is repudiated by the majority of our artists and citizens.

We refrain from signing this protest only – because we wish to doubly emphasize our discontent, and also to escape the charge of merely acting for notoriety.[29]

According to the *New York Times*, "the circular was read carefully for clues to the identity of the author or authors, but no one could supply the answer."[30] It seems strange that nobody should have been able to recognize the verbiage of this protest. As a matter of fact, this must be seen as proof of how ineffectual the author's endless and monotonous rantings had been.[31] Obviously his monthly, *The Art World*, was not very carefully read; the high pitch of his permanent indignation and the constant flow of abuse could wear out the patience even of those who happened to agree with him. As a consequence, nobody bothered to analyze the dreadful style and content of his writings, in which lunacy was intimately mixed with hysterical aggression. The almost enviable richness of his vocabulary, composed of insults and derogatory terms, the tiresome sameness of his unrelenting accusations expressed in an endless variety of words, the use of terminologies borrowed from psychoanalysis, and the appearance of such favorite verbs of his as "to buncoe," with – since the end of the war – a hallucinatory tendency to see Bolshevism in anything to which he objected, pointed directly to one man: F. W. Ruckstull. Indeed, here were all his perennial expressions (varied though his vocabulary was, it did not renew itself): "mental impotence," "artistic rot," "fraudulent art," "taints of hereditary or acquired insanity," "cult of the ugly and the obscene," "hideous examples of mental degeneracy," "abominable rubbish," "ghastly mutilations of natural forms," and many others. These highly reprehensible manifestations of "neurotic Ego-Maniacs" were now unmasked as Bolshevik propaganda aimed at destroying the existing social order. This would have made Cézanne a Bolshevik agent, not to mention the fact that he also shared certain character traits with Jack the Ripper.

It was obviously not a task for the daily press to demonstrate the madness of these accusations, but the sad fact is that even the *New York Times* treated this as though it not only had news fit to print, but also deserved favorable editorial comments:

> It is difficult to understand and impossible to approve or even excuse, the caution that prompted the author or authors of the circular to send it out with the names of the protestants omitted. . . . They well could have afforded, whoever they are, to take full responsibility for what they say in this very unusual document, for it's excellently written, and while some of the statements can, and doubtless will, be attacked, both by the Museum authorities and the critics who think they see merit in this sort of art, their position is so strong that its defense would be easy. . . . One of the strongest points made against the Museum's acquiescence with the claim that the so-called modernistic art is real art is the declaration in the circular that just such pictures as these are produced in every insane asylum, and that, there as elsewhere, they are the product of brains seriously affected in substance or function.[32]

The Metropolitan Museum's own reaction was made public in a short declaration that appeared in the same issue of the *Times*. "The anonymous circular," it read, "delivered at the Museum this morning, is the first intimation the Museum has received of any protest against the present loan exhibition of impressionist and post-impressionist paintings, although it has been opened to the public since the beginning of May. In accordance with the original agreement with the lenders, the exhibition will be closed on the 15th of this month."[33]

The same September 7 *Times* issue also contained the first counterattack, signed by John Quinn, intimately linked to, and a staunch defender of, what the newspaper

delicately called "this sort of art." More of his loans had met with the disapproval of the anonymous pamphleteer than those of any other collector.

"This is Ku Klux art criticism," Quinn wrote. "I was amazed that any New York paper should publish such screed. One does not argue with degenerates who see nothing but degeneracy around them. . . . A new way of stating truth and depicting beauty is always a scandal to some men. In their panic and impotent rage they have recourse to denial and abuse. . . . The whole thing reeks with ignorance. It is rancid with envy. It is filled with shrieks of impotent rage. Its vulgarity is equalled only by its cowardice. . . . No one argues with anonymous libellers. Let these Ku Klux art critics stand up and take off their masks, give their names and show their credentials."[34]

Did Quinn guess at the identity of the author? His references to impotent rage and rancid envy fitted Ruckstull like a glove. Quinn was not the only one to come to the "rescue" of the Metropolitan Museum exhibition. Robert Henri, among others, called it a particularly fine show for which everyone should be thankful, and Hamilton Easter Field declared that the charge of Bolshevist influence was "pure rot."[35] On the other hand, Joseph Pennell found the occasion too tempting to refrain from again voicing his reactionary views. While he considered the Post-Impressionist section of the exhibition to be dangerous and corrupting for young Americans, he also offered new historic interpretations according to which "post-impressionism is not an outgrowth of impressionism at all but a pure degeneracy, the same form of degeneracy that brought on the war: and with peace it has been abandoned even in Germany where it came from."[36]

It goes without saying that there were reports on the controversy in newspapers throughout the country and numerous articles both for and against the exhibition although, on the whole, probably more of the latter. But hardly any of these comments contained original contributions. The *Cincinnati Times Star* announced that "the principal effect of the widely distributed anonymous blast against the exhibition of paintings of the modern French school was a great increase in the number of persons who went to view them."[37] The *Boston Herald* ran a long article by F. W. Coburn which was sympathetic to the premises of the show, although the author admitted not having seen it. He concluded, "The effort of Paris picture dealers to sell canvases by Cézanne to rich Americans may be criminal; one suspects, though, that the practice is base only when the pictures in question are of a kind we personally don't like."[38]

The Metropolitan Museum avoided being drawn any further into the dispute. It was only in its September *Bulletin* that the museum stated simply that it would have welcomed helpful criticism from citizens and supporters, and that it could not understand why, if this criticism were intended to be useful, it should not have been sent directly to the Museum authorities, and at the opening of the exhibition, early in May, instead of just at its closing. The museum also let it be known that it had "received only ten letters of disapproval from its membership of over 7,000 men and women who are of more than average intelligence and culture or from the great body of citizens to whom the protest was addressed."[39]

Not surprisingly, the prominence given to the findings of the distinguished alienists in the anonymous onslaught was read with particular interest in

Philadelphia. Even though Dr. Dercum declared that he was not interested in the circular, in spite of the fact that it quoted him and his associates at length, he nevertheless launched another attack. But now there appeared a new defender of modern art, a not altogether unexpected one, although it had taken him a long time to come forward. It was only in October 1921, and in reply to Dercum's second denunciation of modern art, that Dr. Barnes finally spoke up. As reported by the *American Art News*:

Dr. Albert C. Barnes, a prominent and wealthy physician of Philadelphia, rallied to the support of the Metropolitan Museum [?], and singled out for chief attack his fellow townsman, Dr. Francis X. Dercum. . . . Dr. Barnes has offered to donate his entire collection of paintings, valued at millions of dollars, and a gallery to house them, to the city of Philadelphia if Dr. Dercum could prove himself qualified in the science of normal and abnormal psychology. The offer not being taken up, a few days later Dr. Barnes increased it by proposing to build in addition a gallery large enough to house the fine collection left to the city by the late John G. Johnson.

"I have no sympathy with the painters of futuristic and cubistic pictures," Dr. Barnes said, "but I believe that the spirit of fair play should be extended to the group of honest, intelligent, and capable artists whom Dr. Dercum holds up to ridicule and misrepresentation."

He then formulated the following eight points, upon Dr. Dercum's satisfactory answers to which depends his offer to the city.

First. – Show, in scientific terms, the difference in basic principles between pictures by Gauguin, Degas and Renoir, which Dr. Dercum says he does not condemn, and those paintings exhibited last spring at the Pennsylvania Academy of the Fine Arts, which Dr. Dercum says are the work of insane people.

Second. – If he will name one artist who exhibited at the Philadelphia Academy last spring whose work intelligent, informed people classify as futurist or cubist.

Third. – If he can defend or define in terms of science the sentence "departed widely from normal standards in color and form and in conception of orientation."

Fourth. – If he can defend, as inconsistent with the principles of esthetics, his statement: "All shapes and normal proportions seemed to be disregarded; I found no distinction between foreground and background, and no indication of the relative position of objects." Dr. Dercum's attention is respectfully called to the very famous works of art, the windows in the cathedral of Chartres, which would come within the specification of his marks of insane or non-artistic objects. . . .

Fifth. – If he will point out in any authoritative work on psychology the principles that make common sense, as applied to art, out of the sentence, "The colors employed in the alleged paintings were in no sense those seen in nature, nor could their use be construed as suggesting or evoking a sense of the beautiful."

Sixth. – If he will show by a single concrete example "the absence of appearance of color and form in futurist and cubist art."

Seventh. – If he will give a definition of what he calls "normal art" that will bear analysis which could not safely come within the meaning of every single objection he made to the exhibition held last spring at the Pennsylvania Academy.

Eighth. – If he can prove that his use of the words "art," "beautiful," "futuristic," "cubistic," "insane," "normal" are not typical examples of loose thinking; that is the kind of thinking which ignores established principles of logic, psychology and esthetics, to say nothing of intelligence, experience, and culture.[40]

The outcome of this controversy has not been recorded. The faint possibility arises that perhaps Dr. Dercum did not reply to Dr. Barnes's challenge because he wished to "protect" the city of Philadelphia from the embarassing gift of his antagonist's degenerate paintings by Cézanne, Matisse, Picasso, and others. It is unfortunate that nothing further has come to light.[41] Indeed, it would have been fascinating to know whether some noted local alienist also carefully observed Dr. Barnes unobserved and came to the conclusion that he was an egomaniac.

When an exhibition closes, almost nothing remains of it. The catalog that had accompanied the Metropolitan Museum show was – like most catalogs in those days – neither very informative nor fully illustrated. It was hardly more than a checklist, and its reproductions were printed in black and white. This did not constitute a worthy memento of the extraordinary manifestation that ended on September 15, 1921. If the exhibition exerted any influence on young artists, nobody pointed this out, a fact that is not really surprising, since the original shock of modern art had been provided in 1913 by the Armory Show, which, in the recollections of visitors, weakened the impact of the Metropolitan Museum's offering. Yet, the exhibition did play an important role in the lives of those for whom it was the initial experience of modern art. Among these was an American student named Meyer Schapiro.

Born in 1904, Schapiro had been too young to derive any benefits from the Armory Show, but around the time he was about fifteen and was beginning to be interested in contemporary art, he heard a great deal about the Armory Show from various painters of his acquaintance. It was then, too, that he came across the earliest American book that dealt extensively with Cézanne, Willard Huntington Wright's *Modern Painting*.[42] During his first year in college he developed an immense admiration for the writings of Roger Fry, but his knowledge of works by Cézanne was derived solely from illustrations in books and periodicals. It was the 1921 exhibition at the Metropolitan Museum that provided Schapiro with his first opportunity to see and study the artist's works. A freshman at Columbia College at the time, Schapiro defended Cézanne's paintings in conversations with skeptical teachers who were interested in art; a professor subsequently asked him to take his chair for an hour in his course on the philosophy of art and give a lecture on modern painting. The seventeen or eighteen-year-old college student focused on Cézanne as a starting point of the new twentieth-century art.[43] Three decades later, among his many contributions to the history of art, and to world scholarship as a whole, Schapiro would offer a lifetime's observations and evaluations of Cézanne's work in a book that remains one of the essential publications in the vast literature on the artist.[44]

I, 2 Exactly thirty years after Miss Hallowell had taken the first two canvases by Cézanne to the United States and had been unable to sell them privately, the artist began to find a steadily increasing audience there. Despite incredible derision, scarcely a year passed that did not see the addition of his works to American private collections and then to American museums. F. W. Ruckstull lived long enough to see the Metropolitan Museum open its doors to the Cézannes willed to it by Mrs. H. O. Havemeyer. Bequests by other lenders to the 1921 exhibition, such as Adolph

Lewisohn, eventually followed. The Cézanne paintings and watercolors owned by Miss Bliss would become an essential factor in the founding of New York's Museum of Modern Art. From bequest to bequest, from exhibition to exhibition, from auction sale to auction sale, from publication to publication, Cézanne's renown in America grew. The beginning had been inauspicious, but the artist slowly gained a foothold in America, which today can pride itself on owning more of his major paintings than any other country. Cézanne's position in the history of art in general, and in America in particular, can finally be considered secure.

NOTES

1. Anonymous review, *New York Times*, Feb. 15, 1920.

2. Ibid.

3. Leopold Stokowski, in *Exhibition of Paintings and Drawings by Representative Modern Masters*, exhibition catalog, Pennsylvania Academy of the Fine Arts, Philadelphia, April 17–May 9, 1920, [p. 4].

4. A misprint in the catalog lists numbers 58 and 59 as still lifes lent by Walter C. Arensberg, who actually owned only one still life and a composition of bathers.

5. *The Press*, April 17, 1920. On this exhibition see Joseph J. Rishel, "Cézanne and Collecting in Philadelphia," in *Cézanne in Philadelphia Collections*, exhibition catalog, Philadelphia Museum of Art, June 19–Aug. 21, 1983.

6. *The Press*, April 18, 1920. The idea that Cézanne was an anarchist seems to have been widespread at the time; in a popular book on still life painting which appeared in 1921, Edwin Arthur Bye wrote in a special chapter on the artist that "his enemies branded his work as that of a dangerous person – an anarchist." See E. A. Bye, *Pots and Pans or Studies in Still-Life Painting* (Princeton: Princeton University Press, 1921), p. 133.

7. *The Public Ledger*, April 18, 1920.

8. "French Art of the Great Show," *New York Evening Telegram*, May 10, 1920. This article was brought to my attention by Jayne Warman.

9. *The Philadelphia Record*, April 17, 1921.

10. *The Public Ledger*, April 17, 1921.

11. See notably *American Art News*, May 7, 1921, p. 5, and "Modernists Insane Say These Medics," ibid., June 4, 1921, p. 3.

12. *Amercan Art News*, May 7, 1921, p. 5.

13. Ibid.

14. Ibid.

15. Hamilton Easter Field, "French Show at Brooklyn Museum," *Brooklyn Eagle*, March 27, 1921.

16. Ibid.

17. "French Masters in Big Exhibition," *American Art News*, April 2, 1921.

18. Ibid.

19. Archives of the Metropolitan Museum of Art, New York (courtesy the late Anthony M. Clark).

20. See Stieglitz's letter to the *New York Evening Sun*, Dec. 14, 1911 quoted above, Chapter VII, note 5.

21. See Judith Zilczer, *"The Noble Buyer": John Quinn, Patron of the Avant-Garde*, exhibition catalog, Hirshhorn Museum and Sculpture Garden, Washington, D.C., 1978, p. 54.

22. "Art Without Charm," *American Magazine of Art*, June 1921, p. 206.

23. Bryson Burroughs, "Introduction," *Loan Exhibition of Impressionist and Post-Impressionist Paintings*, exhibition catalog, Metropolitan Museum of Art, New York, May 3–Sept. 15, 1921, p. XV.

24. B. B. [Bryson Burroughs], "Exhibition of French Impressionists and Post-Impressionists," *Bulletin of the Metropolitan Museum of Art*, April 1921, p. 70.

25. Burroughs, "Introduction," p. XII.

26. Ibid., pp. XIII–XIV.

27. The Editor [Hamilton Easter Field], "The Metropolitan French Show," *The Arts*, May 1921.

28. *American Art News*, May 7, 1921, p. 5.

29. Anonymous circular, *A Protest Against the Present Exhibition of Degenerate 'Modernistic' Works in the Metropolitan Museum of Art*, n.d. [New York, early Sept. 1921].

30. *New York Times*, Sept. 7, 1921.

31. Information derived from the stock books of the Bernheim-Jeune Galleries in Paris.

32. "Topics of the Times," *New York Times*, Sept. 7, 1921.

33. *New York Times*, ibid.

34. "Some Artists Exempted," ibid.

35. "Artists Rise in Aid of Impressionists," ibid.

36. "Pennell Enters into Art War Here," *New York Times*, Sept. 8, 1921.

37. *Cincinnati Times Star*, Sept. 12, 1921. This assertion was subsequently denied by the Metropolitan Museum in its Annual Report of the Trustees.

38. F. W. Coburn, *Boston Herald*, Sept. 18, 1921.

39. See "Defends Impressionist Pictures," *New York Times*, Sept. 23, 1921.

40. See "Counter Attack in Fight on Modernists," *American Art News*, Oct. 15, 1921.

41. The two biographies of Barnes contain hardly any information on this incident. William Schack, *Art and Argyrol: The Life and Career of Dr. Albert C. Barnes* (New York: Thomas Yoseloff, 1960), pp. 131–32 (an "anti-Barnes" biography) provides a brief report of Barnes's offer; Henry Hart, *Dr. Barnes of Merion: An Appreciation* (New York: Farrar, Straus, 1963), pp. 75–76 (the "official" posthumous biography) gives even less attention to the matter. A request addressed to the director of the Barnes Foundation for any *published* material concerning the controversy resulted in a negative reply.

A recent third biography, Howard Greenfeld, *The Devil and Dr. Barnes: Portrait of an American Art Collector* (New York: Viking, 1987), does not really provide much new material on Barnes's collecting activities.

42. On Willard Huntington Wright, see above, Chapter X.

43. This information is based on a detailed letter from Professor Meyer Schapiro to the author, Sarasota, Florida, Feb. 17, 1976.

44. Meyer Schapiro, *Paul Cézanne* (New York: Harry N. Abrams, 1952).

Epilogue

WHEREAS in America cultural activities had continued almost unabated during World War I, they had practically ceased throughout Europe. After the armistice, it became possible at last in many countries, deprived of any contact with art for a number of years, to think of exhibitions again. In 1920, Paul Signac undertook the organization of the French section of the revived Venice Biennale, which opened in May. He was generously supported by various collectors and was thus able to devote an impressive special exhibition to the paintings of Cézanne; it was the first time the painter was presented extensively in Italy. With the exception of a small early painting lent by the family of Camille Pissarro, all the works by Cézanne came from the collections of two American expatriates, Egisto Fabbri and Charles Loeser. Fabbri was by far the most generous.

There were rumors that Fabbri had transferred his collection from Florence to the south of France during the hostilities and there allowed Signac to select no fewer than twenty-four canvases.[1] However, since Italy had fought on the side of the Allies, Florence had not actually been in any particular danger. On the other hand, it is known that Fabbri had left many of his pictures in his Paris studio on the top floor of a building in Montmartre, where they were seriously threatened during the German bombardments of the city. Indeed, several bombs had landed nearby and had caused the studio walls to tremble. When Fabbri went to fetch the canvases, he discovered that some had fallen to the floor. Apparently they had not been damaged,[2] but it must have been at that time that he decided to stash them away in the Midi where Signac went to make his selection.

Fabbri's contribution to the exhibition was staggering. It consisted of almost his entire collection, including some small early works, a few still lifes that cannot be identified (among them probably one of the two that Sara Hallowell had taken to the United States in 1891),[3] some major landscapes, such as a group of houses near L'Estaque (V.397), a view of Gardanne (V.430), another of the banks of the Marne River (V.629), and the majestic row of chestnut trees at the Jas de Bouffan in winter with their bare branches outlined against the sky (V.476). There were also several important figure pieces, such as the artist's wife in a striped skirt (V.292), the young boy with a white scarf (V.374), a self-portrait with short, pointed beard (V.693), and, especially, the boy in a red waistcoat (V.682). In addition to the Fabbri paintings there were three loans from the widow of the usually reluctant Charles Loeser, a group of bathers (V.265) and two splendid still lifes. Strangely, Signac did not contribute the Cézanne landscape he had purchased directly from *père* Tanguy. All

1

161, 9

60, 6

5

27

337

in all, there were twenty-eight paintings, in Huneker's not particularly fortunate phrase, to "blister one's eyeballs."

Blister or not, the exhibition left a deep impression on many visitors, especially those who knew Cézanne only from hearsay. Notable among those for whom it was a true revelation was the painter Giorgio Morandi, who was then about thirty years old. More than forty years later he still spoke with real emotion of that exhibition, which in some way was to sustain him for the rest of his solitary life.[4] Morandi devoted himself almost exclusively to still lifes and occasional landscapes, in which he by no means imitated Cézanne although he always showed a profound spiritual kinship with the master. Another artist whose eyes were opened by the Venice exhibition and on whom it had a lifelong effect was Alberto Giacometti. Ten years younger than Morandi, he was in a more impressionable stage of his evolution.[5] He, too, never imitated Cézanne, yet like Morandi – but in a completely different way, in a less placid-lyrical and more nervous fashion – Giacometti, in his paintings and drawings, "continued" the master's search for expression.

It is a strange circumstance that the various French artists who had gone to Aix to visit Cézanne during his last years, without exception turned into mediocre painters, especially Emile Bernard, who, after highly promising beginnings, produced works of appalling quality. Among Cézanne's first ardent American admirers there were also a good many artistic nonentities, notably Walter Pach. But Fabbri's collection, shown in Venice, helped at least two European artists, Morandi and Giacometti, achieve a personal style that represents a fundamental contribution to the art of this century.

The next year, Fabbri and Loeser again lent several of their pictures, this time to a large Cézanne retrospective in Basel. But it would soon be time for Fabbri to take a decisive step. Around 1926, then past sixty and in failing health, Fabbri decided to sell the major part of his collection. Various circumstances prompted this decision. Several of his sisters were living in beautiful apartments in the Palazzo Capponi in Florence, which they might have to vacate if the building were to be sold. For the sake of his family, Fabbri bought the Palazzo when it was put on the market. He himself spent the last years of his life there in modest quarters, surrounded by sisters, nieces, and nephews.[6] Also, Fabbri wished to establish a school for Gregorian chant in the Casentino Valley. Fortunately, he found a Catholic order willing to supervise such an enterprise. He not only entrusted the order with the continuation of his labor for the revival of Gregorian chant in liturgy, but also left it endowed. "I shall die happy, because the Mantellate Sisters have understood my work," Fabbri said toward the end of his life.[7]

For these goals Fabbri was willing to sacrifice his collection. It is true that the overpowering presence of Cézanne's work had prevented the timid artist from fully developing his own personality. But now he simply rearranged his priorities, even his artistic ones – from painting to music – and his innate mystic strain won out over the sheer pleasure provided by the contemplation of Cézanne's canvases. Thus, sometime in 1927, Fabbri's French nephew Lucien Henraux approached the Paris dealer Jean Dieterle with a list of twenty paintings, including most of the masterpieces from the collection. A global price of 6,000,000 French francs was asked. Dieterle, together with the Knoedler gallery, offered only 4,500,000, an offer

that was rejected. A little later, the dealer Paul Rosenberg concluded the deal for 7,000,000 francs, for which, it seems, he also obtained the pictures that Fabbri had originally planned to keep. Rosenberg made the purchase in collaboration with his partner Georges Wildenstein.

Bernard Berenson's reaction to this news was somewhat strange, except to those who may have been familiar with his devious, jealous, and petty character. Years later, and long after Fabbri's death, Berenson went to considerable lengths to explain that for I Tatti, his house in Settignano outside Florence, he had never purchased anything with the intention of selling it "at a high profit in money or pride."[8] This assertion reflects a monumental self-deception; one might consider it almost naïve, were it possible ever to suspect Berenson of naïveté. Whether Berenson purchased any object for his own house with the thought of gain seems totally irrelevant. It is well established, notably through his wife's letters and diaries, published after his death,[9] that Berenson did acquire works in order to sell them. Moreover, there is the fact that Berenson spent decades in the service of Duveen, the most powerful, and notorious, art dealer of the period, whose transactions he carefully monitored so as to receive his share of the enormous profits.

Having denied that he was ever interested in monetary gain as far as his personal collection was concerned, Berenson went on to say "I could have made a fortune acquiring Cézannes at a time when they could be had for 'a few coppers,' when indeed a friend of the time, Egisto Fabbri, bought a dozen or more to sell them several decades later for many millions of francs."[10] This was a gratuitous slur, since Fabbri had collected Cézanne's works with a painter's passion and devotion and not for "investment" (to use the current expression); and the nastiness is even greater because Berenson knew that Fabbri had not sold his pictures for personal gain. Not with one word did he allude to this; only years later, in a posthumous publication, was Fabbri's involvement with the school of Gregorian chant mentioned, and then in a note by the editor.[11]

Berenson concluded his passage on Cézanne and Fabbri by explaining that he had not bought any works by Cézanne because "I could not see myself living with masterpieces so little in harmony with an Italian dwelling."[12] This seems to be a peculiar explanation since *masterpieces* (the word used by Berenson himself) can be fitted in anywhere. Both Loeser, who also collected Renaissance works, and Fabbri had shown that an Italian dwelling can perfectly well accommodate paintings by Cézanne, while the Steins had hung their Cézannes, Picassos, and Matisses in rooms filled with Italian furniture. The plain fact is that when Berenson first saw Fabbri's Cézannes back in 1904, he found them "disappointing."[13] It had taken him a very long time to realize that they were actually masterpieces. Had he been certain of that in the days when they could be obtained for "a few coppers," his entire attitude might have been different.

It is not unlikely that it was the growing interest in the long-neglected Piero della Francesca that made Berenson realize to what extent increasing admiration for Cézanne had opened the eyes of a new generation to the particular qualities of the Renaissance master. Not only did Berenson begin to reflect on the various elements of style and attitude that the two artists shared, he also availed himself of Cézanne's popularity in comments he wrote on a work by Piero for his patron Duveen, to help

173 him sell it in America. "The 'Crucifixion' that you ask about," he stated, "is an autograph painting by Piero della Francesca. Although of small size it is large in scale and produces nearly the same impression as his famous frescoes at Arezzo. What differences there are, are rather in favour of your painting [after all, Duveen could not sell the Arezzo frescoes!]. . . . The handling of your little picture reminds me of Cézanne. It has become a commonplace to assert that this greatest of modern French masters had a sense of form and a feeling for atmosphere and placing singularly like Piero's. It was left to your 'Crucifixion' to reveal how curiously like these two great artists are in handling as well."[14] In a strange way, history had come full circle. As a matter of fact, Berenson remained interested in Cézanne. Roger Fry's monograph on Cézanne, published in 1927, the first serious and highly rewarding study of the artist's evolution, is in Berenson's library at I Tatti, even though he was never reconciled with the author.[15] Fry's publication was to remain a milestone among scholarly studies of the artist, partly because there were few who could approach Cézanne with a similar wealth of knowledge and perceptivity.

In the United States, despite occasional setbacks, appreciation of Cézanne's work continued apace, even though Stieglitz had closed his gallery in 1917. The following year Marius de Zayas did the same for his Modern Gallery that he had opened three years previously. But in 1919 he started a new one, called the De Zayas Gallery, whose run was even shorter; it was discontinued in 1921. Yet there were also events to compensate for these closings. In 1921 Duncan Phillips opened his Phillips Memorial Collection in Washington for which he was to acquire a number of outstanding works by Cézanne. His first purchase of a painting by the artist dates

174 from 1925 when he bought one of the finest views of Mont Sainte-Victoire (V.455).

173 Piero della Francesca *Crucifixion*

174 *Mont Sainte-Victoire with Pine Trees* 1886–87 (V.455)

In the field of criticism, the most serious loss was certainly Willard Huntington Wright's change of métier. Discouraged by private tragedies and by the indifference with which his brave, lucid, and informed writings on art were received, he gave up art criticism altogether, a circumstance that deprived Cézanne of his most articulate advocate in America. Instead, Wright turned his gifts to the writing of mysteries, in which his connoisseur-hero, Philo Vance, intermittently reveals Wright's previous involvement with art. When Wright's suspense novels, written under the pen name S. S. Van Dine, met with tremendous success and were even turned into movies, he also reaped considerable profits from them.

Sales of Cézanne's works might be characterized by both highs and lows, but the number of collectors grew steadily. In 1922, the dealer Dikran Kelekian decided to follow the exhibition of his private collection of modern paintings with an auction sale, as many had suspected he would. The sale, which took place in New York, was 175 accompanied by a sumptuous catalog, but many of the bids were disappointing, and Kelekian bought back a number of the offerings. The Cézanne landscape (V.472) that had been so admired at the Brooklyn Museum and Metropolitan shows did not 166 reach Kelekian's expectations and, according to an arrangement made with John Quinn, was "bought" by the latter on its owner's behalf; it reached $9,500. Miss Lillie Bliss paid the highest price of the sale, $21,000 for Cézanne's large still life (V.736). Seven years later, in the fall of 1929, it hung at the Museum of Modern Art's 168

175 Charles Loeser's diary
entry concerning the sale of
the Kelekian collection, 1922

inaugural exhibition in its temporary quarters. Organized by the museum's young
director, Alfred H. Barr, Jr., the show was devoted to the four painters who were,
without contest, perceived as the forerunners of modern art: Cézanne, Gauguin,
Seurat, and van Gogh. The impressive group of Cézanne's works, which comprised
loans from Europe, consisted of twenty-nine paintings and six watercolors.

At the beginning of the previous year the Wildenstein Galleries of New York had
organized a large Cézanne retrospective which included a number of paintings from
the Fabbri collection lent by Paul Rosenberg. What was remarkable about this
exhibition and that of the Museum of Modern Art was the number of new names
among the lenders. There were now five collections open to the public that owned
works by Cézanne: the Albright Art Gallery of Buffalo; the Phillips Memorial
Gallery of Washington (a private institution); the Art Institute of Chicago; and the
Brooklyn Museum and the Metropolitan (the recent recipient of five Cézanne
paintings from the Havemeyer bequest), neither of which participated in either
exhibition. Among the new private collectors were Drs. Harry and Ruth Bakwin,
Mr. and Mrs. Chester Dale (Mrs. Dale wrote the introduction to the catalog of the
Wildenstein show), Dr. F. H. Hirschland, and Josef Stransky of New York; John
Nicholas Brown, Robert Treat Paine II, and John T. Spaulding of Boston; Ralph M.
Coe of Cleveland; A. Conger Goodyear of Buffalo; Carroll S. Tyson, Jr., and S. S.
White III of Philadelphia; and Joseph Winterbotham of Burlington, Vermont.
There were of course familiar names who had lent previously, such as Adolph
Lewisohn, Miss Bliss (who lent anonymously), and John Quinn, who had died in
1924 but was represented by his portrait of the artist's wife, lent anonymously by
Mrs. Cornelius J. Sullivan.

Among new collectors who did not lend, or were not solicited, were the Cone
sisters of Baltimore, who had added a superb view of Mont Sainte-Victoire to their
collection in 1925 and the next year had acquired a small composition of bathers
from their old friend Gertrude Stein. After fulfilling his mother's bequest to the
Metropolitan Museum, Horace Havemeyer still retained a number of highly

important paintings by Cézanne,[16] a fact that may not have been known; in any case, he did not lend. The Eugene Meyers did not lend this time; nor did the innately uncooperative Dr. Albert C. Barnes, whose collection, which had been established in 1923 as a foundation, contained some fifty works by Cézanne. Many of the European lenders were dealers, such as Etienne Bignou, Paul Guillaume, G. F. Reber, Paul Rosenberg, and Ambroise Vollard. The latter had reopened his gallery after the war and was doing "business as usual," if not better, due to an ever-increasing number of Americans who were demonstrating a lively interest in the works of Cézanne.

In 1936 Vollard undertook his only Atlantic crossing invited by none other than Dr. Albert C. Barnes. Old feuds had long been forgotten and Barnes welcomed the guest in a radio speech that began: "The cultural world in America has rarely been excited to the extent that it is at this moment, all because the most important figure in the art history of the nineteenth and twentieth centuries has arrived in New York on his first visit to this country." He then retraced the difficulties of Vollard's distant beginnings when "nobody wanted to buy Cézanne's pictures," and related how, through Mary Cassatt, he had sold a canvas by the artist to Mrs. Havemeyer for the "enormous amount" of $800, though most of Cézanne's works that Vollard was able to sell "were bought for a pittance." Barnes did not mention and probably did not know that among other early buyers had been such Americans as Charles Loeser and Egisto Fabbri, but he certainly was aware of the role the Steins had played among Cézanne's initial patrons, although he did not allude to it.

Speaking of the other masters whose work Vollard had sponsored, such as Degas, Renoir, Picasso, and the *douanier* Rousseau, Barnes reminded his listeners that "it took several decades to win public recognition for these once obscure and maligned artists, and it was largely Vollard's knowledge, courage and patience that put their work in the important collections of the world, side by side with the great pictures of all time. This monumental feat entitles Vollard to high esteem as an educator, a leader in moulding intelligent, well-informed public opinion." (Barnes assuaged Vollard's susceptibilities by not even mentioning the pioneering role played by Durand-Ruel.)

Standing next to Barnes, Vollard then answered briefly (in French): "It has been a great personal satisfaction to me and a source of real emotion to see the Havemeyer collection in the Metropolitan Museum. It reminded me of how much I owe to the great American artist, Mary Cassatt, who was responsible for the bringing together of this collection.[17] I am still under the spell of my visit to the Barnes Foundation, where I saw so many of the paintings which I knew, defended and loved and which I had not seen since the turn of the Century."[18]

The fact is that Barnes had not been Vollard's client around the turn of the century but had appeared only a dozen or so years later. But Vollard may have meant the numerous paintings from the Hoogendijk collection in the Foundation which, indeed, he had sold before 1900. In the glow of pleasant memories Vollard also refrained from mentioning *The Artist's Wife in a Green Hat* (V.704) which the *124* Durand-Ruels had been obliged to buy from him "for their own collection," so that the price could be brought down to a level acceptable to Barnes. (Vollard died three years after this trip as a result of a car accident.)

Charles Loeser had died in 1928; he left his Cézanne paintings to the president of the United States, a group of two hundred sixty-two Old Master drawings to the

Fogg Art Museum of Harvard University, and his Renaissance paintings and sculpture to the city of Florence.[19] His important collection of prints remained in the hands of his widow and daughter, who eventually sold it through Sotheby's of London at the Palazzo Capponi, which had once belonged to Egisto Fabbri. When, during World War II, Fascist Italy joined Nazi Germany, Mrs. Loeser left for the United States; Berenson provided her with a letter of introduction to Mrs. Alfred H. Barr, Jr., recommending to her "the widow of Charles Loeser, my most fierce enemy-friend and would be competitor, as well as really fine collector."[20] Most of the Cézanne paintings, still in the custody of Mrs. Loeser, had to be left behind.

After the liberation of Italy, an exhibition of French paintings from Florentine collections was organized during the summer of 1945 at the Palazzo Pitti. Mrs. Loeser lent eight paintings by Cézanne, many of which had never been seen publicly before. Bernard Berenson wrote the introduction to the catalog and briefly discussed some of Loeser's pictures, although his comments appear rather flat. Of the small *XVI* canvas of peaches that is now, with most of the other Loeser gifts, owned by the American government, he wrote: "Cézanne is especially himself in the four peaches, a still life in which you can touch, smell, and taste the fruits better than in the work of any other painter of the last generations. Less exquisite, less delicate than Chardin, but more delectable, more sensuous."[21]

Whether this description really does justice to Cézanne now appears almost beside the point. Next to Paris, Florence had, in a strange way, been a center from which the painter's fame had radiated thanks to the more or less accidental gathering there of a group of cultured Americans. Berenson had been the first to mention Cézanne in a scholarly volume; such important collectors as Loeser, Fabbri, and Leo Stein had lived there. The collections of these pioneers no longer exist, but it is no accident that many of the masterpieces they owned are now in American museums.

In a biography of William the Silent, U. V. Wedgewood has stated: "History is lived forwards but it is written in retrospect. We know the end before we consider the beginning and we can never wholly recapture what it was to know the beginning only."

This observation obviously applies also to the story of Cézanne's slow rise to recognition and fame. Even though we are aware of his tremendous stature in the art world of today, we are not familiar with the way in which this stature was achieved. What these pages have endeavored to reveal is that without the slightest cooperation from the artist himself, without interviews or a sensational life, without public relations agents, and without any advertisement, Cézanne attained world fame through the admiration manifested by his earliest advocates. Through their selfless efforts on behalf of his work, in an almost miraculous way, it gained – little by little – its commanding place in modern art. It is no secret, of course, that Cézanne's first "discoverers" and propagandists were an international breed: Englishmen like Roger Fry, Frenchmen like *père* Tanguy, Victor Chocquet, Emile Bernard and Maurice Denis, Dutchmen like Cornelis Hoogendijk, Germans like Julius Meier-Graefe, Russians like Ivan Morosov and Sergei Shchukin, a German Swiss like Hugo von Tschudi. But the fact that a great many of Cézanne's earliest and most active admirers were Americans – a fact that may not be universally known – provided the raison d'être for this study.

NOTES

1. See *Bulletin de la Vie Artistique*, May 1920, pp. 294–96.

2. See Lucien Henraux, "I Cézanne della Raccolta Fabbri," *Dedalo*, no. 1 (1920), p. 58.

3. The catalog simply lists three paintings together under Nos. 4–6 as "Tre Nature morte (1875)." But Fabbri is known to have owned one of the Hallowell still lifes, which he lent the following year to the Cézanne exhibition in Basel.

4. Interview with the author, Bologna, 1969.

5. Conversations with the author over the years. James Lord, in *Giacometti* (New York: Farrar, Straus, Giroux, 1983), gives a somewhat different account.

6. See Mabel La Farge, *Egisto Fabbri* (New Haven: privately printed, 1937), p. 17.

7. Ibid., p. 19.

8. Bernard Berenson, *Sketch for a Self-Portrait* (New York: Pantheon, 1949), p. 167.

9. See *Mary Berenson: A Self-Portrait from Her Letters & Diaries*, ed. Barbara Strachey and Jayne Samuels (London: Victor Gollancz, 1983).

10. Berenson, *Sketch*, p. 168.

11. Bernard Berenson, *Sunset and Twilight: From the Diaries of 1947–1958*, ed. Nicky Mariano (New York: Helen and Kurt Wolff/Harcourt, Brace and World, 1963), p. 66.

12. Berenson, *Sketch*, p. 167. This statement is in some ways contradicted by what Berenson wrote in 1950 in *Piero della Francesca, or the Ineloquent in Art*, where he stated: "After sixty years of living on terms of intimacy with every kind of work of art, from every clime and every period, I am tempted to conclude that in the long run the most satisfactory creations are those which, like Piero's and Cézanne's, remain ineloquent, mute, with no urgent communication to make, and no thought of rousing us with look or gesture." (*The Bernard Berenson Treasury*, ed. Hanna Kiel [New York: Simon and Schuster, 1962], p. 287). Does this really mean that, while Berenson's sensitivity could have lived quite well with paintings by Cézanne, it was his Italian dwelling that could not?

13. Bernard Berenson to his wife, see above, Chapter I, note 29.

14. Bernard Berenson to Joseph Duveen, Settignano, Nov. 18, 1915; quoted in Sylvia Sprigge, *Berenson* (Boston: Houghton Mifflin, 1960), pp. 206–7. The work was acquired by John D. Rockefeller and eventually was donated to the Frick Collection in New York. It is in extremely poor condition (a fact on which Berenson did not comment) and is not on display. Later critics, such as Roberto Longhi and Kenneth Clark, judged it "to be by an assistant of Piero"; see Meyer Schapiro, "Mr. Berenson's Values," *Encounter*, Jan. 1961, p. 57. On Berenson's certificates, etc., see also David Alan Brown, *Berenson and the Connoisseurship of Italian Painting* (Washington, D.C.: National Gallery of Art, 1979).

15. Roger Fry, *Cézanne, A Study of His Development* (New York: Macmillan, 1927); the copy in the library at I Tatti is not inscribed, which would indicate that Fry did not present it to Berenson.

16. On the Cézanne paintings in the Havemeyer collection and their ultimate fate, see Frances Weitzenhoffer, *The Havemeyers: Impressionism comes to America* (New York: Harry N. Abrams, 1986).

17. On Mary Cassatt and her role in the forming of the Havemeyer collection, see Frances Weitzenhoffer, *The Havemeyers*.

18. Radio allocations by Dr. Albert C. Barnes and Ambroise Vollard, Nov. 9, 1936, WINS Broadcasting Station, New York City. These documents were brought to my attention by Richard I. Wattenmaker.

19. On Charles Loeser's will, see above, Chapter IV, note 30.

20. Bernard Berenson to Mrs. Alfred H. Barr, Jr., Settignano, April 22, 1941; published in *The Selected Letters of Bernard Berenson*, ed. A. K. McComb (Boston: Houghton Mifflin, 1964), p. 182.

21. Bernard Berenson, preface to *La Peinture française à Florence*, exhibition catalog, Palazzo Pitti, Florence, Summer 1945, p. 21 (here translated from the French).

LIST OF ILLUSTRATIONS

All works are by Cézanne, and in oil on canvas, unless otherwise stated. Measurements are given in centimeters and inches within brackets. The V. and RWC. numbers refer to the Venturi and Rewald Watercolors catalogs.

COLOR PLATES

I *Milk-can and Apples* 1879–80. 50.1 × 60.9 (19¾ × 24). Collection William S. Paley, New York. (V.338)

II *L'Estaque* 1878–79. 58.1 × 72 (22⅞ × 28⅜). Musée d'Orsay, Paris (Caillebotte Bequest). (V.428)

III Maurice Denis *Homage to Cézanne* 1900. 180 × 240 (70⅞ × 94½). Musée d'Orsay, Paris

IV *Self-Portrait with a Cap* 1875. 73.3 × 38.1 (28⅞ × 15). Hermitage Museum, Leningrad (formerly collections H. O. Havemeyer, New York, and Ivan Morosov, Moscow). (V.289)

V *Portrait of the Artist's Wife* probably started c. 1878, reworked 1886–88. 92.3 × 73 (36⅜ × 28¾). Foundation E. G. Bührle Collection, Zürich (formerly collection Leo and Gertrude Stein). (V.369)

VI Pablo Picasso *Portrait of Gertrude Stein* 1906. 99.6 × 81.2 (39¼ × 32). The Metropolitan Museum of Art, New York (Bequest of Gertrude Stein) 1946

VII Pablo Picasso *Leo Stein* 1906. Gouache, 24.7 × 17 (9¾ × 6¾). The Baltimore Museum of Art: The Cone Collection, formed by Dr. Claribel Cone and Miss Etta Cone of Baltimore, Maryland. BMA 1950.276

VIII *Madame Cézanne and Hortensias* c. 1885. Watercolor, 30.4 × 46 (12 × 18⅛). Private collection, Zürich. (RWC.)

IX *The Hill of the Poor (La Colline des pauvres)* 1888–90. 65.1 × 81.3 (25⅝ × 32). Acquired by the Metropolitan Museum of Art, New York, from Ambroise Vollard during the Armory Show, 1913. The Metropolitan Museum of Art, Wolfe Fund, 1913. Catharine Lorillard Wolfe Collection (13.66). (V.660)

X *Woman with a Rosary* 1895–96. 85 × 64.8 (33½ × 25⅝). National Gallery, London. (V.702)

XI *Portrait of the Artist's Wife in a Striped Dress* 1883–85. 56.8 × 47 (22⅜ × 18½). Art Salon Takahata, Osaka, Japan (formerly collection John Quinn, New York). (V.229)

XII Stanton Macdonald-Wright *Willard Huntington Wright* 1913–14. 91.4 × 30.7 (36 × 30). National Portrait Gallery, Smithsonian Institution (museum purchase and gift of the Smithsonian Society)

XIII *Still Life with Apples, Pears, and a Gray Jug* 1893–94. 59 × 72.3 (23¼ × 28½). Collection Mrs. John Hay Whitney, New York (formerly collections Hoogendijk and Barnes Foundation). (V.601)

XIV *Mountains in Provence (near L'Estaque?)* c. 1879. 53.3 × 72.3 (21 × 28½). National Museum of Wales, Cardiff (Gwendoline E. Davies Bequest). (V.490)

XV *Château Noir* 1900–04. 73.7 × 96.6 (29 × 38). National Gallery of Art, Washington, D.C. Gift of Eugene and Agnes E. Meyer. (V.796)

XVI *Still Life with Three Peaches* 1885–87. 28.5 × 30.1 (11¼ × 11⅞). American Ambassador's Residence in Paris. On loan from the National Gallery of Art, Washington, D.C. (presented to the government of the United States in memory of Charles A. Loeser). Photo J. Hyde

MONOCHROME PLATES

1 Auguste Rodin *Arthur Jerome Eddy* 1898. Bronze, 47.6 (18¾). Arthur Jerome Eddy Memorial Collection, 1931.502. © 1987 The Art Institute of Chicago. All Rights Reserved

2 *Still Life with Milk-can, Carafe, and Coffee Bowl* 1879–80. 45 × 53.9 (17¾ × 21¼). Hermitage Museum, Leningrad (Shchukin Collection). (V.337)

3 *Farmyard* c. 1879. 62.8 × 52 (24¾ × 20½). Musée d'Orsay, Paris (Caillebotte Bequest). (V.326)

4 Egisto Fabbri, photograph

5 *Boy in a Red Waistcoat* 1888–90. 88.1 × 72.3 (35¼ × 28½). Collection Mr. and Mrs. Paul Mellon, Upperville, Virginia. (V.682)

6 *Self-Portrait with a Beret* 1898–1900. 64.1 × 53.3 (25¼ × 21). Museum of Fine Arts, Boston (Purchase, Charles H. Bayley Picture and Painting Fund and partial gift of Elizabeth Paine Metcalf). (V.693)

7 *Still Life with Rum Bottle* c. 1890. 59.7 × 73 (23⅜ × 28¾). Private collection, New York (formerly collection Mary Cassatt). (V.606)

8 *Harvesters* c. 1880. 26 × 40.9 (10¼ × 16⅛). Private collection, Paris (formerly collection John Osborne Sumner, Boston). (V.1517)

9 *Gardanne* c. 1885. 63.5 × 99 (25 × 39). Barnes Foundation, Merion, Pennsylvania. (V.430)

10 *The Deep-Blue Vase* c. 1880. 34.3 × 29.8 (13⅝ × 11¾). Present whereabouts unknown (formerly collection Mrs. Montgomery Sears, Boston)

11 *The House of the Hanged Man, Auvers-sur-Oise* c. 1873. 54.6 × 66 (21⅝ × 26). Musée d'Orsay, Paris (Camondo Bequest). (V.133)

12 *Mardi Gras* 1888. 101.9 × 80.9 (40⅛ × 31⅞). Hermitage Museum, Leningrad (Shchukin Collection). (V.552)

13 *Melting Snow at Fontainebleau* 1879–80. 73.6 × 100.3 (29 × 39⅝). Museum of Modern Art, New York (Gift of Mr. and Mrs. André Meyer; formerly collection Claude Monet). (V.336)

14 *The Blue Vase* 1889–90. 61.9 × 51.1 (24⅜ × 20⅛). Musée d'Orsay, Paris (Camondo Bequest). (V.512)

15 James G. Huneker, photograph, 1900. Charles Scribner's Sons records, Archives of American Art, Smithsonian Institution. Photo Sarony

16 *The Abduction* 1867. 90.1 × 116.8 (35½ × 46). Fitzwilliam Museum (King's College), Cambridge (formerly collections Emile Zola and Havemeyer). (V.101)

17 *L'Estaque* 1879–83. 80 × 73.9 (31½ × 29⅛). Museum of Modern Art, New York (Gift of William S. Paley, the owner retaining a life interest; formerly collection Claude Monet). (V.492)

18 *Apples* c. 1878. 19 × 26.6 (17½ × 10½). Private collection, London (formerly collection Edgar Degas). (V.190)

19 *Bather with Outstretched Arms* 1877–78. 33 × 23.8 (13 × 9⅜). Private collection, Zürich (formerly collection Edgar Degas). (V.544)

20 and 21 Page from Vollard's ledger

22 *Landscape near Bellevue* 1892–95. 35 × 50 (14¼ × 19¾). Phillips Collection, Washington, D.C. (formerly collection Egisto Fabbri). (V.449)

23 *Turning Road at Auvers-sur-Oise* c. 1881. 59.7 × 73 (23⅜ × 28¾). Private collection, Scotland (formerly collection Charles A. Loeser). (V.127)

24 *Portrait of Gustave Boyer with Straw Hat* c. 1871. 54.6 × 38.7 (21⅝ × 15¼). Metropolitan Museum of Art, New York (The H. O. Havemeyer Collection; bequest of Mrs. H. O. Havemeyer). (V.131)

25 *Five Bathers* 1880–82. 59.7 × 73 (23⅜ × 28¾). Private collection, Paris (formerly collection Egisto Fabbri). (V.390)

26 *Five Bathers* 1879–80. 34.3 × 38.1 (13⅝ × 15). Detroit Institute of Arts (Robert H. Tannahill Bequest; formerly collection Egisto Fabbri). (V.389)

27 *Bathers* 1874–75. 36.8 × 45 (14¼ × 17¾). Metropolitan Museum of Art, New York (Bequest of Joan Whitney Payson, 1975; formerly collection Charles A. Loeser). (V.265)

28 *Still Life with Cherries* 1885–87. 50.1 × 60.9 (10¾ × 24). Los Angeles County Museum of Art (Gift of The Adele R. Levy Fund, Inc.; formerly collection Charles A. Loeser). (V.498)

29 *House on the Marne* 1888–90. 73 × 91.1 (28¾ × 35⅞). National Gallery of Art, Washington, D.C. (presented to the

government of the United States in memory of Charles A. Loeser)

30 *The Forest* 1890–92. 73 × 92 (28¾ × 36¼). National Gallery of Art, Washington, D.C. (presented to the government of the United States in memory of Charles A. Loeser). (V.645)

31 *Mont Sainte-Victoire and Hamlet near Gardanne* 1886–90. 62.2 × 91.1 (24⅝ × 35⅝). National Gallery of Art, Washington, D.C. (presented to the government of the United States in memory of Charles A. Loeser). (V.435)

32 Leo, Gertrude and Michel Stein in the courtyard of Leo and Gertrude's apartment, rue de Fleurus, Paris. Photograph, early 1906. Baltimore Museum of Art, The Cone Archives.

33 *The Conduit* c. 1879. 58.4 × 48.8 (23 × 19¼). Barnes Foundation, Merion, Pennsylvania. (V.310)

34 *Group of Bathers* 1898–1900. 26.7 × 46 (10⅝ × 18⅛). Baltimore Museum of Art (Bequest of Miss Etta and Dr. Claribel Cone; formerly collection Leo and Gertrude Stein). (V.724)

35 *Five Apples* 1877–78. 12.7 × 26.6 (5 × 10½). Collection Mr. and Mrs. Eugene V. Thaw, New York (formerly collection Leo and Gertrude Stein). (V.191)

36 *Man with Pipe* 1892–96. 26 × 20.3 (10¼ × 8). National Gallery of Art, Washington, D.C. (Gift of the W. Averell Harriman Foundation in memory of Marie N. Harriman; formerly collection Leo and Gertrude Stein). (V.566)

37 *The Smoker* 1890–91. Watercolor, 46.9 × 33.6 (18½ × 13¼). Barnes Foundation, Merion, Pennsylvania (formerly collection Leo and Gertrude Stein). (RWC.381)

38 *Mont Sainte-Victoire* 1900–02. Watercolor, 31.1 × 47.9 (12¼ × 18⅞). Cabinet des Dessins, Musée du Louvre, Paris (formerly collection Leo and Gertrude Stein). (RWC.502)

39 *Head of the Artist's Son* c. 1880. 17.1 × 14.9 (6¾ × 5⅞). Henry and Rose Pearlman Foundation, New York (formerly collection Michael and Sally Stein).

40 Michael and Sally Stein, Henri Matisse, Allan Stein, and Hans Purrman at Michael and Sally's apartment, rue Madame, Paris. Photograph, c. 1908. Baltimore Museum of Art, The Cone Archives.

41 *Landscape by the Waterside* 1878–80. Watercolor, 31.1 × 46.9 (12¼ × 18½). Private collection, New York (formerly collection Leo and Gertrude Stein). (RWC.95)

42 *Forest Path* 1882–84. Watercolor, 46.9 × 31.1 (18½ × 12¼). Private collection, Munich (formerly collection Leo and Gertrude Stein). (RWC.170)

43 *The Coach House at Château Noir* 1890–95. Watercolor, 30.4 × 47.6 (12 × 18¾). Barnes Foundation, Merion, Pennsylvania (formerly collection Leo and Gertrude Stein). (RWC.394)

44 *Olive Grove* c. 1900. Watercolor, 40.9 × 56.1 (16⅛ × 22⅛). Private collection, Hamburg (formerly collection Leo and Gertrude Stein). (RWC.522)

45 Leo Stein in the rue de Fleurus apartment, Paris. Photograph, c. 1906. Baltimore Museum of Art, The Cone Archives

46 Leo and Gertrude Stein's apartment, rue de Fleurus, Paris. Photograph, 1906. Baltimore Museum of Art, The Cone Archives

47 Morgan Russell *Three Apples* 1910. 24.7 × 30.7 (9¾ × 12⅛). The Museum of Modern Art, New York. Given anonymously

48 Alice B. Toklas and Gertrude Stein, rue de Fleurus, Paris, 1922. Photograph Man Ray. Baltimore Museum of Art, The Cone Archives, formed by Dr. Claribel and Miss Etta Cone

49 Alfred Maurer *Still Life* 1907–08. 54.6 × 45.7 (21½ × 18). Courtesy Salander-O'Reilly Galleries, New York

50 Alfred Maurer *Fauve Landscape*. 55.2 × 45.7 (21¾ × 18). Courtesy Salander-O'Reilly Galleries, New York

51 Stanton Macdonald-Wright *Still Life No. 1*. 40.6 × 50.8 (16 × 20). Columbus Museum of Art (Gift of Ferdinand Howald)

52 Andrew Dasburg *Floral Still Life* 1914. 50.8 × 40.6 (20 × 16). The Regis Collection, Minneapolis, Minnesota

53 Patrick Henry Bruce *Leaves* 1912

54 Patrick Henry Bruce *Still Life* 1911

55 Patrick Henry Bruce *Still Life* c. 1921–22. 88.9 × 116.2 (35 × 45¾). Whitney Museum of American Art, New York (anonymous gift)

56 Max Weber *The Apollo Plaster Cast in Matisse's Studio* 1908. 58.4 × 45.7 (23 × 18). Forum Gallery, New York

57 *Three Bathers* 1876–77. 52 × 54.6 (20½ × 21½). Musée de la Ville de Paris, Petit Palais, Paris (Gift of Henri Matisse). (V.381)

58 *Portrait of Ambroise Vollard* 1899. 100.3 × 81.2 (39½ × 32). Musée de la Ville de Paris, Petit Palais, Paris (Bequest of Ambroise Vollard). (V.696)

59 *see color plate V*

60 *Young Man with a White Scarf (Portrait of Louis Guillaume)* 1879–80. 55.8 × 46.9 (22 × 18½). National Gallery of Art, Washington, D.C. (Chester Dale Collection; formerly collection Egisto Fabbri). (V.374)

61 Cézanne letter to K.-X. Roussel, February 20, 1906

62 Entry from Charles Loeser's diary, February 20, 1909

63 *The Large Bathers* c. 1906. 208.2 × 248.9 (81 × 98). Philadelphia Museum of Art (Wilstach Collection). (V.719)

64 Page from *Burr-McIntosh Monthly* (March 1908), showing Cézanne article

65 Albert Marquet *River Landscape*. 50.4 × 62.8 (19⅞ × 24¾). Marlborough Fine Art Ltd., London (published in *Burr-McIntosh Monthly* as a painting by Cézanne)

66 *Still Life with Green Jug and Tin Kettle* 1867–69. 63.1 × 80 (24⅞ × 31½). Musée d'Orsay, Paris. (V.70)

67 *Self-Portrait* 1878–80. 60.9 × 46.9 (24 × 18½). The Phillips Collection, Washington, D.C. (V.290)

68 *The Banks of the Marne* 1888–90. 64.7 × 80.9 (25½ × 31⅞). Hermitage Museum, Leningrad (formerly collections H. O. Havemeyer, New York, and Ivan Morosov, Moscow). (V.630).

69 *The Gulf of Marseilles Seen from L'Estaque* c. 1885. 73 × 100.3 (28¾ × 39½). Metropolitan Museum of Art, New York (The H. O. Havemeyer Collection; bequest of Mrs. H. O. Havemeyer, 1929). (V.429)

70 *Mont Sainte-Victoire with Viaduct, Seen from Bellevue* 1882–85. 65.4 × 81.5 (25¾ × 32⅛). Metropolitan Museum of Art, New York (The H. O. Havemeyer Collection; bequest of Mrs. H. O. Havemeyer, 1929). (V.452)

71 Edward Steichen *Alfred Stieglitz at "291"* 1915. Photograph. Metropolitan Museum of Art, New York (Alfred Stieglitz Collection, 1933)

72 Walter Sickert *Self-Portrait* 1897. Grey wash, pencil on paper, 24.7 × 19.6 (9¾ × 7¾). Present whereabouts unknown

73 *Turning Path with Well in the Park of Château Noir* c. 1900. Watercolor, 64.8 × 49.5 (25⅝ × 19⅝). Present whereabouts unknown. (RWC.513)

74 *Mont Sainte-Victoire* 1885–87. Watercolor, 31.4 × 47.6 (12⅜ × 18¾). The Home House Society Trustees, Courtauld Institute Galleries, London. (RWC.279)

75 *Roofs and a Tree* 1888–90. Watercolor, 40 × 45.4 (15¾ × 17⅞). Museum Boymans-van Beuningen, Rotterdam. (RWC.360)

76 *The Large Pine Tree* c. 1890. Watercolor, 27.6 × 43.8 (10⅞ × 17¼). Künsthaus, Zürich. (RWC.287)

77 *Trees and Rocks* c. 1890. Watercolor, 42.5 × 29.2 (16¾ × 11½). Philadelphia Museum of Art (The S. S. White III and Vera White Collection). (RWC.328)

78 *Group of Trees* 1880–85. Watercolor, 28.8 × 46 (11⅜ × 18⅛). Philadelphia Museum of Art (Louise and Walter Arensberg Collection). (RWC.233)

79 *The Well in the Park of Château Noir* 1896–98. Watercolor, 47.6 × 30.7 (18¾ × 12⅛). Collection Mr. and Mrs. John W. Warrington, Cincinnati, Ohio. (RWC.428)

80 *Washerwomen* c. 1880. Watercolor, 31.1 × 46.9 (12¼ × 18½). Private collection, Zürich. (RWC.103)

81 *The Mill on the Banks of La Couleuvre near Pontoise* 1881. 72.3 × 89.8 (28½ × 35⅜). Nationalgalerie, East Berlin (Gift of Wilhelm Staudt, 1897). (V.324)

82 *Still Life with Fruit and Flower Holder* c. 1905. 81.2 × 100.4 (32 × 39⅝). National Gallery of Art, Washington, D.C. (Gift of Eugene and Agnes E. Meyer)

83 *The Old Sailor* 1905–06. 107.9 × 74.6 (42¼ × 29⅜). National Gallery of Art, Washington, D.C. (Gift of Eugene and Agnes E. Meyer)

84 *The Old Sailor, Full Face* 1905–06. 100.3 × 81.2 (39½ × 32). Private collection, Geneva (formerly collection Josef Müller, Switzerland). (V.717)

85 *Toward Mont Sainte-Victoire* 1878–79. 45 × 53.3 (17¾ × 21). First purchase made by William Glackens for Albert C. Barnes. Barnes Foundation, Merion, Pennsylvania. (V.424)

86 *Five Bathers* 1877–78. 39.3 × 41.9 (15½ × 16½). Purchased by Albert C. Barnes at the Henri Rouart Sale in Paris, 1912. Barnes Foundation, Merion, Pennsylvania. (V.383)

87 *Grapes and a Peach on a Plate* 1877–79. 16.5 × 28.8 (6½ × 11⅜). Purchased by Albert C. Barnes at the Henri Rouart Sale in Paris, 1912. Barnes Foundation, Merion, Pennsylvania. (V.192)

88 One of the Van Gogh rooms at the "Sonderbund" exhibition in Cologne, 1912. Photograph

89 Roger Fry (?) *View of the Second Post-Impressionist Exhibition, London, 1912.* Musée d'Orsay, Paris. Photo Réunion des musées nationaux

90 Still from Jean Luc Godard's movie *Bande à Part* 1964, used as a hypothetical photograph of Kenyon Cox running through the Armory Show while reviewing it, 1913

91 James McNeill Whistler *Portrait of Arthur Jerome Eddy* 1894. 80.2 × 93.3 (31½ × 36¾). Arthur Jerome Eddy Memorial Collection, 1931.501. © 1987 The Art Institute of Chicago. All Rights Reserved

92 *Portrait of Gustave Boyer* c. 1870. 59.7 × 45 (23⅜ × 17¾). Collection Bernoulli-Bernasconi, Basel. (V.130)

93 The Armory Show in New York, 1913. Photograph courtesy Professor Milton W. Brown

94 and 95 Installation of the Armory Show in Chicago, 1913. Photograph

96 *The Road* c. 1871. 59.6 × 72.3 (23½ × 28½). Collection Mr. and Mrs. William Rosenwald, New York (formerly collections Enrico Costa and Lillie P. Bliss). (V.52)

97 *Four Bathers* 1877–78. 38.1 × 46 (15 × 18⅛). Private collection, Japan. (V.384)

98 *Landscape near Melun* c. 1879. 59.7 × 73 (23⅜ × 28¾). Najonalgaleriet, Oslo (Gift of Tryggve Sagen). (V.304)

99 *Landscape near Auvers-sur-Oise* c. 1881–82. 90.2 × 73.3 (35⅝ × 28⅞). Private collection, Lausanne. (V.312)

100 *Self-Portrait with Bowler Hat* c. 1885. 44.4 × 35.5 (17½ × 14). Ny Carlsberg Glyptotek, Copenhagen. (V.514)

101 *Portrait of the Artist's Wife* c. 1865. 46 × 38.1 (18⅛ × 15). Collection Heinz Berggruen, Geneva. (V.520)

102 *see color plate X*

103 *Self-Portrait with a Felt Hat* c. 1890. 59.7 × 48.8 (23⅜ × 19¼). Bridgestone Museum, Tokyo. (V.579)

104 Vollard letter to Bryson Burroughs, 1913. Archives, Metropolitan Museum of Art, New York. Unpublished document

105 *The Artist's Father reading "L'Evénement"* 1866. 198.7 × 120 (78¼ × 47¼). National Gallery of Art, Washington, D.C. (Collection of Mr. and Mrs. Paul Mellon, 1970). (V.91)

106 *Struggling Lovers* c. 1880. 37.7 × 46.3 (14⅞ × 18¼). National Gallery of Art, Washington, D.C. (Gift of the W. Averell Harriman Foundation in memory of Marie N. Harriman). (V.380)

107 *The Harvest* c. 1877. 45.7 × 55.2 (18 × 21¾). Private collection, Japan. (V.249)

108 *Cardplayers* 1890–92. 135.2 × 181.6 (53¼ × 71½). Barnes Foundation, Merion, Pennsylvania. (V.560)

109 *Still Life with Basket of Apples* c. 1893. 65.4 × 81.2 (25¾ × 32). Art Institute of Chicago (Helen Birch Bartless Memorial Collection). (V.600)

110 *Woman with a Boa* (after El Greco) c. 1885. 53.3 × 48.8 (21 × 19¼). Private collection, Lausanne. (V.376)

111 *The Smoker* c. 1891. 92 × 73 (36¼ × 28¾). Kunsthalle Mannheim, Germany (by 1914). (V.684)

112 *The Young Philosopher* 1896–98. 127 × 94.6 (50 × 37¼). Barnes Foundation, Merion, Pennsylvania. (V.679)

113 Marius de Zayas *Portrait of Paul B. Haviland* c. 1910. Francis M. Naumann, New York

114 F. W. Ruckstull *Evening* c. 1887. Marble (?). Honorable mention at the Paris Salon of 1888. Grand Gold Medal, Chicago World's Fair. Metropolitan Museum of Art, New York

115 *House in front of Mont Sainte-Victoire near Gardanne* 1886–90. 65.4 × 81.2 (25¾ × 32). The John Herron Art Institute Museum, Indianapolis (Gift of Mrs. James W. Fessler). (V.433)

116 Paul Cézanne in his Lauves Studio in front of his large composition of *Bathers.* Photograph by Emile Bernard, 1904

117 Photograph of Willard Huntington Wright, c. 1916. Reproduced from *The Smart Set,* Papers of Willard Huntington Wright, Princeton University Library

118 *Mont Sainte-Victoire with a Large Pine Tree* c. 1887. 66.6 × 91.7 (26¼ × 36⅛). Courtauld Institute Galleries, London. (V.454)

119 *Still Life with Apples and Oranges* c. 1899. 73.9 × 92.7 (29⅛ × 36⅝). Musée d'Orsay, Paris (Camondo Bequest). (V.732)

120 Florine Stettheimer *Studio Party* after 1915. Collection of American Literature, Beinecke Rare Book & Manuscript Library, Yale University

121 *Group of Bathers* 1892–94. 29.2 × 39.3 (11½ × 15½). Barnes Foundation, Merion, Pennsylvania (formerly collection Leo and Gertrude Stein). (V.590)

122 *see 35*

123 *see 33*

124 *The Artist's Wife in a Green Hat* 1891–92. 97.7 × 80 (38½ × 31½). Barnes Foundation, Merion, Pennsylvania. (V.704)

125 *Still Life with Bottle, Tablecloth, and Fruits* c. 1890. 47.6 × 71.1 (18¾ × 28). Barnes Foundation, Merion, Pennsylvania. (V.605)

126 Dr. Albert C. Barnes. Photograph by Carl Van Vechten

127 Durand-Ruel invoice to Albert C. Barnes of July 8, 1920. Unpublished document

128 *The Arc Valley and Mont Sainte-Victoire* 1892–95. 71.1 × 90.1 (28 × 35½). Barnes Foundation, Merion, Pennsylvania (formerly collection Hoogendijk). (V.457)

129 *House near Aix-en-Provence* c. 1886. 64.8 × 82.5 (25⅝ × 32½). Dallas Museum of Art (The Wendy and Emery Reves Collection; formerly collections Hoogendijk and Barnes Foundation). (V.451)

130 *Saint-Henri near L'Estaque, seen from afar* c. 1876. 43.1 × 80 (17 × 31½). Barnes Foundation, Merion, Pennsylvania (formerly collection Hoogendijk). (V.293)

131 *Still Life with Jug and Fruits* 1893–94. 40.9 × 72 (16⅛ × 28⅜). Present whereabouts unknown (formerly collections Hoogendijk and Barnes Foundation). (V.499)

132 *Still Life with Apples and a Pear on a Plate* 1895–98. 44.4 × 52 (17½ × 21½). Barnes Foundation, Merion, Pennsylvania (formerly collection Hoogendijk). (V.740)

133 *Still Life with Milk-pot and Curtain* 1892–94 (unfinished). 63.5 × 53.9 (25 × 21¼). Barnes Foundation, Merion, Pennsylvania (formerly collection Hoogendijk). (V.745)

134 *Still Life with Potted Plants, a Coffee Pot, and a Rum Bottle* c. 1890. 90.8 × 71.7 (35¾ × 28¼). Barnes Foundation, Merion, Pennsylvania (formerly collection Hoogendijk). (V.602)

135 *Chrysanthemums* 1896–98. 69.8 × 57.1 (27½ × 22½). Barnes Foundation, Merion, Pennsylvania (formerly collection Hoogendijk). (V.755)

136 *Still Life of Fruits against a Blue Curtain* 1893–94. 25 × 35.5 (9⅞ × 14). Barnes Foundation, Merion, Pennsylvania (formerly collection Hoogendijk). (V.611)

137 *Still Life with Ginger Jar, Fruits, and Towel* c. 1895. 72.3 × 59 (28½ × 23¼). Barnes Foundation, Merion, Pennsylvania (formerly collection Hoogendijk). (V.737)

138 *Still Life of Fruits in a Dish and a Small Pot of Preserves* 1880–81. 19.6 × 35.5 (7¾ × 14). Barnes Foundation, Merion, Pennsylvania (formerly collection Hoogendijk). (V.363)

139 *Still Life of a Skull and Fruits* 1896–98. 53.9 × 64.8 (21¼ × 25⅝). Barnes Foundation, Merion, Pennsylvania (formerly collection Hoogendijk). (V.758)

140 *Bathers Resting* 1876–77. 79 × 97.1 (31⅛ × 38¼). Barnes Foundation, Merion, Pennsylvania (formerly collection Gustave Caillebotte and refused by the French government with his bequest). (V.276)

141 *Mill* 1888–90. 63.5 × 79.3 (25 × 31¼). Barnes Foundation, Merion, Pennsylvania. (V.646)

142 *Still Life with Putto c.* 1895. 69.8 × 57.1 (27½ × 22½). Courtauld Institute Gallery, University of London. (V.706)

143 List of works by Cézanne lent by the Bernheim-Jeune Gallery of Paris to the Montross Gallery, New York, in 1916. Unpublished document

144 *Seven Apples and a Tube of Color* 1878–79. 17.1 × 24.1 (6¾ × 9½). Musée Cantonal, Lausanne. (V.195)

145 *Turning Road in a Forest c.* 1873. 55.2 × 45.7 (21¾ × 18). Solomon R. Guggenheim Museum, New York (partial Gift of George Tetzel in memory of Oscar Homolka and Joan Tetzel Homolka). (V.140)

146 *The Oil Mill c.* 1872. 36.8 × 45 (14½ × 17¾). Present whereabouts unknown. (V.136)

147 *View of L'Estaque and the Château d'If* 1883–85. 71.1 × 57.7 (28 × 22¾). Fitzwilliam Museum, Cambridge. (V.406)

148 *see 7*

149 *Rocks and Trees* 1890–95. Watercolor, 44.4 × 29.2 (17½ × 11½). Collection Mr. and Mrs. John W. Warrington, Cincinnati, Ohio (formerly collection Arthur B. Davies). (RWC.399)

150 *Self-Portrait* (after a photograph) *c.* 1885. 55.2 × 46.3 (21¾ × 18¼). Museum of Art, Carnegie Institute, Pittsburgh (acquired through the generosity of the Sarah Mellon Scaife family). (V.1519)

151 *Conversation (The Two Sisters)* 1870–71. 91.7 × 73 (36⅛ × 28¾). Bernheim-Jeune, Paris. (V.120)

152 *The Roofs of L'Estaque* 1883–85. 60.6 × 70.4 (23⅞ × 27¾). Collection Mr. and Mrs. John L. Loeb, New York. (V.405)

153 *Cardplayers* 1892–93. 96.8 × 130.1 (38⅛ × 51¼). Private collection, Switzerland. (V.556)

154 *Bouquet of Flowers* 1900–03. 101.6 × 82.5 (40 × 32½). National Gallery of Art, Washington, D.C. (Gift of Eugene and Agnes E. Meyer). (V.757)

155 Bill of the Modern Gallery for purchases made by Eugene Meyer, New York, August 28, 1916. Unpublished document

156 *The Large Bather c.* 1885. 127 × 96.8 (50 × 38⅛). Museum of Modern Art, New York (Lillie P. Bliss Bequest). (V.548)

157 *Still Life with Green Jar and White Cup c.* 1877. 60.6 × 73.6 (23⅞ × 29). Metropolitan Museum of Art, New York (H. O. Havemeyer Collection; bequest of Mrs. H. O. Havemeyer). (V.213)

158 *Rocks at Fontainebleau* 1893–94. 73.3 × 92.3 (28⅞ × 36¾). Metropolitan Museum of Art, New York (H. O. Havemeyer Collection; bequest of Mrs. H. O. Havemeyer). (V.673)

159 *Pines and Rocks (Fontainebleau?)* 1896–99. 81.2 × 65.4 (32 × 25¾). Museum of Modern Art, New York (Lillie P. Bliss Collection). (V.774)

160 *Still Life with Fruits and Wine-glass* 1877–79 (fragment). 26.3 × 32.7 (10⅜ × 12⅞). Philadelphia Museum of Art (Louise and Walter Arensberg Collection)

161 *Houses in Provence* 1878–82. 81.2 × 64.7 (25½ × 32). National Gallery of Art, Washington, D.C. (Collection of Mr. and Mrs. Paul Mellon). (V.397)

162 *Group of Bathers* 1892–94. 21.5 × 30.7 (8½ × 12⅛). Philadelphia Museum of Art (Louise and Walter Arensberg Collection)

163 *Bathers* 1885–90. Watercolor, 12.7 × 20.6 (5 × 8⅛). Museum of Modern Art, New York (Lillie P. Bliss Collection). (RWC.130)

164 *Bathers under a Bridge c.* 1900. Watercolor, 20.9 × 26 (8¼ × 10¼). Metropolitan Museum of Art, New York (Maria De Witt Jesup Fund, acquired from the Museum of Modern Art, Lillie P. Bliss Collection). (RWC.601)

165 *see 19*

166 *Provençal Landscape* 1892–95. 82.5 × 66 (32½ × 26). Museum of Art, Carnegie Institute, Pittsburgh (acquired through the generosity of the Sarah Mellon Scaife family). (V.472)

167 *Four Peaches on a Plate* 1890–94. 24.1 × 36.1 (9½ × 14¼). Barnes Foundation, Merion, Pennsylvania (formerly collection D. K. Kelekian). (V.614)

168 *Still Life with Apples* 1895–98. 68.5 × 92.7 (27 × 36½). Museum of Modern Art, New York (Lillie P. Bliss Collection; formerly collection D. K. Kelekian). (V.736)

169 and 170 Installation photographs of the "Loan Exhibition of Impressionist and Post-Impressionist Paintings" at the Metropolitan Museum, New York, 1921

171 *Portrait of Uncle Dominique c.* 1866. 80 × 64.1 (31⅝ × 25¼). Metropolitan Museum of Art, New York. (V.73)

172 *Still Life with Ginger Jar, Sugar Bowl, and Oranges* 1902–06. 60.6 × 73.3 (23⅞ × 28⅞). Museum of Modern Art, New York (Lillie P. Bliss Collection; sold by Marius de Zayas). (V.738)

173 Piero della Francesca *Crucifixion.* Copyright The Frick Collection, New York

174 *Mont Sainte-Victoire with Pine Trees* 1886–87. 59.6 × 72.3 (23½ × 28½). The Phillips Collection, Washington, D.C. (V.455)

175 Charles Loeser, diary entry concerning the sale of the Kelekian collection, 1922. Unpublished document

p. 103 Cézanne's tomb in Aix-en-Provence. Photograph

INDEX

Roman numerals in *italic* refer to the color plates; page numbers in *italic* to the illustrations

A-B-C of Aesthetics 249

Abduction, The 43, 44, 99, 306, 307

Académie Julian 31, 53

Adam, Paul 201

Aix-en-Provence 42, 44, 55, 97, 98, 99, 118, 205, 206, 227

Albright Art Gallery, Buffalo 342

Alexander, John W. 203, 205

Altman, Benjamin 121

American Academy of Design 203

American Art News 136, 291, 320, 333

American Federation of Arts 323

American Magazine of Art 323

Anarchie dans l'Art, L' 16

Anderson, Margaret Steele 220–21

Apollinaire, Guillaume 130, 245

Apollo Plaster Cast in Matisse's Studio, The (Weber) 80, 82

Apples 44, 45

Arc Valley and Mont Sainte-Victoire, The 271, 272, 272

Arden Gallery 306, 308

Arensberg, Mr., Mrs. Walter C. 203, 246, 308, 323

Armory Show 27, 40, 165–6, 168, 170, 171, 172–5, 179–96, 191, 195, 198–205, 207, 211, 243, 263; in Chicago 191, 192, 193

Art Amateur Magazine 13

Art and Criticism 13

Art and I 231

Art Institute, Chicago 188, 191, 342

Art Journal (London) 16, 156

Art moderne, L' 43

Art World, The (journal) 331

Artist's Father reading "L'Evénement", The 210, 219

Artist's Wife in a Green Hat, The 262, 268, 343

Arts and Decoration 182

Association of American Painters and Sculptors 157, 168, 179

Autobiography of Alice B. Toklas 71, 256

Auvers-sur-Oise 116, 192, 195, 196, 197

Baigneuses 192

Bakwin, Drs. Harry and Ruth 342

Banks of the Marne, The 122, 123

Barnes, Dr. Albert C. 63, 68, 74, 161, 162, 165, 174, 246, 248–9, 251–3, 256, 259, 263–78, 268, 270, 311, 333–4, 343

Barr, Alfred H. Jr. 342

Barrès, Maurice 267

Basel (Cézanne retrospective) 338

Bather with Outstretched Arms 44, 45, 319, 320

Bathers 230, 231

Bathers (RWC.130) 314, 316

Bathers (V.265) 52, 53, 337

Bathers Resting 276, 277

Bathers under a Bridge 314, 316

Beckwith, Carrol 308

Bell, Clive 61, 73, 133, 245

Bell, Vanessa 137

Bellows, Georges 188

Benton, Thomas Hart 317

Berenson, Bernard 19–20, 22, 26, 34, 66, 68, 71,

133–4, 135, 245, 344
Bernard, Emile 92–3, 101, 114–15, 116, 118, 119, 130, 155, 165, 182, 225, 227, 238, 250, 338, 344
Bernheim-Jeune Gallery 37, 40, 44, 56, 90, 92, 110, 111, 130, 133, 141, 155, 156, 159, 161, 164, 166, 168, 171, 172, 213, 269, *288, 289,* 289, 308
Bernstein, M. 159
Bibémus 172, 206
Bignou, Etienne 343
Bingham, Mrs. Henry Payne 323
Birnbaum, Martin 168
Blashfield 188
Bliss, Lillie P. 151, 165, 169, 170, 193, 203, 305, 306, 307–8, 317, 319, 323, 335, 341, 342
Blot, Eugène 37, 39–40, 93
Bluemner, Oscar 181–2, 212
Blumenthal, George 205
Boat in Front of Trees 146
Bois, Guy Pène du 131, 182
Bollag, Gustav and Leon 319
Bonnard, Pierre 64, 93, 130, 167, 170, 171
Boston 114, 192
Boston Herald 332
Boudin, Eugène 101, 134
Bouguereau, William 95, 109–110, 308–9
Bouquet of Flowers 302, 302, 306
Bourgeois, Stephen 173, 174, 192, 199, 301
Boy in a Red Waistcoat 23, 25, 337
Boyer, Gustave *190,* 193, 306
Brancusi, Constantin 158, 174, 180, 308
Braque, Georges 77, 167, 191, 287, 305
Bridgman, Frederic A. 16
Brooklyn Daily Eagle 139, 149, 320
Brooklyn Museum Exhibition 319, 320, 351, 342
Brown, John Nicholas 342
Bruce, Patrick Henry 76, *79,* 81
Brugière 174
Bulletin of the Metropolitan Museum of Art 205
Burlington Magazine 118, 135, 149–50, 184
Burr, Dr. Charles W. 318
Burr-McIntosh Monthly 117, 117
Burroughs, Bryson 121, 157, 163, 165, 203–5, 206, 207, 323, 324–5, 326

Cabanel, Alexandre 108
Caffin, Charles H. 155–6, 244, 245
Camera Work 146, 155, 174, 181, 222, 287
Camondo, Count Isaac de 37, 39; bequest 165
Cardozo, Sousa 191, 223
Cardplayers (Joueurs de Cartes, V.556) *301,* 302
Cardplayers (V.560) *214,* 219
Carles, Arthur B. 76, 312, 317
Carrière, Eugène 93, 95, 99
Carstairs, Charles 203
Cassatt, Mary 11, 15, 16, 25–6, 41, 72, 94, 109, 122, 130, 163, 164, 165, 290, 306, 312, 317, 343
Cassirer, Paul and Bruno 133
Central Italian Painters of the Renaissance 22, 134
Certains 42
Champs de Mars Salon 1901 40, 99
Chardin, J.-B.-S. 53, 96, 99, 102, 158
Chase, William Merrit 81, 112, 165, 188, 189
Château Noir 206
Château Noir 302, 306, *XV*
Child, Theodore 13
Chocquet, Victor 34, 37, 39, 93, 111, 122, 344
Christian Science Monitor 231, 305
Chrysanthemums 271, *275*
Cincinnati Times Star 332
Coady, Robert J. 76, 226
Coburn, F. W. 332
Coe, Ralph M. 342
Colline des Pauvres: see The Hill of the Poor
Cologne 166, 168, 171, 212
Columbian Exposition (1893), Chicago 11

Conduit, The 55, *57, 256,* 256, *257,* 257
Cone, The Misses 342
Conversation (The Two Sisters) 300, 301
Corot, Camille 99, 162, 179, 319
Cortissoz, Royal 103, 185–6, 199, 226–7, 244, 295–6, 297
Costa, Enrico 169, 193, 306
Coubine, Ottokar 259
Courbet, Gustave 99, 163, 240, 319, 323
Couvent des Oiseaux 81, 200
Cox, Kenyon 186, *188,* 188, 201, 224, 229
Creative Will: Studies in the Philosophy and the Syntax of Aesthetics, The 249
Cross, H.-E. 133, 167
Crowninshield, Frederick 188
Crucifixion (Pierro della Francesca) *340,* 340
Cubism 74, 75, 76, 155, 186
Cubists and Post-Impressionism 224
Curtain of Trees, A 148, 149

Dale, Mr. and Mrs. Chester 342
Dance at the Spring (Picabia) 223
Danseuses à la barre (Degas) 164
Darmstadt 212
Dasburg, Andrew 66–7, 77, *79,* 89, 132
Daugherty, Paul 323
Daumier, Honoré 49, 162, 179
Davies, Arthur B. 122, 125–6, 132, 141, 151, 157, 165, 166, 168, 169, 170, 172, 174, 175, 179, 188, 189, 190, 193, 202–3, 212
Davis, Stuart 184
Dawson, Manierre 77, 223
Deep Blue Vase, The 31, 34, 130, 173, 192, 196–8
Degas, Edgar 44, 47, 64, 92, 95, 97, 109, 110, 137, 156, 162, 164, 165, 174, 180, 224, 267, 325
Degeneration 115
Delacroix, Eugène 80, 99, 108, 162, 216, 308
Delight the Soul of Art 223
Demuth, Charles 201
Denis, Maurice 40, 41, 64, 75, 95, 97–8, 99, 107, 114–15, 116, 133, 155, 165, 170, 182, 344, *III*

Derain, André 77, 133, 167
Dercum, Dr. Francis X. 318, 333–4
Detaille, Edouard 40
Development of Modern Art 116, 140
Dewey, John 277
Dewhurst, Wynford 101, 117
Dickinson, Preston 61n17
Dieterle, Jean 338–9
Dine, S. S. Van 341
Dodge, Mabel 63–4, 175, 247
Dove 287
Dresden 112, 135, 171
Druet, Eugène 133, 170, 171, 174, 192, 200
Duchamp, Marcel 165, 180, 182, 190, 308
Durand-Ruel Galleries 12, 13, 14, 37, 40, 41, 44, 66, 90, 92, 100, 119, 121, 122, 130–31, 133, 134, 141, 156, 161, 171, 174, 180, 256, 263, 265–70 passim, 312
Durand-Ruel, George 122–4, 264
Durand-Ruel, Jeanne 276–7
Durand-Ruel, Joseph 122–3, 264
Durand-Ruel, Paul 13, 37, 122
Duret, Théodore 43, 94, 100, 116, 140, 161
Duveen 339–40

Echo de Paris 101
Ecole des Beaux-Arts 31, 102
Eddy, Arthur Jerome 12, 188, *189,* 190–91, 222–5, 263
El Greco 74, 130, 167, 219, 254, 267
Enlèvement, L': see The Abduction
Ernst, Agnes 77, 158; *see also* Meyer, Mrs. Agnes Ernst
Estaque and the Bay of Marseilles, L' 124, 125, 311
Estaque, L' (V.428) 19, 20, *II*

Estaque L' (V.492) 44, *45*
Evening (Ruckstull) *228,* 228
Evening Mail, The (New York) 146

Fabbri, Egisto 12, *22,* 22, 24–6, 44, 49, 55, 56, 97, 130, 136, 156, 165, 171, 215, 337, 338, 339, 342, 344
Fantin-Latour, Henri 40, 134
Farmyard 15, *21*
Faure, Elie 132, 182–3
Fauve Landscape (Maurer) 76, *78*
Fauves, Fauvism 74, 81, 111, 204, 225
Femme à l'éventail, La: see Portrait of the Artist's Wife (V.369)
Femme au Chapelet: see Woman with a Rosary
Fénéon, Félix 141, 201, 289
Field, Hamilton Easter 320, 332
Five Apples 56, *58,* 67, *256,* 256
Five Bathers 162, *163*
Floral Still Life (Dansburg) *79*
Florence, Italy 53, 76, 134, 338, 344
Forain, Jean-Louis 109–10
Forest, Robert de 204, 205, 320, 323
Forest, The 54, 55
Forum Exhibition 247
Fountain, The 149, 149
Four Bathers 172, 194, *195*
Four Peaches on a Plate 320, *322*
Francesca, Piero della 71, 339, *340*
François Zola Dam, The 286, 290
Freer, Charles 319
French Impressionists, The 100
French, Daniel Chester 205
Freud, Sigmund 247, 252
Frick, Henry Clay 203
Fry, Roger 14, 61, 110, 117, 118, 133–7, 139, 149–50, 157, 165, 166, 171, 172, 179, 182, 185, 203, 245, 308, 325, 334, 340, 344
Funeral, The 121

Gachet, Dr. Paul 116
Gardanne 29, 337
Gauguin, Paul 41, 47, 64, 74, 75, 90, 93, 133, 136, 140, 141, 162, 165–7, 170–71, 180, 182, 186, 191, 213, 221, 287, 288, 319, 325, 342
Gazette des Beaux-Arts 97
Geffroy, Gustave 14–15, 43, 102, 116
Gérôme, Léon 16, 108
Giacometti, Alberto 338
Gil Blas 101
Gill, Eric 185
Glackens, William 157, 161, 165, 174
Gogh, Vincent van 64, 74, 75, 77, 80, 82, 116, 117, 133, 136, 141, 155, 156, 165, 166–7, 168, *169,* 171, 174, 180, 181, 182, 183, 186, 190, 216, 287, 342
Goodyear, A. Conger 342
Grafton Exhibition 133, 135, 136–7, 171, 172
Grafton Galleries, London 133, 180, 245
Grafton Post-Impressionist Exhibition 133, 165
Grapes and a Peach on a Plate 162, *164*
Gregg, Frederick James 179, 289
Group of Bathers 314, 316
Group of Bathers (V.590) 248, *249,* 256
Group of Bathers (V.724) 56, *58*
Guillaume, Louis 98
Guillaume, Paul 343
Gulf of Marseilles Seen from L'Estaque, The 124, 125, 311

Hallowell, Sara 11, 12, 13, 14, 26, 34, 334, 337
Halvorsen, Walther 308
Hapgood, Hutchins 68
Harper's Weekly 13, 187
Hartley, Marsden 76, 125, 129, 131, 151, 174, 186, 192, 247
Harvest, The 214, 219
Harvesters 27, 173, 192, 196
Hassam, Childe 31
Havemeyer, H. O. and L. 11, 26–7, 44, 49, 56,

61, 92, 99, 110, 121, 122, 125–6, 165, 174, 343
Havemeyer, Lousine 26–7, 34, 92, 122, 123, 124–5, 156, 163–4, 193, 271, 306, 334, 343
Haviland, Paul B. 222, *223*
Head of the Artist's Son 60, *60*
Henraux, Lucien 338
Henri, Robert 31, 81, 187, 224, 247, 332
Hermitage Museum, Leningrad 12n3
Hessel, Jos. 156, 174, 269
Hill of the Poor, The 192, 200, 204, 205, 207, 325, *IX*
Hind, C. Lewis 61, 186, 231
Hirschland, Dr. F. H. 342
Histoire des peintres impressionniste 100
Holmes, C. J. 137, 165, 201–2
Homage to Cézanne (Denis) 40, 41, 42, 95, 99, *III*
Homage to Manet (Fantin-Latour) 40
Homer, Winslow 224, 309
Hoogendijk, Cornelis 44, 268–9, 270–71, 344
Hopper, Edward 61n17, 98
Horne, Sir William Van 173, 192, 200, 212
House in front of Mont Sainte-Victoire near Gardanne 229, *230*
House near Aix-en-Provence 271, *273*
House of the Hanged Man, The 32, 37
House on the Marne 54, 55
Houses in Provence 314, *315*, 337
Huneker, James Gibbons 41–2, *43*, 44, 95, 96, 97, 99, 100, 101, 102, 103, 110, 112, 114, 115, 118, 119, 121, 122–3, 130–31, 140, 212, 220, 227, 245, 295
Huysmans, J. K. 42–3, 103

Impressionist Painting, Its Genesis and Development 101
Impressionist Show, New York 41
International Exhibition, New York 216

Jeune homme au foulard blanc: see Young Man with a White Scarf
John, Augustus 139, 141, 173, 174, 180, 185
Johnson, John G. 204–5, 207, 268
Joueurs de Cartes: see Cardplayers

Kahnweiler, Henry D. 173, 174, 263
Kandinsky, Vasili 167, 192, 222
Kelekian, Dikran K. 319, 320, 341, *342*
Kent, Rockwell 76, 182
Klee, Paul 167, 223
Kneeling Woman (Lehmbruck) 167
Knoedler Galleries 203, 301, 338
Kokoschka, Oskar 167, 168
Kozmutza, Ottilie de 117
Kroll, Leon 191, 224
Kropotkin, Piotr Alexevich 140
Kuhn, Walt 141, 157, 168–9, 171, 172, 182, 188, 203

Landscape 192, *194*, 194
Landscape in Provence 320, *321*, 327, 341
Landscape near Melun 192, 195, *196*
Landscape with Figures 306
Lantier, Claude 100
Large Bather, The 305, *307*
Large Bathers, The 112, *113*
Large Pine Tree, The 144, *145*
Lauves 119, *231*
Lawson, Ernest 31
Leaves, Leaves 1912 (Bruce) *79*
Lecomte, Georges 37–9, 43
Lee, Vernon 252
Lehmbruck, Wilhelm 167, 168
Leibl, Wilhelm 168
Les Amateurs d'Estampes 49
Lewisohn, Adolph 301, *312*, 317, 323, 325, 335, 342
Lhermitte, L. 110
Loan Exhibition of Impressionist and Post-Impressionist Paintings 320–34

Loeser, Charles M. 20–21, 22, 26, 34, 44, 49, 53, 55, 56, 63, 74, 98, 109, 113, 124, 134, 169, 171, 257, 337, 338, 339, 343–4
Los Angeles Times 237
Louvre 102, 165, 240
Luks, George 122
Luxemburg Museum, Paris 15, 19, 37, 61, 75

Macbeth Gallery 114, 169–70, 174
MacColl, D. S. 135, 137, 185
Macdonald-Wright, Stanton 76, *78*, 211, 237, 317, *XII*
Madame Cézanne: see Portrait of the Artist's Wife (V.229, V.369, V.520)
Madame Cézanne and Hortensias 143, 149, *VIII*
Madame Cézanne with a Green Hat: see The Artist's Wife in a Green Hat
Madame Charpentier and Her Children 110, 325
Maillol, Aristide 82
Man with Pipe 56, *58*
Manet, Edouard 110, 116, 121, 132, 133, 136, 162, 179, 216, 223, 240, 325
Marcel, Henri 96
Mardi Gras 33, 34, 37
Marin, John 131, 146, 180, 287
Marin, Le 160, 305
Marks, Montague 11n1
Marquet, Albert *117*, 118, 133
Marx, Roger 43
Mather, Frank Jewett, Jr. 27, 103, 185, 194, 201, 244, 245, 297–8
Matisse, Henri *61*, 61, 63, 66, 68, 71, 73, 74, 75, 77, 81, 82, 92, 93, 111, 130, 133–4, 136, 155, 163, 165, 167, 171, 174, 180, 182, 183, 185, 190, 194, 216, 221, 229, 253, 255, 258, 278, 288, 311, 319, 320, 325
Mauclair, Camille 100, 115, 116, *117*, 122, 137
Maurer, Alfred 31, 63, 76, *78*, 80, 131, 161, 169
McBride, Henry 206, 207, 246, 291, 306, 311
Meier-Graefe, Julius 44, 116–17, 140, 167, 268, 344
Melun 192, 194–5, *196*
Mencken, H. L. 237, 238
Mercure de France 118
Metropolitan Museum, New York 110, 121, 136, 156–7, 203, 204, 311, 317, 320, 323, 324, 325, 328, 331, 332, 341, 342, 343
Meyer, Mr. and Mrs. Eugene 158, 161, 165, 170, 174, 222, 226, 305, 317
Meyer, Mrs. Agnes Ernst 287, 305, 306, 308, 323; *see also* Ernst, Agnes
Michelangelo 66, 230, 254
Milk-can and Apples 11, *I*
Mill on the Banks of La Couleuvre near Pontoise, The 156, *157*
Miller, Kenneth Hayes 182
Mirbeau, Octave 43, 116
Modern Gallery, New York 102, *305*, 305
Modern Painting: Its Tendency and Meaning 247, 249, 253, 334
Monet, Claude 15, 37, *44*, 66, 67, 74, 92, 99, 110, 118, 133, 137, 156, 174, 180, 224
Mont Sainte-Victoire 206
Mont Sainte-Victoire 56, *59*, *143*, 148
Mont Sainte-Victoire and Hamlet near Gardanne 53, 55
Mont Sainte-Victoire with a Large Pine Tree 239, *240*
Mont Sainte-Victoire with Pine Trees 340, *341*
Mont Sainte-Victoire with Viaduct 125, 125
Mont Sainte-Victoire with Viaduct Seen from Bellevue 125, 311
Montross Exhibition 288–97
Montross Gallery, 288–9, 296, 298, 311
Montross, Newman Emerson 246, 288, 289, 290
Moore, George 42, 43
Morandi, Giorgio 338
Morgan, J. P. 22
Morisot, Berthe 16, 110, 114, 317
Morosov, Ivan 61, 124, 158, 344

Moulin de la Galette 16
Mountains in Provence (near L'Estaque?) 290, 299, *XIV*
Muller, Joseph 160–61
Museum of Modern Art, New York 170, 335, 341–2

Nathan, George Jean 238
Nation, The (journal) 294
National Academy of Design 166
National Galerie, Berlin 156
National Portrait Gallery, London 137
Nemes, Marczell de 265
New Republic 252, 254, 258
New York 114, 205, 215, 341
New York Commercial Advertiser 34
New York Evening Post 103, 287
New York Evening Sun 156
New York Evening World 146
New York Globe 146
New York Herald 34, 95
New York Sun 95, 103, 118, 122–3, 130, 150, 155, 158, 206, 227
New York Sunday Times 175
New York Times 132, 135, 148, 186, 212–13, 215–16, 219, 291, 331
New York Times Magazine 296, 306
Newspaper Reader 210, 219
Nietzsche, Friedrich 140
Nordau, Max 115, 116, 117
Nude Descending a Staircase (Duchamp) 204

Oeuvre, L' 74, 100
Oil Mill, The 290, *292*
Old Sailor, The 159, *160*, 305, 306, 317
Old Sailor, The (full face) 159, *161*
Olivier, Fernande 56
Orwell, George 220
Osborn, William Church 317, 325
Osthaus, Karl Ernst 269

Pach, Walter 32, 76, 82, 112, 113, 114, 121, 122, 126, 132, 141, 155, 165, 169, 170, 171, 172, 193, 201, 203, 205, 212, 288, 338
Paine, Robert Treat, II 342
Pellerin, Auguste 44, 92, 112, 156, 158, 159, 171, 240, 306
Pennell, Joseph 332
Pennsylvania Academy of the Arts 312, 317
Philadelphia 115, 312, 317, 318, 333
Philadelphia Art Alliance 318
Philadelphia Record (newspaper) 318
Phillips Memorial Collection/Gallery, Washington 340, 342
Photo-Secession Gallery, New York 129, 131, 146, 148, 149
Picabia, Francis 93, 180, 190, 191, 223, 287, 288, 305
Picasso, Pablo 64, 66, 71, 72, 74, 75, 76, 77, 133, 141, 155, 165, 167, 168, 171, 174, 180, 182, 183, 191, 223, 229, 253, 259, 278, 287, 305, 311, 320, 324, *VI*, *VII*
Pines and Rocks 314, *314*
Pissarro, Camille 26, 42, 43, 92, 110, 180, 196, 216, 240, 317, 337
Pitti, Palazzo, Florence 53, 344
Portrait de Cézanne 192
Portrait of Ambroise Vollard 90, *91*
Portrait of Arthur Jerome Eddy 188, *189*
Portrait of Gustave Boyer 190, *193*
Portrait of Gustave Boyer with Straw Hat 50, *193*, 311
Portrait of Mme Cézanne: see Portrait of the Artist's Wife (V.229)
Portrait of Paul B. Haviland (de Zayas) 222, *223*
Portrait of the Artist's Wife (V.229) 130, 133, 165, 173, 198, 212, 263, 306, 317, *327*, 337, *XI*
Portrait of the Artist's Wife (V.369) 55, 56, 63, 72, *94*, 94, *V*
Portrait of the Artist's Wife (V.520) *199*

Portrait of Uncle Dominique 327
Post-Impressionist Exhibition, London 185, 201
Prendergast, M. B. 32, 34, 96, 114, 165, 201
Promenades of an Impressionist 130, 150, 245
Protest Against the Present Exhibition of Degenerate "Modernistic" Works in the Metropolitan Museum of Art 328
Public Ledger (journal) 318
Puvis de Chavannes, Pierre 64, 93, 95, 122, 179

Quinn, John 139, 140–41, 146, 165, 166, 168, 172–3, 179, 180, 183, 192, 198, 203, 225, 263, 306, 307, 308, 317, 323, 331–2, 341, 342

Raffaelli 110
Ray, Man 151
Reaper 214, 219
Reber, Gottlieb Friedrich 213, 215, 219, 306, 343
Redon, Odilon 40, 133, 165, 168, 170, 172, 174, 180, 182, 191
Rembrandt 124, 156, 201
Renard, Jules 96
Renoir, Auguste 16, 63, 64, 74, 92, 93, 95, 110, 132, 137, 155, 160, 164, 165, 167, 174, 180, 237, 239, 254, 255, 256, 267, 268, 276, 278, 317, 319, 325
Revolution in Art: An Introduction to the Study of Cézanne, Gauguin, Van Gogh, and Other Modern Painters 139
Rilke, Rainer Maria 115, 130
River Landscape 117, 118
Road, The 194, 193, 306
Robinson, Dr. Edward 205, 206
Rocks and Trees 297, 298
Rocks at Fontainebleau 311, 313
Rodin, Auguste 12, 12, 132, 155, 158, 174, 222, 229
Roofs and a Tree 143, 144
Roofs of L'Estaque, The 300, 301
Roosevelt, President Theodore 200–1
Rosenberg, Paul 269, 339, 342, 343
Ross, Robert 185
Rossetti, Dante Gabriel 221
Rothenstein, William 19
Rouart, Henri 82, 93, 133, 162, 163, 164, 165, 256
Rousseau, Henri 32, 112, 132, 180
Roussel, K.-X. 107, *108*
Rubens 241, 254
Ruckstull, F. Wellington 228, 228–31, 331, 334
Russell, Morgan 66, 67, 237
Rutter, Frank 61, 139, 140

Saint Louis 96
Saint-Henri near L'Estaque, seen from afar 271, 273
Salon d'Automne 112, 184
Salon d'Automne (1903) 93
Salon d'Automne (1904) 55, 74, 93, 94, 96, 99, 115, 118
Salon d'Automne (1905) 81, 111, 112
Salon d'Automne (1906) 81, 87
Salon d'Automne (1907) 81, 112, 126, 130, 201, 212
Salon d'Automne (1908) 77
Salon des Indépendants 32, 111
Santayana, George 14
Sargent, John S. 224
Saturday Evening Post (New York) 278
Schapiro, Meyer 277, 334
Scribner's (magazine) 121
Sears, Mrs. Montgomery 32, 34, 72, 130, 164, 165, 173, 192, 196, 290
Segonzac, Dunoyer de 191, 224
Self-Portrait (after a photograph) 290, 299
Self-Portrait (Walter Sickert) 138, 139
Self-Portrait (1878) 120, 121
Self-Portrait with a Beret 24, 25, 337

Self-Portrait with a Cap IV
Self-Portrait with a Felt Hat 202, 202
Self-Portrait with Bowler Hat 173, 198, 199
Seurat, Georges 14, 74, 95, 111, 133, 166, 167, 180, 201, 325, 342
Seven Apples and a Tube of Color 290, 291
Shaw, George Bernard 115n23
Shchukin, Sergei 12, 44, 61, 158, 344
Sheeler, Charles 77
Sickert, Walter 136, 138, *139*, 139, 165, 186
Signac, Paul 14, 32, 95, 130, 133, 167, 171, 319, 337
Sisley, Alfred 110, 157, 180, 184, 319
Sloan, John 32, 136, 184
Smoker, The (RWC.381) 56, *59*
Smoker, The (V.684) 219, *220*
Sonderbund 166, 167, 168, *169*, 212
Spaulding, John T. 342
Spring-House: see The Conduit
Steichen, Edward 76–7, 111, 129, 131, 141, 144, 145, 155, 165, 174, 212, 246
Stein, Gertrude 71, 72, *73*, 80, 125, 175, 256, 342, *VI*
Stein, Leo 53, *63*, 63, 67, 68, 93, 95, 97, 112, 130, 134, 165, 201, 237, 238, 245, 247, *248*, 248–59, 344, *VII*
Stein, Leo and Gertrude 53–82, 55, *56*, 56, 60, 61, 63, 66, 68, 71–7, 81, 82, 89, 114, 133, 139, 158, 161, 180, 226, 237, 339
Stein, Michael *56*, 56, 60, *61*, 74, 82, 130, 171, 249, 259
Stein, Sally 60, *61*, 66, 81, 82, 259
Stella, Joseph 317
Sterne, Maurice 82, 94, 95, 97, 184, 247
Stettheimer, Florine 247, *248*
Stieglitz, Alfred 76, 77, 111, 129, *131*, 132, 144, 146, 150, 155, 156, 157, 158, 166, 168, 174, 175, 179, 180, 181, 184, 198, 203, 222, 226, 245, 247, 249, 287, 312, 317, 323, 340
Still Life (Macdonald-Wright) 76, *78*
Still Life (Maurer) 78
Still Life 1911 (Bruce) 79
Still Life 1921–2 (Bruce) 79
Still Life of a Skull and Fruits 271, 276
Still Life of Fruits against a Blue Curtain 271, 275
Still Life of Fruits in a Dish and a Small Pot of Preserves 271, 275
Still Life with Apples 320, 322
Still Life with Apples and a Pear on a Plate 271, 274
Still Life with Apples and Oranges 239, 241
Still Life with Apples, Pears, and a Gray Jug XIII
Still Life with Basket of Apples 215
Still Life with Bottle, Tablecloth, and Fruits 263, 264
Still Life with Cherries 52, 53
Still Life with Fruit and Flower Holder 158, 159, 161, 170
Still Life with Fruits and Wine-glass 314, 315
Still Life with Ginger Jar 327, 328
Still Life with Ginger Jar, Fruits, and Towel 271, 275
Still Life with Green Jar and White Cup 311, 313
Still Life with Green Jug and Tin Kettle 118, 119
Still Life with Jug and Fruits 271, 274
Still Life with Milk-pot and Curtain 271, 274
Still Life with Potted Plants, a Coffee Pot, and a Rum Bottle 271, 274
Still Life with Putto 280, 290
Still Life with Rum Bottle 25, 25, 130, 290, 294, 298, 306
Still Life with Three Peaches 344, XVI
Stokowski, Leopold 312
Stransky, Josef 342
Struggling Lovers 213, 219
Studio Party (Stettheimer) 247, *248*
Studio, The (journal) 101
Study of Modern Painting, The 220

Study of the Modern Evolution of Plastic Expression, A 222
Sullivan, Mrs. Cornelius J. 342
Sumner, John O. 26, 173, 192, 196
Sunday Afternoon at the Grande Jatte, A (Seurat) 325
Synchromism 237, 238, 239, 248, 253, 317

Tanguy, père 11, 12, 14, 49
Three Bathers 81, 82
Three Lives 72
Toklas, Alice B. 71, *73*
Toulouse-Lautrec, Henri de 32, 74, 93, 132, 171, 180
Toward Mont Sainte-Victoire 161, 162
Tree Trunks 148, 149
Tribune 103
Tschudi, Hugo von 156, 163, 344
Turning Road 194, 194, 314, 317
Turning Road at Auvers-sur-Oise 48, 49
Turning Road in a Forest 290, 292
Twachtman, John 185
Tyson, Carroll S., Jr. 312, 342

Uffizi, Florence 53, 98

Vallier 159
Vauxcelles, Louis 43, 101, 102
Venice Biennale 337–8
Venturi, Lionello 277
Vie Artistique, La 14
Vienna 135, 171
View of L'Estaque and the Château d'If 290, 293
View of Toledo 125, 267
Vlaminck 133, 167, 263, 319
Vollard, Ambroise 14, 19, 22, 24, 26, 37, 40, 44, 46, 46, 47, 47–9, 53, 55, 56, 89, 90, 91, 93–4, 97, 98, 107–11 passim, 121, 130, 132, 133, 138, 155, 158–9, 160, 164, 165, 167, 169, 170, 172, 180, 192, 193, 194, 195, 200, 203, 205, 206, 206, 225–6, 250, 263–9 passim, 271, 276, 287, 295, 302, 343
Von Kunst und Künstlern 115
Vuillard, Edouard 64, 93, 130, 167, 170, 171, 319

Walkowitz, Abraham 76, 77, 98, 132, 180, 287
Walters, Henry 205
Washerwomen 149, 150
Watts, Harvey M. 318, 319
Weber, Max 76, *80*, 82, 98, 112, 131, 132, 180, 201, 290, 291
Weekly Review 318
Weir, J. Alden 22
Well in the Park of Château Noir 149, 149, 174, 202–3
What Nietzsche Taught 238
Whistler, James McNeill 100, 165, 179, *189*
Whitley 77
Whitney, Gertrude V. 323
Wildenstein Galleries 319, 342
Wildenstein, Georges 339
Williams, Mrs. Oliver 114
Winterbotham, Joseph 342
Woman with a Boa 216, 219
Woman with a Rosary 133, 136, 137, 170, 172, 184, 200, 201, 203, 212, 215, X
Woman with Head-dress and Boa 219
World's Fair (Chicago) 11, 96
Wright, Willard Huntington 66, 211, 227, 237–46, 239, 247, 248, 249, 253, 254, 297, 298, 306, 334, 341, XII
Wyzewa, Teodor de 267

Young Man with a Skull 276
Young Man with a White Scarf 97, 98, 136, 337
Young Philosopher, The 219, 221
Young, Mahonri 63

Zayas, Marius de 155, 221, 223, 246, 284, 287, 288, 308, 312, 319, 326, 340
Zola, Emile 43, 44, 74, 99, 100, 114, 119, 206, 306